YALE UNIVERSITY PRESS
PELICAN HISTORY OF ART

FOUNDING EDITOR: NIKOLAUS PEVSNER

RUDOLF WITTKOWER

ART AND ARCHITECTURE IN ITALY
1600–1750

REVISED BY JOSEPH CONNORS AND JENNIFER MONTAGU

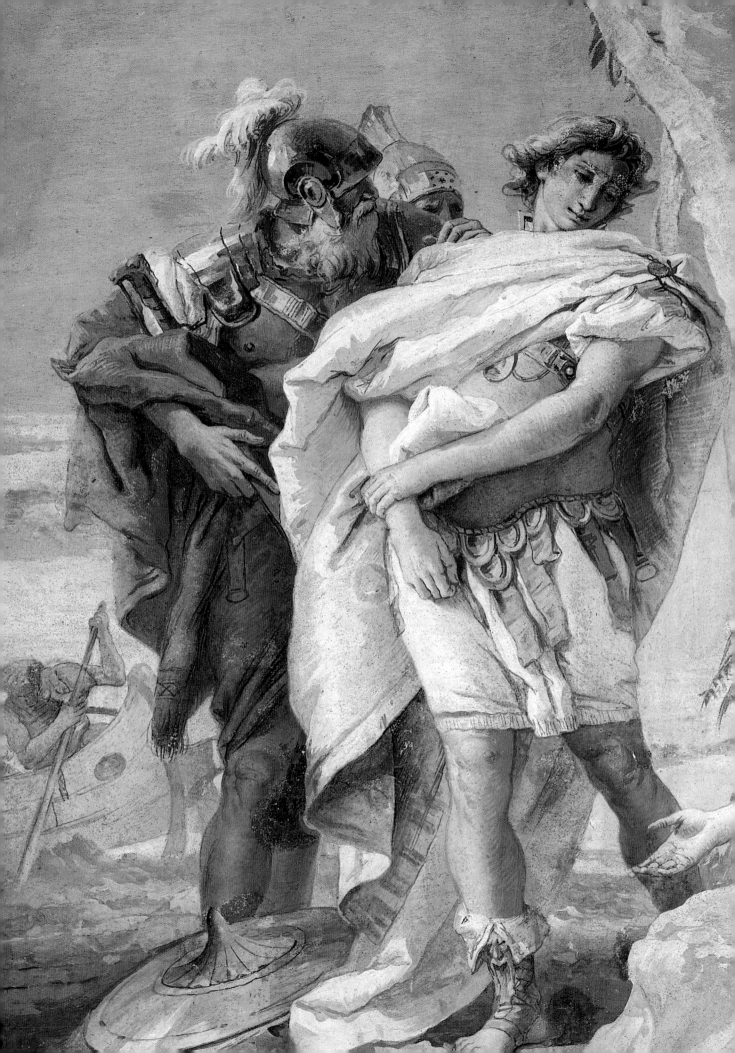

Rudolf Wittkower
Revised by Joseph Connors and Jennifer Montagu

Art and Architecture in Italy 1600–1750

PART THREE

Late Baroque and Rococo

1675–1750

Yale University Press New Haven and London

To
My Wife

First published 1958 by Penguin Books Ltd
Sixth edition, revised by Joseph Connors and Jennifer Montagu,
first published 1999 by Yale University Press
10 9 8 7 6 5 4 3 2 1

Set in Monophoto Ehrhardt by Best-set Typesetter
Printed in Singapore
Designed by Sally Salvesen

TITLE PAGE: Giambattista Tiepolo, *Rinaldo and Armida*, Vicenza,
Villa Valmarana.

Library of Congress Cataloging-in-Publication Data

Wittkower, Rudolf.
 Painting in Italy, 1600–1750 / Rudof Wittkower, revised by
Joseph Connors and Jennifer Montagu
 p. cm.
 Updated ed. of: Art and architecture in Italy, 1600 to 1750.
 Contents: [1] Early Baroque – [2] High Baroque – [3] Late
Baroque.
 Includes bibliographical references and index.
 ISBN 0-300-07890-0 (cloth 3 vols. : alk. paper), ISBN 0-300-
07889-7 (paper 3 vols. : alk. paper), – ISBN 0-300-07939-7 (paper:
v. 1 : alk. paper) – ISBN 0-300-07940-0 (paper : v. 2 : alk. paper) –
ISBN 0-300-0741-9 (paper : v. 3 : alk. paper)
 1. Art, Italian–History. 2. Art, Modern– 17th–18th cen-
turies–Italy. I. Connors, Joseph, II. Montagu, Jennifer. III.
Wittkower, Rudolf. Art and architecture in Italy, 1600–1750. IV.
Title.
N6926.W5 1999
759.5–dc21 98-49066
 CIP

Contents

Principles followed in the new edition

TEXT: Unchanged, except for some dates of artists for which new secure documents have emerged; these have been incorporated where we are aware of them, but no serious attempt has been made to check those given in the previous edition. These changes have not been noted, except where they invalidate a statement in the text, in which case a starred note is provided. Dates of works of art have not been similarly changed; however, where newly-found documentation (concerning dates, or other facts) makes the text seriously misleading, this has been indicated with a starred note. Such notes have been kept to the minimum. Cross-references to other volumes are cited in the form (II: Chapter 4, Note 27).

NOTES: Unchanged, except for artists' dates (as for the Text); a few starred notes correct the more misleading errors. Some references, now omitted from the Bibliography, have been expanded. The bibliography in the Notes is now badly out of date: for artists given individual bibliographies these should be consulted; more recent information on most of the others can be found through the general books listed either under the relevant art, or the relevant region. The same applies to the works.

BIBLIOGRAPHY: Wittkower felt that his bibliography was already long enough; we have therefore tried to limit the inevitable extension by eliminating many works cited in earlier editions, even though these may be important for historiography. This applies particularly to articles dealing with a limited aspect of an artist, or a few works, where these have been adequately covered by a later monograph. This decision was the more easily taken in the realisation that almost everything that has been deleted from the bibliography is still cited in the Notes; it is the more easy to justify where there is a good modern work with a full bibliography, but it has been somewhat relaxed where more recent literature may be hard to find. Frequent references are made to reviews; almost invariably, these are critical, because these are the ones that add significant new material, or point out short-comings that the reader should be warned about; in many cases this is unfair, and the same book may have been well received by some, or even most other reviewers. However, some books do deserve harsh judgement, while meriting inclusion in the bibliography for their illustrations, or simply because they are the only studies available. It should be noted that, perhaps inadvisably, we have omitted theses published from microfilm. (1) Arts: Wittkower's text very rarely mentions prints or drawings; we have added nothing on prints, and even on drawings (where there have been innumerable publications) we have tried to select the more important and reliable, such as the major museum catalogues covering this period, and the most important exhibition catalogues. The same principle has been applied to the Regions. Museum catalogues of paintings have not been included – with one exception. (2) Artists: The principles upon which Wittkower distinguished between those artists for whom summary bibliographies were provided only in the Notes, and those listed in the Bibliography, are not clear. In the case of artists of some importance, on whom a good monograph now exists, we have decided to add them. On the other hand, a number of relatively minor figures formerly included in the Bibliography (and some not so minor) can best be studied either through the general books, or from the *Dizionario biografico degli italiani* or the *Dictionary of Art* (published by Macmillan), and they have been omitted. Artists mentioned by Wittkower only in the notes, or omitted altogether, have not been included, even where there is a good modern monograph (with one exception). Because of the abundance of new publications, it has not been possible to list articles with the generosity of previous editions. Where there is a recent monograph, articles are listed only if they add substantial new information (not, for example, those that only publish one or two new works), or if they provide important factual information on works dealt with at some length in the text; however, sometimes a recent article is cited, where it points to earlier bibliography. Where there is no good monograph, a selection of the more important articles is given. As Wittkower said very little about drawings, books or exhibitions of drawings by artists whose drawings are not discussed in the text have only very seldom been included. However, for some artists catalogues of their drawings constitute virtual monographs, and these have been cited. For many Genoese and Neapolitan artists, while there are numerous articles dealing with individual aspects or a few works, more useful references can be found through the general works on those cities. For other centres some general books, e.g. *I pittori bergamaschi*, contain what are in effect brief monographs, and references have been given also under the individual artists.

ILLUSTRATIONS: One hundred illustrations have been added to this edition. The first priority was to illustrate those works which Wittkower describes, or specifically comments upon, so that the reader can better follow the text, The second priority was to give a better indication of the work of some of the major artists who had been rather inadequately represented, and, finally, an attempt has been made to flesh out the personalities of some of those artists dismissed in a brief sentence or two in the text. In the captions to these new illustrations account has been taken of new locations, which occasionally differ from those given in the text, and also changes in the dating confirmed by newly published documents, or authorised by more recent studies; captions to the original illustrations have not been changed. References to illustrations in other volumes are given in the form [II: 23] to indicate plate 23 of volume II.

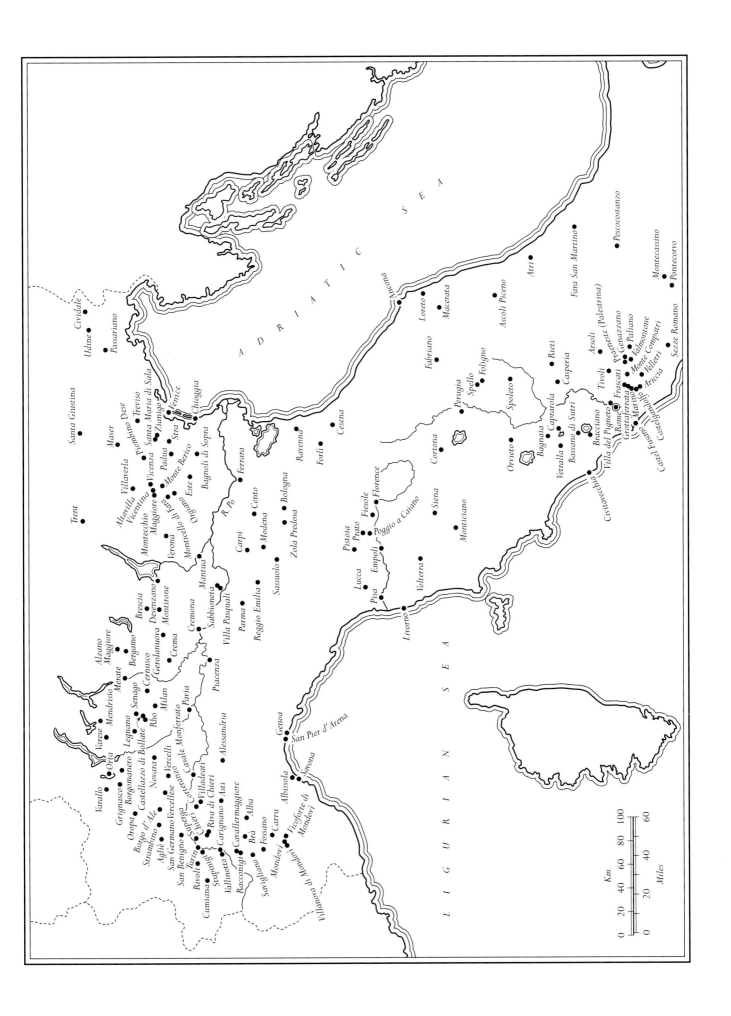

Introduction

After the death of Alexander VII (1667) papal patronage in Rome rapidly declined, and even the aged Bernini was starved of official commissions. On the other hand, it was precisely at this moment, during the last quarter of the seventeenth and the beginning of the eighteenth centuries, that the Jesuits and other Orders as well as private patrons gave painters unequalled opportunities. Yet Maratti's international Late Baroque in painting, the fashionable style of the day, had as little power to electrify and galvanize and to lead on to new ventures as Carlo Fontana's parallel manner in architecture. In fact, Rome's artistic supremacy was seriously challenged not only by much more stirring events in the north and south of Italy, but above all by the artistic renaissance in France, which followed in the wake of the amassing of power and wealth under Louis XIV's centralized autocracy. The time was close at hand when Paris rather than Rome came to be regarded as the most dynamic art centre of the western world.

None the less the Roman Baroque had an unexpectedly brilliant exodus. Under the Albani Pope Clement XI (1700–21) Rome began to rally, and the pontificates of Benedict XIII Orsini (1724–30) and Clement XII Corsini (1730–40) saw teeming activity on a monumental scale. It was under these popes that many of the finest and most cherished Roman works saw the light of day, such as the Spanish Stairs, the façade of S. Giovanni in Laterano, and the Fontana Trevi. Moreover, foreigners streamed to Rome in greater numbers than ever before, and artists from all over Europe were still magically drawn to the Eternal City. But the character of these pilgrimages slowly changed. Artists no longer came attracted by the lure of splendid opportunities as they did in the days of Bernini and Pietro da Cortona; more and more they came only to study antiquity at the fountain head.

To a certain extent the French Academy in Rome, founded as early as 1666, anticipated this development, and in the eighteenth century the students of the Academy were almost entirely concerned with the copying of ancient statuary. With the growth of French influence in all spheres of life, political, social, and artistic, the classicizing milieu of the Academy developed into a powerful force in Rome's artistic life; and it was due to this centre of French art and culture on Roman soil that countless French artists were able, often successfully, to compete for commissions with native artists.

The popes themselves nourished the growing antiquarian spirit.[1] Preservation and restoration of the remains of antiquity now became their serious concern. From the mid sixteenth century on antique statues had left Rome in considerable numbers.[2] This trade assumed such proportions that Innocent XI (1676–89) prohibited further export, and Clement XI's edicts of 1701 and 1704 confirmed this policy. Clement XI also inaugurated a new museological programme by planning the Galleria Lapidaria and the Museum of Early Christian Antiquities in the Vatican. Clement XII (1730–40) and Benedict XIV (1740–58) followed in his footsteps; under them the Museo Capitolino took shape, the first public museum of ancient art. In keeping with the trend of the time, the learned Benedict XIV opened four Academies in Rome, one of them devoted to Roman antiquities. Clement XIII (1758–69) set the seal on this whole movement in 1763 by appointing Winckelmann, the father of classical archaeology, director general of Roman antiquities, an office, incidentally, first established by Paul III in 1534. Finally, it was in 1772, during Clement XIV's pontificate (1769–74), that construction began of the present Vatican museum, the largest collection of antiquities in the world.

Archaeological enthusiasm was also guiding the greatest patron of his day, Cardinal Alessandro Albani, when he planned his villa outside Porta Salaria.[3] Built literally as a receptacle for his unequalled collection of ancient statues (now mainly in Munich), the villa, erected by Carlo Marchionni between 1746 and 1763, was yet intended as a place to be lived in – an imperial *villa suburbana* rather than a museum. The Cardinal's friend and protégé Winckelmann helped to assemble the ancient treasures; and it was on the ceiling of the sumptuous great gallery that Anton Raphael Mengs, the admired apostle of Neo-classicism, painted his *Parnassus*, vying, as his circle believed, with ancient murals.

There was, to be sure, a strong nostalgic and romantic element in the eighteenth-century fascination with the ancient world. Nowhere is this more evident than in the work of Giovanni Battista Piranesi (1720–78), who, coming from Venice, where he had studied perspective and stage design, settled permanently in Rome in 1745.[4] The drama and poetry of his etchings of Roman ruins (*Le Antichità romane*, 1756) have no equal, even at this time when other artists of considerable merit were attracted by similar subjects, stimulated, more than ever before, by a public desirous to behold the picturesque remains, true and imaginary, of Roman greatness. Although Piranesi was deeply in sympathy with the new tendencies, a devoted partisan of Roman pre-eminence and a belligerent advocate of the great variety in Roman art and architecture,[5] his vision, procedure, and technique ally him to the Late Baroque masters. Yet he never tampered with the archaeological correctness of his views in spite of his play with scale – contrasting his small, bizarre figures derived from Salvator to the colossal size of the ruins – or in spite of the warm glow of Venetian light pervading his etchings and of the boldness of his compositions, in which, true to the Baroque tradition, telling diagonals prevail. It is the Baroque picturesqueness of these plates, so different from the dry precision of Neo-classical topographical views, that determined for many generations the popular conception of ancient Rome.

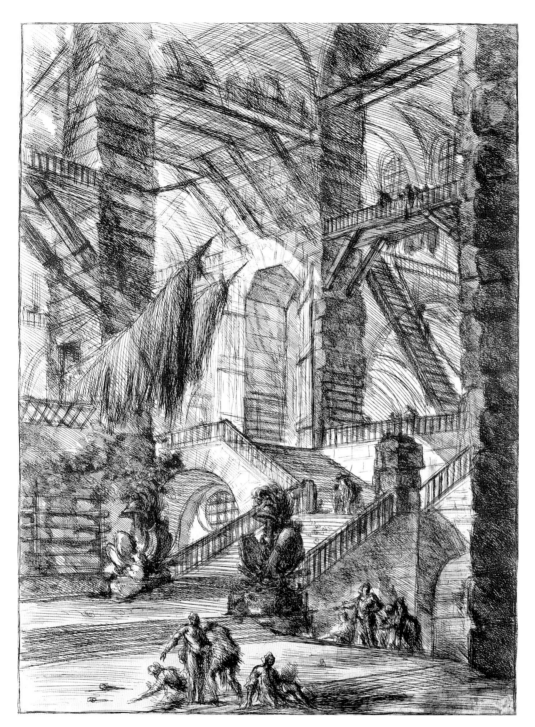

1. Giovanni Battista Piranesi:
Plate from the *Carceri*, 1745.
Etching

Piranesi's *vedute* of ancient Rome no less than those of the contemporary city (*Vedute di Roma*, published from 1748 on) reveal the trained stage designer, whose early and most famous series of plates, the *Carceri d'Invenzione*, first issued in 1745 and re-etched in 1760–1, are romantic phantasmagorias derived from Baroque opera sets [1]. The *Carceri* and the *Vedute*, with their oblique perspectives which add a new dimension of drama and spatial expansion, reveal the influence of Ferdinando Bibiena's 'invention' of the *scena per angolo* (Chapter 5, Note 47) [108]. Thus in the *vedute* Piranesi wedded two traditions which seem mutually exclusive: that of the Baroque stage with that of topographical renderings of an 'architectural landscape'. Piranesi's case,

however, was far from unique, for in the course of the eighteenth century ideas and conceptions of the stage designer invaded many sectors of the other arts.[6]

It should be recalled that during most of the seventeenth century the influence of the stage on painting and architecture was more limited than is usually believed. It is, of course, true that effects first developed for the stage were also used in works of a permanent character.[7] But the basic High Baroque concept of the unification of real and artistic space, that illusionism which blurs the borderline between image and reality, is not by its very nature a 'theatrical' device. It may be argued that the theatre and the art of the seventeenth century developed in the same direction, for in

both cases an emotionally stirring and often overwhelming chain of seemingly true impressions was to induce the beholder to forget his everyday existence and to participate in the pictorial 'reality' before his eyes. Yet Roman fresco painting from Cortona's Barberini ceiling to Gaulli's work in the Gesù shows as little direct impact from the theatre as Borromini's architecture. In another chapter I have attempted to demonstrate that the Venetian Baldassare Longhena, by contrast, owed decisive impulses to the stage and that it was he who laid the foundation for the scenographic architecture of the eighteenth century. Similarly, in the history of Late Baroque painting from Padre Pozzo to Tiepolo stage requisites such as the proscenium arch, the curtain, the *quadratura* backdrop, and the painted 'actors' stepping out of the painted wings play an important and often overwhelming part. To what extent painting in the grand manner and stage design were then regarded as basically identical operations may be gathered from Pozzo's work *Perspectiva pictorum et architectorum* (Rome, 1693) which was to serve the theatre and the Church alike. Statistical facts illuminate the growing obsession with the theatre during the Late Baroque period: in 1678, for instance, 130 comedies were represented on private stages in Rome alone.[8] In the early eighteenth century the theatre had even greater importance; it was certainly as significant for the creation of visual conventions and patterns as cinema and television are in the twentieth century.[9]

If in the new era it is pertinent to talk of the ascendancy of the stage designer over the painter (often, of course, one and the same person), the ascendancy of the painters over the sculptors seems equally characteristic. There is circumstantial documentary evidence that on many occasions painters were called upon to make designs for the sculptors to work from – a situation utterly unthinkable in Bernini's circle. Only a few examples can here be given. Maratti seems to have had a hand in the work of many sculptors. He was a close friend and constant adviser of Paolo Naldini; he made designs for four allegorical statues in S. Maria in Cosmedin,[10] for Monnot's tomb of Pope Innocent XI, and for the monumental statues to be placed in Borromini's tabernacle niches in the nave of S. Giovanni in Laterano.[11] Gaulli is credited with the designs of Raggi's rich stucco decorations in the Gesù.[12] The Genoese painter Pietro Bianchi, who settled in Rome, maintained close contacts with the sculptors Pietro Bracci, Giovanni Battista Maini, Filippo della Valle, Francesco Queirolo, and others and supplied them with sketches, as his biographer relates in detail.[13] The new custom appears also to have spread outside Rome, to mention only the Neapolitan Solimena who helped the sculptor Lorenzo Vaccaro with designs.[14] This whole trend, which of course came to an end with the dawn of Neo-classicism, was not in the first place the result of the inability of sculptors to cope with their own problems. It was, to a certain extent in any case, connected with a revaluation of the sketch as such, a question which must be discussed in a wider context.

In the age of the Renaissance, drawing became the basis for the experimental and scientific approach to nature. But drawing remained a means to an end, and the end was the finished painting. The latter was prepared by many stages,

from the first sketches and studies from nature to the carefully executed final design and cartoon. As early as the sixteenth century artists began to feel that this laborious process maimed the freshness and vitality of the first thought. Vasari, writing in 1550, made the memorable observation that 'many painters ... achieve in the first sketch of their work, as though guided by a sort of fire of inspiration ... a certain measure of boldness; but afterwards, in finishing it, the boldness vanishes.' So, an academic Mannerist arose as the mouthpiece of anti-academic spontaneity of creation. Throughout the seventeenth and even the eighteenth century the Renaissance method of careful preparation, fully re-instated by Annibale Carracci, remained the foundation of academic training, but a number of progressive artists, although never working on canvas *alla prima* (possibly with the exception of Caravaggio), attempted to preserve something of the brio of spontaneous creation, with the result that the finish itself became sketchy. During the eighteenth century, from Magnasco to Guardi, the masters working with a free, rapid brush-stroke assumed steadily greater importance and foreshadowed the position of romantic painters like Delacroix, for whom the first flash of the idea was 'pure expression' and 'truth issuing from the soul'. It is in the context of this development that the painter's sketch as well as the sculptor's bozzetto were conceded the status of works of art in their own right, and even the first ideas of architects, such as the brilliant 'notes' by Juvarra, were looked upon in the same way.

All this required a high degree of sophistication on the part of the public. The rapid sketches no less than the works of the masters of the loaded brush made hitherto unknown claims on sensibility and understanding, for it surely needs more active collaboration on the part of the spectator to 'decipher' a Magnasco than a Domenichino or a Bolognese academician. The eighteenth-century virtuoso was the answer. Keyed up to a purely aesthetic approach, he could savour the peculiar qualities and characteristics of each master; he would be steeped in the study of individual manner and style and find in the drawing, the sketch, and the bozzetto equal or even greater merits than in the finished product. Behind this new appreciation lay not only the pending emergence of aesthetics as a philosophical discipline of sensory experience, but above all the concept of the uniqueness of genius. The new interpretation of genius made its entry from about the middle of the seventeenth century on, and comparative changes in the artist as a type were not long delayed. But the early eighteenth-century artist was not the genius of the romantic age who revolted against reason and rule in favour of feeling, naiveté, and creation in sublime solitude. By contrast, the Late Baroque artist was a man of the world, rational and immensely versatile, who produced rapidly and with the greatest ease; and since he felt himself part of a living tradition, he had no compunction in using the heritage of the past as a storehouse from which to choose at will. Juvarra and Tiepolo are the supreme examples.

But now it is highly significant that none of the new terms of reference arising during the Late Baroque were of Italian origin. Aesthetics as an autonomous discipline was a German accomplishment;[15] the nature of genius was defined

in England; and it was the Englishman Jonathan Richardson who laid down the rules of the 'science of connoisseurship'.[16] Nor had Italy a collector of drawings of the calibre and discriminating taste of the Frenchman Mariette. The theory of art, that old domain of Italian thought, lay barren. In the eighteenth century the relationship between Italy and the other nations was for the first time reversed: English and French treatises appeared in Italian translations. While in England the whole structure of classical art theory was attacked and replaced by subjective criteria of sensibility, Conte Francesco Algarotti (1712–64),[17] at this period the foremost Italian critic but in fact no more than an able vulgarizer, dished up all the old premises, precepts, and maxims of the classical theory. Not only Roman, but Italian supremacy had seen its day. France and, as the century advanced, England assumed the leading roles.

It is all the more surprising that never before had Italian art attracted so many foreigners. The treasures of Italy seemed now to belong to the whole of Europe and nobody could boast a gentleman's education without having studied them. It is equally surprising that never before were Italian artists a similar international success. In an unparalleled spurt they carried the torch as far as Lisbon, London, and St Petersburg – just before it was extinguished.

Architecture

INTRODUCTION
LATE BAROQUE CLASSICISM AND ROCOCO

An authoritative history of Italian eighteenth-century architecture cannot yet be written. Many of the monuments are not at all or only insufficiently published; the dating of many buildings is controversial or vague; the buildings without architects and the names of architects without buildings abound. It has been pointed out that in one corner of Italy, the province of Treviso alone, about 2,000 palaces, churches, and oratories were built in the course of the century. Nobody has seriously attempted to sift this enormous material, and it is only recently that a number of major architects have been made the subject of individual studies.[1] Any attempt at a coherent vision of the period would therefore appear premature. And yet it seems that certain conclusions of a general nature may safely be drawn.

From the end of the seventeenth century onwards architects looked back to a dual tradition. There was close at hand and still fresh before everybody's eyes the great work of the Roman seventeenth-century masters, which decisively altered the course of architecture and formed a large reservoir of new ideas and concepts. There was, moreover, the older tradition, that of the Cinquecento, and behind it that of classical antiquity itself. It is at once evident that from the end of the seventeenth century onwards the repertory from which an architect was able to choose had almost no limits, and it is a sign of the new period that architects were fully aware of this and regarded it as an asset. Juvarra is a case in point. His studies ranged over the whole field of ancient and Italian architecture without any aesthetic blinkers – from measured drawings of the Pantheon to Brunelleschi, Sanmicheli, the Palazzo Farnese, Bernini, and Borromini, among many others. This attitude is nowadays usually condemned as wicked, academic and eclectic, and, to be sure, it cannot be dissociated from the intellectualism of the academies and their steadily growing influence. Hesitatingly, however, I have to pronounce once more the all-too-obvious commonplace that every artist and architect in so far as he works with a traditional grammar and with traditional formulas is an 'eclectic' by the very nature of his activity. It is the mixture and the interpretation of this common 'language' (and, naturally, also the reaction against it) on which not only the personal style and its quality but also the evolution of new concepts depend. The longer a homogeneous artistic culture lasts – and to all intents and purposes the Italian Renaissance in its broadest sense spanned an epoch of more than 350 years – the larger is, of course, the serviceable repertory. How did the architects from the late seventeenth century onwards handle it?

No patent answer can be given, and this characterizes the situation. On the one hand, there are those, typical of a waning epoch, who reach positions of eminence by skilfully manipulating the repertory without adding to it a great many original ideas, and among their number Carlo Fontana, Ferdinando Fuga, and Luigi Vanvitelli must be counted. Then there are those who fully master the repertory, choose here and there according to circumstances, and yet mould it in a new and exciting way. The greatest among these revolutionary traditionalists is certainly Filippo Juvarra. Finally there is the band of masters, possibly smaller in numbers, who contract the repertory, follow one distinct line, and arrive at unexpected and surprising solutions. They are still the least known and often not the most active architects of the period; thus the names of Filippo Raguzzini, Gabriele Valvassori, Ferdinando Sanfelice, and Bernardo Vittone, to mention some of the most important, convey very little even to the student of Italian architecture.

Admittedly our division is far too rigid, for architects may at different periods of their careers or in individual works tend towards one side or the other. But on the whole one may safely postulate that the first two groups drew on the store of classical forms and ideas rather than on the Borrominesque current, without, however, excluding a temperate admixture from the latter. The last group, by contrast, found its inspiration directly or indirectly mainly in Borromini. When discussing Bernini's and Cortona's architecture, I tried to assess the specific quality of their 'classicism'. Architects could follow their lead without accepting the dynamic vigour of their work. Dotti's draining of Cortona's style in the Madonna di S. Luca near Bologna is as characteristic as Vanvitelli's formalization of Bernini's S. Andrea al Quirinale in the Chiesa dei PP. delle Missioni at Naples (c. 1760). The classicism that emerged often replaced the wholeness of vision of the great masters by a method of adding motif to motif, each clearly separable from the other (p. 8); to this extent it is permissible to talk of 'academic classicism', but we shall see that the term should be used with caution.

A rather severe classicism was the leading style in Italy between about 1580 and 1625. After that date a tame classicizing architecture (e.g. S. Anastasia and Villa Doria-Pamphili in Rome; cathedral at Spoleto) was practised by some minor masters parallel to the work of the giants of the High Baroque. Towards the end of the century a new form of classicism once again became the prevalent style. In the process of revaluation Carlo Fontana must be assigned a leading part. Venice with Tirali and Massari soon followed, and various facets of a classicizing architecture remained the accepted current until they merged into the broad stream of Neo-classicism. But by comparison with the architecture of Neo-classicism the classical architecture of pre-Neo-classicism appears varied and rich and full of unorthodox incidents. We may therefore talk with some justification of 'Late Baroque Classicism', and it would be a contradiction in terms to circumscribe this style by the generic epithet 'academic'. The process of transition from 'Late Baroque

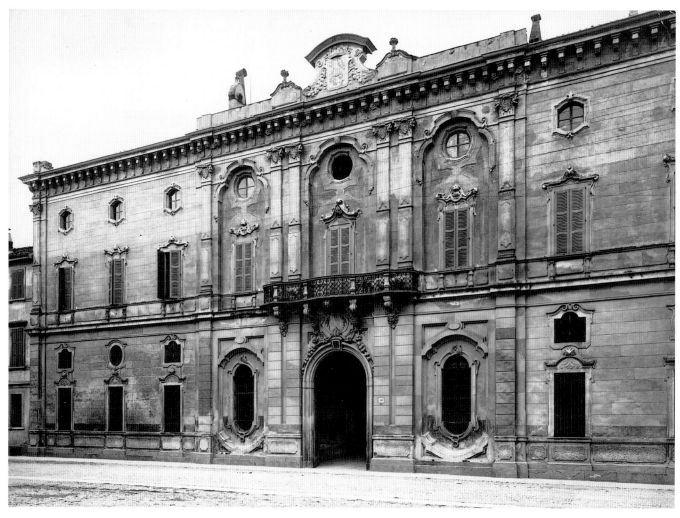

2. Cremona, Palazzo Stanga, early eighteenth century

Classicism' to Neo-classicism can often be intimately fol-
lowed, and before the monuments themselves there is not a
shadow of doubt when to apply the terminological division.

What differentiates Late Baroque Classicism from all
previous classical trends is, first, its immense versatility,[2]
and to this I have already alluded. In Rome, Turin, and
Naples it may be flexible enough to admit a good deal of
Borrominesque and pseudo-Borrominesque decoration;
even Late Mannerist elements, such as undifferentiated
framing wall strips, often belong to the repertory. One of the
strangest cases is the façade of S. Maria della Morte in
Rome, where Fuga weds Ammanati's Mannerist façade of S.
Giovanni Evangelista (Florence) with the aedicule façade
stemming from Carlo Rainaldi. Venice, by contrast, steers
clear of any such adventures and returns straight to
Scamozzi, Palladio, and beyond, to classical antiquity. The
second feature characteristic of the style is its deliberate
scenic quality, which is not only aimed at by men born many
years apart, like Fontana, Juvarra, and Vanvitelli, but also by
the masters of the non-classical trend, as a glance at
Raguzzini's Piazza S. Ignazio proves. Finally, both classicists
and non-classicists favour a similar kind of colour scheme:
broken colours light in tone, blues, yellows, pinks, and much

white – in a word typically eighteenth-century colours, and
in Carlo Fontana's work the turning away from the warm,
full, and succulent colours of the High Baroque may be
observed. Thus, on a broad front the classical and non-clas-
sical currents have essential qualities in common.

In the over-all picture of eighteenth-century architecture
Late Baroque Classicism appears to have the lead. But one
should not underestimate the importance of the other trend,
which may safely be styled 'Italian Rococo' – not only
because of the free and imaginative decoration and the relin-
quishing of the orders as a rigid system of accentuation, but
mainly because of the rich play with elegant curvilinear
shapes and spatial complexities. Most of the architects who
brought about the anti-classical vogue were born between
1680 and 1700, the majority in the nineties, just like the
sculptors and painters with similar tendencies. From about
1725 on and for the next twenty-five years these masters had
an ample share in the production of important buildings.
Next to Rome, the chief centres are Naples, Sicily, and
Piedmont; but other cities can also boast a number of
unorthodox Rococo designs, of which we may here remem-
ber Gianantonio Veneroni's majestic Palazzo Mezzabarba at
Pavia (1728–30), so similar to Valvassori's Palazzo Doria-

Pamphili,[3] the extravagant Palazzo Stanga at Cremona [2],[4] and the façade of S. Bartolomeo at Modena (1727) which recalls works of the southern German Baroque.[5]

By and large it may be said that the official style of the Church and the courts was Late Baroque Classicism and that the Italian version of the Rococo found tenacious admirers among the aristocracy and the rich bourgeoisie. In Rome, in particular, numerous palaces of unknown authorship were built[6] which form a distinct and coherent group by virtue of their elegant window-frames and by the fact that the windows in different tiers are interconnected; so that for the first time in its history the Roman palace shows a primarily vertical accentuation accomplished not by the solid element of the orders but by the lights.

There cannot be any doubt that the rocaille decoration which one finds in Northern Italy rather than Rome derives from France, whence the Rococo conquered Europe. Yet it would be wrong to believe that France had an important formative influence on the style as a whole. The Italian Rococo has many facets and cannot be summed up by an easy formula; but far from being foreign transplantations, all the major works of the style, such as the Spanish Stairs in Rome or Vittone's churches in Piedmont, are firmly grounded in the Italian tradition and have little in common with French buildings of the period. It is not so strange, however, that it was the other, the classical current that often took its cue from France; for French classicism, filtered through a process of stringent rationalization, gave the world the models of stately imperial architecture. And from Juvarra's Palazzo Madama in Turin to Vanvitelli's palace at Caserta the French note makes itself strongly felt.

It was also in France that two theoretical concepts, Italian in origin, were taken up and developed which, when handed back to Italy, became instrumental in undermining the relative freedom of both the Late Baroque Classicism and the Italian Rococo. One of these, proportion in architecture, which had always fascinated the Italians, was turned into an academic subject during the seventeenth century by Frenchmen like M. Durand and F. Blondel.[7] When in the course of the eighteenth century it was taken up again by the Italians Derizet (a Frenchman by birth), Ricciolini, Galiani, F. M. Preti, G. F. Cristiani, Bertotti-Scamozzi, and others, it had the stereotyped rigidity given to it by the French. Canonical proportions can, of course, be applied only where divisions are emphatic, unambiguous, and easily readable – in a word, in a rational, i.e. classical architectural system. The age of reason was dawning, and to it also belongs the second concept in question. The Frenchman de Cordemoy (1651–1722) had first preached in his *Nouveau Traité* of 1706 that truth and simplicity must dictate an architect's approach to his subject and that the purpose of a building must be expressed in all clarity by its architecture – intellectual requirements behind which one can sense the rational concept of a 'functional' architecture.[8] Antique in origin, the principle of the correspondence between the purpose of a building and the character of its architecture had always been a cornerstone of Italian architectural theory; nothing else is adumbrated by the demand of 'decorum'. But now, interpreted as simplicity and naturalness, the concept had implicitly a strong anti-Baroque and anti-Rococo bias. The

new ideas found an energetic advocate in the Venetian Padre Carlo Lodoli (1690–1761);[9] he in turn prepared the ground not only for the influential works of the French Abbé Laugier but also for the neo-classical philosophy of Francesco Milizia, who, by describing Borromini's followers as 'a delirious sect', determined the pattern of thought for more than a hundred years.

Venetian architects returned to pure classical principles at a remarkably early date, probably owing to an intellectual climate that led to the rise of Lodoli, the prophet of rationalism.[10] This helps to explain what would otherwise look like a strange paradox. Venice, where in the eighteenth century gaiety had a permanent home, the city of festivals and carnivals as well as of polite society, the only Italian centre where the feminine element dominated – Venice seemed predestined for a broad Rococo culture, and her painters fulfil our expectations. But in contrast to most other Italian cities, Venice had no Rococo architecture. In the privacy of the palace, however, the Venetians admitted Rococo decoration. It is there that one finds rocaille ornament of a daintiness and delicacy probably without parallel in Italy.[11]

It is in keeping with the political constellation that, next to Rome, the two Italian kingdoms, Naples in the South and Sardinia in the North, absorbed most of the great architects of the period and offered them tasks worthy of their skill. While we can, therefore, discuss summarily the rest of Italy, these three centres require a closer inspection. By far the most interesting architectural events, however, took place in the Piedmontese realm of the Kings of Sardinia; for this reason a special chapter will be devoted to architecture in Piedmont.

ROME

Carlo Fontana (1638–1714)

Carlo Fontana, born in 1638[12] near Como, in Rome before 1655, was the man on whose shoulders fell the mantle of the great High Baroque architects. He began his career in the later 1650s as an architectural draughtsman and clerk of works to Cortona, Rainaldi, and Bernini. We have often come across his name in these pages. His suave and genial manners and his easy talent made him an ideal collaborator, and one soon finds him playing the role of mediator between the masters whom he served. Bernini employed him for about ten years on many of his major undertakings, and it was he who had the strongest formative influence on Fontana's style. Before 1665, he came into his own with the interesting little church of S. Biagio in Campitelli (originally at the foot of the Capitol but now reassembled on Piazza Capizucchi). His manner is fully formed in the façade of S. Marcello al Corso (1682–3) [3], probably his most successful work, which impressed the younger generation of architects very much. This façade must be regarded as a milestone on the way to Late Baroque Classicism; it is, in fact, separated by a deep gulf from the great High Baroque façades, despite the use of such devices as the concave curvature and the illusionist niche of the upper tier. Here everything is unequivocal, proper, easily readable. Like Maderno at the beginning of the century, Fontana works

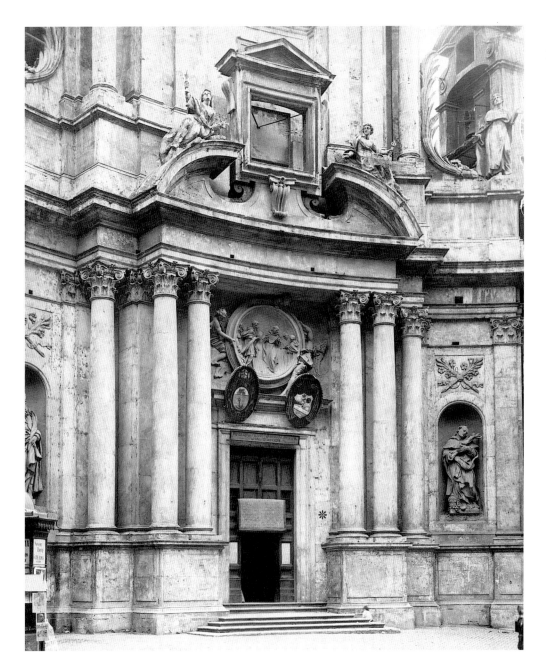

3. Carlo Fontana: Rome,
S. Marcello. Façade, 1682–3.
Detail

again with wall projections dividing the whole front into single bays framed by orders. But by contrast to Maderno, every member of the order has its precise complement (thus a full pilaster appears at the inside of each outer bay below, behind the column, corresponding to the pilaster at the corner), and this is one of the reasons why the façade is essentially static in spite of the accumulation of columns in the centre. By contrast to Maderno, too, the wall projection corresponds exactly to the diameter of the columns, so that the encased column forms an isolated motif, clearly separated from the double columns of the central bay. The aedicule framing this bay is, as it were, easily detachable, and behind the pairs of freestanding columns are double pilasters which have their precise counterpart in the upper tier. Thus the orders in both tiers repeat, which is, however, obscured by the screening aedicule. It is precisely the 'detachability' of the aedicule motif that gives its superstructure – the broken pediment with the empty frame[13] between the segments – its

scenic quality. The principle here employed corresponds to that of theatrical wings which are equally unconnected, a principle, as we have noted before (II: p. 114), that is foreign to Roman High Baroque structures but inherent in Late Baroque Classicism. Essentially different both from the Early and the High Baroque, the conception of the façade of S. Marcello provides a key to Fontana's architecture as well as to many other Late Baroque classicist buildings.

A study of Fontana's largest ecclesiastical ensemble, the Jesuit church and college at Loyola in Spain, reveals the limitations of his talent. The layout as a whole in the wide hilly landscape is impressive enough; but the church, designed over a circular plan with ambulatory (II: p. 115), lacks the finesse of Longhena's Salute, among others, because the shape of the pillars is determined by the radii of the circle, which makes trapezoid units in the ambulatory unavoidable.[14] In many respects the design echoes current Roman conceptions; the high drum derives from that of S.

4. Carlo Fontana: Project for the
completion of the Piazza of St
Peter's, Rome, 1694

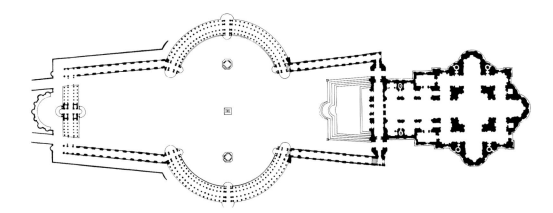

Maria de' Miracoli on the Piazza del Popolo,[15] while the façade is a classicizing adaptation of Rainaldi's unexecuted plan of 1662 for S. Maria in Campitelli. Other features,[16] besides the idea of the ambulatory, point to a study of S. Maria della Salute. Even if Fontana cannot be made responsible for the details, this gathering together of diverse ideas into a design of dubious merit is characteristic for the leading master of the new era.

Apart from some undistinguished palaces, he built many chapels in Roman churches, of which the Cappella Ginetti in S. Andrea della Valle (1671), the Cappella Cibò in S. Maria del Popolo (1683–7), the Baptismal Chapel in St Peter's (1692–8), and the Cappella Albani in S. Sebastiano (1705) may be mentioned. In these smaller works, which hark back to the rich polychrome tradition of the Roman High Baroque,[17] he gave his best. An endless number of designs for tombs (among them those of Clement XI and Innocent XII),[18] altars, fountains, festival decorations, and even statues came from his studio, and it is probably not too much to say that at the turn of the century there was hardly any major undertaking in Rome without his name attached to it. His eminence was publicly acknowledged by his election as *Principe* of the Academy of St Luke in 1686 and, again, for the eight years 1692–1700 – a mark of esteem without precedent. As a town-planner he indulged in somewhat fantastic schemes on paper, such as the building of a large semicircular piazza in front of the Palazzo Ludovisi (later Montecitorio, which he finished with classicizing alterations of Bernini's design) or the destruction of the Vatican Borghi, finally carried out in Mussolini's Rome. A second, less ambitious project for the completion of the Piazza of St Peter's [4] elaborates Bernini's idea of erecting a clock-tower outside the main oval, set back into the Piazza Rusticucci. But in contrast to Bernini's decision to make this building part and parcel of the Piazza (II: p. 36), Fontana intended to remove it so far from the oval that the beholder, on entering the 'forecourt', would have seen the main area as a separate entity. The near and far ends of the arms of the colonnades, moreover, would have appeared in his field of vision like isolated wings on a stage – a model example of how, by seemingly slight changes, a dynamic High Baroque structure could be transformed into a scenographic Late Baroque work.[19] Theatrical in a different sense would have been Fontana's planned transformation of the Colosseum into a forum for a centralized church. A telling symbol of the supersession of

the crumbled pagan world by Christianity, the ancient ruins would have formed sombre wings to the centre of the stage on which the house of God was to stand.

As an engineer, Fontana was concerned with the regulation and maintenance of water-ways and pipe-lines and, above all, with an investigation into the security of the dome of St Peter's. He supported many of his schemes and enterprises with erudite and lavishly produced publications, of which the *Templum Vaticanum* of 1694 must be given pride of place. Numberless drawings and many hundred pages of manuscript survive as a monument to his indefatigable industry.[20] It was this man, methodical and ambitious and without the genius of the great masters of the earlier generation, who brought about in Rome the turn to a classicizing, bookish, and academic manner in architecture. Nevertheless his influence was enormous, and such different masters as Juvarra in Italy, Pöppelmann and Johann Lucas von Hildebrandt in Germany and Austria, and James Gibbs in England looked up to him with veneration.

Even at the time when Carlo Fontana was the undisputed arbiter of taste in Rome, the spirit of adventure was not quite extinguished. Proof of it are Antonio Gherardi's (1644–1702) Avila and Cecilia Chapels, the former in S. Maria in Trastevere built before 1686, the latter in S. Carlo ai Catinari dating from a few years later (1691). Both chapels are daring essays in a strange type of picturesque architecture, translations of *quadratura* painting into three dimensions (Gherardi himself was also a painter), based on a close study of Bernini's use of light and on his experiments in unifying architecture and realistic sculpture. In the S. Cecilia Chapel,[21] moreover, Gherardi fell back upon the Guarinesque idea of the truncated dome through which one looks into another differently shaped and brilliantly lit space. It is the variety and quantity of motifs, freely distributed over the broken wall surfaces, that stamp the chapel as a work of the Late Baroque.

The Eighteenth Century

Carlo Fontana had a large number of pupils and collaborators, most of whom can safely be left unrecorded. Mention may be made of his son Francesco (1668–1708), whose death preceded that of the father. He is the architect of the large but uninspired church of SS. Apostoli (1702–24). Carlo's nephew, Girolamo, designed the academic two-tower façade

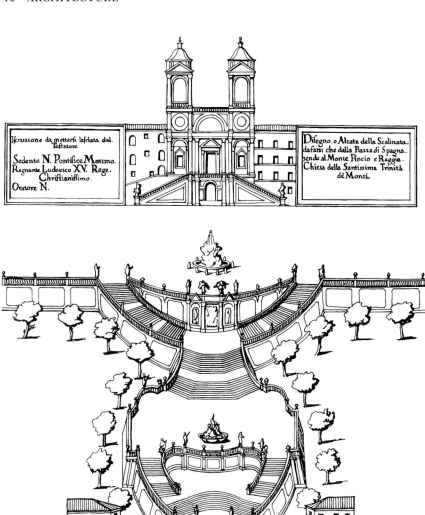

5. Francesco de Sanctis: Rome, the Spanish Staircase, project, 1723, redrawn from the original in the Ministère des Affaires Étrangères, Paris

6. Francesco de Sanctis: Rome, the Spanish Staircase, 1723–6

of the cathedral at Frascati (1697–1700, towers later); in spite of its traditional scheme it is typical for this phase of the Late Baroque by virtue of its slow rhythm and an accumulation of trifling motifs. Among Carlo's other pupils, three names stand out, that of the worthy Giovan Battista Contini (1641–1723),[22] who erected a number of tasteful chapels in Rome but had to find work mainly outside, e.g. at Montecassino and Ravenna and even in Spain (Cathedral, Saragossa); further, those of Carlo Francesco Bizzacheri (1656–1721) and Alessandro Specchi (1668–1729). The former, the architect of the façade of S. Isidoro (c. 1700–4), would be worth a more thorough study;[23] the latter is a better-defined personality, known to a wider public through his work as an engraver.[24] The Palazzo de Carolis (1716–22),[25] his largest building, somewhat anachronistic in 1720, has been mentioned (II: p. 110). His name is connected with two more interesting enterprises: the port of the Ripetta (1704), formerly opposite S. Girolamo degli Schiavoni, and the design of the Spanish Stairs. The port no longer exists and Francesco de Sanctis superseded him as architect of the Staircase.[26] But in these designs Specchi broke with the classicizing repertory of his teacher and found new scenographic values based on an interplay of gently curved lines. Thus the pendulum began to swing back in a direction which one may associate with the name of Borromini.

At the beginning of the eighteenth century there was a dearth of monumental architectural tasks in Rome. While during the seventeenth century Rome had attracted the greatest names, it is characteristic of the early eighteenth that the real genius of the period, Filippo Juvarra, left the city in 1714, to return only on rare occasions. The whole first quarter of the new century was comparatively uneventful, and it looked as if the stagnation of the Fontana era would last for ever. But once more Rome recovered to such an extent that she seemed to reconquer her leading position. For twenty years, between about 1725 and 1745, talents as

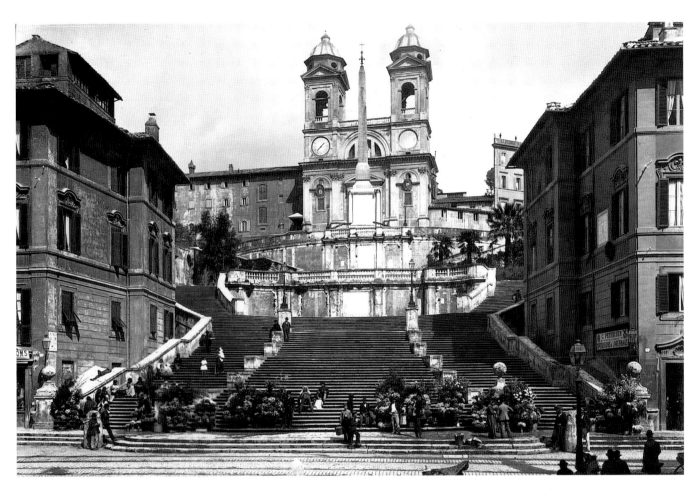

well as works of sublime beauty crowded there. A chrono-
logical list of the more important structures of the period
may prove it:

1723 Francesco de Sanctis: façade of SS. Trinità de'
 Pellegrini[27]
1723–6 De Sanctis: the Spanish Staircase [5, 6]
1725–6 Filippo Raguzzini: Hospital and Church of S.
 Gallicano
1727–8 Raguzzini: Piazza S. Ignazio [7, 8]
1728–52 Girolamo Teodoli: SS. Pietro e Marcellino[28]
1730–5 Gabriele Valvassori: Palazzo Doria-Pamphili, wing
 towards the Corso [9]
1732–7 Ferdinando Fuga: Palazzo della Consulta [11][29]
1732–7 Fuga: Chiesa dell'Orazione e Morte, Via Giulia[30]
1732–5 Alessandro Galilei: Cappella Corsini, S. Giovanni
 in Laterano
1732–62 Nicola Salvi: Fontana Trevi. After Salvi's death in
 1751 finished by Giuseppe Pannini [10]
1733–6 Galilei: façade of S. Giovanni in Laterano [13]
1733–5 Carlo de Dominicis: SS. Celso e Giuliano[31]
1734 Galilei: façade of S. Giovanni de' Fiorentini[32]
1735 Giuseppe Sardi(?): façade of S. Maria Maddalena[33]
1736–41 Antonio Derizet: church of SS. Nome di Maria in
 Trajan's Forum[34]
1736–after 1751 Fuga: Palazzo Corsini
1741 Manoel Rodrigues dos Santos[35] (and Giuseppe
 Sardi): SS. Trinità de' Spagnuoli in Via
 Condotti

1741 Fuga: monumental entrance to the atrium of
 S. Cecilia
1741–3 Fuga: façade of S. Maria Maggiore
1741–4 Paolo Ameli: Palazzo Doria-Pamphili, façade
 towards Via del Plebiscito[36]
1741–4 Pietro Passalacqua and Domenico Gregorini:[37]
 façade and renovation of S. Croce in
 Gerusalemme
1743–63 Carlo Marchionni: Villa Albani[38]

The new flowering of architecture in Rome is mainly
connected with the names of Raguzzini (*c.* 1680–1771),[39]
Valvassori (1683–1761),[40] Galilei (1691–1737),[41] De Sanctis
(1693–1731, not 1740), Salvi (1697–1751), and Fuga (1699–
1782).[42] Each of the first five created one great masterpiece,
namely the Piazza S. Ignazio, the façade of the Palazzo
Doria-Pamphili, the façade of S. Giovanni in Laterano, the
Spanish Stairs, and the Fontana Trevi, and only the sixth,
Fuga, the most profuse talent of the group, secured a num-
ber of first-rate commissions for himself.

Our list opens with two major works of the Roman
Rococo, the Spanish Stairs and the Piazza S. Ignazio – the
one grand, imposing, fabulous in scale, aristocratic in char-
acter, comparable to the breathtaking fireworks of the
Baroque age; the other intimate, small in size, and with its
simple middle-class dwelling-houses typical of the rising
bourgeois civilization. Also, in the urban setting these works
belong to diametrically opposed traditions. The Spanish
Staircase [5, 6][43] is in the line of succession from Sixtus V's

7 *(left)*. Filippo Raguzzini: Rome, Piazza S. Ignazio, 1727–8.

8 *(above)*. Filippo Raguzzini: Rome, Piazza S. Ignazio, 1727–8. Plan

9 *(below, left)*. Gabriele Valvassori: Rome, Palazzo Doria-Pamphili, 1730–5. Detail

10 *(right)*. Nicola Salvi: Rome, Fontana Trevi, 1732–62

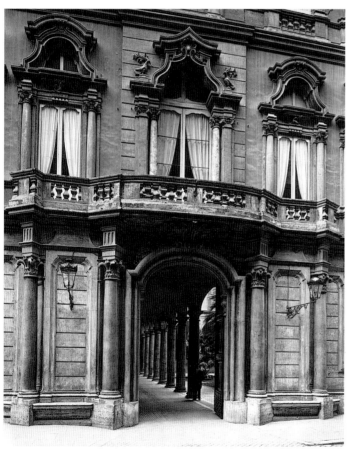

great town-planning schemes focused on long straight avenues and characteristic viewpoints. For seventeenth-century Roman architects the town-planner's ruler had far less attraction. But influenced by Carlo Fontana, the early eighteenth century was again smitten with the concept of long perspectives, to which the French of the seventeenth cen-

tury had so enthusiastically responded. A comprehensive vision unites now the whole area from the Tiber to the Trinità de' Monti, and although Specchi's port (unfortunately no longer existing) and De Sanctis's staircase are not on the same axis, they look on old town-plans (e.g. that by G.B. Nolli of 1748) like the overture and the finale of a vast scheme: exactly equidistant from the little piazza, a 'nodal point' widening out on the main artery, the Corso, they lie at the far ends of straight, narrow streets which cut the Corso at similar angles.

While the Spanish Staircase is composed for the far as well as the near view – the more one approaches it the richer and the more captivating are the scenic effects – the enclosed Piazza S. Ignazio [7, 8] only offers the near view, and on entering it an act of instantaneous perception rather than of progressive revelation determines the beholder's mood. The Roman masters of the seventeenth century preferred the enclosed court-like piazza to a wide perspective and exploited fully the psychological moment of dazzling fascination which is always experienced at the unexpected physical closeness of monumental architecture. Raguzzini's piazza is in this tradition. But he performed an interesting volte-face, for, in contrast to the square of S. Maria della Pace, it is now the dwelling houses, arranged like wings on a stage – and not the (older) church façade – that form the scenic focus.

What unites the conceptions of the Spanish Staircase and the Piazza S. Ignazio is the elegance of the curvilinear design,[44] and the same spirit may also be found in the playful movement of the window pediments, the balconies and balusters of Valvassori's façade of the Palazzo Doria-Pamphili [9]. Works like the façade of S. Maria Maddalena or the Fontana Trevi are in a somewhat different category. In spite of its flourishing rocaille decoration, the former is structurally rather conventional; it contains, however, distinctly Borrominesque motifs, above all, the dominating central niche, so close to that of the Villa Falconieri at

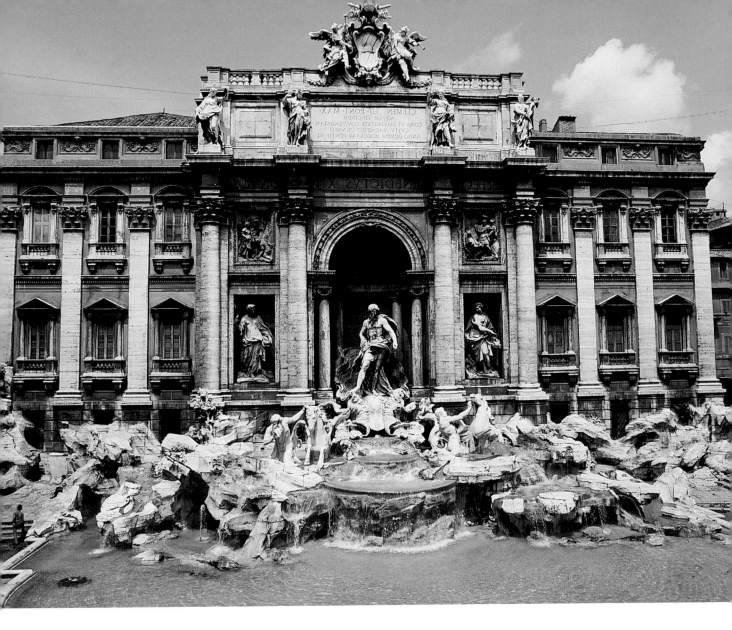

Frascati. The Fontana Trevi is not without marginal Rococo features such as the large rocaille shell of Neptune, but Salvi's architecture is remarkably classical [10].[45] Taking up an idea of Pietro da Cortona, who had first thought of combining palace front and fountain (II: p. 74), Salvi had the courage and vision to wed the classical triumphal arch with its allegorical and mythological figures to the palace front. It was he, too, who filled the larger part of the square with natural rock formations bathed by the gushing waters of the fountain. The Rococo features in the Fontana Trevi are entirely subordinated to a strong Late Baroque classical design that is as far from Fontana's formalization of Bernini's manner as it is from the puristic approach of Neoclassicism.

The years 1731–3 are the most varied and exciting in the history of Rome's eighteenth-century architecture. To them belongs the peak of the regeneration after the Fontana period. Next to Valvassori's Palazzo Doria-Pamphili and Salvi's Fontana Trevi, Fuga's Palazzo della Consulta was rising in these years [11]. Based on the simple rhythm of light frames and darker panels, this palace contains a superabundance of individual motifs, which to a certain extent are elegant re-interpretations of Michelangelo's Manner-

ism. Fuga's easy virtuosity resulted at this early phase of his career in an extremely refined style with a note of Tuscan sophistication, so different from Valvassori's deft brilliance and Salvi's sense for Roman grandeur. To the same moment belongs Galilei's reticent Cappella Corsini, a balanced Greek-cross design articulated by a uniform Corinthian order crowned by a simple hemispherical dome with classical coffers. Severely classical when compared to the other works of these years, the chapel is still far from real Neoclassicism, mainly on account of the sculptural decoration (p. 56) and the subtle colour symphony of its marbles with pale violets and mottled greens prevailing. The year 1732 also saw the most notable architectural event of the period, namely Galilei's victory in the competition for the façade of S. Giovanni in Laterano arranged by Pope Clement XII.

Never before in the history of architecture had there been such a mammoth competition.[46] Twenty-three architects, a number of them non-Romans, took part. The jury under the chairmanship of Sebastiano Conca, president of the Academy, was entirely composed of academicians, and the intrigues were fabulous. Nevertheless, it was an historic event that Galilei's model was chosen. It meant the official *placet* to a severely classical design at a time when the preva-

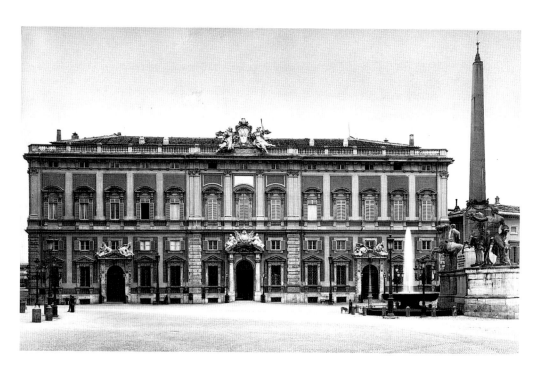

11. Ferdinando Fuga: Rome, Palazzo della Consulta, 1732–7

12 *(below, left)*. Carlo Maderno: Rome, St Peter's. Façade, 1605–13. Detail

13 *(below, right)*. Alessandro Galilei: Rome, S. Giovanni in Laterano. Façade, 1733–6. Detail

lent taste was non-classical. But a good deal that is less than half-truth has been said about Galilei's work. Critics usually believe that it reveals the impact of English Palladianism. It is true that Galilei had spent five years in England (1714–19) before he returned to his native Florence. Although at the time of his departure from

London hardly any Neo-Palladian building had gone up,[47] the façade of S. Giovanni shows a family likeness to certain projects by the aged Sir Christopher Wren. In actual fact, however, the façade is firmly rooted in the Roman tradition, combining, among others, features from Maderno's façade of St Peter's [12, 13] and Michelangelo's Capitoline palaces;

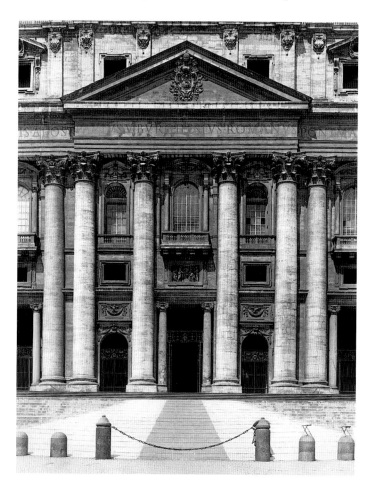

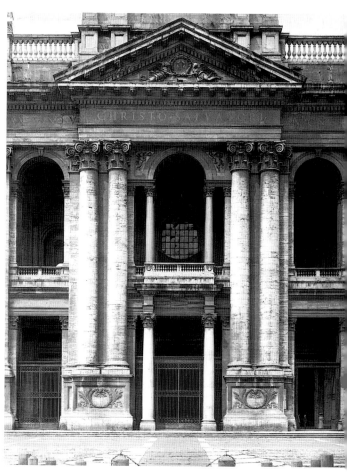

features, incidentally, which belonged to the repertory of all Italian architects of the period and were usually incorporated into the highest class of monumental design. Thus some of Galilei's competitors worked with the same vocabulary. What distinguishes his façade from its great model, the façade of St Peter's, is not only its essentially static structure, achieved by a process similar to that described in the case of Fontana's S. Marcello, but also the new relationship between open and closed parts. Here the whole front is practically opened up so that the chiaroscuro becomes most important; it helps define the orders and entablatures sharply. The effect of classical discipline and precision is partly due to this pictorial device which is an element of Late Baroque Classicism rather than of Neo-classicism. In his façade of S. Maria Maggiore, Fuga used exactly the same compositional characteristics. Add to all this Galilei's magnificent sense of scale, so similar to Maderno's in the façade of St Peter's and much superior to any of his competitors, further the crowning of the façade with the traditional Baroque figures and the freak design of the central pedestal with the blessing figure of Christ – and it must be admitted that we have before us a severe work of late Baroque Classicism that is intrinsically less revolutionary than art historians want to make it.

Once the façade was standing (1736), the impetus of the Roman Rococo was almost broken as far as monumental structures were concerned. After Galilei's death in 1737,

Fuga's predominant position was never challenged, and that alone spelled a development along Late Baroque classicist lines. Moreover, the vigour of his early manner slowly faded into a somewhat monotonous form of classicism. I do not mean his felicitous design of the façade of S. Maria Maggiore; but for this aspect one may compare S. Maria della Morte with his design for S. Apollinare or the Palazzo della Consulta [11] with the Palazzo Cenci Bolognetti (c. 1745; see II: Chapter 2, Note 87) and with the long, rather dry front of the Palazzo Corsini. In the coffee house in the Gardens of the Quirinal (1741–3) his puristic classicism was already firmly established, but far from being Neo-classical, this style was mainly modelled on late Cinquecento examples. In 1751 Fuga left Rome for Naples - an indication how the wind was blowing - and it was there that he practised during the last decades of his life. In 1752 he began the enormous Albergo de' Poveri (length of the façade c. 1000 feet) and in 1779 the even larger Granary (destroyed). Shortly before his death he designed the Chiesa dei Gerolamini (1780), which shows that up to a point he remained faithful to the Late Baroque tradition long after the rise of Neo-classicism.

With Fuga's departure from Rome the brief and brilliant flowering of Roman eighteenth-century architecture was to all intents and purposes over. Neither Marchionni's Villa Albani with its impressive Late Baroque layout[48] nor Piranesi's few picturesque essays in architecture[49] could

14. Andrea Tirali: Venice, S. Nicolò da Tolentino. Façade, 1706–14

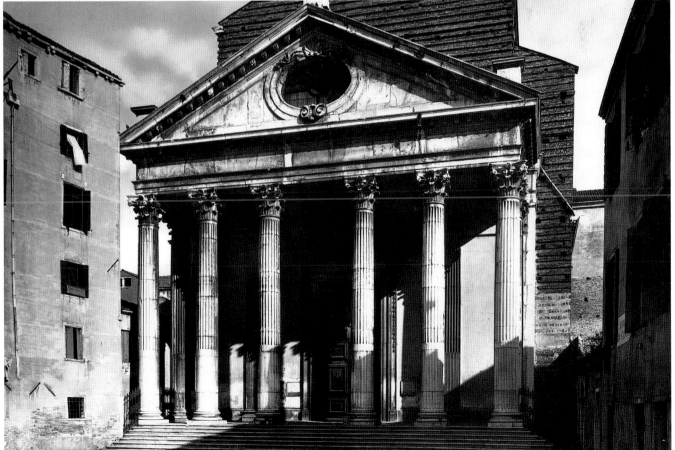

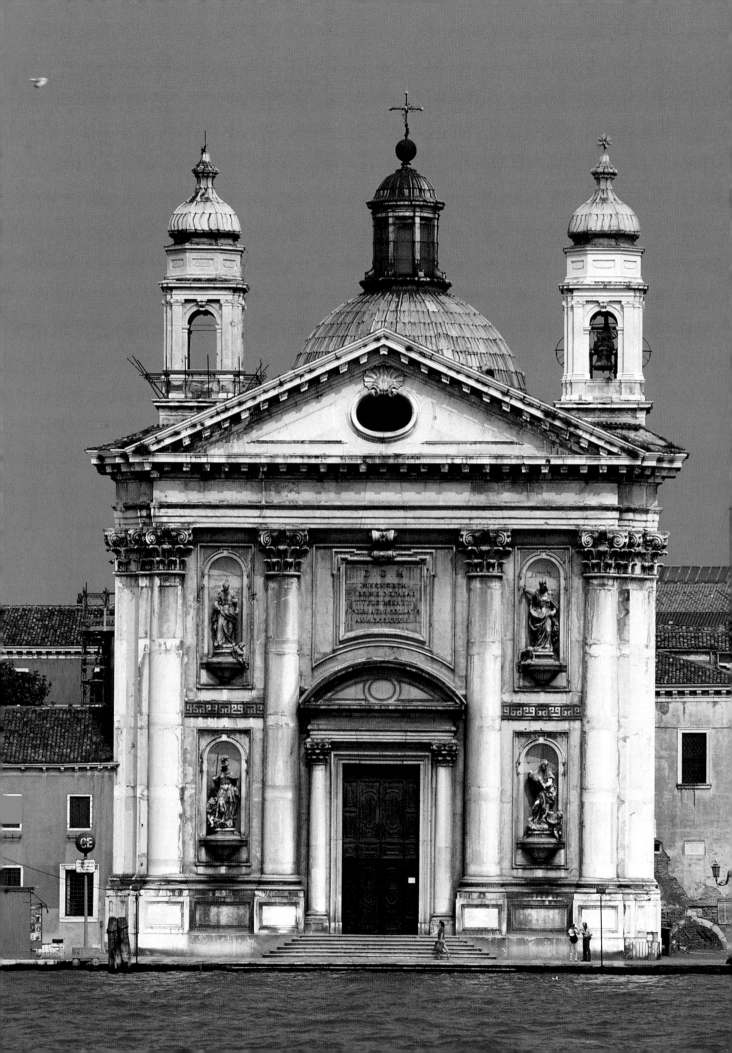

15. Giorgio Massari: Venice,
Chiesa dei Gesuati, 1726–43

16. Giorgio Massari: Venice,
Palazzo Grassi-Stucky, 1749 ff.

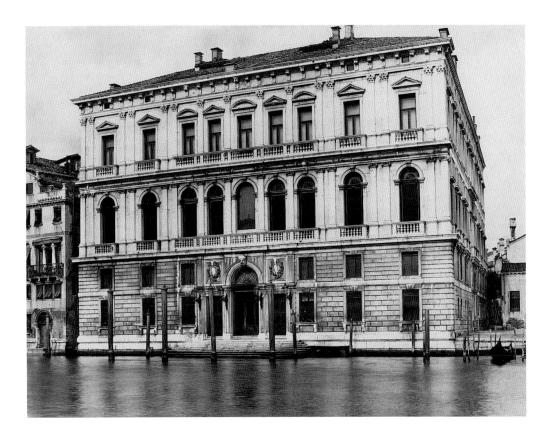

retrieve the situation. Contrary to what is usually said, the Late Baroque lingered on in Rome until the days of the great Valadier (1762–1839), whose work belongs mainly to the nineteenth century.

NORTHERN ITALY AND FLORENCE

Longhena's activity in Venice was not in vain.[50] Although he had no successor of the highest rank, architects vacillated for a time between the ebullient plasticity and chiaroscuro of his manner and the linear classicism of Scamozzi. This is apparent in the work of Giuseppe Sardi (c. 1621–99), Alessandro Tremignon, and the younger Domenico Rossi (1657–1737). They may turn Longhena's High Baroque sense for structure into typically Late Baroque diffused and flickering pictorial effects, for which only Tremignon's notorious façade of S. Moisè need be mentioned.[51] Rossi, in particular, who built the richly decorated Baroque Chiesa dei Gesuiti (1715–29),[52] prepares in the Palazzo Corner della Regina (begun 1724) the return to a classical architecture. The real master of transition from one manner to the other is Andrea Tirali (1657–1737). Although he designed in 1690 the Late Baroque chapel of S. Domenico in SS. Giovanni e Paolo and the profuse Valier monument in the same church (1705–8),[53] he turned his back on the Baroque tradition in the façades of S. Nicolò da Tolentino [14] and S. Vidal (Vitale). Both façades are Palladian revivals: the first (1706–14) resuscitates a Vitruvian portico in the wake of Palladio's project of 1579 for S. Nicolò,[54] the second (datable 1734)[55] follows closely S. Giorgio Maggiore.

More important than Tirali and probably the greatest Venetian architect of the first half of the eighteenth century is Giorgio Massari (1687–1766).[56] His masterpiece, the Chiesa dei Gesuati (1726–43) [15], has a powerful temple façade derived from the central portion of Palladio's S. Giorgio Maggiore, while the interior is indebted to Palladio's Redentore, a debt hardly obscured by the typically eighteenth-century features. Massari's finest domestic work is the majestic Palazzo Grassi-Stucky (1749 ff.); its staircase hall with the frescoes formerly ascribed to Alessandro Longhi[56a] is the grandest in Venice. But the façade, faithful to the characteristics of the Venetian palazzo type, is almost as sober and flat as Scamozzi's [16].[57]

It will be noticed that, in contrast to the course of Venetian painting, Venetian architecture of the eighteenth century lived to a large extent on its tradition,[58] and this is also true for its last great practitioner, Giovanni Antonio Scalfarotto (c. 1690–1764), the architect of SS. Simeone e Giuda (also called S. Simeone Piccolo, 1718–38) [17, 18]. This church, which greets every visitor to Venice on his arrival, is clearly based on the Pantheon. But above the classical portico, to which one ascends over a staircase modelled on ancient temples, rises a stilted Byzantine–Venetian dome. The interior somewhat varies the Pantheon motifs. There is, however, one decisive change: the congregational room opens into a domed unit with semicircular apses, a formula derived via the Salute from Palladio. This blending of the Pantheon with Byzantium and Palladio is what one would expect to find in eighteenth-century Venice, and that it really happened is almost too good to be true.[59]

The analysis just made has shown that Scalfarotto did not yet take the definite step across the Neo-classical barrier. Nor can his pupil Matteo Lucchesi (1705–76) be dissociated from a vigorous Late Baroque classicism. It was only with

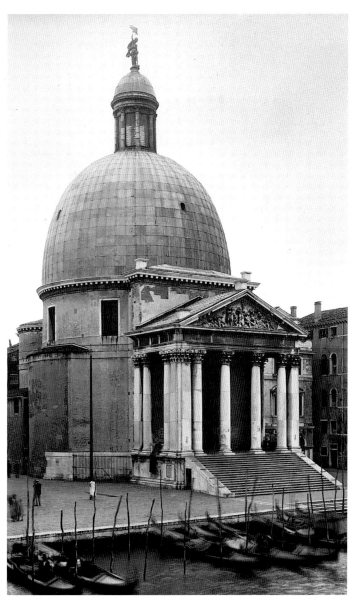

17. Giovanni Antonio Scalfarotto: Venice, SS. Simeone e Giuda, 1718–38

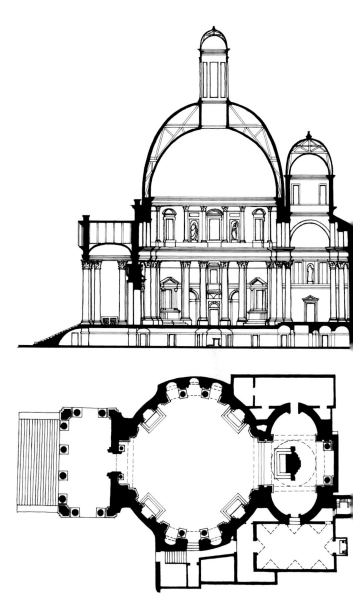

18. Giovanni Antonio Scalfarotto: Venice, SS. Simeone e Giuda, 1718–38. Section and plan

Tomaso Temanza (1705–89)[60] and his pupil G. Antonio Selva (1753–1819) that Venetian architecture became a branch of the general European movement. In S. Maria Maddalena (1748–63), Temanza, the friend of Milizia, produced a corrected version of his teacher's and uncle's design of SS. Simeone e Giuda: it spelled an uncompromising return to classical standards.

In Vicenza Antonio Pizzócaro (c. 1600–80), Carlo Borella, and others kept Scamozzi's classicism alive throughout the seventeenth century.[61] The eighteenth century witnessed a splendid Palladian revival to which such a great master as Francesco Muttoni (1668–1747) contributed with sensitive works (Biblioteca Bertoliana, 1703)[62] and which ran its course with the Palladio scholar and architect Ottavio Bertotti-Scamozzi (1719–90) and Count Ottone Calderari (1730–1803).[63]

A word must be added about the villas of the *terra ferma*.[64] Most of the villas of the Venetian hinterland, numbering at least a thousand, were built in the eighteenth century, and although their variety is immense, certain common features can be found. The splendid Palladian tradition of the aristocratic villa *all' antica* had, of course, an indelible influence, and even in the pearl of the Settecento villas, the imposing pile of the Villa Pisani at Stra (1735–56) [19], the Palladian substance is not obscured by Baroque grandeur. A second type, no less important than the first, derives from the Venetian palace as regards spatial organization as well as the typically Venetian grouping of the windows in the façade. The simple house which Tiepolo built for himself at Zianigo may be mentioned as an example. This type of house also illustrates the middle-class aspect of eighteenth-century civilisation, the primary reason for the enormous growth in the number of villas at the time. There are infinite transitions to the princely villas, which vie in magnificence though not in architectural style with Versailles, such as the Villa Manin at Passariano (1738) and the Villa Pisani, which has

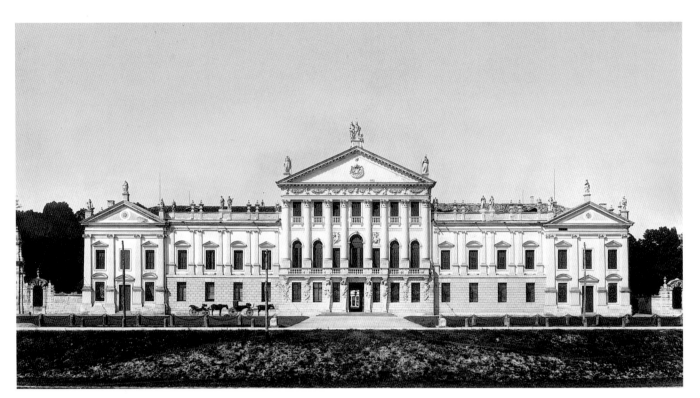

19. Francesco Maria Preti: Stra, Villa Pisani, 1735–56

been mentioned.[65] The latter, built to a design by Francesco Maria Preti, possesses in its rich painterly decoration – traditional since Palladio's day – a veritable museum of the Venetian school, a pageantry which culminates in Tiepolo's *Glory of the Pisani Family* [124] painted on the ceiling of the great hall.

Bologna had at least two Late Baroque architects of distinction, Carlo Francesco Dotti (1670–1759)[66] and Alfonso Torreggiani. Dotti's masterpiece is the Sancturary of the Madonna di S. Luca, on a hill high above the city (1723–57) [20]. The Baroque age was fond of such sanctuaries. As widely visible symbols, they dominate the landscape: they suggest nature's infinitude controlled by men in the service of God. The architect's task was made particularly difficult since he had not only to emulate the grand forms of nature herself by creating a stirring silhouette for the view from afar, but had also to attract those who would ascend the hill of the sanctuary. This dual problem was solved by Dotti in a masterly way. A homogeneous elliptical shape, encasing a Greek-cross design, is crowned by the dome – an effective combination of simple geometrical forms to be seen from a distance. For the near view he placed before the approach to the church a varied, richly articulated, and undulating building, reminiscent of the work of the the eighteenth-century Bolognese *quadraturisti*. Less interesting is the interior, where Dotti followed Cortona's SS. Martina e Luca. But the changes are even more telling than the analogies. Dotti conventionalized Cortona's dynamic motifs, returned to traditional conceptions (e.g. in the form of the drum), emphasized the vertical tendencies, and, by reducing the transverse arms to deep elliptical chapels, gave the building a distinct axial direction. The attached sanctuary, into which

one looks from the congregational room, owes not a little to Rainaldi's S. Maria in Campitelli. Thus adapted to new conditions, the Roman prototypes retain their formative influence.

Alfonso Torreggiani (d. 1764), the architect of the charming Oratory of St Philip Neri (1730, partly destroyed

20. Carlo Francesco Dotti: Bologna, Madonna di S. Luca, 1723–57. Plan

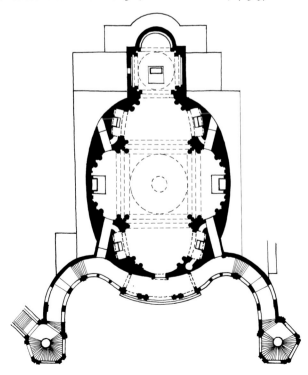

21. Giambattista Piacentini: Bologna, Palazzo di Giustizia. Staircase hall, 1695

22 *(above, right)*. Antonio Arrighi: Cremona, Palazzo Dati. Staircase hall, 1769

23 *(below, right)*. Cremona, Palazzo Dati. Plan; staircase by Antonio Arrighi, 1769

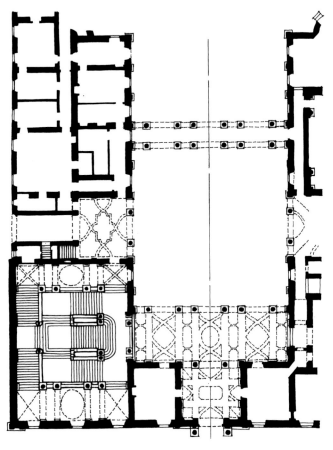

during the war), led Bolognese architecture close to a Rococo phase. This is also apparent in his façade of the Palazzo Montanari (formerly Aldrovandi, 1744–52), which represents the nearest approach at Bologna to Valvassori's style in Rome. Like G. B. Piacentini (staircase, Palazzo di Giustizia, 1695) [21][67] and Francesco Maria Angelini (1680–1731: staircases, Palazzo Montanari and Casa Zucchini) before him, he was a master of grand scenic staircases. He executed that of the Palazzo Davia-Bargellini, designed by Dotti in 1720 – the impressive stuccoes are by G. Borelli – and later those of the Palazzi Malvezzi-De Medici (1725) and the Liceo Musicale (1752), where the ornament has a particularly light touch. The tradition of this type of monumental staircase was continued at Bologna right to the end of the century, mainly by Dotti's pupil Francesco Tadolini (1723–1805),[68] and in other cities near Bologna not a few splendid examples may also be found.[69] A climax is reached in the largest and most complex of all, that of the Palazzo Dati at Cremona [22, 23], attributed to the otherwise unknown architect Antonio Arrighi (1769). Bologna also possesses in Antonio Bibiena's elegant Teatro

Comunale (1756–63) one of the finest Baroque theatres in Italy.[70]

Lombardy was comparatively unproductive during this period.[71] In Milan, after the building boom of the Borromeo and post-Borromeo era, church building declined. Next to Bartolomeo Bolli's (d. 1761) Palazzo Litta (Note 5 to this chapter) with Carlo Giuseppe Merli's impressive staircase,[72] only Giovanni Ruggeri's (d. c. 1743) Palazzo Cusani need be mentioned. Both palaces are very large in size but not as similar as they are usually believed to be: Ruggeri, the Roman, is much more reticent than the Milanese Bolli.[73] Like the latter, Marco Bianchi favoured the Rococo in his almost identical façade designs of S. Francesco di Paola (1728) and S. Pietro Celestino (1735). With Vanvitelli's pupil Giuseppe Piermarini (1734–1808), the builder of the Scala (1776–9), the period of true Neo-classicism opens at Milan.[74]

Genoa, by contrast, harbours Late Baroque work in unexpected quantity and quality. But, surprisingly, it still remains almost a *terra incognita*. While late seventeenth-century palaces, such as the monumental Palazzo Rosso (1671–7) built by Matteo Lagomaggiore for the brothers Brignole Sale, are well known,[75] the eighteenth century has attracted little attention. Who knows the names of Antonio Ricca (c. 1688–c. 1748), the architect of S. Torpete (1730–1); of Andrea Orsolino, who built the majestic Ospedale di Pammatone (1758–80); of Gregorio Petondi, to whose genius we owe the present Via Cairoli and the rebuilding of the Palazzo Balbi with its scenographic staircase, in the same street (1780); of Andrea Tagliafichi (1: p. 87), who erected superb villas in the vicinity of Genoa? The city is rich in Late Baroque churches, among which the delightful Oratorio di S. Filippo Neri may be singled out, and typically eighteenth-century palace designs, usually anonymous, abound (e.g. the palace at Piazza Scuole Pie 10). But Genoa's main glory are the interior decorations. The relationship of the Genoese nobility to Paris was particularly close, and French Rococo designs are therefore common.[76] Side by side with this foreign import, however, developed an autonomous Genoese Rococo, dazzling, ebullient, and masculine. The most splendid example of this manner is the gallery in the Palazzo Carrega-Cataldi (now Camera di Commercio, Via Garibaldi) designed by Lorenzo de Ferrari, surely one of the most sublime creations of the entire eighteenth century.[77]

Equally autonomous is the development of the Genoese villa. The layout of the Villa Gavotti at Albissola, built in 1744 for Francesco Maria della Rovere, Genoa's last Doge, has few equals: terraces, grand undulating staircases, and water combine to wed the house to the landscape. Staircases and terraces extend from the house into the hilly landscape like enormous tentacles. Man's work ennobles the landscape without subduing it; this is as far from the French method of making the landscape subservient to the will of man as it is from the 'natural' English landscape garden which came into its own at precisely this moment.

Florence has some typically Late Baroque chapels built by Foggini and decorated by him and his school (p. 63). Among the late palaces that of Scipione Capponi and the Palazzo Corsini deserve special mention. The former,

erected in 1705 by Ferdinando Ruggieri (d. 1741), possibly from a design by Carlo Fontana, is a reticent and noble building with a very long front. The large, airy staircase hall is placed, according to tradition, in one wing far away from the entrance. This disposition is as antiquated as the staircase itself with its four flights ascending along the walls (thereby forming a well). How different are the imaginative staircase designs in the cities of the Po valley! The extensive, sober mass of the Palazzo Corsini, designed by Pier Francesco Silvani (Note 79 to this chapter) for Marchese Filippo Corsini (d. 1706), may not appear very attractive, but the interior contains Antonio Maria Ferri's (d. 1716) masterpieces.[78] The monumental staircase (c. 1690), richly decorated with stuccoes by Giovanni Passardi in the manner of Raggi, is revolutionary for Florence; yet it is a clever adaptation of the new Bolognese type rather than the work of an independent talent. Equally unorthodox for Florence is the *gran salone* with its canopies formed of heavy coupled columns and, above them, the undulating entablature and gallery encompassing the entire hall. Once again Ferri's imagination was fired by foreign examples, this time by such Roman works as Borromini's nave of S. Giovanni in Laterano.

The major ecclesiastical Settecento structure in Florence is the impressive front of S. Firenze. Ruggieri executed the façade to the Chiesa Nuova (on the left-hand side) in 1715.[79] Zanobi Filippo del Rosso (1724–98), who had studied with Vanvitelli and Fuga, copied this front between 1772 and 1775 for the Oratory on the right-hand side and united the two façades by the palace-like elevation of the monastery. The design of this remarkable front is to a certain extent still tied to Mannerist precepts; thus the inverted segments of pediments, derived from Buontalenti, provide a conspicuous crowning feature. To the end the Florentines remained faithful to their anti-Baroque tradition.[80]

NAPLES AND SICILY

For no less than two hundred years southern Italy was as a rule misgoverned by Spanish viceroys. At the Peace of Utrecht, in 1713, Philip V of Spain lost his south Italian dominion for good, but in 1734 his son was crowned King in Palermo as Charles III, and for the next sixty-four years until the Napoleonic era the Bourbons remained in possession of their throne, only to return in 1816 for another uneasy forty-five years. Charles III governed his country by enlightened despotism until 1759, when he inherited the Spanish crown. It is mainly during the twenty-five years of his reign that Naples and Sicily saw an unprecedented flowering of the arts, and to this period belong some of the largest architectural schemes ever devised in Italy. Such vast enterprises as the palaces of Capodimonte[81] and Caserta, the Albergo de' Poveri, the Granary, and the theatre of S. Carlo may be recalled.

After Fanzago's long and undisputed lead, architecture in Naples developed in two stages. A specifically Neapolitan group carried architectural design over into the style usually associated with the term 'barocchetto'. The principal practitioners of this group were pupils of the painter Francesco Solimena, who also has some architectural works to his

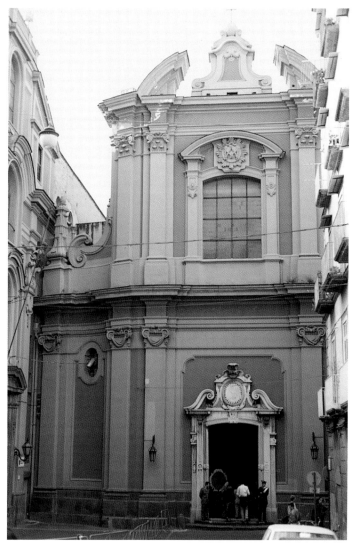

24. Ferdinando Sanfelice: Naples, Chiesa delle Nunziatelle, begun 1713

elegance to decorative profusion and richness. He produced with almost incredible ease, and the vastness of his *œuvre* vies with that of the most productive architects of all time. In this as in other respects he recalls Juvarra; like the latter, he was also specially gifted as a manipulator of perishable decorations,[83] and his sure instinct for scenographic effects is one of the most characteristic traits of his art. His work in ecclesiastical architecture began in 1701 (S. Maria delle Periclitanti at Pontecorvo), to be followed by innumerable additions, alterations, and renovations in Naples and smaller towns. A particular jewel is the small Chiesa delle Nunziatelle [24], probably dating from the mid 1730s, with a colourful façade which forms a splendid *point de vue* at the end of a narrow street. The simple polychrome nave with two chapels to each side blends perfectly with the lofty vault decorated with Francesco de Mura's grandiloquent fresco of the Assumption.[84]

It is as the architect of domestic buildings that Sanfelice gives his best. One of the most distinguished among the long list of palaces attributed to him by the biographer of Neapolitan artists, de Dominici, is the Palazzo Serra Cassano (1725–6), a long structure on sloping ground with a front of sixteen bays. The rhythm given to the façade is typical of Sanfelice's free handling of the tradition. Giant pilasters over the rusticated ground floor frame the first, fifth, twelfth, and sixteenth bays (with the pilasters of the fifth and twelfth bays over rich portals); bays 2, 3, 4, and 13, 14, 15 are evenly spaced, without orders, while bays 6, 7, 8, and 9, 10, 11 are grouped together as trios with a large gap between bays 8 and 9, that is, in the centre of the entire

25. Ferdinando Sanfelice: Naples, Staircase, 1728

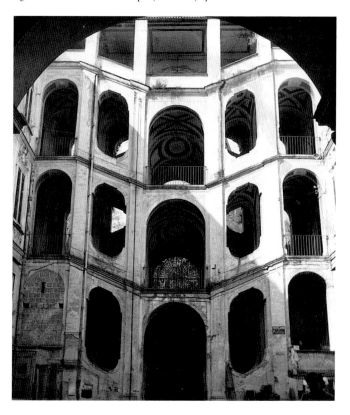

credit. Among his followers, Giambattista Nauclerio (active 1705–37), Domenico Antonio Vaccaro (1681–1750), painter, sculptor, and architect, and Ferdinando Sanfelice (1675–1750) are the most important. The second, later phase has a more international, Late Baroque classicist character; Fuga and Vanvitelli are the architects who were responsible for most of the monumental buildings in this manner.

Excepting Sanfelice, little space can be given to the first group. Solimena's only major architectural work is the simple and dignified façade of S. Nicola alla Carità (1707?). Otherwise, his contribution to architecture consists mainly in the design of tombs (Prince and Princess of Piombino, Chiesa dell'Ospedaletto, 1701) and altars (high altar, Cappella del Tesoro, S. Gennaro, 1706) and, above all, in the influence exercised on his pupils. Nauclerio and Vaccaro[82] may be passed over in favour of Sanfelice, who is the most gifted and most prolific Neapolitan architect of the first half of the eighteenth century. His work, even more than that of Vaccaro, is the precise counterpart to Raguzzini's and Valvassori's buildings in Rome. It is spirited, light-hearted, unorthodox, infinitely imaginative, and ranges from a severe

façade. The main glory, however, of this and other palaces by Sanfelice is the monumental staircase, which ascends in two parallel flights, each of which returns, forming a complicated system of bridges in a large vaulted vestibule.

Sanfelice's ingenuity was focused on staircase designs [25, 26];[85] in this field he is without peer. It is impossible to give even the vaguest idea of the boldness, variety, and complexity of his designs. In the crowded conditions of Naples these staircases often seem tucked away in the most unexpected places, and this adds to their surprise effect. De Dominici gives the crown to the staircase of the palace of Bartolomeo di Majo as the most 'capricious' in the whole of Naples – and there is no reason to disagree with him. This staircase ascends in convex flights inside a vestibule reminiscent of the plan of Borromini's S. Carlo alle Quattro Fontane. There is nothing in the rest of Italy to match Sanfelice's scenographic staircases; in addition, central and northern Italy took no note of the unconventional development of staircase designs in the South. On the other hand, it has been pointed out that a link exists between some of Sanfelice's and certain Austrian staircase designs.[86] And contrary to the previous two centuries, it was the North that influenced Naples. At precisely the same time Naples and Piedmont – as will be shown – admit northern ideas, and this invites comment to which I shall turn in the next chapter.

Sanfelice and Vaccaro died in the same year, 1750. The following year the King called to Naples the two architects Fuga and Vanvitelli, who, at this historical moment, must have been regarded as the leading Italian masters, and it was to them that he entrusted the largest architectural tasks of the eighteenth century in Naples. The two architects were almost exact contemporaries, but while Fuga had passed the zenith of his creative power, Vanvitelli had still his most fertile years before him. Fuga's activity in Naples has already been briefly mentioned (p. 15). It remains to give an account of Vanvitelli's career.

Luigi Vanvitelli (1700–73),[87] born in Naples, the son of the painter Gaspar van Wittel from Utrecht, spent his youth in Rome, first studying painting under his father. He emerged as an architect of considerable distinction during the Lateran competition, to which he contributed a design. His first period of intense architectural activity coincided with the building boom in Rome (p. 11). Commissioned by Pope Clement XII, he constructed at Ancona the pentagonal utilitarian *lazzaretto*, the austerely classical Arco Clementino, began the quay and lighthouse, and erected the Gesù (1743–5), which foreshadowed the infinitely grander late Chiesa dell'Annunziata at Naples. In these years, mainly in the 1740s, he assumed the role of an itinerant architect, so common in the eighteenth century. He worked at Pesaro, Macerata, Perugia, and Loreto (tower, Santa Casa), made a design for the façade of Milan Cathedral (1745), and practised in Siena and again in Rome, where the sober monastery of S. Agostino, the rebuilding of Michelangelo's S. Maria degli Angeli, and, under Salvi, the lengthening of Bernini's Palazzo Chigi-Odescalchi (II: p. 30) are mainly to be recorded.

Charles III summoned him to Naples for the express purpose of erecting the royal residence at Caserta, about 20 miles north of the capital.[88] In a sense Caserta is the over-

26. Ferdinando Sanfelice: Naples, palace in Via Foria. Double staircase and plan

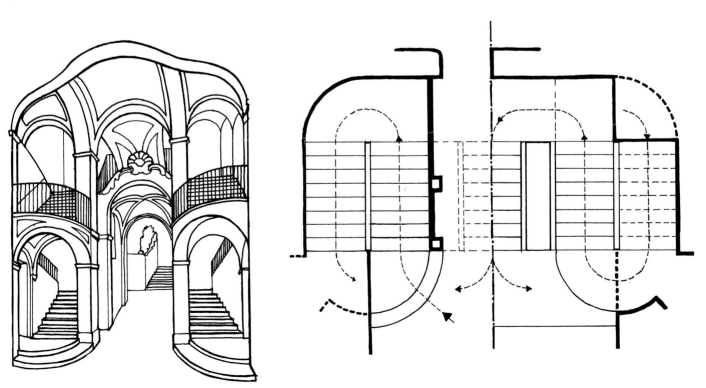

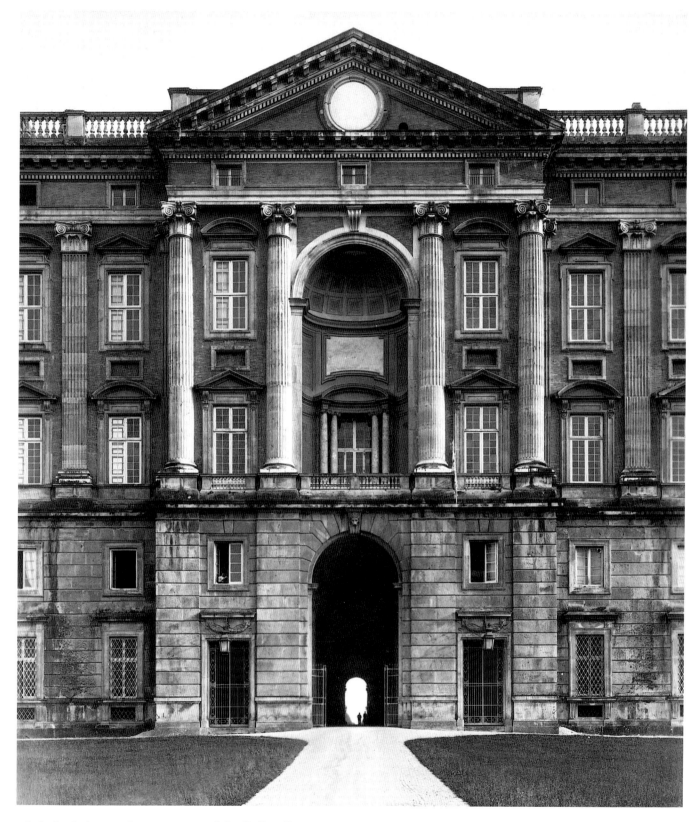

whelmingly impressive swansong of the Italian Baroque. The scale both of the palace with its 1,200 rooms and of the entire layout is immense. For miles the landscape has been forced into the strait-jacket of formal gardening – clearly Versailles has been resuscitated on Italian soil. But it would be wrong to let the matter rest at that, for into the planning has gone the experience of Italian and French architects accumulated over a period of more than a hundred years. The palace is a high, regular block of about 600 by 500 feet, with four large courtyards formed by a cross of wings. The Louvre, the Escorial, Inigo Jones's plans for Whitehall Palace come to mind; we are obviously in this tradition. None of these great residences, however, was designed with the same compelling logic and the same love for the absolute

27 and 28. Luigi Vanvitelli:
Caserta, former Royal Palace,
begun 1752. Detail of façade
(opposite) and plan

29. Luigi Vanvitelli: Caserta,
former Royal Palace, begun 1752.
Staircase

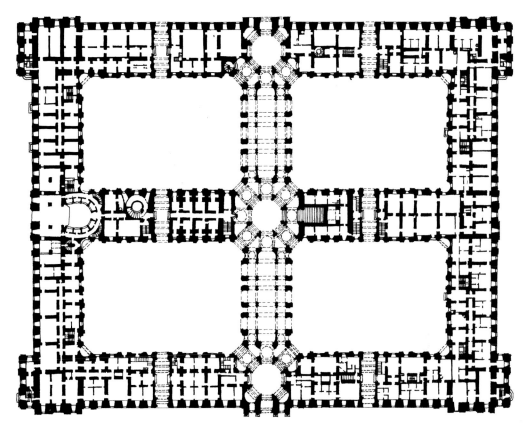

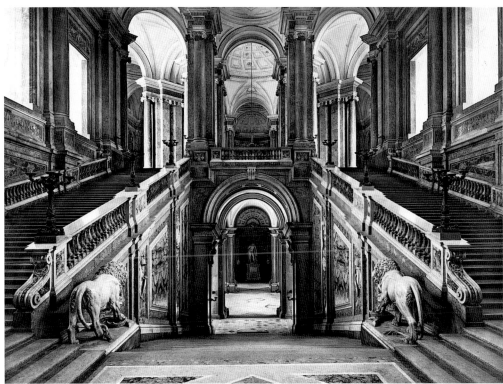

geometrical pattern, characteristics which have a long
Italian ancestry and reveal, at the same time, Vanvitelli's
rationalism and classicism. A similar spirit will be found in
the strict organization of the elevations. The entire structure
rises above a high ground floor treated with horizontal
bands of sharply cut rustication. Projecting pavilions,
planned to be crowned by towers in the French tradition and

articulated by a giant order, frame each of the long fronts.
The pavilions are balanced in the centre of the main and
garden fronts by a powerful pedimented temple motif [27].
While the long wall of the principal front remains otherwise
austere without articulating features, on the garden front
the giant composite order is carried across the entire length,
creating a long sequence of narrow bays. Apart from certain

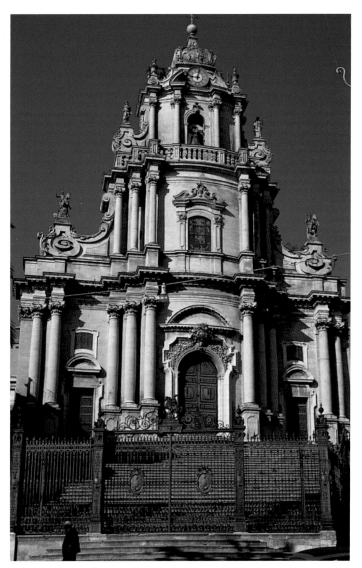

30. Rosario Gagliardi: Ragusa (Sicily), S. Giorgio, 1744

angles. Its rather austere decoration may be fashioned after Versailles, but the staircase hall as such and the staircase [29] with its central flight leading to a broad landing from where two flights turn along the walls and end under a screen of three arches – all this has a North Italian pedigree (Bologna), which ultimately points back to Longhena's scenographic staircase in S. Giorgio Maggiore [II: 142]. The staircase leads into a vaulted octagonal vestibule corresponding to that on the lower level, and from there doors open into the state rooms and – opposite the staircase – into the chapel, the similarity of which to that of Versailles has always been pointed out.[89] Once again, from the vestibules on both levels vistas open in all directions, and here Vanvitelli's source of inspiration is evident beyond doubt. These vestibules, octagons with ambulatories, derive from Longhena's S. Maria della Salute.[90] Although many decorative features of the interior are specifically Roman and even Borrominesque, Vanvitelli's basic approach spells a last great triumph for Longhena's principles. But he emulates all that went before; for from the return flights of the staircase the beholder looks through the screen of arches into stagelike scenery beyond, viewing a Piranesi or Bibiena phantasmagoria in solid stone. The scenographic way of planning and seeing ties Vanvitelli firmly to the Late Baroque, and it is in this light that his classicism takes on its particular flavour.

The principal ecclesiastical building of Vanvitelli's immensely active Neapolitan period is the Chiesa dell' Annunziata (1761–82). Its concave façade in two tiers is ultimately dependent on Carlo Fontana's S. Marcello, and the scenographic interior with its severely conceived columnar motif that encompasses the three separate units of the church takes its cue from Rainaldi's S. Maria in Campitelli.[91] Among Vanvitelli's remaining works may be mentioned the Foro Carolino (now Piazza Dante, 1757–65). The large segmental palazzo front articulated by a giant order, reminiscent of Pietro da Cortona (II: p. 74), is interrupted in the centre by the dominating motif of the niche, a late retrogression to the *Nicchione* of the Vatican Belvedere. But the slow rhythm of this architecture calls to mind northern counterparts, such as J. Wood the younger's Royal Crescent at Bath (1767–75), and the similarity – in spite of all differences – once again shows to what extent Vanvitelli's style falls into line with the international classicism of the period.

Finally, a word must be said about Vanvitelli's uncommon ability as an architect of utilitarian structures. This is demonstrated not only by his cavalry barracks 'al ponte di Maddalena' (1753–74), a work of utter simplicity and compelling beauty (which seems to have had a considerable influence on Italian twentieth-century architecture), but above all by the Acquedotto Carolino (1752–64), the aqueduct of about 25 miles length which supplies Naples with water. As regards engineering skill as well as the grandeur of the bridges this work vies with Roman structures. More than anything else, such works indicate that a new age was dawning.

The last Neapolitan architect of the eighteenth century deserving attention is Mario Gioffredo (1718–85). Schooled by Solimena, he began before 1750 with works still in keeping with the Neapolitan Baroque. Overshadowed by Fuga and Vanvitelli, Gioffredo has never been given his due. After

national idiosyncrasies, such as the density and plasticity of forms and motifs, this style was internationally in vogue during the second half of the eighteenth century. It may be found not only in France (e.g. G. Cammas' Capitole, Toulouse, 1750–3), but also in England (e.g. Sir William Chambers's Somerset House, London, 1776–86) and even in Russia (Kokorinov's Academy of Art, Leningrad, 1765–72).

But in one important respect Caserta is different from all similar buildings. Vanvitelli had been reared in the scenographic tradition of the Italian Late Baroque, and it was at Caserta that scenographic principles were carried farther than anywhere else. From the vestibule vistas open in several directions: courtyards appear on the diagonal axes, and, looking straight ahead, the visitor's eye is captivated by the vista through the immensely long, monumental passage which cuts right through the entire depth of the structure [28], and extends at the far end along the main avenue into the depth of the garden. From the octagonal vestibule in the centre Italy's largest ceremonial staircase ascends at right

31. Noto (Sicily), Chiesa Madre di
S. Nicolò, c.1694–1776

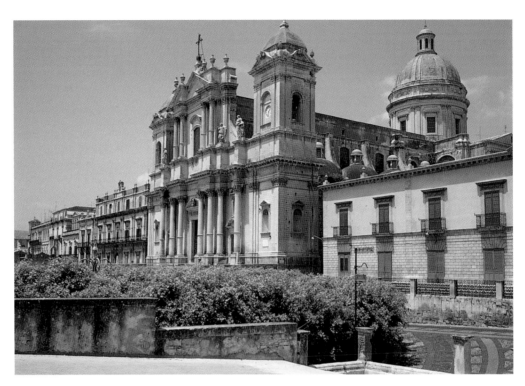

1760 he steered determinedly towards a Neo-classical conception of architecture. His dogmatic treatise *Dell' Architettura* (1768), of which only the first volume appeared, shows this as clearly as his masterpiece, the church of Spirito Santo, completed in 1774. Unlike Vanvitelli, Gioffredo breaks here for the first time with the polychrome Neapolitan tradition. Moreover, the walls of the nave with the even, sonorous rhythm of the colossal Corinthian order usher in a new period. And yet even he paid homage to a tradition which he despised: in the interior of the church the attentive observer will discover motifs derived from S. Maria in Campitelli, while the large dome is, in fact, a memorial to Cortona's dome of S. Carlo al Corso.[92]

*

Little can here be said about the charming, volatile, and often abstruse Apulian Baroque, which has some contacts with the Neapolitan and even Venetian development. It has recently been shown that the often overstated connexions with the Plateresque and Churrigueresque Spanish Baroque are most tenuous. Examples of this highly decorative local style may be found at Barletta, Gravina, Manduria, Oria, Gallipoli, Francavilla Fontana, Galatone, Nardò, and other places. But it has its main home in the provincial capital, Lecce. For its small size Lecce can boast an unequalled number of monumental structures, which form a strikingly imposing ensemble.[93]

In spite of a building history extending from the mid sixteenth to the eighteenth century, Lecce's Baroque conveys the impression of stylistic harmony and uniformity. The reason is evident: this style is pure surface decoration, often strangely applied to local building conventions which, in this remote corner of Italy, had an extraordinarily long lease of life. What M. S. Briggs wrote in 1910 (p. 248) is still true today: 'All that is unique in Lecce architecture may be accounted for by the combination and fusion of these

three great elements – the new Renaissance spirit slowly percolating to the remote city, the unrivalled relics of the Middle Ages standing around its gates, and the long rule of Spain.'

The strange union of what would seem incompatible is particularly evident in the façade of S. Croce (also called Chiesa dei Celestini), the most impressive structure at Lecce, where elements of the Apulian Romanesque are happily wedded to wildly exuberant Baroque decoration. At a first glance this façade appears to be uniform, but it was begun before 1582 by Gabriele Riccardi and finished more than sixty years later (1644) by Cesare Penna (upper tier). Again, the adjoining monastery (now Prefettura) would seem of one piece with the church; its dates, however, lie between 1659 and 1695 and the architect is Giuseppe Zimbalo, who built the cathedral (1659–82), S. Agostino (1663), and the magnificent façade of the Chiesa del Rosario (begun 1691). Less bizarre than the window-frames of the monastery, but otherwise close in character, is the front of the Seminario, erected between 1694 and 1709 by Zimbalo's pupil, Giuseppe Cino. The latter was responsible, among other works, for S. Chiara (1687–91), the façade of SS. Nicola e Cataldo (1716), and the Madonna del Carmine (1711); in these buildings a spirit closer to the international Baroque may be noticed. Before taking leave of Lecce, the most eccentric building may be mentioned, namely Achille Carducci's façade of S. Matteo, which is covered over and over with scales.

The Sicilian Baroque would deserve closer attention than it can here be given.[94] Artists from the mainland supplied to a large extent pre-Seicento art and architecture in Sicily. This situation changed in the course of the seventeenth century, and for more than 150 years most major building operations in cities large and small were carried out by Sicilians, who, incidentally, were almost without exception priests. Since the eastern towns – Syracuse, Catania, and Messina – were devastated in the earthquake of 1693, it is only at

Palermo that a continuous development can be followed throughout the seventeenth century.

During the first half of the new century building practice was on the whole retardataire. Witness the three-storeyed Quattro Canti at Palermo, monumental buildings on the piazza (created in analogy to the Quattro Fontane in Rome) where the two main arteries of the city intersect;[95] or the severe Arsenal (Palermo, 1630), designed by the Palermitan Mariano Smiriglio (1569–1636), painter and architect; Giovanni Vermexio's block-shaped Palazzo Comunale at Syracuse (1629–33) with a portal lifted straight out of Vignola's treatise;[96] or, finally, Natale Masuccio's imposing Jesuit College and church at Trapani (finished 1636). With Angelo Italia (1628–1700), Paolo Amato (1633–1714) and his namesake Giacomo Amato (1643–1732), Palermitan architecture entered a new, High Baroque phase.[97] In 1682 Paolo Amato began S. Salvatore, the first Sicilian church over a curvi-linear plan. The masterpieces of the Palermitan Baroque are, however, Giacomo Amato's façades of the Chiesa della Pietà (1689, church consecrated in 1723) and of S. Teresa della Kalsa (1686–1706), both with powerful orders of columns in two tiers. Giacomo had spent more than ten years in Rome (1673–85) where he had a share in the design of the monastery of S. Maria Maddalena. His work at Palermo leans heavily on Roman precedent, the façade of the Chiesa della Pietà, for instance, following closely that of S. Andrea della Valle. Thus by Roman standards this belated High Baroque is rather conservative. Angelo Italia's masterpiece is the Cappella del Crocifisso in the cathedral of Monreale, executed between 1688 and 1692, with exuberant and colourful Hispano-Sicilian marble decorations. They seem to be on the same level of intensity as the hieratic Byzantine mosaics which were possibly a source of inspiration to Baroque architects and decorators.[98]

The stage reached by Giacomo Amato was superseded by Giovanni Biagio Amico from Trapani (1684–1754), who erected important buildings in his native city as well as in other provincial towns and in Palermo. Although his Late Baroque façade of S. Anna in Palermo (1736)[99] with its convex and concave curvatures is superficially Borrominesque, it is additive in conception and lacks the dynamic sweep of similar Roman structures.

The glory of eighteenth-century Palermitan architecture are the villas in the vicinity, particularly at Bagheria.[100] Some of them have extravagant plans and form part of large and complex layouts, such as the villa built by Tommaso Maria Napoli (1655–1725) for Francesco Ferdinando Gravina, Principe di Palagonio (1715); the Villa Valguarnera, begun by the same architect before 1713; the Villa Partanna, erected 1722–8 for Laura La Grua, Principessa di Partanna; or the villa of the Principe di Cattolica (1737?). The Villa Palagonia is notorious for the strange 'baroque' whim of its late eighteenth-century proprietor, who had the entire place decorated with crudely carved monstrosities – the supreme example of a play with emblematical Baroque *concetti*. Goethe in his often-quoted description of the villa coined the phrase 'Palagonian paroxysm' for what seemed to him the epitome of aberration from good taste.[101]

Like Naples, Palermo abounds in scenographically effec-tive staircases. The most famous of them in the Palazzo Bonagia, designed by Andrea Giganti (1731–87), forms a picturesque screen between the cortile and the garden. All the large villas can boast extravagant staircase designs of which V. Ziino has made an illuminating study. Once again, the thought of Austrian architecture is never far from one's mind before such works. For twenty years from 1713 to 1734, the political links between Sicily and Austria were close.[102] I do not find records of many Sicilian architects visiting Vienna, but it is known that Tommaso Maria Napoli made the journey twice.

After the earthquake of 1693 the eastern part of the island saw a fabulous reconstruction period. The Baroque Messina in turn was to a large extent destroyed in the earthquake of 1908. Syracuse had an architect of distinction in Pompeo Picherali (1668–1746), who is, however, wrongly credited with the impressive façade of the cathedral.[103] Magnificent structures arose in small towns such as Modica and Ragusa [30]; Noto and Grammichele were entirely rebuilt on new sites; Noto, in particular [31], with its array of monumental structures erected by Paolo Labisi, Rosario Gagliardi (worked 1721–70), and the late, neo-classicist Vincenzo Sinatra,[104] is matched only by Catania itself. The greatest figure of the reconstruction period, Giovan Battista Vaccarini (1702–68),[105] turned Catania into one of the most fascinating eighteenth-century cities in Europe. Born in Palermo, he was educated in Rome in Carlo Fontana's studio, but, being a contemporary of the Roman 'Rococo' architects, his development parallels theirs. A protégé of Cardinal Ottoboni, he settled at Catania in 1730 and in the next two decades brought about a Sicilian Rococo by blending the Borrominesque with the local tradition. He entirely super-seded the popular 'Churrigueresque' style – that effusive manner which owes so much to Spain and of which Catania has splendid examples in the Palazzo Biscari and the Benedictine monastery,[106] the largest in Europe, the impres-sive bulk of which dominates the town.

The list of Vaccarini's works is long and distinguished, from the façade of the cathedral (begun 1730, reminiscent of Juvarra's style), which shows an interesting play with the position of the orders, and the powerful and extravagantly imaginative design of the Palazzo Municipale (1732) to the large Collegio Cutelli (1754), where, keeping abreast with the times, he is well on the road to a new classicism. His most important ecclesiastical work, S. Agata (begun 1735), has a façade with a deep concave recession between flanking convex bays – altogether an unexpected transformation of Borrominesque ideas and wholly unorthodox in the detail. Vaccarini's manner was continued in the second half of the eighteenth century by the festive art of the Roman Stefano Ittar. If his Chiesa Collegiata, where he combined features from Carlo Fontana's S. Marcello with some from the façade of S. Maria Maddalena, could almost have been created in Rome between 1730 and 1740, his S. Placido, a refined and subtle jewel of classicizing Rococo taste, has its nearest par-allels in Piedmont. Thus it is in the two parts of Italy which are the farthest removed from each other that the resistance against the cool objectivity of the rising Neoclassicism remains strongest.

Architecture in Piedmont

THE PRELUDE

The extraordinary part played by Piedmont in the art and architecture of the Seicento and Settecento cannot be dissociated from the country's rapid political development. It began with the energetic Emanuele Filiberto, who made Turin his capital in 1563. The rebuilding and enlarging of the town gathered momentum under his successor Carlo Emanuele I (1580–1630). For about three generations building activity in Turin was mainly in the hands of three architects in succession: Ascanio Vittozzi (1539–1615), Carlo di Castellamonte, and his son Amedeo (d. 1683). Turin was a Roman *castrum* town, and its chessboard layout survived the Middle Ages. Carlo Emanuele I pursued with energy the modernization of the whole city, first with Vittozzi and, after the latter's death, with Carlo Castellamonte as his architect. Castellamonte was in charge of all building activity when in 1620 the ceremonial foundation of the new town was laid. It was he who was responsible for one of the first coherent street-fronts in Italy (Via Roma) and for the entirely unified Piazza S. Carlo (1638). While Central Italian architects hardly ever abandoned the individual palazzo front, the break with that old-established tradition in Turin suggests a strong French influence. Under Carlo Emanuele II (1638–75) Amedeo di Castellamonte carried on the enlargement of the town in the direction of the River Po (1673).[1] Next to the leading architect, Francesco Lanfranchi showed more than ordinary ability in transforming Turin after the middle of the seventeenth century into a great Baroque city.[2] Under Vittorio Amedeo II followed the third great systematization of the city in the direction of the Porta Susina with Juvarra in charge (begun 1716). This programme was extended later in the eighteenth century, and during the twentieth century Turin's great Baroque tradition was continued by one of the most extensive town-planning schemes of modern times.[3]

These few remarks indicate that there was an adventurous and vigorous spirit alive in seventeenth-century Turin.[4] Nevertheless, what Castellamonte and Lanfranchi had to offer was somewhat provincial in spite of real distinction; they skilfully combined Roman and North Italian with French aspirations. But in 1666 Guarini appeared on the Turinese stage, with consequences of the utmost importance. In fact, in matters of architecture Turin became the most advanced Italian city almost precisely at the moment when creative energies in Rome began to decline. Guarini's settling in Turin opens the era of the extraordinary flowering of Piedmontese architecture which lasted for about a hundred years and is epitomized by the names of three men of genius: Guarini himself, Juvarra, and Vittone.

GUARINO GUARINI (1624–83)

It may be reasonably argued that Guarini's architecture belongs to a late stage of the High Baroque and that it has certain qualities in common with the Roman architecture of the mid seventeenth century, such as the full-blooded vigour and the preference for determined articulation and for strong and effective colour schemes. But while nobody will doubt that his architecture is nearer to that of Borromini and Cortona than to that of Juvarra, his aims transcend those of the Roman masters, from whom he is separated by a deep gulf. There is considerable justification, therefore, for discussing his work at this late stage. Guarini was born at Modena on 17 January 1624.[5] In 1639 he entered the Order of the Theatines and in the same year moved to Rome, where he studied theology, philosophy, mathematics, and architecture. At this period the interior of Borromini's S. Carlino [II: 51] as well as the façade of the Oratory of St Philip Neri [II: 72] were finished, and these events were certainly not lost upon him. Back at Modena in 1647, he was ordained priest and soon appointed lecturer in philosophy in the house of his Order. During these years he began architectural work in a modest way at S. Vincenzo, the church of the Theatine Order.[6] When in 1655 differences arose between him and the ducal court, he left Modena. In 1660 he settled in Messina, teaching philosophy and mathematics.

It was then that he began his literary career with a tragicomedy[7] and his architectural career with two important buildings. While his design of the church of the Padri Somaschi was never executed, the façade of the SS. Annunziata together with the adjoining Theatine palace were certainly built. What was standing of his work was destroyed in the earthquake of 1908,[8] but his designs are preserved in the plates in his *Architettura civile*, posthumously published by Vittone in 1737. The Annunziata façade, raised over a concave ground-plan, is strongly influenced by traditional Roman church façades and shows a distinct retrogression to Mannerist compositional and decorative principles. The church of the Padri Somaschi is more revealing; its regular hexagonal plan with ambulatory is strange enough.[9] Even stranger is the elevation [32], for the transition from the hexagonal body of the church to the zone of the dome is accomplished by pendentives above which is a circular cornice but not – as one would expect – a cylindrical drum. Instead of the normal drum and dome, the design shows a hybrid structure consisting of a hexagon with six large windows and parabolic ribs spanned between them in such a way that a kind of diaphanous dome is created: drum and dome are telescoped into one and the same structural zone. The novelty of this is no less surprising than Guarini's use of pendentives for the transition of the hexagon into the round, only to return to the hexagon again. Crowning the pseudo-dome is another hybrid motif, a proper small drum and dome, together exactly as high as the pseudo-dome and therefore much too large as a lantern.

Reminiscent of centralized churches of the Renaissance, the exterior is identical on all six fronts, and this contrasts

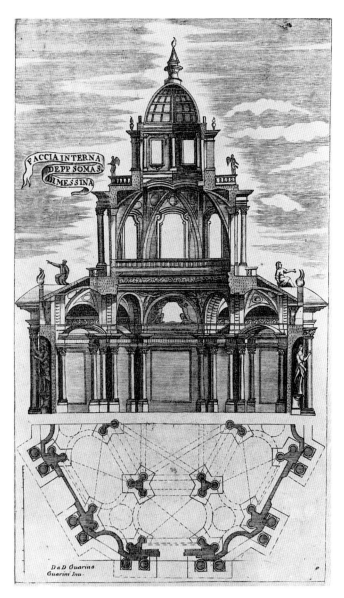

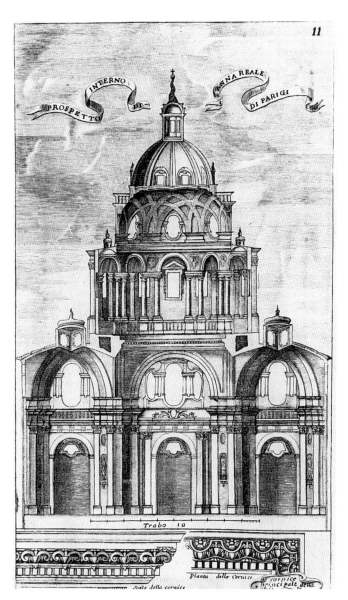

32. Guarino Guarini: Messina, Church of the Somaschi. Project. Engraving from *Architettura civile*, 1737

33. Guarino Guarini: Paris, Sainte-Anne-la-Royale, begun 1662. Destroyed. Section from *Architettura civile*, 1737

with the Roman Baroque tendency to regard the façade as an essential manifestation of the spatial movement and direction of the interior. The ample use of free-standing columns links the building superficially to the main current of Baroque architecture, but the superimposition of three unrelated tiers as well as the carpentry-like detail recall – at least in the engraving – Late Mannerist tabernacles rather than a church. Had Guarini stayed on at Messina, his buildings would probably have remained extravagant freaks.

In 1662 he was back at Modena, from where he soon moved to Paris. During his stay there he built the Theatine church, Sainte-Anne-la-Royale, and wrote an immensely learned mathe-matical-philosophical tome, *Placita philosophica* (1665), in which he defended, rather surprisingly at this late date, the geocentric universe against Copernicus and Galilei. The church [33], not finished until 1720 with considerable changes and entirely destroyed in 1823,[10] was erected over a fairly normal Greek-cross plan with undu-

lating façade, similar to that of S. Carlo alle Quattro Fontane. Once again Guarini's extravagance is most apparent in the zone of the vaulting. In this case he built a real drum above pendentives but crowned it by a dwarf dome which he decorated with a system of interlaced double ribs. This dome is topped by a smaller truncated dome with lantern of traditional design, to be seen from the floor of the church through the large octagonal opening of the dwarf dome.[11] Externally the church rose pagoda-like in five tiers,[12] and the encased dwarf dome with windows reminiscent of bellies of violins looked like a second drum above the principal one. Guarini had certainly studied Borromini's use of bandlike ribs for vaults (II: p. 55), but while the latter introduced this device in order to tie together a whole structure, no such idea guided the former. On the contrary, each of the major units of the church strikes an entirely new note. Far from being a provincial 'atomization', it will soon be seen that this was a deliberate artistic principle.

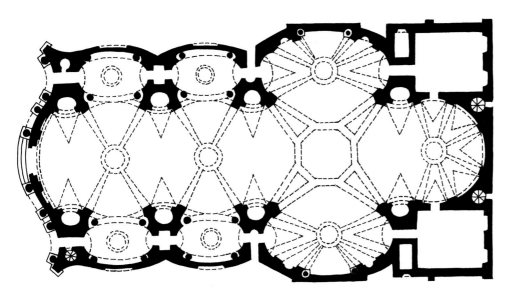

34. Guarino Guarini: Lisbon, S. Maria della Divina Providenza. Plan from *Architettura civile*, 1737

35. Guarino Guarini: Turin, Cappella SS. Sindone, 1667–90. Plan from *Architettura civile*, 1737

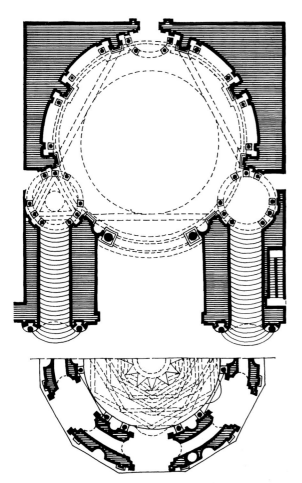

Guarini may have travelled again before settling in Turin. Although this is unrecorded, he may have gone to Spain and Portugal, where S. Maria della Divina Providenza at Lisbon was erected from his design [34].[13] Destroyed in the earthquake of 1755, this important church is known only from the engravings of the *Architettura civile*. Like St Mary of Altötting in Prague (1679) and S. Filippo in Turin, the

church has a longitudinal plan which derives from the traditional North Italian type showing a sequence of domed units; but here the walls undulate, and the salient points across the nave are no longer linked by an arch; they contain instead, in the zone of the vaulting, windows set into lunettes. An intricate and baffling combination of spatial shapes results which one cannot easily visualize or describe in simple geometrical terms. This architecture required a new kind of mathematics, and Guarini himself laid the foundation for it by devoting long passages of his treatise to conic sections. Although they must be regarded as essential for the development of the German and Austrian Baroque, Guarini's longitudinal churches take up a place secondary in importance compared with his centralized buildings.

When Carlo Emanuele II of Savoy called him to Turin, Guarini had still seventeen years to live, and in these years he erected the structures for which he is mainly famous. Apart from S. Filippo Neri, which remained unfinished, collapsed, and was finally replaced by Juvarra's church,[14] he built two great palaces, the Collegio dei Nobili (1678, now the Academy of Science and Art Gallery) and the magnificent Palazzo Carignano (1679),[15] and three centralized churches: the Cappella della SS. Sindone, S. Lorenzo, and the sanctuary La Consolata. The latter is the least interesting of these buildings and not much of the present structure is by Guarini.[16] His two other ecclesiastical works, however, belong to the finest class of Italian Seicento architecture.

After his arrival at Turin, Guarini was appointed architect of the Cappella della SS. Sindone, itself the size of a church [35–8]. The House of Savoy possessed one of the holiest relics, the Holy Shroud, which Emanuele Filiberto transferred from Chambéry to the new capital with the intention of having a church erected for it. But finally it was decided to build a large chapel at the east end of the cathedral and in close conjunction with the palace. In 1655 Carlo Emanuele II commissioned Amedeo di Castellamonte, and work was begun in 1657. When Guarini took over, ten years

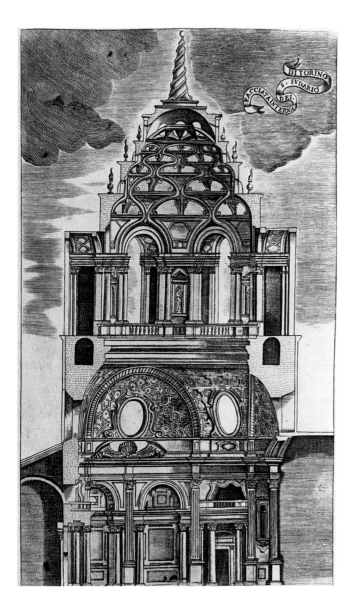

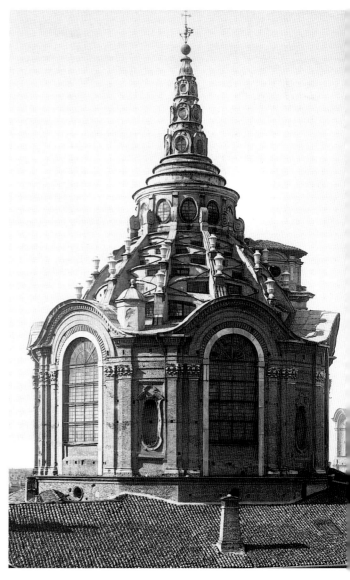

later, the structure was standing up to the entablature of the lower tier.[17] The cylindrical space of the chapel was articulated by the regular sequence of an order of giant pilasters and, placed between them, a smaller order forming the so-called Palladio motif. According to Castellamonte's design, the cylindrical body of the chapel was probably to continue into a spherical dome. Guarini disturbed this perfectly normal design. He introduced the convex intrusions of three circular vestibules into the main space; he entirely changed the meaning of the regular articulation by creating above the cylinder a zone with pendentives; and he spanned every two bays by a large arch, three in all, and these 'enclosed' bays alternate with the 'open' bays in which lie the segmental projections of the entrances. All this led to peculiar contradictions. Now the giant pilaster in the centre of each large arch has no function; he crowned it with a complex ornamental motif. The three pendentives open into large circular windows, corresponding to those set into the arches. Thus, reversing the division into arches and pendentives, the sequence of six windows produces a regular rhythm. It is even more puzzling that Guarini borrowed the penden-

tives from the Greek-cross design, adapted them to three instead of four arches – an unheard-of idea – and used them, paradoxically, as a transition between the circular body of the chapel and the circular ring of the drum.

The next zone above the pendentives consists of a high drum where six large arched openings alternate with solid pillars which contain Borrominesque convex tabernacle niches [37]. With this unbroken rhythm of pillar and arch the turmoil of the lower tiers seems resolved, and one would expect a spherical dome above this drum. Yet once again we are faced with an entirely unexpected feature, in fact the most extraordinary of the building. Segmental ribs are spanned from centre to centre of the six arches, resulting in a hexagon. By spanning other ribs from the centre of the first series of ribs and by repeating this method six times in all, a welter of thirty-six arches is created, of which three are always on the same vertical axis. Since each rib has a vertical spine (bisecting a segmental window), no less than twelve vertical divisions result, which are clearly visible outside as the structural skeleton of the dome [38].

Objectively, Guarini's cone-shaped dome is not very high;

36. Guarino Guarini: Turin, Cappella SS. Sindone, 1667–90. Section from *Architettura civile*, 1737

37 and 38. Guarino Guarini: Turin, Cappella SS. Sindone, 1667–90. Exterior of dome *(left)* and view into dome *(right)*

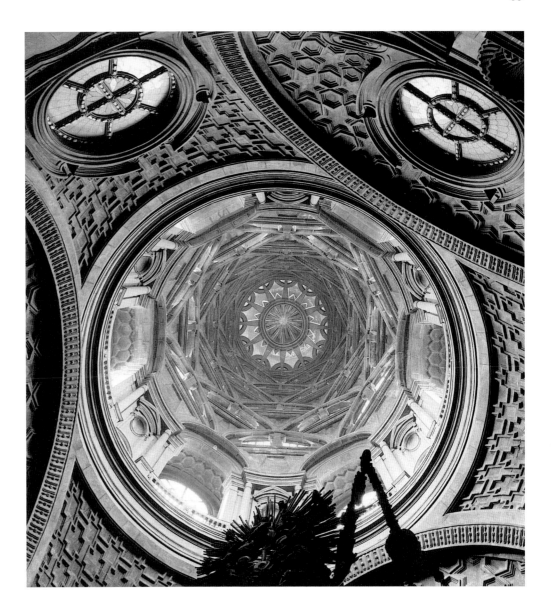

but subjectively, seen from the floor of the chapel, the diminution of the ribs appears to be due to perspective foreshortening so that the dome looks much higher than it is [37]. This impression is supported by the judicious use of colour. The contrast between the black marble and gilding below and the grey of the dome seems to result from the softening of tone values at great distance. At the summit the dome opens into a twelve-edged star, at the centre of which there hovers the Holy Dove strongly lit by the twelve oval windows of the lantern.

No less remarkable than the interior is the exterior, where again one unexpected feature follows another [38]. The principal motif in the lower zone is the six large windows of the drum, united under an undulating cornice. Above it, without transition and even without any intelligible reason (in any case for the beholder who does not know the interior), appears the exciting maze of zigzag steps, which are actually the segmental ribs of the dome. Finally, there is the serene horizontal motif of rings diminishing in size, crowned by the pagoda-like structure to which nothing corresponds inside.

It may be noticed that a trinitarian concept pervades the whole building: witness the triangular geometry of the plan, the intrusion of the three satellite structures into the main space with their columns arranged in triads, the multiples of three in the drum, dome, and lantern; further the three circular steps and three-storeyed 'pagoda' of the exterior. The whole building therefore assumes an emblematical quality: in ever new geometrical realizations the all-embracing dogma of the Trinity is reasserted.[20]

Hardly less exciting than the Cappella della SS. Sindone is the nearby church of S. Lorenzo.[21] Guarini began work on it in 1668; in 1679 the building was standing, but it was not entirely finished until 1687 [39–42]. The basic form of the plan is an octagon with the eight sides curving into the main space. Each of these sides consists of a 'Palladio motif' with a wide open arch. For this reason it is difficult or even impossible to perceive the octagon as the constituent shape of the congregational room. The eye is led past the arches to the real boundary of the church. Behind the screen of sixteen red marble columns are niches with statues, white before a black background and framed by white pilasters.

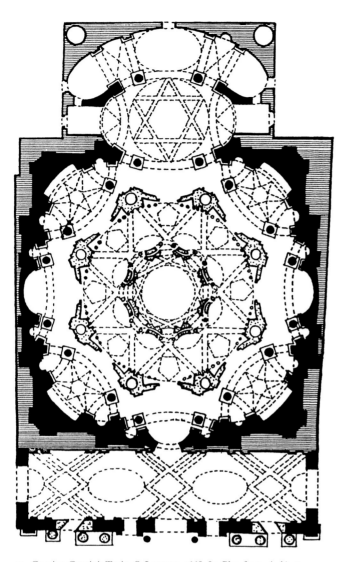

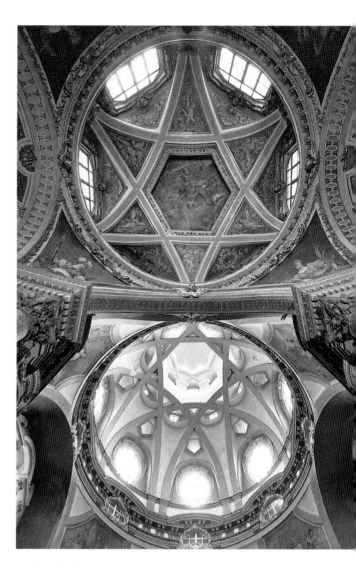

39. Guarino Guarini: Turin, S. Lorenzo, 1668–87. Plan from *Architettura civile*, 1737

40. Guarino Guarini: Turin, S. Lorenzo, 1668–87. View into main dome and dome of the presbytery

Thus there exists a certain continuity of motifs along the boundary, but they complicate rather than simplify an understanding of the structure; for so many different units and so many similar motifs are found side by side and at odd angles that no coherent vision is possible.[22] The strong, uninterrupted entablature above the arches emphasizes and clarifies the octagonal shape. But in the next zone there is an unexpected change of meaning similar to that in the Cappella della SS. Sindone. Pendentives are placed in the diagonal axes, and at this level the octagon is transformed into a Greek cross with very short arms. The extraordinary fact must be clearly grasped that the pendentives and arches of the cross are functionally divorced entirely from their supports, which belong, as we have seen, to another spatial entity. How revolutionary Guarini's conception is will be realized when one compares it with the slightly earlier Greek cross of S. Agnese in Piazza Navona [II: 65]. Above the pendentive zone there is a gallery with oval windows, and between them are eight piers from which the ribs of the vaulting spring. These ribs are arranged in such a way that

they form an eight-pointed star and a regular open octagon in the centre. We are thus faced with a hybrid feature similar to that planned for the Church of the Somascian Fathers at Messina. And precisely as in the design of that church, there rises above the central opening a lantern – consisting of drum and dome – just as high as the main dome itself. Also, outside, the dome has again the appearance of a drum which is crowned by a second small drum and dome. In spite of these similarities, S. Lorenzo is infinitely more complex. Particular reference may be made to the insertion of a zone with windows between the dome and the lantern. These cast their light through an open ring of segments laid round the inner octagon of the dome. By this device the diaphanous and mysterious quality of the dome is considerably enhanced.

In the longitudinal axis of the church, the circular Cappella Maggiore with a simpler ribbed dome is added to the congregational room. The chapel is delimited by two Palladio motifs, one opening into an altar recess with oval vaulting, the other into the main space. Thus the same

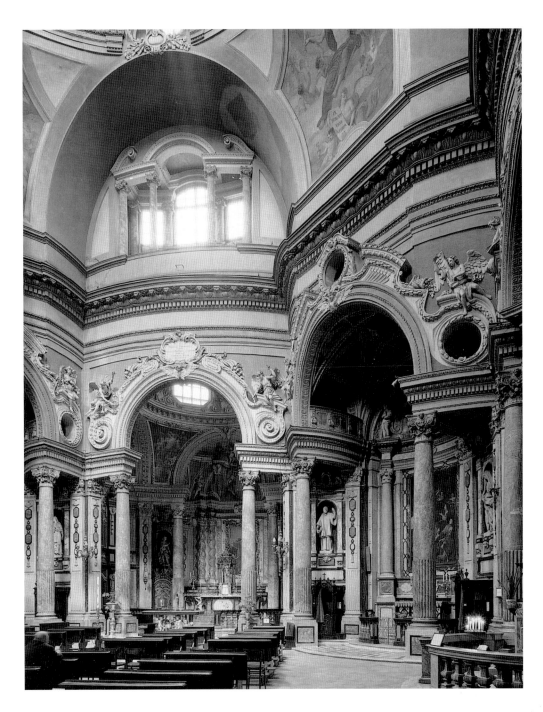

41. Guarino Guarini: Turin, S. Lorenzo, 1668–87. View of the interior

Palladio motif which appears as a convex penetration into the main room forms the concave boundary of the chapel. In spite of such interpenetrations of different spatial entities, each of the three domed spaces forms a separate unit with architectural characteristics of its own. With this arrangement Guarini kept well within the North Italian tradition; moreover the scenic effect produced by the longitudinal vista links his plan to the tradition leading from Palladio to Longhena.

We can now summarize a few of the principles which seem to have guided Guarini. Domes have pride of place in his system of architecture. Guarini opened the chapter on vaulting in his *Architettura civile* with the remark 'Vaults are the principal part in architecture', and expressed surprise that so little had been written about them.[23] What is so new

about Guarini's own domical structures? The Baroque dome, continuing and developing the formula of the dome of St Peter's, was of classical derivation. Although Borromini broke with this tradition, he too relied on classical prototypes and maintained the solidity of the domical surface. It is this principle that Guarini abandoned. Of course, the models of his diaphanous domes were not Roman. The similarity of the dome of S. Lorenzo to such Hispano-Moresque structures as the eighth-century dome in the mosque at Cordova has often been pointed out; but even if an influence from this side can be admitted,[24] it is the differences rather than the similarities that are important. The Hispano-Moresque domes are not diaphanous, for their vaults rest on the structural skeleton of the ribs. Guarini's domes are infinitely bolder than any of the Spanish models;

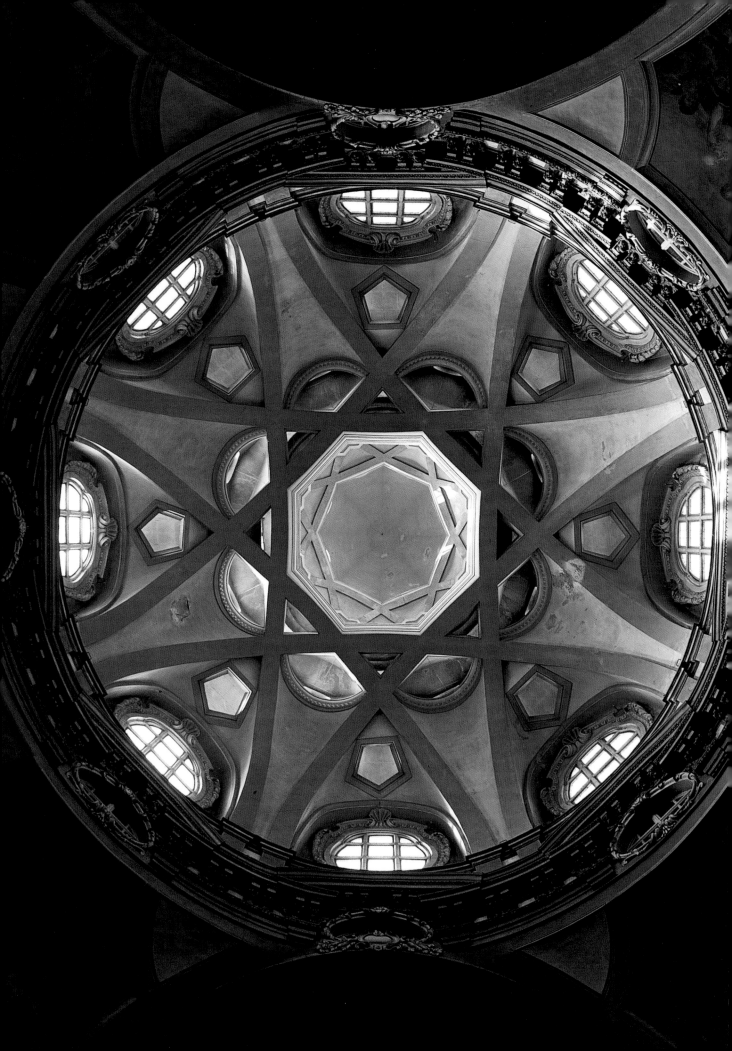

he eliminated the wall surface between the ribs and perched high structures on their points of intersection.

It is clear then that Guarini, far from being an imitator, turned over a new leaf of architectural history. A passage in the *Architettura civile* seems to reveal his intentions. With a perspicacity unknown at that date, he analysed the difference between Roman and Gothic architecture. He maintained that in contrast to the qualities of strength and solidity aimed at by Roman architects, Gothic builders wanted their churches to appear structurally weak so that it should seem miraculous how they could stand at all. Gothic builders – he writes – erected arches 'which seem to hang in the air; completely perforated towers crowned by pointed pyramids; enormously high windows and vaults without the support of walls. The corner of a high tower may rest on an arch or a column or on the apex of a vault. . . . Which of the two opposing methods, the Roman or the Gothic, is the more wonderful, would be a nice problem for an academic mind.' It does not appear far-fetched to conclude that the idea of his daring diaphanous domes with their superstructures, which seem to defy all static principles, was suggested to Guarini by his study and analysis of Gothic architecture. And he also used the formula of Hispano-Moresque domes to display structural miracles as astonishing as those of the Gothic builders.[25]

But his domes are more than structural freaks. They seem the result of a deep-rooted urge to replace the consistent sphere of the ancient dome, the symbol of a finite dome of heaven, by the diaphanous dome with its mysterious suggestion of infinity. If this is correct, not only his domes but also the other essential characteristics of his architecture become intelligible. The element of surprise, the entirely unexpected, the seemingly illogical, the reversal of accustomed values, the deliberate contradictions in the elevation, the interpenetration of different spatial units, the breaking up of the coherent wall boundary with the resulting difficulty of orientation – all this may be regarded as serving one and the same purpose.

It would be futile to search in Guarini's treatise for a single sentence in support of this interpretation. And yet the treatise contains an indirect clue. More than one-third of the text is concerned with a new kind of geometry, namely the plane projection of spherical surfaces and the transformation of plane surfaces of a given shape into corresponding surfaces of a different shape. Guarini was perhaps the only Italian architect who had studied Desargues's Projective Geometry,[26] first published in Paris in 1639, which was informed by the modern conception of infinity.

As a writer[27] Guarini sides with seventeenth-century rationalism, but for him as a priest[28] the suggestion of infinity by architectural devices must have been a pressing religious problem. We may surmise that it was the balance between the new rationalism and the modern mathematical mysticism epitomized in Guarini's work that made his architecture so attractive to the masters of the Late Baroque in Austria and southern Germany.

FILIPPO JUVARRA (1678–1736)

When Guarini died in 1683, Juvarra was five years old. He came to Turin as a fully fledged architect in 1714, thirty-one years after Guarini's death.[29] Thus there is no trace of continuity in Piedmontese architecture, nor do Juvarra's buildings at Turin show any Guarinesque influence. On the contrary, Juvarra's conception of architecture was diametrically opposed to that of Guarini. And yet there is a peculiar link between them, for Juvarra was born at Messina and grew up with Guarini's buildings before his eyes. His father was a silversmith of distinction, and Juvarra's life-long interest in designing works of applied art and in rich decorative detail probably dates back to these years.[30] His early training and impressions were, however, overshadowed by a ten years' stay in Rome (1703/4–14). He joined Carlo Fontana's studio, and it is reported that his teacher advised him to forget what he had learned before. Juvarra followed this advice, absorbed Fontana's academic Late Baroque, and studied ancient, Renaissance, and contemporary architecture with enthusiasm and impartiality (p. 5). His immense gift as a draughtsman, his extraordinary imagination, and his ceaselessly active mind prevented him from perpetuating

42. Guarino Guarini: Turin, S. Lorenzo, 1668–87. View into main dome

43. Filippo Juvarra: Turin, S. Cristina, 1715. Façade

44. Filippo Juvarra: Turin, Palazzo Madama, 1718–21. Façade

his master's manner. He gave proof of his great and original talent when in 1708 he entered the service of Cardinal Ottoboni, for whose theatre in the Cancelleria he poured out stage design after stage design of unmatched boldness.[31] Many hundreds of drawings show, moreover, that from as early as 1705 onwards he directed his creative energies towards the most diverse enterprises, such as the vast plans for the systematization of the area round the Capitol, the designs for the completion of the Palazzo Pubblico at Lucca,[32] for a palace of the Landgraf of Hesse-Cassel, and the altars in S. Martino at Naples; in addition there are designs for innumerable occasional works like the funeral decorations for Emperor Leopold I, King Peter II of Portugal, and the Dauphin; for coats of arms, cartouches, tabernacles, lamps, and even book illustrations. Very little of all this, however, was executed.

Juvarra's great opportunity came in 1714 when Vittorio Amedeo II of Savoy (recently created King of Sicily) asked him to enter his service at Messina.[33] At the end of the year we find him at Turin, and with his appointment as 'First Architect to the King' he was immediately raised to a position which had no equal in Italy. He soon enjoyed a unique international reputation, to be compared only with that of Tiepolo a generation later. As early as 1711 Emperor Joseph I of Austria had asked him for stage designs for the Vienna theatre. Between 1719 and 1720 he spent a year in Portugal planning the palace at Mafra for King John V.[34] The year 1720 also saw him in London[35] and Paris. He dedicated a volume with drawings to August the Strong of Saxony;

finally, in 1735, he was given permission to go to Madrid in order to design a royal palace for Philip V.[36] In Madrid he suddenly died on 31 January 1736.

When Juvarra settled in Turin, he had only twenty-two years to live, but what he accomplished in this relatively brief span seems almost superhuman. It is impossible to give even a remote idea of his splendid achievement. Leaving aside the work done or planned outside Turin and its neighbourhood – at Como, Mantua, Belluno, Bergamo, Lucca, Chambéry, Vercelli, Oropa, and Chieri; leaving aside also the many important projects for Rome[37] and omitting the mass of minor and occasional work at Turin, there still remains an imposing array of buildings, all in or near the Piedmontese capital. The list contains five churches[38] apart from the façade of S. Cristina (1715–28) [43]; four royal residences;[39] four large palaces in town;[40] and finally the entire quarters of Via del Carmine-Corso Valdocco (1716–28) and Via Milano-Piazza Emanuele Filiberto (1729–33). The building periods of many of these structures are long and overlap, and it is therefore difficult to see a clear development of Juvarra's style. It would seem more to the point to differentiate between the styles used for different tasks, such as the richly articulated façade of the royal palace in town, the Palazzo Madama [44], in contrast to the classical simplicity of the royal hunting 'lodge', Stupinigi [45], or the relative sobriety of aristocratic residences. Moreover, with his absolute mastery of historical and contemporary styles, Juvarra, with admirable ease, used what he regarded as suitable for the purpose. Thus when designing the façades of S. Cristina or

45 and 46. Filippo Juvarra: Stupinigi,
Castle, 1729–33. Façade and plan

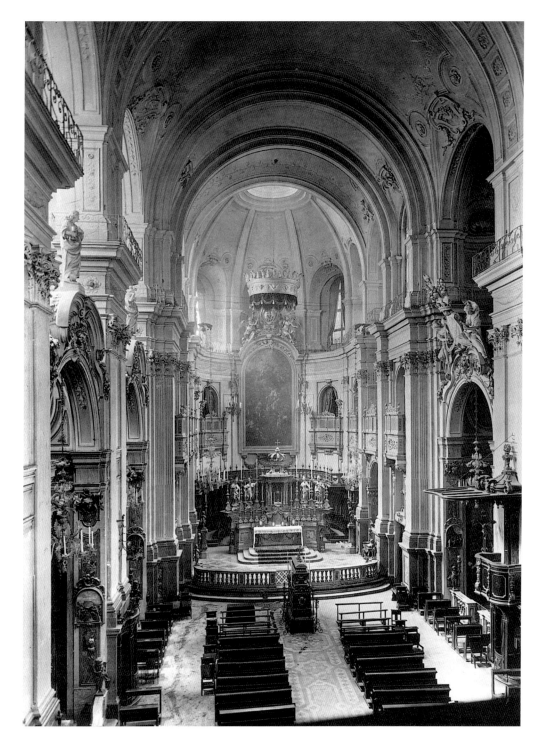

47. Filippo Juvarra: Turin, Chiesa del Carmine, 1732–5. View towards altar

S. Andrea at Chieri (1728) he turned to Rome, while the Palazzo Madama was fashioned on the model of Versailles. The way he absorbed and transformed the models from which he took his cue shows that he was more than an immensely gifted practitioner. In this respect a comparison of the front of the Palazzo Madama with the garden front of Versailles is most illuminating. It cannot be doubted that the former is much superior to the latter. Instead of the petty co-ordination of tiers in Versailles, Juvarra's *piano nobile* dominates the design; and by introducing bold accents and a determined articulation he creates an essentially Italian palace front.[41] The interior is independent of French sources; it contains one of the grandest staircase halls in Italy, taking up almost the whole width of the present façade. It also affords an excellent opportunity for studying Juvarra's decorative style, which is entirely his own. It derives from a fusion of Cortonesque and Borrominesque conceptions; boldly treated naturalistic motifs appear next to flat dynamic stylizations; exuberant ornament next to chaste, almost Neo-classical wall treatment.

While planning Stupinigi, Juvarra wavered for a time between the French and the Italian tradition. He considered both the French château type with the staircase hall adjoining the vestibule and the Italian star-shaped plan, where cor-

48 and 49. Filippo Juvarra: Turin, Chiesa del Carmine, 1732–5. Section *(above)* and side aisle cupola *(below)*

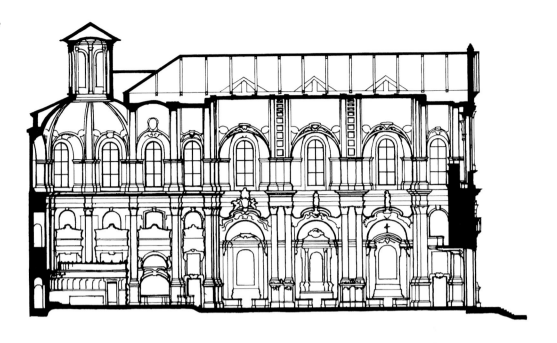

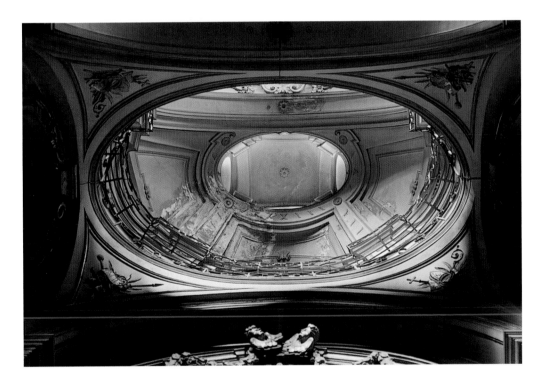

responding units are grouped round a central core.[42] He chose the latter type of design [45, 46], extended it to a scale which has no parallel in northern Italy, and transformed it so thoroughly that Stupinigi is really in a class of its own.

If it is difficult to discern a development of Juvarra's architecture in the traditional sense, an evolution – or even revolution – of certain fundamental spatial conceptions may yet be observed. On the one hand, Juvarra must be regarded as the most distinguished legatee of architectural thought accumulated in Italy in the course of the previous 300 years. On the other hand, he broke away from that tradition more decisively than any other Italian architect since the

Renaissance. This may first be demonstrated by comparing his design of S. Filippo Neri (1715)[43] with that of the Chiesa del Carmine (1732–5) [48, 49].[44] Despite the ample and airy proportions, the design of S. Filippo does not depart from the old tradition which goes back through Alberti to ancient thermae and is epitomized in Palladio's Redentore. The Chiesa del Carmine also has a wide nave and three chapels to each side, but the design has been fundamentally changed. Here there are high open galleries above the chapels [47], creating the following result: (i) along the nave two arches always appear one above the other, that of the chapel and that of the gallery; (ii) the clerestory is elimi-

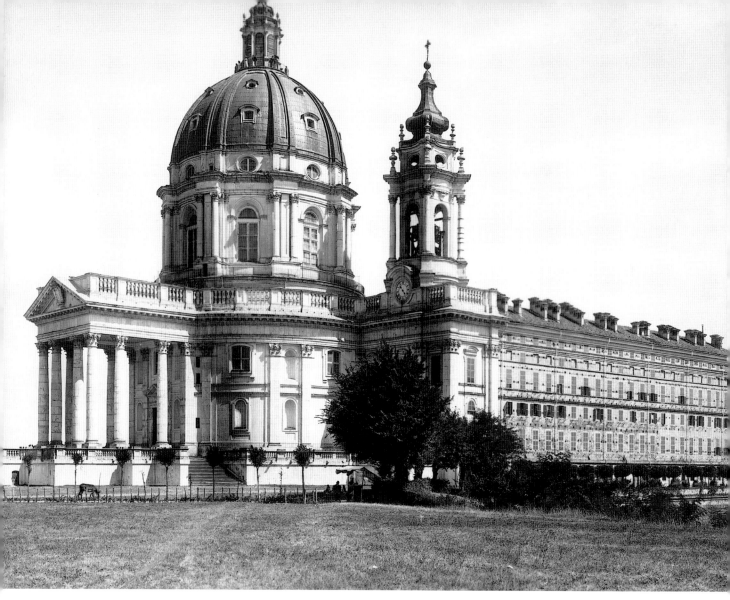

50 and 51. Filippo Juvarra: Superga near Turin, 1717–31, exterior *(above)*
and view into the dome *(opposite)*

nated, and the nave is lit through the windows of the gallery; (iii) and most important, the wall as a boundary of the nave has been replaced by a skeleton of high pillars.

All this is without precedent in Italy. No Italian architect of the Renaissance or the Baroque had wanted or dared to sacrifice the coherent enclosure of the wall and to create such immensely high openings resulting in a shift of importance from the vaulting to the slender supports. This was a thorough reversal of the Italian tradition, indeed, of the classical foundation of Renaissance architecture. Where did Juvarra turn for inspiration? High open galleries are well known from the architecture of the Middle Ages, even in Italy (e.g. S. Ambrogio, Milan); but their first monumental appearance in Renaissance architecture in connexion with the classical barrel vault is to be found in the crypto-Gothic design of St Michael, Munich (1583–97). The type remained common in Germany, and Juvarra was doubtless aware of it. For the first time since the Renaissance, the North had a vital contribution to make to Italian architecture.

Another point deserves close attention. The chapels of the Chiesa del Carmine are not self-contained units with their own source of light but have oval openings through which light streams from the windows of the gallery. The idea of using hidden light and conducting it through an opening behind or above an altar was conceived by Bernini (St Teresa altar); it was acclimatized in Austria through Andrea Pozzo and Fischer von Erlach[45] and was at the same time transferred from altars to whole chapels. It is plausible that this happened first in the North,[46] for the simple reason that there was no tradition in Italy for churches with galleries. So we see Italian ideas adapted in the North to the traditional longitudinal nave with galleries, and although the chapel fronts of the Chiesa del Carmine preserve something of the character of the Italian altar, it seems safe to assume that Juvarra was guided also for this device by German or Austrian examples.

The highest aspirations of Italian architects were always focused on the centralized church with dominating dome. True to that tradition, Juvarra was constantly engaged on fresh solutions of the old problems. Characteristically, the series begins with an ideal project which he presented in 1707 to the Accademia di S. Luca on his election as academician. And typical of his Late Baroque versatility, he integrates in this project the most diverse tendencies without,

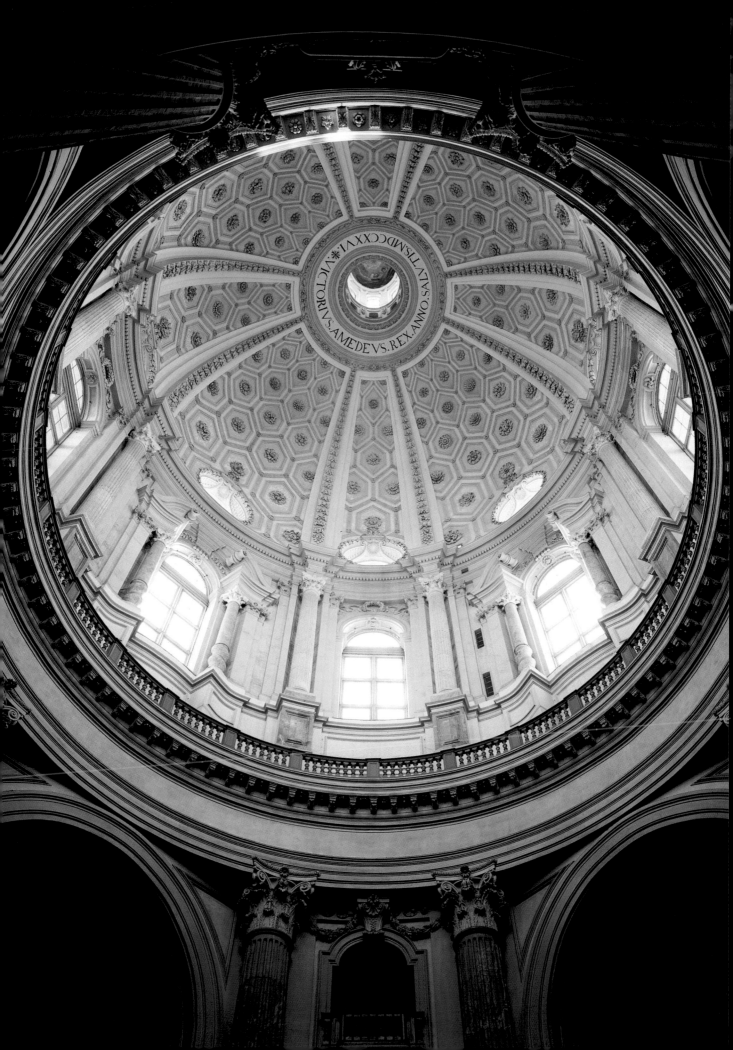

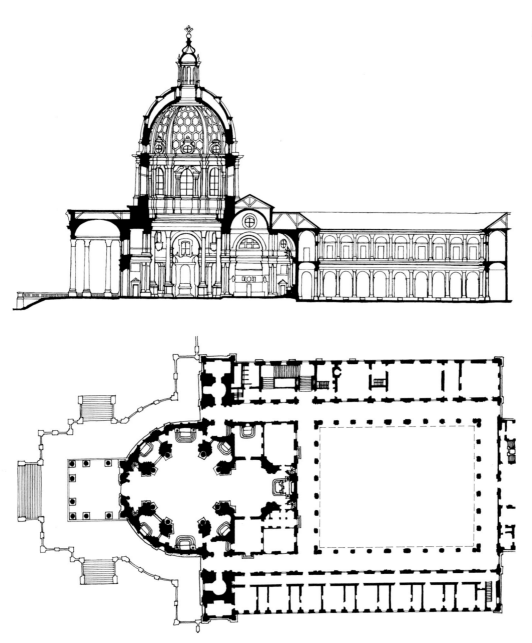

however, eclipsing the customary approach to centralized planning.[47] The same applies to his first executed centralized structure, the church of the Venaria Reale near Turin (1716–21–28). He combined here the Greek cross of St Peter's with ideas derived from S. Agnese and also introduced the scenographic element of screening columns in analogy to Palladio's Redentore.[48]

In the same year in which he was engaged on this design, he also began his masterpiece, the Superga, high up on a hill a few miles east of Turin [50, 51].[49] The Superga is by far the grandest of the great number of Baroque sanctuaries on mountains, of which I have spoken before (p. 19). Again, the church contains little that would point into the future, but it is the brilliant epitome of current ideas, brought together in an unexpected way. While a part of the church is enclosed by the short side of an extensive rectangular monastery, three-quarters of its circular exterior jut out from the straight line of this building. This side, facing the plain of Turin and a glorious range of Alpine peaks, is stone-faced and treated as

a coherent unit which conceals the long brick fronts of the monastery. The principal ratios used are of utter simplicity: the square portico in front of the church has sides corresponding in length exactly to the straight walls adjoining the church, a measure which is half that of the church's diameter; the body of the church, the drum, and the dome are of equal height. Similar to the Venaria Reale, the ground plan shows large openings in the cross-axes and satellite chapels in the diagonals. One tends to read into the plan the bevelled pillars of a Greek cross with columns in recesses (reminiscent of S. Agnese). But the elevation reveals that there is no pendentive zone and that the columns which, in analogy to S. Agnese, one would expect to support the high arches of the Greek-cross arms, carry instead the uninterrupted ring of the entablature, on which rests the high cylinder of the drum. In contrast to many of Guarini's structures, in which a pendentive zone is unexpectedly introduced, here, equally unexpectedly, it has been suppressed. But Juvarra's design lacks the quality of contradiction which we found in

53. Filippo Juvarra: Sketch for the
Duomo Nuovo, Turin, after 1729

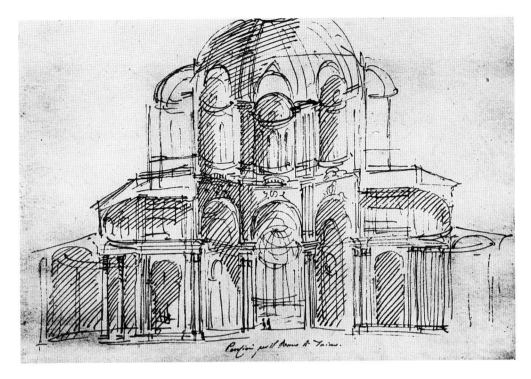

Guarini. Juvarra has combined in one building the two prin-
cipal types of domical structure [52]: the Pantheon type,
where the dome rises from the cylindrical body, and the
Greek-cross type; and these two different centralized sys-
tems remain clearly discernible. The body of the church is
octagonal, as it should be in a Greek cross with bevelled pil-
lars; and the transition from the octagon to the circle is
boldly conceived,[50] for the circular entablature is set into the
octagon touching it only in the centre of the four arches.

The decoration of the church owes as much to Borromini
as to Bernini. Borrominesque are the undulating windows of
the drum, while the combination of ribs and coffers in the
dome is close to Bernini's Castelgandolfo. But the colour
scheme with its prevailing light bluish and yellowish tones
has no relationship to the past and is typically eighteenth-
century. A small centralized altar room, attached to the con-
gregational room, is treated as an isolated unit. Without
being attracted by Guarini's pioneering interpenetration of
spatial entities, Juvarra returns in this respect to the North
Italian Renaissance tradition.

In the exterior he took up the old problem of the high
dome between flanking towers. Although the latter are
clearly indebted to those of S. Agnese, he returned to
Michelangelo's design of St Peter's for the alternating
rhythm of wide and narrow bays in the body of the church
as well as for the vertical continuation of the pilasters into
the double columns of the drum and the ribs of the dome. If
Michelangelo, therefore, informed the principle of
unification, the relationships are utterly different. In keep-
ing with a Baroque tendency which has been discussed
(II: p. 53), Juvarra increased the height of the drum and
dome at the expense of the body of the church, and in this
respect he went far beyond the position reached in S.
Agnese.[51]

Indirectly the portico also stems from Michelangelo's St
Peter's. In 1659 Bernini had tried to revive Michelangelo's

idea, and from then on all classically-minded architects
placed a portico in front of centralized buildings. The exam-
ple of the Pantheon was, of course, close at hand, and it is
characteristic of Juvarra's classicizing Late Baroque that he
took his cue from the ancient masterpiece. But he went even
further and endeavoured to improve upon it, firstly by inte-
grating his portico with the body of the church, and sec-
ondly by reducing the number of columns. This enabled
him to fulfil Vitruvius's demand for a wider central interco-
lumniation and, moreover, to create a light and airy struc-
ture, true to eighteenth-century aspirations.

It may well be said that this building represents the
apogee of a long development: the problems of centralized
planning, the double-tower façade, the high drum and dom-
inating dome, the tetrastyle portico and its wedding to the
church – all this was carried a step beyond previous realiza-
tions, in a direction which one might expect if the whole
evolution were before one's mind. Yet there is something
un-Italian about this work. It is mainly the way in which the
monastic buildings have been connected with the church.
One cannot avoid recalling the large monastic structures
north of the Alps such as Weingarten, Einsiedeln, and Melk,
the dates of which, incidentally, almost correspond with that
of the Superga. It is hardly possible to doubt that Juvarra
was conversant with such works. And it was precisely the
impact of the North that also revolutionized his approach to
centralized building.

His late centralized church designs were not executed.
Most important among them are the many projects for the
new cathedral, dating from 1729, in which essentially he
returned to the grouping of Leonardo's schemes. But this
is true only for the plans and not for the elevations. The
strangest among the latter [53] shows a skeleton structure
with immensely high piers and arched openings in two tiers
between them.[52] The dome as an independent, dominating
feature has been eliminated. Nor has the drum a *raison d'être*

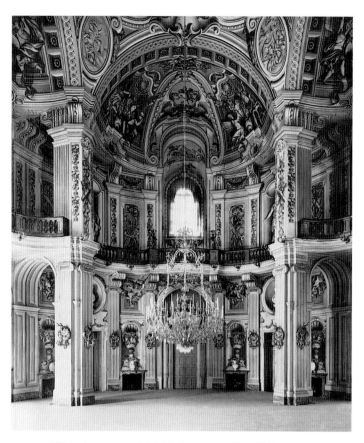

54. Filippo Juvarra: Stupinigi, Castle, 1729–33. Great Hall

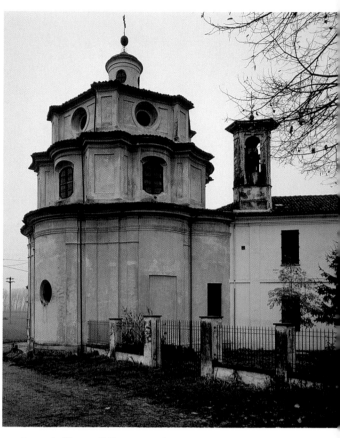

55. Bernardo Vittone: Vallinotto near Carignano, Sanctuary, 1738–9. Exterior

in such a design. It is now clear that in his late work Juvarra applied the same revolutionary principles to the planning of both longitudinal and centralized buildings. The volte-face expressed in the designs for the new cathedral corresponds exactly to that of the Chiesa del Carmine.

Once again German buildings provide the key to this development. When uninfluenced by Italy, German architects never accepted the southern drum and dome, not even for their centralized churches. They always preferred (essentially anti-Renaissance) skeleton structures capped by low vaults.[53] While the late Juvarra consented to this principle of spatial organization, he still adhered to the Italian articulation of his units and sub-units. No vaulted structures corresponding to his cathedral designs will be found in Germany.

In the central hall of Stupinigi Juvarra's new ideas reached the stage of execution [54]. And in this hall one will also understand why he was so much attracted by the northern approach to planning. These skeleton structures, with their uninterrupted vertical sweep and the unification of central and subsidiary rooms, have a marked scenic quality. In spite of his classical leanings, Juvarra never ceased to think in terms of the resourceful stage designer.

When all is said and done, it remains true that Juvarra not only perfected the most treasured of Italian architectural ideals, but also abandoned them. Just because he was the greatest of his generation, this surrender is more than a matter of local or provincial import. It adumbrates the end of Italian supremacy in architecture.[54]

BERNARDO VITTONE (1702, not 1704/5–70)

The improbable rarely happens, but it does happen sometimes. An architect arose in Turin who reconciled the manner of Guarini with that of Juvarra. His name is Bernardo Vittone, and he was, unlike Guarini and Juvarra, a Piedmontese by birth.[55] Outside Piedmont Vittone is still little known, and yet he was an architect of rare ability, full of original ideas and of a creative capacity equalled only by few of the greatest masters. His relative obscurity is certainly due to the fact that most of his buildings are in small Piedmontese towns, seldom visited by the student of architecture. He studied in Rome, where he won a first prize in the Accademia di S. Luca in 1732.[56] Early next year he returned to Turin, in time to witness the rise of Juvarra's late works. The Superga had just been completed, the large hall at Stupinigi was almost finished, and the Carmine was going up. It was this architecture that made an indelible impression upon him.[57]

Shortly after his return from Rome, the Theatines who owned Guarini's papers won Vittone's collaboration in editing the *Architettura civile*, which appeared in 1737. In this way he acquired his exceptional knowledge of Guarini's work and ideas; nor did he fail to learn his lesson from the long chapters on geometry. On this firm foundation he set out on his career as a practising architect,[58] and from shortly after Juvarra's death until his own death in 1770 we can follow his activity almost year by year. His few palaces are without particular distinction. His interest was focused on ecclesiastical

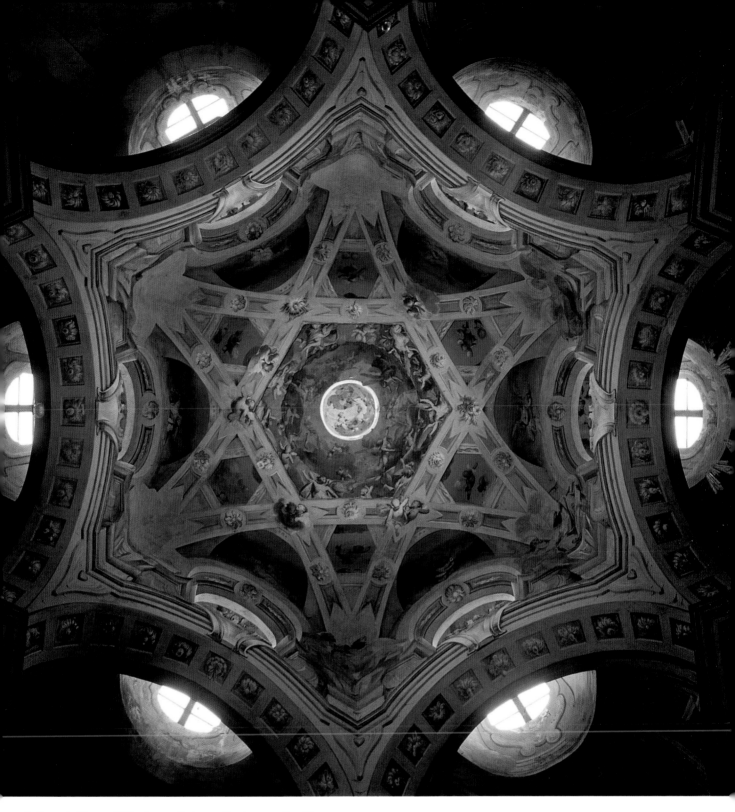

56. Bernardo Vittone: Vallinotto near Carignano, Sanctuary, 1738–9. View into the dome

architecture, and it is a remarkable fact that, with one or two exceptions, his churches – and they are many – are centralized buildings or derive from centralized planning. One would therefore presume that as a rule he followed his own counsel and that the clergy of the small communities for which he worked hardly interfered with his ideas.

His first building, to our knowledge, the little Sanctuary at Vallinotto near Carignano (south of Turin), is also one of his most accomplished masterpieces [55–8]. It was erected between 1738 and 1739 as a chapel for the agricultural labourers of a rich Turin banker.[59] The exterior immediately illustrates what has just been pointed out: it combines features of both Guarini's and Juvarra's styles. From Guarini's specific interpretation of the North Italian tradition derives the pagoda-like diminution of tiers.[60] But in contrast to Guarini's High Baroque treatment of the wall with pilasters

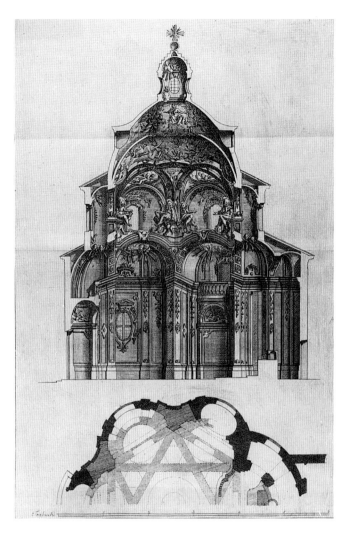

57. Bernardo Vittone: Vallinotto near Carignano, Sanctuary, 1738–9. Engraving of section and plan

vaults, one above the other: two solid ones with circular openings, diminishing in size, and, capping them, the hemisphere of the lantern.

The idea of a solid spherical dome with a large opening, allowing a view into a second dome, is also Guarini's,[62] but the latter never combined this type with the diaphanous dome, and neither Guarini nor any other architect ever produced a dome with three (or, counting the lantern, which forms part of the scheme, four) different vaults. The adaptation and fusion of Guarinesque domical structures was for Vittone a means to a different end. It will be recalled that Guarini always separated the zone of the dome from the body of the church, true to his principle of working with isolated and contrasting units. Not so Vittone; in his case the ribs of the vaulting are continuations of the pillars. He even omits the traditional entablature above the arches of the hexagon, thus avoiding any break in continuity. Instead, he introduces a second ring of high arches above the arches of the chapels. Thus he creates a lofty system of arches with which the ribbed vaulting forms a logical entity. The second ring of arches has a further purpose: it conducts the light

58. Bernardo Vittone: Brà, S. Chiara, 1742. Elevation, section, and plan. Engraving

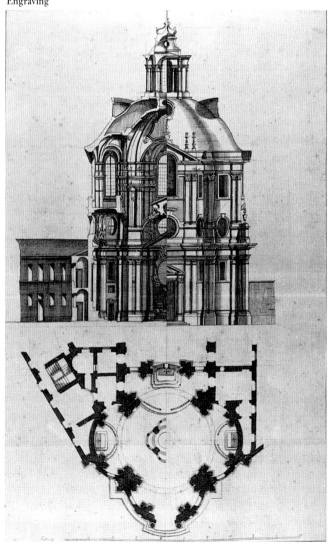

and columns, niches and pediments, ornament and statues, we find here walls of utter simplicity, accentuated only by unobtrusive pilasters and plain frames and panels. Obviously this was done under the influence of Juvarra's classicist detail such as the exterior of Stupinigi. In spite of the utmost economy of detail, the church makes a gay and cheerful Rococo impression, and this is due not only to its brilliant whiteness, also to be found in Stupinigi, but above all to the lively silhouette and the undulating rhythm of the walls.

If anything, the impression of the interior surpasses that of the exterior. All the characteristic features of Vittone's style are here assembled – it is a climax right at the beginning. The plan consists of a regular hexagon with six segmental chapels of equal width spanned by six equal arches [57]. But the treatment of the chapels varies; for open chapels alternate with others into which convex *coretti* have been placed. Since, therefore, non-corresponding chapels face each other across the room, the geometrical simplicity and regularity of the plan is not easily grasped.[61] The glory of this little church is its dome [56]. Following Guarini, Vittone formed its first diaphanous shell of intersecting ribs. Through the large hexagonal opening appear three more

from the large windows of the first 'drum' into the main room and under the ribbed vault. At the same time these windows supply a strong sky-light for the chapels, the vaults of which have oval apertures.

It is evident that the arrangement of the arches as well as the lighting of the main room and the chapels derive from Juvarra's Carmine. We are faced with the extraordinary fact that the northern nave type with galleries, introduced by Juvarra into a longitudinal building, has here been transferred to a centralized structure. No stranger and more imaginative union of Guarinesque and Juvarresque conceptions could be imagined.

While the ribbed dome is lit by a strong indirect light, the second dome has no source of light at all. By contrast, the third dome is directly lit by circular windows, but they are invisible to the beholder from any point in the church. Precisely the same type of lighting was used by Guarini in his design of S. Gaetano at Vicenza. The two forms of concealed lighting to be found in the Sanctuary derive therefore from Juvarra's Carmine and Guarini's S. Gaetano. Their common source is, of course, Bernini. But while Bernini focuses the concealed light on one particular area, the centre of dramatic import, no such climax is intended by Vittone. A gay and festive bright light fills the whole space and the differently lit realms of the dome are only gradations of this diffuse luminosity. Vittone himself made it clear that he wanted the different vaults to be seen as one unified impression of the infinity of heaven. On the vaults is painted the hierarchy of angels, of which Vittone writes in his *Istruzioni diverse*: 'The visitor's glance travels through the spaces created by the vaults and enjoys, supported by the concealed light, the variety of the hierarchy which gradually increases' (i.e. towards the spectator).

The altar in this church stands free between two pillars through which one looks into a space behind. Thus even Vittone, who always concerned himself with strict centralized planning, accepted the Palladian tradition of a screened-off space, a tradition with which he was conversant through both Juvarra and Guarini. But we have seen (II: p. 28) that this device made it possible to preserve the integrity of the centralized space and, at the same time, to overcome its limitations. Vittone, in fact, more than once used and varied this motif and thoroughly exploited its scenic possibilities and mysterious implications.[63]

In a small sanctuary of this character a high standard of finish cannot be expected. All the architectural ornaments are rather roughly painted. The colours used here and in other churches by Vittone are predominantly light grey and reddish and greenish tones, in other words typical Rococo colours somewhat similar to those used by Juvarra, but entirely different from the heavy and deep High Baroque colour contrasts with which Guarini worked.

The church of S. Chiara at Brà of 1742 is probably Vittone's most accomplished work [58, 59]. Here four identical segmental chapels are joined to a circular core. As in the Sanctuary at Vallinotto, the external elevation follows the basic shape of the plan. S. Chiara is a simple brick structure, and only the top part is white-washed, emphasizing the richly undulating quatrefoil form of the building. Inside, four relatively fragile pillars carry the vaulting. The section

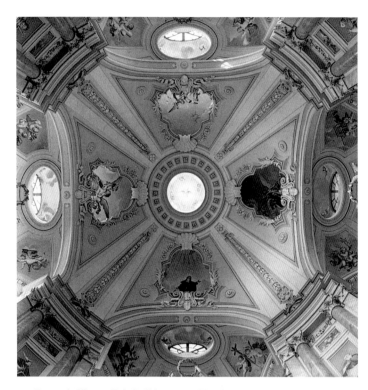

59. Bernardo Vittone: Brà, S. Chiara, 1742. View into dome

[58] immediately recalls Juvarra's designs for the new cathedral [53]. But Vittone introduced a nuns' gallery with high arches which correspond exactly to the arches of the chapels beneath and cut deeply into the lower part of the vault. Much more closely than at Vallinotto, Vittone adjusted the system of Juvarra's Carmine to his centralized plan.[64] Of the low domical vault little remains, and what there is seems to hover precariously above the head of the beholder. This impression is strengthened by an extraordinary device: each of the four sectors of the vault has a window-like opening through which one looks into the painted sky with angels and saints in the field of vision. Sky and figures are painted on the second shell, which forms the exterior silhouette of the dome, and receive direct and strong light from the nearby windows. And these windows also serve as sky-lights to the gallery.

Vittone found in this church a new and unexpected solution for Guarini's idea of the diaphanous dome: a fragile man-made shell seems to separate constructed space from the realm in which saints and angels dwell [59]. Although structurally insignificant, the dome is still the spiritual centre of the building. By means of a transformed Guarinesque conception, the anticlimax of Juvarra's late designs was here endowed with new meaning.

Also in Vittone's later work hardly any fully developed dome will be found. This is paralleled in Austrian and German church building where the native tradition led to a general acceptance of low vaults. But Vittone's designs are so different from those of the North that a direct contact must be excluded. The stimulus received from Juvarra's Chiesa del Carmine, from the latter's late centralized projects, and the great hall at Stupinigi, in combination with

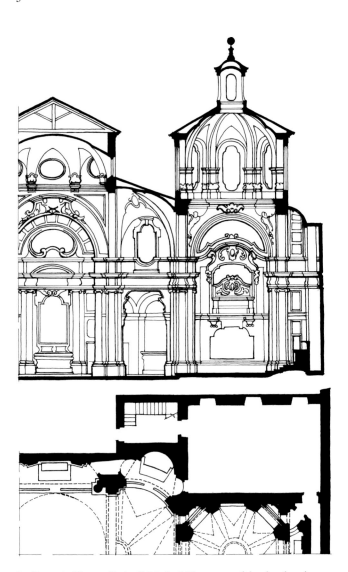

60. Bernardo Vittone: Turin, S. Maria di Piazza, part of the church and choir, 1751–4. Section and plan

ideas derived from Guarini, fully account for Vittone's strange development. In his later buildings he found ever new realizations of the same problem. S. Gaetano at Nice shows the adaptation of the design of S. Chiara at Brà to an oval plan. In S. Bernardino at Chieri (1740–4) he was handicapped by an existing building and was forced to use a more traditional form of dome. But he made the dome appear to hang weightless in space above the chapels and created diaphanous pendentives through which fall the rays of the sun. In other designs he transformed the dome into a shaft-like feature. This may be studied in his relatively early project for S. Chiara at Alessandria:[65] its diaphanous vault owes a very great deal to Guarini and is, indeed, far removed from the broad stream of the northern development.

The next important step, which further widened the gap with northern designs, was taken by Vittone in 1744 in the church of the Ospizio di Carità at Carignano[66] which shows a new concept brought to full fruition two years later in the choir of S. Maria di Piazza at Turin (1751–4) [60]. Here he designed a normal crossing with four arches and pendentives between them. But instead of separating the zone of

the pendentives from the drum by a circular ring, he fused pendentives and 'drum' indissolubly. This he achieved by hollowing out the pendentives and giving them a deep concave shape; in other words, he transformed them into a kind of inverted squinches. Thus the medieval squinch, which had been swept away by the Renaissance and was revived by Borromini in some marginal works (II: p. 49), found a strange resuscitation just before the close of a long epoch. As a result of the new motif it was possible to arrange the piers of the 'drum' in the form of an octagon and to let the tall windows between them return to the square of the crossing: there are two windows at right angles above each pendentive. Entirely unorthodox, Vittone's domical feature, so rich in spatial and geometrical relations, belongs in a class with Guarini's hybrid dome conceptions.

Vittone availed himself of the infinite possibilities which the inverted squinch offered, and it is remarkable that no other architect, to my knowledge, took up the idea. The maturest manifestation of the new concept is to be found in S. Croce at Villanova di Mondovì (1755) [61].[67] In this church the square of the crossing consists of very wide and high arches. By widening the 'pendentive-squinch', Vittone found an entirely new way of transforming the square into a regular octagon. Thus arches, pendentives, drum, and dome merge imperceptibly into an indivisible whole.

Towards the end of his life Vittone seems to have returned to more conventional designs (church at Riva di Chieri, begun 1766).[68] This phase is reflected in the work of pupils and followers such as Andrea Rana from Susa, the architect of the impressive Chiesa del Rosario at Strambino (1764–81),[69] or Pietro Bonvicini (1741–96), who built S. Michele in Turin (1784).[70] It was these men, among others, who carried on Vittone's Piedmontese Late Baroque almost to the end of the eighteenth century.

When Vittone died, Neo-classicism was conquering Europe. In historical perspective his intense Late Baroque may therefore be regarded as a provincial backwater. But judged on its own merits, his work is of rare distinction. He attacked centralized planning, that old and most urgent problem of Italian architects, with boldness and imagination; and perhaps no architect before him, not even Leonardo, had studied it with equal devotion and ingenuity. His architecture could be conceived only on the broadest foundation. Through the merging of Guarini and Juvarra he looked back to the 'bizarre' as well as the 'sober' tradition in Italian architecture – to Borromini on the one hand; to Carlo Fontana, Bernini, and Palladio on the other. He himself differentiated between the classical trend and the architecture 'di scherzo e bizzaria', for which he named Borromini and Guarini. Moreover he incorporated in his work the scenic qualities of the North Italian Palladian tradition. Finally, Juvarra familiarized him with Germano-Austrian conceptions of planning, and Guarini with a theoretical knowledge of modern French geometry. It was this knowledge that enabled him to discover the potentialities of a combination of pendentive with squinch, a combination geometrically extremely intricate, used neither by French nor German eighteenth-century architects.

What little we know about him suggests that his was an obsessed genius. This is also the impression one carries away

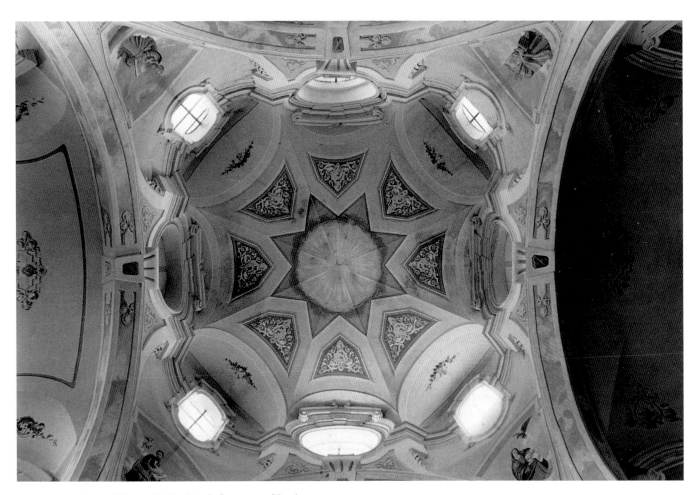

61. Bernardo Vittone: Villanova di Mondovì, S. Croce, 1755. View into vaulting

from reading his two treatises, the *Istruzioni elementari* of 1760 and the *Istruzioni diverse* of 1766. The earlier treatise is one of the longest ever written, and the later consists to a large extent of appendices to the first. But the published work is only a small part of his literary production. Large masses of manuscripts existed which have so far not been traced. Now the extraordinary thing about his treatises is that basically he has not moved far from Alberti's position. To be sure, the language has changed: where Alberti wanted to elevate and inform the mind, Vittone wants to delight. He also incorporates recent research – but for what purpose? Newton's splitting up of white light into the colours of the rainbow is for him the supreme confirmation of the old musical theory of proportion. Proportion is the one and all

of these treatises, and Vittone's terms of reference are precisely those of Renaissance theory. He even intersperses his text with musical notations, and by squaring his paper he claims to have found an infallible method of ensuring the application of correct proportions. He concludes the second treatise with a special long paper on music which he commissioned from his assistant Giovanni Galletto, whom he never paid for the contribution.[71]

Thus in spite of all the formal development during 300 years of Italian architectural history, beginning and end meet. And it is also in the spirit of the Renaissance treatises that Vittone dedicated his first work to the 'Signore Iddio', to God Himself, and the second to 'Maria Santissima, Madre di Dio'.[72]

Sculpture

ROME

Towards the end of the seventeenth century French influence, particularly on sculptors, increased rapidly. The reason for it seems obvious. After the foundation of the French Academy in Rome (1666), French sculptors went to the Eternal City in great numbers, often not only to study but to stay. But this is only part of the story. It would appear that Rome was no longer strong enough to assimilate the national idiosyncrasies of the Frenchmen. It may be recalled that during the preceding 150 years hardly any Roman artist had been a Roman by birth. Bernini was half Tuscan, half Neapolitan; the Carracci, Domenichino, and Algardi came from Bologna; Duquesnoy from Brussels; Caravaggio, Borromini, and a host of others from Northern Italy; and this list could be continued indefinitely. Yet since the days of Bramante, Raphael, and Michelangelo, Rome had had a most extraordinary formative influence on artists: they imbibed that specifically Roman quality which is described by the word *gravità* – a grandeur and severity that stamp all these artists as typically Roman, however widely their personal styles may differ. In Bernini's immediate circle we find Germans and Frenchmen, but without documentary evidence[1] it would be entirely impossible to discover their non-Roman or even non-Italian origin. Now, at the end of the seventeenth century, the position changed. In the works of a Monnot, a Théodon, a Legros [62], or later of a Michelangelo Slodtz [76], we sense something of the typically French *bienséance* and linear grace. In spite of these un-Roman qualities, however, the artists just mentioned absorbed so much of the Roman Baroque spirit that one feels inclined to talk of them as semi-Romans. It is not until after the middle of the eighteenth century that French works like Houdon's *St Bruno* in S. Maria degli Angeli break away from the Roman tradition entirely.

Support for French influence came from the Italians themselves, and in particular from an artist from whom we should expect it least, namely Domenico Guidi, the only important sculptor of his generation who was still alive in 1700. After the deaths of Ferrata and Raggi in the same year, 1686, he was generally acknowledged as the first sculptor in Rome. In a previous chapter we have discussed the somewhat dubious practices of this artist, whose workshop supplied the whole of Europe with sculpture. His social ambition led him into the higher regions of official academic art; he was *principe* of the Academy of St Luke in 1670 and again in 1675, while Bernini was still alive, and his position put him on an equal footing with Charles Lebrun, the embodiment of the suave and accomplished professional artist. It was Guidi who proposed Lebrun for the post of *principe* of the Academy of St Luke, an honour which the latter accepted for 1676 and 1677. But since he could not leave Paris, it was arranged that Charles Errard, the Director of the French Academy in Rome, should act as his deputy. Thus a mere decade after Bernini had made the Paris acad-

emicians and courtiers recoil in fear before Italian genius, the same academicians were, symbolically at least, the masters of Rome – due to the initiative of the unsophisticated Guidi who began as the archenemy of the *professori*. The academic ties between Rome and Paris were further strengthened when the French reciprocated by appointing Guidi one of the Rectors of the Paris Academy and by asking him to keep an eye on the work of the French students in Rome. Lebrun, moreover, repaid Guidi's compliment by obtaining for him in 1677 the commission for a group at

62. Pierre Legros the Younger: St Louis Gonzaga in Glory, 1698–9. Rome, S. Ignazio

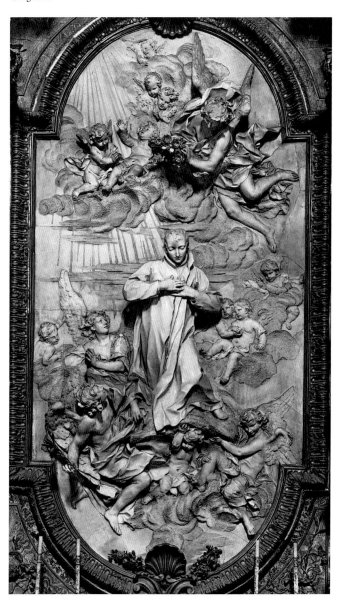

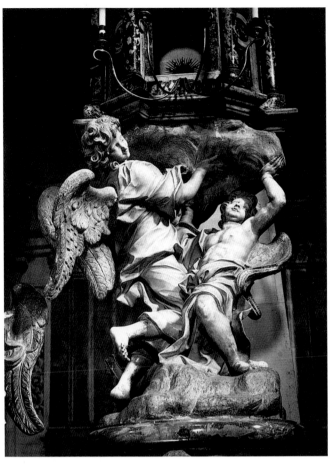

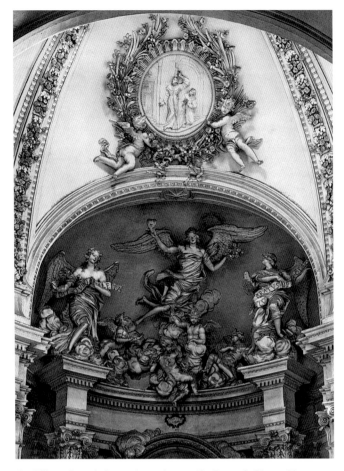

63. Giuseppe Mazzuoli: *Angels carrying the Ciborium, c.* 1700. Siena, S. Martino

64. Filippo Carcani: Stucco decoration, *c.* 1685. Rome, S. Giovanni in Laterano, Cappella Lancellotti

Versailles. In accordance with French custom, Lebrun himself supplied a drawing from which Guidi was expected to work. The wheel had turned full circle; never before had a Roman artist taken his cue from Paris. Guidi, however, was still steeped in the Roman grand manner, and the Baroque exuberance of his group gave little satisfaction after its arrival in Versailles.[2]

It must not be forgotten that the exchange of Academic niceties between Lebrun and Guidi took place at a time when Bernini was still vigorously active. Bernini himself was surrounded by friends, old and young, who always remained true to the art of their master. Among the older men there was Lazzaro Morelli (1608–90), the faithful collaborator on the Cathedra, the tomb of Alexander VII, and many other works; among the younger there were Giulio Cartari, who had accompanied Bernini to Paris, Michele Maglia, Filippo Carcani, and above all Giuseppe Mazzuoli. The last three were actually Ferrata's pupils, but Bernini employed them on more than one occasion and particularly for the tomb of Alexander VII. The most important artist of this group was Mazzuoli (1644–1725),[3] a slightly older contemporary of the Frenchmen Théodon, Monnot, and Legros; and it was he rather than anybody else who kept the Berninesque tradition alive into the eighteenth century and entirely by-passed fashionable French classicism. Instead of illustrating one of his many monumental works, we show as illustration 63 a detail

of the two angels who carry the ciborium above the main altar in S. Martino at Siena (*c.* 1700); here the spirit of the Cathedra angels is still alive. Another of Ferrata's pupils, Lorenzo Ottoni, one of the most prolific artists the generation born towards the middle of the seventeenth century (1648–1736), remained Berninesque in his many stucco works but followed the classical French trend in his monumental marbles;[4] the same observation may be made in the case of some minor artists of the period. Works by Ottoni found their way to all parts of Italy, from Montecassino (destroyed) to Rieti, Pesaro, Ancona, and Mantua.

Filippo Carcani, most of whose work was carried out in the twenty years between 1670 and 1690, commands particular interest. Imbued with Bernini's late style, he was attracted by Raggi, and it was Carcani, above all, who carried on Raggi's highly-strung manner – but with this difference: in Raggi's as well as in Bernini's late style the structure of the body remained important; one can always sense the classical model even if the body is hidden under a mass of drapery and even if the drapery contrasts with the stance. Carcani, however, was no longer interested in classical structure. In his stuccoes, bodies are immensely elongated and fragile, as if they were without bones, while draperies laid in masses of parallel folds envelop them [64]. Some of Carcani's work, particularly the stuccoes in the Cappella Lancellotti in S. Giovanni in Laterano (*c.* 1685),[5] can only be

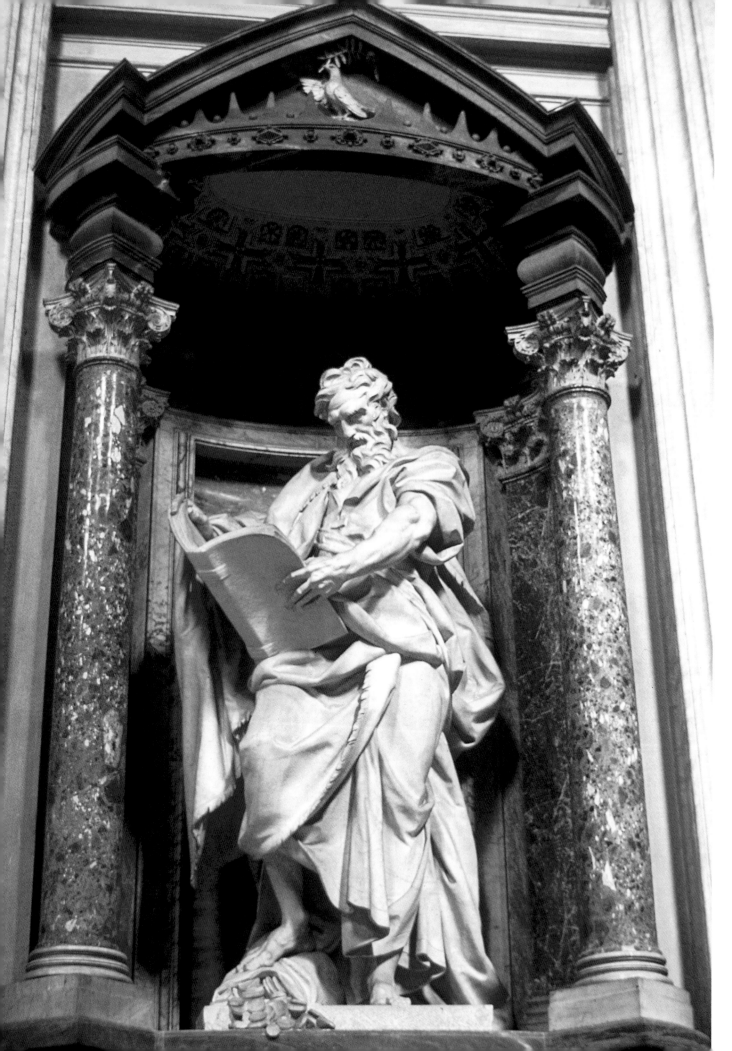

described as a strange proto-Rococo, and the eighteenth-century charm of the sweet heads of his figures would easily deceive many a connoisseur. It is surprising that this 'Rococo' transformation of Bernini's late manner could be performed, so soon after the latter's death, by a sculptor who had worked in close association with him. Carcani's proto-Rococo, however, had no immediate following in Rome.

Despite the continuity of Bernini's late style, at the close of the century it was the French who were given the best commissions. They had the lion's share in the most important sculptural work of those years, the altar of St Ignatius in the left transept of the Gesù.[6] Confidence in the victory of Catholicism had never been expressed so vigorously in sculptural terms and with so much reliance on overpowering sensual effects. Unrivalled is the colourful opulence of the altar, its wealth of reliefs and statues; but a typically Late Baroque diffuse, picturesque pattern replaces the dynamic unity of the High Baroque. In this setting one is apt to overlook the mediocre quality of the over-life-size marble groups supplied by the main contributors, the Frenchmen Legros and Théodon. Next to the Frenchman Monnot, the Italians Ottoni, Cametti, Bernardo Ludovisi,[7] Angelo de' Rossi, Francesco Moratti, and Camillo Rusconi were given subsidiary tasks, which show, however, more distinction than the work of their French colleagues.

Rusconi (1658–1728), who had first been selected for one of the large marble groups but was replaced by his contemporary Legros, reasserted his position at the beginning of the next century. To be sure, he was the strongest personality among Roman sculptors in the first quarter of the eighteenth century.[8] After an early and brief 'Rococo' phase (*Cardinal Virtues*, Cappella Ludovisi, S. Ignazio, 1685), deriving like Carcani's style from Raggi rather than from his Roman teacher Ferrata, he reverted, perhaps under the influence of his older friend Carlo Maratti, to Duquesnoy and Algardi and also absorbed the teachings of the French artists in Rome without, however, discarding the Berninesque heritage. The result can be studied in the heroic Late Baroque classicism of his four Apostles for Borromini's tabernacles in S. Giovanni in Laterano (1708–18) [65]. They form part of the series of twelve monumental marble statues, the largest sculptural task in Rome during the early eighteenth century.[9] These statues provide an opportunity of assessing the prevalent stylistic tendency between 1700 and 1715, and the distribution of commissions is, at the same time, a good yardstick for measuring the reputation of contemporary sculptors. Rusconi has pride of place with four figures. Legros and Monnot executed two statues each, and only one was assigned to each of the following: Ottoni, Mazzuoli, Angelo de' Rossi, and Francesco Moratti. Of the two latter, Angelo de' Rossi was by far the more distinguished artist [66].[10] Born in Genoa in 1671, he had imbibed Bernini's manner under Filippo Parodi, but after his arrival in Rome in 1689 had turned more and more towards the classicizing French current. Moratti from Padua was also Parodi's pupil; he died young, in about 1720,

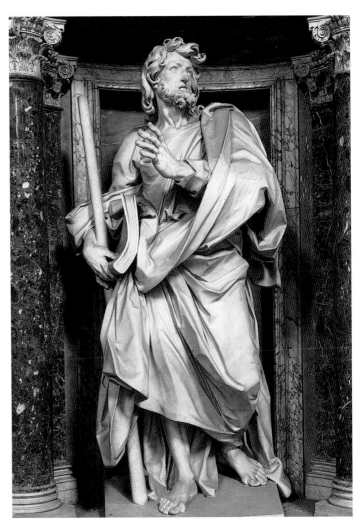

66. Angelo de' Rossi: *St James Minor*, 1705–11. Rome, S. Giovanni in Laterano

and his *œuvre* is therefore rather small. Though not influenced by Monnot, his *Apostle Simon*, next to Mazzuoli's *Philip*, is the only other Berninesque statue of the whole series. With eight of the twelve statues the work of Rusconi, Legros, and Monnot, this survey confirms the preponderance of different facets of a Late Baroque classicism, a style anticipated in the painting of Carlo Maratti, but exactly paralleled in contemporary architecture.

The next generation (born between 1680 and 1700) did not pursue wholeheartedly the powerful Late Baroque for which Rusconi stood. Among the many practitioners of that generation four names stand out by virtue of the quality and quantity of their production: those of Agostino Cornacchini (1686–1754), Giovanni Battista Maini (1690–1752), Filippo della Valle, and Pietro Bracci (1700–73). Cornacchini, educated in Foggini's studio at Florence, came to Rome in 1712 working in a manner which watered down his teacher's reminiscences of Ferrata and Guidi. His work often has a mawkish flavour, and if he occasionally aspired to grandeur in the Roman artistic climate, he became guilty of grave errors of taste, as is proved by his *St Elijah* (St Peter's, 1727) with its borrowings from Michelangelo as well as by the equestrian monument of Charlemagne under the portico of St Peter's

65. Camillo Rusconi: *St Matthew*, 1713–15. Rome, S. Giovanni in Laterano

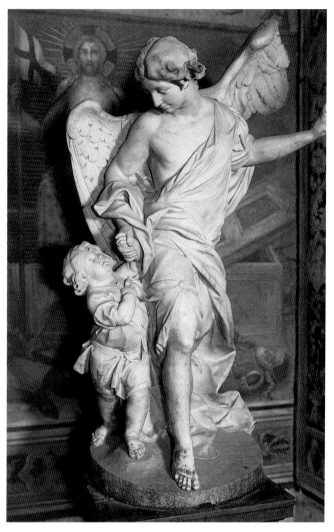

67. Agostino Cornacchini: *The Guardian Angel*, 1729. Orvieto, Cathedral

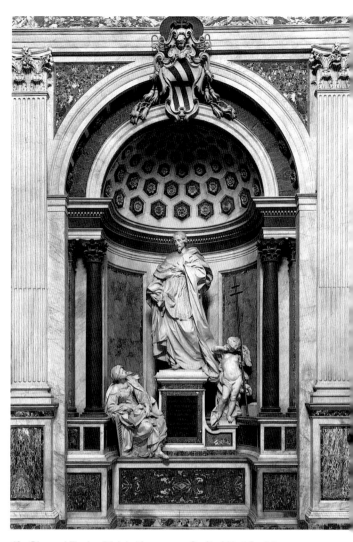

68. Giovanni Battista Maini: *Monument to Cardinal Neri Corsini*, 1732–5. Rome, S. Giovanni in Laterano, Cappella Corsini

(1720–5), which is nothing but a weak and theatrical travesty of its counterpart, Bernini's *Constantine*.[11] The less pretentious Archangels Michael and Gabriel in the cathedral at Orvieto (1729) [67] show that he could command a typically eighteenth-century charm, and in such works his manner is close to that of Pietro Bracci. Giovanni Battista Maini,[12] coming from Lombardy and, like Rusconi, learning his art from Rusnati in Milan, was for a time associated in Rome with his older compatriot, and it was he together with Giuseppe Rusconi (1687–1758, not related to Camillo) who upheld Camillo's heroic classicism during the thirties and forties of the eighteenth century. Maini's most important works are in Galilei's Cappella Corsini in S. Giovanni in Laterano: the bronze statue of Clement XII (1734), almost a straight classicizing copy after the pope of Bernini's Urban tomb, and, more characteristic, the monument to Cardinal Neri Corsini[13] (1732–5) [68], in which the Marattesque figure of the Cardinal recalls Philippe de Champaigne's *Richelieu* in the Louvre, while the allegory of Religion is closely related to that of Rusconi's tomb of Gregory XIII.

The rich sculptural decoration of the Cappella Corsini is as vital for our understanding of the position in the 1730s as the Lateran Apostles were for that of about 1710. No less than eleven sculptors were employed and at least six of them were directly or indirectly indebted to Rusconi.[14] But they tend to transform Rusconi's 'classicist Baroque' into a 'classicist Rococo', very different from Carcani's passionate 'Rococo' of almost fifty years before. Most characteristic of this style is perhaps Filippo della Valle's *Temperance* [69]. Like Cornacchini, this artist (1698–1768)[15] had gone through Foggini's school at Florence; in Rome he attached himself closely to Camillo Rusconi. He is certainly one of the most attractive and poetical sculptors of the Roman eighteenth century. But the French note in his work is very marked, and there cannot be any doubt that Frenchmen like his contemporary Michelangelo Slodtz – with whom he collaborated in about 1728 in S. Maria della Scala – brought him in contact with recent events in Paris.[16] His monumental relief of the Annunciation in S. Ignazio (1750), a counterpart to the relief created fifty years earlier by Legros [62], illustrates, however, that Filippo della Valle, for all his engaging and craftsmanlike qualities, was an epigone: this relief, embodying a late version of Algardi's painterly relief style, shows an accretion of subordinate detail not dissimilar

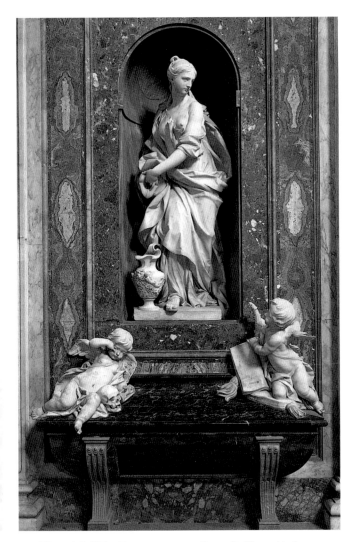

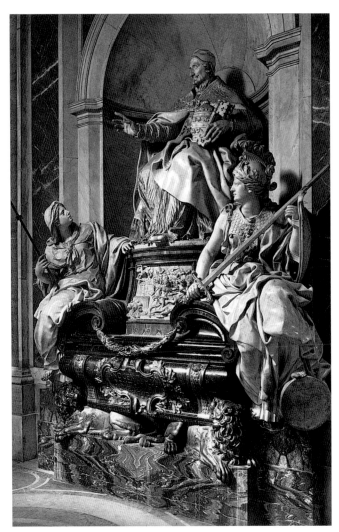

69. Filippo della Valle: *Temperance*, *c.* 1735. Rome, S. Giovanni in Laterano, Cappella Corsini

70. Pietro Stefano Monnot: Tomb of Innocent XI, 1697–1704. Rome, St Peter's

to the manner introduced by Guidi in the first phase of the Late Baroque.

Finally, there is Pietro Bracci,[17] the most prolific artist of this group. He made a great number of tombs, among them those of the Popes Benedict XIII [71] and Benedict XIV, and many portrait busts with a fine psychological penetration and a masterly vibrating treatment of the surface. Still dependent on Bernini's idiom, he transformed it into a tender and lyrical, though sometimes sentimentalizing, eighteenth-century style. Filippo della Valle and Bracci represent most fully the Rococo phase in Roman sculpture. They belonged to the generation of the masters who brought about the brief flowering of the Rococo in Roman architecture. Both artists were, of course, the chief contributors to the sculptural decoration of the last great collective work of the Roman Late Baroque, the Fontana Trevi [10].[18] The legend is difficult to kill that only Bernini could have designed the combination of figures, masses of rock, sculptured vegetation, and gushing waters; similarly, he is also made responsible for the design of the figures themselves. But Bracci's slightly frivolous *Neptune*, standing like a dancing master on an enormous rocaille shell, is as far removed

from the spirit of Bernini's works as is the picturesque quality of the many rivulets or the artificial union of formalized basins with natural rock. Nevertheless, the Fontana Trevi is the splendid swansong of an epoch which owed all its vital impulses to one great artist, Bernini.

Typological Changes: Tombs and Allegories

Instead of pursuing further individual contributions by minor masters, it may be well to turn to a few specific problems and discuss from another angle the change that took place from the High to the Late Baroque. The papal tomb remained, of course, the most important sculptural task right to the end of the eighteenth century. Its history is a touchstone not only for assessing the contributions of the leading sculptors, their style, and the quality of their work, but also for the appreciation of the profound spiritual development that occurred at this period. Between 1697 and 1704 Pietro Stefano Monnot erected the tomb of Innocent XI [70] in a niche opposite Algardi's tomb of Leo XI.[19] Features deriving both from Bernini and Algardi are here combined: the tomb of Urban VIII served as model for the polychrome

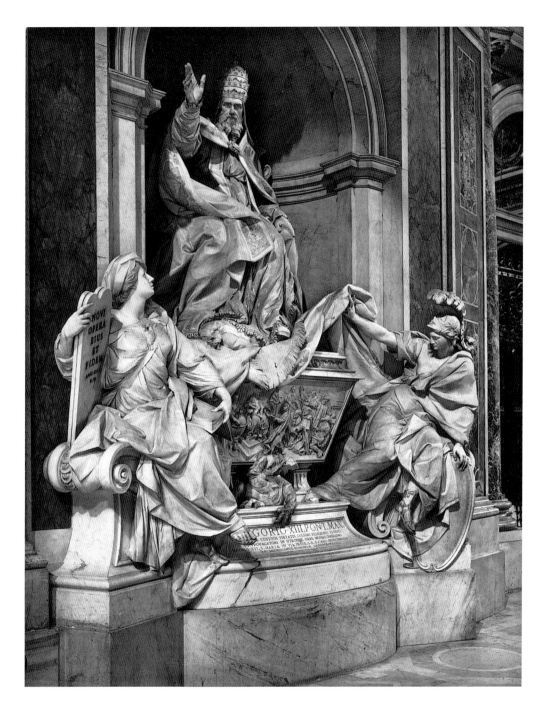

71. Camillo Rusconi: Tomb of
Gregory XIII, 1719–25. Rome,
St Peter's

treatment, as the dark bronze sarcophagus with large scrolls
clearly shows; but for the types of the allegories and the nar-
rative relief Monnot followed Leo XI's tomb. He placed the
relief, however, not on the sarcophagus itself, but on the
pedestal of the papal statue. The insertion of this pedestal
made it necessary to reduce considerably the size of the
papal figure, compared with Algardi's. The latter's Leo XI
fills the whole niche; the weak and somewhat gaunt figure of
Innocent XI, by contrast, seems rather too small for its
niche. To be sure, one of the statues is by a great master, the
other by a mediocre follower; but apart from this, the
increased importance of decorative elements at the expense
of the figures illuminates the stylistic change from the High
to the Late Baroque. Precisely the same observations apply
to Angelo de' Rossi's tomb of Alexander VIII in St Peter's

(1691–1725), the design of which closely follows that of
Urban VIII; but again the addition of a high pedestal with a
narrative relief results in figures of considerably shrunken
volume and an undue emphasis on the architectural and
decorative parts.

More interesting than these monuments is Camillo
Rusconi's tomb of Gregory XIII [71], erected between 1719
and 1725 in a niche in the right aisle of St Peter's corre-
sponding to Monnot's tomb in the left aisle. While being
profoundly indebted to Bernini's conception of sculpture,
Rusconi blended elements from Algardi's Leo XI and
Monnot's Innocent XI. The allegories and their position on
the scrolls reveal Monnot's influence; from Algardi derive
the unrelieved whiteness of the whole monument, the trape-
zoid sarcophagus with relief, and the idea of placing the

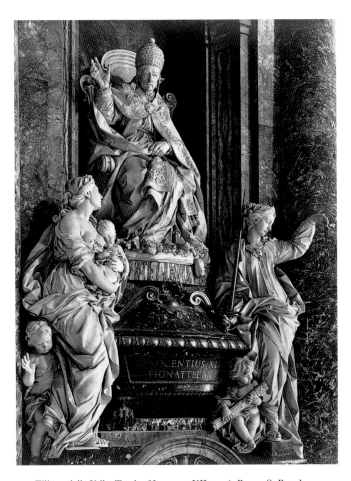

72. Filippo della Valle: Tomb of Innocent XII, 1746. Rome, St Peter's

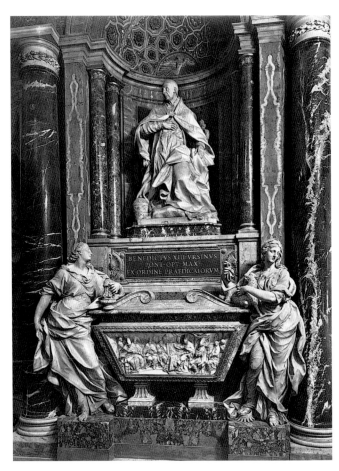

73. Pietro Bracci and others: Tomb of Benedict XIII, 1734. Rome, S. Maria sopra Minerva

seated pope on the sarcophagus without an isolating pedestal. Rusconi's design is, however, not a simple repetition of the pattern established by Algardi and modified by Monnot. His monument is asymmetrically arranged: the pope does not sit on the central axis, nor do the allegories follow the customary heraldic arrangement.[20] The tomb was evidently composed to be seen as a whole from one side. This is proved not only by the attitude and gesture of the blessing pope and the postures of the allegories, but also by such details as the direction given to the realistic dragon, the armorial animal of the Buoncompagni. Moreover, 'Courage'* lifts high a large piece of drapery (the pall that had covered the sarcophagus, a motif taken from Bernini's tomb of Alexander VII); viewed from the left, this creates a dominating diagonal which links the allegory to the figure of the pope. Rusconi composed for the side view because the passage is so narrow that a comprehensive view on the central axis is not possible. By taking such issues into consideration and limiting himself to one main view, Rusconi had recourse to principles which we associate with Bernini rather than Algardi.[21] The spirit of Bernini's High Baroque has also come to life again in the powerful gesture of the blessing hand which recalls the attitude of Urban VIII. If this tomb represents a rare synthesis of the classicizing and Baroque

tendencies of Algardi and Bernini, successfully accomplished only in what I have called Rusconi's 'heroic Late Baroque', it yet exhibits a new departure of great importance. Whereas in the older tombs allegories were personal attributes expressing particular virtues of the deceased by their presence and actions, 'Courage' here raises a curtain in order to be able to study the relief celebrating Gregory's reform of the calendar. This implies a change in the meaning of allegories, to which we shall presently return.

The history of papal tombs continues with those of Clement XII by Maini and Monaldi in the Cappella Corsini of the Lateran (1734) and of Innocent XII by Filippo della Valle in St Peter's (1746) [72], the former with a tendency towards classicizing coolness, the latter showing almost Rococo elegance.[22] These monuments repeat the structure of papal tombs, by then conventionalized from the type created by Bernini at the height of the Catholic Restoration as an adequate expression of papal power. In Rusconi's work something of this spirit had been kept alive – one might almost say – anachronistically;* for in the course of the seventeenth century the political influence of the papacy had been gradually waning, and this is reflected in the papal monuments of the period. Already Guidi's Clement IX in S. Maria Maggiore (1675) and Ferrata's Clement X in St

* This figure represents 'Magnificence' (F. Martin, 1998).

* This late tomb was made for a pope who had reigned 1572–85.

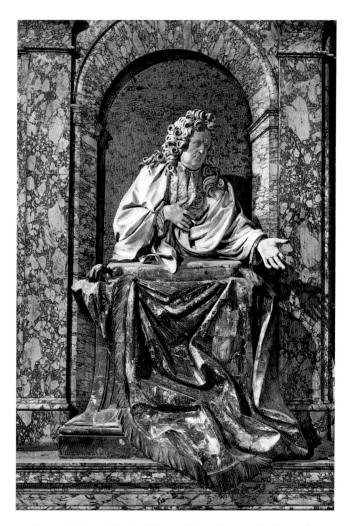

74. Bernardo Cametti: Tomb of Giovan Andrea Giuseppe Muti, 1725. Rome, S. Marcello

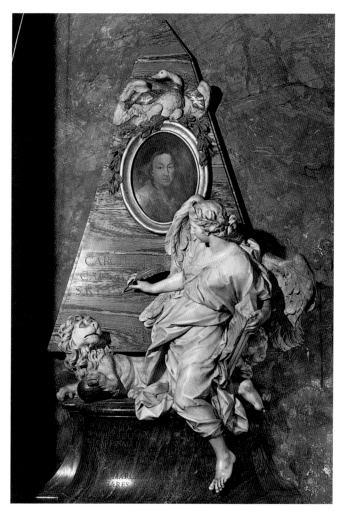

75. Pietro Bracci: Tomb of Cardinal Carlo Leopoldo Calcagnini, 1746. Rome, S. Andrea delle Fratte

Peter's (c. 1685) had shown a considerably weakened energy of the blessing gesture and a shrinking of volume; this process went on, though not without interruption, until Filippo della Valle made his Innocent XII a fragile old man rather than the symbolic head of Christianity. Shortly before, Pietro Bracci had replaced the ritualistic gesture by a purely human attitude. His Benedict XIII on the tomb in S. Maria sopra Minerva (1734) [73][23] is bareheaded, sinks on one knee, and turns towards the altar of the chapel in deep veneration. The type had been anticipated about sixty years before by Bernini in the tomb of Alexander VII [II: 20] though it had not been followed in any of the later papal tombs. But where Bernini's kneeling pope shows an unshaken confidence, an almost impersonal and eternal attitude of prayer, Bracci portrayed his Benedict XIII as a man of a less stable constitution, who seems aware of the troubles of the human heart and the frailty of man's existence. It was left to Canova to carry this development to a logical conclusion. In his tomb of Clement XIII (1788–92) he even discarded the customary Baroque allegories.[24] What remains is the unheroic figure of the custodian of Faith lost in deep prayer.

The series of papal tombs represents the most coherent group of Baroque monuments, the high political character of which did not, however, admit too many expressions of personal idiosyncrasies either of patron or artist. On the other hand, turning to the tombs of the higher and lower clergy, of aristocracy and bourgeoisie, we find that the variety of types is immense. In spite of the kaleidoscopic picture some significant changes in the broad development from the seventeenth to the eighteenth century can be discovered. The leading motif in tombs from about 1630 onwards is the figure of the deceased represented in deep adoration, turned towards the altar. This type of tomb lived on into the eighteenth century, but already in the 1670s and 80s such figures began to lose their devotional fervour, and during the eighteenth century they appear more often than not like fashionable courtiers attending a theatrical performance. A comparison between Bernini's Fonseca bust [II: 157] and Bernardo Cametti's[25] bust of Giovan Andrea Giuseppe Muti in S. Marcello, Rome (1725) [74], illuminates the change. On the opposite wall Cametti represented Muti's much younger and equally fashionable wife. The whole chapel forms an architectural and colouristic unit of a light and airy character, and the new eighteenth-century spirit is as perfectly expressed by the graceful elegance of the worshippers

behind their priedieus as was that of the seventeenth century by mystic devotees in profound contemplation.

Besides the kneeling worshipper, the seventeenth century knew the completely different type of tomb which Bernini introduced in the Valtrini and Merenda monuments. In the former, a winged skeleton, seemingly flying through space, carries a medallion with the portrait in relief to which it directs the beholder's attention by a pointing gesture. The tomb, therefore, contains two different degrees of reality, that of the 'real' skeleton and that of the 'image' of the departed. We are, as it were, given to understand that it would be anachronistic to represent a dead person 'alive' and that his likeness can be preserved for us only in a portrayal. This idea shows a new rational approach to the conception of funeral monuments, and its occurrence simultaneously with the type of the mystical worshipper is more revealing for the seventeenth-century dichotomy between reason and faith than would at first appear. It was not, however, until the end of the seventeenth century that the medallion type began to gain prominence, while in the course of the eighteenth century it entirely supplanted the tomb with the deceased in devotional attitude. At the end of this process belong tombs like that of Cardinal Calcagnini by Pietro Bracci, in S. Andrea delle Fratte (1746) [75], where even low relief seemed too realistic and so was replaced by a painted portrait[26] set in a pyramid on which a flying figure of Fame writes the memorial inscription. From about 1600 onwards the pyramid,[27] the symbol of Eternity, was used for tombs in ever-increasing numbers in Rome and Italy, and soon also in the rest of Europe; but the combination with the painted portrait hardly ever occurred before the early eighteenth century. Although in the personification of Fame Bracci employed the traditional Baroque language of forms, the spirit of such tombs is very different from that of the High Baroque. What is expressed through the paraphernalia of Bracci's monument is the somewhat trite assurance that the memory of the deceased will be kept alive in all eternity. No longer is the monument concerned with the union of the soul with God – it is now purely commemorative, a memorial made for the living. No longer can the 'dead' worshipper and the beholder meet in the same reality. The commemorative picture is far removed from our sphere of life, it cannot step out of its frame and turn in adoration towards the altar. The magic transformation of time and space was a thing of the past. We are in the age of reason, and the new approach to the problem of death, an approach much closer to our own than to that of the broad current of the seventeenth century, admitted neither the High Baroque conception of space nor the more elaborate type of Baroque allegory.

Allegory was, of course, not banned from eighteenth-century monuments, but it underwent a characteristic change. High Baroque allegory, for all its realism, was meant to convey in visual terms notions of general moral significance. Though its realism aimed at pressing home convincingly the timeless message, the allegory never acted out a scene. This was precisely the eighteenth-century procedure and consequently allegory lost in symbolical meaning what it gained in actuality. 'Liberality' now hands a coin to her child-companion, 'Disinterestedness' refuses with violent gestures to

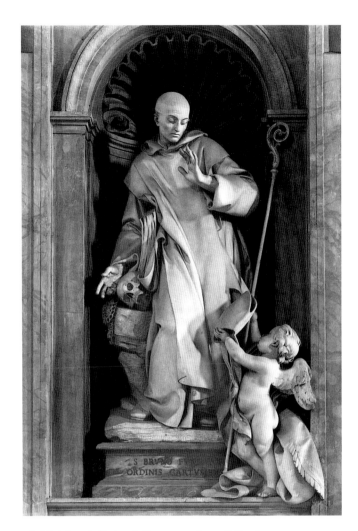

76. Michelangelo Slodtz: *St Bruno*, 1744. Rome, St Peter's

accept any of the treasures from an overflowing cornucopia, or 'Justice' orders the little bearer of the fasces to carry his load to the place which seems proper to her. We found even in Rusconi's tomb of Gregory XIII [71] that 'Courage' was engaged in an activity which lay outside her allegorical vocation. When allegory was turned into genre, a visual mode of expressing abstract concepts – peculiar to the arts from ancient times onwards – began to disintegrate.

A similar change may be observed in eighteenth-century religious imagery. A poignant incident replaced, whenever possible, the simple rendering of devotion and vision. When Michelangelo Slodtz was commissioned to execute the statue of St Bruno for one of the niches of the nave of St Peter's (1744) [76],[28] he chose for representation the saint's dramatic refusal of the bishop's mitre and staff. Interest in the episode seems to weaken the supra-personal content. This does not mean, of course, that Slodtz's statue lacks quality. The graceful curve of the saint's body, the elegant sweep of his cowl, the precious gesture as well as the putto who forms part of the movement – all this must be valued in its own right and not judged with Bernini's work before one's mind. Such a figure illustrates extremely well the elegant French Rococo trend in Roman sculpture of the mid

eighteenth century. Obviously this style was not possible without Bernini's epoch-making achievement, but it stands in a similar relation to his work as did Giambologna's refined Mannerism to Michelangelo's *terribilità* two hundred years before.

SCULPTURE OUTSIDE ROME

In contrast to the flowering of Baroque painting in many regions of Italy throughout the seventeenth century, it is peculiar to Baroque sculpture that its wide dissemination in Italy and the rest of Europe coincides with the waning of the High Baroque in Rome. It has been mentioned that no coherent school of High Baroque sculpture existed outside Rome. But from the late seventeenth century onwards we find hundreds of names of sculptors and scores of thousands of plastic works all over Italy. As before, Rome remained the centre – different from the development in the other arts. Every provincial sculptor endeavoured to receive his training there or, failing that, in the school of a master who had worked in a Rome studio. The artistic pedigree of most provincial sculptors leads back, directly or indirectly, to Bernini; he was the ancestor of the largest school of sculp-

78. Giovanni Baratta: *Tobias and the Angel*, 1697–8. Florence, S. Spirito

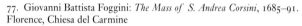

77. Giovanni Battista Foggini: *The Mass of S. Andrea Corsini*, 1685–91. Florence, Chiesa del Carmine

tors that ever existed. However, no attempt can here be made to give even a vague impression of the diffusion of the Berninesque idiom. In fact the details of this story are, with few exceptions, of no more than marginal interest.

It characterizes the situation that it remained customary for commissions of outstanding importance to be placed in Rome. Thus, when Vittorio Amedeo II wanted to decorate the Superga with large reliefs, he turned to Rome and placed the work with Cornacchini and Cametti, the former born in Tuscany, the latter a Piedmontese, and both at the height of their reputation in about 1730. A little earlier, the monks of Montecassino asked Roman and not Neapolitan sculptors to carry out their vast sculptural programme; masters like Ottoni, Legros and his collaborator Pier Paolo Campi, Francesco Moratti, and Maini worked for them. Needless to say, all the memorial statues of popes for cities of the papal state were carved in Rome, and so were many portrait busts and tombs commissioned not only from all over Italy but also by foreign admirers of Roman art.[29]

And yet at the end of the seventeenth and the beginning of the eighteenth century most Italian centres had sculptors who were capable of satisfying up-to-date taste. These artists kept abreast of the stylistic development in Rome. The most distinguished Florentine sculptor of the period,

Ferrata's pupil Giovanni Battista Foggini (1652–1725),[30] introduced to his native city a style which combined details reminiscent of his teacher with the discursive painterly compositions characteristic of Guidi's work.[31] If his Cappella Corsini in the Carmine (1677–91) [77] and his Cappella Feroni in SS. Annunziata (1691–3) were in Rome, one would regard them as somewhat exaggerated products of that rather crude, patchy, crowded, and disorderly manner which we associate with the first phase of the Late Baroque. In Florence, however, these chapels are the high-water mark of Berninesque sculpture.[32] Ferrata also instructed Massimiliano Soldani (1656, not 58, –1740), who led the native tradition of working in bronze to new heights; his rich œuvre has been masterly reconstructed by K. Lankheit.[33] The older sculptors of Foggini's school were mediocre talents.[34] The best among his younger pupils was Giovanni Baratta (1670–1747), a member of the great family of sculptors from Carrara; in his painterly Baroque a typically Florentine reserve may be detected [78].[35] It was a pupil of the Roman Maini, Innocenzo Spinazzi (d. 1798), who brought about the change to Neo-classicism in Florence.

We have seen how Late Mannerist traditions in Lombardy lived on virtually into the second half of the seventeenth century. With sculptors like Giuseppe Rusnati (d. 1713), the pupil of Ferrata in Rome and teacher of Camillo Rusconi, the situation had changed. Rusnati's *Elijah* on the exterior of Milan Cathedral looks like an anticipation of Rusconi's *St Matthew* in the Lateran, while Carlo Simonetta

79. Andrea Fantoni: Confessional, 1680–1703. Bergamo, S. Maria Maggiore

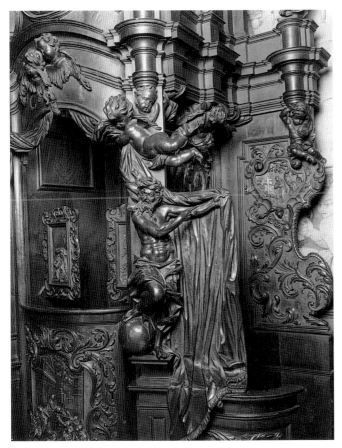

(d. 1693) seems to have come under the influence of Puget.[36] Other slightly younger masters perform the transition to the lighter rhythm of the eighteenth century. This process may have begun with Francesco Zarabatta and can be followed to the Late Baroque charm of Carlo Francesco Mellone (d. 1736), to the easy elegance of Carlo Beretta, and the typically mid-eighteenth-century fragility of Elia Vincenzo Buzzi.[37] But it cannot be maintained that all this has more than strictly limited interest.[38] A master in his own right was Andrea Fantoni from Rovetta (1659–1734) who worked exclusively in the provinces. His wooden confessional in S. Maria Maggiore, Brescia [79], as well as his celebrated pulpit in S. Martino at Alzano Maggiore, both richly decorated with statues, reliefs, and flying putti, have an almost un-Italian Rococo quality and are probably unmatched by anything produced at the same period in Milan.

The impact of the Roman High Baroque first came to Genoa through Algardi's work for the Cappella Franzoni in S. Carlo. In 1661 the French sculptor Pierre Puget settled in Genoa and stayed for six years. He had absorbed Bernini's and Cortona's style in Rome, and his works at Genoa with their Berninesque vigour and fire of expression had a decisive influence on the formation of a school of sculptors in that city.[39] But even more important was Filippo Parodi (1630–1702), Genoa's first and greatest native Baroque sculptor; he had studied for six years with Bernini (1655–61),[40] and on his return to Genoa met in Puget an artist with tendencies similar to his own. Some of his works of the 1660s and 70s still have a High Baroque flavour. They correspond to the emotional and sensitive style of Melchiorre Caffà and Raggi (see his *Ecstasy of St Martha*, S. Marta, Genoa, and *St John*, S. Maria di Carignano); he often introduced a graceful note (*Virgin and Child*, S. Carlo, Genoa) which occasionally endows his works with an un-Roman, rather French elegance. Later, in his tomb of Bishop Francesco Morosini (d. 1678) in S. Nicolò da Tolentino at Venice, he combines recollections of Bernini with proto-Rococo features [80] not unlike the style of the Roman Filippo Carcani. At the same time, the picturesque composition of this tomb is characteristic of the new tendencies of the Late Baroque.[41]

Filippo Parodi was the man of destiny for the further development of Genoese sculpture. Among his pupils were Angelo de' Rossi (whom we found working in Rome), Giacomo Antonio Ponsonelli (1651–1735) who accompanied him to Venice and Padua, his son Domenico (1668–1740), sculptor, painter, and architect, and the two Schiaffino.[42] Bernardo Schiaffino (1678–1725) and his younger brother Francesco (1689–1765) gave the style the lighter eighteenth-century touch of the Rusconi school. In fact, Francesco went to Rome, studied with Rusconi, and after his return to Genoa executed from the latter's model the celebrated *Pluto and Proserpina* group of the Palazzo Reale.[43] The last great name of the Genoese school of Baroque sculptors is Bernardo Schiaffino's pupil Francesco Queirolo (1704–62). But he hardly ever worked in his native city. He soon went to Rome where he spent some time in Giuseppe Rusconi's studio and also had independent commissions until, in 1752, he was called to Naples to take part in the sculptural decoration of the Cappella Sansevero. Genoa also had a flourish-

80. Filippo Parodi: Tomb of Bishop Francesco Morosini, 1678. Detail. Venice, S. Nicolò da Tolentino

81. Anton Maria Maragliano: *Stigmatization of St Francis*. Genoa, Chiesa dei Cappucini e delle SS. Concenzione

ing school of woodcarvers,[44] but it was only Anton Maria Maragliano (1664–1739) who raised a popular tradition to the level of high art [81]. He often worked from designs of his teacher, the painter Domenico Piola. The style of his many multi-figured pictorial groups is close to that of the Schiaffino: he knew how to combine the expression of ecstatic devotion with true Rococo grace.

Sculpture in wood had a home in Piedmont too. The principal practitioners were Carlo Giuseppe Plura (1655–1737)[45] and Stefano Maria Clemente (1719–94) who continued a popular Late Baroque far into the eighteenth century. In view of the architectural development in Turin, it is strange that a local school of sculptors arose only towards the end of the period with which we are concerned. Next to Francesco Ladatte (1706–87),[46] who studied in Paris and was entirely acclimatized to France but was appointed court sculptor in Turin in 1745, the most distinguished names are those of Giovanni Battista Bernero (1736–96) and of the brothers Ignazio (1724–93) and Filippo Collini;[47] but most of their work belongs to the history of Neo-classicism.

Bologna had a first-rate sculptor of Rusconi's generation in Giuseppe Mazza (1653–1741), who harmoniously fused the general stylistic tendencies with local traditions. His Late Baroque classicism has nothing of Roman grandeur and the emotional moderation of his work reveals that he had imbibed the 'academic' atmosphere of Bologna. In his many statues and reliefs in stucco, marble, and bronze, to be

found not only in his native city but also at Ferrara, Modena, Pesaro, and above all Venice, he appears to perpetuate the classical current coming down from Algardi, but it is a classicism drained of High Baroque vigour. This is fully proved by his masterpiece, the six monumental bronze reliefs of the Cappella di S. Domenico in SS. Giovanni e Paolo, Venice [82].[48]

Baroque sculpture in Venice does not begin until the middle or second half of the seventeenth century. Alessandro Vittoria (d. 1608), Tiziano Aspetti (d. 1607), and even Girolamo Campagna (d. 1623) belong to a history of sixteenth-century sculpture; with them a glorious development of almost two hundred years comes to an end. Just as in the history of Venetian painting, the continuity was broken, and hardly a bridge exists to later Seicento sculpture. The only name of distinction belonging to the first half of the century is that of Nicolò Roccatagliata (1539–1636) who, Genoese by birth, was thoroughly acclimatized to Venice; but in his many bronzes he adhered faithfully to the older tradition and even reverted to Jacopo Sansovino, in other words to pre-Vittoria tendencies in Venetian sculpture.[49]

Up-to-date ideas reached Venice belatedly through two different channels: first, through sculptors coming from North of the Alps,[50] and secondly through Italians who, for longer or shorter periods, resided in Venice. Of the latter, both the Genoese Filippo Parodi and the Bolognese Giuseppe Mazza have been mentioned; they exerted a

82. Giuseppe Mazza: *St Dominic baptizing*, c. 1720. Venice, SS. Giovanni e Paolo

strong influence on further events in Venice which is not yet sufficiently investigated. The most vigorous among the northern artists who settled in Venice was Josse de Corte (1627–79), in Italy called Giusto Cort or Lecurt, who was born at Ypres and, after a stay in Rome, made Venice his home from 1657 onwards. Many of his numerous works are for buildings by Longhena, who seems to have preferred him to any other sculptor. His style may best be studied in Longhena's S. Maria della Salute where Giusto's rich sculptural decoration of the high altar (1670) [83] perpetuates in marble the theme of the dedication of the church: 'Venice' kneels as a suppliant before the Virgin who appears on clouds while the horrifying personification of the 'Plague' takes to flight, gesticulating wildly. Though the style of this *tableau vivant* is characteristically Late Baroque in the sense which we have indicated in these pages, the soft surface realism, the almost Gothic brittleness of the picturesque drapery, and the weakness in composition give this and others of his works a distinctly Flemish quality. In a detail like that of one of the caryatids from the Morosini monument in S. Clemente all'Isola (1676), shown as illustration 84, this Flemish note is very obvious.[51]

De Corte's collaborators and pupils continued his manner to a certain extent until after 1700. Among them were artists of considerable merit, such as Francesco Cavrioli from Treviso (who worked in Venice between 1645 and 1685), Francesco Penso, called Cabianca (1665?–1737),[52] Orazio Marinali (1643–1720),[53] and others. These sculptors,

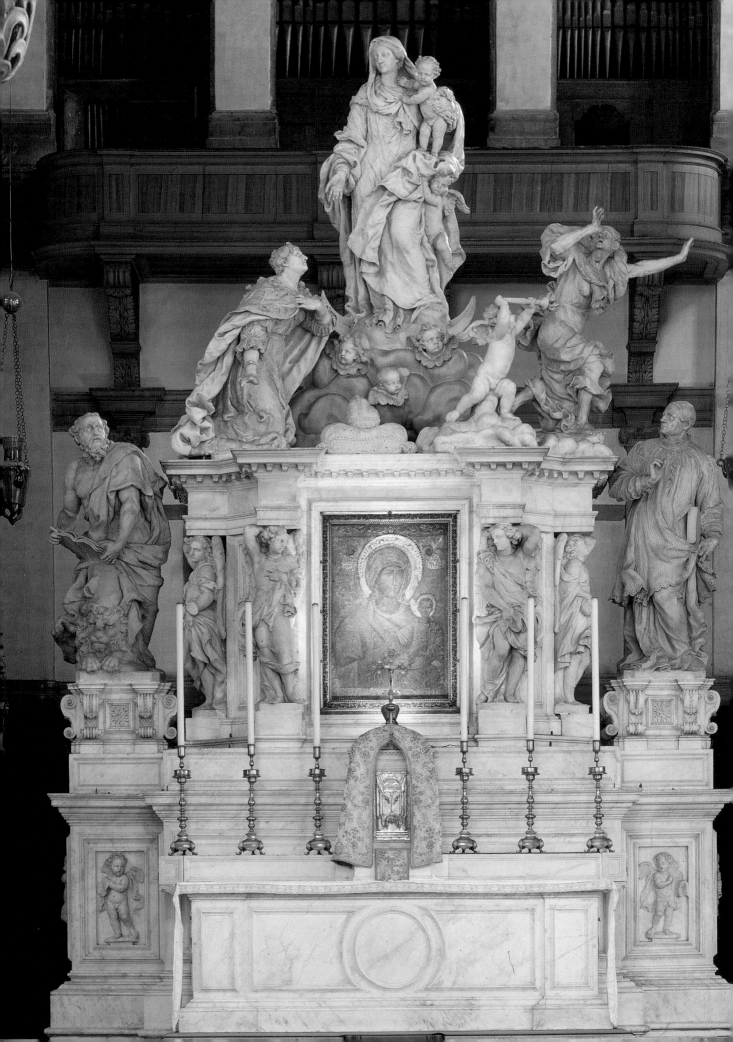

83 (*opposite*). Josse de Corte: *The Queen of Heaven expelling the Plague*, 1670. Venice, S. Maria della Salute, high altar

84 (*above, left*). Josse de Corte: *Atlas* from the Morosini Monument, 1676. Venice, S. Clemente all'Isola

85 (*above, centre*). Antonio Corradini: *Virginity*, 1721. Venice, S. Maria del Carmine

86 (*above, right*). Giovanni Marchiori: *David*, 1743. Venice, S. Rocco

together with some foreigners,[54] were responsible for the rich sculptural decoration of the exterior of S. Maria della Salute. Profuse sculptural decoration of church façades became fashionable from Tremignon's S. Moisè on. Giuseppe Sardi's façades of S. Maria del Giglio (1678–83) and of the Chiesa degli Scalzi (1672–80) as well as Domenico Rossi's façades of S. Stae and the Chiesa dei Gesuiti (1714–29; executed by G. B. Fattoretto) and Massari's Chiesa dei Gesuati (1724–36) are characteristic examples. For all these commissions the collaboration of many hands was required. The large Valier monument in SS. Giovanni e Paolo, designed by Tirali in 1705, and the façade of S. Stae of 1709 give a good idea of the position at the beginning of the eighteenth century. It was mainly sculptors born in the 1660s who were responsible for the somewhat bombastic, painterly, and refreshingly unprincipled Late Baroque of these monuments.[55] Most of us no longer have the eye to see and savour the magnificent scenic spirit that created the tightly intertwined group balancing precariously free in space upon an enormous bracket high above the portal of S. Stae.

Twenty years later the situation had changed. The sculptors born in the 1680s and 90s brought about a refined and serene style parallel to, but quite independent of, the Filippo della Valle and Bracci style in Rome. The transition to the new manner may be observed in such works as the Cappella del Rosario in SS. Giovanni e Paolo (1732) or the façade of the Gesuati (1736).[56] It was mainly three artists on whom the change depended. The oldest of them, Antonio Corradini[57] (1668–1752), belongs to the generation of the well-known Andrea Brustolon[58] (1662–1732), who never broke away from the early phase of the international Late Baroque. Corradini began in this manner, to which he still adhered in his monument of Marshal von der Schulenburg[59] in Corfù of 1718. But his allegory of *Virginity* [85] in S. Maria del Carmine, Venice, of 1721, shows the new idiom. This style is precious, harking back not to antiquity but to Alessandro Vittoria – it is, in other words, a sentimental revival of the Venetian brand of Late Mannerism. Corradini's *neo-Cinquecentismo* even led him back to Sansovino (*Archangel Raphael* and *Sarah* at Udine), but he combined this archaism with a typically post-Berninesque virtuosity of marble treatment.[60] If my analysis is correct, one cannot regard this style as an anticipation of Canova.

A similar development may be observed with Giovanni Marchiori (1696–1778) and Gian Maria Morlaiter

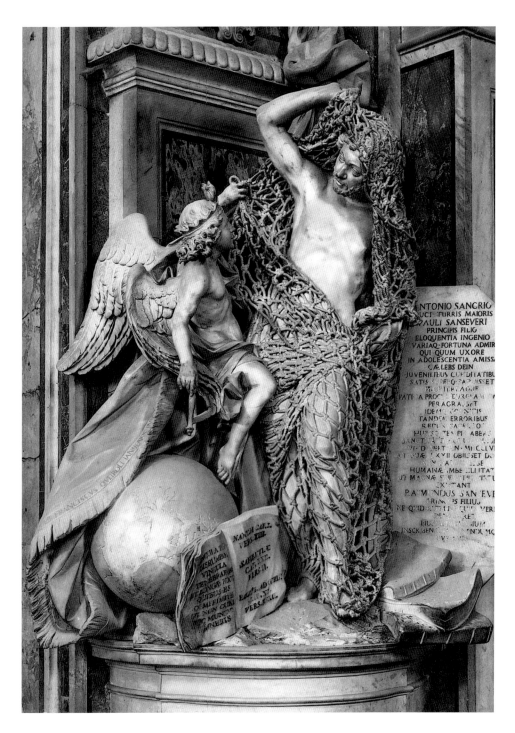

87. Francesco Queirolo: *Allegory of 'Deception Unmasked'*, after 1750. Naples, Cappella Sansevero de' Sangri

88 (*right*). Luigi Vanvitelli: Caserta, Castle. The great cascade, *c.* 1776

(1699–1781).[61] Only fairly recently more than a hundred bozzetti from Morlaiter's studio were discovered: their style, highly sensitive, ranges from a light imaginative touch like German Rococo and from what might be called a sculptural interpretation of Tiepolo to an elegant classicism comparable to the early Canova. Marchiori, the pupil of Andrea Brustolon, developed towards a refined 'classicist Rococo' after a neo-Cinquecentesque phase. Although his style seems to contain all the formal elements of Neo-classicism, it is again precious and picturesque and not unlike Serpotta's. This is shown by his figures of *St Cecilia* and *David* [86] in S. Rocco, Venice (1743). It appears, then, that the general trend in Venetian sculpture is close to that in

Venetian painting. Also in sculpture is the eighteenth century more specifically Venetian than the seventeenth, and this 'home-coming' was achieved by reviving the local tradition of Vittoria and Jacopo Sansovino.

The great and notorious monument of the late Neapolitan Baroque is the Cappella Sansevero de' Sangri, called Pietatella, founded in 1590, continued in the seventeenth century, and decorated for Raimondo del Sangro between 1749 and 1766.[62] There were older monuments in the chapel, but they were entirely eclipsed by the rich sculptural decoration of the eighteenth century. At this time the chapel was transformed into a veritable Valhalla of the del Sangro family, but the allegorical statues before the

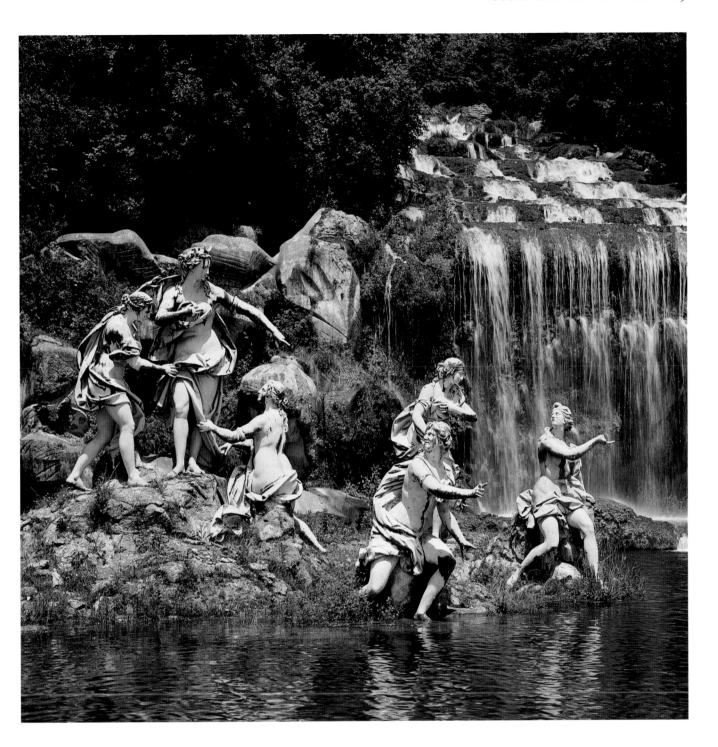

pillars overshadow the medallion portraits of the dead to such an extent that the beholder is in doubt as to the primary function of the place. Nothing is left of the spiritual unity of the great Roman Baroque churches and chapels, and the monuments excel by virtue of their technical bravura rather than through Christian spirituality. Emphatically Late Baroque in character, the chaotic and unrelated impression of the chapel seems closer to the mentality of the nineteenth than that of the eighteenth century. Queirolo and Corradini, the main contributors to the sculptural decoration, have been mentioned. The former is responsible for the group of the *Disinganno* [87], representing a personification of the human mind in the shape of a

winged angel who liberates a nude man, the personification of humanity, from the entanglement of the symbolically significant net of deception. With such a work, which is matched only by other *tours de force* in the same chapel, we have reached the end of a development. While Bernini used realism and surface refinement to express convincingly the ethics of the Catholic Restoration, here the shallow symbolical genre seems to be a pretext for a display of technical bravura. A piece of similar hypertrophic virtuosity is Corradini's *Chastity*, where the thin veil through which the body is visible as if nude, belies the theme of the figure.[63] The same device was imitated by the prolific Giuseppe Sammartino (1720?–93?) in his *Christ lying under the Shroud*

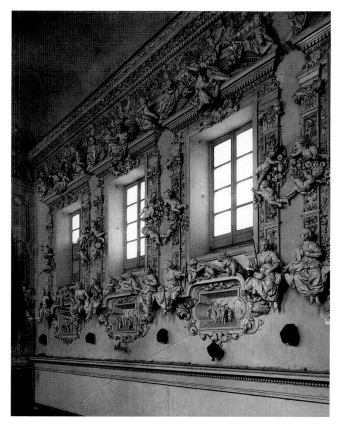

89. Giacomo Serpotta: Palermo, Oratorio del SS. Rosario in S. Cita, entrance wall, after 1685–c.1718

90. Giacomo Serpotta: *Courage*, 1714–17. Palermo, Oratorio del SS. Rosario in S. Domenico, c.1708–17

(1753).[64] Sammartino's contemporary Francesco Celebrano (1729–1814) executed, among others, the heavy and crowded relief of the Pietà over the altar, concluding the stylistic epoch which began with Guidi's relief compositions. Sammartino and Celebrano had many other notable commissions which show that they retained their Late Baroque style right to the end of the eighteenth century.[65]

As in Rome, the last great Baroque achievement of the Neapolitan circle is connected with fountains. Caserta follows the example of Versailles, and the garden too with its long avenues and parterres is fashioned after this model, although an English landscape garden was added at a late date (1782). Even the mythological programme of the nineteen fountains, planned by Vanvitelli from 1752 onwards, is reminiscent of Versailles. What was eventually carried out (1776–9) under Luigi's son Carlo is much less elaborate than the original projects, but the fountains which exist surpass in extent and grandeur anything that had been done in Italy before. There are, above all, the multi-figured groups of *Diana and Actaeon* at both sides of the great cascade [88]. These elegant, pseudoclassical, white marble figures play out their roles as if in a pantomime, in a way that immediately recalls Girardon's Apollo group in the garden at Versailles. There is, however, an important difference. Girardon's group stood originally not in a cave of natural rock (executed by Hubert Robert, 1778) but under an isolating canopy. The figures in Caserta form part of the land-

scape. They seem to move freely over the open rocks; water, hill, woods, rocks, and figures combine in a great Arcadian *ensemble*. Superficially it might seem that Bernini's principles of sculpture had been carried to their fullest conclusion – that this is not so is due to the lack of seriousness and organic integration. The cascade is nicely terraced, the approach laid out with ruler and square, and we cannot help being very conscious of the artifice which has gone into giving an appearance of reality: the groups of Diana and Actaeon are, in fact, *tableaux vivants*,[66] and we know we are spectators, not participants.

A few words must be added about the picturesque art of making Christmas cribs; they form part of an old tradition of popular polychrome sculpture and, though they were created in many Italian towns particularly during the seventeenth and eighteenth centuries, Naples has pride of place.[67] These cribs, often consisting of hundreds of small, even tiny, figures, gaily dressed and placed in painstakingly realistic architecture and landscape, are the last buoyant descendant from the medieval miracle plays; this truly popular art of vivid narrative power and intense liveliness developed into a great industry requiring the specialized skill of many hands. Even sculptors of repute like Celebrano, Vaccaro, Sammartino, and Matteo Bottiglieri did not hesitate to work in this modest medium. It is significant that there is no

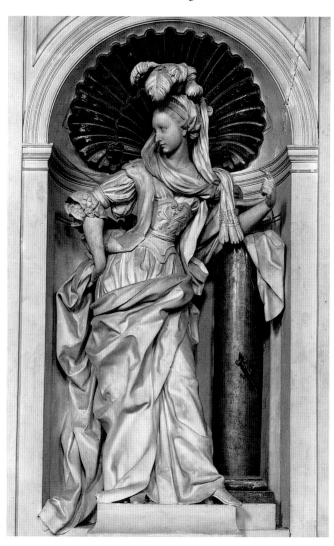

antagonism between the boundless realism of their small figures for cribs and the virtuosity of their works in marble. Their monumental sculpture may perhaps appear in a new light if regarded as no more and no less than the sophisticated realization of a style which has its roots in an old and popular traditional art.

Sicily's one great boast during this period was the sculptor Giacomo Serpotta (1656–1732), an exact contemporary of Camillo Rusconi. Serpotta appears to us now as an isolated figure, a meteor in the Sicilian sky. This is probably not consistent with the historical facts. It is true that after the fifteenth- and sixteenth-century work of the Gaggini, immigrants from Lombardy, Sicily had no great sculptors. There were, however, local schools throughout the seventeenth century working primarily in wood and stucco, and masters like Tommaso and Orazio Ferraro, active at the turn of the sixteenth to the seventeenth century, foreshadowed the climax reached with Serpotta's activity. But that tradition alone would perhaps not have sufficed to develop Serpotta's genius. Although a stay in Rome is not documented, there are sufficient indications[68] that he spent a few years there in his youth and so studied sculpture at the fountain-head. His name first appears in Palermo in 1682 in connexion with the equestrian statue of Charles II, German Emperor and King of Spain and Sicily. Of this statue, which was cast in bronze by Gaspare Romano from Serpotta's model and destroyed in 1848, a small cast survives (Trapani, Museum), which shows that Serpotta was an artist conversant with Pietro Tacca's monument of Philip IV in Madrid as well as with Bernini's *Constantine*. Soon afterwards, with the decoration of the Oratory of S. Lorenzo at Palermo (1687?–96?) he inaugurated that long series of church interiors where he covered the walls with stucco figures, and it is for these decorations that he is famed. The highlights of his later activity are the decoration of S. Orsola (1696; much ruined and badly restored); the Chiesa dell'Ospedale dei Sacerdoti (1698; partly executed by Domenico Castelli); the Chiesa delle Stimmate (1700, now Museo Nazionale, Palermo); the Oratories of S. Cita (begun 1686–8, continued 1717–18, execution partly by Domenico Castelli [89]), del Rosario in S. Domenico (1714–17), and di S. Caterina all'Olivella (1722–6); and the churches of S. Francesco d'Assisi (1723) and S. Agostino (1726–8, with the help of pupils).*

His figures are often reminiscent of Roman Baroque sculpture, some of Raggi, others of Ferrata; some are extremely elongated, elegant, and *mouvementé*; others follow antique prototypes so closely that they look almost Neoclassical. All of them, however, are imbued with a delicacy and fragility, a simple sensual charm and grace far removed from the dynamic power of the Roman High Baroque. Possibly nowhere else has Italian sculpture come so close to a true Rococo spirit [90]. Serpotta was a great master of the putto; playing, laughing, weeping, flying, and tumbling, they accompany every one of his decorations, spreading a cheerful and festive atmosphere. If his individual figures show a

connexion with Rome, the context in which they are placed does not. As a rule, his principle of organization is simple: the stuccoes – statues, reliefs, and decoration – seem to cover the walls like creepers, producing the effect of a rich and diffused pattern. A part of this pattern is often formed by deeply receding reliefs in which tiny figures appear as if in a peep-show. This, too, is entirely un-Roman and evidently continues the Lombard tradition which the Gaggini had brought to Sicily. In the course of his development Serpotta tended to an increase in the realism of his figures, coupled with a bias towards dressing them in contemporary costume. At the same time the programmes of his decorations grew more rather than less complicated, and his charming allegories show that to the end he remained deeply steeped in Baroque *concettismo*.

None of his Sicilian contemporaries comes anywhere near equalling his quality, neither his collaborator Domenico Castelli, whose figures entirely lack Serpotta's grace, nor his son Procopio who carried on the paternal tradition; nor even contemporary masters of some merit like Carlo d'Aprile and Vincenzo di Messina, although the latter's stuccoes in the church of Partanna (1698) reveal something of Serpotta's spirit. With Serpotta's school the particular Sicilian expression of the Late Baroque came to an end. Ignazio Marabitti (1719–97) [91],[69] the last great Sicilian sculptor of the Baroque, closely imitated his master Filippo della Valle, and maintained this manner to the end of the century.

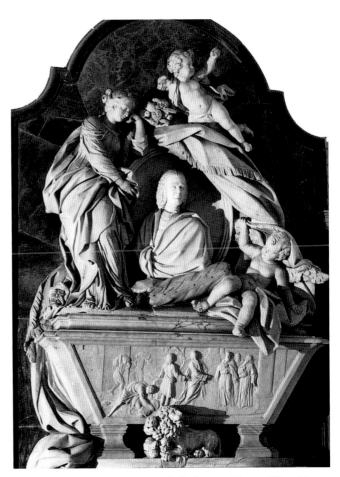

91. Ignazio Marabitti: Monument to Carlo Cottone. Palermo, Chiesa dei Cappucini

* D. Garstang has shown that the Oratory of S. Lorenzo was decorated 1699–1707, and that Serpotta's work in S. Agostino (without substantial aid by his pupils) should be dated 1711–28. Domenico Castelli did not work on the stucchi of S. Cita.

92. Luca Giordano: *Triumph of Judith*, 1704. Fresco. Naples, S. Martino,
Cappella del Tesoro

Painting

INTRODUCTION

The history of Italian eighteenth-century painting is, above all, the history of Venetian painting. Better known than almost any period and school discussed in this book, the names of Sebastiano Ricci and Piazzetta, Canaletto and Guardi, not to mention the greatest genius, Giambattista Tiepolo, immediately evoke lively associations. A fairly thorough treatment of this school alone would have gone far beyond the space at my disposal; nor could I have added to the researches of such pioneers as G. Fiocco, R. Pallucchini, and others, to whose works the reader must be referred for further guidance. The history of painting of the period is so rich in talents also outside Venice – a few of the first and many of the second rank – that any attempt at doing them justice within the compass of this book was from the start condemned to fail. As I have pointed out in the Foreword, I have therefore chosen to discuss eighteenth-century painting most cursorily. This course, moreover, seemed justified because it was then that France and England assumed a leading position; apart from Venetian painting and a few events in other centres, the Italian contribution ceases to be a major factor in the intra-European development.

As far as the history of painting is concerned, the seventeenth century was by and large a 'dark' century. Roughly between 1660 and 1680 a change came about and a trend towards the lightening of the palette began, culminating in Tiepolo and the Rococo masters of the Venetian school. While Venice accomplished the transition to Rococo painting through a luminosity derived from a new scale of airy, transparent colours, through new patterns of undulating or zigzag compositions which are precariously 'anchored' along the lower edge of the picture, through elegant and elongated types of figures calling to mind the Mannerist *figura serpentinata*, through the gallant or voluptuous or arcadian or even flippant interpretation of their subjects – while all this happened in Venice during the 1720s and 30s, the leading Roman and Bolognese masters continued to practise their feeble Late Baroque far into the eighteenth century. They believed themselves to be the legatees of the great Italian tradition and looked with scorn upon its perversion. How deeply this was felt may be gathered from the anti-Rococo cry raised in 1733 by Antonio Balestra (1666–1740). Himself trained by Maratti, but practising mainly in Venice, he wrote from a position of eminence: 'All the present evil derives from the pernicious habit, generally accepted, of working from the imagination without having first learned how to draw after good models and compose in accordance with the good maxims. No longer does one see young artists studying the antique; on the contrary, we have come to a point where such study is derided as useless and obnoxious.'[1]

In Rome and Bologna, however, some artists began to realize that they had followed much too long the well-trodden path of the 'good maxims' which were, in fact, the worn-out formulae of the Late Baroque. Few dared to revolt (G. M. Crespi), others sought salvation in a return to the great models of the past, doing precisely what Balestra had despaired of. Their proto-Neo-classicism, first noticeable in Rome from about 1715 on, was far from a clear-cut decision. Nor was the break with the Baroque tradition brought about by the new and broader wave of proto-Neo-classicism which began in the 1740s. Epitomized in the figure of Anton Raphael Mengs, this Late Baroque classicism found an echo throughout the peninsula and even in Venice, where the late manner of artists like Piazzetta, Amigoni, and Pittoni seems to reflect some contact with the all-Italian movement. In the end, disastrous results followed in the wake of the academic, rationalistic, and classicizing reform. Not only did it kill the Baroque tradition, but the perennial tradition of Italian painting itself.

The champions of proto-Neo-classicism and Neo-classicism in Italy were primarily concerned with the restoration of the theory and practice of the grand manner, which had outlived its day. The present as well as the future lay, however, with those masters whom Balestra had attacked, those who tried more or less successfully to discard the ballast of the grand historical style. It was they who committed the capital sin against the letter and the spirit of the great tradition in that they destroyed clear contours and plastic form, and implicitly the customary concept of finish. Naturally, they looked back to their own tradition: the old contrast between Venice and Rome, between colour and design, also adumbrates the events of the eighteenth century. They crowned the work of the Seicento masters *di tocco*, for they painted with short, rapid, and often nervous brush-strokes and obliterated the clear borderline between sketch and execution. It seems a foregone conclusion that this development, which helped Italian painting secure a last spell of international importance, took place in Venice rather than in the centres where the fetishes of plastic form and of the classical tradition could never be discarded.

NAPLES AND ROME

In the seventeenth century Naples had emerged as an art centre of primary importance. It was also in Naples that the most vital contribution was made to the future course of grand decorative painting. Briefly, the new type of fresco-painting derived from a fusion of Venetian colourism with Pietro da Cortona's grand manner, which on its part owed much of its vitality to Venice (II: p. 81 ff.). This synthesis of Rome and Venice was accomplished by the prodigious Luca Giordano (1634–1705),[2] who must be regarded as the quintessence of the new epoch although most of his work belongs to the seventeenth century. The prototype of the itinerant artist, he travelled up and down Italy, worked in Rome, Florence, Venice, and Bergamo, and for ten years was court painter in Madrid (1692–1702). The speed with which he

produced his grand improvisations was proverbial ('Luca Fa Presto'). Perhaps the first *virtuoso* in the eighteenth-century sense, he considered the whole past an open book to be used for his own purposes. He studied Dürer as well as Lucas van Leyden, Rubens as well as Rembrandt, Ribera as well as Veronese, Titian as well as Raphael, and was capable of painting in any manner he chose. But he never copied, a fact noticed by his contemporaries (Solimena). He played with all traditions rather than being tied to one, and his personal manner is always unmistakable. Whatever he did, his light touch and the brio and verve of his performance carry conviction, while his unproblematical and joyous interpretation of subjects anticipates the spirit of the eighteenth century. Clearly, the purpose of painting for him was delight [92, 99]. In Rome and Venice his influence became extraordinarily strong, and on the international stage the effect of his art can hardly be overestimated. He immensely attracted his Neapolitan successors by his typically southern grandiloquent manner and telling rhetoric, qualities one associates with the next fifty years of grand decorative painting in his native city.[3]

Luca's heir-apparent was Francesco Solimena (1657–1747),[4] who headed the Neapolitan school unchallenged during the first half of the eighteenth century. Next to Luca Giordano and Cortona, Lanfranco and Preti exercised the most formative influence upon his work. From the latter stem the brownish shadows of his figures – as much a mark of his style as the vivid modulation, the flickering patterning of the picture plane, and, in his later work, the somewhat pompous elegance of his figures. Although carefully constructed, many of his multi-figured compositions make the impression of an inextricable mêlée, in line with the general tendencies of the Late Baroque [93].[5] But if one takes the trouble of surveying figure by figure, their studied poses and academic manner is evident, and it is easy to distinguish conventional and even canonical figures and groups deriving from such acknowledged classical authorities as Annibale Carracci, Domenichino, and even Raphael.[6] In studying the architecture and sculpture of the period we have found a similar discursive approach to the past. This rationalistic tendency was nourished in Solimena's own Academy, which became the centre of Neapolitan artistic life. Numberless painters were here educated, foremost among them Francesco de Mura (1696–1784), Corrado Giaquinto (1703–65), and Giuseppe Bonito (1707–89).[7] The latter, who ended his career as Director of the Neapolitan Academy, is now remembered less for his rather dreary academic grand manner than for his popular genre pieces (p. 98).

Solimena worked in Naples all his life, and yet became one of the most influential European painters; after Maratti's death and before the rise of Tiepolo's star he had no peer. His reputation secured large commissions abroad for his pupils. De Mura did his best work as court painter in

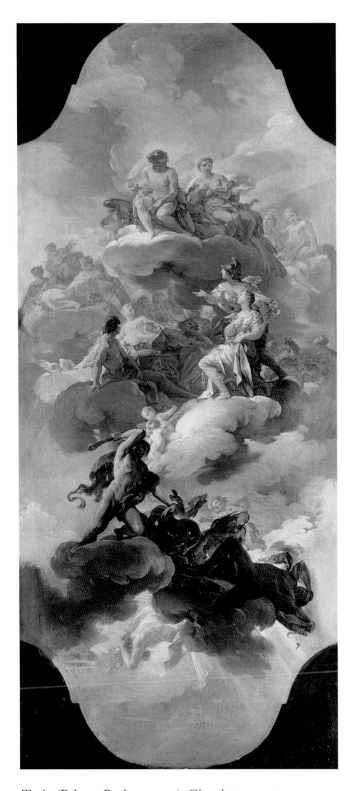

93 (*left*). Francesco Solimena: *The Fall of Simon Magus*, 1690. Fresco. Naples, S. Paolo Maggiore

94. Corrado Giaquinto: *Minerva presenting Spain to Jupiter and Juno*. Oil sketch for a ceiling, *c.* 1751, now in the Palazzo Sanseverino, Rome. London, National Gallery

Turin (Palazzo Reale, 1741–3). Giaquinto spent many years in Rome (1723–53), and succeeded Amigoni as court painter in Madrid (1753–61) where he was also appointed Director of the Academy of San Fernando; he left Madrid upon the arrival of Mengs.[8] Giaquinto was a more subtle artist than the often frigid de Mura.[9] Although both used typically eighteenth-century light and transparent colours, only Giaquinto carried Neapolitan painting over into a Rococo phase, and some of his work is stylistically and qualitatively a close parallel to Boucher's in France [94].[10]

95. Sebastiano Conca: *The Crowning of St Cecilia*, 1725. Fresco. Rome, S. Cecilia

When he settled in Rome, Giaquinto joined the studio of an older Neapolitan painter and pupil of Solimena, Sebastiano Conca (1679–1764),[10a] who, after Maratti's and Luti's deaths, held a position of unequalled eminence. His ceiling fresco with the *Crowning of St Cecilia* in S. Cecilia, painted in 1725 [95], gives the measure of his achievement and allows an assessment of the situation in Rome after the first quarter of the eighteenth century. This work is clearly in the tradition of Maratti's fresco in the Palazzo Altieri [II: 181], but not without a difference: here the balanced symmetrical composition belies the Baroque paraphernalia, an indication of the growing academic mentality. Of course,

gone for ever are the intensity and spirituality, the hot breath and vigour, the chiaroscuro and mysticism of the Late Baroque moment represented by Gaulli [II: 175] – what remains is the competent handling of well-worn formulae.

This had been the position for some time past: monumental painting in Rome was in the hands of facile successors. Giovanni Odazzi (1663–1731) and Lodovico Mazzanti (d. after 1760) – who also worked at Perugia, Viterbo, and Naples – continued Gaulli's manner, sapped of its strength, far into the eighteenth century.[11] But the day belonged to versions of Maratti's Late Baroque classicism. The reader will recall that the ascendancy of Maratti dates from the mid

96. Francesco Trevisani: *Dead Christ borne by Angels, c.* 1705–10. Vienna, Kunsthistorisches Museum

was a thing of the past. In a more limited sense, however, and much less distinctly than in contemporary architecture, one may discover an antithesis between the Marattesque manner and a brief Rococo phase on the one hand and a classicizing Rococo trend on the other. But the camps are not clearly divided. Benedetto Luti's work is a case in point. Next to his monumental Roman manner, Francesco Trevisani (1656–1746),[16a] who never forgot his Venetian upbringing under Antonio Zanchi, produced cabinet pictures in a true Rococo style [96]. Rivalling Sebastiano Conca's popularity, Trevisani's 'sweet Madonnas and porcelainly children' (Waterhouse) found a ready market all over Europe. But none of the Romans came closer to a French version of the Rococo than Michele Rocca (1670/5–after 1751).[17]

If the Rococo phase forms, as it were, the anti-conventional 'left wing' of Marattesque classicism, a new 'right wing' began to emerge for which that insipid manner was too Baroque and formalistic. It was mainly three artists who made heroic attempts at leading Roman painting back to a sounder foundation: Marco Benefial (1684–1764), half French, pupil of the Bolognese Bonaventura Lamberti, by an intense study of nature and by returning to the classical foundations of Raphael and Annibale Carracci (his remarkable *Transfiguration*[18] [97] shows to what extent he suc-

1670s, which corresponds fairly precisely with Guidi's in sculpture and Carlo Fontana's in architecture. At about this moment artists of the second and third rank changed their manner to fall in with the new fashion. Painters such as Giuseppe Ghezzi (1634–1721), the father of the better-known Pier Leone, Lodovico Gimignani (1643–97),[12] the son of Giacinto, and the rather banal Luigi Garzi (1638–1721) may here be mentioned; and more considerable masters like Niccolò Berrettoni (1637–82) and even Guglielmo Cortese (1627–79), who had begun as a Cortona pupil[13] and Gaulli follower, embraced the new manner. The oldest of Maratti's pupils was the Palermitan Giacinto Calandrucci (1646– 1707),[14] the most faithful Giuseppe Chiari (1654–1727),[15] the most original Giuseppe Passeri (1654–1714), the biographer's nephew; but only the distinguished Benedetto Luti from Florence (1666–1724), a figure of international reputation, renowned also as a collector and teacher, accomplished the transformation of the Marattesque into an elegant and sweet eighteenth-century style. Maratti's manner was carried over even into the second half of the eighteenth century by artists like Agostino Masucci (1692–1768) and the more considerable Francesco Mancini[16] (c. 1700–58) and his pupil Stefano Pozzi (1708–68).

The general verdict on the course of Maratti's succession must be that it ended in a pleasant but purely conventional art, a soft and feeble formalism without a hope of regeneration. It is only to be expected that with the victory of Maratti's international Late Baroque, the old contrast of artistic ideals embodied in the names of Sacchi and Cortona

97. Marco Benefial: *Transfiguration, c.* 1730. Vetralla, S. Andrea

98. Pompeo Batoni: *Education of Achilles*, 1746. Florence, Uffizi

may be traced back to some of his older contemporaries. Mengs himself had started under Benefial, yet was not impervious to the qualities of Solimena's Baroque. In the last analysis he is as much an end as a beginning.

He set the seal on that characteristically Roman classic-idealistic trend, the tenets of which were constantly shaped and coloured by the ever-changing 'Baroque' antithesis. Reference to the three sets of names: Carracci – Caravaggio; Sacchi – Cortona; Maratti – Gaulli, summarizes the course of events in three consecutive generations. In the struggle of artistic convictions and sentiments the fronts remained fluid. As the theory hardened (Bellori) in the second half of the seventeenth century, the practice began to fall out of step (Maratti). Late Baroque classicism was on the whole the weak shadow of a great past. If Mengs saddled the classic-idealistic horse again, he lacked the genius and strength for a bold ride. Measured against his greater forerunners, and even Maratti, he appears a dry pedant; measured against the work of a fully-fledged Neo-classicist of real talent like Jacques-Louis David, he seems sweet, inert, sentimental, Baroque, and not without the affectation of much of the art produced on his doorstep.

The classic-idealistic theory, revived by Winckelmann in its most rigorous form, once again conquered the world from Rome, but no longer did it have the power to revitalize monumental painting on the soil which had seen its greatest triumphs in the wake of Raphael and Michelangelo.[21]

FLORENCE AND BOLOGNA

Until well after the middle of the seventeenth century Florentine painting was provincial but had a distinct character of its own. This changed later in the century. If the reasons for the loss of identity cannot be wholly accounted for, one may at least point out four different events which determined the further course of painting in Florence: Cortona's work in the Palazzo Pitti (1640–7); Luca Giordano's frescoes, executed between 1682 and 1683, in the dome of the Corsini Chapel (Chiesa del Carmine), in the Biblioteca Riccardiana, and in the long gallery of the Palazzo Riccardi – the latter a grand allegorical pageant glorifying the reign of the Medici dynasty with dazzling *élan* and strikingly fresh and vivid colours [99]; the visit in 1706–7 of Sebastiano Ricci, whose frescoes in the Palazzo Marucelli-Fenzi [112] gave Florentines their first sensational experience of modern Venetian art; and, finally, the influence of Maratti's style as well as of Bolognese classicism, particularly through the work of the leading master, Carlo Cignani. The pattern then is clear enough; there developed in Florence two different trends, both rather international in character, the one anti-classical, accepting the Cortonesque Baroque or its thinned-out Ciro Ferri version and, in turn, Luca Giordano and Ricci; the other classical, following Marattesque or Bolognese precepts.

The classical trend is most fully represented by the precise and frigid Anton Domenico Gabbiani (1652–1726), the painter dear to the heart of Grand Duke Cosimo III and the Florentine nobility, whose palaces abound in his work.[22] While Gabbiani was primarily a Maratti follower, Giovan Camillo Sagrestani (1660–1731)[23] came from Cignani,

ceeded); the Frenchman Pierre Subleyras (1699–1749), who spent the last twenty years of his life in Rome, by introducing in his work a noble simplicity and precision of design and expression together with a limited but carefully considered light scale of tone values; and, finally, Pompeo Batoni (1708–87), by steering more decisively towards the newly rising ideal of the antique [98].[19] In a varying degree, all three artists take up special positions on the borderline between Rococo and Neo-classicism. These masters, and even Batoni in pictures farthest on the road to Neo-classicism, stuck tenaciously to Late Baroque formulae of composition. Nor is the lyric, languid, and often sentimental range of expressions really divorced from contemporary painting.[20]

It is well known that the more radical turn towards a Neo-classical mode of painting was taken by the romanized Bohemian, Anton Raphael Mengs (1728–79). A mediocre talent, but enthusiastically supported by Winckelmann, the intellectual father of Neo-classicism, he was hailed by the whole of Europe as the re-discoverer of a lost truth. The work and ideas of this moralist and rationalist, who saw salvation in a denial of Baroque and Rococo painterly traditions and pleaded for an unconditional return to principles of design, cannot here be discussed. Suffice it to say that the Baroque allegorical method as well as the preciosity of Rococo art linger on in Mengs's art, while elements of his style (such as the choice of clear and bright local colours)

99. Luca Giordano: *Pluto and Proserpina*. Oil study for the Gallery of the Palazzo Medici-Riccardi, 1682. London, D. Mahon Collection

100. Alessandro Gherardini: *The Dream of St Romuald*, 1709. Fresco. Florence, S. Maria degli Angeli (now Circolo della Meridiana)

whose slick modelling he maintained; this made him as well as his pupil Matteo Bonechi (*c.* 1672–1726)[24] an easy prey to French Rococo influence. In the next generation Giovanni Domenico Ferretti (1692–1768), a profuse decorative talent, carried on this tradition. Once again he was mainly formed by the Bolognese Cignani and Marcantonio Franceschini and to a certain extent remained tied to their Late Baroque classicism.[25]

On the other side of the fence were the *Cortoneschi*, who have been mentioned in a previous chapter (II:Chapter 8, Note 65). The real rebel against the worn-out academic con-

ventions and an artist in a class of his own was Alessandro Gherardini (1655–1726),[26] who in his transparent frescoes in S. Maria degli Angeli, Florence (1709) [100], combined the lessons learned from Giordano and Sebastiano Ricci. To what extent he mastered the new artistic language may also be seen in his principal work, the frescoes in S. Maria degli Angeli (now Università Popolare), Pistoia (after 1711), which – as M. Marangoni pointed out many years ago – might almost have been painted by a contemporary Venetian master. Gherardini's worthy pupil, Sebastiano Galeotti (1676–1746?), also formed his style on Cortona, Giordano,

and Ricci. He spent more than the last three decades of his life as a most successful fresco-painter in Liguria, Lombardy, and Piedmont, practising his truly international art [101].[27]

If Florence had no longer an organic school of painting with a physiognomy of its own, she could boast at least of competent painters, though some of the more enterprising ones, such as Luti, Batoni, and Galeotti, sought their fortunes permanently outside their native town. The situation at Bologna was vastly different.[28] The tradition of the Carracci 'Academy' had an extraordinary power of survival, and through all vicissitudes Bolognese classicism, even in a provincial and sometimes debased, feeble, and flabby form, continued to be a power which for good or evil made itself felt in many other centres. Not only Florentines but also Romans and Venetians were convinced that it was only in Bologna that an artist could procure a solid training in the perennial principles of good design. Carlo Cignani

101. Sebastiano Galeotti: *Triumph of Virtue over Vice*, detail. Genoa, Chiesa della Maddelena

102. Carlo Cignani: *Assumption of the Virgin*, 1683–1706. Fresco. Forlì, Madonna del Fuoco

103 *(right)*. Marcantonio
Franceschini: *Communion of the
Apostles*, 1690–96. Bologna,
Corpus Domini

104 *(far right)*. Gian Gioseffo
dal Sole: *Mystic Marriage of St
Catherine*, 1716? Vienna,
Kunsthistorisches Museum

105 *(below)*. Donato Creti:
Sigismonda(?), *c.* 1740. Bologna,
Comune

(1628–1719), Albani's pupil, was the celebrated guardian of this tradition and the head of an immensely active studio [102].[29] The late Reni and a renewed study of Correggio contributed to form his fluid and polished style, which contemporaries admired. N. Pevsner[30] indicated to what extent this versatile classicism falls in with Late Baroque principles. From Cignani comes, above all, Bologna's greatest decorative talent of the Late Baroque, Marcantonio Franceschini (1648–1729) [103],[31] the Bolognese Maratti,

whose manner was widely diffused through his works in Rome, Genoa, Piedmont, Spain, and Germany. His great cycle of frescoes in the church of Corpus Domini, Bologna (1687–94), illustrates most fully this facet of Bolognese painting. Next to him, Gian Gioseffo dal Sole (1654–1719),[32] 'il Guido moderno', was a much sought after, dexterous practitioner of this rather sentimental kind of Late Baroque classicism [104].

A new situation arose in the next generation which

reacted in two contrary ways to the facile conventions of the academicians. One group, led by Donato Creti (1671–1749),[33] Pasinelli's pupil, who at one time tended towards Rococo (frescoes, Palazzo Pepoli, Bologna, 1708), sought salvation in a sophisticated archaism. The Bolognese counterpart to Benefial's manner in Rome, this proto-Neo-classicism with distinct Mannerist overtones is perfectly illustrated by the small picture of illustration 105[34] which recalls works by such masters as Primaticcio. To a lesser extent some minor artists, Aurelio Milani (1675–1749),[35] Francesco Monti (1685– 1768),[36] and Ercole Graziani (1688–1765),[37] fell in with Creti's radicalism.

The other reaction came from Giuseppe Maria Crespi, called lo Spagnuolo (1665–1747), the only real genius of the late Bolognese school. Rejecting the teachings of his masters Canuti and Cignani,[38] he found instruction to his taste in the study of Lodovico Carracci, Mastelletta, and, above all, the early Guercino. Moreover, it has been shown[39] that he must have had direct contacts with Sebastiano Mazzoni (II: p. 153), echoes of whose intense chiaroscuro and freedom of touch appear in Crespi's early work. But Crespi went a decisive step beyond his models. He swept away the last vestiges of academic formalism and opened up an immediacy of approach to his subject-matter without parallel at this moment. Linked to the popular trend, which had had a home in Bologna since the days of the Carracci (I: p. 40), he applied his new vision equally to religious imagery [106], to contemporary scenes, portraiture, and genre [107]. Every-

106. Giuseppe Maria Crespi: *The Queen of Bohemia confessing to St John Nepomuc*, 1743. Turin, Pinacoteca

107. Giuseppe Maria Crespi: *The Hamlet, c.* 1705. Bologna, Pinacoteca

thing he touched is permeated with a depth of sincere feeling, a sensibility and tenderness which is as far from the ecstasy of the 'quietists' as it is from the preciosity and affectation of the academicians. Like his younger contemporary Magnasco, he is an outsider; like Magnasco, he never abandoned his chiaroscuro and remained essentially a Seicento master; but diametrically opposed to him, he chose as his theme the purely human rather than the grotesque and demoniacal. And yet both attitudes seem to have the same root, characteristic of the Baroque age: the will to freedom, which opens the way as much to Crespi's unconditional humanism as to Magnasco's chaotic abandonment.[40]

Canuti had died in 1684, Cignani had gone to Forlì in 1686, and Pasinelli died in 1700. There remained Crespi and, next to him, Giovan Antonio Burrini (1656–1727),[41] who had studied with both Canuti and Pasinelli and became Bologna's representative of an extrovert Late Baroque style; Zanotti called him 'il nostro Cortona e il nostro Giordano'. Although Crespi opened a school in 1700, few names of his Bolognese succession are worth recording, apart from his rather trivial son, Luigi Crespi (1709–79), famed as the writer of the lives of contemporary Bolognese artists,[42] and the Paduan Antonio Gionima (1697–1732).[43] All the greater was his influence on Venetian painters; Piazzetta as well as Bencovich owed much to him.

Official painting of the Baroque era at Bologna drew to a close with such able decorators as Vittorio Maria Bigari (1692–1776),[44] whose delightful scenographic cabinet pictures in the Pinacoteca, Bologna, show him at his best, and with the brothers Ubaldo (1728–81) and Gaetano (1734–1802) Gandolfi and the lesser Domenico Pedrini (1728–1800), artists who brought about the blending of the academic Bolognese tradition with the light and freedom of Tiepolo's manner. The Gandolfi were capable of large and skilfully arranged compositions with a strong Rococo flavour. But if one measures their work against that of the great Venetians, it appears no more than the flotsam of a once proud native tradition. After two hundred years of changing fortunes Bolognese painting had run its course.

Before we leave Bologna, however, a word must be added about *quadratura* painting, which had its home in Bologna from the late sixteenth century on, and remained vigorous to the end of the eighteenth century. Scenographic painting and allied practices continued to be Bologna's most important artistic export. Truly Late Baroque, the brothers Enrico (1640–1702)[45] and Anton Maria (1654–1732) Haffner, both pupils of Canuti, amplified and diversified Colonna's and Mitelli's more architectural *quadratura* style; they form the link with the imaginative scenographers of the eighteenth century. Anton Maria worked mainly in Genoa in collaboration with G. A. Carlone, Domenico Piola, Gregorio de Ferrari, and others. Enrico assisted his teacher till the latter's death in 1684; thereafter he collaborated with Giovan Antonio Burrini (Chiesa dei Celestini, Bologna) and, above all, with Marcantonio Franceschini, for whom he painted, among others, the Corpus Domini *quadratura*. The tradition was kept alive by Marcantonio Chiarini (1652–1730) and his pupil Pietro Paltronieri, il Mirandolesi (1673–1741), who worked in Venice and also for Pittoni; by Mauro Aldrovandini (1649–80), his nephew Tommaso

108. Giuseppe Bibiena: Engraving from *Architetture e Prospettive*, Augsburg, 1740

(1653–1736), Cignani's pupil, and his son Pompeo (1677–1739?), whose pupil Stefano Orlandi (1681–1760) collaborated with Bigari, Francesco Monti and others and, together with Gioseffo Orsoni (1691–1755), won laurels as a stage designer at Lucca and Turin; by Tiepolo's faithful associate, Girolamo Mengozzi-Colonna from Ferrara (*c.* 1688–*c.* 1772), his pupils Gianfrancesco Costa (1711–72) and Francesco Chiaruttini (1748–96), and many others.[46]

This long list goes to show that the greatest dynasty of *quadraturisti*, the Galli, called Bibiena after their place of origin, arose in a congenial artistic climate. Equally distinguished as designers and organizers of festivals, 'the most sumptuous that Europe ever witnessed' (Lanzi), as stage designers and inventors, as draughtsmen of extraordinary scenographic fantasies [108], as painters and theatre architects, four members of the family should be singled out, the brothers Ferdinando (1657–1743) and Francesco (1659–1739), and Ferdinando's sons, Giuseppe (1696–1757) and Antonio (1700–74). Ferdinando spent twenty-eight years in the service of Ranuccio Farnese at Parma as 'primario pittore e architetto' and in the same capacity transferred to the

109. Giambattista Crosato:
Sacrifice of Iphigenia, 1733.
Fresco. Stupinigi, Castle

110. Alessandro Magnasco:
The Synagogue, c. 1725–30.
Cleveland, Museum of Art

imperial court at Vienna in 1708. While Ferdinando was probably the most profuse genius of the family, Francesco gave Europe its finest theatres, establishing a tradition which has not yet seen its end. All the courts of Europe sought the services of the Bibiena, and Ferdinando's sons held offices at the courts of Vienna, Dresden, Berlin, and that of the Elector Palatine.[47]

The free play of the imagination as seen in the drawings of the Bibiena, and the classical tradition on which the Bolognese school thrived, seem to be incompatible with each other. And yet Ferdinando and Francesco Bibiena came from Cignani's school. The explanation lies in that the Bolognese always regarded *quadratura* – the basis of the art of the Bibiena – as a science concerned with the accurate rendering of the laws of vision. As such, *quadratura* had first been the handmaid of the grand manner. But later a para-doxical situation arose. By the mid seventeenth century, with Colonna and Mitelli, *quadratura* had reached the status of an art in its own right. In the course of the eighteenth century it was the *quadratura* artists, culminating in the Bibiena family, who held all the trumps of a truly interna-tional art, while the Bolognese grand manner was increas-ingly reduced to a provincial shadow existence.

NORTHERN ITALY OUTSIDE VENICE

Throughout the eighteenth century the smaller cities of northern Italy had flourishing schools of painters: Verona above all which, from the Middle Ages on, was always an important artistic centre, and Bergamo and Brescia,[48] where local traditions, however, yielded more and more to the overbearing Venetian influence. Apart from the Bergamasque Fra Galgario and the 'Bresciano' Ceruti – artists who will be discussed later – these provincial schools need not detain us. Nor do the big centres Milan, Genoa, and Turin require much attention.

Piedmont had to rely almost entirely on artists from abroad in order to carry out the considerable undertakings which, owing to the accumulation of power and wealth under the House of Savoy, were waiting for painters. At the end of the seventeenth century it was mainly Daniel Seiter (1649–1705),[49] born in Vienna but trained in Venice under J. C. Loth, and the Genoese Bartolomeo Guidobono (1654–1709) who held for many years positions of eminence. Although later the Florentine Sebastiano Galeotti and the fashionable Charles André Vanloo from Nice (1705–65), Luti's pupil in Rome, had large commissions[50] and firmly established the international Late Baroque in Turin, it was really Neapolitan and Venetian artists who had the major share – an interesting constellation, for the two most vig-orous Italian schools vied here for supremacy. The Neapolitans Conca, Giaquinto, and de Mura followed calls to Turin, and Solimena sent many canvases.[51] Yet the palm went to the Venetians; Sebastiano and Marco Ricci, Nicola Grassi, and Giambattista Pittoni accepted commissions, and Giambattista Crosato (1685–1758) [109] and Giuseppe Nogari (1699–1763) spent years of their lives there. Crosato,[52] above all, with his charming and ample frescoes in the Castle at Stupinigi, the Villa Regina, the Palazzo Reale, and a number of Turin churches helped to transform

Piedmont into an artistic province of Venice. The second-rate Mattia Bortoloni (p. 91) found a rewarding occupation in the Sanctuary at Vicoforte di Mondovì where he painted, not without skill, the enormous dome (1745–50), a commis-sion which illness seems to have prevented Galeotti from executing. The foremost representative of what may euphemistically be called the local school was the court-painter Claudio Francesco Beaumont (1694–1766), of French extraction, trained in Rome under Trevisani; his facile Rococo manner, a not unattractive international court style, can best be studied in the Palazzo Reale.[53] The most successful practitioner of the next generation was Vittorio Amedeo Cignaroli (1730–1800),[54] a member of the well-known Verona family of artists, a slight talent, mainly renowned for his landscapes in the manner of Zuccarelli.

Genoese grand decorative painting still flourished throughout the first quarter of the eighteenth century (p. 354); thereafter it was on the decline and handled by suc-cessors of minor calibre.[55] Milan's painters perpetuated the international Baroque.[56] But two artists must be singled out: the Genoese Alessandro Magnasco (1667, not 77,–1749), called Lissandrino, and the Mantuan Giuseppe Bazzani (1690–1769). Both are solitary figures, tense, strange, mystic, ecstatic, grotesque, and out of touch with the triumphal course the Venetian school was taking from the second decade onwards; both delight in deformities; both are masters of the rapid, nervous brush-stroke and of magic light-effects.

Magnasco went early to Milan, where he worked under Filippo Abbiati (1640–1715). Interrupted only by a stay in Florence (c. 1709–11), he remained in Milan until 1735, when he finally settled in his native Genoa. The formation of his style is not easily accounted for. In any case, Morazzone's Early Baroque mysticism must have attracted him as much as Callot's over-sensitive Late Mannerist etch-ings and Rosa's tempestuous romantic landscapes. Magnasco's phantasmagorias [110], that strange diabolical world which seems the product of a morbid imagination – the fearsome woods, the tribunals and tortures, the cruel martyrdoms and macabre scenes peopled with ghostlike monks – open up problems of interpretation. For Lanzi all these were *bizarrie*; even if one cannot agree with the distin-guished author, the question remains unsolved how much religious fanaticism, how much quietism or criticism or farce went into the making of his pictures. The reason for this uncertainty of interpretation lies in the peculiar unreal-ity of his figures. Magnasco's personal idiom was inimitable, but his impromptu way of painting, the sketchy character of his canvases, the anguished, rapid brushstroke – all this, crowning the pursuits of a distinct group of Seicento artists (II: p. 148), had a most invigorating effect on the develop-ment of painting in the new century, and the Venetians from Sebastiano and Marco Ricci to Guardi learned their lesson from him.[57]

Bazzani,[58] too, must have studied his work, but, charac-teristic of the new virtuoso type of artist, he is not easily summed up by a formula. His work vacillates between influences from Rubens, Van Dyck, and Fetti, the temperate climate of Balestra's art, Dorigny's classicism, and Watteau's and Lancret's Rococo grace; and many of his canvases call to

111. Giuseppe Bazzani: *The Imbecile* (fragment?), *c.* 1740. Columbia, University of Missouri, Museum of Art and Archaeology

mind the eccentric world of Francesco Maffei and of his own contemporary Bencovich [111]. Apart from a few minor imitators, Bazzani's manner had no sequel in Italy,[59] though it did appeal to Austrian Baroque painters.[60]

VENICE

Politically and economically Venice had long been on the decline. After her sea and mercantile power had dwindled, she became in the eighteenth century the meeting-place of European pleasure-hunters, and, indeed, there was no city in Europe which equalled her in picturesque beauty, stately grandeur, luxury, and vice. To be sure, the foreigners brought wealth to Venice, equal or perhaps greater wealth than the industry of her inhabitants had acquired by commerce in previous centuries. It is also true that with the shift of patronage from the Venetian nobility to the rich foreigners – English, Spanish, French, German, and Russian – Venetian art became international in a new sense; for (to give only a few instances), with Sebastiano and Marco Ricci, Pellegrini, Amigoni, and Canaletto in London, with Tiepolo in Würzburg and Madrid, with Rosalba Carriera in Paris and Vienna, with Bernardo Bellotto at the courts of Dresden and Warsaw, with lesser masters like Bartolomeo Nazari at the court of the Emperor Charles VII and Fontebasso and J. B. Lampi at that of St Petersburg, the Venetians appeared as their own ambassadors. But how it happened that on the social quicksand of Venice there arose the most dynamic school of painters will for ever remain a mystery.

We know now that the rise was not so sudden as it seemed not so many years ago. But in spite of the revival of the great native tradition in the second half of the seventeenth century, it was only at the beginning of the next that Venice far outdistanced Rome, Naples, Bologna, and Genoa: her European triumph dates from the second decade of the eighteenth century.[61]

Sebastiano Ricci and Piazzetta

This change of fortune is connected with the name of Sebastiano Ricci (1659–1734), who began as a pupil of Sebastiano Mazzoni, and then went to Bologna where he imbibed the teachings of the Bolognese school under Giovanni Gioseffo dal Sole; finally he studied at Parma and Rome. Thus he had the varied experience typical of the Late Baroque artist; at the age of twenty-five he had run through the whole gamut of possibilities: from the free brush-stroke of Mazzoni and the polished classicism of the Bolognese to Correggio, Annibale Carracci, and the great decorative fresco painters in Rome. His first frescoes, in the dome of S. Bernardino dei Morti in Milan (1695–8), reflect the study of Cortona and Correggio. He returned to Venice in 1700 and worked there for twelve years, interrupted, however, by long journeys to Vienna (1701–3), Bergamo (1704), and Florence (1706–7). There in the frescoes of the Palazzo Marucelli he achieved full maturity [112]: the luminous brilliant art of the eighteenth century prepared in the work in S. Marziale, Venice (1705), is born. Ricci's new homogeneous style was the result of an intelligent rediscovery of Veronese and the study of Luca Giordano. *The Virgin enthroned with Nine Saints* in S. Giorgio Maggiore, Venice (1708), is the *chef d'œuvre* of this neo-Cinquecentesque manner, enriched, however, by a quick and nervous eighteenth-century brush-stroke. In the second decade, which saw Sebastiano in London (1712–16)[62] and Paris (1716), his brush-stroke becomes more agitated, under the influence, it has been claimed, of Magnasco's work. And this, together with a renewed study of Veronese after his return to Venice, made him, in the third decade, change to the scintillating, colourful works, painted with a light nervous touch, which belong to the Venetian Rococo. Ricci is the typical extrovert eighteenth-century virtuoso, and as such his brilliance may appear somewhat superficial. Roberto Longhi talked about 'his paintings smacking of an able reportage of all European motives'.[63] But it needed precisely Ricci's easy and versatile talent to steer Venetian art back to a new understanding of the great past and forward towards the synthesis achieved in Tiepolo's heroic style.

Ricci's antipode, an artist of equal or even greater talent, was Giovanni Battista Piazzetta (1682–1754), whose training, life-story, and convictions as an artist were the antithesis to everything concerning his older colleague: instead of the itinerant artist, a man of steady habits; instead of the brilliant virtuoso, a slow and patient worker; instead of decorative superficiality, a new depth and intensity of expres-

112. Sebastiano Ricci: *Hercules and the Centaur*, 1706–7. Fresco. Florence, Palazzo Marucelli

113. Giovanni Battista Piazzetta: *The Virgin appearing to St Philip Neri*, 1725–7. Venice, S. Maria della Fava

sion; instead of the light and vibrant palette, recourse to chiaroscuro and plastic form; instead of new conquests to the end, a slow decline of creative powers during the last years.

After beginning in Antonio Molinari's studio, Piazzetta also made the journey to Bologna, but in order to finish his education under Giuseppe Maria Crespi. Back in Venice before 1711, he never left his native city again. His *tenebroso* art appears formed in the *St James led to his Martyrdom* (S. Stae, Venice, 1717) and reaches a climax in the *Virgin appearing to St Philip Neri* (S. Maria della Fava, 1725–7) [113], a composition of terse zigzag lines, built up of plastic bodies intense with mystic supplication and dramatized by a poignant chromatic scale of contrasting warm and cold reddish and brown tones. At the same moment he painted his only great decorative work, the ceiling (on canvas) with the

Glory of St Dominic in SS. Giovanni e Paolo [114], twirling in a great sweep from the borders towards the luminous centre. In the 1730s his chiaroscuro lightened under the influence of Lys and Strozzi, and a pastoral mood replaced the previous tension. This is particularly true of a group of pictures around 1740, of which the *Fortune Teller* (1740, Accademia, Venice)[64] is one of the most splendid examples. At that moment he was nearest a Rococo phase.

But this was also the period when great numbers of students began to assemble in his atelier. His house became a kind of private academy, and in 1750, at the foundation of the Venetian Academy, Piazzetta appeared to be the obvious choice as its first Director. To this late period belong works increasingly executed with the help of pupils, in which a rhetorical shallowness is supported by an *outré* chiaroscuro.

From the mid twenties on Piazzetta showed a growing interest in paintings of heads and half-figures; they were an enormous success with the public but at the same time contained the looming danger of academic petrifaction. This is also true of the many finished drawings with which Piazzetta flooded the market. In any case, his interest in the design of heads, plastically but luminously modelled in black chalk, reveals a master who upheld the tradition of *disegno* – and implicitly of the classical tradition – in a world that was mainly concerned with the painterly loosening of form. Despite his rich, typically Settecentesque, chromatic orchestration, the finest nuances of white, the light dabbing on to the canvas of his pinks and emerald greens, Piazzetta's attempt to persevere in an essentially Seicentesque *tenebroso* manner was bound to fail. But his dynamic reform of sound principles had a salutary effect, and even the young Tiepolo profited more from him than from anyone else.

With the antithesis Sebastiano Ricci–Piazzetta, the Venetian stage in the first decades of the eighteenth century was set for every artist to decide between the former's luminous decorative manner and the latter's rich chromatic chiaroscuro. Some artists wavered, such as Francesco Polazzo (*c.* 1683–1753),[65] who began as a Ricci follower but later switched his allegiance to Piazzetta. By and large, Tiepolo's development goes the opposite way. But among the great number of Piazzetta's pupils and followers there was, characteristic, none of major format, whereas mediocrities abound.[66] Only a few independent artists knew how to assimilate Piazzetta's manner more successfully. Giulia Lama[67] should here be mentioned and, above all, Federico Bencovich, who was probably born in Dalmatia about 1677 (d. Gorizia, 1753).[68]

His first works (Palazzo Foschi, Forlì, 1707) show the influence of his Bolognese teacher, Carlo Cignani, whose academic manner he soon abandoned for that of Giuseppe Maria Crespi. Thus Bencovich's chiaroscuro has the same pedigree as Piazzetta's, to whom he felt naturally drawn during his Venetian period. Also influenced by the powerful art of Paolo Pagani,[69] Bencovich created a manner of his own, dramatic, strange, forceful, agonized, a manner which

114. Giovanni Battista Piazzetta: *The Glory of St Dominic*, 1725–7. Venice, SS. Giovanni e Paolo

116. Francesco Fontebasso, *The Banquet of Zenobia*, 1744–50. Santa Bona (Treviso), Cá Zenobio

115 (*left*). Federico Bencovich: *Sts Andrew, Bartholomew, Carlo Borromeo, Lucy and Apollonia*, *c.* 1725. Senonches, Parish Church

117. Giovanni Battista Pittoni, *Solomon and the Queen of Sheba*, *c.* 1730–32. Liverpool, Walker Art Gallery

impressed the young Tiepolo as much as the Viennese in whose city he spent many years from 1733 on [115].[69a]

Sebastiano Ricci also found a following among minor masters. But it was not they, Gaspare Diziani (1689–1767), Francesco Migliori (1684–1734), Gaetano Zompini (1700–78), and the more interesting Francesco Fontebasso (1709–69),[70] on whom the victory of the 'light trend' depended [116]: this was due to a group of more considerable artists and, of course, to Tiepolo.

Pellegrini, Amigoni, Pittoni, Balestra

The first three names stand for a festive Rococo art of considerable charm. Antonio Pellegrini (1675–1741),[71] trained by the Milanese Paolo Pagani, found his bright palette through the study of Ricci and the late Luca Giordano. His light-hearted Rococo frescoes, painted with a fluid brush, were done in England (1708–13, Kimbolton Castle, Castle Howard, etc.), in Bensberg Castle near Düsseldorf (1713–14), in Paris (1720, frescoes destroyed), in the Castle at Mannheim (1736–7), and elsewhere. No less an international success was the more frivolous Jacopo Amigoni (1682–1752).[72] Born in Naples, he must have arrived in Venice already experienced in Solimena's manner, but once again Giordano and Ricci exercised the most important formative influence upon him. In 1717 he was called to the

118. Antonio Balestra: *Nativity*, 1704–5. Venice, S. Zaccaria

119. Giambettino Cignaroli: *The Death of Rachel*, 1770. Venice, Accademia

Bavarian court where he painted his fresco cycles in Nymphenburg, Ottobeuren, and Schleissheim. He lived in England between 1730 and 1739, but only his frescoes in Moor Park near London survive. His last years from 1747 on he spent as court painter in Madrid. His later manner degenerated into a languid and melodramatic classicizing Rococo, a trend paralleled in the works of other artists not only in Italy but also in France and England.[73]

Although he does not seem to have left Venice, Giovanni Battista Pittoni (1687–1767) has an important share with Pellegrini and Amigoni in the international success of the Venetian Rococo [117]. Beginning under his uncle, the weak Francesco Pittoni, he first formed his style in opposition to that of the Piazzetta–Bencovich circle. In the 1720s and 30s he produced with a nervous brush light and vibrant Rococo pictures, which reveal his attachment to Sebastiano Ricci and Tiepolo. A sophisticated colourist, he shows in his works a fragrant elegance and an arcadian mood distinctly close in feeling to the French Rococo.[74] Later, a further lightening of his palette goes hand in hand with tamer compositions, not uninfluenced by the general trend towards Neo-classicism.[75] In Pittoni's early work there are also suggestions of Roman Late Baroque influence, and these are due, as R. Pallucchini has shown, to his contact with Antonio Balestra (1666– 1740),[76] from Verona.

Balestra, first trained in Venice under Antonio Bellucci, spent several years in Maratti's school in Rome (*c.* 1691–4), and later divided his time about equally between Venice and Verona. Without ever deserting Maratti's Late Baroque classicism, he found, like Ricci, decisive stimuli in the art of Veronese and the late Giordano. His new formula of an equilibrium between the form-preserving academic Roman

tradition and Venetian tonality prevented him from making concessions to Rococo art [118]. He found a large following, mainly among provincial painters; as a distinguished *caposcuola* Balestra determined the further course of the Veronese school and influenced not a few lesser Venetian artists.[77] His principal successors at Verona were his pupils Pietro Rotari (III: Chapter 5, Note 109) and Giambettino Cignaroli (1706–70),[78] the latter a typical representative of the classicizing Rococo with false sentimental and moralizing overtones *à la* Greuze [119], and therefore the darling of the bourgeois art-loving public of the time.[78a] Cignaroli's art is the North Italian counterpart to the trend represented by Benefial and Batoni in Rome. In Venice, Pietro Longhi began under Balestra but soon deserted him, while Giuseppe Nogari,[79] Mattia Bortoloni[80] (1695–1750), Angelo Trevisani[81] (1669–1753), and, as I have mentioned, the young Pittoni moved in his orbit.

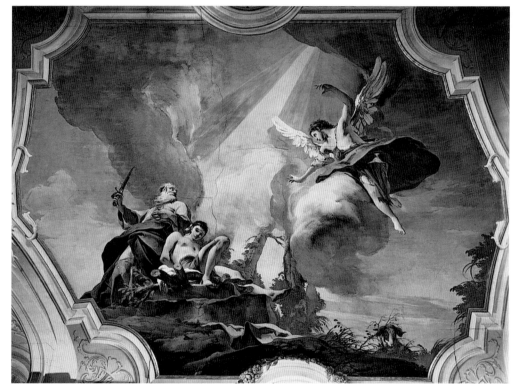

120. Giambattista Tiepolo:
Madonna del Carmelo, *c.* 1720–22.
Milan, Brera

121. Giambattista Tiepolo: *The
Sacrifice of Isaac*, 1726–7. Udine,
Archiepiscopal Palace

Giambattista Tiepolo (1696–1770)

All the pictorial events in Venice during the early years of the eighteenth century look in retrospect like a preparation for the coming of the great genius, Giambattista Tiepolo.[82] From his first work, painted at the age of nineteen (Ospedaletto, Venice), his ascendancy over his older colleagues seemed a foregone conclusion. His career was meteoric; soon he had risen to the position of peerless eminence which he maintained for half a century. From the start his output was prodigious. He began under the retardataire Gregorio Lazzarini but was immediately attracted by Piazzetta's *tenebroso* and the dramatic and bizarre art of Bencovich. These attachments are discernible in his first monumental work, the *Madonna del Carmelo*, painted *c.* 1721 (now Brera, Milan) [120]. Piazzettesque reminiscences linger on in one of his first frescoes, the *Glory of St Teresa* in the Chiesa degli Scalzi, Venice (*c.* 1725). In 1726 he began his first important fresco cycle

outside Venice, in the Cathedral and the Archiepiscopal Palace at Udine [121], the masterpiece of his early period and a landmark on the way to his new airy and translucent art. After Udine, his work often took him outside Venice: in 1731 and again in 1740 to Milan where he painted first the ceilings in the Palazzi Archinto (destroyed during the war) and Casati-Dugna and, at the later visit, that in the Palazzo Clerici.[83] In 1732 and 1733 followed the frescoes in the Colleoni Chapel in Bergamo and between 1737 and 1739 the great ceiling with *St Dominic instituting the Rosary* in the Chiesa dei Gesuati, Venice [122]. The next decade led him from triumph to triumph: the great canvases of the Scuola dei Carmini (1740–7); one of his grandest frescoes, the *Madonna di Loreto* on the vault of the Chiesa degli Scalzi (1743–4, destroyed during the first war);[84] and, *c.* 1744–5, the superb central saloon of the Palazzo Labia with the story of Cleopatra [123] – these are some of the highlights of this period.

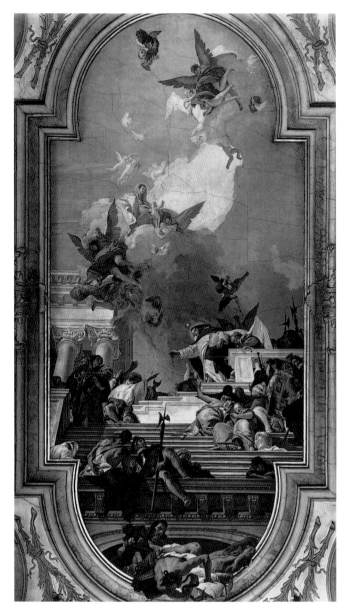

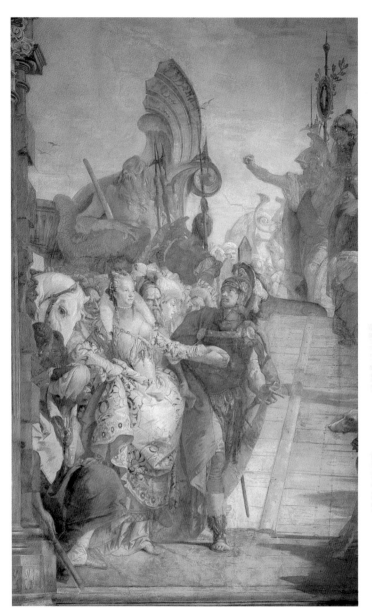

122. Giambattista Tiepolo: *St Dominic Instituting the Rosary*, 1737–9. Fresco. Venice, Chiesa dei Gesuati

123. Giambattista Tiepolo: *The Embarcation of Anthony and Cleopatra*, *c.* 1746. Fresco. Venice, Palazzo Labia

A new chapter in his career started at the beginning of the next decade, when he was commissioned to decorate the Kaisersaal and the Grand Staircase of the new Residenz at Würzburg, the capital of Franconia (December 1750–November 1753).[85] This immense task, the greatest test yet of his inexhaustible creative resources, was followed after his return to Venice by the *Triumph of Faith* on the ceiling of the Chiesa della Pietà (1754–5) and the decoration of a number of villas in the Veneto, among them the charming series of frescoes in the Villa Valmarana near Vicenza (1757). Works like the frescoes in the two rooms of the Palazzo Rezzonico, Venice (1758), the *Assumption* fresco in the Chiesa della Purità at Udine, painted in the course of one month in 1759, the *Triumph of Hercules* in the Palazzo Canossa at Verona (1761), and the *Apotheosis of the Pisani Family* in the great hall of the Villa Pisani at Stra (1761–2) [124] occupied him during his last Italian years. In the sum-

mer of 1762, following an invitation from King Charles III, he arrived in Madrid, and it was there that he spent the last eight years of his life executing the enormous *Apotheosis of Spain* in the Throne Room of the Palace as well as two lesser ceilings,[86] and carrying out a multitude of private commissions. It was at the threshold of death that the aged painter had to face his first major defeat. At the instigation of the powerful Padre Joaquim de Electa, the King's Confessor, who was a supporter of Mengs, Tiepolo's seven canvases painted for the church of S. Pascal at Aranjuez were removed and replaced by works of his rival.

This survey indicates that Tiepolo was in the first place a painter in the grand manner, and it is in this capacity that he should be judged. In order to pinpoint his historical position, I have chosen to discuss one of his more modest fresco cycles, that of the Villa Valmarana, painted at the height of his career.[87] The programme in the five frescoed rooms is

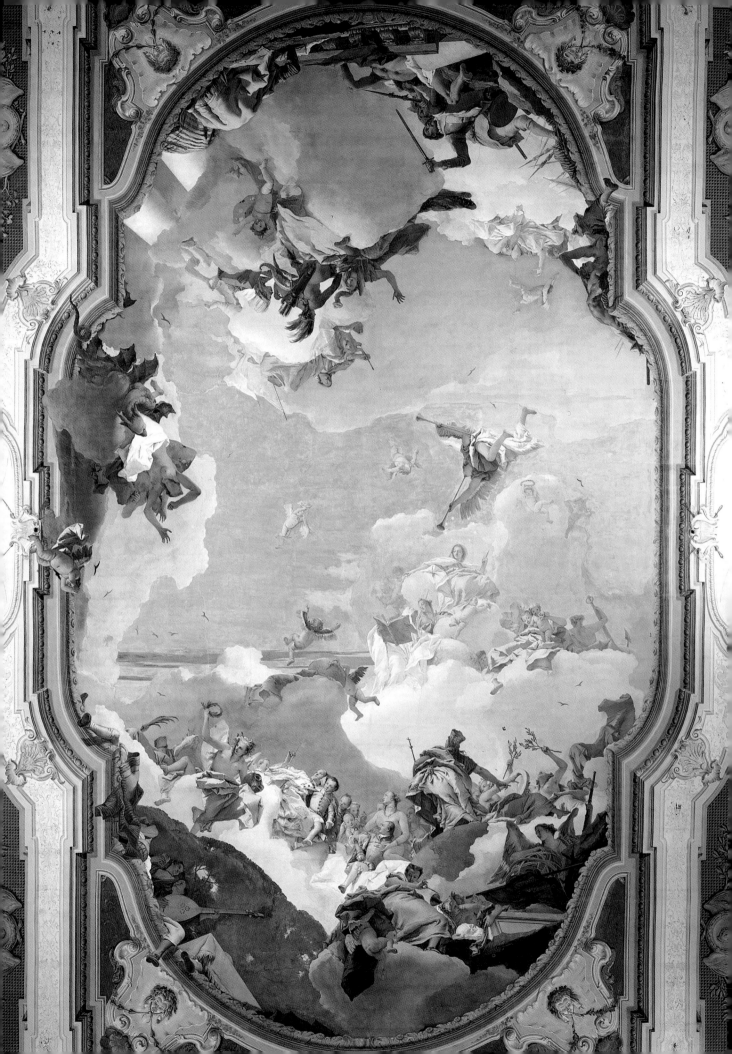

124. Giambattista Tiepolo: *The Apotheosis of the Pisani Family*, 1761–2. Fresco. Stra, Villa Pisani

125. Giambattista Tiepolo: *Sacrifice of Iphigenia*, 1757. Fresco. Vicenza, Villa Valmarana

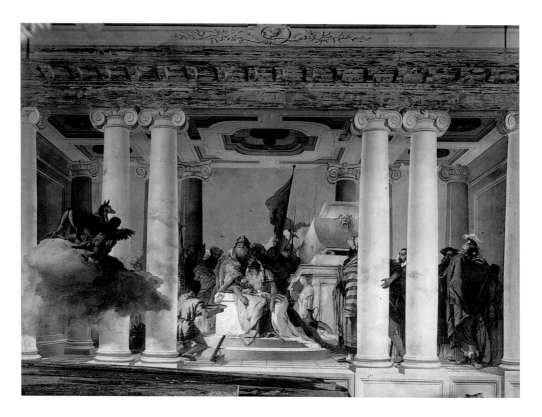

wholly in the tradition of grand history painting, illustrating scenes from Homer (probably in Valerius Maximus's version) and Virgil, from Ariosto and Tasso. Illustration 125 shows the long wall of the hall with the *Sacrifice of Iphigenia*: in the centre the high priest, ready to thrust a butcher's knife into Iphigenia's body, and a servant with a platter to receive the sacrificial blood. But the killing does not take place; led by little cupids the deer dispatched by the goddess Diana – appeased and moved by the girl's innocence – arrives post-haste on a cloud in order to take Iphigenia's place, and the high priest as well as the crowd turn astonished in the direction of the unexpected sight. Only Agamemnon, Iphigenia's father, hiding his face in his cloak,[88] is still unaware of the miracle.

The scene takes place under a portico, the painted frontal columns of which seem to carry the actual cornice. With every means at his disposal Tiepolo produced the illusion that the perspective space of the fresco is a continuation of real space.[89] The illusionist extension of space is carried over to the opposite wall, where the portico architecture is repeated as setting for Greek warriors watching the events across the room. Moreover, the cloud with the deer seems to float far inside the beholder's space. On one side of the ceiling the goddess herself turns with commanding gesture towards the sacrifice, on the other side the wind-gods begin to blow again, and they blow in the direction of the Greek fleet, lying at anchor behind the portico of the opposite wall. Thus a web of relationships is created across the room and from the ceiling to both walls, and the beholder's space is made to form an integral part of the painted story. With remarkable logic, it is also the imaginary light shining from the painted sky that determines the distribution of light and shade in the frescoes.

Similar illusionist effects are operative in the Palazzo Labia, where Antony and Cleopatra seem to step down the painted staircase as if to join the crowds in the hall. Although the same degree of illusion could rarely be applied, Tiepolo revelled in illusionist devices such as the motif of the drawn curtains in the Kaisersaal of the Würzburg Residenz. It is evident that he takes his place in the monumental Renaissance–Baroque tradition, and if he revived the kind of illusionism familiar from Veronese and his school, he needed for his stronger effects the support of Bolognese *quadratura*; it is well known that he often employed his faithful *quadraturista*, Mengozzi-Colonna.[90] Behind the illusionist totality at which he aimed lies the accumulated experience of monumental Baroque art – not only the theory and practice of the *quadraturisti*, but in various ways also that of Cortona and Bernini, who had found new concepts for breaking down the boundary between real and imaginary space.

Nobody has ever been misled by the fictitious reality of the painted world. But just as in the theatre, the Baroque spectator craved for the maximum of illusion and was prepared to surrender to it. In contrast, however, to seventeenth-century illusionism, Tiepolo's emphatically rhetorical grand manner is sophisticated and hyperbolical in a typically eighteenth-century sense. Although he uses every means of illusion to conjure up a fictitious world, he seems himself to smile at the seriousness of the attempt. In the hall of the Villa Valmarana and in front of many of his secular works John Gay's epigram comes to mind: 'Life is a jest and all things show it . . .'.

The Villa Valmarana frescoes also reveal the extent to which Tiepolo abides by the classical compositional patterns of monumental painting. One finds a distinct emphasis on triangles and basic diagonals and, while this may not be so obvious in multi-figured works, a close study shows

126. Giambattista Tiepolo: Plate from the *Varj Cappricj*, published 1749. Etching

128. Giambattista Tiepolo: Head from *Rinaldo and Armida*, 1757. Fresco. Vicenza, Villa Valmarana

127. Giambattista Tiepolo: Sketch, pen and wash. New York, Pierpont Morgan Library

that even in these each figure is clearly defined by a network of significant compositional relationships.[91] In the last analysis the figures themselves belong to the perennial repertory of the Italian grand manner; the links with Veronese are particularly strong, but even Raphael may be sensed.

I have stressed Tiepolo's traditionalism so much because he is in every sense the last link in a long chain. He himself was well aware of the full extent of the tradition. Veronese and Titian, Raphael and Michelangelo, even Dürer, Rembrandt, and Rubens and, of course, the whole development of Italian Baroque painting were familiar to him, and he did not hesitate to use from the past whatever seemed suitable. True to the new approach first encountered in Luca Giordano, he carried the weight of this massive heritage lightly and displayed his unrivalled virtuosity with unbelievable ease. Without the least sign of inhibition he turned the accumulated experience of 250 years to his own advan-

tage: but since he was so sure of himself, every one of his works is an unimpaired entity, strong and immensely vigorous. The virile and heroic quality of his art is apparent even where he comes closest to French Rococo. Shepherds' idylls were not for him; whatever he touched had the epic breadth of the grand manner.

But Tiepolo was not simply the last great practitioner of history painting in the classical tradition – his particular glory and one of the reasons for his European success lies in his revolutionary palette. His early work was still relatively dark, with striking chiaroscuro effects and lights flickering over the surface. It was at this time that Rembrandt had a strong hold on him. The Udine frescoes of 1726–7 mark the decisive change: light unifies the work and penetrates into every corner. For the two other great magicians of light, Caravaggio and Rembrandt, light had always a symbolic quality and needed darkness as its complement. Tiepolo's light, by contrast, is the light of day, which resulted in the transparency and rich tonal values of all shadows. He created this light by using a silvery tone which reflects from figures as well as objects. It is this light that must be regarded as the crowning achievement of Tiepolo's art and, in a sense, of the inherent tendencies of Venetian painting. Contrary, however, to the warm palette of the older Venetian masters, Tiepolo's palette had to be cool in order to produce his daylight effect. As a result, his most brilliant accomplishment is his frescoes rather than his easel-paintings, so that his works in galleries, splendid as they may be, will never convey a full impression of his genius. This has to be emphasized, since we tend nowadays to prefer the intimate oil study, the rapid sketch in pen and wash, or the spirited etched capriccio to the rhetoric of the grand manner [126, 127]. All these are, of course, of the highest quality, but, true to tradition, to Tiepolo these were trifles to be indulged in as a pastime (unless they were preparatory studies for monumental works).[92]

129. Gian Domenico Tiepolo: *Peasant Women* (detail), 1757. Fresco. Vicenza, Villa Valmarana

Fresco-painting is the technique ideally suited to the grand manner with its requirement for monumentality, and, except in Venice, the masterpieces of Italian painting were therefore executed in this technique. It is like an act of historical propriety that the last giant of the grand manner was a Venetian and chose the fresco as his principal medium. Yet in one important respect Tiepolo broke away from customary procedure. Instead of the finish which one associates with fresco technique, he used a rapid and vigorous stroke, so that in reproductions details of his frescoes often look almost like sketches [128]. It is precisely this inimitable brush-stroke that endows his frescoes with their intensity, exuberance, and freshness.

In the guest-house of the Villa Valmarana a few rooms are decorated with idyllic and topical subjects. The change of programme corresponds to a change of style for which Gian Domenico Tiepolo was responsible. Giambattista's heroic, epic, and mythological scenes are expressed in the language and grammar of the grand manner, while Gian Domenico's masquerades and village scenes are inconsistent with the compositional patterns of the classical tradition; the idealization of figures, too, is replaced by an anti-conventional and realistic idiom [129]. This change marks a change of generation. Gian Domenico, born in 1727, died as late as 1804: he buried the grand manner right under his father's vigilant eye.

Five years after the Villa Valmarana frescoes Tiepolo settled in Madrid. Shortly before him, Mengs had come to take up his appointment as painter to the king. When Tiepolo died, Goya was twenty-four years old – a fascinating constellation where Tiepolo as well as Mengs could only be the losers: the last great pillar of the Baroque tradition and the most celebrated exponent of academic art had to yield to the prophetic genius who gave rise to the art of the new century.[93]

THE GENRES

In the first chapter will be found some remarks about the so-called 'secularization' of painting in the seventeenth century and the growth of various specialities. As the century advanced, the specialists of landscape painting in its various facets, of battle- and animal-pieces, popular scenes and genre, of fruit, flower, fish, and other forms of still life, and finally of portraiture grew considerably in numbers.[94] This answered a need, because these artists catered to a rapidly growing middle-class with new ideas of domestic comfort. Nevertheless the Italian position remained vastly different from that of a Protestant bourgeois civilization such as Holland's, where the process of specialization had begun a hundred years earlier. In Italy the nobility of monumental painting was never seriously challenged, and it is for this reason that, with the exception of portraiture, artists of rank rarely made the concession of delving into the 'lower' genres; only outsiders like Crespi were equally at home in religious imagery and the *petite manière* of domestic scenes. It is for the same reason that for the modern observer some of the most exciting and refreshing paintings of the late seventeenth and eighteenth centuries came from the 'unprincipled' specialists. Yet, although much of their work may have a greater appeal than the large history-paintings of the Bolognese or Roman schools, compared with the endless number of practitioners, the real innovators, masters with a vision of their own, are few. It is mainly with these that I shall deal in the following pages, while many worthy artists of minor stature must be left unmentioned.

Portraiture

Almost all the great Late Baroque artists were excellent portrait painters – from Maratti to Batoni and Mengs, from Luca Giordano to Solimena, from Crespi to Tiepolo. It is an interesting aspect that their portraits were, as a rule, painted without theoretical encumbrances and therefore often speak to us more directly and more forcefully than their grand manner. Among the specialists in portraiture, two masters of rank may be singled out, Giuseppe Ghislandi, called Fra Vittore del Galgario (1655–1743), and Alessandro Longhi (1733–1813). Fra Galgario, born in Bergamo, studied in Venice under the portrait painter Sebastiano Bombelli (1635–1716), thus laying the foundation for his magnificent blending of Venetian colourism with the native tradition of Moroni's portraiture. From the latter he learned the secret of straightforward characterization of the sitter. It is his ability of unvarnished representation of character, to which he knew how to subordinate the pose, the often pompous or

130. Giuseppe Ghislandi: *Portrait of Isabella Camozzi de' Gherardi, c.* 1730.
Costa di Mezzate, Bergamo, Conti Camozzi-Vertosa Collection

elegant contemporary dress, and the chromatic key, that makes him the most distinguished portrait painter of the Late Baroque period [130].

Alessandro Longhi, whose activity began a decade after Fra Galgario's long career had ended, represents to a certain extent the opposite pole in portrait painting.[95] Trained under his father Pietro and under Giuseppe Nogari (1699–1763), a specialist in rather facile character studies, he became the acknowledged master of Venetian state portraiture – of doges, senators, and magistrates – rendered with an infallible sense for tonal nuances; but in his portraits it is the stately robe rather than the character that makes the man. His gallery of Venetian dignitaries, continued without much change of style till after 1800, shows how little Venetian Rococo culture yielded to the temper of a new age.

On a lesser level portraiture flourished during the period, particularly in Venice and the *terra ferma*. Rosalba Carriera's (1675–1758) charming Rococo pastels come to mind; in her time these made her one of the most celebrated artists in Europe. Her visits to Paris (1721) and Vienna (1730) were phenomenal successes; in Venice all the nobles of Europe flocked to her studio. But her work, mellow, fragrant, and sweet, typically female and a perfect scion of the elegant Rococo civilization of Venice, is interesting (in spite of a

recent tendency to boost it)[96] as an episode in the history of taste rather than for its intrinsic quality.

The Popular and Bourgeois Genre

In recent years much stir has been made by the masters whom Roberto Longhi called ' pittori della realtà'[97] – the masters who take 'life as it really is' as their subject and paint it with unconventional freedom and directness. But as Longhi himself made abundantly clear, this happy phrase has meaning only in a metaphorical sense. The Milan Exhibition of 1953 showed that an almost abstract Lombard quality unites the portraits of Carlo Ceresa, the still lifes of Baschenis, and the popular genre of Ceruti, a 'magic immobility' (Longhi), a sophisticated convention far removed from a 'naive' approach to reality.

Giacomo Ceruti, called 'il Pitocchetto', also a history and portrait painter, remains, in spite of intense study,[98] something of an enigma. Active mainly in the second quarter of the eighteenth century, he left us a depressing gallery of beggars and idiots, of vagabonds, cripples, and dumb folk painted sparingly in a dark key, but with such descriptive candour that the spectre of Surrealism is not far from our minds [131]. The popular genre as such had fairly wide currency then, so that Ceruti's fascination with the forgotten and lost of humanity was not altogether unique.

Linked by many strands with the Flemish and Dutch masters, imported by them directly and indirectly into Italy, the lower genre appears during the seventeenth century in many guises: as animal pictures and rustic scenes in Genoa, as Bambocciate in Rome, as market scenes and low-class gatherings in Naples, or simply as semi-burlesque types in Annibale Carracci's *Arti di Bologna*. Yet it was only from the turn of the seventeenth to the eighteenth century on that the common man, the anonymous crowd, their doings, behaviour, and psychology attracted many painters, among them Giuseppe Maria Crespi [107], Magnasco, and Piazzetta.

But the artists who regarded this genre as their special and sometimes only province form a group apart. Gaspare Traversi in Naples,[99] setting out from Caravaggesque sources, painted (between 1732 and 1769) episodes from the life of the middle classes with considerable temperament, psychological insight, and a lively sense for the farcical and grotesque. Concentrating entirely on the mute communication of figures often irrationally arranged on the canvas [132], his work strikes a truer note than the more polite genre scenes of his contemporary Giuseppe Bonito (p. 75), who transferred something of the respectability of academic art into this sphere. Rome had in Antonio Amorosi (*c.* 1660–after 1736) a painter who conceived popular genre scenes on a rather monumental scale. A revival of a certain amount of Caravaggism together with the reserve and intensity of his figures are the reason why many of his pictures went and still go under the names of Spanish artists, even of that of Velasquez. Amorosi, along with his contemporary Pier Leone Ghezzi[100] (1674–1755), was the pupil of the latter's father, Giuseppe Ghezzi (1634–1721). Pier Leone, whose frescoes and altarpieces are now all but forgotten, survives as the witty caricaturist of hundreds of contemporary Roman notables[101] – drawn, however, in a stereotyped

131. Giacomo Ceruti: *Two Wretches*, *c.* 1730–40. Brescia, Pinacoteca

132. Gaspare Traversi: *A wounded Man*, before 1769. Venice, Brass Collection

manner – rather than as the painter of genre scenes. Giuseppe Gambarini[102] (1680–1725) in Bologna, who always reveals his Bolognese academic background, tends in some of his pictures towards the idyllic Rococo genre. But it was mainly in Lombardy and the Venetian hinterland that the lower and bourgeois genre, even before Ceruti, had its home with such minor practitioners as Pietro Bellotto (1625, not 27,–1700), a pupil of Forabosco and painter of meticulously observed heads of old people; Bernardo Keil[103] ('Monsù Bernardo', 1624–87), Rembrandt's pupil, working in Italy from 1651 on; Pasquale Rossi[104] called Pasqualino (1641–1725) from Vicenza, who practised mainly in Rome and may have influenced Amorosi; Antonio Cifrondi (1657–1730), Franceschini's pupil at Bologna, whose paintings are definitely related to the *Arti di Bologna* etchings; and Giacomo Francesco Cipper[105] called il Todeschini, probably a Tirolese working in the first half of the eighteenth century in a manner reminiscent of Ceruti's. These painters delight in illustrating homely or gaudy and grotesque scenes, and the beholder is entertained by the narrative. All this is different in the case of Ceruti, where it is the scrupulous 'portrayal' of misery that has our attention.

Now Annibale Carracci's *Arti di Bologna*[106] were what may be called the incunabula of 'pure representation' of low-class types, and this tradition was kept alive in Giuseppe Maria Mitelli's (1634–1718) engravings. It would seem that Ceruti's art developed against this background[107] and that his paintings, therefore, represent types rather than portraits and contain literary connotations of which the modern beholder is unaware.

This observation leads to the major problems of the entire class of genre painting. Not 'real life', but traditions of old – visual as well as literary recollections – inform the incongruously farcical as well as the imaginary idyllic genre. Upon closer inspection it appears that the choice of subjects was limited. A standardized set was endlessly repeated, such as the Schoolmistress, the Sewing School, the Musical Party, the mendicant Friar, the old Drunkard, and so forth. In not a few cases the roots lie far back in the allegorical rep-

133. Pietro Longhi: *The House Concert, c.* 1750. Milan, Brera

134. Gian Paolo Pannini: *Piazza del Quirinale, c.* 1743. Rome, Quirinal Palace

resentations of the Middle Ages (e.g. the Schoolmistress as personification of Grammar, one of the Liberal Arts), in others the pattern derives from religious imagery or history painting (e.g. the Sewing School from Reni's fresco of the Virgin sewing). Moreover, it has rightly been pointed out[108] that by and large in Italy this class of painting lacks spontaneity, that the derivation from, and connexion with, the great formal tradition can often be sensed, and that Italians concentrate on the human figure rather than on the ambience. In contrast to the painters of northern countries, many of the Italian genre painters also practised the grand manner, or tried and, disappointed, deserted it. In addition, it can probably be shown that there was a lively exchange between Naples, Rome, and Lombardy with Bologna taking up a key position; that, in other words, the painters here named and many others knew of each others' work. What would seem an impromptu reaction against the formalism of the grand manner and the established conventions of decorum, springing up in a number of centres, was in fact an art with its own formal and iconographical conventions – a kind of academic routine of 'low art', far from any improvisation.

It is only when one turns to Pietro Longhi (1702–85) that one is faced with conversation pieces in the modern, eighteenth-century sense. At the opposite pole to Ceruti's restricted formula for the rendering of low-class types, Longhi, the most versatile Italian practitioner of the pleasant and unproblematical bourgeois genre, is more interested in catching the flavour of the scene enacted than in the characters of the actors [133]. While working at Bologna under Crespi, he came into contact with Gambarini's rather polished paintings of well-mannered peasants and washer-

women, an interpretation of everyday life that struck allied chords. Back in Venice, he became the recorder of the life and entertainments of polite society, always painted in the small cabinet format. But compared with the magic of a Watteau, the charm of a Lancret, the intimacy of a Chardin, or the biting wit of a Hogarth, the limitations of his talent are obvious.

Longhi's flair for showing the public their own lives in a somewhat beautifying mirror won him enthusiastic admirers.[109] Everywhere in Europe the bourgeois society of the second half of the century craved for a descriptive, anecdotal art, and, next to Longhi, minor artists in Venice like Francesco Maggiotto and Antonio Diziani catered for this taste in various ways. It was perhaps a timely decision when Giambattista Tiepolo left for Spain in 1762.[110]

Landscape, Vedute, Ruins

During the seventeenth century the important events in the history of Italian landscape painting took place on Roman soil. It was there that the Venetian landscape of the sixteenth century was transformed by Annibale Carracci into the classically constructed humanist landscape which led on to the development of Claude's and Poussin's ideal and heroic landscape style; it was there that through Brill and Elsheimer the 'realistic' northern landscape got a firm foothold, was italianized by Agostino Tassi, and disseminated further by scores of northern artists who had settled in Rome; it was there, finally, that Salvator created the 'romantic' landscape which determined to a large extent the further history of Italian landscape painting.

For the following period it is necessary to differentiate, at least theoretically, between the landscapists proper and the masters of *vedute*, i.e. of topographical views. *Vedute*, which do not become important till the second half of the seventeenth century, are in fact a late offshoot, often combining landscape elements with the work of the trained architectural designer as well as the *quadraturista* or scene painter. At the time one distinguished between the *vedute esatte*, precise renderings of topographical situations, and the *vedute ideate* or *di fantasia*, imaginary views, which offered the possibility of indulging in dreamlike flights into the past and, above all, of rendering romantic and nostalgic pictures of ruins.[111] In Rome the arcadian and pastoral classical landscape remained in vogue, practised mainly by the exceedingly successful italianized Fleming Jan Frans van Bloemen, called Orizzonte (1662–1749),[112] and by Andrea Locatelli (1695–*c.* 1741),[113] whose elegant and tidy work shows a typically eighteenth-century luminosity and transparency. Neapolitan landscapists such as Gennaro Greco,[114] called Mascacotta (1663–1714), Pietro Cappelli, a Roman (d. 1727), Leonardo Coccorante (1700–50), and even the late

Carlo Bonavia (or Bonaria, active 1750–88), stem mainly from Rosa and often emphasize the bizarre and fantastic.[115] Compared with these attractive but minor specialists, Rome had at least one great master who raised both the *veduta esatta* and *ideata* to the level of a great art.

Gian Paolo Pannini,[116] born at Piacenza in 1691/2, first formed by impressions of the Bibiena and other scenographic artists, in 1711 joined the studio of the celebrated Benedetto Luti in Rome. His frescoes in the Villa Patrizi (1718–25, destroyed) established him firmly as a master in his own right. Patronized by Cardinal Polignac and married to a Frenchwoman, his relations with France became close and his influence on French artists increasingly important. During the last thirty years of his life (he died in Rome in 1765) he was primarily engaged on topographical views of Rome, real and imaginary [134], and one cannot doubt that he received vital impulses from the precise art of Giovanni Ghisolfi (1623–83),[117] whose *vedute ideate* show the characteristically Roman scenic arrangement of ruins. The boldness of Pannini's views, the sureness with which he placed his architecture on the canvas – clear signs of the trained

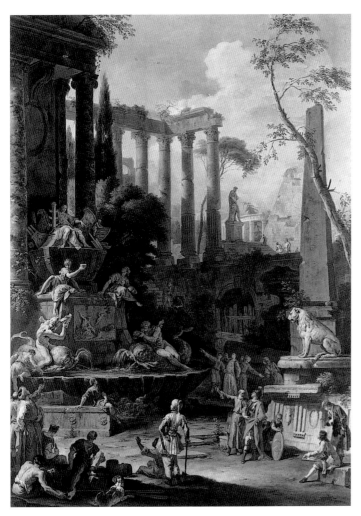

135. Sebastiano and Marco Ricci: *Epitaph for Admiral Shovel*, c. 1726.
Washington, National Gallery of Art

quadraturista – the handling and placing of his elegant figures, the atmosphere pervading his pictures, the crystalline clarity of his colours, the precision of his draughtsmanship – all these elements combine into an art *sui generis*, which had as much influence on the majestic visions of a Piranesi as on the arcadian world created by Hubert Robert.

Earlier than most of Pannini's *vedute*, but influenced by them at the end of his career, are the often somewhat dry topographical renderings of the city by the Dutchman Gaspar van Wittel,[118] called Vanvitelli, who was born at Amersfoort in 1653, made Italy his home in 1672, and worked mainly in Naples and Rome where he died in 1736. Deriving from the northern microcosmic tradition of a Berkheyde, in Italy he soon developed a sense for well-composed panoramic views without ever abandoning the principle of factual correctness.

With Vanvitelli and Pannini and later with the magnificent engraved work of the Venetian Giambattista Piranesi (pp. 1–2), Rome maintained a position of eminence in the special field of topographical and imaginary *vedute*.[119] Nonetheless, Venice also asserted her ascendancy in landscape painting and the allied genres. Marco Ricci (1676–1730),[120] Sebastiano's nephew and collaborator [135],

must be regarded as the initiator of the new Venetian landscape style, which through him became an immediate international success. He worked in Turin, Florence, and Milan, and visited London twice between 1708 and 1716, the second time (1712–16) in the company of his uncle. From 1717 on he made Venice his home. With his knowledge of intra-Italian developments Marco combined quick reactions and a spirit of real artistic adventure. Thus, in the first three decades of the eighteenth century his manner underwent many changes: the early 'scenographic' views derive from Carlevarijs, the dark, tempestuous landscapes betray the study of Salvator and Micco Spadaro, the more arcadian ones that of Claude; in the second decade his landscapes show some of the magic and nervous tension of Magnasco; later his interest in classical ruins grows; at the same time his vision broadens, his palette lightens, and the landscapes take on an eighteenth-century luminous and atmospheric character [135]. At this late moment he appears as a master of the *vedute ideate*, fantastic visions of crumbled antiquity, even before Pannini had developed his own style in this genre.

Giuseppe Zais (1709–84) formed his rustic style as a landscapist upon the art of Marco Ricci before he came into contact with the Tuscan Francesco Zuccarelli (1702–88), who settled in Venice about 1732 and soon found himself in the leading position vacated by Marco Ricci's death. Trained in Florence by Paolo Anesi and in Rome possibly by Locatelli, Zuccarelli had little of Marco's bravura although he strove to emulate the latter's atmospheric luminosity. But Tuscan that he was, his festive idylls and arcadian elysiums under their large blue skies – more in line of descent from Claude than from Marco – always retain a non-Venetian colouristic coolness. His sweet and amiable art secured him international success. He worked in Paris and London, where he became a foundation member of the Royal Academy (1768), and his influence on the history of English landscape painting is well known.

The most gifted follower of Marco Ricci, but probably Canaletto's pupil, was Michele Marieschi (1710–43);[121] with a quick brush he painted imaginary views of Venice, landscapes with ruins, and capriccios in which something of the scenographic tradition is retained. It has long been known that his work, usually in strong chiaroscuro and glittering with the warm and brilliant light of the Venetian lagoon, had a formative influence on the greater Francesco Guardi.

To the extent that all these landscapists were also *vedutisti*, it was primarily the *veduta di fantasia* that interested them. But parallel with the *veduta esatta* by Vanvitelli and Pannini runs a development at Venice: if Luca Carlevarijs from Udine (1663–1730) was the Venetian Vanvitelli, Antonio Canale, called Canaletto (1697–1768), was the Venetian Pannini. Carlevarijs,[122] also renowned as an engraver, approached his subject with the eye and knowledge of the trained *quadraturista*. The scenic effect of his views of the Piazza S. Marco and the Canal Grande with their studied emphasis on perspective, the crowds, gondolas and accessories filling his pictures, his interest in the narrative or the festive event (e.g. the *Reception of the Fourth Earl of Manchester as Ambassador at Venice*, 1707, City Art Gallery, Birmingham) – all this shows how different his art is from that of his Roman counterpart. Yet like Vanvitelli he

136. Canaletto: *Piazza S. Marco*, c. 1760. London, National Gallery

137. Bernardo Bellotto: *Verona from the Ponte Nuovo*, 1747. Edinburgh, National Gallery of Scotland

138. Gianantonio Guardi: *Story of Tobit*, after 1753. Detail. Venice, S. Raffaele, parapet of organ

was mainly a 'chronicler', concerned with the factual rather than the poetical aspect of the scene recorded. It was precisely this, the poetical quality, the responsiveness to the mood of Venice, to her light and atmosphere, that Canaletto knew how to render. He began as a theatrical designer under his father. After an early visit to Rome (1719), he worked first with Carlevarijs, and his choice of views and motifs reveals it even at a much later date.

Canaletto's characteristic style was formed as early as 1725 (four pictures for Stefano Conti at Lucca, now Montreal, private collection).[123] Although he slowly turned from an early *tenebroso* manner to a brightly and warmly lit atmospheric interpretation of his *vedute*, in keeping with the general eighteenth-century trend, he remained faithful to a fluid and smooth paint; and it is this that helps to convey the impression of a dispassionate festive dignity and beatitude [136]. No eighteenth-century painter was more to the taste of the British, and owing to the patronage of the remarkable Consul Smith at Venice there was soon a steady flow of Canalettos to England, followed between 1746 and 1755 by three visits of the artist to London.[124]

A high-class imitator of Canaletto's manner was his pupil Giuseppe Moretti;[125] but only Bernardo Bellotto (1720–80), Canaletto's nephew, was capable of a personal interpretation of the older artist's work [137]. He left Venice at the age of twenty and, after working in Rome, Turin, Milan, and Verona, sought his fortune north of the Alps. Between 1747 and 1756 he was court painter in Dresden, later he went to Vienna and Munich, and the last thirteen years of his life he spent as court painter in Warsaw, poetically ennobling cities and buildings under northern skies by the mathematical precision of his vision and the terse application of a small range of cold 'moonlight' colours.[126]

139. Francesco Guardi: *View of the Lagoon*, *c.* 1790. Milan, Museo Poldo
Pezzoli

Often allied with the name of Canaletto, but in fact taking up a diametrically opposite position, Francesco Guardi (1712–93) must be given the palm among the *vedutisti*. His modest life-story remains almost as anonymous as that of a medieval artist. Although in 1719 his sister was married to Tiepolo, it is only after patient research that a minimum of facts has become known about him. He never attracted the attention of foreign visitors, and not till he was seventy-two was he admitted to the Venetian Academy. Until 1760 his personality was submerged in the family studio headed by his brother Gianantonio (1699, not 98, –1760).[127] In this studio Francesco plodded along like an artisan of old and never relinquished antiquated practices. As a man of over thirty he seems also to have worked in Marieschi's studio and when over forty in that of Canaletto. Moreover, he did not hesitate to repeat himself nor to use other artists' works – next to Canaletto's, compositions by Sebastiano Ricci, Fetti, Piazzetta, Strozzi, Crespi – and one of his most ravishing paintings, the *Gala Concert* of 1782 (Munich, Alte Pinakothek), was cribbed from a dry engraving by Antonio Baratti after a design by Giovanni Battista Canal. Finally, much of his output was the work of collaboration in the studio, where every kind of commission was accepted, from religious pictures[128] to history paintings, battle-pieces, and even frescoes (1750s, Cà Rezzonico, Venice).

Only in his later years and, above all, after the death of the elder brother does he seem to have concentrated on the painting of *vedute*, for which he is now mainly famed.

It was his collaboration with Gianantonio that opened up a major problem of criticism. Until fairly recently it was believed that Francesco was the real and only genius in the studio. Now, however, the scales have been reversed and Gianantonio seems to emerge as an equally great figure.[129] If he – as seems likely – and not Francesco was the master of the paintings for the organ in the Chiesa dell'Angelo Raffaele (after 1753) [138], then, indeed, the palm must go to him. In spite of such re-valuation of far-reaching importance and in spite of the seeming shortcomings of Francesco's practices, his work speaks an unmistakable language.

While Canaletto stands in the old tradition of fluid and even application of paint, a tradition which was ultimately concerned with the preservation of form, Guardi stems from the 'modern' masters of the loaded brush, the masters *di tocco*, and the ancestry of his art goes back through Marieschi and Marco Ricci to Magnasco, and further to Maffei, Fetti, and Lys. While Canaletto is primarily concerned with the skilful manipulation of architectural prospects and therefore remains inside the great Italian tradition of firm compositional structure, Guardi drifts more and more towards so free and personal an interpretation of

the material world [139] that its structure appears accidental rather than essential to his dreamlike visions. While Canaletto objectifies even the poetry of Venice, Guardi subjectifies even factual recordings. While the former, in a word, is still a child of the Renaissance tradition in so far as the thing painted is an intrinsic part of the painter's performance, the latter steps outside that tradition in so far as the thing painted seems to have no more than extrinsic value.

But whether it was Gianantonio or Francesco who crowned the pursuits of the masters of the free brush-stroke, it is in their work that solid form is dissolved and dematerialized to an extent undreamed of by any precursor [138]. Between them, the two brothers opened the way to the 'pure' painters *di tocco* of the next century, the Impressionists, who like them thought that form was fleeting and conditioned by the atmosphere that surrounds it.

Thus two masters essentially of the *petite manière* had bro-

ken through the vicious circle of Renaissance ideology and vindicated the development of a free painterly expression which had started with the late Titian, with Tintoretto and Jacopo Bassano, had constantly invigorated Italian Baroque painting at all levels, and had contributed even more to the course painting took in the Low Countries and Spain.

On this note the book might well have ended, were it not for a strange paradox. Francesco Guardi's art has often been compared with the music of Mozart. Despite his modernity, Guardi was a man of his century and, more specifically, a man of the Rococo. He continued creating his spirited capriccios and limpid visions of Venice long after the spectre of a new heroic age had broken in on Europe. When he died in the fourth year of the French Revolution, few may have known or cared that the reactionary backwater of Venice, the meeting place of the ghostlike society of the past, had harboured a great revolutionary of the brush.

List of the Principal Abbreviations Used in the Notes and Bibliography

Archivi	*Archivi d'Italia*
Art Bull.	*The Art Bulletin*
Baglione	G. Baglione, *Le Vite de' pittori, scultori, architetti . . .* Rome, 1642
Bellori	G. P. Bellori, *Le Vite de' pittori, scultori ed architetti moderni.* Rome, 1672
Boll. d'Arte	*Bollettino d'Arte*
Boll. Soc. Piemontese	*Bollettino della Società Piemontese di architettura e delle belle arti*
Bottari	G. Bottari, *Raccolta di lettere.* Milan, 1822
Brauer-Wittkower	H. Brauer and R. Wittkower, *Die Zeichnungen des Gianlorenzo Bernini.* Berlin, 1931
Burl. Mag.	*The Burlington Magazine*
Donati, *Art. Tic.*	U. Donati, *Artisti ticinesi a Roma.* Bellinzona, 1942
G.d.B.A.	*Gazette des Beaux-Arts*
Golzio, *Documenti*	V. Golzio, *Documenti artistici sul seicento nell'archivio Chigi.* Rome, 1939
Haskell, *Patrons*	F. Haskell, *Patrons and Painters: A Study in the Relations between Italian Art and Society in the Age of the Baroque.* London, 1963
Jahrb. Preuss. Kunstslg.	*Jahrbuch der Preussischen Kunstsammlungen*
J.S.A.H.	*Journal of the Society of Architectural Historians*
J.W.C.I.	*Journal of the Warburg and Courtauld Institutes*
Lankheit	K. Lankheit, *Florentinische Barockplastik.* Munich, 1962
Mâle	É. Mâle, *L'art religieux de la fin du XVIe siècle . . .* Paris, 1951
Malvasia	C. C. Malvasia, *Felsina pittrice.* Bologna, 1678
Passeri-Hess	G. B. Passeri, *Vite de' pittori, scultori ed architetti.* Ed. J. Hess. Vienna, 1934
Pastor	L. von Pastor, *Geschichte der Päpste.* Freiburg im Breisgau, 1901 ff.
Pollak, *Kunsttätigkeit*	O. Pollak, *Die Kunsttätigkeit unter Urban VIII.* Vienna, 1927, 1931
Quaderni	*Quaderni dell'Istituto di storia dell'architettura* (Rome)
Rep. f. Kunstw.	*Repertorium für Kunstwissenschaft*
Riv. del R. Ist.	*Rivista del R. Istituto di archeologia e storiadell'arte*
Röm. Jahrb. f. Kunstg.	*Römisches Jahrbuch für Kunstgeschichte*
Titi	F. Titi, *Descrizione delle pitture, sculture e architetture . . . in Roma.* Rome, 1763
Venturi	A. Venturi, *Storia dell'arte italiana.* Milan, 1933 ff.
Voss	H. Voss, *Die Malerei des Barock in Rom.* Berlin, 1924
Waterhouse	E. Waterhouse, *Baroque Painting in Rome.* London, 1937
Wiener Jahrb.	*Wiener Jahrbuch für Kunstgeschichte*
Wittkower, *Bernini*	R. Wittkower, *Gian Lorenzo Bernini.* London, 1955
Zeitschr. f. b. Kunst	*Zeitschrift für bildende Kunst*
Zeitschr. f. Kunstg.	*Zeitschrift für Kunstgeschichte*

Notes

CHAPTER 1

1. For the following see the relevant passages in Pastor, vols 14–16, and in Carl Justi, *Winckelmann und seine Zeitgenossen*, Leipzig, 1898, vols 2 and 3.

2. A. Bertolotti in *Archivio storico artistico . . .* ed. F. Gori, I (1875) and P. G. Hübner, *Le statue di Roma*, Leipzig, 1912, 73.

3. M. Praz in *Magazine of Art*, XXXII (1939), 684.

4. The best recent study of Piranesi is by A. H. Mayor (1952); see Bibliography.

J. Harris ('Le Geay, Piranesi and International Neoclassicism in Rome 1740–1750', *Essays in the History of Architecture presented to R. Wittkower*, London, 1967, 189 ff.) ingeniously reconstructed the Roman career of Jean Laurent Le Geay, who probably had a formative influence on the young Piranesi.

5. R. Wittkower, 'Piranesi's "Parere su l'architettura"', *J.W.C.I.*, II (1938–9), 147.

6. See, above all, H. Tintelnot's remarkable but not always reliable study *Barocktheater und barocke Kunst*, Berlin, 1939.

7. R. Bernheimer in *Art Bull.*, XXXVIII (1956), 239, finds that as early as 1600 in the performance directed by Buontalenti in Florence on the occasion of Maria de' Medici's wedding with Henry IV of France the barriers which separate the stage from the audience had been abolished. Spectators were placed on the stage and 'continued the court into the world of make-believe and thus provided that element of illusion, at which many artists of the Baroque were to try their hand'.

K. Schwager has made some acute observations on the Baroque notion of the theatre, in *Röm. Jahrb. f. Kunstgesch.*, IX–X (1961–2), 379.

8. A. Ademollo, *I teatri di Roma nel secolo decimosettimo*, Rome, 1888, 36.

9. Tintelnot, *op. cit.*, 151, 215 refuses to acknowledge a major influence from the stage on Tiepolo and finds it mainly among such eighteenth-century painters and engravers of *vedute* and ruins as Pannini, Francesco Fontanesi, Luca Carlevarijs, Vittorio Bigari, and others.

10. G. M. Crescimbeni, *L'istoria della basilica . . . di S. Maria in Cosmedin di Roma*, Rome, 1715, 159. For Naldini see above, II: p. 126.

11. Monnot did not accept Maratti's design, nor does it seem that the sculptors of the statues in S. Giovanni in Laterano were delighted (see also p. 55 and III: Chapter 4, Note 9). Although it was not till slightly later that sculptors welcomed the collaboration of painters, it is almost certain that Padre Andrea Pozzo made oil sketches for reliefs on the altar of St Ignatius in the Gesù; see B. Kerber, in *Art Bull.*, XLVII (1965), 499.

12. Titi, ed. 1686, 155. – At the same time C. Fancelli worked from designs of Gio. Francesco Grimaldi in the Palazzo Borghese; see above, II: Chapter 7, Note 40.

13. C. G. Ratti and R. Soprani, *Delle vite de' pittori . . . genovesi*, Genoa, 1769, II, 303.

The almost forgotten Pietro Bianchi, Luti's student in Rome, produced Arcadian Rococo pictures of great charm; see A. M. Clark in *Paragone*, XV (1964), no. 169, 42.

14. B. de Dominici, *Vite de' pittori . . . napoletani*, Naples, 1742–3, 458.

K. Lankheit (70 and *Mitteilungen d. Flor. Inst.*, VIII (1957–9), 48) has shown that Foggini used the help of the painter Anton Domenico Gabbiani in the Corsini Chapel in S. Maria del Carmine, Florence, before 1680.

15. Baumgarten's *Aesthetica* appeared in 1750.

16. *The Connoisseur; an Essay on the whole Art of Criticism . . .*, London, 1719.

17. A. Gabrielli, 'L'Algarotti e la critica d'arte in Italia nel Settecento', *Critica d'Arte*, III (1938), 155, IV (1939), 24. For Algarotti, see also Haskell, *Patrons*, 347 (and index).

CHAPTER 2

1. Juvarra, Fuga, Vanvitelli, Salvi, Raguzzini, Galilei, and Preti.

2. For the concept of stylistic liberty and fast changes of style at this period, see the pertinent remarks by R. Berliner in *Münchner Jarhb. d. bild. Kunst*, IX–X (1958–9), 282.

3. The Palazzo Mezzabarba is the earliest of four interconnected palaces of supreme importance. To the group belong, apart from the Doria-Pamphili, the exactly contemporary façades of the Palazzi Litta at Milan (Note 5) and Montanari at Bologna (p. 390). Veneroni (*c.* 1680–after 1745), almost unknown a few years ago, is emerging as a major figure of North Italian Baroque architecture. A pupil of Giuseppe Quadrio in Milan, he was appointed 'engineer' of

the province of Pavia in 1707. The Borrominesque façade of S. Marco (1735–8) remains, next to the remarkably sophisticated Palazzo Mezzabarba, as a witness to the high quality of Veneroni's architecture at Pavia; see C. Thoenes in *Atti dello VIII convegno nazionale di storia dell'architettura*, Rome, 1956, 179, and S. Colombo in *Commentari*, XIV (1963), 186; also M. G. Albertini, *Considerazioni sull'architettura lodigiana del primo Settecento*, dissertation, Pavia University, 1963–4 (unpublished). For other works by him, see L. Grassi, *Province del Barocco e del Rococò*, Milan, 1966, 443 ff.

Veneroni's Pavia contemporary, Lorenzo Cassani (1687–*c.* 1765), has been studied by A. Casali, *Boll. d'Arte*, LI (1966), 58 ff.; less progressive than Veneroni, Cassani reveals a belated attachment to Ricchino's architecture.

4. The architect of the façade, one of the most original creations of the eighteenth century, seems to be unknown. The staircase hall, too, was later remodelled (by Faustino Rodi, 1780s). It has an oval dome with gallery, through which appears a second ceiling, a design which is probably indebted to Guarini. See G. Mezzanotte, *Architettura neoclassica in Lombardia*, Naples, 1966, 219.

5. Other examples are: *Bologna*: Torreggiani's buildings, see below; *Carpi*: Santuario del SS. Crocifisso; *Cesena*: Madonna del Monte (staircase hall); *Crema*: SS. Trinità by Andrea Nono (1737); *Forli*; Palazzo Reggiani (staircase hall); *Milan*: Palazzo Litta, façade by Bartolomeo Bolli, 1743–60, also interior ('Sala degli Specchi'); *Ravenna*: S. Maria in Porto; *Santa Maria di Sala* (Veneto): Villa Farsetti, the richest French Rococo villa in North Italy, but for the classicizing exterior forty-two columns from the Temple of Concord in Rome were used; *Stra*: Villa 'La Barbariga'.

See also Ferdinando Bibiena's diaphanous vaulting in the choir of S. Antonio at Parma (1714 ff.), in the parish church at Villa Pasquali (1734), and in a chapel of S. Maria Assunta at Sabbioneta. The two latter consist of curvilinear gratings through which the painted blue sky appears. For the church at Villa Pasquali, see D. de Bernardi, *Arte Lombarda*, XI (1966), 51 ff.

For Venice, see p. 7.

6. A. Neppi, 'Aspetti dell'architettura del Settecento a Roma', *Dedalo*, XV (1934), 18–34; M. Loret, 'L'Architetto Raguzzini e il rococò in Roma', *Boll. d'Arte*, XXVII (1933–4), 313–21; *Associazione fra i cultori di architettura*, 'Architettura minore in Italia', Rome [n.d.]; M. Rotili, *Raguzzini*, Rome, 1951, 103.

7. For the following, Wittkower, *Architectural Principles*, 3rd ed., 1962, 144.

8. Schlosser, *Kunstliteratur*, 578. Massimo Petrocchi, *Razionalismo architettonico e razionalismo storiografico*, Rome, 1947.

9. He never wrote himself. His ideas were later published by his admirer Andrea Memmo, *Elementi d'architettura lodoliana*, Venice, 1786, and second ed. 1834. Count Francesco Algarotti (1712–64), the well-known Venetian courtier, writer, and patron of the arts, was one of the first to write about Lodoli's theories (*Saggio sopra l'architettura*, Pisa, 1753). Piranesi, too, the steadfast upholder of the supremacy of Roman architecture, came under Lodoli's influence, as the text of his *Della magnificenza ed architettura de' Romani*, Rome, 1761, reveals. See Wittkower, 'Piranesi's "Parere su l'architettura"', *J.W.C.I.*, II (1938–9), 147.

10. This judgement seems to me correct, although Lodoli attacked, of course, the tenets of classical architecture. Haskell, *Patrons*, 321, underestimates perhaps Lodoli's influence on architects. See also E. Kaufmann Jr, in *Art Bull.*, XLVI (1964), 172.

11. A. Ravà, 'Appartamenti e arredi Veneziani del Settecento', *Dedalo*, I (1920), 452 ff., 730 ff. Rocaille stuccoes, among others, in the Palazzi Barbarigo, Foscarini, Rezzonico (particularly good quality), Vendramin, and the Casino Venier, the latter two published in *Dedalo*.

12. Correct birth-date in Donati, *Art. Tic.*, 263.

13. The frame, probably intended for a relief, was never filled.

14. On this problem, see above, II: p. 112. Fontana's plan dates from 1681. Foundation stone of the church 1689; in 1710 the convent into which the church is incorporated was partly finished. 1738: consecration of the church without the decorations. The latter executed by Spaniards, after that date. O. Schubert, *Gesch. des Barock in Spanien*, Esslingen, 1908, 263; Coudenhove-Erthal, *Carlo Fontana*, Vienna, 1930, 133.

15. Fontana himself was partly responsible for it; see above II: p. 104.

16. E.g., the high pedestals on which the pilasters of the interior stand; further, the gallery above the pilasters and the (admittedly later) statues crowning the pilasters of the drum. Also the open balustrade, on which the pediment of the façade is superimposed, is to be found in the Salute.

17. The most concise assessment of the development of polychromy between the sixteenth and the eighteenth centuries in L. Bruhns, *Die Kunst der Stadt Rom*, Vienna, 1951, 575.

18. Not everybody agreed with his designs. The diarist Valesio calls Fontana's design of the tomb of Queen Christina of Sweden in St Peter's, finished in 1702, 'in extremely poor taste'. He, moreover, talks about the architect as 'the liar Carlo Fontana'. See Scatassa in *Rassegna bibliografica*, XVII (1914), 179 f. For the history of this tomb, see now A. Braham and H. Hager (Bibliography).

19. Further to this problem, Coudenhove-Erthal (in *Festschrift H. Egger*, Graz, 1933, 95), who makes the point that in contrast to Bernini and his generation, Fontana dealt with comprehensive urban projects.

20. Twenty-seven volumes from Fontana's estate were purchased for King George III from Cardinal Albani and are now in the Royal Library at Windsor. When writing his biography of Fontana, Coudenhove-Erthal was unaware of their existence.

21. The painting of the altar with the *Inspiration of S. Cecilia* is also by his hand.

22. On Contini as well as all the members of the Fontana family, see U. Donati, *Art. Tic.*, with further bibliography. See also H. Hager, 'G. B. Contini e la loggia del Paradiso dell'Abbazia di Montecassino', *Commentari*, XXI (1970).

There seems now to be a measure of agreement to attribute the delightful Borrominesque façade of the little church of S. Maria della Neve (S. Andrea in Portogallo) to Francesco Fontana and date it 1707–8; see N. J. Mallory, in *J. Soc. Arch. Hist.*, XXVI (1967), 89.

23. He is, for instance, responsible for the rebuilding of the interesting Palazzo di S. Luigi de' Francesi (1709–12), which foreshadows the Rococo palace in Rome. See also above, II: Chapter 6, Note 32.

For Bizzacheri, see M. Tafuri, in *Diz. Biograf. degli Italiani*, X, 1968.

24. For Specchi, Thomas Ashby and Stephen Welsh in *The Town Planning Review*, XII (1927), 237–48. Specchi illustrated many of Fontana's works and collaborated in works on Roman topography and architecture.

25. Alessandro Bocca, *Il Palazzo del Banco di Roma*, Rome, 1950 (last ed. 1967).

26. But W. Lotz, in *Röm. Jahrb. f. Kunstg.*, XII (1969), has made it likely that Specchi had a formative influence on De Sanctis' final project.

It may also be mentioned that between 1718 and 1720 Specchi skilfully completed the façade of S. Anna de' Palafrenieri, which had been left unfinished in 1575, after Vignola's death; see M. Lewine, in *Art Bull.*, XLVII (1965), 217.

27. This façade shows an interesting development away from Fontana's S. Marcello in the direction of Juvarra's S. Cristina at Turin – but probably without a knowledge of the latter.

28. Teodoli, also Theodoli (1677–1766), philosopher, poet, and architect, three times *principe* of the Academy of St Luke (1734–5, 1742, 1750) and therefore a figure of considerable standing, has to our present knowledge only this one church to his credit. The interior is without special merit, but the exterior with the stepped dome reveals an interesting personality. Nibby ascribes to him the campanile and monastery of S. Maria di Monte Santo (pp. 283 ff.), dated 1765, which is, however, by Cav. F. Navona (see H. Hager, *Röm. Jahrb. f. Kunstg.*, XI (1967–8), 282). Teodoli's contribution to the design of the Teatro Argentina is problematical; see F. Milizia, *Memorie degli architetti*, II, Bassano, 1785, 257.

29. A. Agosteo and A. Pasquini, *Il Palazzo della Consulta*, Rome, 1959.

30. H. Hager, *S. Maria dell'Orazione e Morte* (Chiese di Roma illustrate, 79), Rome, 1964 contains a thoughtful discussion of the church, with new documents.

31. For De Dominicis, a minor architect in the orbit of Raguzzini, see V. Golzio in *L'Urbe* (1938), no. 7, 7 ff.; F. Fasolo in *Quaderni* (1953), no. 4, 1. Also G. Segni – C. Thoenes – L. Mortari, *SS. Celso e Giuliano* (Chiese di Roma illustrate, 88), Rome, 1966.

32. Neo-Cinquecentesque, not without dignity, but astonishingly tame for the architect of S. Giovanni in Laterano. Documents for the façade published by V. Moschini in *Roma*, III (1925), no. 6.

33. Sardi (*c.* 1680–1753, not to be mixed up with the Venetian architect of the same name, *c.* 1621–99) often acted as clerk of the works to other architects. The complicated history of S. Maria Maddalena, to which G. A. Rossi and Carlo Quadrio contributed, has been cleared up by V. Golzio in *Dedalo*, XII (1932), 58, but the façade still presents a puzzle. It is usually attributed to Sardi; it was, however, built by Carlo Giulio Quadrio between 1697 and 1699 and only the facing and the extravagant stucco decoration date from 1735. N. A. Mallory (see Bibliography under Sardi) argued rather convincingly that there are no indications in Sardi's documented work that would favour an attribution of Rococo frames and rich floral decoration to him. By contrast, P. Portoghesi (*Roma barocca*, Rome, 1966, 348) eloquently advocates Sardi's authorship. Even the richly and elegantly decorated church of the SS. Rosario at Marino near Rome, the attribution of which to Sardi is supported by contemporary tradition (see S. Benedetti, in *Quaderni*, XII, 67–70 (1965), 7 ff.), has nothing in common with the Rococo decoration of S. Maria Maddalena.

34. Derizet (1697–1768), born at Lyons, came to Rome as a student of the French Academy (1723) and stayed there until his death. See A. Martini–M.

L. Casanova, *SS. Nome di Maria* (Chiese di Roma illustrate, 70), Rome, 1962, 23 (with documents). A paper on Derizet by W. Oechslin is about to appear in *Quaderni*.

35. The architect was a Portuguese who had made Rome his home as early as 1728 (Lidia Bianchi, *Disegni di Ferdinando Fuga*, Rome, 1955, 110) and was still there in 1772. Sardi acted as his clerk of works at SS. Trinità. M. Tafuri, in *Quaderni*, XI, 61 (1964), 1 ff., gives the history of the church and monastery from documents and the drawings preserved in the Archivio di Stato.

36. Ameli's design is graceful, but infinitely less powerful and original than Valvassori's.

37. V. Golzio in *L'Urbe* (1938), no. 7, 7 ff. On P. Passalacqua from Messina, see M. Accascina in *Archivio storico messinese*, L–LI (1949–50).

38. The material assembled by R. Berliner in *Münchner Jahrb. f. bild. Kunst*, IX–X (1958–9), 302 ff., shows that both beginning and end of the building are difficult to determine. The dates given in the text are approximations. According to J. Gaus (*Marchionni*, 1967, 23, 25, see Bibliography) the planning began in 1748 and the villa was completed in 1762.

39. Mario Rotili, *Filippo Raguzzini e il rococò romano*, Rome, 1951, with further literature.

40. M. Loret in *Illustrazione Vaticana*, IV (1933), 303, and A. Rava in *Capitolium*, X (1934), 385–98. See also F. Fasolo, *Le chiese di Roma nel '700*, Rome, 1949, 70.

41. Ilaria Toesca in *English Miscellany*, III (1952), 189–220.

42. Guglielmo Matthiae, *Ferdinando Fuga e la sua opera romana*, Rome, 1951; L. Bianchi's *Catalogue* (see Note 35); R. Pane, *F. Fuga*, Naples, 1956.

43. For its history, see mainly E. Hempel in *Festschrift H. Woelfflin*, Munich, 1924, 283 ff.; C. Bandini in *Capitolium*, VII (1931), 327; P. Pecchiai, *La scalinata di piazza di Spagna*, Rome, 1941; and the exhaustive paper by W. Lotz (quoted above, Note 26).

44. Raguzzini's undulating façade of S. Maria della Quercia reveals the same spirit; see A. Martini, *S. Maria della Quercia* (Chiese di Roma illustrate, 67), Rome, 1961.

45. Clement XII arranged a competition in 1732. Sixteen designs were exhibited in the Quirinal and Salvi's was chosen. After the latter's death, Giuseppe Pannini was appointed architect of the fountain (1752). The major change he introduced is the three formal basins under Neptune.

The literature on the Fontana Trevi is vast. The most recent studies by Armando Schiavo (*La Fontana di Trevi e le altre opere di Nicola Salvi*, Rome, 1956) and H. Lester Cooke, Jr (*Art Bull.*, XXXVIII (1956)) are fuller than any previous treatment without, however, presenting the entire material on the history of the fountain. In addition, Cooke's article should be used with caution. See also C. d'Onofrio, *Le Fontane di Roma*, 1957, 225–62, with some new material, but also unacceptable assertions and attributions.

46. The history of this most important event has not yet been fully reconstructed. For information see F. Cerroti, *Lettere e memorie autografe*, Rome, 1860; A. Prandi, 'Antonio Derizet e il concorso per la facciata di S. Giovanni in Laterano', *Roma*, XXII (1944), 23; Rotili, *Raguzzini* (Note 39); L. Bianchi's *Catalogue* (Note 35); A. Schiavo, *op. cit.* (Note 45), 37, and *idem*, 'Il Concorso per la facciata di S. Giovanni in Laterano e il parere della Congregazione', *Bollettino dell'Unione Storia ed Arte*, Rome, May–June 1959, 3. V. Golzio has published Galilei's own memorandum about his design in *Miscellanea Bibl. Hertzianae*, 1961, 450. See also the New York University M.A. thesis by Virginia Schendler (summary in *Marsyas*, XIV (1968–9), 78).

Only seventeen of the twenty-three competitors are mentioned in the literature, amongst them the Bolognese Ferdinando Galli Bibiena and C. F. Dotti, the Venetian Domenico Rossi, the Sienese Lelio Cosatti, and the Neapolitan L. Vanvitelli. Two other competitors, overlooked by all those who have written about this matter, were Pietro Carattoli (1703–60) from Perugia, the architect of the Palazzo Antinori (Gallenga Stuart, 1748–58), the most impressive Baroque palace of his native city; and Bernardo Vittone from Turin (see his *Istruzioni elementari*, Lugano, 1760, 443 and plate 74). Another competitor, rediscovered by H. Hager, was Ludovico Rusconi Sassi (1678–1736), about whom see Donati, *Art. Tic.*, 393.

47. It was not until January 1726 that Galilei, then in Florence, was advised from London that 'the reigning taste is Palladio's style of building', a fact of which he was obviously unaware. See I. Toesca, *op. cit.*, 220.

Just before leaving London in 1719, Galilei may have designed Castletown, Co. Kildare, near Dublin in a vaguely Palladian manner; see M. Craig and the Knight of Glyn, in *Country Life*, CXLV (27 March 1969), 722 ff.

48. Marchionni's second great work is the well-known Sacristy of St Peter's (1776–87). New documents in the important paper by Berliner (Note 38, 368, 395), who published the extensive *œuvre* of drawings for a great variety of purposes by Carlo (1702–86) and his son Filippo (1732–1805). For the Sacristy of St Peter's also H. Hager, *Juvarra*, 1970, 49 (see Bibliography), and the extensive chapter in Gaus's book on Marchionni (Bibliography), 67 ff.

49. W. Körte, 'Piranesi als praktischer Architekt', *Zeitschr. f. Kunstg.*, II (1933), 16–33. Wittkower in *Piranesi*, Smith College Museum of Art,

Northampton, Mass., 1961, 99, has reconstructed the history of Piranesi's S. Maria del Priorato on the Aventine (1764–6) from documents and original drawings.

The mediocre Alessandro Dori, architect of the Palazzo Rondanini (c. 1760; see L. Salerno, in *Via del Corso*, 1961, 124), indicates the relatively low standard of Roman architecture at this moment.

50. For the history of Venetian Baroque architecture see E. Bassi's basic work (1962). For the survival and transformation of the Palladian tradition, see Wittkower in *Barocco europeo e Barocco veneziano*, Florence, 1962, 77, and *Bollettino del Centro Internaz. di Studi di Architettura*, V (1964).

51. S. Moisè is early, 1668. The undifferentiated Late Baroque quality ensues from the profusion of Meyring's ('Arrigo Merengo's') later sculptural decoration rather than from the structural pattern, which is basically Palladian.

For Tremignon, see C. Semenzato in *Atti della Accademia Patavina di scienze, lettere ed arti*, N.S. LXIV (1952), and G. B. Alvarez in *Boll. del Museo Civico di Padova*, L (1961), 59.

52. The entire interior of the Chiesa dei Gesuiti is spun over with inlaid marble imitating tapestry. The high altar is by Andrea Pozzo's brother, Jacopo Antonio (1645–1725), a specialist in altar designs, whose importance has only recently been discovered; see F. Pilo Casagrande in *Palladio*, VIII (1958), 78. The façade, closely set with free-standing columns, is Rossi's largest work. His earlier façade of S. Stae (1709) is more interesting, for its structure is based on an unorthodox handling of Palladio's interpenetration of a large and a small order.

53. Yet a comparison of Tirali's Valier with Longhena's Pesaro monument of 1669 in the Frari shows that the classical element of the column has been given new weight, while the statues, the principal feature of the Pesaro, are disproportionately small.

The principal source for Tirali's life is Temanza's *Zibaldon*, ed. N. Ivanoff, Venice–Rome, 1963, 17.

54. For Palladio's project, see W. Timofiewitsch in *Arte Veneta*, XIII–XIV (1959–60), 79.

55. D. Lewis, 'Notes on XVIII Century Venetian Architecture', *Boll. dei Musei Civici Veneziani*, XII (1967), no. 3, has given rather convincing arguments in favour of this late date in preference to the previously accepted dating of 1700.

56. E. Bassi's chapter (Note 50) on Massari supersedes the studies by V. Moschini in *Dedalo*, XII (1932), 198–229, and C. Semenzato in *Arte Veneta*, XI (1957), I.

56a. G. Fiocco, in *Saggi e Memorie di storia dell'arte*, VI (1968), 118 ff., attributes the painted architecture to Francesco Zanchi, the chiaroscuri to Michelangelo Morlaiter, and the figures to Giacomo Antonio Ceruti.

57. Massari's chief assistant, Bernardo Maccaruzzi (c. 1728–1800), the architect of S. Giovanni Evangelista in Venice (c. 1755–9) and of the Cathedral at Cividale (1767 ff.), deserves mention; see D. Lewis (above, Note 55), I ff.

58. We may add the name of Andrea Cominelli, who enlarged the Palazzo Labia before 1703 (E. Bassi, *Architettura . . . a Venezia*, 1962 (see Bibliography), 236 ff., and that of the priest Carlo Corbellini from Brescia, who in the large church of S. Geremia (1753–60) returned to a classicizing Greek-cross type with additional satellite chapels at the west. His use of a giant order of half-columns all round the interior is in the tradition coming down from Palladio, but the type as such belongs to the eighteenth-century revival of similar late sixteenth-century churches (I: p. 81). The strong Baroque façade of Corbellini's S. Lorenzo Martire at Brescia (1751–63) also contains neo-cinquecentesque elements.

For the continuity of the Palladian tradition in Venice, see R. Wittkower, in *Boll. del Centro Internaz. di Studi di Architettura*, V (1964), 61 ff.

59. For the carefully calculated system of proportion (p. 7), see Cicognara–Diedo–Selva, *Le fabbriche e i monumenti cospicui di Venezia*, Venice, 1858, II, 95. D. Lewis (above, Note 55), 40, emphasized the reliance of SS. Simeone e Giuda on Palladio's Tempietto at Maser.

60. D. Lewis, *op. cit.*, has skilfully reconstructed the small but important œuvre of M. Lucchesi. – For Temanza's life, see Ivanoff's Introduction to T. Temanza, *Zibaldon* (Note 53). Temanza or, more likely, his uncle Scalfarotto was the teacher of Giovanni Battista Novello, the architect of the mid-eighteenth-century Palazzo Papafava at Padua, which displays surprising originality; A. Rowan, *Burl. Mag.*, CVIII (1966), 184 ff.

61. Fausto Franco, 'La scuola architettonica di Vicenza', *I Monumenti Italiani*, III (1934), and *idem*, 'La scuola Scamozziana "di stile severo" a Vicenza', *Palladio*, I (1937), 59 ff.

For the continuity of Scamozzi's classical formulas at Vicenza, see, e.g., Pizzócaro's Istituto dei Proti and Palazzo Piovini-Beltrame, both 1658, and his masterpiece, the Villa Ghellini Dall'Olmo at Villaverla (1664–79; for Pizzócaro, see L. Puppi in *Prospettive*, no. 23 (1960–1), 42, and R. Cevese in *Boll. del Centro Internaz. di Studi di Architettura*, IV (1962), 135), and Carlo Borella's Palazzo Barbieri-Piovene (1676–80), also attributed to Tremignon and Giacomo Borella. Carlo Borella, the architect of the Sanctuary on Monte Berico (1688–1703), was not averse to using a certain amount of Baroque para-

phernalia. But the Chiesa dell' Araceli (began in 1675), always attributed to him, was based on a design by Guarini; see P. Portoghesi in *Critica d'Arte*, no. 20 (1957), 108 and no. 21, 214. For Borella, see Cevese, *op. cit.*, 140.

62. Francesco Muttoni (see F. Franco, *ibid.*, 147), the tireless builder of villas (Villa Fracanzan, Comune di Orgiano, 1710; 'La Favorita' at Monticello di Fara, 1714–15; Villa Valmarana at Altavilla Vicentina, 1724; etc.), is famed for his creations in a mildly Baroque taste: principal example, his well known Palazzo Repeta at Vicenza (now Banca d'Italia, 1701–11) with a large scenic staircase. Yet he never denied his Palladian derivation (see F. Barbieri in *Quaderni*, VI–VIII (1961), 287; also M. Tafuri, 'Il parco della Villa Trissino a Trissino e l'opera di Francesco Muttoni', in *L'Architettura, cronache e storia*, X, no. 114 (1965), 832 ff.). It is interesting for the rise of Palladianism in England that he maintained close contact with Lord Burlington.

The Villa Cordellina at Montecchio Maggiore, previously attributed to Muttoni, is by Massari (1735), see C. Semenzato in *Arte Veneta*, XI (1957), 6; see also *Connoisseur*, CXL (1957), 151.

63. F. Barbieri in *Arte Veneta*, VII (1953), 63. Also R. Cevese, 'Palladianità di Ottone Calderari', in *Odeo Olimpico*, V (1964–5), 45 ff.

For a survey of Baroque architecture at Verona, Padua, Treviso, and Bassano, see the papers by P. Gazzola, G. M. Pio, M. T. Pavan, and C. Semenzato in *Boll. del Centro Internaz. di Studi di Architettura*, IV (1962).

For the Veronese Neo-classicist Alessandro Pompei, see Semenzato, *Arte Veneta*, XV (1961), 192.

64. See *Le ville venete*. Catalogo a cura di Giuseppe Mazzotti (many collaborators), Treviso, 1954, with full bibliography.

65. Giovanni Ziborghi who is otherwise unknown signed as architect of the Villa Manin (1738). The monograph by C. Grassi, *La Villa Manin di Passariano*, Udine, 1961, is disappointing. See also A. Rizzi in *Boll. Ufficiale della Camera di Commercio, Industria . . . di Udine* (March 1964), 3–10.

The Villa Pisani is usually incorrectly attributed to Girolamo Frigimelica. M. Favaro-Fabris, *L'architetto F. M. Preti*, Treviso, 1954, has proved that Preti's design was executed. It must, however, be pointed out that this work is of infinitely higher quality than the unusually dry Palladian buildings of the architect from Castelfranco (1701–74).

Frigimelica (1653–1732), who worked in his native Padua (S. Maria del Pianto, 1718–26), at Rovigo, Modena, Vicenza, Stra, etc., would deserve more attention. See Bibliography.

66. Fogolari in *L'Arte*, XVI (1913), 401–18. See also now the book by A. M. Matteucci, 1969 (Bibliography under Bologna).

67. See *Commune di Bologna*, XI (1933), 69.

68. See the Palazzo of the Credito Italiano (Via Monte Grappa 5), 1770; the Casa del Linificio Nazionale (formerly Palazzo Ghisilieri); and the Palazzo Scagliarini (Via Riva di Reno 77), 1796, where the entrance, the courtyards, and the staircase form a picturesque ensemble. In Angelo Venturoli's (1749–1821) staircase of the Palazzo Hercolani (Via Mazzini 45) of 1792 the Baroque tradition is also continued without a break.

69. See, e.g., Tommaso Mattei's mid-eighteenth-century staircase of the Palazzo Arcivescovile at Ferrara or G. F. Buonamici's grand staircase of the Palazzo Baronio (now Rasponi Bonanzi) at Ravenna (the palace was built by Domenico Barbiani, 1744). The Palazzo Albergoni at Crema has a superb eighteenth-century staircase on the pattern of Longhena's staircase in S. Giorgio Maggiore.

70. C. Ricci, *I teatri di Bologna*, Bologna, 1888, 176 ff.

71. For a fuller survey, see P. Mezzanotte's chapters in *Storia di Milano*, 1958, XI, 441; and 1959, XII, 659.

72. For Merli or Merlo, see now the excellent monograph by M. L. Gatti Perer (Bibliography).

73. The contemporary tradition as to Ruggeri's place of birth is ambiguous, but he was born in Rome rather than Milan; see G. Mezzanotte, 'G. R. e le ville di delizia lombarde', *Boll. Centro Internaz. Studi di Archit.*, XI (1969), 243.

The façade of the Palazzo Litta is often wrongly attributed to Ruggeri, who is the architect of the splendid Villa Alari-Visconti at Cernusco. His pupil Giacomo Muttone (1662–1742) built the well-known Villa Belgioioso (now Trivulzio) at Merate. Among the minor Milanese practitioners may be mentioned Federico Pietrasanta (1656–c. 1708, see M. L. Gengaro in *Riv. d'Arte*, XX (1938), 89), Francesco Croce (Gengaro in *Boll. d'Arte*, XXX (1936), 383), Giovan Battista Quadrio and his pupil, Bernardo Maria Quarantini (1679–1755); see M. L. Gatti Perer in *Arte Lombarda*, VIII (1963), 161, and XI (1966), 43 ff.

Lodi had Late Baroque architects in Michele and Pier Giacomo Sartorio, and Bergamo in Achille and Marco Alessandri. For other names, see L. Angelini, 'Architettura settecentesca a Bergamo', *Atti dello VIII convegno nazionale di storia dell'architettura*, Rome, 1956, 159.

Giuseppe Antonio Torri's (1655–1713) S. Domenico at Modena (1708–31) is a remarkable centralized building. The façade is an interesting version of the aedicule façade, consisting of a closely set colossal order of pilasters applied to a red-brick wall.

Brescia had native Baroque architects in Antonio Turbini and his son Gaspare and in Giovan Battista Marchetti and his son Antonio (1724–91). The latter built the Palazzo Gambara (now Seminario Vescovile) and the Palazzo Soncini (1760s), both with impressive staircase halls, and the Villa Negroboni, now Feltrinelli, at Gerolanuova (1772–92) in an international Baroque style; see G. Cappelletto in *Arte Lombarda*, III (1958), 51.

74. For Piermarini and other neo-classical Lombard architects and their revealing connexions with the earlier eighteenth-century manner, see G. Mezzanotte, *Architettura neoclassica in Lombardia*, Naples, 1966.

75. M. Labò, 'Studi di architettura Genovese', *L'Arte*, XXIV (1921), 139–51, repeats the traditional attribution of the palace to Pier Antonio Corradi. C. Marcenaro in *Paragone*, XII (1961), no. 139, 24, has corrected the attribution on the basis of documents. The splendid pictorial decoration of the palace by Gregorio de Ferrari, Giovan Andrea Carlone, Bartolomeo Guidobono, and others began in 1679.

76. See, among others, rooms in the Palazzo Durazzo (formerly Reale), which – according to tradition – was given its final shape towards the garden from designs by Carlo Fontana (1705); further rooms in the Palazzi Granello (Piazza Giustiniani) and Saluzzo (Via Albaro) and, above all, in the Palazzo Balbi Cattaneo (Via Balbi).

77. According to Soprani, *Vite*, II, 271, De Ferrari's last work, executed shortly before his death in 1744 at the age of 64. There is now a satisfactory monograph by E. Gavazza on L. de Ferrari (see Bibliography).

78. Hugh Honour, 'The Palazzo Corsini, Florence', *Connoisseur*, CXXXVIII (1956), 160.

79. For the early history of S. Firenze, above p. 246. The church itself was built by Pier Francesco Silvani after 1668, and not by Ferri, as is usually said. See Paatz, *Kirchen von Florenz*, II, 115.

80. Buontalenti influence is also to be found in the work of Ignazio Pellegrini (1715–90), who was born in Verona but practised in Florence between 1753 and 1776; see R. Chiarelli in *Riv. d'Arte*, XXXI (1958), 157; also *idem*, *Architetture fiorentine e toscane di I.P. (1715–1790)*, 1966, and *Architetture pisane di I.P. nei disegni dell'archivio Pellegrini di Verona*, Università di Pisa, 1966.

81. Begun in 1738 by Giovanni Antonio Medrano with the assistance of Antonio Canevari (1681–c. 1750), and not yet finished in 1759. Medrano also built the theatre of S. Carlo (1737) to which later Fuga and G. M. Bibiena contributed. It was destroyed by fire in 1816. See A. Venditti, *Architettura neoclassica a Napoli*, Naples, 1961, 237.

For the following see mainly R. Pane, *Architettura dell'età barocca in Napoli*, Naples, 1939, and *idem*, *Napoli imprevista*, Turin, 1949; also Bibliography.

82. R. Mormone, 'D. A. Vaccaro architetto', *Napoli Nobilissima*, I (1961–2), 135.

83. He was responsible in 1701 for the funeral decorations for King Charles II in the Cappella del Tesoro; in 1702 for the festival decorations on the occasion of Philip V's visit to Naples; in 1731 for the funeral decorations of the Duke Gaetano Argento; in 1734 he designed the festival decorations for the entry into Naples of the new King, Charles III, in 1738 those for the king's wedding, etc.

84. Other churches by him: Chiesa delle Crocelle; S. Maria succurre miseris; façade of S. Lorenzo, 1743; chiostro, monastery of Donnaregina together with the restoration and enlargement of the church and monastery, etc.

85. Further on his staircases, Pane, *op. cit.*, 182 ff. Illustration 26 after Pane, 187, illustrates the double staircase in the palace in Via Foria 234. (This address given by Pane is no longer correct.) The charming staircase of the Palazzo Fernandez, attributed to Nauclerio, follows the type shown in illustration 25.

86. By Sir Anthony Blunt in lectures given at the Courtauld Institute. Fuga's staircase of the Palazzo della Consulta (p. 13), unique in Rome, derives from staircases by Sanfelice (see Pane, *Fuga* (Note 42), 41) – thus an Austrian conception makes its entry into Rome via Naples.

87. See mainly L. Vanvitelli Jr, *Vita dell'architetto L. Vanvitelli*, Naples, 1823; F. Fichera, *Luigi Vanvitelli*, Rome, 1937, with further literature. On Vanvitelli's work at Ancona, L. Serra in *Dedalo*, X (1929). The eighth Congress of the History of Architecture was to a large extent devoted to Vanvitelli; see *Atti dello VIII convegno nazionale di storia dell'architettura*, Rome, 1956, with many valuable contributions.

88. G. Chierici, *La Regia di Caserta*, Rome, 1937; F. de Filippis, *Caserta e la sua reggia*, Naples, 1954 (also the same author's *Il Palazzo Reale di Caserta e i Borboni di Napoli*, Naples, 1968); Marcello Fagiolo-Dell'Arco, *Funzioni simboli valori della Reggia di Caserta*, Rome, 1963, with full bibliography. The foundation stone of Caserta was laid on 20 January 1752; between 1759 and 1764 interrupted; after Luigi's death in 1773 the work was continued by his son, Carlo. The exterior was finished in 1774, not entirely in accordance with Luigi's plans. E. Rufini, 'L'importanza di un epistolario inedito di L. Vanvitelli', in *Studi in memoria di G. Chierici*, Rome, 1965, 281 ff., reports an extensive find (in the Archive of S. Giovanni de' Fiorentini, Rome) of letters which Vanvitelli addressed to his brother Don Urbano between 1751 and 1768, written from Caserta and to a large extent concerned with the building of the castle.

89. But the differences are not negligible; see Fichera, *op. cit.*, 42.

90. Fagiolo-Dell'Arco, *op. cit.*, 46, wants to derive the Caserta octagons from Early Christian or Byzantine sources (precisely what I have claimed for S. Maria della Salute) and, without supporting his argument, refuses to accept the obvious: the direct impact of the Salute, a building well known to Vanvitelli.

91. It is noteworthy not only that Vanvitelli in this church made use of Borrominesque detail but that he fashioned the design of the dome after Cortona's SS. Martina e Luca. In keeping with his rationalism, however, he did not superimpose the ribs of the vault upon the coffers and gave the latter a severely geometrical octagonal star-form.

92. For Neapolitan architecture of the second half of the eighteenth century, see A. Venditti, *Architettura neoclassica a Napoli*, Naples, 1961, 51 and *passim*.

93. Work on Apulian architecture of the seventeenth and eighteenth centuries is in its beginnings. The older book by M. S. Briggs, *In the Heel of Italy*, London, 1910, is still useful. In his article in *Commentari*, V (1954), 316, M. Calvesi applies historical methods to the investigation of the architecture of Lecce for the first time. M. Calvesi and M. Manieri-Elia, *Architettura barocca a Lecce . . .*, 1971, replaces the previous literature on the subject.

Interesting contributions by G. Bresciani Alvarez, M. Calvesi, and M. Manieri-Elia appeared in the *Atti del IX Congresso Nazionale di storia dell'architettura*, Rome, 1959, 155, 177, 189. These authors turn against the legend of the Spanish influence and emphasize the importance of Naples and Sicily for Apulia.

94. For the literature see Bibliography, section SICILY.

95. The Quattro Canti are traditionally attributed to the Roman (?) Giulio Lasso, 1608; Mariano Smiriglio directed the work in 1617 and Giovanni de Avanzato in 1621; see F. Meli, *Arch. Stor. per la Sicilia*, IV–V (1938–9), 318. For Smiriglio, *ibid.*, 354; G. B. Commandè in *Atti del VII Congresso Naz. di storia dell'arch.*, Palermo, 1956, 307.

96. Many features of this palace derive from the stock of Mannerist motifs, but the balcony surrounding the entire structure and the large supporting brackets superimposed on the triglyphs of the entablature underneath are typically Sicilian.

For Vermexio, see E. Mauceri, *Giovanni Vermexio*, Syracuse, 1928; G. Agnello, 'Il tempio vermexiano di S. Lucia a Siracusa', *Arch. Stor. per la Sicilia orientale*, VII (1954), 153; and *idem*, *I Vermexio*, Florence, 1959 (also A. Blunt's review in *Burl. Mag.*, CII (1960), 124).

97. I have been unable to find out whether the book by V. Grazia Pezzini, *Giacomo Amato e l'architettura barocca a Palermo*, announced in 1961, has ever appeared. L. Biagi's 'Giacomo Amati e la sua posizione nell'architettura palermitana', *L'Arte*, XLII (1939), 29, gives less than the title promises. Documentary material for Paolo and Giacomo Amato in Meli, *op. cit.*, 359, 367. Paolo Amato's *La nuova pratica della prospettiva* (Palermo, 1736), published posthumously by his friend Giuseppe de Miteli, is prefaced by a life of the architect (presumably written by De Miteli) which includes a list of works with dates.

Giuseppe Mariani from Pistoia (1681–1731), probably Giacomo Amato's pupil, whose work has a Borrominesque flavour, became court architect in Palermo in 1722; see V. Scuderi in *Commentari*, XI (1960), 260.

98. A. Chastel in *Revue des sciences humaines*, fasc. 55–6 (1949), 202.

99. E. Calandra, *Breve storia dell'architettura in Sicilia*, Bari, 1938, 134, reports nineteenth-century alterations to this façade. The only monographic treatment of G. B. Amico is by V. Scuderi, *Palladio*, XI (1961), 56 (with chronological work catalogue). G. B. Comandè (in *Quaderni*, XII, 67–70 (1965), 33 ff.) published a summary of Amico's rare book *L'Architetto pratico* of 1726.

100. For these villas, see the fine study by V. Ziino, *Contributi allo studio dell'architettura del 700 in Sicilia*, Palermo, 1950. For the correct dating of the Villa Valguarnera, see V. Ziino in *Atti* (see Note 95), 329.

101. Monstrosities always exercise a particular fascination and, therefore, more has been written about this villa than about any other Sicilian monument. The most recent book on the subject is by K. Lohmeyer, *Palagonisches Barock*, Frankfurt, 1943; see also Brassaï in *G.d.B.A.*, LXI (1960), 351, and G. Levitine, *ibid.*, LXIII (1964), 13, with further references.

102. Later, Maria Carolina, Maria Theresa's daughter, became the Queen of Bourbon Naples, and her daughter, Maria Theresa, Princess of Naples and Sicily, married the Hapsburg Emperor Francis II.

103. See above, II: Chapter 6, Note 9. For Picherali, see G. Agnelli in *Arch. stor. per la Sicilia*, II–III (1936–7), VI (1939), and series III, vol. II (1947), 281. For Luciano Alì, the architect of the remarkable Palazzo Beneventano at Syracuse (1779), see S. L. Agnello in *Atti dello VIII convegno nazionale di storia dell'architettura*, Rome, 1956, 213.

104. O. Sitwell, 'Noto, a Baroque City', *Architectural Review*, LXXVI (1934), 129; N. Pisani, *Noto, la Città d'Oro*, ed. Ciranna, 1953; J.-J. Ide in *Journal R.I.B.A.*, LXVI (1958), II; F. Popelier in *G.d.B.A.*, LIX (1962), 81. S. Bottari in *Palladio*, VIII (1958), 69, is mainly concerned with Gagliardi's work.

Gagliardi's and other Sicilian architects' church façades with high central tower are un-Italian and point once again to Austrian prototypes. To this class belong Gagliardi's Cathedral and S. Giuseppe at Ragusa and S. Giorgio at Modica.

105. F. Fichera, *G. B. Vaccarini e l'architettura del Settecento in Sicilia*, Rome, 1934.

106. The Benedictine monastery has a long and complicated building history for which see Fichera, *op. cit.*, 80, 143, etc. The main contributors were Antonino Amato and his sons Lorenzo and Andrea (until 1735), Francesco Battaglia (1747–56), Giuseppe Palazzotto (until 1763), and Stefano Ittar (1768).

CHAPTER 3

1. For Vittozzi, see Bibliography. On the Castellamonte see C. Boggio, *Gli architetti Carlo ed Amedeo di Castellamonte*, Turin, 1896, and G. Brino (and others), *L'opera di Carlo e Amedeo di Castellamonte*, Turin, 1966. Buildings by Amedeo: S. Salvario in via Nizza (1646–53), Chiesa di Lucento (1654), S. Martiniano (1678, destroyed), Palazzo della Curia Maxima (1672), Hospital of S. Giovanni (now containing also collections of the University, begun 1680), and, above all, the Palazzo Reale, begun in 1646. The architect and engraver Giovenale Boetto (1640–c. 1678) reveals close links with Vittozzi and Carlo di Castellamonte in his buildings in Piedmont; see monograph by N. Carboneri-A. Griseri (Bibliography) see N. Carboneri, A. Griseri, *Giovenale Boetto*, Fossano (Cassa di Risparmio), 1966.

2. His most important buildings: the extensive Palazzo di Città (1659–63), enlarged by Alfieri; see E. Olivero in *Torino*, V (1927), 373 ff.), Chiesa della Visitazione (1661, façade 1765), S. Rocco (1667–91, façade 1890), SS. Maurizio e Lazzaro (1679 dome and façade 1835), the latter church according to Olivero by Lanfranchi's son, Carlo Emanuele. All these churches are centralized buildings, S. Rocco and SS. Maurizio e Lazzaro with impressive use of free-standing columns. For Lanfranchi, see A. Cavallari-Murat in *Boll. Soc. Piemontese di archeologia e di belle arti*, XIV–XV (1960–1), 47–82.

3. For the whole question of Turin's urban development, see P. Gribaudi, 'Lo sviluppo edilizio di Torino dall'epoca romana ai giorni nostri', *Torino*, XI (1933), no. 8; also M. Passanti, 'Le trasformazioni barocche entro l'area della Torino antica', *Atti del X Congresso di storia dell'architettura*, Rome, 1959, 69–100.

4. Further for seventeenth-century Piedmontese architecture: A. E. Brinckmann, *Theatrum Novum Pedemontii*, Düsseldorf, 1931; A. Ressa, 'L'architettura religiosa in Piemonte nei secoli XVII e XVIII)', *Torino*, XIX (1941); M. Passanti, *Architettura in Piemonte*, Turin, 1945. On the richly decorated Castello del Valentino, the planning of which is essentially French, see the monograph by Cognasso, Bernardi, Brinckmann, Brizio, and Viale, Turin, 1949. On the Baroque architecture at Carignano near Turin, see G. Rodolfo, in *Atti del IIº congresso della Società Piemontese di Archeologia e Belle Arti* (A cura della R. Deput. subalpina di storia patria), Turin, 1937, 130–86. See also Bibliography, III.

5. Apart from P. Portoghesi's monography on Guarini (Milan, 1956), which is useful in spite of the brief text, see T. Sandonnini, 'Il Padre Guarino Guarini', *Atti e mem. R. Deput. di storia patria . . . provincie modenesi e parmensi*, ser. 3, V (1888), 483; E. Olivero, 'La vita e l'arte del P. Guarino Guarini', in *Il Duomo di Torino*, II, no. 5 (1928); W. Hager in *Miscellanea Bibl. Hertzianae*, 1961, 418; M. Passanti, *Nel mondo magico di Guarino Guarini*, Turin, 1963 (an architect's study who follows up the genesis of Guarini's motifs). The pedestrian dissertation by M. Anderegg-Tille, *Die Schule Guarinis*, Winterthur, 1962, contains little information of interest. For the enormous increase of Guarini studies in recent years the reader is referred to the Bibliography.

6. T. Sandonnini, *op. cit.*, 489, and Portoghesi, *op. cit.*

7. On Guarini's writings, E. Olivero in *Il Duomo di Torino*, II, no. 6 (1928).

8. M. Accascina in *Boll. d'Arte*, XLI (1956), 48, published an old photograph of the façade of the Annunziata; see also W. Hager, 'Guarinis Theatinerfassade in Messina' in *Das Werk des Künstlers. Hubert Schrade zum 60. Geburtstag dargebracht*, Stuttgart, 1960, 230. The picturesque façade of S. Gregorio, destroyed in 1908, is often illustrated as a characteristic example of Guarini's style. But documents prove (Accascina, *ibid.*, XLII (1957), 153) that the façade was not finished until 1743. The strange campanile 'a lumaca' was finished in 1717, M. Accascina suggests from a design by Juvarra; this does not seem convincing.

9. Portoghesi, *op. cit.*, wants to date the design about 1670, and Hager (last Note), 232, follows Portoghesi's late dating. There seems to be a general inclination to favour the late date.

10. L. Hautecœur, *Histoire de l'architecture classique en France*, II, Paris, 1948, 245, with further literature. The history of the church has now been clarified by D. R. Coffin in *Journal of the Society of Architectural Historians*, XV (1956), no. 2.

11. The correspondence with similar devices used by François Mansart at an earlier date (A. Blunt, *Art and Architecture in France*, 148; P. Smith, *Burl. Mag.*, CVI (1964), 114, figure 20, suggests that Mansart had devised a cut-off dome design for the Val de Grâce as early as 1645) is striking. There seems to have been an interesting give and take between Guarini and the French. While Guarini's truncated dome of Sainte-Anne-la-Royale (1662) was in all likelihood

developed from Mansart's staircase at Blois, the latter in turn followed Guarini's version of Sainte-Anne for the design of the Bourbon Chapel at Saint-Denis (1665). In his church of the Invalides (1679 ff.), J. Hardouin-Mansart used the same type of dome, but adjusted the curve of the second vault, which he closed in the centre (instead of opening it into a lantern). Once again Guarini incorporated this latest version into his project for S. Gaetano at Vicenza (last period).

12. The pagoda-like build-up, for which precedents exist in Northern Italy (I: p. 87), was often used by Guarini and developed much further than ever before. The most advanced example: his design for the Sanctuary at Oropa (1680).

13. A. Terraghi in *Atti del X Congresso di storia dell' arch.*, Rome, 1959, 373, suggests a date between 1656 and 1659 for the church and offers a hypothesis regarding Guarini's likely stay in Portugal. But at the Guarini Congress in Turin (1968) F. Chuecas suggested that Guarini's church was not built until 1698.

14. Begun later by Michelangelo Garove (1650–1713). Further for the history of the church, G. Chevalley, 'Vicende costruttive della Chiesa di San Filippo Neri', *Bollettino del Centro di studi archeologici . . . del Piemonte*, fasc. II (1942). Here, too, further information on Garove's work. See now R. Pommer, *Eighteenth-Century Architecture in Piedmont*, New York–London, 1967, 79–84.

15. The Palazzo Carignano (1679–92) is by far the most important of Guarini's domestic buildings. Its plan combines motifs from Borromini's designs for the Palazzo Carpegna and Bernini's first Louvre project, but in the treatment of detail and of the decoration Guarini is highly original. Much material in O. Cravero, 'Il Palazzo Carignano', *Atti e Rass. tecnica della Soc. Ingegneri e Architetti in Torino*, XVII (1963). A fine analysis of the palace in H. A. Millon, *Baroque and Rococo Architecture*, New York, 1961, 22. Guarini also made designs for the royal castle at Racconigi (between 1679 and 1683; C. Merlini in *Torino*, XIX (1941), 35) and for other palaces (see Portoghesi, *op. cit.*). We leave a discussion of all this aside in favour of an analysis of his major ecclesiastical work at Turin.

16. His design of 1678 had to incorporate an older church; the dome of 1703 does not correspond to Guarini's design; enlargement by Juvarra, 1714. Decoration finished in 1740. Façade, 1854–60. Addition of four elliptical chapels, 1899–1904. See P. Buscalioni, *La Consolata nella storia di Torino*, Turin, 1938. See also A. Lange, 'Turin: La Consolata', *Congrès Archéologique du Piémont* (1978), 107–12.

17. According to documents in the State Archive, Turin (available in the Soprintendenza), Bernardino Quadri directed the work until 1667, supported by Antonio Bettino (1659–64). 1660–3: construction of the sacristy and the communication with the Palazzo Reale. 1667: the carpenter G. Rosso is paid for the wooden model of Guarini's project. Guarini had to use marble and bronze which had already been worked. The altar, planned by Guarini, was executed by Antonio Bertola. 1690: execution of the pavement. 1694: transfer of the relic into the finished chapel. See also Olivero in *Il Duomo di Torino*, II (1928), no. 3 (*ibid.*, no. 7, material about Bertola, 1647–1719, who was mainly a military architect); A. Midana, 'Il Duomo di Torino', in *Italia Sacra*, V (1929); and above all M. Passanti, 'Real Cappella della S. Sindone', in *Torino*, XX (1941), nos. 10, 11; and *idem*, *Nel mondo magico* (above, Note 5). For Antonio Bertola, see N. Carboneri, in *Studi di Storia dell'Arte in onore di Vittorio Viale*, Turin, 1967, 48 ff.

18. See the oval reliefs in the pendentives of S. Carlo alle Quattro Fontane.

19. The Palazzo Carignano may illustrate how he applied similar contrasts to a palace; see the undulating window frames (produced as if by chance) contained by hard geometrical forms, particularly the constantly repeated star-pattern of the court front.

20. See also E. Battisti, 'Note sul significato della Cappella della S. Sindone', *Atti del X Congresso di storia dell'arch.*, Rome, 1959, 359.

21. S. Lorenzo is a Theatine church. Its foundation stone had been laid, long before Guarini, in 1634. See G. M. Crepaldi, *La Real Chiesa di San Lorenzo in Torino*, Turin, 1963.

22. Reference may be made to the fact that two adjoining niches with statues always vary in depth and stand at angles to each other which cannot easily be perceived. Moreover, since the sides of the octagon are not equally curved (the curves are flatter in the main axes than in the diagonals), the relationships differ between two adjoining columns and the niches behind.

23. The *Architettura civile* contains, however, no chapter on domes. This omission suggests that the MS. was unfinished at the time of Guarini's death.

24. With Naples and Sicily belonging to the Kingdom of Castile, it seems unnecessary to speculate about Guarini's early contacts with Hispano-Moresque architecture.

The eight-pointed star-shaped dome above the crossing of the cathedral of Saragossa probably comes nearest to the dome of S. Lorenzo. The extraordinary twelfth-century vestibule of the cathedral at Casale Monferrato near Turin with a vault consisting of intersecting ribs was, of course, known to Guarini. In 1671 Guarini himself designed S. Filippo at Casale Monferrato,

based on a complex interpenetration of circular spaces. This church was completely altered in 1877. See also Terraghi (above, Note 13), 369.

25. Similarly, the system of the dome of the Cappella della SS. Sindone may have been stimulated by the stalactite work in Islamic architecture.

26. But see W. Müller, 'The Authenticity of Guarini's Stereotomy in his *Architettura Civile*', *Journal Soc. Architect. Historians*, XXVII (1968), 202 ff., and *idem*, in *Guarino Guarini e l'internazionalità del Barocco*, Turin, 1970, I, 531 ff.

27. His publications of the 1670s and 80s are mainly concerned with mathematics and astronomy.

28. Guarini celebrated the first Mass in S. Lorenzo – probably a unique case of the alliance of architect and priest in the same person.

In the same year, 1680, Emanuele Filiberto Amedeo, Prince of Carignano, appointed him his 'teologo'. The revealing document mentions that in him 'are united the highest philosophical, moral and theological sciences, which befit a zealous priest'. See Olivero in *Il Duomo di Torino*, II (1928), no. 4.

29. For Piedmontese architecture between the death of Guarini and the arrival of Juvarra, see H. Millon, 'Michelangelo Garove and the Chapel of the Beato Amedeo of Savoy in the Cathedral of Vercelli', *Essays in the History of Architecture presented to R. Wittkower*, London, 1967, 134 ff. Next to Garove, the most gifted successor to Amedeo Castellamonte and Guarini (see above, Note 14), the following minor architects were active: Maurizio Valperga, Giovanni Francesco Baroncelli (d. 1694), who built the Palazzo Barolo (1692–3) and to whom the Palazzo Graneri (1682–3) is traditionally attributed, Carlo Emanuele Lanfranchi (1632–1721) and Antonio Bertola (1647–1719) who worked on three of the buildings left unfinished by Guarini.

For Bertola, see also above Note 17; for Garove, R. Pommer, *Eighteenth-Century Architecture in Piedmont*, New York–London, 1967, *passim*.

30. The principal publication on Juvarra is that by L. Rovere, V. Viale, and A.E. Brinckmann ('A cura del Comitato per le onoranze a F.J.'), of which only the first volume appeared in 1937. See now the recent full monograph by Boscarino.

For the early Juvarra, see G. Chevalley in *Boll. Soc. Piemontese*, N.S. I (1947), 72, and, above all, M. Accascina in *Boll. d'Arte*, XLI (1956), 38; XLII (1957), 50. For the work in Piedmont see A. Telluccini, *L'arte dell' architetto Filippo Juvara in Piemonte*, Turin, 1926.

31. Sketchbooks in the Victoria and Albert Museum, London, and the Biblioteca Nazionale, Turin. For the theatre, see A. Rava, *Il Teatro Ottoboni nel Palazzo della Cancelleria* (R. Istituto di Studi Romani, III), Rome, 1942.

32. Brinckmann, *Theatrum Ped.* (above, Note 4), 31. A. A. Tait, *Burl. Mag.*, CVIII (1966), 133 f., attributes the work on the Palazzo Pubblico at Lucca to Francesco Pini on the basis of documents. But see now S. Benedetti, *Palladio* (1973), 145–83, who restores the design to Juvarra, and M. Paoli, *Provincia di Lucca*, XV (1975), 106–11.

33. Here Juvarra planned an enlargement of the old royal palace, which was, however, not executed; see Augusta Lange in *Bollettino storico-bibliografico subalpino*, XLIV (1942), nos. 1–4; M. Accascina, *Boll. d'Arte*, XLII (1957), 158.

34. Juvarra's project remained on paper; the palace was built by Johann Friedrich Ludwig and his son Johann Peter.

Juvarra also designed the lighthouse in the harbour of Lisbon and the church and palace of the Patriarch.

35. In 1730 he dedicated a volume with architectural fantasies to Lord Burlington, now at Chatsworth; see Wittkower in *Boll. Soc. Piemontese*, N.S. III (1949).

36. The wooden model of Juvarra's design in the Museo de Artilleria, Madrid. The palace was executed between 1738 and 1764 by Juvarra's pupil, Giovanni Battista Sacchetti, who reduced its size and admitted a strong influence from Bernini's Louvre project. Sacchetti followed Juvarra's design more closely in the execution of the garden front of the palace of La Granja at S. Ildefonso near Segovia. New documents for this work, published by E. Battisti in *Commentari*, IX (1958), 273. See also A. Scotti, *Colóquio*, XXVIII (1976), 51–63.

37. None of his great projects for Rome (Sacristy of St Peter's, Spanish Staircase, façade of S. Giovanni in Laterano) were executed. Juvarra was not an official participant in the Lateran competition of 1732, but his early biographers mention that he was invited to send a project; for this sketches survive (Turin). As regards his other work in Rome, see M. Loret in *Critica d'Arte*, I (1936), 198, and R. Battaglia in *Boll. d'Arte*, XXX (1937), 485, and also *Arti Figurative*, III (1947), 130.

38. With the exception of S. Croce, Turin (1718 ff.), these churches will be discussed later.

39. The palace of the Venaria Reale (1714–26), Palazzo Madama (1718–21), the castles at Rivoli (1718–25; see A. Telluccini in *Boll. d'Arte*, X (1930/1), 145, 193) and at Stupinigi (begun 1729).

40. Palazzi Birago, now Della Valle; Martini di Cigala, now Belgrano (both 1716); Richa di Covasolo; and Guarene, now d'Ormea (both 1730).

41. This would have been even more evident if the wings had been built.

The palace, which screens the medieval castle, was erected for the widow of Carlo Emanuele II. Contruction was interrupted in 1721. A. Telluccini, *Il Palazzo Madama di Torino*, Turin, 1928.

I cannot always follow W. Collier's analyses ('French Influence on the Architecture of Filippo Juvarra', *Architectural History*, VI, 1963, 41), but he is certainly not correct in maintaining that the French influence on Juvarra has been overlooked. See also L. Mallé, *Il Palazzo Madama di Torino*, I, Turin, 1970.

42. It should, however, be pointed out that the type with radiating wings was also developed in eighteenth-century Austria and France. Boffrand even maintained in his *Livre d'architecture*, Paris, 1745, where he published the Château La Malgrange near Nancy with a plan similar to Stupinigi, that the latter was designed by him. A. E. Brinckmann (*Baukunst des 17. und 18. Jahrhunderts in den romanischen Ländern*, Berlin, 1919, 316) has shown that Boffrand's assertion is without foundation. But J. Garms, in *Wiener Jahrb.*, XXII (1969), 184 ff., accepts Boffrand's X-shaped plan as a genuine product of 1711–12. M. Passanti in *L'Architettura*, III (1957), 268, published good measured drawings. After Juvarra's death Alfieri (see Note 72) was probably responsible for the planning of the considerable extension of Juvarra's project (1739). The park was begun in 1740 by the Frenchman F. Bernard. For further information, see M. Bernardi, *La Palazzina di Caccia di Stupinigi*, Turin, 1958. N. Gabrielli (with M. Tagliapietra Rasi and L. Tamburini), *Museo dell'Arredamento Stupinigi. La Palazzina di caccia*, Catalogo, Turin, 1966, contains the history of Stupinigi and its decoration based on a wealth of new documents. The same documentation was used by Pommer for his comprehensive analysis of Stupinigi in *Eighteenth-Century Architecture in Piedmont*, New York–London, 1967, 61–78, 188–218. The apogee of Stupinigi studies is L. Mallè's folio of over 500 pages, *Stupinigi. Un capolavoro del Settecento europeo tra barocchetto e classicismo*, Turin, 1968.

43. The origianl great design, published by Tavigliano in 1758, was influenced by Rainaldi's S. Maria in Campitelli. In 1730 it was reduced to its present form without crossing and dome. On the complex history of this church, see G. Chevalley's paper, and R. Pommer, quoted above, Note 14.

44. L. Tamburini, *Le chiese di Torino dal rinascimento al barocco*, Turin, 1968, 339–50. The church was gutted during the last war.

In 1734 Juvarra made a design similar to that of the Carmine for the church of the Padri Gesuiti at Vercelli; execution later (1741–73) with considerable changes. See V. Viale in *Atti del X Congresso di storia dell'arte*, Rome, 1959, 427.

45. See Pozzo's altars in S. Maria degli Scalzi, Venice, and, later, in the Jesuitenkirche, Vienna (1703–5). Fischer von Erlach used the motif first in a design for the high altar in the church at Strassengel (c. 1690, Albertina).

46. The earliest example seems to be the Stiftskirche Waldsassen, Oberpfalz, 1685–1704, designed by the Italianizing A. Leutner from Prague, with Georg Dientzenhofer as clerk of works.

47. Rovere–Viale–Brinckmann, *op. cit.*, plates 31 and 32. One will easily recognize the features deriving from Borromini, Bernini, Rainaldi, Carlo Fontana, and even from Longhena's Salute (figures above columns inside). In view of Juvarra's further development, the change of proportion as compared with S. Agnese is notable. In S. Agnese the body of the church is related to drum and dome as 1 : 1, in Juvarra's project as 1 : 1⅔, i.e. the importance of drum and dome has grown.

48. Another scenic feature (without pedigree) is the perforating of the pillars with three openings in the balcony zone through which one can look into the domes of the stallite chapels. The detail of the church combines classical tabernacle frames with ornament that shows almost a Rococo tinge.

49. The church was intended as a thanksgiving by King Vittorio Amedeo II for the support given by the Virgin to the royal house. In May 1717 the wooden model, still existing in the monastery, was paid for; by 1726 the structure had been carried as high as the lantern; in 1727 the campanili were built, and in 1731 the decoration of the interior was finished. See also G. A. Belloni in *Torino*, XI (1931), nos 9, 10, and M. Paroletti, *Description historique de la . . . Superga*, Turin, 1808. See now N. Carboneri, *Superga*, Turin, 1979.

50. By horizontal segments of masonry. The same method was used in the satellite chapels. The probable source is Borromini's doors in S. Ivo.

51. The ratio is now 1 : 1⅔; see Note 47. The body of the church looks therefore like a base to drum and dome.

Similar relationships prevail in Fischer von Erlach's Karlskirche in Vienna (designed 1715, begun 1716, executed until 1722, but drum and dome finished after Fischer's death, 1739). The not unlikely connexion between the two churches would need further investigation.

52. The designs for S. Raffaello are similar. They are usually dated as early as 1718, which seems to be untenable in view of Juvarra's other production at that period.

53. See W. Herrmann in *Jahrbuch für Kunstwissenschaft*, IV (1927), 129 ff.

54. Among Juvarra's contemporaries and followers should be mentioned Gian Giacomo Planteri, the architect of the Chiesa della Pietà and S. Maria dell' Assunta at Savigliano (both begun 1708) and of the magnificent Palazzo

Saluzzo-Paesana at Turin (1715–22); for Planteri, see A. Cavallari Murat in *Atti e Rassegna tecnica Soc. Ingegneri e Architetti in Torino*, XI (1957), 313, and S. J. Woolf, *ibid.*, XV (1961, September issue); further G. B. Sacchetti (see Note 36) and the Conte Ignazio Tavigliano (Note 43). The most extensive architectural practice next to Juvarra's was that of Francesco Gallo from Mondovì (1672–1750); he was, however, infinitely less imaginative than either Juvarra or Vittone. Among his more distinguished works may be named the Chiesa Parrocchiale at Carrù (1703–18; see II: Chapter 6, Note 7), with a characteristic centralized plan, often varied by him; the Chiesa della Misericordia (1708–17) and the cathedral at Mondovì (1743–63); S. Giovanni at Racconigi (1719–30); SS. Trinità at Fossano (1730–9); and the oval S. Croce (also called S. Bernardino) at Cavallermaggiore (1737–43), which is perhaps his masterpiece and betrays Vittone's influence. He was also responsible for the completion of Vittozzi's Sanctuary at Vicoforte di Mondovì (1701–33). All his buildings excel in the richness, harmony, and taste of their decoration. A fully documented monograph about him was published by Nino Carbonieri, Turin, 1954.

55. On Vittone see the monograph by E. Olivero (Turin, 1920) which is useful for the collection of factual material. Further: G. Rodolfo, 'Notizie inedite dell'architetto Bernardo Vittone' in *Atti della Soc. Piemontese di Arch. e Belle Arti*, XV (1933); C. Baracco, 'Bernardo Vittone e l'architettura Guariniana' in *Torino*, XVI (1938), 22; Olivero in *Palladio*, VI (1942), 120; C. Brayda, 'Opere inedite di Bernardo Vittone' in *Boll. Soc. Piemontese*, N.S. I (1947); P. Portoghesi, *ibid.*, XIV–XV (1960–1). P. Portoghesi published a very well-illustrated monograph in 1966; it also contains the long inventory of Vittone's estate and other documents. R. Pommer, *op. cit.* (Note 14), made it likely that Vittone was born in about 1702 rather than in 1704 or 1705 as is usually assumed.

See now the proceedings of the Vittone congress (ed. V. Viale), 2 vols. (1972).

56. H. A. Millon (*Boll. Soc. Piemontese*, N.S. XII–XIII, 1958–9) has shown that Vittone was a practising architect before going to Rome and that he was still in Turin on 29 July 1730.

57. Vittone himself calls Juvarra his teacher; see *Istruzioni elementari*, Lugano, 1760, 285.

58. Very little of his pre-Roman activity is known, see Note 56.

59. Height less than 70 feet, diameter *c.* 50 feet. The exterior was whitewashed in 1939.

60. It is particularly close to Guarini's unexecuted design for S. Gaetano, Nice, later built by Vittone himself.

61. See our discussion of hexagonal planning in relation to Borromini's S. Ivo (II: p. 45 ff.). The plan of S. Ivo with alternating concave and convex recesses probably influenced Vittone.

Hexagonal plans occur often in Vittone's *œuvre*; see the Chiesa Parrocchiale at Grignasco (1752–67), the designs for S. Chiara, Alessandria, and the church of the Collegio dei Chierici Regolari, Turin; also S. Chiara at Vercelli, the Chiesa Parrocchiale at Borgo d'Ale (1770), and others.

62. Again, the closest analogy is to be found in the design of S. Gaetano, Nice.

63. See, e.g., S. Maria Maddalena at Alba, 1749, and the project for S. Chiara at Alessandria.

64. It should be mentioned that there is a close connexion between the architectural conception of S. Chiara at Brà and the *quadratura* frescoes in the dome of the Consolata, Turin, executed by Giambattista Alberoni from designs by Giuseppe Bibiena, with figures by Giambattista Crosato; to be dated, according to F. Fiocco, *Giambattista Crosato*, Padua, 1944, 49, in 1740, i.e. just before Vittone planned his church. The relationship of Vittone's architecture to Piedmontese *quadratura* painting would need further investigation.

65. Millon (Note 56) suggests as date 1738–40 and places correctly in the same period the little jewel, S. Luigi Gonzaga at Corteranzo.

66. The first stone of the Hospital was laid in 1744. It was erected at the expense of Antonio Faccio, who was also responsible for the Sanctuary at Vallinotto. The church was consecrated in 1749. See G. Rodolfo, *Barocco a Carignano* (above, Note 4), 139.

67. Badly redecorated in 1945.

68. E. Olivero in *Boll. Soc. Piemontese* IX (1925), nos 1–2.

69. On Rana, see C. Brayda, *Torino*, XIX (1939), 16.

70. On Bonvicini, see Augusta Lange in *Bollettino storico-bibliografico subalpino*, XLIV (1942), no. 1.

71. Like some other great men, Vittone was extraordinarily mean. His heirs had to pay large sums to some of his collaborators who had not received any money for a long time.

72. Vittone's most distinguished contemporary among Piedmontese architects was the Conte Benedetto Alfieri (1700–67), who succeeded Juvarra as 'First Architect to the King'. Outstanding among his palaces are the Palazzo Ghilini at Alessandria (now Palazzo del Governo) executed in 1732 from a design by Juvarra; his own palace at Asti (1749); and the Palazzo Caraglio (now

Accademia Filarmonica) at Turin. He is particularly remembered for his share in the decoration of the Palazzo Reale, Turin, and above all, for S. Giovanni Battista at Carignano (1757–64) with its extraordinary horseshoe plan. For Alfieri, see now A. Bellini (1978), D. de Bernardi Ferrero in *Atti e Rassegna tecnica Soc. Ingegneri e Architetti in Torino*, XIII (1959), and V. Moccagatta in *Atti e Memorie del Congresso di Varallo Sesia*, Turin, 1960, 151.

Among those influenced by Vittone's manner may be mentioned, apart from Rana and Bonvicini (Notes 69, 70), Costanzo Michela who was responsible for the undulating plan of S. Marta a Agliè (1760; R. Pommer, *Art Bull.*, L (1968), 169 ff.); Giovan Battista Maria Morari (d. *c.* 1758), who built the parish church at Cumiana (Olivero, *Miscellanea di archit. Piemontese del Settecento*, Turin, 1937, 5); the spirited G. B. Ferroggio, the architect of the church at San Germano Vercellese (1754–64), of the Chiesa dello Spirito Santo at Turin (1764–7, Olivero in *Torino*, XII (1934), no. 12; bombed during the war) and the interesting oval S. Caterina at Asti (1766–73); and the Conte Filippo di Robilant (1723–83), the builder of S. Pelagia at Turin (1770; for this and his other works, see Olivero in *Torino*, X (1932), 42, and N. Carbonieri, 'Per un profilo dell'architetto Filippo Nicolis di Robilant', in *Studi in memoria di G. Chierici*, Rome, 1965, 183 ff.).

With Vittone's devoted pupil Mario Quarini, Piedmontese architecture turns towards Neo-classicism (see his large cathedral at Fossano, 1779–91, after the model of St Peter's).

CHAPTER 4

1. See, e.g., the German brothers Schor, in particular Giovan Paolo, whom we recognize now as an important artist in Bernini's studio; until fairly recently he was almost entirely unknown (see above, II: Chapter 8, Note 33). Among the Frenchmen of Bernini's circle may be mentioned Claude Poussin ('Claudio Francese' or 'Claudio Porissimo' in Italian documents), who was responsible for the River Ganges on Bernini's Four Rivers Fountain (the statue is usually wrongly given to another Frenchman, Claude Adam); Niccolò Sale, whom Bernini employed very often, e.g. on the tomb of the Countess Matilda, for the Cappella Raimondi in S. Pietro in Montorio, and the Four Rivers Fountain; and Michel Maille ('Michele Maglia', 'Monsù Michele', 'Monsù Michel Borgognone' in documents), who worked the figure of Alexander VII of the pope's tomb (1675–6); he belonged to Ferrata's studio and carried on the Berninesque tradition in independent works until 1702, when he seems to have died.

2. This group, known as *La Renommée*, shows Fame writing the deeds of the King into the Book of History which is carried by Time, together with a medallion portrait of Louis XIV. The work was not finished until 1686. Its present position is near the Bassin de Neptune in the garden of Versailles. For the relations of Guidi with Lebrun, see A. de Montaiglon, *Correspondance des directeurs de l'Académie de France à Rome*, I, 76 ff.; L. Hautecœur in *G.d.B.A.*, IV, vii (1912), 46; Wittkower in *J.W.C.I.*, II (1938–9), 188.

3. For Mazzuoli see, above all, V. Suboff in *Jahrb. Preuss. Kunstslg.* III. (1928), 33, and F. Pansecchi in *Commentari*, X (1959), 33, with new material, mainly at Siena.

4. Wittkower in *Rep. f. Kunstw.*, L (1929), 6. Ottoni's best friend was the French sculptor Théodon, who cunningly managed to take over Bernini's studio behind St Peter's which the Congregation had promised to Ottoni. Ottoni's most extensive stucco work is in St Peter's, particularly above the arcades of choir and transept (1713–26).

5. The illustration shows the stuccoes above the altar and one of the four medallions of the vault with scenes from the life of St Francis. They are surrounded with realistic palm leaves and roses and carried by putti; the chapel is entirely white. All this lends support to the rather gay and light quality of Carcani's art. In his marbles Carcani followed Berninesque prototypes more closely. The allegory of Charity on the Bonelli tomb in S. Maria sopra Minerva (1674), for instance, derives directly from the tomb of Urban VIII. Similar observations may be made in regard to later works, e.g. the tomb of Monsignor Agostino Favoriti in S. Maria Maggiore (1682–6).

6. Design of the altar by Andrea Pozzo. The sculptural work, begun in 1695, was mainly finished in 1699. For the altar, see now Pio Pecchiai, *Il Gesù di Roma*, Rome, 1952, with further literature. See also C. Bricarelli in *Civiltà Cattolica*, LXXIII (1922), 401, and G. M. March in *Archivum Historicum Societatis Jesu*, III (1934), 300. For the contribution of the Florentine bronze sculptor Lorenzo Merlini, see Lankheit, 183. For Pozzo's oil sketches preparing the small bronze reliefs by René Fremin, Angelo de'Rossi, Peter Paul Reiff, and Pierre Étienne Monnot, see B. Kerber, in *Art Bull.*, XLVII (1965), 499. Altogether over a hundred artists and artisans worked for the altar. Fullest discussion, based on new documents, in Kerber, *A. Pozzo*, 1971, 140–80.

7. For Ludovisi, see U. Schlegel, *Mitteilg. des kunsthist. Inst. in Florenz*, X (1963), 265. The author wants to exclude Ludovisi's collaboration on the St Ignatius altar and argues that the sculptor was probably not born before 1700.

But see E. Lavagnino, *Altari barocchi in Roma*, 1959, 174, and R. Enggass, *Burl. Mag.*, CX (1968), 438 ff., 494 ff., and 613 ff.

8. He had come to Rome from Milan, where he had worked for twelve years under Giuseppe Rusnati. For Rusconi, see A. L. Elkan, Thesis, Cologne, 1924; Wittkower in *Zeitschr. f. b. Kunst*, LX (1926–7), 43; S. Baumgarten in *Revue de l'art*, LXX (1936), 233; Donati, *Art. Tic.*, 1942; Samek Ludovici in *Archivi*, XVII (1950), 209; V. Martinelli in *Commentari*, IV (1953), 231; I. Lavin in *Boll. d'Arte*, XLII (1957), 46.

9. Carlo Maratti supplied designs for these statues; see M. Loret in *Archivi*, II (1935), 140; L. Montalto, *Un Mecenato in Roma barocca*, Florence, 1955, 279, 442, 530, 545.

10. Suboff, *Zeitschr. f. b. Kunst*, LXII (1928–9), 111.

11. For Cornacchini, see H. Keutner in *North Carolina Museum of Art Bulletin*, I (1957–8) and II (1958); Lankheit, 188; Wittkower in *Miscellanea Bibl. Hertzianae*, 1961, 464: full documentation for the Charlemagne. Also C. Faccioli, in *Studi Romani*, XVI (1968), 431 ff.

In the context of the relationship of such Late Baroque works to the theatre (see above, p. 366), it is worth noting that a copy of Cornacchini's Charlemagne was shown on the stage of Cardinal Ottoboni's theatre in 1729 on the occasion of the opera *Carlo Magno* performed in honour of the birth of the Dauphin (engraving by Gabbuggiani). See A. Rava, *I Teatri di Roma*, Rome, 1953, 83.

For Cornacchini's statue of Clement XII in Ancona, see W. E. Stoppel, in *Röm. Jahrb. f. Kunstg.*, XII (1969), 203 ff.

12. See Wahl in *Rep. f. Kunstw.*, XXXIV (1911), 15, and J. Fleming and H. Honour, in *Essays in the History of Art presented to R. Wittkower*, London, 1967, 255 ff.

13. Erected by Clement XII to his uncle's memory. It is not without interest in our context that Cardinal Neri Corsini was papal Nunzio in Paris in 1652.

14. Apart from Maini, the principal contributors were Cornacchini (marbles and stuccoes), Filippo della Valle, Pietro Bracci, Giuseppe Rusconi (the classicizing allegory of *Courage*), Giuseppe Lironi (1679, not 1689,–1749; for Lironi, see U. Schlegel, above, Note 7, 259), another pupil of Camillo Rusconi (his is the cool allegory of *Justice*), and Carlo Monaldi (1691–1760), who is more Baroque in his allegories in S. Maria Maddalena (1727) than in the figures which accompany Maini's statue of Clement XII in the Corsini Chapel (for Monaldi see R. Chyurlia in *Commentari*, I (1950), 222). In addition, there worked the less important Bartolomeo Pincellotti and Paolo Benaglia and, unconnected with the Rusconi circle, the Frenchmen Pierre Lestache and Lambert-Sigisbert Adam.

Between 1731 and 1733 most of these sculptors, among a host of others, supplied important works for the cathedral at Mafra (Portugal); see A. de Carvalho, *A escultura em Mafra*, Mafra, 1956.

15. V. Moschini in *L'Arte*, XXVIII (1925); H. Honour in *Connoisseur*, CXLIV (1959), 172 (with *œuvre* catalogue); Lankheit, 190.

16. It should also be recalled that Bouchardon worked in Rome between 1723 and 1732.

17. See the monograph by K. v. Domarus (Strasbourg, 1915) and C. Gradara (Milan, 1920).

18. The history of the Fontana Trevi is long and complicated. It began in the reign of Pope Nicholas V as early as 1453 and developed through many stages from 1629 onwards for fully a hundred years. After Nicolò Salvi's project was chosen in 1732, the execution progressed fairly quickly. The four statues of the attic by Bartolomeo Pincellotti, Agostino Corsini, Bernardo Ludovisi, and Francesco Queirolo were finished in 1735 (see inscription). The second period of the execution began under Salvi's successor, Giuseppe Pannini (further for the history of the fountain, see III: Chapter 2, Note 45). To this period belongs the sculptural decoration of the lower part: 1759–62; Bracci's Neptune and Tritons, Filippo della Valle's Health and Fecundity, and the reliefs illustrating legendary episodes of the origin of the Fontana Trevi by Giovanni Battista Grossi and Andrea Bergondi.

19. See O. Sobotka's classic article in *Jahrb. Preuss. Kunstslg.*, XXXV (1914), which can, however, no longer entirely be followed; see also M. V. Brugnoli, *Boll. d'Arte*, XLV (1960), 342.

20. A preparatory sketch in the Düsseldorf Akademie (I. Budde, *Katal. der Handzeichnungen*, no. 449, plate 66) shows that Rusconi began with a symmetrical composition.

21. Algardi's tomb of Leo XI is centrally composed but affords a number of satisfactory views, while Rusconi's tomb offers a coherent view only if one approaches it coming from the transept (compare the illustration here with the wrong view published by Donati, *Art. Tic.*, figure 461).

22. Filippo della Valle departs slightly from tradition by placing the sarcophagus in an isolated zone under the triangle of the figures; but for the latter, he reverts to Bernini, his *Charity* being derived from that of the tomb of Alexander VII, but he translates Bernini's drama into calm graciousness.

23. The architecture of the chapel is by Raguzzini. The tomb was designed by Carlo Marchionni (1704–80), the architect of the Villa Albani and the Sacristy of St Peter's, who also executed the relief. The allegory of Humility is

by Bracci's collaborator, Bartolomeo Pincellotti. According to Soprani (*Vite de'pittori . . . genovesi*) it was the painter Pietro Bianchi who helped Marchionni on this and other occasions. For Bianchi, see III: Chapter 1, Note 13.

24. It is true, however, that he used *one* allegory, Faith (and not the customary two). Together with the Angel of Death and the lions, it belongs to a zone compositionally and spiritually entirely divorced from the praying pope.

25. This interesting artist, who was born at Cattinara in Piedmont in 1669 (not 1682) and died in Rome in 1736, worked for fifteen years in the studio of Lorenzo Ottoni. His most important works are the four Barberini tombs in S. Rosalia, Palestrina, of which the two earlier ones of 1704 show Baroque angels related to Raggi's style. C. Pericoli in *Capitolium*, XXXVIII (1963), 131, contributes some new material for Cametti but erroneously believes that he was born in Rome in 1670. For a full monographic treatment of Cametti with reliable *œuvre* catalogue, see U. Schlegel in *Jahrb. Preuss. Kunstslg.*, N.F. V (1963), 44, 151.

26. Painted portraits on tombs occur, of course, before the eighteenth century. The most interesting is perhaps the one which Giovan Battista Ghisleri erected for himself in 1670 in S. Maria del Popolo with the figure of Death looking out of his vault. The inscriptions under the portrait NEQUE HIC VIVUS and under Death NEQUE ILLIC MORTUUS (Mâle, 221) point out that 'he (Ghisleri) is neither alive here nor dead in the beyond'.

27. This feature was introduced by Raphael in the memorial chapel of the Chigi family in S. Maria del Popolo. During the sixteenth and the first half of the seventeenth centuries, however, tombs with pyramids remained rare. It was once again Bernini who, with the redecoration of the Chigi Chapel (1652 ff.), opened the way to using the pyramid as a Baroque sepulchral element. For Raphael's Chigi Chapel and later changes, see J. Shearman in *J.W.C.I.*, XXIV (1961), 129 (134, on pyramid tombs), and J. Pope-Hennessy, *Italian High Renaissance and Baroque Sculpture*, London, 1963, Catalogue, 43.

28. Michelangelo Slodtz (1705–64), member of a family of Flemish artists who had settled in Paris, went to Rome in 1728 and remained there for seventeen years. The St Bruno is his masterpiece in Rome. See Bibliography.

29. The first important examples of Italian export of Baroque sculpture are works by Bernini: the bust of Cardinal Melchior Klesl in the cathedral of Wiener Neustadt (Austria), the (destroyed) bust of King Charles I of England, and the portrait of Mr Baker (Victoria and Albert Museum). (For these see Wittkower, *Bernini*, Cat. nos 22, 39, 40.) Also fairly early is Algardi's marble relief of Mary Magdalen carried up to Heaven (1640) in the church at Saint-Maximin in Provence. Among later exports may be mentioned Ferrata's and Guidi's figures for the memorial chapel of Cardinal Friedrich, Landgraf of Hesse Darmstadt, in the cathedral at Bratislava (1679–83; see B. Patzak, *Die Elisabethkapelle des Breslauer Doms*, Bratislava, 1922); Guidi's monument to Louis Phélypeaux de la Vrillière in the church of Châteauneuf-sur-Loire (1681; see Sobotka in *Amtliche Ber. d. kgl. Pr. Kunstslg.*, XXXII (1910/11), 235); Raggi's tomb of Lady Jane Cheyne in Chelsea Old Church, London (1671, partly destroyed); and Monnot's tomb of John Cecil and his wife in St Martin's at Stamford (1704).

30. For Foggini and the following, see Lankheit, 47 ff. and *passim*. Foggini was with Ferrata for three years (1673–6). In 1687, after Ferdinando Tacca's death, he was appointed court sculptor and slightly later also court architect. His all-powerful position was therefore assured. His 'Giornale', a sketchbook of almost 300 drawings (Uffizi and Victoria and Albert Museum; see Lankheit, 51–9 and *idem, Riv. d'Arte*, XXXIV (1961), 55), gives an excellent idea of the great variety of enterprises on which the artist was engaged in the years 1713–18. See also K. A. Piacenti, in *Festschrift Ulrich Middeldorf*, Berlin, 1968, 488 ff.

31. Foggini's tomb of Donato dell'Antella in SS. Annunziata (1702), according to Lankheit, 73, by an assistant, is particularly close to Guidi.

32. Corsini Chapel: Lankheit (70, 83, and *Mitteilungen des Flor. Inst.*, VIII (1957), 35) believes that of the three large pictorial reliefs of the chapel only that over the altar with the *Apotheosis of S. Andrea Corsini* (1677–83) is by Foggini's hand. Feroni Chapel: Lankheit, 88. The execution lay in the hands of twelve collaborators, among whom Marcellini, Andreozzi, Giuseppe Piamontini, Giovacchino Fortini, and Soldani may be mentioned.

Even though Lankheit (77) claims that these as well as other works executed with the help of assistants should not be used to assess Foggini's potentialities as a sculptor, they were his responsibility and demonstrate, moreover, how in Florence the few major sculptural tasks were handled in which all the available talent joined forces.

Foggini himself, in the finest of his portrait busts (Cosimo III de'Medici and Gran Principe Ferdinando de'Medici, both *c.* 1685, Donaueschingen; Lankheit, figures 175, 176), despite his reliance on Bernini's busts of Charles I, Francis I of Este, and Louis XIV, smothered the heads in emphatically suggestive accessories and played havoc with the 'amputated' arm.

33. Lankheit, 110–60, with further literature. For Soldani as architect, see U. Procacci, in *Festschrift Ulrich Middeldorf*, Berlin, 1968, 476 ff.

34. Lankheit, 162. Carlo Marcellini, Anton Francesco Andreozzi, Francesco Ciaminghi, Giovanni Camillo Cateni, Giuseppe Piamontini are hardly men-

tioned in art historical writing before Lankheit. All these sculptors studied in the Florentine Academy in Rome before it closed its doors in 1686.

35. For Giovanni Baratta and his brothers Pietro and Francesco, see H. Honour in *The Connoisseur*, CXLII (1958), 170 (with *œuvre* catalogue); also *idem* in *Diz. Biogr. degli Italiani*, 1963, V, 790; and Lankheit, 172. Giovanni's best known work is the very Florentine monumental *Tobias and Angel* relief in S. Spirito, Florence (1697–8). Later, Giovanni had a distinguished career as sculptor to the Turin court. The Florentine note is also very strong in Giovacchino Fortini, who is the sculptor of the tomb of General Degenhard of Hochkirchen in the cathedral of Cologne; see F. Schottmueller in *Boll. d'Arte*, XXVI (1932–3), and Lankheit, 175.

Among the sculptors of this generation Girolamo Ticciati, Antonio Montauti (the artist of the *Pietà* in the crypt of the Corsini Chapel, S. Giovanni in Laterano, Rome, a work of doubtful merit but traditionally attributed to Bernini), and the skilful bronze sculptor Lorenzo Merlini (see above, Note 6) are worth mentioning. For these artists, see Lankheit, *passim*.

36. Another (reputed) pupil of Ferrata, Giovan Battista Barberini (*c.* 1625–91), deserves a note. Like Ferrata and so many others born in the Lake Como region, he became one of the most sought after stucco sculptors in northern Italy. His work is to be found at Cremona, Bologna, Genoa, Mantua, Bergamo, Como, and elsewhere and, in addition, in Vienna, Kremsmünster, and Linz. His emotional, typically Lombard realism shows few links with his master. The almost forgotten book by H. Hoffmann, *Der Stuckplastiker G. B. Barberini (1625–91)*, Augsburg, 1928, is unusually informative (many documents). See also E. Gavazza in *Arte Lombarda*, VII (1962), 63.

37. See G. Piccaluga Ferri, in *Commentari*, XVIII (1967), 207–24. Buzzi was born in Viggiù in 1708 and died there in 1780.

38. Further on Lombard sculpture: S. Vigezzi, *La scultura lombarda nell'età barocca*, Milan, 1930, and G. Nicodemi, *I Caligari scultori bresciani del Settecento*, Brescia, 1924. The work of the Caligari often has real Rococo charm.

39. F. Ingersoll-Smouse, 'La Sculpture à Gènes au XVIIe siècle', *G.d.B.A.*, LVI, ii (1914).

40. P. Rotondi, 'La prima attività di Filippo Parodi scultore', *Arte Antica e Moderna*, II, no. 5 (1959), 63 (and *idem*, *F. Parodi*, 1962, 24), suggests that Parodi studied with Ferrata rather than Bernini, but this is supported neither by the sources nor by the evidence of Parodi's Genoese work. Moreover, in her not entirely satisfactory book (p. 66) she offers the improbable hypothesis that Parodi was in Rome not only from 1655 to 1661 but again from 1668 to 1674.

41. Parodi's main work in the territory of Venice and one of the principal monuments of the Late Baroque in northern Italy is the Cappella del Tesoro in the Santo at Padua; he executed the rich multi-figured decoration between 1689 and 1692 with the help of pupils. A late Genoese work, S. Pancratius, was published by R. Preimesberger, in *Pantheon*, XXVII (1969), 48 ff.

Reference should also be made to Parodi's magnificent decorative sculpture and furniture, to which P. Rotondi has drawn attention (*Boll. d'Arte*, XLIV (1959), 46).

42. Another collaborator was Francesco Biggi, who executed the famous lions at the foot of the staircase of the Palazzo dell'Università from Parodi's models.

43. V. Martinelli in *Commentari*, IV (1953), 231.

For Francesco Schiaffino's and Diego Carlone's collaboration in the twelve large stucco figures in S. Maria di Carignano (1739–40), executed in a post-Rusconi nervous quasi-Rococo manner, see E. Gavazza, *Arte Lombarda*, VII (1962), 105.

44. *Le casacce e la scultura lignea sacra genovese del Seicento e del Settecento* (Catalogue of the Genoese Exhibition, 1939).

45. J. Fleming in *Connoisseur*, CXXXVIII (1956), 176. See also E. Olivero, *La chiesa di S. Francesco di Assisi in Torino*, Chieri, 1935, with much documentary material for C. Giuseppe and his son Giovan Battista Plura (who died in London in 1757), for Clemente and G. B. Bernero (1736–96).

46. The latest summing up of Ladatte's career is by L. Mallè, in *Essays in the History of Art presented to R. Wittkower*, London, 1967, 242 ff., with bibliography.

47. A. Telluccini, 'Ignazio e Filippo Collini e la scultura in Piemonte nel secolo XVIII', *Boll. d'Arte*, II (1922–3), 201, 254; M. Strambi, 'La cultura dei Collino', in *Boll. Società Piemontese Arch. e Belle Arti*, 1964; L. Rosso, *La pittura e la scultura del '700 a Torino*, Turin, 1934.

For Piedmontese sculpture, see also J. Fleming, *Apollo*, LXIV (1963, i), 188, and L. Mallè's chapter in the Catalogue of the Turin Baroque Exhibition, 1963.

48. In his stucco work Mazza was capable of displaying a luscious Late Baroque manner (Palazzo Bianconcini, Bologna), which vies with the richest decorations anywhere in Italy. For Mazza, see J. Fleming in *Connoisseur*, CXLVIII (1961), 206 (with *œuvre* catalogue). Giuseppe Mazza, who began his career as a painter, was the son of Camillo Mazza (1602–72), Algardi's pupil. Giuseppe's pupil, Andrea Ferreri (1673–1744), settled at Ferrara, where he was appointed director of the Academy (1737). Angelo Piò (1690–1770), a pupil of Ferreri and

Mazza, followed the general trend by going to Rome in 1718, where he worked under Camillo Rusconi; see E. Riccòmini, *Arte Antica e Moderna*, VI, no. 21 (1963), 52, and *idem*, *Paragone*, XVIII (1967), no. 213, 60. Filippo Scandellari (1717–1802) continued the Late Baroque tradition of Mazza and Piò to the end of the century. Best information on Bolognese sculpture of the eighteenth century in Riccòmini's exhibition Catalogue (1965, see Bibliography).

49. See L. Planiscig, *Venezianische Bildhauer der Renaissance*, Vienna, 1921, 597. Nicolò's *antependium* in the sacristy of S. Moisè, Venice (executed together with his son, Sebastiano; signed and dated 1633), deserves special mention. It is a work of fascinating beauty. Its strange iconography would require detailed investigation, but the depth of sensibility and devotion expressed by the many small bronze figures ally it closely to the religious temper of counter-reformatory art.

50. The following names may be mentioned: Melchior Barthel (1625–72) from Dresden and the Tirolese Thomas Ruer and Heinrich Meyring, all three notorious for their facile handling of the Berninesque idiom (Meyring's clumsy imitation of Bernini's S. Teresa in the Chiesa degli Scalzi, 1699, is well known); and the Hungarian Michele Fabris, called 'Ongaro' or 'Ungheri', whose painterly and diffused style may be studied in the chapel of Cardinal Francesco Vendramin built by Longhena in S. Pietro di Castello (*c.* 1670–4). Also John Bushnell (b. *c.* 1630) may be mentioned; he left England after 1660, spent some time in Rome, and settled in Venice for about six years where under Josse de Corte he executed parts of the large Mocenigo monument in S. Lazzaro dei Mendicanti. For Meyring, see D. Lewis, in *Boll. dei Musei Civici Veneziani*, XII (1967), 15 f. Lewis removed the large Holy Family in the Scalzi from the work of Giuseppe Torretti and attributed it to Meyring (1700–2).

51. For de Corte see N. Ivanoff, 'Monsù Giusto ed altri collaboratori del Longhena', *Arte Veneta*, II (1948), 115. De Corte's tomb of Caterino Cornaro in the Santo at Padua shows a standing figure of the admiral, baton in hand, surrounded by trophies with prisoners at his feet; it became the prototype of many similar tombs. The pictorial tendencies of the main altar of S. Maria della Salute were further developed in his last work, the sculptural decoration of the main altar of S. Andrea della Zirada (1679).

For de Corte and the other Venetian Baroque sculptors mentioned below, see C. Semenzato, *La scultura veneta del seicento e del settecento*, Venice, 1966.

52. Knowledge of this sculptor's work is based on Temanza, *Zibaldon*, ed. N. Ivanoff, Venice, 1963, 42. The *Zibaldon* should also be consulted for Michele Fabris, Thomas Ruer, and Antonio Tarsia.

53. Marinali was also influenced by Parodi. His *œuvre* has been collected by Carmela Tua in *Riv. d'Arte*, XVII (1935), 281. His most important commission was the sculptural decoration of the Sanctuary on Monte Berico near Vicenza (1700 ff.); see F. Barbieri's monograph, 1960 (Bibliography). Barbieri also published Marinali's work in the Museo Civico, Vicenza, in *Studi in onore di Federico M. Mistrorigo*, Vicenza, 1958, III. See also L. Puppi, 'Nuovi documenti sui Marinali', *Atti dell'Istituto Veneto di scienze, lettere ed arti* (cl. di scienze morali, lettere ed arti), CXXV (1966–7), 195 ff.

54. The above-mentioned Thomas Ruer and Michele Fabris, see Note 50.

55. On the Valier monument were engaged the Carrarese Pietro Baratta, Giovanni Bonazza (*c.* 1654–1736), the head of a family of sculptors, Antonio Tarsia (1663–1739), and Marino Groppelli (1662–1721). On the façade of S. Stae worked the same Pietro Baratta and Antonio Tarsia and, in addition, Paolo and Giuseppe Groppelli, Paolo Callalo, Matteo Calderoni, Francesco Cabianca, and two more significant artists, Giuseppe Torretti (*c.* 1661–1743) and Antonio Corradini (on whom see below).

For Pietro Baratta (1688–*c.* 1773), see C. Semenzato, *Critica d'Arte*, V (1958), 150, and H. Honour in *Dizionario biografico degli Italiani*, 1963, V, 793. For Antonio Tarsia (*c.* 1663–1739), see H. Honour, *Connoisseur*, CXLVI (1960), 27 (with *œuvre* catalogue). For Giuseppe Bernardi, called il Torretti, see C. Semenzato, *Arte Veneta*, XII (1958), 169.

56. The older and younger generation collaborated on these works. The façade of the Gesuati has sculpture by Antonio Tarsia, Francesco Cabianca, Giuseppe Torretti, Francesco Bonazza, Alvise Tagliapietra, Gaetano Fusali, and Gian Maria Morlaiter; in the Cappella del Rosario, which suffered in the fire of 1867, worked Giovanni Bonazza and his sons, Giuseppe Torretti, Alvise Tagliapietra and his son Carlo, and, above all, Gian Maria Morlaiter.

Giovanni Bonazza and his sons spent most of their lives at Padua. The best known of his sons is Antonio (1698–1763), who is famed for the garden figures in the Villa Widmann at Bagnoli di Sopra (Padua), executed in a charming realistic Rococo style (1742); see C. Semenzato, *Antonio Bonazza*, Padua, 1957.

57. Corradini has been fairly well studied; see G. Biasuz in *Boll. d'Arte*, XXIX (1935–6); A. Callegari, *ibid.*, XXX (1936–7); G. Mariacher in *Arte Veneta*, I (1947), and A. Riccoboni, *ibid.*, VI (1952) with *œuvre* catalogue; T. Hodgkinson, in *Victoria and Albert Museum Bulletin*, IV (1968), 37.

58. G. Biasuz and A. Lacchin, *A. Brustolon*, Venice, 1928.

59. For Schulenburg as a collector and patron see A. Binion, *Burl. Mag.*, CXII (1970), 297 ff.

60. He specialized in veiled figures in which all the forms under the veil are discernible; see Note 63. Corradini had the typical career of the migrant eighteenth-century Venetian artist; it took him to Vienna, Prague, Dresden, Rome, and Naples.

Giuseppe Torretti (see above, Notes 50, 55) practised a highly sophisticated Rococo style; see his excellent statues in the crossing at the Chiesa de'Gesuiti. For Torretti's work at Udine (mainly Cappella Manin, 1732–6), see H. Tietze *Zeitschr. f. b. Kunst*, XXXIX (1917–18), 243. Torretti's nephew, Giuseppe Bernardi-Torretti (c. 1694–1774), was Canova's first teacher (A. Muñoz, *Boll. d'Arte*, IV (1924–5), 103).

61. For Marchiori, see W. Arslan in *Boll. d'Arte*, V (1925–6) and VI (1926–7), and L. Menegazzi, *Arte Veneta*, XIII–XIV (1959–60), 147 (a sketchbook *after*, not by Marchiori, as the author believes); for Morlaiter, see G. Lorenzetti in *Dedalo*, XI (1930–1) and W. Arslan in *Riv. di Venezia*, XI (1932). L. Coletti, *Arte Veneta*, XIII–XIV (1959–60), 138, makes the point that the bozzetti mentioned in the text need not necessarily be by Morlaiter. See also G. Mariacher, 'G. M. Morlaiter e la scultura veneziana del Rococò', in *Sensibilità e Razionalità del Settecento*, ed. V. Branca, Venice, 1967, II, 591 ff.

62. M. Picone, *La Cappella Sansevero*, Naples, 1959, with full documentation.

63. Other similar veiled figures by him are: the *Sarah* in S. Giacomo, Udine; a female bust, Museo Correr, Venice; *Faith* of the altar of the Sacrament, Cathedral, Este; a similar figure from the Manin Monument, Cathedral, Udine, c. 1720; *Time and Truth*, Grosser Garten, Dresden; *Tuccia*, Staatl. Skulpturenslg., Dresden; etc. See also G. Matzulevitsch, 'La "Donna Velata" del Giardino d'Estate di Pietro il Grande', *Boll. d'Arte*, L (1965), 80 ff.

64. The relationship of Sammartino's marble to Corradini's model in the Museo Nazionale di S. Martino was discussed by G. Alparone in *Boll. d'Arte*, XLII (1957), 179. See also M. Picone (Note 62), 108 ff.

* The matter has been further complicated by the appearance of further *bozzetti*; for a succint account of the situation see R. Cioffi, *La Cappella Sansevero*, 1987 (III: NAPLES, Sculpture), pp. 61–3.

65. Among other Late Baroque sculpture at Naples may be mentioned the decoration of the nave of S. Angelo a Nilo with a number of symmetrically arranged tombs (1709), a coherent programme echoing the influence of churches like Gesù e Maria in Rome.

Attention may also be drawn to the following names: Paolo Persico, who worked in the Cappella Sanseverino and at Caserta; the versatile Domenico Antonio Vaccaro (1681–1750), prominent member of the well-known family of artists, whose work in the Certosa di S. Martino is worth a more thorough study; and Matteo Bottiglieri and Francesco Pagano, both pupils of Lorenzo Vaccaro who collaborated in the decoration of the Guglia dell'Immacolata (1747–51) designed by Giuseppe di Fiore.

66. The artists responsible for the figures are, above all, Paolo Persico, Angiolo Brunelli, and Pietro Solari.

67. R. Berliner, *Denkmäler der Krippenkunst*, Augsburg [1925–30]; idem, *Die Weihnachtskrippe*, Munich, 1955.

Mention should here at least be made of the macabre wax allegories of the Sicilian sculptor Gaetano Giulio Zumbo (1656–1701); they tie up with the South Italian taste for supra-realistic popular imagery, but it is telling that Zumbo worked for the Florentine Court (see R. W. Lightbown, Bibliography).

68. A. Sorrentini in *Boll. d'Arte*, VII (1913), 379. *Garstang argues cogently against such a visit (1990, 65–6; 1984, 48–9).

69. G. Agnello, 'Il prospetto della cattedrale di Siracusa e l'opera dello scultore palermitano Ignazio Marabitti', *Archivi*, IV (1937), 63, 127, with bibliography concerning Sicilian Baroque, and *ibid.*, XXII (1955), 228 with further literature.

According to documents published by R. Giudice, *F. Ignazio Marabitti*, Palermo, 1937, 12, the sculptor was born in 1719; he went to Rome in 1740/1 and stayed there for fully five years.

CHAPTER 5

1. Letter to Cav. Gabburi, 10 September 1733. Bottari, *Lettere*, II, 404.

2. Good surveys of Neapolitan eighteenth-century painting by L. Lorenzetti in *La pittura napoletana dei secoli XVII, XVIII, XIX*. Mostra, Naples, 1938, and R. Causa, *Pittura napoletana dal XV al XIX secolo*, Bergamo, 1957. See also Bibliography.

For Luca Giordano see, above all, Posse's excellent article in Thieme-Becker. Also A. Griseri, *Paragone*, VII (1956), no. 81, 33; G. Heinz, *Arte Veneta*, X (1956), 146; F. Bologna, *Solimena*, 1958, 34; Y. Bottineau, *G.d.B.A.*, LVI (1960), 249; M. Milkovich, *L.G. in America* (loan exhib., Brooks Gallery), Memphis, Tennessee, 1964 (with full bibliography). The three-volume monograph by O. Ferrari and G. Scavizzi (1966) supersedes most of the older literature; see Bibliography. See also O. Ferrari, *Burl. Mag.*, CVIII (1966), 298 ff., and H. E. Wethey, *ibid.*, CIX (1967), 678 ff.

3. Among Luca's pupils may be mentioned Solimena's competitor, the facile and academic Paolo de Matteis (1662–1728), whom Lord Shaftesbury chose as a congenial painter to translate into visual terms the directives given in his dogmatic essay, the *Choice of Hercules*; further, the Fleming Willem Borremans (c. 1670–1744), who brought his master's style to Sicily (principal work: the frescoes in the cathedral of Caltanisetta, 1720); and Nicola Malinconico (1663–1722), who endeavoured to emulate his teacher (U. Prota-Giurleo, *Pitt. nap. del Seic.*, 1953, 38).

A special place must be assigned to Giacomo del Po, who was born in Rome in 1659, moved to Naples in 1683, and worked there until his death in 1726. Under Giordano's and Solimena's influence but never forgetting the lesson learned from Cortona and Gaulli in Rome, he developed in his late works towards a free, painterly, quasi-Rococo manner; see M. Picone in *Boll. d'Arte*, XLII (1957), 163, 309.

4. See F. Bologna's fine monograph, with a preliminary œuvre catalogue and full bibliography. For Giordano's influence see *idem*, in *Art Quarterly*, XXXI (1968), 35 ff.

5. An early work, dated 1690, *The Fall of Simon Magus*, S. Paolo Maggiore [93], shows the characteristic arrangement of figures radiating from a nodal point in the centre like spokes of a wheel.

6. E.g., the nude man in the right-hand corner of illustration 93 and the soldier with the fasces above him derive from the *Ignudi* of the Farnese Gallery; the mother seen from the back with her child clinging to her is a standard group coming down from Domenichino, etc. Solimena's *Heliodorus* in the Gesù Nuovo, Naples, combines features from Raphael's Vatican *Heliodorus* and *School of Athens*.

7. Many painters of the Solimena succession are at present not much more than names, but work on them is proceeding; see R. Enggass, *Burl. Mag.*, CIII (1961), 304, for Andrea dell'Aste (c. 1673–c. 1721) and Matteo Siscara (1705–65), and M. Volpi, *Paragone*, X (1959), no. 119, 51, for Domenico Mondo (c. 1717–1806), whose paintings are often mixed up with those by Giaquinto. Also H. Voss, in *Festschrift Ulrich Middeldorf*, Berlin, 1968, 494 ff., for Lorenzo de Caro.

8. For Giaquinto's career, see M. Volpi, *Boll. d'Arte*, XLIII (1958), 263, and d'Orsi's monograph (Bibliography); for Amigoni and Giaquinto in Madrid, see the documents published by E. Battisti, *Arte Antica e Moderna*, III, no. 9 (1960), 62. See also the book by A. Videtta (Bibliography).

9. For a full study of de Mura's attractive decoration of the Chiesa della Nunziatella at Naples with the large ceiling fresco of the Assumption of the Virgin (1751), see R. Enggass, *Boll. d'Arte*, XLIX (1964), 133 ff. De Mura's manner was continued by his pupil Giacinto Diano (1730–1800), who enjoyed a considerable reputation.

10. The problems connected with our illustration 94 were solved by I. Faldi, *Burl. Mag.*, CI (1959), 143. The illustration represents the oil sketch for a ceiling of c. 1751, originally in the Palazzo Santa Croce, Palermo, and installed in the Palazzo Rondanini-Sanseverino, Rome, more than fifty years ago.

10a. G. Sestieri, 'Contributi a Sebastiano Conca', *Commentari*, XX (1969), 317–41; XXI (1970), 122–38, with œuvre catalogue.

11. Mazzanti's paintings are sometimes mixed up with those by Francesco Fernandi, called Imperiali (b. Milan, 1679), whose pleasant Marattesque pictures were fashionable in early-eighteenth-century Rome; reconstruction of his œuvre by E. Waterhouse, *Arte Lombarda*, III (1958), 101, and A. M. Clark, *Burl. Mag.*, CVI (1964), 226.

12. F. Zeri, *Paragone*, VI (1955), no. 61, 55, discussed this artist's links with Gaulli's manner. For a fuller treatment, see G. di Domenico Cortese, *Commentari*, XIV (1963), 254.

13. See above, II; Chapter 8, Note 1. On Cortese, see F. A. Salvagnini, *I pittori borgognoni Cortese*, Rome, 1937.

14. An interesting contribution by E. Schaar to the artist's preparation in sketches of his 'Sacrifice of Ceres' in the Villa Falconieri at Frascati, in *Festschrift für Ulrich Middeldorf*, Berlin, 1968, 422 ff.

15. Chiari's biographer, B. Kerber (see Bibliography), shows that the artist also drew inspiration from the Carracci, Reni, Cortona, and Sacchi.

16. For Masucci, see A.M. Clark, 'A.M.: A Conclusion and a Reformation of the Roman Baroque'. *Essays in the History of Art present to R. Wittkower*, London, 1967, 254–64. Mancini began as a pupil of the Bolognese Carlo Cignani and painted mainly in the Marches and Umbria. His principal work in Rome is the frescoes in the 'Kaffeehaus' of the Palazzo Colonna (1735–40; see E. Toesca, *L'Arte*, XLVI (1943), 7), the attractive architecture of which is due to Niccolò Michetti (1731).

16a. See F. R. di Federico, 'Documentation for Francesco Trevisani's Decorations for the Vestibule of the Baptismal Chapel in St Peter's', in *Storia dell' Arte*, no. 6 (1970), 155 ff.; this monumental commission occupied Trevisani for almost the last 35 years of his life.

17. G. V. Castelnovi, in *Studies in the History of Art. Dedicated to William E. Suida*, London, 1959, 333, with further references.

18. The picture is a fascinating re-interpretation of Raphael's *Transfiguration*

in a Correggio-Lanfranco manner. For Benefial, see G. Falcidia, *Boll. d'Arte*, XLVIII (1963), III: discusses decoration of the salone in the Palazzo Massimo, Arsoli (1750). See also A. M. Clark, *Paragone*, XVII (1966), no. 199, 21 ff., and M. G. Paolini, *ibid.*, XVI (1965), no. 181, 70 ff.

Benefial's contemporary, Placido Costanzi (probably 1701–59), pupil of Trevisani and Luti, may here be mentioned. He has become a tangible figure owing to A. M. Clark's paper in *Paragone*, XIX (1968), no. 219, 39 ff.; his great ceiling fresco in S. Gregorio Magno, dated 1727, reveals a classicizing sobriety which is scarcely independent of Conca's style in his S. Cecilia fresco of two years earlier.

19. E. Emmerling, *P. Batoni*, Darmstadt, 1932; L. Marcucci, *Emporium*, XCIX (1944), 95; L. Cochetti, *Commentari*, III (1952), 274; R. Chyurlia, *Emporium*, CXVII (1953), 56; A. M. Clark, *Burl. Mag.*, CI (1959), 233. Much of the older literature has been superseded by the Catalogue of the Batoni Exhibition at Lucca in 1967; see Bibliography. Also F. Russell, *Burl. Mag.*, CXII (1970), 817.

A lesser name, that of Gregorio Guglielmi (1714–73), may here be mentioned. Born in Rome, he worked at the courts of Dresden (1752–3), Vienna (Schönbrunn, 1760–1), Berlin, Turin (1765–6), and St Petersburg in a classicizing Rococo manner; see S. Beguin in *Paragone*, VI (1955), no. 63, 10; A. Griseri, *ibid.*, no. 69, 29; and, above all, Klára Garas in *Acta Hist. Artium*, IX (1963), 269. See also M. Demus, in *Almanach der Österreichischen Akademie der Wissenschaften*, CXV (1965), 1 ff., about the restoration of Guglielmi's ceiling painting of 1755–6 in the large hall of the Vienna Academy.

20. Just as Bellori in his *Life of Maratti* had extolled the latter's artistic genealogy back through Sacchi and Albani to Annibale Carracci, so Benefial saw himself proudly in line of descent, from Annibale to Albani and Carlo Cignani (Bottari, *Lettere*, v, 10) – an indication how such an artist interpreted the high road of the classical tradition.

21. It should be recalled, however, that true classicists judged differently. Winckelmann regarded Mengs's *Parnassus* in the Villa Albani (1760–1) as the most beautiful work of modern art; even for Burckhardt Mengs was the rejuvenator of modern painting.

22. M. Marangoni's article in *Riv. d'Arte* (1912, reprinted in *Arte barocca*, Florence, 1953, 205) is still the foundation of any study of Florentine Settecento painting

For Gabbiani, see A. Bartarelli, *Riv. d'Arte*, XXVII (1951–2), 105. Gabbiani was in Rome between 1673 and 1678 studying with Ciro Ferri. Although he succumbed to the influence of Maratti, Cortonesque reminiscences linger on, for instance, in his masterpiece, the *Apotheosis of Cosimo the Elder* at Poggio a Caiano (1698).

From the large number of Gabbiani's pupils and followers may be singled out Tomaso Redi (1665–1726), who later worked with Maratti in Rome; Giovanna Fratellini (1666–1731), famed in her time for her pastels; and Giovanni Battista Cipriani (1727–85), who made his fortune in England.

23. G. Arrigucci, *Commentari*, V (1954), 40.

24. Bonechi may be studied in the Palazzo Capponi (after 1705), where Sagrestani, Lapi (Note 26), and Antonio Puglieschi (1660–1732) also worked. The latter stemmed from Cortona through his teacher Pier Dandini.

25. L. Berti, *Commentari*, I (1950), 105; Edward A. Maser, *The Disguises of Harlequin by G. D. Ferretti*, The University of Kansas Museum of Art, 1956. The same author has now published a full monograph on Ferretti (see Bibliography).

Mention may be made of Vincenzo Meucci (1694–1766), Ferretti's contemporary, who studied at Bologna with dal Sole and came later under the influence of S. Ricci; his main work is the frescoes in the dome of S. Lorenzo, 1742.

26. M. M. Pieracci, 'La difficile poesia di un ribelle all'Accademia; Alessandro Gherardini', *Commentari*, IV (1953), 299. For a richly illustrated monographic treatment of Gherardini, see G. Ewald in *Acropoli*, III (1963), 81–132 (with a hitherto unpublished Life of the artist by Baldinucci). In the allegoric-mythological cycle of frescoes in the Palazzo Corsini, Gherardini worked next to Gabbiani (they had the lion's share), Pier Dandini, Bonechi, and minor masters.

A modest follower of Luca Giordano was Niccolò Lapi (1661–1732). Francesco Conti (1681–1760) began in Maratti's manner, but later became a Ricci follower.

27. N. Carboneri, *Sebastiano Galeotti*, Venice, 1955; P. Torriti, *Attività di S.G. in Liguria*, Genoa, 1956. Galeotti's most important work at Genoa is the cycle of frescoes in the Chiesa della Maddalena (1729–30; with G. B. Natali (1698–1765) as *quadraturista*), where the transition from Giordano's manner to Domenico Piola's and Gregorio de Ferrari's proto-Rococo may be observed. The full fruit of this change is to be seen in Galeotti's frescoes in the Palazzo Spinola (1736).

28. For older bibliographical references see H. Bodmer, *Mitteilungen des kunsthistorischen Instituts in Florenz*, V (1937), 91. See also *Maestri della pittura del Seicento emiliano*, Catalogue, Bologna, 1959.

29. S. V. Buscaroli, *Carlo Cignani*, Bologna, 1953. Of the Albani pupils who reached fame, only Cignani continued to produce the small cabinet painting in Albani's manner. Cignani's masterpiece is the *Assumption* in the dome of the cathedral at Forlì, 1702–6. Among his pupils may be named Luigi Quaini (1643–1717) and his two sons, Felice and Filippo Cignani. His grandson, Paolo (1709–64), continued the school into the second half of the century. See Emiliani, in *Maestri della pittura del Seicento emiliano*, Bologna, 1959, 146 ff.

30. *Wiener Jahrb.*, VIII (1932), 89.

31. A. Arfelli, *Comune di Bologna*, XXI (1934), no. 11; D. C. Miller, *Boll. d'Arte*, XLI (1956), 318; *idem*, *Burl. Mag.*, XCIX (1957), 231, and *ibid.*, CII (1960), 32; E. Feinblatt, *ibid.*, CIII (1961), 312; P. Torriti, *ibid.*, CIV (1962), 423. D. C. Miller published a *Toilet of Venus* (*Münchner Johrb. d. bild. Kunst*, IX–X (1958–9), 263) which illustrates very well Franceschini's reliance on Albani. For his relationship with Pope Clement XI, *idem*, *Burl. Mag.*, CXII (1970), 373 ff.

For Giulio Quaglio (1668–1751), Franceschini's pupil, a highly successful fresco painter, see R. Marini, *Arte Veneta*, IX (1955), 155; XII (1958), 141.

32. E. Mauceri, *Comune di Bologna*, XIX (1932), no. 6, 35; G. Lippi Bruni, *Arte Antica e Moderna*, II (1959), 109 (with œuvre catalogue).

Dal Sole's pupil, Felice Torelli (1667–1748), though less distinguished than his master, was yet a figure of importance in his day; see D. C. Miller, *Boll. d'Arte*, XLIX (1964), 54 ff. (with œuvre catalogue).

33. C. Alcsuti, *Comune di Bologna*, XIX (1932), no. 9, 17; R. Roli, *Arte Antica e Moderna*, II (1959), 328, and VI, no. 23 (1963), 247; for Roli's monograph of 1967, see Bibliography. Also C. Lloyd, *Burl. Mag.*, CXI (1969), 374 ff. Creti's style has many facets, as the pictures painted for Owen McSwiny prove. On this interesting set of paintings, see Note 63.

Creti's style as a draughtsman, subtle, refined, and elegant, was fashioned on Reni; see O. Kurz, *Bolognese Drawings at Windsor Castle*, London, 1955, and R. Roli, *Boll. d'Arte*, XLVII (1962), 241.

H. Bodmer (Note 28) claims that Benedetto Gennaro the younger, nephew and pupil of Guercino, whose Bolognese activity lies between 1692 and his death in 1715, forms the link between the older generation of Franceschini and the younger of D. Creti.

34. There is a puzzling connexion between our picture and an almost identical but more extensive composition in the National Museum, Lisbon (no. 294), there attributed – for reasons unknown to me – to Charles Alphonse Dufresnoy (1611–68). The reference to the Lisbon painting escaped the attention of R. Roli, *D. Creti*, 1967, 87, nos. 21–8. Roli dates the picture here illustrated in the second decade of the eighteenth century (which appears to me too early).

35. H. Voss, *Paragone*, IX (1958), no. 97, 53, and R. Roli, *Arte Antica e Moderna*, III, no. 10 (1960), 189.

36. Not to be mixed up with his namesake from Brescia (1646–1713), a master of battle-pieces in the manner of Borgognone. For Francesco Monti, see R. Roli, in *Arte Antica e Moderna*, no. 17 (1962), 86 ff.; D. C. Miller, *ibid.*, no. 25 (1965), 97 ff.; and *Art Quarterly*, XXXI (1968), 423 ff. In addition, U. Ruggeri's monograph, *Francesco Monti Bolognese*, Bergamo, 1968.

37. R. Roli in *Arte Antica e Moderna*, VI, no. 22 (1963), 166.

38. Crespi worked under them in 1680–4 and 1684–6 respectively.

39. C. Gnudi, *Bologna* (Riv. del Comune), XXII (1935), 18.

40. V. Constantini, *La pittura italiana del Seicento*, Milan, 1930, II, 202.

41. Between 1686 and 1688 Grespi worked in his studio. See E. Riccòmini, *Arte Antica e Moderna*, II, no. 6 (1959), 219. For Burrini, see H. Brigstocke, *Burl. Mag.*, CXII (1970), 760.

42. He continued Malvasia's *Felsina pittrice*, Rome, 1769.

43. H. Voss, *Zeitschr. f. Kunstg.*, II (1933), 202; R. Roli, *Arte Antica e Moderna*, III, no. 11 (1960), 300.

44. D. C. Miller, in *Art Quarterly*, XXXI (1968), 421 ff., emphasized Donato Creti's influence on Bigari.

45. E. Feinblatt, 'A Letter by Enrico Haffner', *Burl. Mag.*, CXII (1970). 229 ff.

46. An authoritative work on the *quadraturisti* is still wanting. Some material in C. Ricci, *La Scenografia italiana*, Milan, 1930 (with comprehensive bibliography) and V. Mariani, *Storia della scenografia italiana*, Florence, 1930; see also H. Tintelnot, *Barocktheater*, Berlin, 1939.

47. Apart from the works by C. Ricci and Hyatt Mayor, see *I Bibiena scenografi. Mostra dei loro disegni schizzi e bozzetti*, Florence, 1940.

In 1711 Ferdinando published his important *L'Architettura civile preparata sulla geometria e ridotta alle prospettive*, where he discussed at length his 'scene vedute in angolo', stage designs seen from an acute angle. It was thus not entirely new device (Marcantonio Chiarini had staged his *La Forza della Virtù* in Bologna showing a prison as a *scena per angolo* as early as 1694) that revolutionized the Baroque stage. Giuseppe's design, shown as illustration 108, gives an idea of the rich and restless effect of diagonal perspective.

Yet the purpose of the design is in the tradition of the medieval mystery plays. It reproduces one of 'the intricate peepshows, or *theatra sacra*, that Giuseppe constructed yearly for the court chapel at Vienna. Each feast of Corpus Christi brought a fresh variation on the theme of wide ramps of stairs

converging on a balustraded platform where the Man of Sorrows stood under a vast arch opening on lofty architectural distances' (Hyatt Mayor, *op. cit.*, 12).

Giuseppe was famed for his opera sets at Vienna, Dresden, Munich, Prague, Venice, and Berlin. The exuberant decoration of the opera house at Bayreuth is his work (1748).

Francesco's main theatre buildings (only partly surviving) are the Opera House in Vienna and the theatres at Nancy, Verona (Teatro Filarmonico), and Rome (Teatro Aliberti, 1720). Antonio distinguished himself as theatre architect (Teatro Comunale, Bologna; above, p. 391) and as painter of illusionist frescoes (Vienna, Pressburg, etc.).

The Bibiena had a large school. Mention may be made of an outsider, Mauro Tesi (1730–66), an excellent draughtsman in the manner of the Bibiena, who was at an astonishingly early date attracted by Egyptian archaeology as subjects for his designs. His special claim to fame lies in that Count Algarotti patronized and advertised him.

48. For Verona, see below, p. 91. Best survey of the school of Brescia: Emma Calabi, *La pittura a B. nel Seicento e Settecento*, Catalogue, Brescia, 1935. Brescia excelled in minor genre painters such as Faustino Bocchi (1659–1729), a Bambocciante who introduced the trick of showing people with large heads and small deformed bodies; Giorgio and Faustino Duranti (1683–1755, 1695–1766), who made birds and hens their speciality; Francesco Monti (see Note 36), internationally known for his battle-pieces; and the landscapist Giuseppe Zola (1672–1743; see E. Calabi, *Riv. d Arte*, XII (1934), 84). See also for this whole section G. Delogu, *Pittori minori liguri, lombardi, piemontesi del '600 e '700*, Venice, 1931.

49. Voss, 589. Seiter left Rome in 1688 and practised a Cortonesque manner in Turin to the end of his life. Before Seiter's arrival in Turin, Giovan Paolo Recchi and his nephew Giovan Antonio handled large fresco commissions; see A. M. Brizio in *Arte Lombarda*, 11 (1956), 122.

For Piedmontese painting, see L. Rosso, *La Pittura e la Scultura del '700 a Torino*, Turin, 1934, and by V. Viale, 'La pittura in Piemonte nel Settecento', *Torino*, XX (1942), and Andreina Griseri's Catalogue of the Turin Baroque Exhibition, 1963

For the position in Turin at the beginning of the seventeenth century, see A. Griseri, *Paragone*, XII (1961), no. 141, 19.

50. A. Vesme, 'I Van Loo in Piemonte', *Arch. stor. dell'arte*, VI (1893), 333. Other members of this large family of painters, above all Giovanni Battista (1684–1745), also painted in Turin.

51. Conca and Giaquinto were, of course, 'romanized' Neapolitans. Conca was in Turin off and on during the 1720s painting in the Venaria Reale, the Superga, and the Palazzo Reale; Giaquinto came twice, first in 1733 and again in 1740–2 (frescoes Villa della Regina and S. Teresa). De Mura worked in the Palazzo Reale in 1741–3, and in the late forties, the fifties and sixties received payments for work executed in Naples and sent to Turin; see A. Griseri, 'Francesco Mura fra le corti di Napoli, Madrid e Torino', *Paragone*, XIII (1962), no. 155, 22.

52. G. Fiocco, *G. B. Crosato*, Venice, 1941; 2nd ed. 1944; A. Griseri, 'Il "Rococó" a Torino e Giovan Battista Crosato', *Paragone*, XII (1961), no. 135, 42. Crosato came first in 1733 and again in 1740.

53. A. Griseri, 'Opere giovanili di Cl. Fr. Beaumont e alcune note in margine alla pittura barocca', in *Scritti vari*, 11 (a cura della Facoltà di Magistero di Torino), Turin, 1951, with much valuable material; also *idem, Connoisseur*, CXL (1957), 145 (documents). For further references to Beaumont, see Catalogue of the Baroque Exhibition, II, 81.

54. Delogu, *op. cit.*, 235. Mention should also be made of the brothers Domenico (d. before 1771) and Giuseppe (d. 1761) Valeriani who had come from Rome to Venice in about 1720 and painted between 1731 and 1733 the Gran Salone at Stupinigi [54] in a manner reminiscent of contemporary Genoese decorations. For their work and that of Crosato, Carlo Andrea Van Loo, and V. A. Cignaroli at Stupinigi, see A. Tellucci, *Le decorazioni della già Reale Palazzina di Caccia di St.*, Turin, 1924, M. Bernardi's book of 1958, and L. Mallè's *Stupinigi*, Turin, 1969.

For the Galliari, the distinguished Piedmontese family of *quadraturisti* and theatrical designers, see Tintelnot (Note 46), 95; M. Ferrero Viale, *Disegni scenografici dei Galliari*, Catalogue, Turin, 1956, and *idem, La scenografia del Settecento e i fratelli Galliari*, Turin, 1963; for the frescoes of the three brothers Bernardino, Fabrizio, and Giovanni Antonio and of Fabrizio's son's, Giovanni and Giuseppino, see the papers by R. Bossaglia in *Arte Lombarda*, III (1958), 105; IV (1959), 131; *Critica d'Arte*, VII (1960), 377; and her book *I fratelli Galliari pittori*, Milan 1962. The best frescoes of the Galliari are in the Salone of the Villa Crivelli at Castellazzo di Bollate, where the exuberant *quadratura* unifies walls and vault.

55. Lorenzo de Ferrari (1680–1744) has already been mentioned (p. 392). For Domenico Parodi (1668–1740), Filippo's son, see S. Soldani, 'Profilo di Domenico Parodi', *Critica d'Arte*, XIV, no. 87 (1967), 60 ff. Paolo Girolamo Piola (1666–1724), Domenico's son, who switched over to Maratti's international

style, deserves a note, and so do Giovan Maria delle Piane, 'il Mulinaretto' (1660–1745), who painted grandiloquent portraits reminiscent of Rigaud (M. Bonzi, *Il Mulinaretto*, Genoa, 1962), and Carlo Antonio Tavella (1668–1738), a landscapist, who began as friend and follower of the romantic Haarlem master, Pieter Mulier (called 'il Tempesta', *c.* 1637–1701), then followed Claude and Gaspar Dughet, but also collaborated with Magnasco. On Pietro Tempesta, see C. Roethlisberger, *Burl. Mag.*, CIX (1967), 12 ff.

56. Among them Andrea Lanzani (1639–1712), Filippo Abbiati (1640–1715; F. Renzo Pesenti, *Commentari*, XVII (1966), 343 ff.), and Stefano Maria Legnani (1660–1713/15) have pride of place. Lanzani's career is typical. He followed the fashionable course of study by going to Rome and working under Maratti. But his work shows that he was much impressed by Lanfranco. In 1697 he accepted a call to Vienna; later he went to Spain. He returned home shortly before his death; see M. G. Turchi in *L'Arte*, LIX (1960), 99 (with *œuvre* catalogue).

Among other Lombard painters may be mentioned (1) Pietro Gilardi, who studied with Dal Sole in Bologna and became a *quadraturista* of distinction (his fresco of 1715 in the Oratory of S. Angelo, Milan, is a *tour de force*, derived from Pozzo's S. Ignazio ceiling); see M. Bussolera in *Arte Lombarda*, VI (1961), 43; (2) P. Antonio Magatti (1691–1767), who was oriented towards Venice (Pittoni) and shows close connexions with the Piazzetta follower Petrini; see E. Arslan in *Commentari*, VIII (1957), 211, and S. Colombo in *Arte Lombarda*, VIII, 2 (1963), 253; (3) the minor Rococo masters Gian Pietro and Cesare Ligari; see R. Bossaglia in *Commentari*, x (1959), 228; (4) Pier Francesco Guala (1698–1757), who appeared with unconventional and impressive portraits at the Turin Baroque Exhibition, 1963, and won laurels as an arcadian painter in the manner of Crosato See R. Carità, in *Atti Soc. Piemontese d'Archeologia e Belle Arti*, N.S. I (1949), also G.V. Castelnovi, in *Studies in the History of Art Dedicated to William E. Suida*, London, 1959; (5) Carlo Innocenzo Carloni (1686–1775), probably the most gifted Lombard Rococo painter, who was ceaselessly active in many places of Central Europe, above all in Vienna, Prague, southern Germany, and northern Italy; see A. B. Brini and K. Garas (Bibliography). Characteristic for his manner are the hypertrophic *quadratura* frescoes in the Villa Lechi at Montirone near Brescia, painted together with Giacomo Lecchi in 1746; see *Connoisseur*, CXLVI (1960), 153; also A. Barigozzi Brini in *Arte Lombarda* VI (1961), 256.

For these and other Lombard painters, see the excellent chapter by A. M. Romanini in *Storia di Milano*, 1959, XII, 713.

57. The Piedmontese Giuseppe Antonio Pianca (1703–after 1755) was to a certain extent dependent on Magnasco. This long forgotten artist has recently aroused much interest; see C. Debiaggi in *Boll. Soc. Piemontese di archeol. e di belle arti*, XII–XIII (1958–9), 158; M. Rosci in *Atti e Memorie del Congresso di Varallo Sesia*, Turin, 1962, 115; *idem, G. A. Pianca. Catalogo*, Varallo Sesia, 1962 (exhibition catalogue with many illustrations).

58. N. Ivanoff, *Mostra del Bazzani in Mantova*, Bergamo, 1950, with full documentary material and bibliography.

59. Francesco Maria Raineri, called Schivenoglia (1676–1758), whose work is similar to Bazzani's, is just beginning to become a defined personality; see C. Volpe and N. Clerici Bagozzi, *Arte Antica e Moderna*, VI, no. 24 (1963), 337, 339.

60. O. Benesch, *Staedel Jahrbuch*, III–IV (1924), 136, discussed Bazzani's influence on Maulpertsch.

61. For the following I am much indebted to G. Fiocco's work (1929) and, above all, to R. Pallucchini's *La pittura veneziana del '700*, Bologna, 1951, 1952. His *La pittura veneziana del Settecento*, Venice, 1960, contains the latest summary of current research. Part III of Haskell's *Patrons* contains a great deal of new material for eighteenth-century Venice in an eminently readable form.

62. B. Nicolson, *Burl. Mag.*, CV (1963), 121, has collected all data referring to Ricci's relation to Lord Burlington in London.

63. *Viatico per cinque secoli di pitt. ven.*, 1946, 34. Illustration 135 represents a work of collaboration of Sebastiano and Marco Ricci (p. 102). It is unusually brilliant and commands special interest because it belongs to the set of twenty-four allegories commissioned by the impresario Owen McSwiny from the foremost Bolognese and Venetian painters. This series of pictures has been intensely studied; see H. Voss, *Rep. f. Kunstw.*, XLVII (1926), 32; W. Arslan, *Riv. d'Arte*, XIV (1932), 128; *ibid.*, XV (1933), 244, and *Commentari*, VI (1955), 189; T. Borenius, *Burl. Mag.*, LXIX (1936), 245; F. J. B. Watson, *ibid.*, XCV (1953), 362; W. G. Constable, *ibid.*, XCVI (1954), 154; *idem, Canaletto*, 1963, 172 (documents), 432. Best summary in Haskell, *Patrons*, 287.

64. D. M. White and A. C. Sewter, *Art Quarterly*, XXIII (1960), 125, attempted (to my mind, not wholly successfully) to interpret this picture allegorically.

65. R. Pallucchini, *Riv. di Venezia*, XIII (1934), 327; W. Arslan, *Critica d' Arte*, I (1935–6), 188.

66. Of the more important pupils may be mentioned Giuseppe Angeli (1710–98), Francesco Daggiù, called il Cappella (1714–84), Antonio Marinetti, called il Chiozzotto (1720–1803), and Domenico Fedeli, called il Maggiotto (1713–93). About all these artists, see Pallucchini, *Riv. di Venezia*, X (1931), XI

(1932). Maggiotto's pupil Ludovico Gallina from Brescia (1752–87) also worked in Piazzetta's academic manner.

The Ticinese painter Giuseppe Antonio Petrini (1667–1758/9) has recently attracted much attention owing to a comprehensive exhibition at Lugano. A pupil of Bartolomeo Guidobono, he came later under Piazzetta's influence, whose manner he imitated with varying success; see W. Arslan, *G. A. Petrini*, Lugano, 1960 (with *œuvre* catalogue); L. Salmina, *Burl. Mag.*, CII (1960), 118; S. Colombo, *Arte Antica e Moderna*, V (1962), 294 (new documents).

67. M. Goering, *Jahrb. Preuss. Kunstslg.*, LVI (1935), 152, with *œuvre* catalogue.

68. R. Pallucchini, *Riv. d' Arte*, XIV (1932), 301 (with *œuvre* catalogue) and *Critica d' Arte*, I (1953–6), 205; Goering, *ibid.*, II (1937), 177. E. Arslan, *Emporium*, XCVIII (1943), 158, claims Lombard influence on Bencovich through Filippo Abbiati, Magnasco's teacher.

69. On Pagani, see H. Voss, *Belvedere*, VIII (1929), 41; N. Ivanoff, *Paragone*, VIII (1957), no. 89, 52, claims that Giulia Lama also belongs to the circle of Pagani, who has his place on the way which 'leads from the Venetian Caravaggeschi to Piazzetta'.

* Wittkower reproduced the *Madonna del Carmine* in the parish church at Bergantino (illustration 340), noting the influence of G. M. Crespi, and stating that it had 'until recently' been attributed to Crespi; Krückmann appears to accept this, and certainly rejects the attribution to Bencovich; we have therefore selected another illustration to replace it.

70. Fontebasso, an untiring worker, came under Tiepolo's influence and ended his career in a rather tired Tiepolesque manner. At the beginning of the 1760s he followed a call to St Petersburg. Recent studies on Fontebasso by A. Pigler, *Arte Veneta*, XIII–XIV (1959–60), 155, and R. Pallucchini, *ibid.*, XV (1961), 182.

For G. Diziani, see F. Valcanover, *Mostra di pitture del Settecento nel Bellunese*, Venice, 1954, 85; A. Rizi in *Acropoli*, II (1962), III. For Zompini, O. Battistella, *Della vita e delle opere di G. G. Z.*, Bologna, 1930, with *œuvre* catalogue.

For the Veronese painter Giovan Battista Marcola (c. 1701–80), whose style as draughtsman shows undeniable links with Sebastiano Ricci, see U. Ruggeri, *Critica d' Arte*, XVII, no. 110 (1970), 35 ff., and *ibid.*, no. 112, 49 ff., with further literature on the artist.

71. M. Goering, *Münchner Jahrbuch der bildenden Kunst*, XII (1937–8), 233; A. Bettagno, *Disegni e dipinti di Antonio Pellegrini*, Venice, 1959 (basic study).

72. H. Voss, *Jahrb. Preuss. Kunstslg.*, XXXIX (1918), 145; Arslan, *Critica d'Arte*, I (1935–6), 238; J. Woodward, *Burl. Mag.*, XCIX (1957), 21; G. M. Pilo. *Arte Veneta*, XII (1958), 158 (review of older literature); *idem*, *Arte Antica e Moderna*, III, no. 9 (1960), 174 (also for connexions with Ricci and Pellegrini); A. Griseri, 'L'ultimo tempo dell'Amigoni e il Nogari', *Paragone*, XI (1960), no. 123, 21.

73. From Amigoni's school came Pier Antonio Novelli (1729–1804), much of whose work belongs to the history of Neo-classicism (see M. Voltolina, *Riv. di Venezia*, XI (1932)), also Antonio Zucchi (1726–95), Angelica Kauffmann's husband, and the sculptor Michelangelo Morlaiter.

74. L. Coggiola-Pittoni, 'Pseudo influenza francese nell'arte di G.B.P.', *Riv. di Venezia*, XII (1933), with *œuvre* catalogue and bibliography.

75. A development similar to that of Pittoni was taken by Nicola Grassi (1682–1748) from Friuli who began his career in Venice under Nicolò Cassana (d. 1713). An artist of distinction, he was drawn in his late phase to Pittoni's manner; see G. Fiocco, *Dedalo*, X (1929), 427; L. Grossato, *Arte Veneta*, II (1948), 130; G. Gallo, *Mostra di Nicola Grassi*, Catalogue, Udine, 1961.

76. E. Battisti, *Commentari*, V (1954), 26 (with *œuvre* catalogue).

77. G. Fiocco, *Pitt. venez.*, 1929, 47 (English ed.), pointed out that Balestra's influence extended from Mantua to the Trentino and the Austrian Baroque.

78. F. R. Presenti, *Arte Antica e Moderna*, III, no. 12 (1960), 418.

78A. Cignaroli's *Death of Rachel* caused a sensation. In 1770 it was exhibited in the Piazza S. Marco and was, according to a contemporary observer, studied by one and all with admiration and amazement.

79. Hugh Honour, 'Giuseppe Nogari', *Connoisseur*, CXL (1957), 154. For Nogari's connexion with Amigoni, see Griseri (above, Note 72).

80. Derivation from Balestra made Bortoloni an easy prey to the influence of the Frenchman Louis Dorigny (1654–1742), who painted in Venice, Verona, and Udine in Lebrun's cool academic manner. That influence will be noticed in Bortoloni's remarkable decoration of Palladio's Villa Cornaro at Piombino Dese (N. Ivanoff, *Arte Veneta*, IV (1950), 123).

Another Balestra pupil, Giambattista Mariotti (1690–1765), adhered later to the Bencovich-Piazzetta current; see N. Ivanoff, *Boll. Museo Civico Padova*, XXXI–XLIII (1942–54), 145.

81. N. Ivanoff, *Boll. d'Arte*, XXXVIII (1953), 58.

82. See the excellent introduction by Antonio Morassi, *G. B Tiepolo*, London, 1955, with bibliography; and the accompanying *œuvre* catalogue, London, 1962.

83. P. d'Ancona, *Tiepolo in Milan: The Palazzo Clerici Frescoes*, Milan, 1956. It has been suggested that the drawing reproduced as illustration 127 might be

a preliminary sketch for the group of a river god, naiad, and fisher boy at the far end of the south portion of the Clerici ceiling; see J. Bean and F. Stampfle, *Drawings from New York Collections III. The Eighteenth Century in Italy*, New York, 1971, 47, no. 82.

84. G. Knox, 'G. B. Tiepolo and the Ceiling of the Scalzi', *Burl. May.*, CX (1968), 394 ff.

85. M. H. von Freden and C. Lamb, *Die Fresken der Würzburger Residenz*, Munich, 1956.

86. Assisted by his sons, Gian Domenico and Lorenzo, who had accompanied him to Madrid.

87. A. Morassi, *Tiepolo e la Villa Valmarana*, Milan, 1945; R. Pallucchini, *Gli Affreschi di G. B. e G. D. Tiepolo alla Villa Valmarana*, Bergamo, 1945. M. Levey, *J.W.C.I.*, XX (1957), 298, has analysed brilliantly the iconography of the Valmarana cycle.

88. This feature derives from Valerius Maximus ('Agamemnon saw Iphigenia advance towards the fatal altar, he groaned, he turned aside his head, he shed tears, and covered his face with his robe'); classical authors assert that in his famous (lost) painting Timanthes of Sikyon represented Agamemnon in this way; thus he appears on Greek vases and in a Pompeian fresco.

In a learned dispute of his day, Tiepolo sides here with textual fidelity and decorum, as did Lessing in his *Laocoon*, 1766 ('Timanthes knew the limits which the Graces had fixed to his Art'). The opposite viewpoint is epitomized in Falconet's words (1775): 'You think of veiling Agamemnon; you have unveiled your own ignorance . . .'. Reynolds (*Eighth Discourse*, 1778) takes up an empirical, common-sense position: The veiling 'appears now to be so much connected with the subject, that the spectator would, perhaps, be disappointed in not finding united in the picture what he always united in his mind, and considered as indispensably belonging to the subject'.

89. Mengozzi-Colonna was responsible for the *quadratura*.

90. For Tiepolo's help to Mengozzi-Colonna, see A. Morassi, *Burl. Mag.*, CI (1959), 228.

91. See T. Hetzer, *Die Fresken Tiepolos in der Würzburger Residenz*, Frankfurt, 1943.

92. See G. Reynolds, *Burl. Mag.*, LXXXII (1940), 44.

93. For the minor pupils of Tiepolo, Giovanni Raggi, Giustino Menescardi, Francesco Lorenzi, Fabio Canal, and others, see R. Pallucchini, *La pitt. venez.*, II, 25. For Francesco Zugno (1709–87), see the monograph by G. M. Pilo, Venice, 1958; *idem* in *Saggi e Memorie di storia dell'arte*, II (1958–9), 323 (with *œuvre* catalogue), and *Paragone*, X (1959), no. III, 33. Jacopo Guarana (1720–1808) continued the Tiepolesque tradition into the nineteenth century.

94. As early as 1678 Malvasia (*Fels. pitt.*, II, 129) criticized this specialization.

95. For the chronology of Longhi's portraits, see V. Moschini, *L'Arte*, XXXV (1932), 110; also W. Arslan, *Emporium*, XCVIII (1943), 51.

96. See R. Longhi, *Viatico*, etc., 35. It is true that Rosalba had a formative influence on Maurice Quentin de la Tour, Liotard, and others.

Of other portrait painters may be mentioned Francesco Pavona (1692–1777), one of Rosalba's imitators; Bartolomeo Nazari (1699–1758), who began as a follower of Fra Galgario and later embraced Amigoni's more elegant manner (F. J. B. Watson, *Burl. Mag.*, XCI (1949), 75); and Ludovico Gallina (Note 66) from Brescia, whose work has affinities with A. Longhi's and Rosalba's.

97. *I pittori della realtà in Lombardia*, Catalogue. Milan, 1953.

98. Bibliography in the Catalogue quoted in the preceding Note. In addition G. Testori, *Paragone*, V (1954), no. 57.

Owing to fairly recent research and exhibitions (see Bibliography) the number of works now known by Ceruti has almost doubled in recent years; his career can be followed from 1724 to 1761 and perhaps even beyond this date. Unexpectedly, some landscapes and some remarkable still lifes by him have been found; see A. Morassi, in *Pantheon*, XXV (1967), 348 ff.

99. Traversi's career was reconstructed by R. Longhi, *Vita Artistica*, II (1927), 145. Dated religious paintings by him are in Naples (1749), Rome (1752), and Parma (1753). See also Longhi, *Paragone*, I (1950), no. I, 44, and A. G. Quintavalle, *ibid.*, VII (1956), no. 81, 39.

100. M. Abbruzzese, *Commentari*, VI (1955), 303; A. M. Clark, *Paragone*, XIV (1963), no. 165, 11. See also F. Negri Arnoldi, *ibid.*, XXI (1970), no. 239, 67 ff.

101. M. Loret, *Capitolium*, XI (1935), 291, with notes on all his sketch-books with caricatures. See also A. Blunt and E. Croft-Murray, *Venetian Drawings of the XVII & XVIII Centuries . . . at Windsor Castle*, London, 1957, 138 ff., with a detailed analysis of Consul Smith's album of Caricatures. Also D. Bodart, 'Disegni giovanili inediti di P. L. Ghezzi nella Bibl. Vaticana', *Palatino*, XI (1967), 141 ff.

Ghezzi's Venetian counterpart as a caricaturist was Antonio Maria Zanetti the Elder (1680–1767), distinguished collector, engraver, and draughtsman, whose 'Album Cini' (now belonging to the Fondazione Cini, Venice) with about 350 caricatures gives an enchanting impression of the society of eighteenth-century Venice; see A. Bettagno, *Caricature di Anton Maria Zanetti*, Venice, 1969.

102. H. Voss, *Pantheon*, II (1928), 512.

103. R. Longhi, *Critica d'Arte*, III (1938), 121.

104. Longhi, *op. cit.*

105. W. Arslan, *L'Arte*, XXXVI (1933), 255; M. Mojzer, *Acta Historiae Artium* (Budapest), IV (1956), 77.

106. The *Arti di Bologna* appeared several times between 1646 and 1740 and had a wide circulation.

107. The connexion is particularly clear in those cases where the figure, large and isolated in the foreground, is not co-ordinated with the indication of landscape or architecture.

A. Griseri, *Paragone*, XII (1961), no. 143, 24, has pointed out that the Lombard Giovenale Boetto (1604–78) etched popular types (1633 ff.) similar to the *Arti di Bologna* even before the latter appeared and that Boetto may have influenced Ceruti. Griseri studied these problems further in N. Carboneri, A. Griseri, *Giovenale Boetto*, Fossano (Cassa di Risparmio), 1966, 42 ff.

108. Arslan, *op. cit.*, 256.

109. Longhi's pupil, the Frenchman Giuseppe Flipart (1721–97), found a ready public for this type of genre in Spain, where he settled as court painter.

A rather facile genre of a similar kind was practised by Marco Marcola (1740–93) from Verona.

In this context I may come back to another Veronese artist, Pietro Rotari (1707–62), who was a considerable success in his day. His teachers were Balestra in Verona, Piazzetta in Venice, Trevisani in Rome, and Solimena in Naples – a typical eighteenth-century curriculum. He specialized in sweetish heads rendered with great precision in clear, cold colours; see G. Fiocco, *Emporium*, XLVIII (1942), 277.

110. I cannot discuss the battle-piece, animal genre, and still life. All these had their great period during the seventeenth century. The many eighteenth-century painters go the trodden path.

For the battle-piece, see L. Ozzola, *I pittori di battaglie nel Seicento e nel Settecento*, Mantua, 1951, with brief comments on all the practitioners. Francesco Simonini from Parma (1686–1753), who worked in Venice in the 1740s, has been more carefully studied; see A. Morassi in *Pantheon*, XIX (1961), I; G. M. Zuccolo Padrono, *Arte Veneta*, XXI (1967), 185 ff.

In Naples the brilliant Andrea Belvedere (1652–1732) and others followed in the footsteps of Ruoppolo. Felice Boselli (1651–1732) from Piacenza excelled in animal, bird, and fish still lifes; see G. Bocchia Casoni in *Parma per l'Arte*, XIV (1964), 31. Bologna had in the Cittadini a whole family specializing in fruit and flower still lifes. For Pier Francesco Cittadini, see E. Riccòmini, *Arte Antica e Moderna*, IV (1961), 362, and A. G. Quintavalle, *Artisti alla corte di Francesco d'Este*, Modena, 1963, 32. Arcangelo Resani (1668/70–1740), the painter of impressively compact still lifes, may here be mentioned. Born in Rome, he moved early to Bologna and on to Forlì and Ravenna, where he died; see A. Corbara, in *Paragone*, XVI (1965), no. 183, 52 ff., and L. Zauli Naldi, *ibid.*, 55 ff.

Carlo Magini (1720–1806) from Forlì painted homely still lifes with a Caravaggesque flavour; see A. Servolini, *Commentari*, VIII (1957), 125, with further literature.

For still life painting in Emilia, see A. G. Quintavalle, *Christoforo Munari e la natura morta emiliana*: Catalogue of the 1964 Parma Exhibition of this painter (1667–1720).

111. The lure of Roman ruins has a long history of its own going back to Petrarch and, in visual terms, to the *Hypnerotomachia Polifili* (1499). Their early 'romantic' inclusion in landscapes by Brill, the antiquarian tendencies of northern artists, such as Heemskerck, and the appearance of ruins in the work of the Bamboccianti and northern landscapists of the mid seventeenth century cannot here be discussed. For the early history of the cult of ruins see W. G. Heckscher, *Die Romruinen*, Würzburg, 1936; for the general problem Rose Macaulay's excellent book *The Pleasure of Ruins*, London, 1953; for the particular problems under review, L. Ozzola, 'Le rovine romane nella pittura del XVII e XVIII secolo', *L'Arte*, XVI (1913), I, 112.

112. See A. M Clark in *Paragone*, XII (1961), no. 139, 51.

113. A. Busiri Vici, 'La prima maniera di Andrea Locatelli', *Palatino*, XI (1967), 366 ff., and M. M. Mosco, 'Les trois manières d'Andrea Locatelli', *Revue de l'Art*, no. 7 (1970), 19–39. This is the fullest discussion of Locatelli's art; with œuvre catalogue. See also 'Monsù Alto, le maître de Locatelli', *ibid.*, 18.

114. H. Voss, *Apollo*, III (1926), 332.

115. O. Ferrari, 'Leonardo Coccorante e la "veduta ideata" napoletana', *Emporium*, CXIX (1954), 9; W. G. Constable, 'Carlo Bonavia and some Painters of Vedute in Naples', *Essays in Honor of G. Swarzenski*, Chicago, 1952, 198. For Bonavia, see also the same author in *Art Quarterly*, 1959, 1960, 1962.

Mention may also be made of the anonymous northerner 'Monsù X', an artist reconstructed by R. Longhi (*Paragone*, V (1954), no. 53, 39) who worked mostly in Rome and combined influences from Rosa and Courtois with those from Seghers, Rembrandt, and other Dutch painters.

Pandolfo Reschi, born in Danzig in 1643, who spent most of his life in Italy,

imitated Salvator and Courtois. He died in 1699 in Florence where he mainly worked.

116. F. Arisi's monograph (1961) with elaborate, fully illustrated œuvre catalogue supersedes L. Ozzola's monograph of 1921 and must be consulted for all questions concerning Pannini. The author established that Pannini was in Rome as early as 1711.

Paintings by the little-known Alberto Carlini (1672–after 1720) are often attributed to Pannini; see H. Voss, *Burl. Mag.*, CI (1959), 443.

117. M. G. Rossi, *Commentari*, XIV (1963), 54. A fine study of Ghisolfi with much new material was published by A. Busiri Vici, in *Palatino*, VIII (1964), 212–20.

118. C. Lorenzetti, *G. Vanvitelli*, Milan, 1934, with œuvre catalogue and bibliography; G. Briganti in *Critica d'Arte*, V (1940), 129; *idem*, *Gaspar Van Wittel*, Rome, 1966 (see Bibliography).

119. Gaspar Vanvitelli had followers in Rome, above all the Dutchman Hendrik Frans van Lint (1684–1763), who spent most of his life in Italy, and Giovanni Battista Busiri (1698–1757), who had a penchant for the small format and whose work was immensely popular with eighteenth-century English 'Grand Tourists'. See the fully illustrated monograph by Andrea Busiri Vici, *G. B. Busiri. Vedutista romano del'700*, Rome, 1966.

120. See G. M. Pilo's excellent Catalogue of the Marco Ricci Exhibition, 1963 (Introduction by R. Pallucchini), with bibliography listing all previous research.

121. For Marieschi, see, apart from the 1967 Catalogue *I vedutisti veneziani*, A. Morassi, *M. Marieschi. Catalogo*, Bergamo, 1966, and *idem* in *Festschrift U. Middeldorf*, Berlin, 1968, 497 ff.

122. Apart from C. Mauroner's monograph, see H. Voss, *Rep. f. Kunstw.*, XLVII (1926), I. On Carlevarijs's Swedish pupil, Johan Richter (1665–1745), who lived in Venice from 1717 on, see G. Fiocco, *L'Arte*, XXXV (1932).

123. W. G. Constable, *Canaletto*, 1962, 102, 265. J. G. Links, *Burl. Mag.*, CIX (1967), 405 ff., published some paintings unknown to Constable.

124. See the basic article by H. F. Finberg, *Walpole Society*, IX (1920–1), 21; also Constable, *op. cit.*, 32. For Consul Smith, see Haskell, *Patrons*, 299.

Canaletto's later work deteriorated in quality. Mass production and the growing demands made upon him by tourists led to a progressive mechanization of his style.

125. Other minor *vedutisti*, such as Antonio Visentini (1688–1782), famed as architect and engraver, Antonio Jolli (c. 1700–77), Pietro Gaspari (1720–85), and Francesco Battaglioli (b. c. 1722), can only be mentioned; for the whole trend, R. Pallucchini, *Pitt. ven.*, II, and *Pitt. ven. Settecento*, 1960, 205.

126. It is well known that Canaletto as well as Bellotto and other painters before and after them, among them G. M. Crespi and even Guardi, regarded the *camera obscura* as a convenient aid for rendering 'correct' views. Best survey of this problem in H. Allwill Fritzsche, *B. Bellotto*, Burg, 1936; see also J. Byam Shaw, *The Drawings of F. Guardi*, London, 1951, 22; T. Pignatti, *Il quaderno di disegni del Canaletto alle Gallerie di Venezia*, Milan, 1958, 20; and the penetrating analysis by D. Gioseffi, *Canaletto*, Trieste, 1959, who based his research on the same *quaderno*, a sketchbook with 138 original Canaletto drawings, now in the Accademia, Venice. Constable, *Canaletto*, 1962, 162, seems to have been unaware of Gioseffi's publication.

127. See M. Muraro, *Burl. Mag.*, CII (1960), 421.

128. *Idem, ibid.*, C (1958), 3.

129. The question was opened up in a penetrating article by W. Arslan (*Emporium*, C (1944), July–Dec., 3) and first summarized by A. Morassi, *ibid.*, CXIV (1951), 195; see also T. Pignatti, *Arte Veneta*, IV (1950), 144. In 1951 appeared also F. de Maffei's partisan *Gian Antonio Guardi pittore di figure* (Verona), which aroused considerable controversy. G. Fiocco valiantly defends the old position of Francesco's primacy, first defined by him in his classic monograph of 1923 (see *Mostra delle opere di Francesco e Gianantonio Guardi esistenti nel Trentino*, Trent, 1949; also *Arte Veneta*, VI (1952), 99, and, more recently, *Francesco Guardi. L'Angelo Raffaele*, Turin, 1958). Once again, Morassi summarized the problem in *Burl. Mag.*, XCV (1953), 263, where he tried to round off Gianantonio's œuvre.

A 'conciliatory' position was taken up by J. Byam Shaw (*op. cit.*, Note 126, 46) and R. Pallucchini, *Pitt. venez.*, II, 196, and *Pittura venez. del Settecento*, 1960, 131 (full discussion), who do not accept the encomium of Gianantonio at the expense of Francesco. See also N. Rasmo's balanced assessment in *Cultura Atesina* IX (1955).

D. Gioseffi in *Emporium*, CXXVI (1957), 99, once again attributes the S. Raffaele paintings to Francesco and advances reasons for dating them as late as 1780–90, while A. Morassi, *ibid.*, CXXXI (1960), 147, 199, offers new arguments for the attribution to Gianantonio. See also S. Sinding-Larsen, in *Acta ad archaeologiam et artium historiam pertinentia* (Institutum Romanum Norvegiae), I (1962), 171–93. The Bibliography (p. 146) should be consulted for later writings on the Guardi brothers.

Bibliography

The general principles followed in compiling this highly selective bibliography are set out on page VI at the front of this volume. Unlike Wittkower, we have felt it incumbent on us to give first names of authors, and titles and pages of articles. We have also chosen a chronological, rather than an alphabetical order, except in section I,B.

For the literature on art, see Julius Schlosser Magnino, *La litteratura artistica*, 3rd ed., Florence, 1964. This provides particularly useful bibliography for guides to the smaller cities, and lives of local artists.

General art bibliographies were printed at the end of each annual volume of *Commentari* (ceased publication after 1978), and *Zeitschrift für Kunstgeschichte* (abandoned the practice after 1983). Both *Arte lombarda* and *Arte veneta* provide each year exhaustive bibliographies of the art and artists of their respective regions. Histories exist for many cities in Italy, which include chapters or, in some cases, volumes on art; those on Milan and Naples are cited here, but those on lesser centres may provide useful information hard to obtain elsewhere.

Older bibliographies for the artists can be found in Thieme-Becker's *Künstler-Lexikon*; the new Saur *Allgemeines Künstler-Lexikon* should also be consulted (Leipzig 1992 ff.); at the time of writing it has reached 'Cesaretti'. Almost all monographs and exhibition catalogues have full bibliographies, often extending much wider than the specific subject of the book.

Thorough and documented biographies, with very extensive bibliographies, are provided in the *Dizionario biografico degli Italiani* (Rome, 1960 ff.), which at the time of writing has reached 'Fererio'; for those artists covered this is usually the best available source. Select bibliographies, but fuller than those given here, are also to be found in the *Macmillan Dictionary of Art* (ed. Jane Turner), and *The Macmillan Encyclopedia of Architects* (4 vols). New York, 1982. The CD-Roms of the *Repertoire d'Art et d'Archéologie*, and *Bibliography of the History of Art* also provides good, though not exhaustive, recent bibliographies.

For prints (on which little material is included here), attention should be drawn to the relevant volumes of the *Illustrated Bartsch* (New York, in progress), particularly valuable for the volumes of Commentaries, up-dating the nineteenth century original.

Cross-references have been kept to the minimum, but it should be borne in mind that general works may often carry more recent information than the monographs or articles listed under individual headings. These should be consulted in particular for relatively minor artists, or those for whom there is scant recent bibliography. Similarly, chapters on patronage are often included in general works on the regions or cities, and many of the works listed under the artists deal with particular iconographic questions.

The bibliographical material is arranged under the following headings:

I. SOURCES

A. DOCUMENTS AND LETTERS

BOTTARI, GIOVANNI G. and TICOZZI, STEFANO. *Raccolta di lettere sulla pittura, scultura ed architettura* (13 vols). Milan, 1822.

GUALANDI, MICHELANGELO. *Nuova Raccolta di lettere* (3 vols). Bologna, 1844.

CEROTTI, FRANCESCO. *Lettere e memorie autografe ed inedite di artisti tratte dai manoscritti della Corsiniana*. Rome, 1860.

GUHL, ERNST. *Künstlerbriefe*. 2nd ed. by A. Rosenberg. Berlin, 1880.

POLLAK, OSKAR. 'Italienische Künstlerbriefe aus der Barockzeit', *Jahrb. Preuss. Kunstslg.*, XXXIV (1913), *Beiheft*, 63 ff.

ORBAAN, JOHANNES A. F. *Documenti sul barocco in Roma*. Rome, 1920.

POLLAK, OSKAR. *Die Kunsttätigkeit unter Urban VIII*. (2 vols). Vienna, 1927, 1931.

FOGOLARI, GINO. 'Lettere pittoriche del Gran principe Ferdinando di Toscana a Niccolò Cassana (1698–1709)', *Riv. del R. Ist.*, VI (1937–8), 145–86.

GOLZIO, VINCENZO. *Documenti artistici sul Seicento nell'archivio Chigi*. Rome, 1939.

BARONI, COSTANTINO. *Documenti per la storia dell'architettura a Milano nel rinascimento e nel barocco* (2 vols). Florence, Rome, 1940–68.

GARMS, JÖRG (ed.). *Quellen aus dem Archiv Doria-Pamphili zur Kunsttätigkeit in Rom unter Innozenz X*. Rome, Vienna, 1972.

LAVIN, MARILYN A. *Seventeenth-Century Barberini Documents and Inventories of Art*. New York, 1975.

GÜTHLEIN, KLAUS. 'Quellen aus dem Familienarchiv Spada', *Röm. Jahrb. f. Kunstg.*, XVIII (1979), 173–246; XIX (1980), 175–250.

See also Mallory. 1974 and 1976; Minor. 1982 (III: ROME, *General*)

B: LIVES OF ARTISTS

BAGLIONE, GIOVANNI. *Le vite de' pittori, scultori ed architetti ...* Rome, 1642. Facsimile ed. by V. Mariani. Rome, 1935. Facsimile with extensive notes and transcriptions of all *postile* for the first three *giornate* by J. Hess, H. Röttgen (3 vols). Città del Vaticano (Studi e testi, 368–70), 1995.

BALDINUCCI, FILIPPO. *Cominciamento, e progresso dell'arte dell'intagliare in rame ...* Florence, 1686.

——*Notizie de' professori del disegno da Cimabue in qua*. Florence, 1681–1728. Enlarged eds, 1767–74; 1845–7. Facsimile of last ed., with notes, by P. Barocchi (6 vols). Florence, 1974–5.

BELLORI, GIOVAN PIETRO. *Le vite de' pittori, scultori ed architetti moderni*. Rome, 1672. Modern ed. with extensive notes by G. Previtali and E. Borea. Turin, 1976.

——*Vite di Guido Reni, Andrea Sacchi, e Carlo Maratti*. Ed. M. Piacentini, Rome, 1942; also included in the 1976 edition of the *Le Vite de' pittori ...*

CRESPI, LUIGI. *Felsina pittrice. Vite de' pittori bolognesi: tomo III, che serve di supplemento all'opera del Malvasia*. Rome, 1769. Reprint Bologna, 1970.

DE DOMINICI, BERNARDO. *Vite de' pittori, scultori ed architetti napoletani*. Naples, 1742–3.

GIANNONE, ONOFRIO. *Giunte sulle vite de' pittori napoletani*. Ed. O. Morisani, Naples, 1941.

MALVASIA, CARLO CESARE. *Felsina pittrice. Vite de pittori bolognesi*. Bologna, 1678. Revised by Giampietro Zanotti (3 vols). Bologna, 1841. Reprint Bologna, 1967; Ed. M. Brascaglia, Bologna, 1971.

——*Vite de pittori bolognesi (Appunti inediti)*. Ed. A. Arfelli, Bologna, 1961.

——*Le carte di Carlo Cesare Malvasia: le 'Vite' di Guido Reni e di Simone Cantarini dal manoscritto B. 16–17 della Biblioteca Comunale dell'Archiginnasio di Bologna* (Ed. L. Marzocchi). Introd. by A. Emiliani. Bologna, 1980.

MANCINI, GIULIO. *Considerazioni sulla pittura. Viaggio per Roma* (2 vols). Eds A. Marucchi and L. Salerno, Rome, 1956.

ORLANDI, PELLEGRINO ANTONIO. *Abecedario pittorico nel quale compendiosamente sono descritte le patrie, i maestri ed i tempi nei quali fiorirono circa quattromila professori di pittura, di scultura e d'architettura*. Bologna, 1704.

PASCOLI, LIONE. *Vite de' pittori, scultori ed architetti moderni* (2 vols). Rome, 1730–6. Reprints: Rome, 1933 and 1965; Amsterdam, 1953. New ed. by V. Martinelli and A. Marabottini. Perugia, 1992. Extensive commentaries on the 88 lives by 46 scholars.

——*Vite de' pittori, scultori ed architetti viventi: dai manoscritti 1383 e 1743 della biblioteca Comunale 'Augusta' di Perugia*. Eds. V. Martinelli, F. Mancini and I.Belli Barsali, Treviso, 1981.

——*Vite de' pittori, scultori ed architetti perugini.* Rome, 1732. Reprint Amsterdam, 1965.

PASSERI, GIOVANNI BATTISTA. *Vite de' pittori, scultori ed architetti che hanno lavorato in Roma, morti dal 1641 fino al 1673.* Rome, 1772. Definitive ed. by J. Hess. *Die Künstlerbiographien von Giovanni Battista Passeri* (Römische Forschungen der Bibliotheca Hertziana, XI). Leipzig/Vienna, 1934. Reprint Worms am Rhein, 1995.

PIO, NICOLA. *Le vite di pittori, scultori ed architetti [Cod. ms. Capponi 257]* (Studi e testi, 278). Eds C. and R. Engass, Città del Vaticano, 1977.

RIDOLFI, CARLO. *Le meraviglie dell'arte. Ovvero le vite degli illustri pittori veneti e dello stato.* Venice, 1648. Critical ed. with notes by D. von Hadeln. Berlin, 1914–24. Reprint Rome, 1965.

SANDRART, JOACHIM VON. *L'Academia Todesca, oder, Teutsche Academie der Edlen Bau- Bild- und Mahlerey-Künste.* Nuremberg, 1675–9. Edition with notes by A. Pelzer. Munich, 1925. Reprint with introd. by C. Klemm. Nordlingen, 1994.

SCANNELLI, FRANCESCO. *Il microcosmo della pittura.* Cesena, 1657. Facsimile ed. by G. Guibbini. Milan, 1966.

SCARAMUCCIA, LUIGI. *Le finezze de' pennelli italiani.* Parma, 1674. Reprint with notes by G. Giubbini. Milan, 1965.

SOPRANI, RAFFAELE. *Vite de' pittori, scultori ed architetti genovesi, e de' forestieri che in Genova operavano.* Genoa, 1674. 2nd ed. enlarged by Carlo Giuseppe Ratti (2 vols). Genoa, 1768–9. Reprint Genoa, 1965.

SUSINNO, FRANCESCO. *Le vite de' pittori messinesi,* 1724. Ed. V. Martinelli, Florence, 1960.

II. GENERAL STUDIES

A. INTERPRETATIONS OF THE BAROQUE

WÖLFFLIN, HEINRICH. *Renaissance und Barock.* Munich, 1888 [see the challenge posed by H. Hibbard in *J.S.A.H.*, 25 (1966) 141–3].

RIEGL, ALOIS. *Die Entstehung der Barockkunst in Rom.* Vienna, 1908.

WEISBACH, W. *Der Barock als Kunst der Gegenreformation.* Berlin, 1921.

PEVSNER, NIKOLAUS. 'Beiträge zur Stilgeschichte des Früh- und Hochbarock', *Repertorium für Kunstwissenschaft,* 49 (1928), 225–46.

CROCE, BENEDETTO. *Storia dell'età barocca in Italia.* Bari, 1929.

PANOFSKY, ERWIN. *'Idea'. Ein Beitrag zur Begriffsgeschichte der älteren Kunsttheorie* (Studien der Bibliothek Warburg, 5). Leipzig, Berlin, 1924. 2nd ed. Berlin, 1960. *Idea. A Concept in Art Theory.* New York, 1968.

LEE, RENSSELAER. '"Ut pictura poesis": the Humanistic Theory of Painting', *Art Bull.*, XXII (1940). Reprint New York, 1967.

MAHON, DENIS. *Studies in Seicento Art and Theory.* London, 1947. Review R. Lee, *Art Bull.*, 33 (1951), 204–12.

——'Eclecticism and the Carracci: Further Reflections on the Validity of a Label', *J.W.C.I.*, XVI (1953), 303–41.

Retorica e barocco. Atti del III Congresso Internazionale di Studi Umanistici. Ed. E. Castelli, Rome, 1955 [Argan and others on rhetoric and the baroque].

GRASSI, LUIGI. *Costruzione della critica d'arte.* Rome, 1955.

KURZ, OTTO. 'Barocco: storia di una parola', in *Lettere Italiane,* XII (1960), 414–44.

ACKERMAN, GERALD. 'Gian Battista Marino's Contributions to Seicento Art Theory', *Art Bull.*, 43 (1961), 326–36.

BIALOSTOCKI, JAN. 'Le "Baroque": style, époque, attitude', in *L'Information d'Histoire de l'Art,* VII, 1962, 20–33 [comprehensive survey of the literature, especially for the first half of the 20th century].

Manierismo, Barocco, Rococò: concetti e termini, Accademia dei Lincei, CCCLIX (1962), especially Wittkower, 'Il barocco in Italia', and Cantimori, D., 'L'età barocca'.

DONATO, EUGENIO. 'Tesauro's Poetics: Through the Looking Glass', *Modern Language Notes,* LXXVIII (1963), 15–30.

BLUNT, ANTHONY. *Some Uses and Misuses of the Terms Baroque and Rococo as Applied to Architecture.* Oxford, 1973. Italian translation Naples, 1978. Published with C. De Seta. 'Sulla presunta città barocca'.

CONTARDI, BRUNO. *La retorica e l'architettura barocca.* Rome, 1978.

FUMAROLI, MARC. '*Cicero Pontifex Romanus*: la tradition rhétorique du Collège Romain et les principes inspirateurs du mécénat des Barberini', *Mélanges de l'Ecole Française de Rome,* 90.2 (1978), 797–835 [stimulating analysis of rhetorical theory].

B: ICONOGRAPHY

General

SALERNO, LUIGI. 'Il dissenso nella pittura. Intorno a Filippo Napoletano, Caroselli, Salvator Rosa e altri', *Storia dell'arte,* 6 (1970), 34–65 [discussion of the interest in magic and stoicism in a group of painters]

PIGLER, ANDOR. *Barockthemen.* New York, 1971 [new, enlarged edition of that published Budapest, 1956].

Landscape

CHIARINI, MARCO. *I disegni italiani di paesaggio, 1600–1750.* Treviso, 1972.

CAVINA, ANNA OTTANI. 'On the Theme of Landscape – I: Additions to Saraceni; II: Elsheimer and Galileo', *Burl. Mag.*, CXVIII (1976), 139–44; 837.

SALERNO, LUIGI. *Pittori di paesaggio a Roma* (3 vols). Rome 1977–80.

Il paesaggio nella pittura fra Cinque e Seicento a Firenze (exhib. cat.). Poggibonsi, 1980.

See also *L'ideale classico del Seicento in Italia e la pittura del paesaggio,* 1962 (III: BOLOGNA AND EMILIA, *Painting*)

Genre and Caricature

SPIKE, JOHN T. *Giuseppe Maria Crespi and the Emergence of Genre Painting in Italy* (exhib. cat.). Fort Worth, 1986.

PAJES MERRIMAN, MIRA and PERINI, GIOVANNA. In *Accademia Clementina. Atti e memorie,* XXVI (1990).

See also III, ROME, *Painting* (Bamboccianti)

Religious

MÂLE, EMILE. *L'art religieux de la fin du XVIe siècle, du XVIIe siècle et du XVIIIe siècle.* Paris, 1951 [the indispensable study].

VOSS, HERMAN. 'Die Flucht nach Aegypten', *Saggi e memorie,* I (1957), 25–61 [supplements Pigler, who omits this theme].

ASKEW, PAMELA. 'The Angelic Consolation of St Francis of Assisi in Post-Tridentine Italian Painting', *J.W.C.I.*, XXXII (1969), 280–306 [exemplary study].

CATELLO, ELIO. *Francesco Celebrano e l'arte nel presepio napoletano del '700.* Naples, 1969.

FITTIPALDI, TEODORO (ed.). *Scultura e presepe nel Settecento a Napoli* (exhib. cat.). Naples, 1979.

PROSPERI VALENTI RODINÒ, SIMONETTA and STRINATI, CLAUDIO. *L'immagine di S. Francesco nella Controriforma* (exhib. cat.). Rome, 1982.

PACINI, PIERO. 'Contributi per l'iconografia di Santa Maria Maddalena de' Pazzi: una 'vita' di Francesco Curradi', *Mitteilungen des Kunsthistorischen Institutes in Florenz,* XXVIII (1984), 279–350.

MOSCO, MARILENA. *La Maddalena tra sacro e profano* (exhib. cat., Florence). Milan, 1986.

OSTROW, STEVEN F. 'Cigoli's Immaculate Virgin and Galileo's Moon: Astronomy and the Apocalyptic Woman in Early Seicento Rome', *Art Bull.*, LXXVIII (1996), 218–35.

See also P. Askew, 1992 (IV, under CARAVAGGIO)

Battle

OZZOLA, LEANDRO. *I pittori di battaglie.* Milan, 1951.

CHIARINI, MARCO (ed.). *Battaglie dipinte dal XVII al XIX secolo dalle gallerie fiorentini* (exhib. cat.). Florence, 1989.

Still Life

GHIDIGLIA QUINTAVALLE, AUGUSTA. *Cristoforo Munari e la natura morte emiliana* (exhib. cat.). Parma, 1964.

CAUSA, RAFFAELLO. 'La natura morte a Napoli nel Sei e Settecento', *Storia di Napoli,* V, 2 (1972), 995–1055.

SALERNO, LUIGI. *La natura morta italiana.* Rome, 1984.

See also F. Bologna, 1985 (IV, under TRAVERSI)

C: PATRONAGE

General

HASKELL, FRANCIS. *Mecenati e pittori.* Florence, 1998 (the most recent revised version of his frequently republished *Patrons and Painters,* originally published 1963).

Museum Culture

IMPEY, OLIVER and MACGREGOR, ARTHUR (eds). *The Origins of Museums.* Oxford, 1985.

POMIAN, KRZYSZTOF. *Collectionneurs, amateurs et curieux. Paris, Venise: XVIe–XVIIIe siècle.* Paris, 1987. Translated as *Collectors and Curiosities. Paris and Venice, 1500–1800.* London, 1990. Especially 'The Age of Curiosity', 45–64 [important essay defining the 'culture of curiosity'].

SOLINAS, FRANCESCO and NICOLÒ, ANNA. 'Cassiano dal Pozzo and Pietro Testa: New Documents Concerning the *Museo cartaceo*', in Elizabeth Cropper (ed.). *Pietro Testa 1612–1650: Prints and Drawings* (exhib. cat.). Philadelphia, 1988, lxvi–lxxxvi.

GABRIELI, GIUSEPPE. *Contributi alla storia della Accademia dei Lincei* (2 vols). Rome, 1989 [77 essays by the great historian of the Lincei].

SOLINAS, FRANCESCO (ed.). *Cassiano Dal Pozzo: Atti del Seminario Internazionale di Studi,* Rome, 1989.

HASKELL, FRANCIS (ed.). *Il museo cartaceo di Cassiano dal Pozzo.* [n.p.] 1989.

GRIFFITHS, ANTONY. 'The Print Collection of Cassiano dal Pozzo', *Print Quarterly,* VI (March 1989), 3–10.

SPARTI, DONATELLA. 'Carlo Antonio Dal Pozzo (1606–1689). An Unknown Collector', *Journal of the History of Collections,* 2 (1990), 7–19.

CONNORS, JOSEPH. '*Ars Tornandi*: Baroque Architecture and the Lathe', *J.W.C.I.*, LIII (1990), 217–36.

POMIAN, KRZYSZTOF. 'Les deux pôles de la curiosité antiquaire', in *L'anticomanie. La collection d'antiquités aux 18e et 19e siècles*. Eds A.-F. Laurens and K. Pomian, Paris, 1992, 59–68.

FRANZONI, CLAUDIO and TEMPESTA, LESSANDRA. 'Il museo di Francesco Gualdi nella Roma del seicento: tra raccolta privata ed esibizione pubblice', *Boll. d'Arte*, n.72 (1992), 1–42.

CROPPER, ELIZABETH, PERINI, GIOVANNA and SOLINAS, FRANCESCO (eds). *Documentary Culture: Florence and Rome from Grand-Duke Ferdinand I to Pope Alexander VII* (1990). Baltimore, 1992.

Cassiano Dal Pozzo's Paper Museum. London, 1992 (*Quaderni Puteani*, 2 and 3) [Acts of a conference held at the British Museum and Warburg Institute].

HERKLOTZ, INGO. 'Neue Literatur zur Sammlungsgeschichte', *Kunstchronik*, 47.3 (1994), 117–35.

FINDLEN, PAULA. *Possessing Nature. Museums, Collecting, and Scientific Culture in Early Modern Italy*. Berkeley and Los Angeles, 1994.

——'Scientific Spectacle in Baroque Rome: Athanasius Kircher and the Roman College Museum', *Roma moderna e contemporanea*, III (1995), 625–65.

The Paper Museum of Cassiano Dal Pozzo is in course of publication, general eds. Francis Haskell and Jennifer Montagu. Series A (Antiquities and Architecture), ed. Amanda Claridge; Series B (Natural History), ed. David Freedberg. Published to date: John Osborne, *Early Christian and Medieval Antiquities* (2 vols); David Freedberg, *Citrus Fruit*. Two exhibitions *The Paper Museum of Cassiano Dal Pozzo* were held in London, British Museum, 1993, and Edinburgh, National Gallery of Scotland, 1997.

HERKLOTZ, INGO. *Cassiano dal Pozzo und die Archäologie des 17. Jahrhunderts*, Munich, 1999.

Jesuits

GALASSI PALUZZI, C. *Storia segreta dello stile dei gesuiti*, Rome, 1951 [historiography of the idea of a Jesuit style, with extensive bibliography].

PIRRI, PIETRO, S.J. 'Intagliatori gesuiti italiani dei secoli XVI e XVII', *Archivum Historicum Societatis Iesu*, 21 (1952), 3–59.

DE DAINVILLE, FRANÇOIS. 'La légende du style jésuite', *Etudes*, 287 (1955), 3–16.

VALLERY-RADOT, JEAN. *Le recueil de plans d'édifices de la Compagnie de Jésus conservé à la Bibliothèque Nationale de Paris*. Rome, 1960.

WITTKOWER, RUDOLF and JAFFÉ, IRMA (eds). *Baroque Art: The Jesuit Contribution*. New York, 1972.

BÖSEL, RICHARD and GARMS, JÖRG. 'Die Plansammlung des Collegium Germanicum-Hungaricum', *Römische Historische Mitteilungen*. 23 (1981), 335–84; 25 (1983), 225–72.

KÖNIG-NORDHOFF, URSULA. *Ignatius von Loyola. Studien zur Entwicklung einer neuen Heiligen-Ikonographie im Rahmen einer Kanonisationskampagne um 1600*. Berlin, 1982.

BÖSEL, RICHARD. 'Die Nachfolgebauten von S. Fedele in Mailand', *Wiener Jahrbuch für Kunstgeschichte*, XXXVII (1984), 67–87.

——*Jesuitenarchitektur in Italien 1540–1773, Teil I: Die Baudenkmäler der römischen und der neapolitanishen Ordensprovinz* (2 vols). Vienna, 1985.

Dall'isola alla città. I Gesuiti a Bologna. Bologna, 1988 [especially Bösel, 85–93].

BÖSEL, RICHARD. 'Typus und Tradition in der Baukultur gegenreformatorischer Orden', *Römische Historische Mitteilungen*, XXXI (1989), 239–53.

LUCAS, THOMAS, S.J. (ed.). *Saint, Site and Sacred Strategy: Ignatius, Rome and Jesuit Urbanism* (exhib. cat.). Città del Vaticano, 1990.

NOBILE, MARCO ROSARIO. 'Fondi per lo studio dell'architettura dei Gesuiti in Italia', *Il disegno di architettura*, 3 (1991), 35–8.

BÖSEL, RICHARD. 'Tipologie e tradizioni architettoniche nell'edilizia della Compagnia de Gesù', in *L'architettura della Compagnia di Gesù in Italia XVI–XVIII secolo* (1990). Eds L. Patetta and S. Della Torre, Genoa, 1992, 13–26.

FUMAROLI, MARC. 'Baroque et classicisme: l'*Imago Primi Saeculi Societatis Jesu* (1640) et ses adversaires', in *L'école du silence. Le sentiment des images au XVIIe siècle*. Paris, 1994, 343–65.

GIARD, LUCE and DE VAUCELLES, LOUIS, S.J. *Les jésuites à l'âge baroque 1540–1640*. Grenoble, 1996.

LUCAS, THOMAS, S.J. *Landmarking: City, Church & Jesuit Urban Strategy*. Chicago, 1997.

O'MALLEY, JOHN, S.J. (and others) (eds). *The Jesuits: Cultures, Sciences and the Arts 1540–1773*. Toronto, 1999.

Other Religious Orders

HIBBARD, HOWARD. 'The Early History of Sant'Andrea della Valle', *Art Bull.*, 43 (1961), 289–318.

GAUK-ROGER, NIGEL. 'The Architecture of the Barnabite Order 1545–1659: with special reference to Lorenzo Binago and Giovanni Ambrogio Mazenta', diss. Cambridge University,[n.d., c. 1982].

DE MARI, NICOLÒ. 'Le istruzioni di architettura nelle lettere di S. Giuseppe Calasanzio e il 'modo nostro' dei padri delle Scuole Pie', *Palladio*, 8 (July–Dec. 1991), 51–76.

La regola e la fama. San Filippo Neri e l'arte (exhib. cat., Rome). Milan, 1995.

SCHWAGER, KLAUS. 'L'architecture religieuse à Rome de Pie IV à Clément VIII', *L'église dans l'architecture de la Renaissance*. Paris, 1995, 223–44.

NOBILE, MARCO ROSARIO. 'Chiese a pianta ovale tra controriforma e barocco: il ruolo degli ordini religiosi', *Palladio*, 17 (January–June 1996), 41–50.

Florence

CHIARINI, MARCO and ASCHENGREEN PIACENTI, KIRSTEN. *Artisti alla corte granducale*. Florence, 1969.

RUDOLF, STELLA. 'Mecenate a Firenze tra Sei e Settecento', *Arte illustrata*, V (1972), 228–41; VI (1973), 213–28; VII(1974), 279–98.

BORRONI SALVADORI, FABIA. 'Francesco Maria Niccolò Gabburri e gli artisti contemporanei', *Annali della Scuola Normale Superiore di Pisa; Classe di Lettere e Fiolosofia*, ser. 3, IV (1974), 1503–64.

FORLANI TEMPESTI, ANNA and PETRIOLI TOFANI, ANNA MARIA (eds). *Omaggio a Leopoldo de' Medici*, I, *Disegni*; Meloni Trkulja, Silvia, II *Ritrattini* (exhib. cat.). Florence, 1976.

BOREA, EVELINA. *La quadreria di Don Lorenzo de' Medici* (exhib. cat., Poggio a Caiano). Florence, 1977.

GOLDBERG, EDWARD L. *Patterns in Late Medici Art Patronage*. Princeton, 1983.

MASCALCHI, SILVIA. 'Giovan Carlo de' Medici: An Outstanding but Neglected Collector in 17th Century Florence', *Apollo*, CXX (1984), 268–72 [with bibliography].

BAROCCHI, PAOLA (ed.). *Il Cardinal Leopoldo: archivi del collezionismo medico*. Milan, 1987.

GOLDBERG, EDWARD L. *After Vasari. History, Art, and Patronage in Late Medici Florence*. Princeton, 1988.

Rome
Popes

PASTOR, LUDWIG, FREIHERR VON. *The History of the Popes from the Close of the Middle Ages* (40 vols). London and St Louis, 1912–53. Original: *Geschichte der Päpste*. Freiburg im Breisgau, 1901–37 [Italian and French translations also exist. The 17th-century popes begin with vol. 23 in the English ed.; the chapters on their patronage are indispensable].

SIEBENHÜNER, HERBERT. 'Umrisse zur Geschichte der Ausstattung von St. Peter in Rom von Paul III. bis Paul V. (1547–1606)', *Festschrift für Hans Sedlmayr*. Munich, 1962, 229–320.

HAIDACHER, ANTON. *Geschichte der Päpste in Bildern*. Heidelberg, 1965.

IVERSEN, ERIK. *Obelisks in Exile, vol. I: The Obelisks of Rome. Copenhagen, 1968 [essential chapters on the popes who moved the obelisks from Sixtus V through the 18th century]*.

Sixtus V

STEVENSON, E. *Topografia e monumenti di Roma nelle pitture di Sisto V*. 1887.

DELUMEAU, JEAN. *Vie économique et sociale de Rome dans la seconde moitié du XVIe siècle*. Paris, 1957.

SCHWAGER, KLAUS. 'Zur Bautätigkeit Sixtus V. an S. Maria Maggiore in Rom', *Miscellanea Bibliothecae Hertzianae*. Munich, 1961, 324–54.

BUDDENSIEG, TILMANN. 'Gregory the Great, the Destroyer of Idols', *J.W.C.I.*, XXVIII (1965), 44–65.

KRAUTHEIMER, RICHARD. 'A Christian Triumph in 1597', *Essays in the History of Art Presented to Rudolf Wittkower*. London, 1967, 174–8.

MARDER, TOD. 'Sixtus V and the Quirinal', *J.S.A.H.*, XXXVII (1978), 283–94.

HERZ, ALEXANDRA. 'The Sixtine and Pauline Tombs. Documents of the Counter-Reformation', *Storia dell'Arte*, 43 (1981), 241–62.

WITCOMBE, CHRISTOPHER. 'Sixtus V and the Scala Santa', *J.S.A.H.*, 44 (1985), 368–79.

SPEZZAFERRO, LUIGI. 'La Roma di Sisto V', in *Storia dell'Arte Italiana*, 12 (1983), 363–405.

SCHIFFMANN, RENÉ. *Roma felix: Aspekte der städtebaulichen Gestaltung Roms unter Papst Sixtus V*. Bern, 1985.

GAMRATH, HELGE. *Roma sancta renovata: studi sull'urbanistica di Roma nella seconda meta del sec. XVI*. Rome, 1987.

CERUTTI FUSCO, ANNAROSA. 'Il progetto di Domenico Fontana "per ridurre il coliseo di Roma ad habitatione" e le opere sistine di "pubblica utilità"', *Quaderni*, n.s., 12 (1988), 65–84.

SIMONCINI, GIORGIO. 'La concezione originaria del piano sistina', *Saggi in onore di Renato Bonelli (Quaderni*, n.s., fasc. 15–20, 1990–2), II, 667–74.

SETTE, MARIA PIERA and BENEDETTI, SIMONA. *L'arte a Roma al tempo di Sisto V. Architetture per la città*, special issue of *Storia architettura*, n.s., 1 (1992).

MADONNA, MARIA LUISA (ed.). *Roma di Sisto V. Le arti e la cultura.* Rome, 1993.

OSTROW, STEVEN. *Art and Spirituality in Counter-Reformation Rome. The Sistine and Pauline Chapels in S. Maria Maggiore.* Cambridge, 1996.

MANDEL, CORINNE. *Sixtus V and the Lateran Palace.* Rome, 1994.

Clement VIII

ABROMSON, MORTON. 'Clement VIII's Patronage of the Brothers Alberti', *Art Bull.*, 60 (1978), 531–47.

——*Painting in Rome during the Papacy of Clement XIII (1592–1605). A Documented Study.* New York, 1981.

MACIOCE, STEFANIA. *Undique Splendent. Aspetti della pittura sacra nella Roma di Clemente VIII Aldobrandini (1592–1605).* Rome, 1990.

FREIBERG, JACK. *The Lateran in 1600. Christian Concord in Counter-Reformation Rome.* Cambridge, 1995.

Paul V

NOACK, FRIEDRICH. 'Kunstpflege und Kunstbesitz der Familie Borghese', *Repertorium für Kunstwissenschaft*, L (1929), 191–231.

HEILMANN, CRISTOPH. 'Acqua Paola and the Urban Planning of Paul V Borghese', *Burl. Mag.*, 112 (1970), 656–62.

REINHARD, WOLFGANG. 'Ämterlaufbahn und Familienstatus: Der Aufstieg des Hauses Borghese 1537–1621', *Quellen und Forschungen aus Italienischen Archiven und Bibliotheken*, 54 (1974), 328–427.

SCHWAGER, KLAUS. 'Die architektonische Erneuerung von S. Maria Maggiore unter Paul V.', *Röm. Jahrb. f. Kunstg.*, XX (1983), 241–312.

REINHARDT, VOLKER. *Kardinal S. Borghese (1605–1633). Vermögen, Finanzen und sozialer Aufstieg eines Papstnepoten.* Tübingen, 1984.

ROCA DE AMICIS, AUGUSTO. 'Studi su città e architettura nella Roma di Paolo V Borghese (1605–1621)', *Bollettino del Centro di Studi per la Storia dell'Architettura*, 31 (1984), 1–97.

VON FLEMMING, VICTORIA. '"ozio con dignità"? Die Villenbibliothek von Kardinal Scipione Borghese', *Römische Quartalschrift*, 85 (1990), 182–224.

WOLF, GERHARD. 'Regina Coeli, Facies Lunae, "et in terra pax"', *Römisches Jahrbuch der Bibliotheca Hertziana*, 27–8 (1991–2), 283–336.

FUMAGALLI, ELENA. *Palazzo Borghese committenza e decorazione privata.* Rome, 1994.

ANTINORI, ALOISIO. *Scipione Borghese e l'architettura. Programmi, progetti, cantieri alla soglie dell'età barocca.* Rome, 1995 [review by Elena Fumagalli in *Quasar*, 13–14 (1995), 89–95].

Urban VIII

POLLAK, OSKAR. *Die Kunsttätigkeit unter Urban VIII.* (2 vols). Vienna, 1928–31.

LUTZ, GEORG. 'Rom und Europa während des Pontifikats Urbans VIII. Politik und Diplomatie – Wirtschaft und Finanzen – Kultur und Religion', in R. Elze (ed.). *Rom in der Neuzeit: Politische, Kirchliche und Kulturelle Aspekte.* Vienna, Rome, 1976, 72–167.

SCOTT, JOHN BELDON. *Images of Nepotism: The Painted Ceilings of Palazzo Barberini.* Princeton, 1991.

NUSSDORFER, LAURIE. *Civic Politics in the Rome of Urban VIII.* Princeton, 1992.

RICE, LOUISE. 'Urban VIII, the Archangel Michael, and a forgotten project for the apse altar of St Peter's', *Burl. Mag.*, 134 (1992), 428–34.

MERZ, JÖRG. 'Das Fortuna-Heiligtum in Palestrina als Barberini-Villa', *Zeitschrift für Kunstgeschichte*, 56 (1933), 409–50.

HAMMOND, FREDERICK. *Music & Spectacle in Baroque Rome. Barberini Patronage under Urban VIII.* New Haven, London, 1994.

SCOTT, JOHN BELDON. 'Patronage and the Visual Encomium during the Pontificate of Urban VIII: The Ideal Palazzo Barberini in a Dedicatory Print', *Memoirs of the American Academy in Rome*, XL (1995), 197–234.

RICE, LOUISE. *The Altars and Altarpieces of New St Peter's. Outfitting the Basilica, 1621–1666.* Cambridge, 1997.

See above, *Sixtus V*, S. Ostrow, 1996.

Innocent X

GARMS, JÖRG (ed.). *Quellen aus dem Archiv Doria-Pamphilj zur Kunsttätigkeit in Rom unter Innozenz X.* Rome, Vienna, 1972.

PREIMESBERGER, RUDOLF. 'Obeliscus Pamphilius: Beiträge zur Vorgeschichte und Ikonographie des Vierströmbrunnens auf Piazza Navona', *Münchner Jahrbuch der bildenden Kunst*, XXV (1974), 77–162.

—— 'Pontifex Romanus per Aeneam Praesignatus: Die Galleria Pamphilj und ihre Fresken', *Röm. Jahrb. für Kunstg.*, 16 (1976), 221–83.

CHIOMENTI VASSALLI, DONATA. *Donna Olimpia e del nepotismo nel Seicento.* Milan, 1979.

Imago Pietatis 1650. I Pamphilj a San Martino al Cimino (exhib. cat., Viterbo). Rome, 1987.

ZUCCARI, ALESSANDRO and MACIOCE, STEFANIA (eds). *Innocenzo X Pamphilj. Arte e potere a Roma nell'età barocca.* Rome, 1990.

See below, IV. ARTISTS, BORROMINI: Eimer, G., 1970.

Alexander VII

WIBIRAL, NORBERT, 'Contributi alle ricerche sul Certonismo in Roma: I pittori della Galleria di Alessandro VII nel Palazzo del Quirinale', *Boll. d'Arte*, XLV, 1960, 123–65.

KRAUTHEIMER, RICHARD and JONES, ROGER. 'The Diary of Alexander VII', *Röm. Jahrb. f. Kunstg.*, XV (1975), 199–233 [see also G. Morello, *Bernini in Vaticano*, 1981].

KRAUTHEIMER, RICHARD. *The Rome of Alexander VII, 1655–1677.* Princeton, 1985.

SLADEK, ELISABETH. 'Der Palazzo Chigi-Odescalchi an der Piazza SS. Apostoli', *Römische Historische Mitteilungen*, 27 (1985), 439–503.

MORELLO, GIOVANNI. 'I rapporti tra Alessandro VII e Gian Lorenzo Bernini negli autografi del Papa (con disegni inediti)', in E. Cropper, G. Perini and F. Solinas (eds). *Documentary Culture: Florence and Rome from Grand-Duke Ferdinand I to Pope Alexander VII* (1990). Baltimore, 1992, 81–125.

METZGER HABEL, DOROTHY. 'The Projected Palazzo Chigi al Corso and S. Maria in Via Lata: The Palace-Church Component of Alexander VII's Program for the Corso', *Architectura*, 21 (1991), 121–35.

——'Alexander VII and the Private Builder: Two Case Studies in the Development of Via del Corso in Rome', *J.S.A.H.*, 49 (1990), 293–309.

BUTZEK, MONIKA (ed.). *Il Duomo di Siena al tempo di Alessandro VII. Carteggio e disegni (1658–1667)* (Die Kirchen von Siena, Beiheft 2). Munich, 1996.

Clement XI

JOHNS, CHRISTOPHER. *Papal Art and Cultural Politics: Rome in the Age of Clement XI.* Cambridge, 1993.

Clement XII

KIEVEN, ELISABETH. 'Überlegungen zu Architektur und Ausstattung der Cappella Corsini', in Elisa Debenedetti (ed.). *L'architettura da Clemente XI a Benedetto XIV* (Studi sul Settecento Romano 5). Rome, 1989, 69–91.

Benedict XIV

Benedetto XIV e le arti del disegno (symposium 1994). Bologna, in press.

Rome – General

MONTALTO, LINA. *Un mecenate in Roma barocca: il cardinale Benedetto Pamphili, 1653-1730.* Florence, 1955.

Storia dell'arte, IX–X (1971) [important articles, especially by C. L. Frommel and L. Spezzaferro on the patronage and cultural pursuits of Cardinal del Monte].

HEIMBÜRGER RAVALLI, MINNA. *Architettura, scultura e arti minori nel barocco italiano. Ricerche nell'Archivio Spada.* Florence, 1977.

GAMBARDELLA, ALFONSO. *Architettura e committenza nello stato pontificio tra barocco e rococò. Un amministratore illuminato Giuseppe Renato Imperiali.* Naples, 1979.

ZUCCARI, ALESSANDRO. *Arte e committenza nella Roma di Caravaggio.* Turin, 1984.

CONFORTI, CLAUDIA. 'Testimonianze letterarie e disegni inediti sulle residenze estensi a Roma fra il XVI e il XVII secolo', *Palladio*, n.s., II (1989), 44–68.

PAMPALONE, ANTONELLA. *La cappella della famiglia Spada nella Chiesa Nuova: Testimonianza documentaria.* Rome, 1993.

Alesandro Albani patrono delle arti: Architettura, pittura e collezionismo nella Roma del '700 (Studi sul Settecento romano), 9 (1993).

RUDOLPH, STELLA. 'Premessa ad un indagine sul mecenatismo del Cardinale Alderano Cybo ...', *Bollettino dei Musei Comunali di Roma*, VIII (1994), 5–31.

WAZBINSKI, ZYGMUNT. *Il Cardinale Francesco Maria del Monte 1559–1626* (2 vols). Florence, 1994.

MATITTI, FLAVIA. 'Il cardinale Pietro Ottoboni mecenate delle arti. Cronache e documenti (689–1740)', *Storia dell'arte*, 84 (1995), 156–243.

RUDOLPH, STELLA. *Niccolò Maria Pallavicini. L'ascesa al Tempio della Virtù attraverso il mecenatismo.* Rome, 1995.

MONTANARI, TOMASO. 'Il cardinale Decio Azzolino e le collezioni d'arte di Cristina di Svezia', *Studi secenteschi*, XXXVIII (1997), 187–264.

DANESI SQUARZINA, SILVIA. 'The collections of Cardinal Benedetto Giustiniani', *Burl. Mag.*, CXXXIX (1997), 766–91; CXL (1998), 102–18.

See also *Caravaggio e la collezione Mattei*, 1995 (IV, under CARAVAGGIO); *Arte per i Papi ...*, 1990 (III: ROME, *General*)

Other

VIVIAN, FRANCES. *Il console Smith mercante e collezionista.* Vicenza, 1971.

ASKEW, PAMELA. 'Ferdinando Gonzaga's Patronage of the Visual Arts: The Villa Favorita', *Art Bull.*, LX (1978), 274–96.

BINION, ALICE. *La Galleria scomparsa del maresciallo von der Schulenburg: Un mecenate nella Venezia del Settecento.* Venice, 1987.

SOUTHORN, JANET. *Power and Display in the Seventeenth Century: The Arts and their Patrons in Modena and Ferrara.* Cambridge, 1988.

BONFAIT, OLIVIER. 'Il valore della pittura. L'economia del mecenatismo di Pompeo Aldrovandi (é 1752)', *Arte a Bologna. Bollettino dei Musei Civici d'arte antica*, I (1990), 83–94.

LABROT, GÉRARD. *Collections of Paintings in Naples 1600–1780* (The Provenance Index of the Getty Art History Information Program). Munich, New York, 1992.

Le stanze del Cardinale Monti 1635–1650: La collezione ricomposta (exhib. cat.). Milan, 1994.

BJURSTRÖM, PER. *Nicolo Pio as a Collector of Drawings*. Stockholm, 1995.

Le collezioni di Carlo Emanuele I di Savoia. Ed. G. Romano, Turin, 1995.

I Farnese: arte e collezionismo. Studi. Ed. L. Fornari Schianchi, Milan, 1995 [companion volume to the catalogue of the exhibition *I Farnese* (Parma, Naples, Munich, 1995), with some studies more directly relevant to the baroque].

VASCO ROCCA, SANDRA and BORGHINI, GABRIELE (eds). *Giovanni V di Portogallo (1707–1750) e la cultura romana del suo tempo* (exhib. cat., 1990–1). Rome, 1995.

See also R. Cioffi, 1994 (III: NAPLES, *Sculpture*)

D: HISTORIES AND STUDIES OF BAROQUE ART AND ARCHITECTURE

1. The Three Arts

VENTURI, ADOLFO. *Storia dell'arte italiana*, IX–XI. Milan: IX, 6–7 (1933–4), painting; X, 3 (1934), sculpture; XI, 2–3 (1939–40), architecture [these volumes should be used for the transition from the sixteenth to the seventeenth century].

GOLZIO, VINCENZO. *Il Seicento e il Settecento*. Turin, 1968 (third ed.) [encyclopaedic attempt, with close to a thousand illustrations].

GRISERI, ADREINA. *Le metamorfosi del barocco*. Turin, 1950 [an unusual and fascinating work, containing many challenging ideas; concentration on Piedmont].

HUBALA, ERICH. *Die Kunst des 17. Jahrhunderts* (*Propyläen Kunstgeschichte*, IX). Berlin, 1970.

WITTKOWER, RUDOLF. *Studies in the Italian Baroque*. London, 1975.

Grand Tour. The Lure of Italy in the Eighteenth Century. Eds A. Wilton and I. Bignanimi, London (Tate Gallery), 1995.

2: General Italian Architecture Surveys

GURLITT, CORNELIUS. *Geschichte des Barockstiles in Italien*. Stuttgart, 1887.

BRIGGS, MARTIN SHAW. *Baroque Architecture*. London, 1913. Reprint New York, 1967 [a period piece].

BRINCKMANN, ALBERT E. *Die Baukunst des 17. und 18. Jahrhunderts*, vol. I: *Baukunst des 17. und 18. Jahrhunderts in den romanischen Ländern*, Berlin, 1919

RICCI, CORRADO, *Baroque Architecture and Sculpture in Italy*, Stuttgart, 1926

CHIERICI, GINO. *Il palazzo italiano dal secolo XI al secolo XIX*. Milan, 1957. Enlarged ed. 1964 [outdated but a wide selection].

MILLON, HENRY. *Baroque and Rococo Architecture*. New York, 1967.

HAGER, WERNER. *Barock Architektur*. Baden-Baden, 1968, 25–76 [Italy in the context of European baroque].

PALUMBO, PIER FAUSTO (ed.). *Barocco europeo, barocco italiano, barocco salentino* (Congressi Salentini, I). Lecce, 1970 [papers on all regions of Italy as well as the Salentino].

NORBERG-SCHULZ, CHRISTIAN. *Baroque Architecture*. New York, 1971.

WITTKOWER, RUDOLF. *Gothic vs. Classic. Architectural Projects in Seventeenth-Century Italy*. New York, 1974.

JACOB, SABINE. *Italienische Zeichnungen der Kunstbibliothek Berlin*. Berlin, 1975.

BLUNT, ANTHONY. 'Italy', in *Baroque and Rococo Architecture and Decoration*. London, 1978, 8–105 [the best of the pan-European surveys].

DE LOGU, GIUSEPPE. *L'architettura italiana del Seicento e del Settecento* (1936). Bari, 1980.

VARRIANO, JOHN. *Italian Baroque and Rococo Architecture*. Oxford and New York, 1986.

MATTEUCCI, ANNA MARIA. *L'architettura del Settecento*. Turin, 1988 [the best overview of the eighteenth century in Italy].

KIENE, MICHAEL. 'Der Palazzo della Sapienza – Zur Italienischen Universitätsarchitektur des 15. und 16. Jahrhunderts', *Röm. Jahrb. f. Kunstg.*, 23/24 (1988), 219–71 [innovative study of the university as a building type].

FAGIOLO, M. and MADONNA, M.L. (eds). *Il barocco romano e l'Europa* (1987). Rome, 1992.

KIEVEN, ELISABETH. *Von Bernini bis Piranesi. Römische Architekturzeichnungen des Barock* (exhib. cat.). Stuttgart, Graphische Sammlung Staatsgalerie, 1993 [innovative study of architectural draftsmanship].

JARRARD, ALICE. 'The Escalation of Ceremony and Ducal Staircases in Italy, 1560–1680', *Annali di architettura*, 8 (1996), 159–78.

DEL PESCO, DANIELA. *L'architettura del Seicento*. Turin, 1998 [best overview of the seventeenth century].

3. Sculpture

FERRARI, GIULIO. *Lo stucco nell' arte italiana*. Milan, 1910 [handy collection of illustrations].

——*La tomba nell' arte italiana*. Milan, 1916 [see comment on above].

BRINCKMANN, ALBERT E. *Barock-Bozzetti* (4 vols). Frankfurt, 1923–4 [first 2 vols cover Italy; should be used for the important da collection of material, not the attributions].

DE CARVALHO, ROBERT, ARMINDO AYRES. *A Escultura em Mafra*. Mafra, 1956 (2nd ed.) [mainly early eighteenth-century Italian sculpture sent to Portugal].

FALDI, ITALO. *La scultura barocca in Italia*. Milan, 1958 [brief, competent text].

POPE-HENNESSY, JOHN. *Italian High Renaissance and Baroque Sculpture* (3 vols). London, 1970 [a good introduction, though the space allotted to the baroque is relatively brief; scholarly catalogue entries].

ENGGASS, ROBERT. 'Un problème du baroque romain tardif. Projets de sculpture par des artistes non sculpteurs', *Revue de l'art*, XXXI (1976), 21–32 [see also M. Conforti, 1977 (IV, under LEGROS)].

WITTKOWER, RUDOLF. *Sculpture: Processes and Principles*. London, 1977.

BUTZEK, MONIKA. 'Die Papstmonumente im Dom von Siena', *Mitteilungen des kunsthistorischen Institutes in Florenz*, XXIV (1980), 15–78.

NAVA CELLINI, ANTONIA. *La Scultura del Seicento*. Turin, 1982.

——*La Scultura del Settecento*. Turin, 1982.

BOUCHER, BRUCE. *Italian Baroque Sculpture*. London, New York, 1997 [excellent brief English language introduction].

4. Painting

LANZI, LUIGI. *Storia pittorica dell' Italia*. Bassano, 1795–6 (3 vols; first complete edition). First English transl. by T. Roscoe, 1828 [still unequalled for knowledge of the material and breadth of approach].

FRIEDLAENDER, WALTER. *Mannerism and Anti-Mannerism in Italian Painting*. New York, 1957 [reprint of classic articles first published 1925, 1929].

L'ideale classico del Seicento in Italia e la pittura del paesaggio (exhib. cat.). Bologna, 1962 [contains a number of essays of great value].
Review: E. Schaar, *Zeitschr. f. Kunstg.*, XXVI (1963), 52–61.

WATERHOUSE, ELLIS. *Italian Baroque Painting*. London, 1962 [an eminently readable introduction].

PÉREZ SÁNCHEZ, ALFONSO E. *Pittura italiana del s. XVII en España* . Madrid, 1965 [first serious attempt to catalogue and illustrate all Italian Seicento paintings in Spain].
Review: E. Harris, *Burl. Mag.*, CX (1968), 159–60.

Art in Italy, 1600–1700 (exhib. cat.). Ed. F. Cummings, Detroit, 1965. Introduction by R. Wittkower [brought together the best paintings, drawings and sculpture of the period in American collections; learned catalogue entries by seven experts].

MOIR, ALFRED. *The Italian Followers of Caravaggio* (2 vols). Cambridge (Mass.), 1967.

MAXON, JOHN and RISHEL, JOSEPH J. (eds). *Painting in the Eighteenth Century: Rococo to Romanticism* (exhib. cat., Chicago, Minneapolis, Toledo). Chicago, 1970.

Caravaggeschi francesi (exhib. cat.). Eds A. Brejon de Lavergnée and J.-P. Cuzin, Rome, 1973 (subsequently shown as *Valentin et les Caravaggesques françaises*, Paris, 1974.) [Most worked much of their lives in Italy].

SPEAR, RICHARD E. *Caravaggio and his Followers*. New York, 1975 (2nd ed.).

MOREL, PHILIPPE. 'Morfologia delle cupole dipinte da Correggio a Lanfranco', *Boll. d'Arte*, LXIX, 23 (1984), 1–34.

Seicento. Le siècle de Caravage dans les collections françaises (exhib. cat. Paris, Milan). Eds A. Brejon de Lavergnée and N. Volle, Paris, 1988.

La pittura in Italia. Il Seicento (2 vols). Eds M. Gregori and E. Schleier. Milan, 1989 (2nd ed.).

SESTIERI, GIANCARLO. *La pittura del Settecento*. Turin, 1989 [many pictures on the market].
Review: M. T. Caracciolo, *Revue de l'art*, 86 (1989), 86.

La pittura in Italia. Il Settecento (2 vols). Ed. G. Briganti, Milan, 1990.

FERRARI, ORESTE. *Bozzetti italiani dal Manierismo al Barocco*. Naples, 1990.

NICOLSON, BENEDICT. *Caravaggism in Europe*. Milan, 1990 [revised by L. Vertova, from the original *The International Caravaggesque Movement*. Oxford, 1979].
Review: R. Spear, *Burl. Mag.*, CXXI (1979), 317–22.

FINALDI, GABRIELE and KITSON, MICHAEL. *Discovering the Italian Baroque. The Denis Mahon Collection* (exhib. cat.). London, 1997

5. Drawing

STAMPFLE, FELICE and BEAN, JACOB. *Drawings from New York Collections, II, The Seventeenth Century in Italy* (exhib. cat.). New York, 1967.
Review: W. Vitzthum, *Burl. Mag.*, CIX (1967), 253–4.

BEAN, JACOB and STAMPFLE, FELICE. *Drawings from New York Collections, III, The Eighteenth Century in Italy* (exhib. cat.). New York, 1971.

GRAF, DIETER. *Master Drawings of the Roman Baroque from the Kunstmuseum Düsseldorf* (exhib. cat., London and Edinburgh). London, 1973 [catalogues of the Düsseldorf holdings of individual artist are cited in IV].

Sammlung Schloss Fachsenfeld. Zeichnungen, Bozzetti und Aquarelle aus fünf Jahrhunderten in Verwahrung der Staatsgalerie Stuttgart (exhib. cat.). Stuttgart, 1978 [a collection particularly rich in Bolognese drawings].

BEAN, JACOB. *17th Century Italian Drawings in the Metropolitan Museum of Art*. New York, 1979.

WARD JACKSON, PETER. *Victoria and Albert Museum Catalogues. Italian Drawings, II, 17th–18th century*. London, 1980.

MENA MARQUÉS, MANUELA B. *Museo des Prado. Catálogo de dibujos*, VI *Dibujos Italianos del siglo XVII*, Madrid, 1983; VII *Dibujos Italianos del siglo XVIII*, Madrid, 1990.

——*Dibujos Italiano de los siglos XVII y XVIII en la Biblioteca Nacional*. Madrid, 1984 [extensive selection].

BEAN, JACOB and GRISWOLD, WILLIAM. *18th Century Drawings in the Metropolitan Museum of Art*. New York, 1990.

III. REGIONS

BOLOGNA AND EMILIA

General

ZANOTTI, GIOVAN P. *Storia dell'Accademia Clementina*. Bologna, 1739 [see also the Commentary, and Index, produced by A. Ottani Cavina, Bologna, 1977].

MALVASIA, CARLO. *Le pitture di Bologna*. Ed. A. Emiliani, Bologna, 1969 [originally published 1686, most important contemporary guide-book].

RICCI, CORRADO and ZUCCHINI, GUIDO. *Guida di Bologna*. Bologna, 1968.

Società e cultura nella Piacenza del Settecento (exhib. cat.). Piacenza, 1979 [in 5 parts].

La chiesa di S. Giovanni Battista e la cultura ferrarese del Seicento (exhib. cat., Ferrara). Milan, 1981 [wider ranging than the title may suggest].

CIRILLO, GIUSEPPE and GODI, GIOVANNI (eds). *Il trionfo del barocco a Parma nelle feste farnesiane del 1690*. Parma, 1989.

Architecture

CUPPINI, GIAMPIERO and MATTEUCCI, ANNA MARIA. *Ville del bolognese*. Bologna, 1969.

CUPPINI, GIAMPIERO. *I palazzi senatorii a Bologna. Architettura come immagine del potere*. Bologna, 1974.

ADORNI, BRUNO. *L'architettura farnesiana a Parma 1545–1630*. Parma, 1974.

SOLI, GUSMANO. *Chiese di Modena* (Deputazione di Storia Patria per le Antiche Provincie Modenesi, Biblioteca, n.s., 27) (4 vols). Ed. G. Bertuzzi, Modena, 1974 [indispensable collection of monographs by an antiquarian who died in 1927].

MATEUCCI, ANNA MARIA. *Palazzi di Piacenza dal Barocco al Neoclassico*. Turin, 1979.

ADANI, GIUSEPPE, FOSCHI, MARINA and VENTURI, SERGIO. *Ville dell'Emilia Romagna*, vol. ii: *Dai fasti del Settecento al villino urbano*. Milan, 1983 [a photographic survey].

Il Palazzo ducale di Modena. Sette secoli di uno spazio cittadino. Ed. A. Biondi, Modena, 1987.

MATTEUCCI, ANNA MARIA, MANFREDI, CARLO and COCCIOLI MASTROVITI, ANNA. *Ville piacentine*. Piacenza, 1991.

MATTEUCCI, ANNA MARIA and STANZANI, ANNA (eds). *Architetture dell'inganno: cortili bibieneschi e fondali dipinti nei palazzi storici bolognesi ed emiliani* (exhib. cat.). Bologna, 1991.

Sculpture

RICCÒMINI, EUGENIO. *Ordine e vaghezza. La scultura in Emilia nell'età barocca*. Bologna, 1972.

——. *Vaghezza e furore. La scultura del Settecento in Emilia*. Bologna, 1977.

Painting

Maestri della pittura del Seicento emiliano (exhib. cat.). Bologna, 1959.

RICCÒMINI, EUGENIO. *I fasti, i lumi, le grazie; pittori del Settecento parmense*. Parma, 1977.

ROLI, RENATO. *Pittura bolognese 1650–1800; Dal Cignani al Gandolfi*. Bologna, 1977.

L'arte del Settecento emiliano. La pittura. L'Accademia Clementina (exhib. cat.). Bologna, 1979.

Nell'età di Correggio e dei Carracci. Pittura in Emilia dei secoli XVI e XVII (exhib. cat., Bologna, Washington, New York). Bologna, 1986.

FEINBLATT, EBRIA. *Seventeenth-Century Bolognese Ceiling Decorators*. Santa Barbara, 1992.

La pittura in Emilia e in Romagna. Il Seicento (2 vols). Ed. A. Emiliani, Bologna, 1994.

VOLPE, CARLO. *La pittura nell'Emilia e nella Romagna. Raccolta di scritti sul Cinque, Sei e Settecento*. Modena, 1994.

NEGRO, EMILIO and PIRONDINI, MASSIMO. *La scuola dei Carracci* (2 vols). Modena, 1994–5.

LOIRE, STÉFANE. *Musée du Louvre, Département des Peintures: École italienne, XVIIe siècle, I. Bologne*. Paris, 1996 [exceptionally well illustrated with related works].

Drawings

KURZ, OTTO. *Bolognese Drawings of the XVII & XVIII Centuries ... at Windsor Castle*. London, 1955.

EMILIANI, ANDREA. *Mostra di disegni del Seicento emiliano nella Pinacoteca di Brera*. Milan, 1959.

JOHNSTON, CATHERINE. *Disegni Bolognesi* (exhib. cat.). Florence, 1973 [drawings in the Uffizi].

CAZORT, MIMI and JOHNSTON, CATHERINE. *Bolognese Drawings in North American Collections 1500–1800* (exhib. cat.). Ottawa, 1982.

FLORENCE AND TUSCANY

A full bibliography (including individual artists, many of whom are not listed in the bibliography to Wittkower) can be found in Miles Chappell. 'Renascence of the Florentine Baroque', *Dialoghi di storia di arte*, VII (1998), 56–111.

General

BOCCHI, FRANCESCO and CINELLI, GIOVANNI. *Le bellezze della città di Firenze*. Florence, 1677 [best contemporary guide-book].

DEL MIGLIORE, FERDINANDO LEOPOLDO. *Firenze città nobilissima illustrata*. Florence, 1684. Reprint Bologna, 1968.

PAATZ, WALTER and ELISABETH. *Die Kirchen von Florenz*. Frankfurt, 1940–54 [indispensable; includes bibliography for early descriptions].

PROCACCI, UGO. *La Casa Buonarroti a Firenze*. Milan, 1965.

CHIARINI, MARCO. *Artisti alla corte granducale*. Florence, 1969.

GINORI-LISCI, LEONARDO. *I palazzi di Firenze nella storia e nell'arte* (2 vols). Florence, 1972.

COCHRANE, ERIC. *Florence in the Forgotten Centuries, 1527–1800*. Chicago, 1973.

BORRONI SALVADORI, FABIA. 'Le esposizioni d'arte a Firenze dal 1674 al 1767', *Mitteilungen des Kunsthistorischen Institutes in Florenz*, XVIII (1974), 1–166 [index by artist of works exhibited at SS. Annunziata].

The Twilight of the Medici: Late Baroque Art in Florence 1670–1743 (exhib. cat., Detroit); *Gli ultimi Medici ...* (exhib. cat., Florence) 1974.

BIGONGIARI, PIERO. *Il Seicento fiorentino tra Galileo e il 'Recitar Cantando'*. Milan, 1974 [pioneering essays (1962–74) on Florentine artists, the expressive qualities of their art, and relationships to music and literature].

MOSCO, MARILENA. *Itinerario di Firenze barocca*. Florence, 1974 [brief, but useful].

PETRIOLI TOFANI, ANNAMARIA. *Il luogo teatrale a Firenze* (exhib. cat.). Florence, 1975.

Kunst des Barock in der Toskana. Studien zur Kunst unter den letzten Medici. Munich, 1976.

VLIEGENTHART, ADRIAAN W. *La Galleria Buonarotti, Michelangelo e Michelangelo il Giovane*. Florence, 1976 [translation of Dutch ed., with English summary, 1969].

RIEDER-GROHS, BARBARA. *Florentinische Feste des Spätbarock. Ein Beitrag zu Kunst am Hof der letzten Medici 1670–1743*. Frankfurt am Main, 1978.

RIEDL, PETER A. and SEIDEL, MAX (eds). *Die Kirchen von Siena*. Munich, 1985 ff. (in progress) [indispensable full descriptions, progressing in alphabetical order. Has at present reached S. Domenico].

Il Seicento fiorentino (exhib. cat.). Florence, 1986 (3 vols: Painting; drawings, prints, sculpture, minor arts; biographies).

ANDANTI, ANDREA. *Il Seicento ed il Settecento ad Arezzo: Architettura, scultura, pittura*. Arezzo, 1990.

CIARDI, ROBERTO P. (ed.). *Settecento pisano: pittura e scultura a Pisa nel secolo XVIII*. Pisa, 1990.

GREGORI, MINA (ed.). *Cappelle barocche a Firenze*. Florence, 1990.

FANUCCI LOVITCH, MIRIA. *Artisti attivi a Pisa fra XIII e XVIII secoli* (2 vols). Pisa, 1991, 1995 [the second volume is concerned with the baroque period].

Colle di Val d'Elsa nell'età dei granduchi medicei (exhib. cat., Colle di Val d'Elsa). Florence, 1992.

FALLETTI, FRANCA (ed.). *Chiostri Seicenteschi a Pistoia*. Florence, 1992.

PETRIOLI TOFANI, ANAMARIA. 'L'illustrazione teatrale e il significato dei documenti figurativi per la storia dello spettacolo', in *Documentary Culture: Florence and Rome from Grand-Duke Ferdinando I to Pope Alexander VII* (acts of colloquium 1990). Bologna, 1992.

Architecture

GURRIERI, F. (ed.). *Architettura e interventi territoriali nella Toscana granducale.* Florence, 1972.

MORROGH, ANDREW. *Disegni di architetti fiorentini 1540–1640* (exhib. cat.). Florence, 1985.

CRESTI, CARLO. *La Toscana dei Lorena. Politica del territorio e architettura.* Florence, 1987.

—— *L'architettura del Seicento a Firenze.* Rome, 1990.

CACIAGLI, COSTANTINO. *Pisa città e architetture del settecento.* Pisa, 1994.

HINTERKEUSER, GUIDO. 'Die Villa Acciaioli in Montegufoni. Zum Einfluss des römischen Barocks auf die Architektur in der Toskana', *Mitteilungen des Kunsthistorischen Institutes in Florenz,* 39 (1995), 307–73.

Sculpture

LANKHEIT, KLAUS. *Florentinische Barockplastik.* Munich, 1962 [monumental work, opening up a hitherto almost unstudied field].

—— *Die Modellsammlung der Porzellanmanufaktur Doccia: Ein Dokument italienischer Barockplastik.* Munich, 1982 [a vital source for the small-scale sculpture of many Florentine baroque sculptors].
Review: J. Montagu, *Burl. Mag.,* CXXV (1983), 757–9.

ROANI VILLANI, ROBERTA. 'La decorazione plastica dell'arco di porta San Gallo a Firenze', *Paragone,* 437 (1986), 53–67.

CIARDI, ROBERTO P., CASINI, CLAUDIO and TONGIORGI TOMASI, LUCIA. *Scultura a Pisa tra Quattro e Seicento.* Pisa, 1987.

PIZZORUSSO, CLAUDIO. *A Boboli e altrove. Sculture e scultori fiorentini del Seicento.* Florence, 1989.

PRATESI, GIOVANNI (ed.). *Repertorio della scultura fiorentina del Seicento e Settecento.* Turin, 1993.
Review: J. Montagu, *Burl. Mag.,* CXXXVI (1994), 851–2.

BUTTERS, SUZANNE. *The Triumph of Vulcan. Sculptors' Tools, Porphyry and the Prince in Ducal Florence.* Florence, 1996.

See also M. Butzek, 1980 (II, D.3 *Sculpture*)

Painting

MASETTI, ANNA R. 'Il Casino Mediceo e la pittura fiorentina del Seicento', *Critica d'arte,* IX, 50 (1962), 1–27; IX, 53–4 (1962), 77–109.

HIBBARD, HOWARD and NISSMAN, JOAN L. *Florentine Baroque Art from American Collections* (exhib. cat.). New York, 1969.

CANTELLI, GIUSEPPE. 'Precisazioni sulla pittura fiorentina del Seicento. I: I Furiani' *Antichità viva,* X, 4 (1971), 3–16.

CHAPPELL, MILES. 'Portraits and Pedagogy in a Painting by Cristofano Allori', *Antichità viva,* XVI, 5 (1977), 20–34 [A.'s painting as a declaration of a new style in Florence].

MCCORQUODALE, CHARLES. *Painting in Florence 1600–1700.* London, 1979.
Reviews: G. Ewald, *Kunstchronik,* XXXII (1979), 415–21.
C. Pizzorusso, *Antologia di belle arti,* 9–12 (1984), 172–6.

CANTELLI, GIUSEPPE. *Repertorio della pittura fiorentina del Seicento.* Fiesole, 1983 [contains many works on the market].

INGENDAAY RODIO, MARTINA. 'Überlegungen zur Barockmalerei in Siena, 1640–1750', *Storia dell'arte,* 49 (1983), 191–210.

CANTELLI, GIUSEPPE. 'Valori simbolici e sangue nella pittura fiorentina del Seicento', *Paradigma,* 8 (1988), 107–21.

GUICCIARDINI CORSI SALVIATI, ALESSANDRA. *Affreschi di Palazzo Corsini a Firenze.* Florence, 1989.

Pittura toscana e pittura europea. Atti del convegno ... Pisa, 1990. Florence, 1993.

CIARDI, ROBERTO, CONTINI, ROBERTO and PAPI, GIANNI. *Pittura a Pisa tra manierismo e barocco,* Milan, 1992.

MARKOVA, VITTORIA. 'Dipinti del Seicento fiorentino in Russia', *Antichità viva,* XXXIII, 5 (1994), 36–42.

MCGRATH, ELIZABETH. 'A seventeenth-century celebration of Plato in Renaissance Florence', in *Sight & Insight. Essays on art and culture in honour of E. H. Gombrich at 85.* Ed. J. Onians, London, 1994, 191–220.

La pittura a Lucca nel primo Seicento (exhib. cat., Lucca). Pisa, 1994.

Drawing

BACOU, ROSELINE and BEAN, JACOB. *Dessins florentins de la collection de Filippo Baldinucci* (exhib. cat.). Paris, 1958. Italian edition, Rome, 1959.

PROSPERI VALENTI RODINÒ, SIMONETTA. *Disegni fiorentini 1560–1640 dalle collezioni del Gabinetto Nazionale delle Stampe* (exhib. cat.). Rome, 1977.

THIEM, CHRISTEL. *Florentiner Zeichner des Frühbarock.* Munich, 1977.
Reviews: A. Petrioli Tofani, *Prospettiva,* XIX (1979), 74–88.
S. Prosperi Valenti Rodinò, *Storia dell'arte,* 36–7 (1979), 271–7.

VIATTE, FRANÇOISE and MONBEIG GOGUEL, CATHERINE. *Dessins florentins du Musée du Louvre* (exhib. cat.). Paris, 1981.

VIATTE, FRANÇOISE. *Musée du Louvre, Cabinet de Dessins. Inventaire général des dessins italiens, III: Dessins toscans XVIe–XVIIe siècles. I: 1560–1640.* Paris, 1988.

CHIARINI, MARCO. *Bellezze di Firenze: Disegni fiorentini del Seicento e del Settecento dal Museo di Belle Arti di Lille* (exhib. cat.). Milan, 1991.
See also M. Chappell, etc., 1979 (III: ROME, 5 [drawing])

GENOA AND LIGURIA

General

RATTI, CARLO G. *Istruzione di quanto può vedersi di più bello in Genova* (2nd ed). Genoa, 1780. Reprint Bologna, 1976.

ALIZERI, FEDERIGO. *Guida illustrativa ... per la città di Genova.* Genoa, 1875 [best older guide-book].

Le ville genovesi. Genoa, 1967. Published by the Genoese section of 'Italia Nostra'. [a cooperative enterprise by E. De Negri, C. Fera, L. Grossi Bianchi and E. Poleggi; reliable guide to about 150 seventeenth- and eighteenth-century villas in and near Genoa].

GAVAZZA, EZIA and ROTONDI TERMINIELLO, GIOVANNA (eds). *Genova nel età barocca* (exhib. cat., Genoa). Bologna, 1992.

ROTONDI TERMINIELLO, GIOVANNA (ed.). *San Giacomo della Marina: un oratorio di casaccia a Genova nel cammino verso Compostella.* Genoa, 1996.

Architecture

RUBENS, PETER PAUL. *Palazzi di Genova.* Antwerp, 1622. Later eds 1652, 1663, 1708 and 1755. Facsimiles: Genoa, 1955 (of the 1652 ed.); Ed. A. Tait, New York, 1968; Ed. H. Schomann, Dortmund, 1982.

GROSSO, ORLANDO. *Portali e palazzi di Genova.* Genoa, [n.d., c.1910] [a choice selection of vintage photographs].

ROSSI, A. *L'architettura religiosa barocca a Genova.* Genoa, 1959 [good photographic survey].

FIESCHI BOSSOLO, GABRIELLA. 'Aspetti dell'architettura settecentesca in Liguria', *Palladio,* XV (1965), 129–42.

Le ville genovesi. Genoa, 1967 [guide to about 150 villas by E. De Negri, C. Fera, L. Grossi Bianchi and E. Poleggi].

POLEGGI, ENNIO. *Strada Nuova. Una lottizzazione del Cinquecento a Genova.* Genoa, 1972 [a Renaissance street which continues into the baroque period].

PAZZINI PAGLIERI, NADIA and PAGLIERI, RINANGELO. *Architettura religiosa barocca nelle valli di Imperia.* Genoa, 1983.

DE MARI, NICOLÒ. 'La chiesa delle scuole pie a Genova e il ruolo dei Padri Scolopi nella diffusione in Liguria di un impianto barocco de matrice lombarda', *Palladio,* I (June 1988), 135–46.

PAZZINI PAGLIERI, NADIA and PAGLIERI, RINANGELO. *Chiese barocche a Genova e in Liguria.* Genoa, 1992.

MÜLLER PROFUMO, LUCIANA. *Le pietre parlanti. L'ornamento nell'architettura genovese 1450–1600.* Genoa, 1992 [concluding chapter on the early baroque].

Sculpture

La Scultura a Genova e in Liguria II, *dal Seicento al primo Novecento.* Campomorone (Genua), [n.d].

FRANCHINI GUELFI, FAUSTA. *Le casacce: arte e tradizione.* Genoa, 1973.

Painting

GAVAZZA, EZIA. *Lo spazio dipinto.* Genoa, 1975.

PESENTI, FRANCO R. *La Pittura in Liguria, artisti del primo seicento.* Genoa, 1986.

La Pittura a Genova e in Liguria dal Seicento al primo Novecento. Genoa, 1987 (2nd ed.) [less useful than Pesenti].

GAVAZZA, EZIA, LAMERA, FEDERICA and MAGNANI, LAURO. *La pittura in Liguria. Il secondo Seicento.* Genoa, 1990.

MILAN AND LOMBARDY

General

Storia di Milano. Milan (Fondazione Trecani degli Alfieri), X (1957); XI (1958); XII (1959)

Il Seicento lombardo (exhib. cat.). Milan, 1973 (three vols: introductory essays; painting and sculpture; drawings, books, prints).

MAZZOTTA BURATTI, ADELE, and BAGATTI VALSECCHI, PIER FASTO, *Milano nel settecento e le vedute architettoniche di Marc'Antonio Dal Re,* Milan, 1976

BURATTI, ADELE, et al., *La città rituale. La città e lo stato di Milano nell'età dei Borromeo,* Milan, 1982

Il Seicento nell'arte e nella cultura; con riferimenti a Mantova (acts of congress). Milan, 1985.

Atti del convegno barocco: Barocco lombardo – barocco europeo, in *Arte lombarda,* 98–9 (1991).

JONES, PAMELA. *Federico Borromeo and the Ambrosiana: Art Patronage and Reform in 17th Century Milan.* Cambridge, 1993.

Architecture

HOFFMANN, HANS. 'Die Entwicklung der Architektur Mailands von 1550–1650', *Wiener Jahrbuch für Kunstgeschichte,* IX (1934), 63–100.

GENGARO, MARIA LUISA. 'Dal Pellegrini al Richino. Costruzioni Lombarde a pianta centrale', *Boll. d'Arte*, 30 (1936), 202–6.

BARONI, COSTANTINO. *Documenti per la storia dell'architettura a Milano nel Rinascimento e nel Barocco*, I, Florence, 1940; II, Rome, 1968.

——*L'architettura lombarda da Bramante al Ricchini*. Milan, 1941.

BASCAPE, GIACOMO. *I palazzi della vecchia Milano*. Milan, 1945 ['nostalgic itineraries' and social life].

MEZZANOTTE, P. and BASCAPE, G. *Milano nell'arte e nella storia*. Milan, 1948.

Storia di Milano (vols X–XII). Milan, 1957–9 [extensive coverage of Milanese art in essays by P. Mezzanotte, G.A. Dell'Aquila, G. Nicodemi and A.M. Romanini].

GRASSI, LILIANA. *Provincie del Barocco e del Rococò. Proposta di un lessico bio-bibliografico di architetti in Lombardia.*[n.p., n.d] (Milan, 1966) [complete dictionary of Lombard architects with extensive photographic coverage and bibliography].

PEROGALLI, CARLO and FAVOLI, PAOLO. *Ville dei navigli lombardi*. Milan, 1967. 3rd ed., 1982.

LANGÉ, SANTINO. *Ville delle provincie di Como, Sondrio e Varese*. Milan, 1968.

NOVASCONI, ARMANDO. *Il barocco nel Lodigiano*. Milan, 1968.

MADERNA, GIAN BATTISTA. 'Fonti per la storia dell'architettura milanese dal XVI al XVIII secolo. Il Collegio degli Argrimensori Ingegneri e Architetti. Le nomine degli Architetti dal 1735 al 1800', *Arte Lombarda*, 15 (1970), 69–75.

LANGÉ, SANTINO. *Ville della provincia di Milano*. Milan, 1972.

GATTI PERER, MARIA LUISA. 'Cultura e socialità dell'altare barocco nell'antica diocesi di Milano', *Arte Lombarda*, 42–3 (1975), 11–64.

Le alternative del Barocco. Architettura e condizione urbana a Brescia nella prima metà del Settecento (exhib. cat.). Brescia, 1981.

MARTELLI, GISBERTO. 'Indagini su alcune contrade del vecchio centro di Milano: le chiese scomparse', *Bollettino d'Arte*, 24, March–April 1984, 59–78

FIORINO, MARIA TERESA (ed.). *Le chiese di Milano*. Milan, 1985.

DENTI, GIOVANNI. *Architettura a Milano tra controriforma e barocco*. Florence, 1988.

ZUCCHI, CINO. *L'architettura dei cortili milanesi 1535–1706*. Milan, 1989.

COTTINI, PAOLO. *Giardini di Lombardia. Dalle origini all'età barocca*. Varese, 1994.

Biblioteca trivulziana. La raccolta Bianconi. Disegni per Milano dal manierismo al barocco. Archivio storico civico-Biblioteca trivulziana. Ed. I. Balestreri, Milan, 1995.

GATTI PERER, MARIA LUISA. *Il Santuario della Beata Vergine dei Miracoli di Saronno*. Milan, 1996.

GATTI PERER, MARIA LUISA and SPIRITI, ANDREA (eds). 'Atlante del barocco lombardo', *Arte Lombarda*, 119 (1997/1), 58–83 [part of the project for an *Atlante del Barocco*. Ed. M. Fagiolo].

The Sacro Monte

DEL FRATE, SAC. COSTANTINO. *S. Maria del Monte sopra Varese*. Chiavari, 1933 [full photographic coverage].

WITTKOWER, RUDOLF. 'Montagnes sacrées', *L'Oeil*, 59 (1959), 54–61 ; 92.

COLOMBO, SILVANO. *Profilo della architettura religiosa del seicento. Varese e il suo teritorio*. Milan, 1970 [brief overview including the Sacro Monte].

BIANCONI, PIERO, COLOMBO, SILVANO, LOZITO, ALDO and ZANZI, LUIGI. *Il Sacro Monte sopra Varese*. Milan, 1981 [review by William Hood in *Art Bull.*, 67 (1985), 333–7, criticizing Wittkower for interpreting *sacri monti* in the context of post-Tridentine reform].

CARESIO, FRANCO. *Il Sacro Monte di Varallo*. Biella, 1984.

Iconografia del Sacro Monte di Varallo (exhib. cat.) Ed. M. Cometti Valle, Varallo, 1984.

HOOD, WILLIAM. 'The *Sacro Monte* of Varallo: Renaissance Art and Popular Religion', in *Monasticism and the Arts*. Ed. T. Verdon, Syracuse, 1984, 291–311 [Franciscan interpretation of the first Sacro Monte].

LOTTI, CARLO ALBERTO (ed.). *Il Sacro Monte di Varese. La quattordicesima cappella e la 'Fabbrica' del Rosario*. Milan, 1990 [studies following a restoration].

ZANZI, LUIGI. *Sacri monti e dintorni. Studi sulla cultura religiosa ed artistica della Controriforma*. Milan, 1990 [the fullest study].

LANGÉ, SANTINO and PENSA, ALBERTO. *Il sacro monte. Esperienza del reale e spazio virtuale nell'iconografia della passione a Varallo*. Milan, 1991.

LANGÉ, SANTINO and PACIAROTTI, GIUSEPPE. *Barocco alpino. Arte e architettura religiosa del Seicento: spazio e figuratività*. Milan, 1994 [ambitious attempt to document stucco artists in the Alpine regions, with over 300 resumés and extensive bibliography].

Sculpture
See *Il Duome di Milano*, 1969 (below: Individual Monuments)

Painting

I pittori bergamaschi; il Seicento, I–IV. Bergamo, 1983–7.

I pittori bergamaschi; il Settecento, I–II. Bergamo, 1982, 1999.

BONA CASTELLOTTI, MARCO (ed.). *La pittura lombarda del '600*. Milan, 1985 [contains too many works on the market].

—— *La pittura lombarda del '700*. Milan, 1986 [as above].

Il Seicento a Bergamo (exhib. cat.). Bergamo, 1987.

BOSSAGLIA, ROSSANA and TERRAROLI, VALERIO (eds). *Settecento lombardo* (exhib. cat.). Milan, 1991.

Individual Monuments

Il Duomo di Milano. [Atti del] Congresso Internazionale … 1968. Ed. M. L. Gatti Perer, Milan, 1969 [with important contributions to the sculpture, and the planning of the façade in the baroque period].

NAPLES AND THE SOUTH

Guidebooks and maps

SARNELLI, POMPEO. *Guida de' Forestieri curiosi di vedere, e d'intendere le cose più notabili della Regal Città di Napoli e del suo amenissimo distretto*. Ed. A. Bulifon, Naples, 1688.

CELANO, CARLO. *Delle notizie del bello, dell'antico, e del curioso della città di Napoli*. Naples, 1692. Subsequent eds. 1724, 1758–9, 1792, 1856–60 (Ed. G.B. Chiarini, with commentary; anastatic reprint Naples, 1970), 1970 (Eds A. Mozzillo, A. Profeta and F.P. Macchia, with index). See Benedetto Croce. 'Un innamorato di Napoli', *Napoli Nobilissima*, II (1893), 65–70; and Valter Pinto. *Racconti di opere e racconti di uomini. La storiografia artistica a Napoli tra periegesi e biografia 1685–1700*. Naples, 1997 [most important guidebook].

DE SETA, CESARE. *Cartografia della città di Napoli. Lineamenti dell'evoluzione urbana* (3 vols). Naples, 1969 (vol. III is a full-size reproduction of the Duca di Noja plan).

General

Storia di Napoli. Naples (Edizione scientifiche italiane), V.2 (1972); VI.2 (1970); VIII (1971).

Civiltà del '700 a Napoli 1734–1799 (exhib. cat., Naples). Florence, 1979 (two vols: paintings and drawings; sculpture, minor arts, scenography, etc.).

La Puglia tra Barocco e Rococò. Milan, 1982.

STRAZZULLO, FRANCO (ed.). *Settecento napoletano: Documenti, I*. Naples, 1982.

PASCULLI FERRARA, MIMMA. *Arte napoletana in Puglia dal XVI al XVIII secolo*. Fasano, 1983.

Civiltà e culture in Puglia (vol. 3): *La Puglia tra Barocco e Rococò*. Milan, 1982 [especially Mario Manieri Elia. 'Architettura barocca', 32–154; and Michele D'Elia. 'La pittura barocca', 162–320].

Ricerche sul '600 napoletano. Milan, 1983–93 [regular articles on Neapolitan architecture and painting, usually with new documents].

Civiltà del Seicento a Napoli (exhib. cat.). Naples, 1984 (2 vols: painting; drawing, sculpture, decorative arts).

Confraternite, arte e devozione in Puglia (exhib. cat.). Bari, 1994.

NAPPI, EDUARDO (ed.). *Ricerche sul Settecento napoletano*. Milan, 1992 [mainly documents].

CASSIANO, ANTONIO (ed.). *Il Barocco a Lecce e al Salento* (exhib. cat., Lecce). Rome, 1995 [painting, sculpture and the minor arts, but not architecture]

CAZZATO, VINCENZO, FAGIOLO, MARCELLO and PASCULLI FERRARA, MIMMA. *Terra di Bari e Capitanata* (Atlante del Barocco in Italia: Puglia, I). Rome, 1996.

Architecture

PANE, ROBERTO. *Architettura dell'età barocca in Napoli*. Naples, 1939.

——(and others) (eds). *Ville vesuviane del settecento*. Naples, 1950.

STRAZZULLO, FRANCO. *Edilizia e urbanistica a Napoli dal '500 al '700*. Naples, 1968. 2nd ed., 1995 [bibliography updated to 1994].

——*Architetti e ingegneri napoletani dal '500 al '700*. Naples, 1969 [essential collection of biographical data].

MALVESI, MAURIZIO and MANIERI-ELIA, MARIO. *Architettura barocca a Lecce e in terra di Puglia*. Milan and Rome, 1971.

CAUSA, RAFFAELLO. *L'arte nella Certosa di San Martino a Napoli*. Naples, 1973.

BLUNT, ANTHONY. *Neapolitan Baroque and Rococo Architecture*. London, 1975 [comprehensive coverage with full bibliography to date].

ALISIO, GIANCARLO. *Siti reali dei Borboni. Aspetti dell'architettura napoletana del Settecento*. Rome, 1976 [Bourbon residences in Procida, Carditello, Persano, etc.].

FONSECA, COSIMO DAMIANO (and others). 'Barocco' leccese. Arte e ambiente nel Salento da Lepanto a Masaniello*. Milan, 1979.

DE SETA, CESARE, DI MAURO, LEONARDO and PERONE, MARIA. *Ville vesuviane*. Milan, 1980.

——*Architettura, ambiente e società a Napoli nel '700*. Turin, 1981.

FAGIOLO, MARCELLO and CAZZATO, VINCENZO. *Lecce* (Le città nella storia d'Italia). Bari, 1984.

ALISIO, GIANCARLO. *Napoli nel seicento. Le vedute di Francesco Cassiano de Silva*. Naples, 1984.

SALVATORI, GAIA. *Le guglie di Napoli. Storia e restauro*. Naples, 1985.

MANIERI ELIA, MARIO. *Barocco leccese*. Milan, 1989.

All'ombra del Vesuvio. Napoli nella veduta europea dal Quattrocento all'Ottocento (exhib. cat.). Naples, 1990.

CANTONE, GAETANA. *Napoli barocca*. Bari, 1992.

——(ed.). *Barocco napoletano* (symposium 1987). Rome, 1992.

DEL PESCO, DANIELA. 'L'architettura della Controriforma e i cantieri dei grandi Ordini religiosi', *Storia e Civiltà della Campania*, vol. III, (*Il Rinascimento e l'Età Barocca*). Ed. G. Pugliese Carratelli, Naples, 1993, 327–86.

LABROT, GÉRARD. *Palazzi napoletani. Storie di nobili e cortigiani 1520–1750*. Naples, 1993 [a much enlarged and revised verion of *Baroni in città: Residenze e comportamenti dell'aristocrazia napoletana dal 1530 al 1734*. Naples, 1975].

GUERRA, ANDREA, MOLTENI, ELISABETTA and NICOLOSO, PAOLO. *Il trionfo della miseria. Gli alberghi dei poveri di Genova, Palermo e Napoli*. Milan, 1995.

DE MARCO, MARIO. *Architetture leccesi. I palazzi del Rinascimento, del Barocco, e del Rococò*. Lecce, 1995.

Sculpture

FITTIPALDI, TEODORO. *Scultura napoletana del Seicento*. Naples, 1980.

——*Scultura napoletana del Settecento*. Naples, 1980.

CATALANO, MARIA IDA. 'Scultori toscani a Napoli alla fine del Cinquecento: Considerazioni e problemi', *Storia dell'arte*, 54 (1985), 123–32.

GIOTTO BORRELLI, GIAN. 'Note per uno studio sulla tipologia della scultura funeraria a Napoli nel Seicento', *Storia dell'arte*, 54 (1985), 141–56.

RIZZO, VINCENZO. 'Scultori napoletani tra Sei e Settecento: Documenti e Personalità inedite', *Antologia di belle arti*, 25/26 (1985), 22–34.

CIOFFI, ROSANNA. *La cappella Sansevero; arte barocca e ideologia massonica*. Naples, 1994 (1st ed. 1987).

CAZZATO, VINCENZO, FAGIOLO, MARCELLO, BASCULLI FERRARA, MIMMA, *Terra di Barie Capitanata* (Atlante del Barocco in Italia: Puglia, 1), Rome, 1996

Painting

D'ELIA, MICHELE. *Mostra dell'arte in Puglia del tardo antico al Rococò* (exhib. cat., Bari). Rome, 1964 [important for baroque painters working in Apulia].

FERRARI, ORESTE. 'Considerazioni sulle vicende artistiche a Napoli durante il viceregno austriaco (1707–1734)', *Storia dell'arte*, XXXV (1979), 11–27.

RIZZO, VINCENZO. 'Notizie su Gaspare Traversi ed altri artisti napoletani del '700', *Napoli nobilissima*, XX (1981), 19–38.

The Golden Age of Naples (exhib. cat., Detroit, Chicago). Detroit, 1981.

SPINOSA, NICOLA. *La pittura napoletana del '600*. Milan, 1984 [a repertory].

——*Pittura napoletana del Settecento dal Rococò al Classicismo*. Naples, 1987.

——*Pittura napoletana del Settecento dal Barocco al Rococò*. Naples, 1988 (2nd ed.).

PORTER, JEANNE C. and MUNSHOWER, SUSAN S. (eds) *Parthenope's Splendour: Art of the Golden Age in Naples*. University Park, Pa., 1993 [collection of essays].

PAVONE, MARIO A. and FIORE, UMBERTO, *Pittori napoletani del '700: nuovi documenti*. Naples, 1994.

Individual Monuments

CATELLO, ELIO and CORRADO. *La Cappella del Tesoro di San Genaro*. Naples, 1977.

STRAZZULLO, FRANCO. *La real Cappella del Tesoro di S. Genaro. Documenti inediti*. Naples, 1978.

ROME

Old Guidebooks

FELINI, PIETRO MARTIRE. *Trattato nuovo delle cose maravigliose dell'alma dittà di Roma*. Rome, 1610. Facsimile ed. S. Waetzold. Berlin, 1969.

MANCINI, GIULIO. *Viaggio per Roma*. Ed. L. Schudt, Leipzig, 1923.

TOTTI, POMPILIO. *Ritratto di Roma antica*. Rome, 1627; *Ritratto di Roma moderna*. Rome, 1638.

CELIO, GASPARE. *Memoria delli nomi dell'artefici delle pitture che sono in alcune chiese, facciate, e palazzi di Roma*. Naples, 1638. Facsimile ed. by Emma Zocca. Milan, 1967 [good introduction on mid-century guidebooks].

BAGLIONE, GIOVANNI. *Le nove chiese di Roma* (Rome, 1639). Ed. L. Barroero, Rome, 1990. With notes by M. Maggiorani and C. Pujia.

MARTINELLI, FIORAVANTE. *Roma ricercata nel suo sito e nella scuola di tutti gli antiquarii*. Rome, 1st ed. 1644; 2nd ed. 1650; 3rd ed. with plates by Barrière after Borromini, 1658.

BRALION, NICOLA DE. *Les curiosités de l'une et de l'autre Rome*, I. Paris, 1655.

Vol II: *Seconde partie du premier livre*, 1658. Vol. III: *Seconde livre*, 1659 [first French guide to Rome, written during the pontificate of Urban VIII].

MARTINELLI, FIORAVANTE. *Roma ornata dall'architettura, pittura e scultura*, Bibl. Casanatense, MS 4984, [1660–3]. Published by Cesare D'Onofrio as *Roma nel Seicento*. Florence, 1969 [Borromini added marginal notes to the original MS].

MOLA, GIOVANNI BATTISTA. *Breve racconto delle miglior opere...*, *Roma l'anno 1663 di Giov. Batta. Mola*. Ed. K. Noehles, Berlin, 1966.

DONATI, ALESSANDRO, S.J. *Roma Vetus ac Recens*. Rome, 1665 (3rd ed.).

LASSELS, RICHARD. *The Voyage of Italy*. Paris, 1670 [wittiest of the travel accounts].

Specchio di Roma barocca: Una guida inedita del XVII secolo. Eds. Joseph Connors and Louise Rice. Rome, 1991 (2nd. ed) [second French guide, 1677].

DESEINE, FRANÇOIS. *Description de la ville de Rome*. Lyon, 1690. A later edition is *Rome moderne, Premiére ville de l'Europe avec toutes ses magnificences et ses delices* (6 vols). Leiden, 1713 [most complete of the Rome guides].

TITI, FILIPPO. *Studio di pittura, scoltura ed architettura nelle chiese di Roma*. Rome, 1674 and 5 subsequent editions up to 1763. All collated in the edition by B. Contardi and S. Romano (2 vols). Florence, 1987

VENUTI, RIDOLFINO. *Accurata, e succinta descrizione topografica e istorica di Roma Moderna*. Rome, 1766.

SCHUDT, LUDWIG. *Le guide di Roma*. Vienna and Augsburg, 1930 [comprehensive bibliography of guides].

——*Italienreisen im 17. und 18. Jahrhundert*. Vienna and Munich, 1959 [important study with bibliography of older travel literature].

Maps and Vedute

EGGER, HERMANN. *Römische Veduten*. I. Leipzig, 1911; II, Vienna, 1931.

HUELSEN, CHRISTIAN. *Saggio di bibliografia ragionata delle piante icnografiche e prospettiche di Roma dal 1551 al 1748*. Florence, 1933.

FRUTAZ, AMATO PIETRO. *Le piante di Roma* (3 vols). Rome, 1962 [the standard collection of the maps of Rome].

KEAVENEY, RAYMOND. *Views of Rome from the Thomas Ashby Collection in the Vatican Library* (exhib. cat., Vatican City). London and New York, 1988.

JATTA, BARBARA. *Lievin Cruyl e la sua opera grafica. Un artista fiammingo nell'Italia del Seicento*. Brussels and Rome, 1992.

GARMS, JÖRG. *Vedute di Roma: dal Medioevo all'Ottocento. Atlante iconografico, topografico, architettonico* (2 vols). Naples, 1995.

COEN, PAOLO. *Le magnificenze di Roma nelle incisioni di Giuseppe Vasi*. Rome, 1996.

General

MAGNI, GIULIO. *Il barocco a Roma nell'architettura e nella scultura decorativa* (3 vols). Turin, 1911–13 [many of the excellent plates illustrate material which still cannot be found elsewhere].

Le chiese di Roma illustrate. Rome, 1923 ff. [a useful series; older volumes have in many cases been replaced by more up-to-date ones].

D'ONOFRIO, CESARE. *Le fontane di Roma*. Rome, 1957. Revised as *Acque e fontane di Roma*. Rome, 1977 [much new documentary material; the basic work on the subject].

JÜRGEN, RENATE. *Die Entwicklung des Barockaltar in Rom*. Diss. Hamburg, 1956.

LAVAGNINO, EMILIO, ANSALDI, GIULIO R. and SALERNO, LUIGI. *Altari barocchi in Roma*. Rome, 1959.

Guide rionali di Roma. Rome, 1967 ff. [useful, with bibliography for each monument].

BUCHOWIECKI, WALTER. *Handbuch der Kirchen Roms*, I–III. Vienna, 1967–74; vol. IV, published under the name of Birgit Kuhn-Forte. Vienna, 1997.

HESS, JACOB. *Kunstgeschichtliche Studien zu Renaissance und Barock*. Rome, 1967.

MALLORY, NINA A. 'Notizie sulla scultura a Roma nel XVIII secolo (1719–1760)', *Boll. d'Arte*, LIX (1974), 164–77 [extracts from Chracas, *Diario ordinario*; invaluable, although the subject is rather narrowly interpreted].

——'Notizie sulla pittura a Roma nel XVIII secolo (1718–1760)', *Boll. d'Arte*, LXI (1976), 100–13 [see comments on above].

BLUNT, ANTHONY. *Guide to Baroque Rome*. London, 1982.

MINOR, VERNON H. 'References to Artists and Works of Art in Chracas' *Diario ordinario 1760–1785*', *Storia dell'arte*, 46 (1982), 217–77.

ARGAN, GIULIO CARLO. *Immagine e persuasione. Saggi sul barocco*. Ed. B. Contardi, Milan, 1986 [essays on Caravaggio, Bernini, Borromini, etc., and the general theme of baroque as an art of persuasion].

MAGNUSON, TORGIL. *Rome in the Age of Bernini* (2 vols). Stockholm, 1982–5.

Arte per i papi e per i principi nella campagna romana: grande pittura del '600 e del '700 (2 vols). Rome, 1990 [exhib. cat.; studies].

SCHÜTZE, SEBASTIAN. 'Arte Liberalissima e Nobilissima. Die

Künstlernobilitierung im päpstlichen Rom – Ein Beitrag zur Sozialgeschichte des Künstlers in der frühen Neuzeit', *Zeitschr. f. Kunstg.*, LXI (1992), 319–52.

MICHEL, OLIVIER. *Vivre et peindre à Rome au XVIIIe siècle*. Rome, 1996.

Architecture

POLLAK, OSKAR. 'Der Architekt im XVII. Jahrhundert in Rom', *Zeitschrift für Geschichte der Architektur*, III (1909–10), 201–10.

FREY, DAGOBERT. 'Beiträge zur Geschichte der römischen Barockarchitektur', *Wiener Jahrbuch für Kunstgeschichte*, III (XVII) (1924), 5–113.

——*Architettura barocca*. Rome, Milan, [n.d., c.1926] [only Rome].

DONATI, UGO, *Artisti ticinesi a Roma*, Bellinzona, 1942

ELLING, CHRISTIAN. *Rome: The Biography of Her Architecture from Bernini to Thorvaldsen*. Boulder, Colorado, 1975 [published in Danish in 1956 (2nd ed. 1967); a lively social history that was considerably ahead of its time].

Via del Corso. Rome, 1961.

PORTOGHESI, PAOLO. *Roma barocca*. Rome, 1966. Rev. ed., Bari, 1978. English translation, Cambridge, Ma., 1970.

BATTISTI, EUGENIO. 'Lione Pascoli, Luigi Vanvitelli e l'urbanistica italiana del settecento', *Atti del VIII Convegno Nazionale di Storia dell'architettura (1953)*. Rome, 1956, 51–64.

HUBALA, ERICH. 'Roma sotterranea barocca. Unterirdische Andachtsstätten in Rom und ihre Bedeutung für die barocke Baukunst', *Das Münster*, 18 (1965), 157–70.

SCAVIZZI, C. PAOLA. 'Le condizioni per lo sviluppo dell'attività edilizia a Roma nel sec. XVII: la legislazione', *Studi Romani*, XVII (1969), 160–71.

——*Edilizia nei secoli XVII e XVIII a Roma. Ricerca per una storia delle tecniche* (Quaderni dell'Ufficio Studi del Ministero per i Beni Culturali e Ambientali, 6). Rome, 1983.

BRANDI, CESARE. *La prima architettura barocca. Pietro da Cortona, Borromini, Bernini*. Bari, 1970.

Piazza Navona. Isola dei Pamphilj. Rome, 1970.

SALERNO, LUIGI, SPEZZAFERRO, LUIGI and TAFURI, MANFREDO. *Via Giulia. Un'utopia urbanistica del '500*. Rome, 1973 [abundant information on the baroque buildings along this Renaissance street].

MARCONI, P., CIPRIANI, A. and VALERIANI, E. *I disegni dell'archivio storico dell'Accademia di San Luca* (2 vols). Rome, 1974.

MALLORY, NINA. *Roman Rococo Architecture from Clement XI to Benedict XIV (1700–1758)*. New York, London, 1977.

BLUNT, ANTHONY. 'Roman Baroque Architecture: The Other Side of the Medal', *Art History*, III (1980), 61 ff.

WHITMAN, NATHAN (with John Varriano). *Roma Resurgens. Papal Medals from the Age of the Baroque* (exhib. cat.). Ann Arbor, University of Michigan Museum of Art, 1981.

HAGER, HELLMUT (ed.). *Architectural Fantasy and Reality: Drawings from the Accademia Nazionale di San Luca, Concorsi Clementini, 1700–1750* (exhib. cat.). University Park, Penn State Museum, 1981.

MALLORY, NINA. 'Notizie sull'architetura nel settecento a Roma (1718–1760)', *Boll. d'Arte*, 13 (1982), 109–28; 15 (1982), 127–47; 16 (1982), 119–34.

HAGER, HELLMUT. 'The Accademia di San Luca in Rome and the Académie Royale d'Architecture in Paris: A Preliminary Investigation', in *Projects and Monuments of the Roman Baroque* (Papers in Art History from The Pennsylvania State University, 1). University Park, Pa., 1984, 128–61.

FAGIOLO, MARCELLO and MADONNA, MARIA LUISA (eds). *Roma Sancta. La città delle basiliche*. Rome, 1985; *Roma 1300–1875. La città degli anni santi. Atlante*. Milan, 1985.

KUMMER, STEFAN. *Anfänge und Ausbreitung der Stuckdekoration im römischen Kirchenraum* (Tübinger Studien VI). Tübingen, 1987.

BUSCHOW, ANJA. *Kirchenrestaurierungen in Rome vor dem Hintergrund der päpstlichen Kunst- und Kulturpolitik in der ersten Hälfte des 18. Jahrhunderts*. Diss. Bonn, 1987.

CURCIO, GIOVANNA and SPEZZAFERRO, LUIGI. *Fabbriche e architetti ticinesi nella Roma barocca*. Milan, 1989.

CONNORS, JOSEPH. 'Alliance and Enmity in Roman Baroque Urbanism', *Römisches Jahrbuch der Bibliotheca Hertziana*, XXV (1989), 207–94.

WADDY, PATRICIA. *Seventeenth-Century Roman Palaces: Use and the Art of the Plan*. New York, 1990 [innovative study of palace function].

CONTARDI, BRUNO and GIOVANNA CURCIO (eds). *In Urbe Architectus. Modelli disegni misure. La professione dell'architetto Roma 1680–1750* (exhib. cat.). Rome, Castel S. Angelo, 1991 [includes short biographies for all architects active in the period].

KIEVEN, ELISABETH. 'La collezione dei disegni di architettura di Pier Leone Ghezzi', in Elisa Debenedetti (ed.). *Collezionismo e ideologia mecenati, artisti e teorici dal classico al neoclassico* (Studi sul Settecento Romano, 7). Rome, 1991, 143–75.

An Architectural Progress in the Renaissance and Baroque...Essays Presented to Hellmut Hager (Papers in Art History from The Pennsylvania State

University, 8). Eds H. Millon and S. Munshower, University Park, Pa., 1992 [many good short essays on Maderno, Borromini, Fontana, Juvarra, etc.].

ROCA DE AMICIS, AUGUSTO. 'I Pantani e la Suburra: forme della crescita edilizia a Roma tra XVI e XVII secolo', in Mario Coppa (ed.). *Inediti di storia dell'urbanistica*. Rome, 1993, 101–45.

VALONE, CAROLYN. 'Women on the Quirinal Hill: Patronage in Rome, 1560–1630', *Art Bull.*, LXXVI (1994), 129–46.

Ricerche di storia dell'arte, 41–2 (1990) [articles by A. Forcellino and E. Pallottino devoted to colour of Roman stucco revetments].

CARPINETO, GIORGIO. *I palazzi di Roma*. Rome, 1991. 2nd ed. 1993.

KIEVEN, ELISABETH. *Architettura del Settecento a Roma nei disegni della Raccolta Grafica Comunale* (exhib. cat.). Rome, 1991.

SMITH, GIL. *Architectural Diplomacy. Rome and Paris in the Late Baroque*. New York, Cambridge, Ma., 1993 [Accademia di San Luca].

DI CASTRO, ALBERTO, PECCOLO, PAOLA and GAZZANIGA, VALENTINA. *Marmorari e argentieri a Roma e nel Lazio tra Cinquecento e Seicento. I committenti, i documenti, le opere*. Rome, 1994 [many documents and photographs on Roman polychrome chapels around 1600].

DEBENEDETTI, ELISA (ed.). *Roma borghese. Case e palazzetti d'affitto* (2 vols). Rome, 1994–5.

SPAGNESI, GIANFRANCO, ed. *L'architettura della basilica di San Pietro. Storia e costruzione* (*Quaderni dell'Istituto di Storia dell'Architettura dell'Università di Roma*, n.s., 25–30, 1995–7) [many essays on St Peter's in the baroque period].

BENZI, FABIO and VINCENTI MONTANATO, CAROLINE. *Palaces of Rome*. London and Rome, 1997 [lavish colour photographs].

WALKER, STEFANIE, and HAMMOND, FREDERICK, eds., *Life and Arts in the Baroque Palaces of Rome. Ambiente barocco* (exhib. cat.), New Haven and London, 1999.

Villas in Rome and Lazio

FELICI, GIUSEPPE. *Villa Ludovisi in Roma*. Rome, 1952.

D'ONOFRIO, CESARE. *La Villa Aldobrandini di Frascati*. Rome, 1963.

STEINBERG, RONALD. 'The Iconography of the Teatro d'Acqua in the Villa Aldobrandini', *Art Bull.*, XLIV (1965), 453–63.

BELLA BARSALI, ISA. *Ville di Roma*. Milan, 1970.

HEILMANN, CHRISTOPH. 'Die Entstehungsgeschichte der Villa Borghese in Rom', *Münchner Jahrbuch für Kunstgeschichte*, XV (1973), 97–158.

TANTILLO MIGNOSI, ALMAMARIA (ed.). *Villa e paese. Dimore nobili del Tuscolo e di Marino* (exhib. cat.). Rome, 1980.

HUNT, JOHN DIXON .'*Curiosities* to adorn *Cabinets* and *Gardens*', in O. Impey and A. MacGregor (eds). *The Origins of Museums*. Oxford, 1985, 193–203.

DI GADDO, BEATA. *Villa Borghese. Il giardino e le architetture*. Rome, 1985.

HERRMANN FIORE, KRISTINA. 'Il colore delle facciate di Villa Borghese nel contesto delle dominanti coloristiche dell'edilizia romana intorno al 1600', *Boll. d'Arte*, 48 (1988), 93–100.

BENOCCI, CARLA. *Villa Aldobrandini a Roma*. Rome, 1992.

MACDOUGALL, ELISABETH. *Fountains, Statues, and Flowers. Studies in Italian Gardens of the Sixteenth and Seventeenth Centuries*. Washington, D.C., 1994.

GIUSTI, MARIA ADRIANA and TAGLIOLINI, ALESSANDRO (eds). *Il giardino delle muse. Arti e artifici nel barocco europeo* (1993). Florence, 1995 [essays on the baroque garden emphasizing Rome and Tuscany].

BENOCCI, CARLA (with CATALLI, FIORENZO and PETRECCA, MAURO). *Villa Doria Pamphilj*. Rome, 1996.

ELEUTERI, FRANCESCO. 'Villa Corsini fuori Porta S. Pancrazio a Roma', *Palladio*, 18 (July–Dec. 1996), 109–24.

BENEŠ, MIRKA. 'Landowning and the Villa in the Social Geography of the Roman Territory. The Location and Landscape of the Villa Pamphilj, 1645–70', in A. von Hoffman (ed.). *Form, Modernism, and History. Essays in Honor of Eduard F. Sekler*. Cambridge, Ma., 1996, 187–209.

—— 'The Social Significance of Transforming the Landscape at the Villa Borghese, 1606–30: Territory, Trees, and Agriculture in the Design of the First Roman Baroque Park', in A. Petruccioli (ed.). *Gardens in the Time of the Great Muslim Empires*. Leiden, 1997, 1–31.

Ephemera

BJURSTRÖM, PER. *Giacomo Torelli and Baroque Stage Design*. Stockholm, 1961.

——*Feast and Theatre in Queen Christina's Rome*. Stockholm, 1966.

WEIL, MARK. 'The Devotion of the Forty Hours and Roman Baroque Illusions', *J.W.C.I.*, XXXVII (1974), 218–48.

BOITEUX, MARTINE. 'Carnaval annexé: essai de lecture d'une fête romaine', *Annales E.S.C.*, XXXII (1977), 356–80.

Atti del XXIV Congresso Internazionale di Storia dell'Arte (1979), vol. 5: *La scenografia barocca*. Ed. A. Schnapper, Bologna, 1982 [essays on Rome, Bologna, Bernini, Piranesi, etc.].

OECHSLIN, WERNER and BUSCHOW, ANJA. *Festarchitektur. Der Architekt als Inszenierungskünstler*. Stuttgart, 1984.

FAGIOLO, MARCELLO and MADONNA, MARIA LUISA (eds). *Barocco romano e barocco italiano. Il teatro, l'effimero, l'allegoria*. Rome, 1985 [many essays on festivals and *apparati*].

DIEZ, RENATO. *Il trionfo della parola. Studio sulle relazioni di feste nella Roma barocca 1623–1667*. Rome, 1986.

FAGIOLO DELL'ARCO, MAURIZIO. *Bibliografia della festa barocca a Roma*. Rome, 1994.

GORI SASSOLI, MARIO. *Della Chinea e di altre 'Macchine di Gioia'. Apparati architettonici per fuochi d'artificio a Roma nel Settecento* (exhib. cat.). Milan, 1994.

MOORE, JOHN. 'Prints, Salami and Cheese: Savoring the Roman Festival of the Chinea', *Art Bull.*, 77 (1995), 584–608.

FAGIOLO DELL'ARCO, MARCELLO. *La festa a Roma dal rinascimento al 1870* (2 vols). Turin, 1997 [includes brief exhib. cat. (Rome), but primarily studies].

FAGIOLO DELL'ARCO, MAURIZIO. *Corpus delle feste a Roma, 1: La festa barocca*, Rome, 1997; Fagiolo, Marcello, ed., *2: Il Settecento e l'Ottocento*, Rome, 1997 [much amplified edition of Maurizio Fagiolo dell'Arco and Silvia Carandini. *L'effimero barocco: Strutture della festa nella Roma del '600*. Rome, 1977–8. Extensive documentation both visual and literary, organized by pontificate].

IMORDE, JOSEPH. *Präsenz und Repräsentanz. Oder: Die Kunst, den Leib Christi auszustellen (Das vierzigstündige Gebet von den Anfängen bis in das Pontifikat Innozenz X.)*. Berlin, 1997.

Sculpture

BRUHNS, LEO. 'Das Motiv der ewigen Anbetung in der römischen Grabplastik des 16., 17. und 18. Jahrhunderts', *Röm. Jahrb. f. Kunstg.*, IV (1940), 253–432.

RICCOBONI, ALBERTO. *Roma nell'arte. La scultura nell'evo moderno*. Rome, 1942 [many of the attributions are out-dated, but the illustrations in particular are still useful].

CHYURLIA, ROBERTA. 'Di alcune tendenze della scultura settecentesca a Roma e Carlo Monaldi', *Commentari*, I (1950), 222–8.

PRESSOUYRE, SYLVIA. 'Sur la sculpture à Rome autour de 1600', *Revue de l'art*, 28 (1975), 62–77.

SALERNO, LUIGI. *La Cappella del Monte di Pietà di Roma*. Rome [n.d.].

WEIL, MARK S. *The History and Decoration of the Ponte S. Angelo*. University Park (Pa.), 1974.

ENGGASS, ROBERT. *Early Eighteenth-Century Sculpture in Rome* (2 vols). University Park (Pa.), 1976.
Review: F. den Broeder, *Burl. Mag.*, CXX (1978), 537–42

MARTINELLI, VALENTINO (ed.). *Le Statue berniniane del Colonnato di San Pietro*. Rome, 1987 [includes biographies of the sculptors responsible].

Le immagini del Santissimo Salvatore (exhib. cat.). Rome, 1988 [Useful for Lorenzo Ottoni, Michele Maglia and Jean Baptiste Theodon].

MONTAGU, JENNIFER. *Roman Baroque Sculpture: The Industry of Art*. New Haven, London, 1989.

TRATZ, HELGA. 'Die Ausstattung des Langhauses von St. Peter unter Innozenz X.', *Römisches Jahrbuch der Bibliotheca Hertziana*, XXVII/XXVIII (1991–2), 337–74.

BACCHI, ANDREA. *Scultura del '600 a Roma*. Milan, 1996 [exemplary repertory; good summary biographies, and full bibliographies].

San Pietro: Arte e storia nella Basilica Vaticana. Ed. G. R. Coopmans de Yoldi, Bergamo, 1996 [includes detailed studies of the statues in the nave, and the sculptors responsible].

Painting

GLOTON, MARIE-CHRISTINE. *Trompe l'oeil et décor plafonnant dans les églises romaines de l'age baroque*. Rome, 1965.

WATERHOUSE, ELLIS. *Baroque Painting in Rome. The Seventeenth Century*. Oxford, 1976 [revision of the classic lists of 1937; Lanfranco is omitted].

STRINATI, CLAUDIO. 'Roma nell'anno 1600. Studio di pittura', *Ricerche di storia dell'arte*, 10 (1980), 15–48.

CLARK, ANTHONY M. *Studies in Roman Eighteenth-Century Painting*. Ed. E. P. Bowron, Washington, 1981.

BRIGANTI, GIULIO, TREZZANI, LUDOVICA and LAUREATI, LAURA. *The Bamboccianti: The Painters of Everyday Life in Seventeenth Century Rome*. Rome, 1983.

RUDOLPH, STELLA. *La pittura a Roma nel '700*. Milan, 1983 [a repertory].

LEVENE, DAVID A. 'The Roman Limekilns of the Bamboccianti', *Art Bull.*, LXX (1988), 569–89.

Bamboccianti, Niederländische Malerrebellen im Rom des Barock (exhib. cat., Cologne, Utrecht). Milan, 1991.

SESTIERI, GIANCARLO. *Repertorio della pittura romana alla fine Seicento e del Settecento* (3 vols). Turin, 1994.
Review: E. P. Bowron, *Burl. Mag.*, CXXXVI (1994), 627.

Drawings

BLUNT, ANTHONY and COOKE, H. L. *The Roman Drawings of the XVII & XVIII Centuries in the Collection of Her Majesty the Queen at Windsor Castle*. London, 1960 [N.B.: Supplements to the Catalogues of Italian and French Drawings were published by Blunt at the end of Edmund Schilling. *German Drawings ... at Windsor Castle*. London/New York, 1971. The corrections to the Roman school are particularly extensive].

DREYER, PETER. *Römische Barockzeichnungen aus dem berliner Kupferstichkabinett* (exhib. cat.). Berlin, 1969.

CHAPPELL, MILES, KIRWIN, W. CHANDLER, NISSMAN, JOAN L. and RODINÒ, SIMONETTA PROSPERI VALENTI. *Disegni dei Toscani a Roma 1580-1620* (exhib. cat.). Florence, 1979.

BACOU, ROSELINE and BEAN, JACOB. *Le dessin à Rome au XVIIe siècle* (exhib. cat.). Paris, 1988 [drawings in the Louvre].

GERE, JOHN A. and POUNCEY, PHILIP. *Italian Drawings in the Department of Prints and Drawings in the British Museum: Artists Working in Rome c. 1550 to c. 1640*. London, 1983.

LEGRAND, CATHERINE and D'ORMESSON-PEUGEOT, DOMITILLA. *La Rome baroque de Maratti à Piranèse. Dessins du Louvre et des collections publiques françaises* (exhib. cat.). Paris, 1990.

RODINÒ, SIMONETTA PROSPERI VALENTI . *Disegni romani dal XVI al XVIII secolo* (exhib. cat.). Rome, 1995 [drawings in the Istituto Nazionale per la Grafica].

FISCHER PACE, URSULA V. *Disegni del Seicento romano* (exhib. cat.). Florence, 1997 [drawings in the Uffizi].

TURNER, NICHOLAS (with Rhoda Eitel-Porter). *Italian Drawings in the Department of Prints and Drawings in the British Museum: Roman Baroque Drawings (c.1620–c.1700)*. London 1999.

SICILY

RUFFO, VINCENZO. 'Galleria Ruffo nel secolo XVII in Messina (con lettere di pittori e altri documenti inediti)', *Boll. d'Arte*, X (1916), 21–64; 95–128; 165–92; 237–56; 285–320; 369–88 [documents on A. Gentileschi, Guercino, Rembrandt, etc.].

ZIINO, VITTORIO. *Contributi allo studio dell'architettura del'700 in Sicilia*. Palermo, 1950 [villas of Bagheria].

Atti del VII Congresso Nazionale di Storia dell'Architettura (1950). Palermo, 1956 [especially Salvatore Caronia Roberti. 'L'architettura del barocco in Sicilia', 172–98; Guido di Stefano, 'Sguardo su tre secoli di architettura palermitana', 393–407].

TUZET, HÉLÈNE. *La Sicile au XVIIIe siècle vue par les voyageurs étrangers*. Strasbourg, 1955. Italian translation as *Viaggiatori stranieri in Sicilia nel XVIII secolo*. Palermo, 1988.

PISANI, NICOLÒ. *Barocco in Sicilia*. Syracuse, 1958.

ACCASCINA, MARIA. *Profilo dell'architettura a Messina dal 1600 al 1800*. Rome, 1964.

GANGI, GAETANO. *Il Barocco nella Sicilia orientale*. Rome, 1964 [good photographs, mainly of architecture].

LOJACONO, PIETRO. 'La ricostruzione dei centri della Val di Noto dopo il terremoto del 1693', *Palladio*, XIV (1964), 59–74.

LANZA TOMASI, GIOACCHINO. *Le ville di Palermo*. Palermo, 1966.

BLUNT, ANTHONY. *Sicilian Baroque*. New York, 1968.

GANGI, GAETANO. *Il Barocco nella Sicilia occidentale*. Rome, 1968 [see comment on above].

DE SIMONE, MARGHERITA. *Ville palermitane del XVII e XVIII secolo: profilo storico e rilievi* (2 vols). Genoa and Palermo, 1968–74.

CANALE, CLEOFE GIOVANNI. *Noto – La struttura continua della città tardo-barocca. Il potere di una società urbana nel settecento*. Palermo, 1976.

MADONNA, MARIA LUISA. 'Palermo nel Cinquecento. La rifondazione della "Città Felice"', *Psicon*, 8–9 (1976), 40–64.

MAZZOLA, GIUSEPPINA. 'Profilo della decorazione barocca nelle volte delle chiese palermitane', *Storia dell'arte*, 36–7 (1979), 47–56.

GUIDONI MARINO, ANGELA. 'Grammichele', in *Storia dell'Arte Italiana Einaudi*, 8, III.1 (*Inchieste su centri minori*). Turin, 1980, 405–41.

BOSCARINO, SALVATORE. *Sicilia Barocca. Architettura e città 1610–1760*. Rome, 1981 [overview with bibliography].

FAGIOLO, MARCELLO and MADONNA, MARIA LUISA. *Il teatro del sole: la rifondazione di Palermo nel Cinquecento e l'idea della città barocca*. Rome, 1981.

GANGI, GAETANO. *Ragusa barocca*. Palermo, 1982 [photographs of Giuseppe Leone].

TOBRINER, STEPHEN. *The Genesis of Noto*. London, 1982 [a pioneering monograph].

DATO, GIUSEPPE. *La città di Catania. Forma e struttura*. Rome, 1983 [photographic atlas with plans of individual blocks].

TOBRINER, STEPHEN. 'La Casa Baraccata: Earthquake-resistant Construction in 18th-Century Calabria', *J.S.A.H.*, XLII (1983), 131–8.

Caravaggio in Sicilia: il suo tempo, il suo influsso (exhib. cat., Syracuse). Palermo, 1984.

SIRACUSANO, CITTI. *La pittura del Settecento in Sicilia*. Rome, 1986.

DUFOUR, LILIANE. *Siracusa città e fortificazioni* (exhib. cat.). Palermo, 1987.

FAGIOLO, MARCELLO and TRIGILIA, LUCIA (eds) *Il Barocco in Sicilia tra conoscenza e conservazione*, Syracuse, 1987.

DUFOUR, LILIANE. *Augusta: da città imperiale a città militare*. Palermo, 1989.

SILVETTI, JORGE (ed.). *Architectural and Urban Environments of Sicily* (2 vols). Cambridge, Mass., 1989–92.

DUFOUR, LILIANE and RAYMOND, HENRI. *Dalle baracche al barocco. La ricostruzione di Noto. Il caso e la necessità*. Palermo 1990.

NOBILE, MARCO ROSARIO. *Architettura religiosa negli Iblei. Dal Rinascimento al Barocco*. Syracuse, 1990.

TRIGILIA, LUCIA (ed.). *Siracusa: quattro edifici religiosi, analisi e rilievi: San Giovanni alle Catacombe, Santa Lucia al Sepolcro, San Giovannello, San Giuseppe*. Syracuse, 1990.

FORMENTI, GIUSEPPE. *Descrizione dell'isola di Sicilia e delle sue coste*. Ed. L. Dufour, Syracuse, 1991.

DUFOUR, LILIANE. *Atlante storico della Sicilia: le città costiere nella cartografia manoscritta 1500–1823*. Palermo, 1992.

DUFOUR, LILIANE and RAYMOND, HENRI. *1693, Catania, rinascita di una città*. Catania, 1992; *1693, Val di Noto: rinascita dopo il disastro*. Catania, 1994.

—— *Dalla città ideale alla città reale. La ricostruzione di Avola 1693–1695*. Syracuse, 1993.

SARULLO, LUIGI. *Dizionario degli artisti siciliani*. Vol. I, Architettura. Ed. M. C. Ruggieri Tricoli, Palermo, 1993. Vol. II, Pittura. Ed. M. A. Spadaro, Palermo, 1993.

HILLS, HELEN. 'Iconography and Ideology: Aristocracy, Immaculacy and Virginity in Seventeenth-Century Palermo', *Oxford Art Journal*, 17.2 (1994), 16–31.

SCUDERI, VINCENZO. *Architettura ed architetti barocchi del trapanese* (2nd ed.). Marsala, 1994.

Annali del barocco in Sicilia, 1, 1994, *Studi sulla ricostruzione del Val di Noto dopo il terremoto del 1693* [articles plus an extensive bibliography for the 1693 earthquake and subsequent reconstruction]; 2, 1995, *Studi sul seicento e settecento in Sicilia e a Malta* [articles on Palermo, Syracuse and Malta].

NEAL, ERIK. 'Architects and Architecture in 17th & 18th Century Palermo: New Documents', *Annali di Architettura*, 7 (1995), 159–76.

BOSCARINO, SALVATORE and GIUFFRÈ, MARIA. *Storia e restauro di architetture siciliane*, entire number of *Storia architettura*, n.s., 2 (1996).

HILLS, HELEN. 'Mapping the early modern city', *Urban History*, 23.2 (1996), 146–70 [Palermo].

HOFER, PAUL. *Noto. Idealstadt und Stadtraum im sizilianischen 18. Jahrhundert*. Zurich, 1996.

NOBILE, MARCO ROSARIO. *Il Noviziato dei Crociferi. Misticismo e retorica nella Palermo del Seicento*. Palermo, 1997.

HILLS, HELEN, 'Cities and Virgins: Female Aristocratic Convents in Early Modern Naples and Palermo', *Oxford Art Journal*, 22.1, 1999, 29–54.

UMBRIA AND THE MARCHES

GRIMALDI, FLORIANO and SORDI, KATY. *Scultori a Loreto ... Documenti*. Ancona, 1987.

——*Pittori a Loreto ... Documenti*. Ancona, 1988.

Pittura del Seicento: Ricerche in Umbria (exhib. cat., Spoleto). Milan, 1989.

ZAMPETTI, PIETRO. *Pittura nelle Marche*, III, *Dal controriforma al barocco*. Florence, 1990.

——*Pittura nelle Marche*, IV, *Dal barocco all'età moderna*. Florence, 1991.

DAL POGGETTO, PAOLO (ed.). *Le arti nelle Marche al tempo di Sisto V*. Milan, 1992.

ZAMPETTI, PIETRO (ed.). *Scultura nelle Marche dalle origini all'età contemporanea*. Fermo, 1993.

TURIN AND PIEDMONT

GALLONI, PIETRO. *Il Sacro Monte di Varallo*. Varallo, 1909–14 [basic study, but mainly concerned with the pre-baroque].

CHEVALLEY, GIOVANNI. *Gli architetti, l'architettura e la decorazione delle ville piemontesi del XVIII secolo*. Turin, 1912.

BRINCKMANN, A.E. *Theatrum Novum Pedemontii*. Düsseldorf, 1931 [indispensable].

——*Von Guarini Guarini bis Balthasar Neumann*. Berlin, 1932.

DEL FRATE, COSTANTINO. *S. Maria del Monte sopra Varese*. Varese, 1933 [full monograph on the Sacro Monte].

PASSANTI, MARIO. *Architettura in Piemonte da Emanuele Filiberto all'Unità d'Italia (1563–1870)*, E. G. Torretta. Turin, 1990 [originally published 1945].

MALLÉ, LUIGI. *Le arti figurativi in Piemonte*, II, *Dal secolo XVII al secolo XIX*. Turin, 1962 [a comprehensive survey in considerable detail, without notes, but with extensive bibliography].

BAUDI DI VESME, ALESSANDRO. *Schede Vesme: L'arte in Piemonte dal XVI al XVIII secolo*. Turin, 1963–82.

BRAYDA, C., COLI, L. and SESIA, D. 'Ingegneri e architetti del Sei e Settecento in Piemonte', *Atti e Rassegna tecnica della Società degli ingegneri e architetti in Torino*, XVII (1963) [appeared also as a separate publication; 731 names with brief biographies and chronological *oeuvre* catalogues. Extremely useful].

MARINI, GUIUSEPPE LUIGI. *L'architettura barocca in Piemonte*. Turin, 1963 [brief survey].

Mostra del barocco piemontese (3vols) (exhib. cat.). Ed. V. Vitale, 1963. Especially vol. I: Nino Carboneri, 'Architettura' [comprehensive bibliography to date].

PEDRINI, AUGUST. *Ville dei secoli XVII e XVIII in Piemonte*. Turin, 1965 [broad survey with photographs and brief histories].

PEYROT, ADA. *Torino nei secoli* (2 vols). Turin, 1965 [a useful, fully illustrated catalogue of maps and views of Turin].

POMMER, RICHARD. *Eighteenth-Century Architecture in Piedmont. The Open Structures of Juvarra, Alfieri, & Vittone*. New York, London, 1967 [the essential study, with full bibliography to date; an Italian edition is in preparation].

CAVALLARI MURAT, AUGUSTO (ed.). *Forma urbana ed architettura nella Torino barocca (dalle premesse classiche alle conclusioni neoclassiche)* (3 vols). Turin, 1968.

TAMBURINI, LUCIANO. *Le chiese di Torino*. Turin, 1968 [an excellent critical study].

MALLÉ, LUIGI. *Palazzo Madama in Torino* (2 vols). Turin, 1970. Vol. I: *Storia bimillenaria di un edificio* [urban and architectural history through Juvarra].

SCIOLLA, GIANNI CARLO. *'The Royal City of Turin'. Princes, Artists, and Works of Art in the Ancient Capital of a European Dukedom*. Turin, 1982.

SYMCOX, GEOFFREY. *Victor Amadeus II: Absolutism in the Savoyard State*. Berkeley and Los Angeles, 1983.

DARDANELLO, GIUSEPPE. 'Cantieri di corte e imprese decorative a Torino', *Figure del Barocco in Piemonte: la corte, la città, le province*. Ed. G. Romano, Turin, 1988, 193–200.

ROMANO, GIOVANNI (ed.). *Figure del barocco in Piemonte. La corte, la città, i cantieri, le province*. Turin, 1988.

PROLA, DOMENICO. *Architetture barocche in Piemonte. 120 spazi sacri*. Florence, 1988 [fisheye photographs of vaults and cupolas].

Diana trionfatrice. Arte di corte nel Piemonte del Seicento (exhib. cat.). Turin, 1989.

RESSA, ALBERTO. *Chiese barocche in Piemonte: nella evoluzione delle figure planimetriche a simmetria centrale*. Rome, 1990.

POLLAK, MARTHA. *Turin 1564–1680. Urban Design, Military Culture, and the Creation of the Absolutist Capital*. Chicago and London, 1991.

——'Architecture of Power and Dynastic Edification: Turin's Contrada di Po as Theatre and *Stradone*', in *An Architectural Progress in the Renaissance and Baroque...Essays Presented to Hellmut Hager* (Papers in Art History from The Pennsylvania State University, 8). Eds H. Millon and S. Munshower, University Park, 1992, 478–97.

ROMANO, GIOVANNI (ed.). *Torino 1675–1699. Strategie e conflitti del Barocco*. Turin, 1993. Esp. G. Dardanello, 'La scena urbana', 15–120, and 'Il Collegio dei Nobili e la piazza del principe di Carignano (1675–1684)', 175–252.

DARDANELLO, GIUSEPPE, 'Memoria professionale nei disegni dagli Album Valperga. Allestimenti decorativi e collezionismo di mestiere', in G. Romano (ed.) *Le collezioni di Carlo Emanuele I di Savoia*. Turin, 1995, 63–134.

VENICE, VENETO, AND THE NORTH

General

SANSOVINO, FRANCESCO. *Venetia città nobilissima e singolare ... con aggiunta di tutte le cose notabili della stessa città, fatte, & occorse dall'Anno 1580 sinoal presente 1663 da D. Giustiniano Martinioni*. Venice, 1663. Facsimile ed. Lino Moretti (2 vols). Venice, 1968.

ZANETTI, ANTONO MARIA. *Descrizione di tutte le publiche pitture della città di Venezia e Isole circonvicine*. Venice, 1733.

LORENZETTI, GIULIO. *Venezia e il suo estuario*. Rome, 1956 (English translation 1961) [the best Venetian guide-book].

TEMANZA, TOMMASO. *Zibaldon*. Ed. N. Ivanoff, Venice, 1963 [Many of T.'s notes are a primary source, particularly for minor baroque artists in Venice].

RIZZO, ALDO. *Il Settecento (Storia del arte in Friuli)*. Udine, 1967 [although the names of artists dicussed are predominantly Venetian, it contains much unknown or scarcely known material].

——*Il Seicento (Storia del arte in Friuli)*. Udine, 1969 [see comment on the above].

The Glory of Venice. Art in the Eighteenth Century) (exhib. cat., London). Eds. J. Martineau and A. Robison, New Haven, London, 1994.

Architecture

BASSI, ELENA. *Architettura del Sei e Settecento a Venezia*. Naples, 1962 [standard work, superseding most previous studies of Venetian Baroque architecutre].

MAZZOTTI, GIUSEPPE. *Ville venete*. Rome, 1963 (2nd ed.) [short text but vast photographic corpus].

LEWIS, DOUGLAS. *The Late Baroque Churches of Venice*. New York, 1979.

HOWARD, DEBORAH. *The Architectural History of Venice*. London, 1980, 174–88.

BRUSATIN, MANLIO. *Venezia nel Settecento: stato, architettura, territorio*. Turin, 1980.

BASSI, ELENA. *Ville della privincia di Venezia*. Milan, 1987.

Sculpture

SEMENZATO, CAMILLO. *La scultura veneta del Seicento e del Settecento*. Venice, 1966 [The first serious attempt to master the *terra incognita* of Venetian baroque sculpture; biographies and ouevre catalogues].

SPIAZZA, ANNA MARIA (ed.). *Scultura lignea barocca nel Veneto*, Vicenza, 1997.

Painting

ARSLAN, EDOARDO. *Il concetto de 'luminismo' e la pittura veneta barocca*. Milan, 1946 [suggestive ideas].

La pittura del Seicento a Venezia (exhib. cat.). Venice, 1959 [Authors P. Zampetti, G. Mariacher and G. M. Pilo. The first exhibition devoted to this theme; extensive catalogue with full bibiliography. The controversial nature of some of the pictures shown is reflected in the reviews, most notably the following].
Reviews: B. Nicolson, *Burl. Mag.*, CI (1959), 286–8.
A. Morassi, *Arte veneta*, XIII–XIV (1959–60), 269–78.

LEVEY, MICHAEL. *Painting in XVIII Century Venice*. London, 1959 [a general, very readable introduction; Pilo's review is not quite justified].
Review: G. M. Pilo, *Arte veneta*, XIII–XIV (1959–60), 250–2.

PALLUCCHINI, RODOLFO. *La pittura veneziana del Settecento*. Venice, 1960 [standard work; must be consulted for all painters of the Venetian eighteenth century. Bibliographies only up to 1957/8].

RIZZI, ALDO. *Mostra della pittura veneta del Settecento in Friuli* (exhib. cat.). Udine, 1966.

DONZELLI, CARLO and PILO, GIUSEPPE MARIA. *I pittori del Seicento veneto*. Florence, 1967 [a useful illustrated dictionary].

ZAMPETTI, PIETRO. *I vedutisti veneziani del Settecento* (exhib. cat.). Venice, 1967 [includes over 30 pages of bibliography].

RIZZI, ALDO. *Mostra della pittura veneta del Seicento in Friuli* (exhib. cat.). Udine, 1968.

PRECERUTTI GARBERI, MERCEDES. *Affreschi settecenteschi delle ville venete*. Milan, 1968 (English translation, London, 1971) [the first coherent study of this important subject; contains many hitherto unpublished cycles].

ZAMPETTI, PIETRO. *Dall Ricci al Tiepolo. I pittori di figura del Settecento a Venezia*. Venice, 1969 [this did not have an enthusiastic reception, but was illuminating for such artists as Bencovich, Grassi, Diziani and Fontebasso; even for the major masters, its contribution was considerable].

MAGAGNATO, LICISCO (ed.). *Cinquant'anni di pittura a Verona 1580–1630* (exhib. cat., Verona). Venice, 1974.

D ARCAIS, FRANCESCA, ZAVABOCCAZZI, FRANCA and PAVANELLO, GIUSEPPE. *Gli affreschi nelle ville venete del Seicento all'Ottocento* (2 vols). Venice, 1978.

MAGAGNATO, LICISCO (ed.). *La pittura a Verona tra Sei e Settecento* (exhib. cat.). Verona, 1978.

PALLUCCHINI, RODOLFO. *La Pittura veneta del Seicento*. Milan, 1981.
Review: E. Safarik, *Arte veneta*, XXXV (1981), 254–64.

Drawings

A series of exhibitions of Venetian drawings from various countries has been mounted at the Fondazione Cini.

IV. ARTISTS

ALBANI

Van Schaack, Eric. 'Albani's Guida di Bologna', *Le arti a Bologna e in Emilia dal XVI al XVII secolo (Atti del XXIV Congresso Internazionale di Storia dell'Arte)* (1979). Bologna, 1982, 179–81.

Puglisi, Catherine. 'Early Works by F.A.', *Paragone*, 381 (1981), 36–47.

Benati, Daniele. 'Qualche osservazione sulla attività giovanile di F.A.', *Paragone*, 381 (1981), 48–58.

Turner, Nicholas. 'Some Thoughts on F.A. as a Draughtsman', *Renaissance Studies in Honour of Craig Hugh Smyth*. Ed. A. Morrogh (and others), Florence, 1985, I. 493–500.

Benati, Daniele, '"Con pari tenerezza, e miglior disegno": A. (e Reni) prima di Roma', *Arte cristiana*, LXXIX (1991), 23–38; 99–110.

Brogi, Alessandro. 'Il laboratorio dell'ideale: note sulla prima attività di F.A. tra Bologna e Roma', *Paragone*, 483 (1990), 49–66.

Von Flemming, Victoria. *Arma Amoris: Sprachbild und Bildsprache der Liebe: Kardinal Scipione Borghese und die Gemäldezyklen F.A.s*. Mainz, 1996.

Puglisi, Catherine. *F. A.*, New Haven, London, 1999.

ALEOTTI

Aleotti, Giovanni Battista. *Gli artifitiosi et curiosi moti spiritali di Herrone...Et il modo con che si fà artificiosamente salir un Canale d'Acqua viva, ò morta, in cima d'ogni alta Torre*. Ferrara, 1589.

Gandolfi, Vittorio. *Il Teatro Farnese di Parma*. Parma, 1980.

Ivaldi, A.F. 'G.B. Aleotti architetto e scenografo teatrale', *Deputazione provinciale ferrarese di storia patria. Atti*, 27 (1980), 187–225.

Adorni, Bruno. 'Il teatro Farnese a Parma', *Casabella*, 650 (Nov. 1997), 60–77.

G. B. A. (1546–1656). Bologna, 1994–95.

ALFIERI

Bellini, Amedeo. *Benedetto Alfieri*. Milan, 1978.

Benedetto Alfieri. L'opera astigiana (exhib. cat., Asti). Ed. M. Macera, Turin, 1992.

See also Pommer, R., under III.REGIONS: TURIN

ALGARDI

Cellini, Antonia Nava. 'L'Algardi restauratore a Villa Pamphilj', *Paragone*, 161 (1963), 25–37.

Vitzthum, Walter. 'Disegni di A. A.', *Boll. d'Arte*, XLVIII (1963), 75–98.

Cellini, Antonia Nava. 'Note per l'A., il Bernini, e il Reni', *Paragone*, 207 (1967), 35–52.

Neumann, Enno. *Mehrfigurige Reliefs von A.A.: Genese, Analyse, Ikonographie*. Frankfurt am Main, 1985.

Montagu, Jennifer. *A. A.* New Haven, London, 1985.

Preimesberger, Rudolf. 'Eine Peripetie in Stein? Bemerkungen zu A. A.s Relief der Begegnung Leos des Grossen mit Attila', *Aachener Kunstblätter*, LX (1994), 397–416 [an attempt to relate the relief to the contemporary political situation].

Algardi. L'altro faccia del barocco (exhib. cat.), Rome, 1999.

ALLORI

Chappell, Miles. *Cristofano Allori*. Florence, 1984.

AMATO, G.

Tusa, M. Serena. *Architettura barocca a Palermo. Prospetti chiesastici di Giacomo Amato architetto*. Palermo, 1992.

AMATO, P.

Ruggieri Tricoli, M. Clara. *Paolo Amato la corona e il serpente*. Palermo, 1983.

AMIGONI

Scarpa Sonino, Analisa. *Jacopo Amigoni*. Soncino, 1994 [inadequate monograph].

AMOROSI

Maggini, Claudio. *Antonio Mercurio Amorosi: pittore (1660–1738)*. Rimini, 1996 [a not entirely satisfactory, and over-inclusive, monograph].

ANSALDO

Boggero, Franco (ed.). *Andrea Ansaldo, un pittore genovese del Seicento 1584–1638. Restauri e confronti*. Genoa, 1985.

ARPINO

Röttgen, Herwarth. *Il Cavalier d'Arpino* (exhib. cat., Arpino). Rome, 1973.

Tittoni, Maria Elisa. *Gli Affreschi del C. d'A. in Campidoglio. Analisi di un opera attraverso il restauro*. Rome, 1980.

Forcellino, Maria. *Il C. d'A. a Napoli, 1585–1597*. Milan, 1991.

ASSERETO

Longhi, Roberto. 'L'Assereto', *Dedalo*, VII (1926–7), 355–77.

Castelnovi, Gian Vittorio. 'Intorno al A.', *Emporium*, CXX (1954), 17–35.

Newcome, Mary. 'An Unknown Early Painting and some other Works by A.', *Jahrbuch der Berliner Museen*, XXVII (1985), 61–75.

Ausserhofer, Marta. 'Archivnotizen zu G. A. und anderen genueser Malern des 17. Jahrhunderts', *Mitteilungen des Kunsthistorischen Institutes in Florenz*, XXXV (1991), 337–56.

BADALOCCHIO

Salerno, Luigi. 'Per Sisto Badalocchio e la cronologia di Lanfranco', *Commentari*, IX (1958), 44–64; 216–18.

Causa Picone, Marina. 'S. B.: un "petit-maitre" parmense tra I Carracci e Lanfranco', *Prospettiva*, 57–60 (1989–80), 195–204.

Van Tuyll, Carel. 'The Montalto "Alexander" cycle again; the contribution of B.', *Paragone*, 393 (1982), 62–7.

Brogi, Alessandro. 'B.', *Studi di storia dell'arte* (Todi), II (1991), 189–212.

BAGLIONE

Guglielmi, Carla. 'Intorno all'opera pittorica di Giovanni Baglione', *Boll. d'Arte*, XXIX (1954), 311–26.

Longhi, Pietro. 'G.B. e il quadro del processo', *Paragone*, 163 (1963), 23–31.

Pepper, Stephen. 'B., Vanni and Cardinal Sfondrato', *Paragone*, 211 (1967), 69–74.

Bon, Caterina. 'Precisazioni sulla biografia di G.B.', *Paragone*, 347 (1979), 88–93.

Borea, Evelina. 'Date per B.', *Storia dell'arte*, XXXVIII–XI (1980), 315–18.

Bon, Caterina. 'Una proposta per la cronologia delle opere giovanile di G.B.', *Paragone*, 375 (1981), 17–48.

Marini, Maurizio. 'Il Cavalier G.B. pittore e il suo "angelo custode" Tommaso Salini pittore di figure. Alcune opere ritrovate', *Artibus et historiae*, V (1982), 61–74.

Möller, Renate, *Der römische Maler G.B. Leben und Werk...* Munich, 1991.

Meijer, Bert W. 'G.B. in S. Maria Maggiore', *Master Drawings*, XXXI (1993), 414–21 [with extensive bibliography on his drawings].

O'Neil, Maryvelma S. 'Cavaliere G.B.: "il Modo Eccellente di Disegnare",' *Master Drawings*, XXXVI, 1998, 355–77.

BALESTRA

D'Arcais, Franca. 'Per l'attivita grafica di Antonio Balestra', *Arte veneta*, XXXVIII (1984), 161–5.

Polazzo, Marco. *A. B. pittore veronese del Settecento*. Verona, 1978 [oeuvre catalogue based on manuscript autobiography].

See also *I pittori bergamaschi; il Settecento*, III (1989), 79–201 (L. Ghia, E. Baccheschi).

BAMBOCCIO, IL: *see* LAER, P. VAN

BARBIERI, G. F.: *see* GUERCINO

BASCHENIS

Rosci, Marco. *Baschenis Bettera & Co: Produzione e mercato della natura morta del Seicento in Italia*. Milan, 1971.
 Review: I. Bergström, *Art Bull.*, LVII (1975), 287–8.

Un incontro bergamasco, Ceresa–B. nelle collezioni private bergamaschi (exhib. cat., Galleria Lorenzelli). Bergamo, 1972.

Rosci, Marco. *E. B., Bartolomeo Bettera, Bonaventura Bettera*. Bergamo, 1985.

E. B. e la natura morta in Europa (exhib. cat. Bergamo). Milan, 1996.

BATONI

Macandrew, Hugh. 'A Group of Drawings by Batoni at Eton College', *Master Drawings*, XVI (1978), 131–50.

Bowron, Edgar Peters. *P. B.* (exhib. cat., Colnaghi). New York, 1982.

——*P.B. and his British Patrons* (exhib. cat., Kenwood). London, 1982.

Clark, Anthony (ed. E. P. Bowron). *P.B.: a complete catalogue of his works*. Oxford, 1985.

Russell, Francis. 'Notes on Luti, B. and Nathaniel Dance', *Burl. Mag.*, CXXXVI (1994), 438–43.

BAZZANI

Ivanoff, Nicola. *Bazzani* (exhib. cat., Mantua). Bergamo, 1950.

Tellini Perina, Chiara. *Giuseppe Bazzani*. Florence, 1970.

Caroli, Flavio. *G.B. e la linea d'ombra nell'arte lombarda*. Milan, 1988 [Oeuvre catalogue].

Tellini Perina, Chiara. 'G.B. pittore colto', *Paragone*, n.s., 9–11 (1988), 63–74.

BEAUMONT

Zucchi, Mario. *La vita e le opere di Cl. Fr. Beaumont*. Turin, 1921 [brief and unillustrated].

Telluccini, Augusto. 'L'arrazzeria torinese', *Dedalo*, VII (1926–7), 101–31; 167–85.

Viale-Ferrero, Mercedes. 'C.F.B. and the Turin Tapestry Factory', *Connoisseur*, CXLIV (1959), 145–51.

BELLOTTO

Kozakiewicz, Stefan. *Bernardo Bellotto genannt Canaletto*. Recklinghausen, 1972.

B.B.: Le vedute di Dresda (exhib. cat., Venice). Vicenza, 1986.

B.B.: Verona e le città europea (exhib. cat., Verona). Ed. S. Martinelli, Milan, 1990.

Rizzi, Alberto. *La Varsovia di B.* (exhib. cat., Ferrara). Milan, 1990.

Bowron, Edgar P. 'A Venetian Abroad: B. and "The Most Beautiful Views of Rome"', *Apollo*, CXL (September 1994), 26–32.

Marini, Giorgio. 'Il fiume e il castello: precisazioni sul viaggio romano di B.B.', *Artibus et Historiae*, XII (1991), 147–63.

Rizzi, Alberto. *B.B.: Dresda, Vienna, Monaco (1747–1766)*. Venice, 1996 [first of proposed 3 vol. oeuvre catalogue].
 Review: E. P. Bowron, *Burl. Mag.*, CXL (1998), 47–8.

BENCOVICH

Krückmann, Peter Oluf. *Federico Benkovitch 1677–1753*. Hildesheim, Zurich, New York, 1988.
 Reviews: A. Rizzi, *Arte veneta*, 42 (1988), 190–1.
 G. Knox, *Burl. Mag.*, CXXXI (1989), 655–6.

BENEFIAL

Falcidia, Giorgio. 'Per una definizione del 'caso' Benefial', *Paragone*, 343 (1978), 24–51.

Petraroia, Paolo. 'Contributi al giovane B', *Storia dell'arte*, 38/40 (1980), 371–9.

BERNINI, GIANLORENZO

General

Baldinucci, Filippo, *Vita di Gian Lorenzo Bernino scultore, architetto, e pittore*, Florence, 1682. Ed. S. Samek Ludovici, Milan, 1948. English translation by C. Enggass. University Park, Pa., 1966. Foreword by R. Enggass.

Bernini, Domenico. *Vita del Cav. G. L. B.* Rome, 1713. Anastatic reprint Munich, 1988.

Chantelou, Paul Fréart de. *Journal du voyage du Cav. B. en France*. Ed. L. Lalanne, Paris, 1885. English translation by Margery Corbett. *Cavalier B.'s Visit to France* Princeton, 1985. Notes by G. C. Bauer.

Fraschetti, Stanislao. *Il B.* Milan, 1900 [Outdated, but still has useful source material to be picked up; particularly valuable for works no longer ascribed to G.L.B.].

Sachetti Sassetti, Angelo. 'G.L.B. a Rieti', *Archivi d'Italia*, XXII (1955), 214–27 [mainly architecture].

Bernini, G. L. *Fontana di Trevi, Commedia inedita*. Ed. C D'Onofrio, Rome, 1963.

Hibbard, Howard. *B.* Harmondsworth, 1965 [Brief and accessible study, with learned notes].

D'Onofrio, Cesare. *Roma vista da Roma*. Rome, 1967 [on the early years of B., concerned with Mafeo Barberini (later Urban VIII), Scipione Borghese, and the Barcaccia. For attributions, cf. Lavin, 1968].

Fagiolo dell'Arco, Maurizio and Marcello. *B., una introduzione al gran teatro del Barocco*. Rome, 1967.

Lavin, Irving. 'Five Youthful Sculptures by G.L.B. and a Revised Chronology of his Early Works', *Art Bull.*, L (1968), 223–48.

Kauffmann, Hans. *G. L. B. Die figürlichen Kompositionen*. Berlin, 1970 [Primarily of interest as an iconographic study].
 Review: H. Hibbard, *Art Quarterly*, XXXVI (1973), 414–16.

Lavin, Irving. 'B.'s Death', *Art Bull.*, LIV (1972), 159–86.

——*B. and the Unity of the Visual Arts* (2 vols). New York, London, 1980 [wide-ranging study focused on the Cornaro Chapel].
 Reviews: J. Montagu, *Burl. Mag.*, CXXIV (1982), 140–2.
 R. Preimesberger, *Zeitschrift für Kunstgeschichte*, 49 (1986) 190–219

B. in Vaticano (exhib. cat., Vatican City). Rome, 1981.

G. L. B.: Il testamento, la casa, la raccolta dei beni. Ed. F. Borsi, C. A. Luchinat and F. Quinterio, Florence, 1981.

Wittkower, Rudolf. *G. L. B. The Sculptor of the Roman Baroque*. Oxford, 1981 (3rd. ed.).

G. B. New Aspects of His Art and Thought. Ed. I. Lavin, University Park, Pa., 1985.

Bandera Bistoletti, Sandrina. 'Lettura di testi berniniani: qualche scoperta e nuove osservazioni dal *Journal* di Chantelou e dai documenti della Bibliothèque Nationale di Parigi', *Paragone* (Arte), no. 429 (1985), 43–76.

Lavin, Irving. 'Le B. et son image du Roi-Soleil', in *Il se rendit en Italie. Mélanges offerts à André Chastel*. Rome, 1987, 491–78. Reprinted in Italian 1987. Expanded version 'B.'s Image of the Sun King', in *Past-Present. Essays on Historicism in Art from Donatello to Picasso*. Ed. I. Lavin, Berkely, Los Angeles, 1993, 139–200.

Tratz, Helga. 'Werkstatt und Arbeitsweise Berninis', *Röm. Jahrb. f. Kunstg.*, XXIII/XXIV (1988), 395–485.

Antikenrezeption im Hochbarock. Ed. H. Beck and S. Schulze, Berlin, 1989 [Most papers deal with aspects of B.'s art].

Martinelli, Valentino. *G.L.B. e la sua cerchia. Studi e contributi (1950–1990)*. Perugia, 1994.

L'ultimo B. 1665–1680. Ed. V. Martinelli, Rome, 1996 [studies on the Sacrament Altar, portraits of Clement X, etc.].

Coliva, Anna, Schütze, Sebastian (eds). *Bernini scultore. La nascità del barocco in casa Borghese* (exhib. cat., Galleria Borghese), Rome, 1998.

Weston-Lewis, Aidan (ed.). *Effigies and Ecstasies. Roman Baroque Sculpture and Design in the Age of Bernini* (exhib. cat.), Edinburgh, 1998.

Painting

Grassi, Luigi. *B. pittore*. Rome, 1945.

Martinelli, Valentino. ''Il ritratto del padre del B. ... a mano del cavaliere' nell'Accademia di S. Luca', *Storia dell'arte*, 38–40 (1980), 335–8. Reprinted by V. Martinelli, 1994 (BERNINI, General).

Drawing

Brauer, Heinrich and Wittkower, Rudolf. *Die Zeichnungen des G. B.* (2 vols). Berlin, 1931 (a reprint was produced in 1970. A complete new edition has been under way for many years, but the publication date is not in sight).

Harris, Ann S. *Selected Drawings of G. L. B.* New York, 1977.

Drawings by G. B. from the Museum der Bildenden Künste, Leipzig, German Democratic Republic (exhib. cat.). Ed. I. Lavin, Princeton, 1981.

Architecture

Mirot, L. 'Le B. en France', *Mémoires de la Société de l'hisotire de Paris et de l'Ile-de-France*, XXXI (1904), 161–288.

Underwood, Paul. 'Notes on B.'s Towers for St. Peter's in Rome', *Art Bull.*, XXI (1939), 283–7.

Braham, Allan. 'B.'s Design for the Bourbon Chapel', *Burl. Mag.*, 102 (1960), 443–7.

Millon, Henry. 'An Early Seventeenth Century Drawing of the Piazza San Pietro', *Art Quarterly*, XXV (1962), 229–41.

Kitao, Kaori. 'B.'s Church Façades: Method and Design and the *Contrapposti*', *J.S.A.H.*, XXIV (1965), 263–84.

Lotz, Wolfgang. 'Die Spanische Treppe: Architektur als Mittel der Diplomatie', *Röm. Jahrb. f. Kunstg.*, XII (1969), 39–94.

Kitao, Kaori. *Circle and Oval in the Square of St. Peter's*. New York, 1974.

Pühringer-Zwanowetz, Leonore. 'Ein Entwurf B.s für Versailles', *Wiener Jahrbuch für Kunstgeschichte*, 29 (1976), 101–19.

Blunt, Anthony. 'G. B. Illusionism and Mysticism', *Art History*, 1 (1978), 67–89.

Kruft, Hanno-Walter. 'The Origin of the Oval in B.'s Piazza S. Pietro', *Burl. Mag.*, CXXI (1979), 796–800.

Worsdale, Marc. 'An Earlier Project by B. for the Campanili of Saint Peter's', *Apollo*, 111, no. 215 (January 1980), 18–21.

Borsi, Franco. *B. architetto* (with documents and a catalogue raisonné by Francesco Quinterio). Milan, 1980. English translation by Robert Wolf. *B.* New York, 1984 [review by Klaus Güthlein in *Zeitschr. f. Kunstg.*, 49 (1986), 248–52].

Laurain-Portemer, M. 'Mazarin, Benedetti et l'escalier de la Trinité des Monts', in *Etudes Mazarines*. Paris, 1981, I, 311–35. See also 'Nouvelles observations...', 535–44.

Birindelli, Massimo. *La machina heroica. Il disegno di G. B. per piazza San Pietro*. Rome, 1980. Republished as *Piazza San Pietro*. Bari, 1981.

Spagnesi, Gianfranco and Fagiolo, Marcello (eds). *G. L. B. architetto e l'architettura europea del Sei- Settecento* (2 vols). Rome, 1983–4 [many essays on various aspects of B.'s work, influence and reputation].

Boucher, Bruce. 'B. e l'architettura del cinquecento: La lezione di Baldassare Peruzzi e di Sebastiano Serlio', *Bollettino C.I.S.A. 'Andrea Palladio'*, XXIII (1981), 27–43.

Birindelli, Massimo. *La strada nel palazzo. Il disegno di G. B. per la Scala Regia*. Rome, 1982.

Noehles, Karl. 'Eine antikisierende Kolonnadenarchitektur B.s von 1629 für eine Kanonisationsfeier', *Boreas. Münstersche Beiträge zur Archäologie*, 5 (1982), 191–200 (1629 canonization of Andrea Corsini).

Rietbergen, Peter. 'A Vision Come True. Pope Alexander VII, G. B. and the Colonnades of St. Peter's, 1655–1667', *Mededelingen van het Nederlands Institut te Rome*, XLIV, n.s., 9–10 (1983), 111–64 [part of the author's thesis *Pausen, Prelaten, Bureaucraten: Aspecten van de geschiedenis van het Pausschap en de Pauselijke Staat in de 17e Eeuw*. Nijmegen, 1983.].

Marder, Tod. 'The Decision to Build the Spanish Steps: From Project to Monument', *Papers in Art History from the Pennsylvania State University*. Eds H. Hager and S. Munshower, I (1984), 83–99.

Del Pesco, Daniela. *Il Louvre di B. nella Francia di Luigi XIV*. Naples, 1984.

Birindelli, Massimo. *Architettura come modificazione. B. all'Ariccia, e un addizione di Juvarra*. Rome, 1986.

Millon, Henry. 'B.-Guarini: Paris-Turin: Louvre-Carignano', in *Il se rendit en Italie. Etudes offerts à André Chastel*. Rome and Paris, 1987, 479–500.

Del Pesco, Daniela. *Colonnato di San Pietro 'Dei Portici antichi e la loro diversità' Con un'ipotesi di cronologia*. Rome, 1988.

Marder, Tod. 'B. and Alexander VII: Criticism and Praise of the Pantheon in the Seventeenth Century', *Art Bull.*, LXXI (1989), 628–45.

Hager, Hellmut. 'Inquiries into B.'s Architectural Legacy', *Quaderni dell'Istituto di Storia dell'Architettura*, n.s., 15–20 (1990–2), 693–706.

Marder, Tod. 'The Evolution of B.'s Designs for the Façade of Sant'Andrea al Quirinale: 1658–76', *Architectura*, 20 (1990), 108–32.

Goebel, Gerhard. 'B.s Petersplatz und die Ellipse', *Architectura*, 20 (1990), 133–41.

Nobile, Marco Rosario. 'Una geometria "difficile": progetti di chiese pentagonali fra XV e XVIII secolo', *Il disegno di architettura*, 2 (1990), 29–31 [B. and Serlio, etc.].

Marder, Tod. 'Alexander VII, B., and the Urban Setting of the Pantheon in the Seventeenth Century', *J.S.A.H.*, L (1991), 273–92.

Morello, Giovanni. 'I rapporti tra Alessandro VII e G. L. B. negli autografi del Papa (con disegni inediti)', in E. Cropper, G. Perini and F. Solinas (eds) *Documentary Culture Florence and Rome from Grand-Duke Ferdinand I to Pope Alexander VII* (1990). Baltimore, 1992, 81–125.

Baggio, Carlo, Ramina, Renata and Zampa, Paola. 'Considerazioni sulla facciata di Santa Bibiana in Rome', *Quaderni dell'Istituto di Storia dell'Architettura dell'Università degli Studi Roma 'la Sapienza'*, n.s., 21 (1993), 39–62.

Barry, Fabio. 'I "marmi loquaci": Painting in Stone', *Daidalos*, 56 (June 1995), 106–21.

Careri, Giovanni. *B. Flights of Love, the Art of Devotion*. Chicago, 1995.

Ackermann, Felix. 'B.s Umgestaltung des Innenraums von S. Maria del Popolo unter Alexander VII. (1655–1659)', *Römisches Jahrbuch der Bibliotheca Hertziana*, 31 (1996), 369–426.

Terhalle, Johannes. 'Quantität als Qualität. Der Marmor in S. Andrea al Quirinale', *Daidalos*, 61 (1996), 44–9.

Morresi, Manuela. 'Assimilazione e interpretazione barocca del Pantheon: la chiesa e il pronao di S. Andrea al Quirinale', *Rivista storica del Lazio*, IV (1996), 99–123.

Terhalle, Johannes. *Prolegomena zu S. Andrea al Quirinale in Rom. Zur Vorgeschichte von B.s Andreaskirche: 1565–1658*. Diss. Tübingen, 1997.

Marder, Tod. *B.'s Scala Regia at the Vatican Palace*. Cambridge, 1997.

——*The Architecture of G.L.B.* New York, 1998 [with complete bibliography to date].

Major Composite Works

Thelen, Heinrich. *Zur Entstehungsgeschichte der Hochaltararchitektur von St. Peter in Rom*. Berlin, 1967.

Lavin, Irving. *B. and the Crossing of Saint Peter's*. New York, 1968.

Kirwin, W. Chandler. 'B.'s Baldacchino Reconsidered', *Röm. Jahrb. f. Kunstg.*, XIX (1981), 141–71. Reply by I. Lavin, *idem.*, XXI (1984), 405–15.

Hesse, Michael. 'Berninis Umgestaltung der Chigi-Kapelle an S. Maria del Popolo in Rom', *Pantheon*, 41 (1983), 109–26.

Le statue berniniane del colonnato di San Pietro. Ed. V. Martinelli, Rome, 1987.

Perlove, Shelley K. *B. and the Idealization of Death. The Blessed Ludovica Albertoni and the Altieri Chapel*. University Park, Pa., 1990.

Tratz, Helga. 'Die Ausstattung des Langhauses von St. Peter unter Innozenz X.', *Römisches Jahrbuch der Bibliotheca Hertziana*, XXVII/XXVIII (1991/92), 337–74.

Schütze, Sebastian. '"Urbano inalza Pietro, e Pietro Urbano". Beobachtungen zu Idee und Gestalt der Ausstattung von Neu-St. Peter unter Urban VIII.', *Röm. Jahrb. f. Kunstg.*, XXIV (1994), 213–87.

Kirwin, W. Chandler. *Powers Matchless. The Pontificate of Urban VIII, the Baldachin, and G. L. B.* Washington, 1997.

Bridges and Fountains

Hibbard, Howard and Jaffé, Irma. 'B.'s Barcaccia', *Burl. Mag.*, CVI (1964), 159–71 [iconographic study].

Zamboni, Silla. 'G. L. B.: un modello per la "Fontana dei Quattro Fiumi" ritrovato', *Rapporto della Soprintendenza alle Gallerie di Bologna*, VII (1970), 31–43.

Huse, Norbert. 'La fontaine des flueves du Bernin', *Revue de l'Art*, 7, (1970), 7–17.

Preimesberger, Rudolf. 'Obeliscus Pamphilius', *Münchner Jahrbuch der Bildenden Kunst*, XXV (1974), 77–162.

Weil, Mark S. *The History and Decoration of the Ponte S. Angelo*. University Park, Pa., 1974.

La via degli angeli. Il restauro della decorazione scultorea di Ponte S. Angelo. Ed. L. C. Alloisi and M. G. T. Speranz, Rome, 1988 [includes documents].

Tritone ristaurato. Ed. L. C. Alloisi. Rome, 1988.

Tombs and Busts

Gaborit, Jean-René. 'Le B., Mocchi et le buste de Richelieu au Musée du

Louvre: un problème d'attribution', *Bulletin de la Société de l'Histoire de l'Art Français*, 1977 (1979), 85–91.

Preimesberger, Rudolf. 'Das dritte Papstgrabmal B.s', *Röm. Jahrb. f. Kunstg.*, XVII (1978), 157–81.

Bernstock, Judith E. 'B.'s Memorials to Ippolito Merenda and Alessandro Valtrini', *Art Bull.*, LXIII (1981), 210–30.

Lavin, Irving. 'B.'s bust of Cardinal Montalto', *Burl. Mag.*, CXXVII (1985), 32–8.

Martinelli. 'Il busto originale di Maria Barberini ... di G.I.L.B. e Giuliano Finelli', *Antichità viva*, XXVI, 3 (1987), 27–36.

Bernstock, Judith E. 'La tumba del cardenal Domingo Pimentel, de B.', *Archivo Español de arte*, LX (1987), 1–15 [useful for documentation].

Casale, Vittorio. 'Due sculture di G.L.B.: I ritratti di Bartolomeo e Diana Roscioli', *Paragone*, 465 (1988), 3–30.

Contardi, Bruno. 'Precisazioni sul B. nella Cappella Fonseca', *Studi di storia dell'arte* (Todi), I (1990), 273–83.

Koortbojian, Michael. '"Disegni" for the Tomb of Alexander VII', *J.W.C.I.*, LIV (1991), 268–73.

Zollikofer, Kaspar. *B.s Grabmal für Alexander VII. Fiktion und Repräsentation.* Worms, 1994.

Individual sculptures

Wittkower, Rudolf. 'The Vicissitudes of a Dynastic Monument: B.'s Equestrian statue of Louis XIV', *Essays in Honour of Erwin Panofsky.* New York, 1961, 497–531. Reprinted in R. Wittkower. *Studies in the Italian Baroque.* London, 1975, 83–102.

Schlegel, Ursula. 'Zum Oeuvre des jungen G.L.B.', *Jahrbuch der Berliner Museen*, IX (1967), 274–94 [On newly acquired *Infant Struggling with a Fish*].

Winner, Matthias. 'B.s Verità. Baustein zur Vorgeschichte einer "invenzione"', *Munuscula Discipulorum. Kunsthistorische Studien Hans Kauffmann.* Berlin, 1968, 393–413.

Sloane, Catherine. 'Two Statues by B. in Morristown, New Jersey', *Art Bull.*, LVI (1974), 551–4.

Lavin, Irving. 'Afterthoughts on B.'s Death', *Art Bull.* LV (1973), 429–36 [mainly on bust of *Blessing Saviour*]; LX (1978), 548–9.

Raggio, Olga. 'A New Bacchic Group by B.', *Apollo*, CVIII (1978), 406–17.

Ostrow, Seven F. 'G. B., Girolamo Lucenti and the Statue of Philip IV in Santa Maria Maggiore: Patronage and Politics in Seicento Rome', *Art Bull.*, LXIII (1991), 89–118.

For the 'Constantine', see T. Marder. *The Scala Regia.* 1997.

Herrmann Fiore, Kristina (ed.). *Apollo e Dafne del Bernini nella Galleria Borghese.* Milan, 1997.

Tonkovich, Jennifer. 'Two Studies for the Gesù and a "quarantore" design by Bernini', *Burl. Mag.*, 140 (1998), 34–7.

Lesser Works

González-Palacios, Alvar. 'B. as a Furniture Designer', *Burl. Mag.*, CXII (1970), 719–22.

Schlegel, Ursula. 'I Crocefissi degli altari in San Pietro in Vaticano', *Antichità viva*, XX, 6 (1981), 37–42.

Varriano, John. 'Alexander VII, B., and the Baroque Papal Medal', in *Italian Medals (Studies in the History of Art, 21).* Washington (National Gallery), 1987, 249–60.

Bauer, George. 'B.'s Altar for the Val-de-Grace', in *Light on the Eternal City* (Papers in Art History from the Pennsylvania State University, 2). Eds H. Hager and S. Munshower, University Park, Pa., 1987, 176–87.

Harvard University Art Museums Bulletin, VI, 4 (1998) [devoted to the Fogg Museum's important collection of *bozzetti*].

See also M. Fagiolo (ed.), 1997 (III, ROME, *General*).

BERNINI, PIETRO

Martinelli, Valentino. 'Contributi alla scultura del Seicento: IV, Pietro Bernini e figli', *Commentari*, IV (1953), 133–54.

Negri Arnoldi, Francesco. 'Due schede e un'ipotesi per P.B.', *Boll. d'Arte*, LXVIII, 18 (1985), 103–8.

P. B., un preludio al barocco (photographic exhib. cat., Sesto Fiorentino). Florence, 1989.

Kesser, Hans-Ulrich. 'P. B. (1562–1629): Seine Werke in der Certosa di San Martino in Neapel, *Mitteilungen des Kunsthistorischen Institutes in Florenz*, XXXVIII (1994), 310–36.

Kessler, Hans-Ulrich. *P. B.* Forthcoming.

BERRETTINI: *see* CORTONA

BIANCO

Di Raimondi, Armando and Müller Profumo, Luciana. *Bartolomeo Bianco e Genoa: La controversa paternità dell'opera architettonica tra 1500 e 1600.* Genoa, 1982.

BIBIENA

Bibiena, Ferdinando Galli. *L'architettura civile preparata su la geometria, e ridotta alle prospettive.* Parma, 1711.

Mayor, Alpheus Hyatt. *The B. Family.* New York, 1945.

Hadamowski, Franz. *Die Familie G.-B. in Wien. Leben und Werk für das Theater.* Vienna, 1962.

Kelder, Diane M. *Drawings by the B. Family.* Philadelphia, 1968.

Beaumont, Maria Alice and Lenzi, Deanna, eds. *Disegni teatrali dei B.* Florence, 1970.

Muraro, Maria Teresa and Povoledo, Elena. *Disegni teatrali dei B.* (exhib. cat., Venice). Vicenza, 1970.

Müller, Claudia. 'F. G. B.'s "Scene di nuova invenzione"', *Zeitschr. f. Kunstg.*, XLIX (1986), 356–75.

Desenhos dos G. B.. Arquitectura e Cenografia (exhib. cat.). Lisbon, 1987.

Drawings by the B. Family and their Followers (exhib. cat.). London, 1991.

Lenzi, Deanna (and others). *Meravigliose scene, piacevoli inganni. G. B.* (exhib. cat.). Bibiena, 1992.

BILIVERT

Contini, Roberto. *Bilivert: saggio di ricostruzione.* Florence, 1985.

BINAGO

Mezzanotte, Gianni. 'Gli architetti Lorenzo Binago e Giovanni Ambrogio Mazenta', *L'Arte*, 60 (1961), 231–94.

Repishti, Francesco. '*Formula del offitio del Prefetto delle fabriche apresso delli Chierici Regolari della Congregazione di S. Paolo secondo L. B.*', *Arte Lombarda*, 96/97 (1991), no. 1–2, 137–40.

(See under II.C: *Patronage: Religious orders*, Gauk-Roger, 'Architecture of the Barnabite Order')

BIZZACHERI

Mallory, Nina. 'Carlo Francesco Bizzacheri (1655–1721)', *J.S.A.H.*, 33 (1974), 27–47. With an annotated catalogue by John Varriano [short complete monograph].

Carta, Marina. 'C. F. B. e la cappella del Monte di Pietà', *Boll. d'Arte*, 65 (April–June 1980), 49–56.

——'Il muro di cinta di Villa Aldobrandini a Frascati. Un momento della produzione artistica di C. F. B. ', *Boll. d'Arte*, 67 (Jan.–March 1982), 89–96.

——'Un architetto collezionista: C. F. B.', *Paragone*, 36, no. 429 (November 1985), 112–30 [mini-articles adding some documents].

BOLGI

Martinelli, Valentino. 'Andrea Bolgi a Roma e a Napoli', *Commentari*, X (1959), 137–58. (Reprinted by V. Martinelli, 1994 [BERNINI, General]).

Cellini, A. Nava. 'Ritratti di A.B.', *Paragone*, 147 (1962), 24–40.

Gelao, Clara. 'Un aggiunta all'attività napoletano di A.B.', *Storia dell'arte*, 70 (1990), 337–43.

Dombrowski, Damian. 'Aggiunte all'attività di A.B. e revisione critica delle sue opere', *Rivista dell'Istituto Nazionale d'Archeologia e Storia dell'Arte*, ser. III, XIX–XX (1996–7), 252–304.

BOMBELLI

Rizzi, Aldo. *Mostra del Bombelli e del Carneo* (exhib. cat.). Udine, 1964.

Zava Boccazzi, Franca. 'Il testamento di S. B.', *Arte documento*, II (1988), 154–5.

Pilo di Prampero, Mariede. 'Il ritratto di Pietro Enrico di Prompero di S.B.', *Arte documento*, IV (1990), 122–3.

BONAVIA

Constable, William G. 'Carlo Bonavia', *Art Quarterly*, XXII (1959), 19–44 [with oeuvre cat.].

BONAZZA

Semenzato, Camillo. *Antonio Bonazza (1698–1763).* 1957.

——'G. B.', *Saggi e memorie*, II (1959), 281–314.

Barbieri, Franco. 'Gli ignorati Marinali del Giardino Buonaccorsi: una precisazione su G. B. a Macerata', *Annali della Facolta di lettere e filosofia, Università di Macerata*, XXII–XXIII (1989–90), 121–33.

BONONI

Emiliani, Andrea. *Carlo Bononi.* Ferrara, 1962.

Schleier, Erich. 'C.B. and Antonio Gherardi', *Master Drawings*, VII (1969), 413–24.

Dipinti 'reggiani' del B. e del Guercino: pittura e documenti (exhib. cat.). Ed. N. Artioli and E. Monducci, Reggio Emilia, 1982.

Schleier, Erich. 'Five Drawings by C.B.', *Master Drawings*, XXXI (1993), 409–14.

See also E. Schleier (IV, under LANFRANCO)

BORGIANNI

Wethey, Harold E. 'Orazio Borgianni in Italy and Spain', *Burl. Mag.*, CVI (1964), 147–59.

Grado, Marco. 'O.B., l'Accademia di S. Luca e l'Accademia degli Humoristi: documenti e nuove datazioni', *Storia dell'arte*, 76 (1992), 296–345.

Papi, Gianni. *O. B.* Soncino, 1993.
Review: S. Loire, *Burl. Mag.*, CXXXVII (1995), 40–1.

Vannugli, Antonio. 'O.B., Juan de Lezcano and a "Martyrdom of St Lawrence" at Roncesvalles', *Burl. Mag.*, CXL (1998), 5–15.

BORROMINI

Borromini, Francesco. *Opera...*, vol. I (on Sapienza and S. Ivo). Ed. S. Giannini, Rome, 1720; vol. II (so-called *Opus Architectonicum* on Oratorio dei Filippini). Rome, 1725. Facsimiles and editions: (1) Ed. P. Portoghesi, Rome, 1964; (2) Daria De Bernardi Ferrero. *L'Opera di F. B. nella letteratura artistica e nelle incisioni dell'età barocca*. Turin, 1967 [a nearly complete collection of prints after B. 1656–1725]; (3) Ed. P. Bianconi, Lugano, 1967; (4) Gregg Press, London, [n.d.]; (5) vol. i only. Ed. M. De Benedictis, Rome, 1993; (5) MS of vol. ii. Ed. J. Connors, Milan, 1998.

General

Hempel, Eberhard. *F. B.* Vienna, 1924. Italian translation c. 1926 [first book and still one of the best].

Sedlmayr, Hans. *Die Architektur B.s.* Berlin, 1930. 2nd ed. Munich, 1939. Reprint, Hildesheim, New York, 1973. Italian translation by M. Pogacnik. *L'architettura del B.* Milan, 1996.

Argan, Giulio Carlo. *B.* Milan, 1955 [The Spanish translation (Madrid, 1980) has an important essay by Alfonso Rodriguez G. de Ceballos, 'F. B. y España'].

Portoghesi, Paolo. *B. nella cultura europea*. Rome, 1964.
——*B.: Architettura come linguaggio*. Rome, Milan, 1967. 2nd ed. 1984. English translation as *The Rome of B.* Cambridge, Ma., 1968 [extensive photographic coverage of buildings and drawings with full bibliography up to 1967; second edition adds new drawings].

Marconi, Paolo. *La Roma del B.* Rome, 1968.

Brizio, Anna Maria. *Nel terzo centenario della morte di F. B.* (Conferenza tenuta...d'intesa con l'Accademia di San Luca 7 Dicembre 1967), Rome, 1968.

Studi sul B. Atti del Convegno promosso dall'Accademia Nazionale di San Luca (1967) (2 vols.). Rome, 1970–1 [tercentenary commemoration with important essays by Wittkower, Battisti, Fagiolo, etc.].

Bruschi, Arnaldo. *B. Manierismo spaziale oltre il barocco*. Bari, 1978.

Blunt, Anthony. *B.* London, Cambridge, Ma., 1979 [best short introduction].

Raspe, Martin. *Das Architektursystem B.s.* Munich, 1994.

Kahn-Rossi, Manuela, and Franciolli, Marco, *Il giovane Borromini. Dagli esordi a San Carlo alle Quattro Fontane.* Milan, 1999.

Bösel, Richard, and Frommel, Christoph L., *Francesco Borromini e l'universo barocco*. Milan, 1999.

Documents

Del Piazzo, Marcello (ed.). *Ragguagli borrominiani* (Ministero dell'Interno. Pubblicazioni degli Archivi di Stato, LXI). Rome, 1968.

Tournon, Paolo. 'Per la biografia di F. e Bernardo B.', *Commentari*, 18 (1967), 86–9.

Heimbürger Ravalli, Minna. *Architettura scultura e arti minori nel barocco italiano. Ricerche nell'Archivio Spada*. Florence, 1977.

Güthlein, Klaus. 'Quellen aus dem Familienarchiv Spada zum römischen Barock', *Röm. Jahrb. f. Kunstg.*, 18 (1979), 173–246; 19 (1981), 173–250.

Drawings

Thelen, Heinrich. *F. B. Die Handzeichnungen*, Part I: 1620–32 (2 vols). Graz, 1967 [Includes 83 drawings up to 1634; part II will cover drawings for the buildings begun under Urban VIII; part III those begun under Innocent X and continued under Alexander VII. When complete the corpus will contain all known Borromini drawings, studied in the the light of extensive original documentation].
——*70 disegni di F. B. dalle collezioni dell'Albertina di Vienna*. Rome, 1958.
——*F. B. Mostra di disegni e documenti vaticani*. Vatican City, 1967.

Portoghesi, Paolo. *Disegni di F. B.* (exhib. cat.). Rome, 1967.

Bösel, Richard and Sladek, Elisabeth, *Francesco Borromini 1599–1667. L'opera completa dei disegni*. Milan, 1999.

See also Elisabeth Kieven (1993) under II.D.2 above

Churches and Convents

Bosi, Mario. *La serva di Dio Camilla Virginia Savelli Farnese fondatrice del monastero e della chiesa delle oblate agostiniane di Santa Maria dei Sette Dolori in Roma*. Rome, 1953.

Steinberg, Leo. *B.'s San Carlo alle Quattro Fontane. A Study in Multiple Form and Architectural Symbolism*. New York, 1977 [iconography and documentation in a revised diss. of 1960]

Giordano, Luisa. 'Modelli e invenzione: il chiostro di S. Carlo alle Quattro Fontane', *Zeitschrift für Schweizerische Archäologie und Kunstgeschichte*, 46 (1989), 49–59.

Connors, Joseph. *B. and the Roman Oratory: Style and Society*. New York, Cambridge, Ma., 1980. Italian translation. Turin, 1989. Further B. studies in *Burl. Mag.*, 131 (1989), 75–90; 133 (1991), 434–40; 137 (1995), 588–99; 138 (1996), 668–82.

Scott, John Beldon. 'The Counter-Reformation Program of B.'s Biblioteca Vallicelliana', *Storia dell'Arte*, 55 (1985), 295–304.

Ost, Hans. 'B.s römische Universitätskirche S. Ivo alla Sapienza', *Zeitschr. f. Kunstg.*, XXX (1967), 101–42 [classic iconographical study].

De la Ruffinière du Prey, Pierre. 'Solomonic Symbolism in B.'s Church of S. Ivo alla Sapienza', *Zeitschr. f. Kunstg.*, XXXI (1968), 216–32. Revised as 'Revisiting the Solomonic Symbolism of B.'s Church of Sant'Ivo alla Sapienza', *Volume Zero* (The Rensselaer Polytechnic Institute Architectural Journal).

Fagiolo, Maurizio. 'La Sapienza di B.: un progetto per il Palazzo dell'Università; l'emblematica / la natura / la struttura significante', *Storia dell'Arte*, 38/40 (1980), 343–51.

Scott, John Beldon. 'S. Ivo alla Sapienza and B.'s Symbolic Language', *J.S.A.H.*, XLI (1982), 294–317.

Ramirez, Juan Antonio. 'Para leer a San Ivo alla Sapienza (La utopia semantica en el barocco)', *Edificios y sueños (Ensayos sobre arquitectura y utopia)*. Malaga and Salamanca, [n.d.], 183–266.

Cirielli, Elisabetta and Marino, Alessandra. 'Il complesso della Sapienza: le fasi del cantiere, gli interventi successivi al B., le manutenzioni', *Ricerche di Storia dell'Arte*, 20 (1983), 39–64 [thorough documentation of changes in design].

Roma e lo Studium Urbis: Spazio urbano e cultura dal Quattro al Seicento. Rome, 1992.

Connors, Joseph. 'S. Ivo alla Sapienza: The First Three Minutes', *J.S.A.H.*, 1996, 38–57.

Eimer, Gerhard. *La fabbrica di S. Agnese in Navona* (2 vols). Stockholm, 1970.

Raspe, Martin. 'B. und Sant'Agnese in Piazza Navona. Von der Päpstlichen Grablege zur Residenzkirche der Pamphili', *Röm. Jahrb. f. Kunstg.*, 31 (1996), 313–68.

Echols, Robert. 'A Classical Barrel Vault for San Giovanni in Laterano in a B. Drawing', *J.S.A.H.*, LI (1992), 146–60.

Roca De Amicis, Augusto. *L'opera di B. in San Giovanni in Laterano: gli anni della fabbrica (1646–1650)*. Rome, 1995.

Roca De Amicis, Augusto. 'B. in Laterano sotto Alessandro VII. Il completamento della basilica', *Palladio*, 18 (July–December 1996), 51–74.

Antonazzi, Giovanni. *Il Palazzo di Propaganda*. Rome, 1979.

Stalla, Robert. 'Architektur im Dienst der Politik – B.s Kirchenbau der Propaganda Fide in Rom. Ein jesuitischer Bautypus für die Zentrale der Weltmission', *Römisches Jahrbuch der Bibliotheca Hertziana*, XXIX (1994), 289–341.

Zanchettin, Vitale. 'Il tiburio di Sant'Andrea alle Fratte: propositi e condizionamenti nel testo borrominiano', *Annali di architettura*, 9 (1997), 112–35.

Palaces and villas

Neppi, Lionello. *Palazzo Spada*. Rome, 1975.

Thelen, Heinrich. 'F. B.', in E. Berckenhagen. *Fünf Architekten aus fünf Jahrhunderten* (exhib. cat.). Berlin, 1976, 27–62 [Falconieri Palace and Chapel].

Howard, Elizabeth. *The Falconieri Palace in Rome: The Role of B. in its Reconstruction (1646–1649)*. New York, 1981.

Tafuri, Manfredo. 'B. in Palazzo Carpegna. Documenti inediti e ipotesi critiche', *Quaderni dell'Istituto di Storia dell'Architettura dell'Università di Roma*, 79/84 (1967), 85–107.

Carta, Marina. 'Un disegno di B. per la 'vigna' di Bernardino Missori', *Palladio*, n.s., 4 (1989), 69–76.

Curcio, Simonetta. 'Un'opera perduta di B.: il casino Barberini a Monte Mario', *Quaderni dell'Istituto di Storia dell'Architettura dell'Università di Roma*, n.s., 14 (1989), 85–96.

Personality

Wittkower, Rudolf. 'F. B., His Character and Life', in *Studies in the Italian Baroque*. London, 1975, 153–76 (translation of 'F. B.: personalità e destino', *Studi sul B.*, I, 19–48) [insightful psychological study].

Zuccari, Alessandro. 'B. tra religiosità borromaica e cultura scientifica', in A. Zuccari and S. Macioce (eds). *Innocenzo X Pamphilj. Arte e potere a Roma nell'età barocca*. Rome, 1990, 35–73.

Thelen, Heinrich. 'F. B. Bemerkungen zur Persönlichkeit', in G. Staccioli and I. Osols-Wehden (eds). *Come l'uomo s'etterna. Beiträge zur Literatur-, Sprach- und Kunstgeschichte Italiens und der Romania. Festschrift für Erich Loos*. Berlin, 1994, 264–94 [critique of the early lives].

Miscellaneous

Roca De Amicis, Augusto. 'F. B. e la tomba Merlini in Santa Maria Maggiore a Roma', *Architettura Storia e Documenti*, 1–2 (1987), 125–34.

Schütze, Sebastian. 'Die Cappella Filomarino in SS. Apostoli: Ein Beitrag zur Entstehung und Deutung von B.s Projekt in Neapel', *Römisches Jahrbuch der Bibliotheca Hertziana*, XXV (1989), 295–327.

Corradini, Sandro. 'Inediti del B. nella ristrutturazione di S. Martino al Cimino', in A. Zuccari and S. Macioce (eds.). *Innocenzo X Pamphilj. Arte e potere a Roma nell'età barocca*. Rome, 1990, 97–108.

Sladek, Elisabeth. 'I progetti per la sagrestia di San Pietro presentati da F. B. e Francesco Maria Febei ad Alessandro VII Chigi. L'irrisolta questione tra restauro e integrale rinnovamento della rotonda tardoantica di Santa Maria della Febbre', *Annali di architettura*, 7 (1995), 147–58.

Muñoz, Anntonio. 'La formazione artistica del Borromini', *Rassegna d'Arte*, VI (1919), 103–17.

Blunt, Anthony. 'Two Neglected Works by B.', *Röm. Jahrb. f. Kunstg.*, XX (1983), 17–31.

Kappner, Sabine. 'F. B.s Ausbildungsjahre an der Mailänder Dombauhütte 1608 bis 1619', *Arte Lombarda*, 108/9, 1994, 1–2, 14–20.

Gatti Perer, Maria Luisa. 'Nuovi argomenti per F. B.', *Arte Lombarda*, 101 (1997/3), 5–42.

BOSELLI

Boselli, Orfeo. *Osservazioni della scultura antica*. Ed. P. D. Weil, Florence, 1978 (facsimile, with notes).

——*Osservazioni sulla scultura antica. I manoscritti di Firenze e di Ferrara*. Ed. A. P. Torresi (printed text, no notes).

BRACCI

Domarus, Kurt von. *Pietro Bracci. Beiträge zur römischen Kunstgeschichte des XVIII. Jahrhunderts*. Strassbourg, 1915.

Gradara, Costanza. *P. B. scultore romano 1700–1773*. Milan, Rome, 1920 [based on P.B.'s diary].

Kieven, Elisabeth and Pinto, John. *Architecture and Sculpture in Eighteenth- century Rome: Drawings by P. and Virginio B. in the Canadian Centre and Other Collections*. University Park, Pa., 1998.

See also *San Pietro: Arte e storia*, 1996 (III, ROME, *Sculpture*)

BRUSTOLON

Biasuz, Giuseppe and Buttignon, Maria Giovanna. *Andrea Brustolon*. Padua, 1969.

Draper, James. 'Notes on the B. Figural Style', *Antologia di belle arti*, 23–4 (1984), 84–9.

Biasuz, Giuseppe. 'Il Gruppo di Laocoonte in una riproduzione giovanile del A. B.', *Archivio storico di Belluno, Feltre e Cadore*, XLVI (1975), 121–5.

Biasuz, Giuseppe. 'Documenti e appunti su alcune opere del B.', *Archivio storico di Belluno, Feltre e Cadore*, LI (1980), 8–13.

Draper, James. 'A Pair of Boxwood Sculptures by A. B.', *Städel Jahrbuch*, X (1985), 193–8.

——'Brustoloniana', *The Sculpture Journal*. I (1997), 16–21.

CAFFÀ

Preimesberger, Rudolf and Weil, Mark S. 'The Pamphilj Chapel in Sant'Agostino', *Röm. Jahrb. f. Kunstg.*, XV (1975), 183–98.

Jemma, Daniela. 'Inediti e documenti di Melchiorre Caffà', *Paragone*, 379 (1981), 53–8.

Di Gioia, Elena Bianca. 'Un Bozzetto di M. C. per il bassorilievo di S. Eustachio di Santa Agnese in Agone', *Bollettino dei Musei Comunali di Roma*, XXXI (1984), 48–67.

Montagu, J. 'L'Opera grafica del C.', *Paragone*, 413 (1984), 50–61.

Di Gioa, Elena Bianca. 'Un Bronzetto dalla S. Rosa da Lima di M. C. nel Museo di Roma', *Bollettino dei Musei Comunali di Roma*, n.s., 1 (1987), 39–53.

CAGNACCI

Buscaroli, Rezio. *Il pittore Guido Cagnacci*. Forlì, 1962.

Zuffa, Maria. 'Novità per G.C.', *Arte antica e moderna*, VI, 24 (1963), 357–81.

Pasini, Pier Giorgio. *G. C. pittore (1601–1663)*. Rimini, 1986.

Benati, Daniele and Castellotti, Marco Bona. *G. C. (exhib. cat., Rimini)*. Milan, 1993.

CAIRO

Testori, Giovanni (and others). *Francesco Cairo: 1607–1665 (exhib. cat., Varese)*. Milan, 1983

Reviews: N. W. Nielson, *Burl. Mag.*, CXXVI (1984), 508
L. Bassi, *Arte lombarda*, 73/4/5 (1985), 81–7

CAMASSEI

Cortese, Gemma di Domenico. 'La vicenda artistica di Andrea Camassei', *Commentari*, XIX (1968), 281–98.

Harris, Ann S. 'A Contribution to A.C. Studies', *Art Bull.*, LII (1970), 49–70.

Villa, Eleanora. 'Notizie inedite e precisiazioni su A.C.', *Esercizi*, 9 (1986), 60–71.

CAMETTI

Schlegel, Ursula. 'Bernardino Cametti', *Jahrb. Preuss. Kunstslg.*, n.f., V (1963) [Fully documented oeuvre catalogue].

De Ferraris, Paola. 'La fabbrica della chiesa delle Stimmate a Roma e la statua di S. Francesco di B.C.', *Storia dell'arte*, 65 (1989), 69–86.

CANALETTO

Constable, William G. *Canaletto: Giovanni Antonio Canal 1697–1768* Oxford, 1976 (2nd ed., revised by J. G. Links).

Links, Joseph G. *C. and his Patrons*. London, 1977.

—— *C.* Oxford, 1982.

Corboz, André. *C. Una Venezia immaginata*. Milan, 1985.

C. and England (exhib. cat., Birmingham). Ed. M. Liversidge and J. Farrington, London, 1993.

Bromberg, Ruth. *C.'s Etchings*. London, New York, 1974.

CANTARINI

Mancigotti, Mario. *Simone Cantarini, il Pesarese*. Pesaro, 1975.
Review: A. Colombi Ferretti, *Annali della Scuola Normale Superiore di Pisa, classe di lettere e filosofia*, s. III, VI, 3–4 (1976), 1532–8.

Bellini, Paolo. *S. C., disegni, incisioni e opere di riproduzione* (exhib cat.). San Severino Marche, 1987.

S. C. detto il Pesarese(exhib. cat.). Ed. A. Emiliani, Bologna, 1997.

CANUTI

Stagni, Simonetta. *Domenico Canuti, pittore*. Rimini, 1988.
Review: G. Perini, *Burl. Mag.*, CXXXII (1990), 578

CARACCIOLO

Stoughton, Michael. 'Giovanni Battista Caracciolo: New Biographical Documents', *Burl. Mag.*, CXX (1978), 204–5.

Prohaska, Wolfgang. 'Beiträge zu G. B. C.', *Jahrbuch der Kunsthistorischen Sammlungen in Wien*, LXXIV (1978), 153–269.

B. C. e il primo naturalismo a Napoli (exhib. cat.). Ed. F. Bologna, Naples, 1991.
Review: J. T. Spike, *Burl. Mag.*, CXXXIV (1992), 139–41.

Causa Picone, Marina. 'Giunte a Batistello Appunti per una storia critica del B. disegnatore', *Paragone*, 519–21 (1993), 24–87.

Fumagalli, Elena. 'B. C., 161', *Paragone*, 519–21 (1993), 88–94.

CARAPECCHIA

Bartolini Salimbeni, Lorenzo. 'Il taccuino di un apprendista nella Roma di fine Seicento: il 'Compendio architettonico' di Romano Carapecchia', *Architettura Storia e Documenti*, 1990/1–2, 141–63.

Tonna, Jo and De Lucca, Dennis. *R. C.* (Studies in Maltese Architecture, 1). Malta, 1975.

CARAVAGGIO

Longhi, Roberto. *Il Caravaggio*. Milan, 1952. Reprinted with changes. Rome, Dresden, 1968; Ed. G. Previtali, Rome, 1982.
Review: D. Mahon, *Burl.Mag.*, XCV (1953), 213–20 (together with L. Venturi's *Il Caravaggio*, Nogara, 1951).

Friedlaender, Walter. *C. Studies*. Princeton, 1955 [masterly pioneering study, still useful, especially for English translations of the court proceedings].

Longhi, Roberto. 'Un'opera extrema del C.', *Paragone*, 111 (1959), 21–32.

——'Un originale del C. a Rouen', *Paragone*, 121 (1960), 23–36.

——'Il vero 'Maffeo Barberini del C.', *Paragone*, 121 (1960), 3–11.

Posner, Donald. 'C.'s Homo-Erotic Early Works', *Art Quarterly*, XXXIV (1971), 301–24.

Burl. Mag., CXVI (1974), 559–626 [October issue devoted to C.; includes several articles on the controversial *Conversion of the Magdalen* in Detroit].

Röttgen, Herwarth. *Il C.: Ricerche e interpretazioni*. Rome, 1974.

Moir, Alfred. *C. and his Copyists*. New York, 1976.

Pacelli, Vincenzo. 'New Documents Concerning C. in Naples', *Burl. Mag.*, CXIX (1977), 819–29.

Teuschler Lurie, Anne and Mahon, Denis. 'C.'s "Crucifixion of St. Andrew" from Valladolid', *Bulletin of the Cleveland Museum of Art*, LXIV, 1 (1977), 3–24.

Gash, John. *C.* London, 1980 [reedited 1988; useful brief English text].

Hibbard, Howard. *C.* New York, London, 1982 [well-rounded study in English, with translations of early biographies].

Cinotti, Mia and Dell'Acqua, Gian Alberto. *Michelangelo Merisi detto il Caravaggio: Tutte le opere*. Bergamo, 1983 [reprinted from *I Pittori bergamaschi; il Seicento*, I].

The Age of C. (exhib. cat., New York, Naples). New York, 1985.

Christiansen, Keith. 'C. and "l'esempio davani del naturale"', *Art Bull.*, LXVIII (1986), 421–45 [on C.'s working procedures and technique].

Marini, Maurizio. *Michelangelo Merisi da C.: 'pictor praestantissimus'.* Rome, 1987 (revised 1989).

Mahon, Denis. 'Fresh light on C.'s earliest period: his "Cardsharps" recovered' (with technical report by K. Christiansen), *Burl. Mag.*, CXXX (1988), 10–27.

Calvesi, Maurizio. *La Realtà di C.* Turin, 1990.

Cappelletti, Francesca and Testa, Laura, 'I quadri de C. nella collezione Mattei: Nuove documenti e i riscontri con le fonti', *Storia dell'arte*, 69 (1990), 234–44.

Mahon, Denis. 'The singing "Lute-player" by C. from the Barberini collection, painted for Cardinal del Monte' (followed by 'Some observations on the relationship between C.'s two treatments of the "Lute-player"', by K. Christiansen), *Burl. Mag.*, CXXXII (1990), 4–26.

Camiz, Franca Trinchieri. 'Music and Painting in Cardinal del Monte's Household', *Metropolitan Museum Journal*, XXVI (1991), 213–26.

Gregori, Mina (ed.). *Michelangelo Merisi da C.: Come nascono i capolavori* (exhib. cat., Florence, Rome). Milan, 1991 [extensive discussion of materials and techniques; significant distillation of recent scholarship].
> Review: J. T. Spike, *Burl. Mag.*, CXXXIV (1992), 275–7.

Askew, Pamela. *C.'s Death of the Virgin.* Princeton, 1992.
> Review: J. Gash, *Burl. Mag.*, CXXXIV (1992), 186–8 (together with other books on C.).

Benedetti, Sergio. 'C.'s 'Taking of Christ', a masterpiece rediscovered' (with documentary evidence for its early history, by F. Cappelletti), *Burl. Mag.*, CXXXV (1993), 731–46.

Macioce, Stefania. 'C. a Malta e i suoi referenti: Notizie d'archivio', *Storia dell'Arte*, LXXXXI (1994), 207–28.

Gilbert, Creighton, *Caravaggio and His Two Cardinals*, University Park, 1995.

C. e la collezione Mattei (exhib. cat.). Ed. R. Vodret, Rome, 1995.

Michelangelo Merisi da C.: La vita e le opere attraverso i documenti (acts of colloquium, 1995). Rome, 1996.

Gash, John. 'The Identity of C.'s "Knight of Malta"', *Burl. Mag.*, CXXXIX (1997), 156–60.

See also P. Askew, 1969 (II, B, *Religious*); *Storia dell'arte*, 1971 (II, C. *Rome*).

Langdon, Helen, *Caravaggio: A Life*, London, 1998.

Puglisi, Catherine, *Caravaggio*, London, 1998.

CARLEVARIJS
Rizzi, Aldo. *Carlevarijs.* Venice, 1967.
——'Per Luca C.', *Arte veneta*, 36 (1982), 177–82.
L. C. e le vedute veneziane del Settecento (exhib. cat., Padua). Ed. I. Reale and D. Succi, Milan, 1994.
L.C. Le Fabriche, e Vedute di Venetia (exhib. cat., Udine). Venice, 1995.

CARLONE
Biavati, Giuliana. 'Precisazioni su Giovanni Andrea Carlone', *Paragone*, 297 (1974), 62–73.
Newcome Schleier, Mary. 'G. A. C.', *Paragone*, 409 (1984), 40–61.
Lunghi, Elvio. 'Documenti per l'attività di G. A. C. ad Assisi', *Arte cristiana*, LXXIX (1991), 55–62.

CARLONI
Barigozzi Brini, Amalia and Garas, Klára. *Carlo Innocenzo Carloni.* Milan, 1967 [exhaustive monograph].
C. I. C. (1686–1775): Ölskizzen (exhib. cat.). Salzburg, 1986.
Himmel, Ruhm und Herrlichkeit: Italienische Künstler an rheinischen Höfen des Barock (exhib. cat., Bonn). Ed. H. M. Schmidt, Cologne, 1989.
C. C.: Der Ansbacher Auftrag (exhib. cat., Ansbach). Ed. P. O. Krückmann, Landshut, 1990.
C. I. C. (1686/87–1775). Dipinti e bozzetti, ed. Simonetta Coppa, Peter O. Krückmann, Daniele Pescarmona (exhib. cat., Pincaoteca Züst, Recanati). Milan, 1997.

CARNEO
Rizzi, Aldo. *Antonio Carneo.* Udine, 1960.
A. C. nella pittura veneziana del Seicento (exhib. cat., Portogruaro). Milan, 1995.
See also BOMBELLI

CARPIONI
Pilo, Giuseppe M. *Carpioni.* Venice, 1962.
Barbieri, Franco. 'Inediti di Giulio C.', *Ricerche di storia dell'arte*, VI (1977), 129–44.
Brejon de Lavergnée, A. 'Une frise inédit de G.C. sur le thème des quatre âges de l'homme', *Revue de l'art*, 57 (1982), 85–90.

CARRACCI
General
Mostra dei Carracci. Catalogo critico (exhib. cat.). Bologna, 1956.
Bellori, Giovan Pietro. *The Lives of Annibale and Agostino C.* Translation by C. Enggass. University Park, Pa., London, 1968.
Les C. et les décors profanes [acts of colloquium, 1986]. Rome, 1988.
Perini, Giovanna. *Gli scritti dei C.*, Bologna, 1990.
Accademia Clementina – Atti e memorie. XXXII (1993) [number devoted to the C.].
—— XXXIII–XXXIV(1994) [number largely devoted to the C.].
Feigenbaum, Gail. 'Practice in the C. Academy', in *The Artist's Workshop* (*Studies in the History of Art*, 38). Washington (National Gallery), 1993, 59–76.

Agostino
Anderson, Jaynie. 'The "Sala di A. C." in the Palazzo del Giardino', *Art Bull.*, LII (1970), 41–8.
See also Prints (below)

Annibale
Posner, Donald. *A. C.: A Study in the Reform of Italian Painting around 1590* (2 vols). London, 1971.
Dempsey, Charles. *A. C. and the Beginnings of Baroque Style.* Glückstadt, New York, 1977.
> Review: C. Goldstein, *Art Quarterly*, Winter 1979, 112–15.
Borea, Evelina. *A. C. e i suoi incisori.* Rome, 1986.

Lodovico
Bodmer, Heinrich. *L. C.* Burg, 1939.
> Review: W. Friedlaender, *Art Bull.*, XXIV (1942), 190–5.
L. C. (exhib. cat.). Ed. A. Emiliani, Bologna 1993 [fuller than the English catalogue for the version shown at Fort Worth).

Antonio
Van Tuyll van Serooskerken, Carel. 'Two Preparatory Drawings by A. C.', *Master Drawings*, XXXI (1993), 428–32.
See also also Negro and Pirondini (ed.), 1994–5 (III, BOLOGNA, *Painting*) [also for other later members of the family].

Individual frescoes
Tietze, Hans. 'Annibale C.s Galerie im Palazzo Farnese und seine römische Werkstätte', *Jahrbuch der Kunsthistorischen Sammlungen des Allerhöchsten Kaiserhauses*, XXVI(1906), 49–182.
Martin, J. R. *The Farnese Gallery.* Princeton, 1965.
Dempsey, Charles. 'Annibale C. au Palais Farnèse', in *Le Palais Farnèse.* Rome, 1981, I.i, 269–311 [up-dated and reworked version of his article, 'Et Nos Cedamus Amori', in *Art Bull.*, L (1968)].
Bologna 1584: Gli esordi dei C. e gli affreschi di Palazzo Fava (exhib. cat.). Ed. A. Emiliani, Bologna, 1984.
Briganti, Giulio, Chastel, André and Zapperi, Roberto. *Gli Amori degli Dei. Nuove indagini sulla Galleria Farnese.* Rome, 1987.
Emiliani, Andrea. *Le storie di Romolo e Remo di Ludovico, Agostino e Annibale C.* Bologna, 1989.
Campanini, Maria Silvia. *Il Chiostro dei C. a San Michele in Bosco.* Bologna, 1994.

Drawings
Wittkower, Rudolf. *The Drawings of the C. at Windsor Castle.* London, 1952.
Bacou, Rosaline. *Dessins des C.* (exhib. cat., Louvre). Paris, 1961 [drawings in Louvre].
Mahon. *Mostra dei C. Disegni* (exhib. cat.). Bologna, 1956.
Robertson, Clare and Whistler, Catherine. *Drawings by the C. from British Collections* (exhib. cat., Oxford, London). Oxford, 1996.
Robertson, Clare. 'Annibale C. and "invenzione": Medium and Function in the Early Drawings', *Master Drawings*, XXXV (1997), 3–42.
See also Bohlin, 1979 (*Prints*, below)

Prints
Calvesi, Maurizio and Casale, Vittorio. *Le incisioni dei C.* Rome, 1965.
Marabottini, Alessandro. *Le Arti di Bologna di Annibale C.* Rome, 1979.
Bohlin, Diane De Grazia. *Prints and Related Drawings by the C. Family.* Washington, 1979 [updated poorly translated Italian version, *Le stampe dei C.* Bologna, 1984].
See also A. Nova, 1983 (IV under CERANO)

CARRIERA
Sani, Bernardina (ed.). *Rosalba Carriera. Lettere, diari, frammenti.* Florence, 1985.
——*R. C.* Turin, 1988.
> Review: F. Russell, *Burl. Mag.*, CXXXI (1989), 857.

CASTELLAMONTE
Cavallari A., Murat. 'I due Castellamonte, urbanisti di stato', *Come Corena.* Turin, 1982, 264–76.

Roggero Bardelli, Costanza. 'Una piazza dell'Assolutismo: piazza Carlina a Torino tra progetto e realizzazione', *Storia della Città*, n. 54–6 (1993), 141–6.

CASTELLO, BERNARDO

Erbentraut, Regina. *Der genueser Maler Bernardo Castello, 1557?–1629: Leben und Ölgemälde*. Freren, 1989.

CASTELLO, GIOVANNI BATTISTA

Di Fabbio, Clario (ed.). *Gio. Battista Castello, 'Il Genovese': Miniatura e devozione a Genova fra Cinque e Seicento* (exhib. cat.). Genoa, 1990.

CASTELLO, VALERIO

Biavati, Giuliana. 'Valerio Castello: tra manierismo e rococo', *Emporium*, CXXXVI (1962), 99–113.
Manzitti, Camillo. *Valerio Castello*. Genoa, 1972 [Unsatisfactory monograph].
 Review: E. Waterhouse, *Burl. Mag.*, CXVI (1974)

CASTIGLIONE

Blunt, Anthony. *The Drawings of Giovanni Battista Castiglione and Stefano della Bella ... at Windsor Castle*. London, 1954.
Percy, Ann. 'C.'s Chronology: Some Documentary Notes', *Burl. Mag.*, CIX (1967), 672–7.
——*G. B. C., Master Draughtsman of the Italian Baroque* (exhib. cat.). Philadelphia, 1971.
Il Genio di G. B. C. il Grechetto (exhib. cat.). Genoa, 1990.

CAVALLINO

Percy, Ann (ed.). *Bernardo Cavallino of Naples: 1616–1656* (exhib. cat., Cleveland, Fort Worth). Bloomington, 1985 [a version was shown in Naples, 1985].

CAVEDONI

Negro, Emilio and Roio, Nicoletta. *Giacomo Cavedone 1577–1660*. Modena, 1996.

CECCO BRAVO: *see* MONTELATICI

CELESTI

Mucchi, Anton Maria and Della Croce, G. *Il pittore Andrea Celesti*, Milan, 1954 [oeuvre cat. and bibliography].
 Review: T. Pignatti, *Burl. Mag.*, XCVIII (1956), 383.
Morassi, Antonio. *Il pittore A.C.* Rome, 1969.

CERANO

Rosci, Marco. *Mostra del Cerano*. Novara, 1964.
Pesenti, Franco R. 'Il 'quadro delle tre mani' a Brera. Tecnica e stile in G. C. Procaccini, Morazzone e C.', *Studi di storia dell'arte*, III (1980), 7–21.
Nova, Alessandro. 'Postile al giovane C., la data di nascita, un committente e alcune incisioni inedite di Agostino Carracci', *Paragone*, 397 (1983), 46–64.

CERESA

Ruggeri, Ugo. *Carlo Ceresa, dipinti e disegni* ('Monumenta Bergomensia', LIII). Bergamo, 1979.
 Review: E. Waterhouse, *Burl. Mag.*, CXXIII (1981), 105.
Vertova, Luisa (ed.). *C.C. un pittore bergamasco nel '600* (exhib. cat.). Bergamo, 1983.
——*C. C. Bergamo*, 1984 (from *I pittori bergamaschi; il Seicento*, II).
——'Additions to C.C.', *Burl. Mag.*, CXXXVII (1995), 599–607.
See also *Un incontro bergamasco, C.–Baschenis*, 1972 (IV, under BASCHENIS)

CERQUOZZI

Briganti, Giuliano. 'Michelangelo Cerquozzi pittore di nature morte', *Paragone*, 53 (1954), 47–52.
Laureati, Laura. 'Michelangelo delle Battalie', *Paragone*, 523–5 (1993), 52–67.

CERUTI

Gregori, Mina. *Giacomo Ceruti (Monumenta Bergomensia LVIII)*. Bergamo, 1982.
 Review: E. Waterhouse, *Burl. Mag.*, CXXV (1983), 753–4.
G.C., Il Pitocchetto (exhib. cat.). Milan, 1987.

CESI

Graziani, Alberto. *Bartolomeo Cesi*. Milan, 1988.
Vicini, Sara. 'B.C. nel a Certosa di S. Gerolamo: nuove precisazioni', *Accademia Clementina. Atti e memorie*, XXVII (1990), 17–36.
Zacchi, Alessandro. 'B.C. fra tarda maniera e riforma carraccesca: nuove proposte per il catalogo dei disegni', *Arte cristiana*, LXXIX (1991), no. 743, 111–25.

CHIARI

Kerber, Bernhard. 'Giuseppe Bartolomeo Chiari', *Art Bull.*, L (1968), 74–86 [an entirely satisfactory monographic article].

CIGNANI, CARLO

Vitell Buscaroli, Syra. *Carlo Cignani (1628–1710)*. Bologna, 1953.
Emiliani, Andrea. *La cupola della Madonna del Fuoco nella cattedrale di Forlì: l'opera forlivese di C.C.* Bologna, 1979.
Fabbri Buscaroli, Beatrice. *C.C.: affreschi, dipinti, disegni*. Bologna, 1991 [more recent, but not satisfactory].

CIGOLI

Faranda, Franca. *Lodovico Cardi detto il Cigoli*. Rome, 1986.
Contini, Roberto. *Il C.* Soncino, 1991.
L.C. tra manierismo e barocco (exhib. cat.). Florence, 1992.
Chappell, Miles. *Disegni di L.C.* (exhib. cat., Uffizi). Florence, 1992.
Profumo, Rodolfo (ed.). *Trattato pratico di prospettiva di Lodovico Cardi detto il C. Manoscritto 2660A del ... Uffizi*. Rome, 1992.
Kemp, Martin. 'L.C. on the Origins and *Ragione* of painting', *Mitteilungen des Kunsthistorischen Institutes in Florenz*, XXXV (1991), 133–52.
An edition of C.'s treatise on perspective, by Martin Kemp, Miles Chappell, and Michele Camerota is forthcoming.

CODAZZI

Marshall, David R. *Viviano e Niccolò Codazzi and the Baroque Architectural Fantasy*. Milan, Rome, 1993.

COMMODI

Papi, Gianni. *Andrea Commodi*, Florence, 1994

CONCA

Sebastiano Conca (exhib. cat.). Gaeta, 1981

CONTINI, F.

Contini, Francesco. *Adriani Caesaris Immanem in Tiburtino Villam*. Rome, 1668.
Fiore, Francesco Paolo. 'F. e Giovanni Battista C.', *Ricerche di Storia dell'Arte*, 1–2 (1976): 197–210.
Salza Prina Ricotti, Eugenia. 'Villa Adriana in Pirro Ligorio e F. C.', *Atti della Accademia Nazionale dei Lincei*, Memorie, classe di scienze morali, storiche e filologiche, ser. VIII, XVII, 1973, fasc. I, 3–47.
Lotti, Luigi. 'La villa Barberini al Gianicolo e il problema delle fortificazioni meridionali del Vaticano', *L'Urbe*, XLIII.2 (March–April 1980), 1–16.

CONTINI, G.B.

Del Bufalo, A. *G. B. Contini e la tradizione del tardomanierismo nell'architettura tra '600 e '700*. Rome, 1982.
Hager, Hellmut. 'G. B. C. o Carlo Fontana? Osservazioni sui disegni e l'altare berninesco della "Madonna delle Grazie" nel Palazzo Venezia a Roma. *Commentari*, 27 (1976), 82–92.
Mariano, Fabio. 'Opere inedite di G. B. C. nelle Marche. Le chiese di S. Filippo ad Osimo ed a Cingoli', *Palladio*, n.s., 8, n.15 (1995), 39–48.

CORDIER

Pressouyre, Sylvia. *Nicolas Cordier: Recherches sur la sculpture à Rome autour de 1600* (2 vols). Rome, 1984.

CORNACCHINI

Wittkower, Rudolf. 'Cornacchinis Reiterstatue Karls des Grossen in St. Peter', *Miscellanea Bibliothecae Hertzianae*. Munich, 1961, 464–73.
Keutner, Herbert. 'Critical Remarks on the Work of A.C.', *North Carolina Museum of Art Bulletin*, I (1957–8), 13–22; 'The Life of A.C. by F. M. N. Gabburri', *ibid.* II (1958), 37–42.
Corbo, Anna Maria. 'Le Opere di A.C. per la Fabbrica di San Pietro', *Commentari*, XXVII (1976), 311–15.
See also *San Pietro: Arte e storia*, 1996 (III, ROME, *Sculpture*)

CORRADINI

Riccoboni, Alberto. 'Sculture inediti di Antonio Corradini', *Arte veneta*, VI (1952), 151–61.
Matsche, Franz. 'Das Grabmal des hl. Johannes von Nepomuk im prager Veitsdom', *Wallraf-Richartz Jahrbuch*, XXXVIII (1976), 92–122.
Cogo, Bruno. *A. C. scultore veneziano 1688–1752*. Este, 1996.

CORTE

Ivanoff, Nicola. 'Monsu Giusto ed altri collaboratori del Longhena', *Arte veneta*, II (1948), 115–26.
Vio, Gastone. 'L'Altare di San Lorenzo Giustiniani in San Pietro di Castello', *Arte veneta*, XXXV (1981), 209–17.

CORTESE (CORTOIS)

Salvagnini, Francesco Alberto. *I pittori borgognoni Cortese*. Rome, 1937 [outdated].
Graf, Dieter. *Kataloge des Kunstmuseums Düsseldorf, III, 2; Handzeichnungen 2. Die Handzeichnungen von G. C. und Giovanni Battista Gaulli*. Düsseldorf, 1976.
Rodinò, Simonetta Prosperi Valenti. *Disegni di G. C. (Guillaume Courtois) detto il Borgognone* (exhib. cat.). Rome, 1979.

CORTONA
General
[Ottonelli, Giandomenico; Cortona, Pietro da] *Trattato della pittura, scultura, uso, et abuso loro.* Florence, 1652. Facsimile ed. with introduction by Vittorio Casale. Treviso, 1975 [Cortona's role in the composition is limited; see Collareto, Marco. 'L'Ottonelli-Berretini e la critica moralistica', *Annali della Scuola Normale Superiore di Pisa, classe di lettere e filosofia*, ser. III (1975), 177–96; D.L. Sparti, *La Casa di P.d.C.*, 1957].

Fabbrini, Nicola. *Vita del Cav. P. d. C.* Cortona, 1896 [Still useful].

Briganti, Giuliano. *P.d. C. e della pittura barocca* . Florence, 1982 (2nd ed. with additions).

Del Piazzo, Marcello. *P. d. C. Mostra documentaria.* Rome, 1969 [Useful brief guide, but does not give locations].

Campbell, Malcolm. *P. d. C. at the Pitti Palace: A Study of the Planetary Rooms and Related Projects.* Princeton, 1977.
> Reviews: R. Fernandez, *Antologia*, 1978, 7/8, 303–8.
> C. Dempsey, *Art Bull.*, LXI (1979) 141–4.

Zibalone baldinucciano. Ed. B. Santi, II. Florence, 1981 [replaces edition of F. S. Baldinucci by Samek-Ludovici].

Kugler, L. *Studien zur Malerei und Architektur von P. B. d. C. Versuch einer gattungsübergreifenden Analyse zum Illusionismus im römischen Barock.* Essen, 1985.

Merz, Jörg Martin. *P. d. C. Der Aufstieg zum führenden Maler im barocken Rom.* Tübingen, 1991.
> Reviews: R. Kulzen, *Kunstchronik*, 1993, 47, 168–71.
> Reply by Merz, *Kunstchronik*, 47, 1994, 269–74.
> U. Fischer Pace, *Boll. d'Arte*, LXXVII, 761 (1992), 103–18
> Reply by Merz, LXXVIII, 80/81 (1993), 159.

Jarrard, Alice. 'P. d. C. and the Este in Modena', *Burl. Mag.*, CXL (1998), 16–24.

P. d. C. 1597–1669 (exhib. cat., Rome). Ed A. Lo Bianco, Milan, 1997 [including followers].

Frommel, Christoph, and Schütze, Sebastian, eds., *P. d. C., Atti del convegno internazionale Roma–Firenze, 12–15 novembre 1997*, Milan, 1998.

Architecture
Noehles, Karl. 'Die Louvre-Projekte von P. d. C. und Carlo Rainaldi', *Zeitschr. f. Kunstg.*, XXIV (1961), 40–74.

Chiarini, Marco and Noehles, Karl. 'P. d. C. a Palazzo Pitti: Un episodio ritrovato', *Boll. d'Arte*, 52 (1967), 233–9.

Noehles, Karl. 'Architekturprojekte C.s', *Münchner Jahrbuch der bildenden Kunst*, XX (1969), 171–206.

Noehles, Karl. *La chiesa dei SS. Luca e Martina nell'opera di P. d. C.* Rome, 1970 [a watershed in C. studies; see also the author's contribution to the 1997 catalogue cited above].

Noehles, Karl. 'Der Hauptaltar von Santo Stefano in Pisa: C., Ferri, Silvani, Foggini', *Giessener Beiträge zur Kunstgeschichte (Feschrift Günther Fiensch)*, I (1970), 87–123.

Cistellini, Antonio. 'C. and San Filippo Neri in Firenze', *Studi Seicenteschi*, XI (1970), 27–57.

Ost, Hans. 'Studien zu P. d. C.s Umbau von S. Maria della Pace', *Röm. Jahrb. f. Kunstg.*, XIII, 1971, 231–85.

Rasy, Elisabetta. 'P. d. C. I progetti per la Chiesa Nuova di Firenze', in Maurizio Fagiolo dell'Arco (ed.). *Architettura barocca a Roma.* Rome, 1972, 337–79.

Coffey, Caroline. 'P. d. C.'s Project for the Church of San Firenze in Florence, *Mitteilungen des Kunsthistorischen Institutes in Florenz*, 22 (1978), 85–118.

Benedetti, Sandro. *Architettura come metafora. P. d. C. 'stuccatore'.* Bari, 1980.

Riccardi, Maria Luisa. 'La chiesa e il convento di S. Maria della Pace', *Quaderni dell'Istituto di Storia dell'Architettura dell'Università degli Studi Roma 'la Sapienza'.* 163–8 (1981), 3–90 [Cortona cf. 45–78].

Merz, Jörg M. and Blunt, Anthony. 'The Villa del Pigneto Sacchetti', *J.S.A.H.*, XLIV (1990), 390–406.

Noehles, Karl. 'Rhetorik, Architekturallegorie und Baukunst an der Wende vom Manierismus zum Barock in Rom', in Volker Kapp (ed.). *Die Sprache de Zeichen und Bilder-Rhetorik und nonverbale Kommunikation in der frühen Neuzeit.* Marburg, 1990, 190–227.

Metzger Habel, Dorothy. 'The Projected Palazzo Chigi al Corso and S. Maria in Via Lata: The Palace-Church Component of Alexander VII's Program for the Corso', *Architectura*, 21 (1991), 121–35.

Zirpolo, Lilian. 'The Villa Sacchetti at Castelfusano: P. d. C.'s Earliest Architectural Commission', *Architectura*, 26 (1996), 166–84.

Sparti, Donatella Livia. *La casa di P. d. C. Architettura, accademia, atelier e officina.* Rome, 1997 [replaces Giovanni Battista Lugari, *La Via della Pedacchia e la casa di P. d. C.*, Rome, 1885].

Painting
Lavin, Irving. 'P. d. C. Documents from the Barberini Archives', *Burl. Mag.*, CXII (1970), 446–51.

Preimesberger, Rudolf. 'Pontifex Romanus per Aeneam Praesignatus: Die Galleria Pamphilj und ihre Fresken', *Röm. Jahrb. f. Kunstg.*, XVI (1976), 221–83.

Bernini, Dante, Zanardi, Bruno, Lo Bianco, Anna and Verdi, Orietta. *Il Voltone di P.d. C. in Palazzo Barberini (Quaderni di Palazzo Venezia, 2).* Rome, 1983.

Laureati, Laura. 'Un Opera giovanile di P. d. C.', *Paragone*, 503 (1992), 49–52.

Merz, Jörg Martin. 'I Disegni di P. d. C. per gli affreschi nella Chiesa Nuova a Roma', *Boll. d'Arte*, 86/87 (1994), 37–76.

Rodinò, Simonetta Prosperi Valenti. *P. d. C. e il disegno* (exhib. cat., Rome). Milan, 1997.

See also Scott, John Beldon. *Images of Nepotism* (II, C [Patronage, Urban VIII])

COZZA
Trezzani, Laura. *Francesco Cozza 1605–1682.* Rome, 1981.

CRESPI, DANIELE
Ward Neilson, Nancy. *Daniele Crespi.* Soncino, 1996.

CRESPI, GIUSEPPE MARIA
Merriman, Mira Pajes. *Giuseppe Maria Crespi.* Milan, 1980.
> Review: D. C. Miller, *Art Bull.*, LXVII (1985), 339–42.

G. M. C. 1665-1747 (exhib. cat.). Bologna, 1990.

Accademia Clementina. Atti e memorie, XXVI (1990) [special number devoted to G. M. C.]

See also J. T. Spike, 1986 (II.B, *Genre*)

CRETI
Roli, Renato. *Donato Creti.* Milan, 1967.
> Review: D. Miller, *Burl. Mag.*, CXI (1969), 306–7.

Roli, Renato. 'Il C. a Palazzo: il lascito Collina Sbaraglia al Senato di Bologna (1744)', *Arte a Bologna. Bollettino dei Musei Civici d'arte antica*, I (1990), 47–57.

Mazza, Angelo. 'Ercole e Cerbero. Un affresco di C. diciassettenne in Palazzo Fava ed altre opere giovanili', *Arte a Bologna. Bollettino dei Musei Civici d'arte antica*, II (1992), 97–123.

CROSATO
Fiocco, Giuseppe. *Giambattista Crosato.* Venice, 1944.

Mariuz, Adriana. 'Opere sacre di G. C.', *Arte veneta*, 45 (1993), 86–91.

DAL SOLE
Thiem, Christel. *Giovanni Gioseffo dal Sole: dipinti, affreschi, disegni.* Bologna, 1990.

DE FERRARI, GREGORIO
Newcome, Mary. 'Notes on Gregorio de Ferrari and the Genoese Baroque', *Pantheon*, XXVII (1979), 142–9.

Gruitrooy, G. *G. de F.* Berlin, 1987.

Newcome, Mary. *G. F.*, Turin, 1998.

DE FERRARI, LORENZO
Gavazza, Eza. *Lorenzo De Ferrari (1680–1744).* Milan, 1965.

DEL GRANDE
Pollak, Oskar. 'Antonio del Grande, ein unbekannter römischer Architekt des XVII. Jahrhunderts', *Kunstgeschichtliches Jahrbuch der K.K. Zentral-Kommission*, III (1909), 133–61.

DELLA BELLA
De Vesme, Alexander. *Stefano della Bella.* Ed. P. Dearborn Massar, New York, 1971.
> Review: A. Forlani Tempesti, *Paragone*, 279 (1973), 54–76.

Viatte, Françoise. *Dessins de S. d. B. (Musée du Louvre, Cabinet des Dessins, Inventaire général des dessins italiens).* Paris, 1974.
> Reviews: J.-M. Holleaux, *Nouvelles de l'estampe*, XVI (1974), 47
> P. D. Massar, *Master Drawings*, XIII (1975), 54–60.

Forlani Tempesti, Anna. *S. d. B. Incisioni.* Florence, 1973.
> Review: A. Blunt, *Burl. Mag.*, CXVI (1974), 481.

Catelli Isola, Maria. *Disegni di S. d. B. 1610–1664 dalle collezioni del Gabinetto Nazionale delle Stampe* (exhib. cat.). Rome, 1976.

Massar, Phyllis Dearborn. 'A Paris Sketchbook by F.D.B.', *Master Drawings*, XVIII (1980), 227–36.

See also Blunt, 1954 (IV, under CASTIGLIONE)

DELLA GRECA, V. and F.
Lefevre, R. 'Schede su due architetti siciliani a Roma nel '600: I della Greca', *Studi meridionali*, IV (1971), 387–405.

Curcio, Giovanna. 'La 'Breve Relatione' inedita di F. D. G. a la trattatistica funzionale fra il cinquecento e il seicento', *Ricerche di Storia dell'arte*, 8 (1978/79), 99–118.

Blunt, Anthony. 'Roman Baroque Architecture: The Other Side of the Medal', *Art History*, III (1980), 61–80.

Sladek, Elisabeth. 'Beiträge zu einer Monographie F. d. G.', *Römische Historische Mitteilungen*, 30 (1988), 216ff.

DERIZET

Martini, A. and Casanova, M.L. *SS.mo Nome di Maria*. Rome, 1962.

Oechslin, Werner. 'Contributo alla conoscenza di A. D. architetto e teorico dell'architettura', *Quaderni dell'Istituto di Storia dell'Architettura*, XCI (1969), 47–66.

Coletti, S., De Santis, F., and Paganelli, G. 'Roma: SS.mo Nome di Maria', *Ricerca di Storia dell'Arte*, XXXI (1987), 68–70.

Cozzolino, C. 'Due chiese romane di A. D.: progetti e realizzazioni', *Palladio*, IV (1989), 77–90.

DIZIANI

Zugni-Tauro, Anna P. *Gaspare Diziani*. Venice, 1971.

Pavanello, Giuseppe, 'Per G.D. decoratore', *Arte veneta*, 35 (1981), 126–36.

Il cielo domenicano di G.D.: Studi e ricerche in occasione del restauro. Bergamo, 1993.

Clouet, Sergio. 'Per G.D.: Questioni chronologiche e qualche inedito', *Arte veneta*, 42 (1988), 146–51

See also *I pittori bergamaschi; il Settecento.* II (1989), 658–75 (V. Caprara).

DOLCI

Heinz, Günther. 'Carlo Dolci, Studien zur religiösen Malerei im 17. Jahrhundert', *Jahrbuch der Kunsthistorischen Sammlungen in Wien*, LVI (1960), 197–234.

Del Bravo, Carlo. 'C.D. devoto del naturale', *Paragone*, 163 (1963), 32–41.

McCorquodale, Charles. 'A Fresh Look at C.D.', *Apollo*, 97 (1973), 477–88.

——'Some Unpublished Works by C.D.', *Burl. Mag.*, CXXI (1979), 142–50.

Baldassari, Francesca. *C. D.* Turin, 1995 [not yet the monograph C.D. deserves]

DOMENICHINO

Pope-Hennessy, John. *The Drawings of Domenichino in the Collection of His Majesty the King at Windsor Castle.* London, 1948.

Spear, Richard E. *D.* New Haven, London, 1982.

——'D. addenda', *Burl. Mag.*, CXXXI (1989), 5–16.

Rangone, Fiorenza. 'Per un ritratto di Francesco Angeloni', *Paragone*, 499 (1991), 46–67; see also Sparit, Donatella L. 'Il Musaeum Romanum di Francesco Angeloni. La quadreria', *Paragone*, 3s, 17 (1998), 46–79.

Spear, Richard E. 'D.'s will', *Burl. Mag.*, CXXXVI (1994), 83–4.

Curcio, Giovanna. 'Le contraddizioni del metodo. II.L'architetttura esatta di D.', in *D.1581–1641* (exhib. cat.). Milan, 1996, 150–61.

D., 1581–1641 (exhib. cat., Rome). Ed. A. Lo Binco, Milan, 1996.

Kliemann, Julian. 'Kunst als Bogenschiessen. Ds "Jagd der Diana" in der Galleria Borghese', *Römisches Jahrbuch der Bibliotheca Hertziana*, XXXI (1996), 273–311.

DOTTI

Matteucci, Anna Maria. *Carlo Francesco Dotti e l'architettura bolognese del Settecento* Bologna, 1969 (2nd ed.). [essential foundation for the larger field of architecure in Emilia-Romagna].

Oechslin, Werner. 'C. F. D. (1670–1759) Architekt des frühen Settecento in Bologna', *Zeitschr. f. Kunstg.*, 34 (1971), 208–39.

DUQUESNOY

Fransolet, Mariette. *François du Quesnoy sculpteur d'Urbain VIII.* Brussels, 1942 [Badly outdated, but still the only serious monograph].

Faldi, Italo. 'Le "Virtuose opperationi" di F. D. scultore incomparabile', *Arte antica e moderna*, II, 5 (1959), 52–61.

Dhanens, Elisabeth. 'De bozzetti van F. du Q: Het probleem van de ontwerpen voor de graftombe van Mgr. Triest', *Gentse bijdragen tot de kunstgeschiedenis en de Oudheidkunde*, XIX (1961–6), 103–22.

Martinelli, Valentino. 'Un "modello di creta" di Francesco Fiammingo, *Commentari*, XIII (1962), 113–20.

Noehles, Karl. 'F.D.: un busto ignoto e la cronologia delle sue opere' *Arte antica e moderna*, VII (1964), 86–96.

Haderman-Misguich, Lydie, *Les d. Q.*, Namur, 1970.

Lavin, Irving. 'D.'s "Nano di Crequi" and Two Busts by Francesco Mochi', *Art Bull.*, LII (1970), 132–49.

Toesca, Ilaria. 'A Group by D.?', *Burl. Mag.*, CXXVII (1975), 668–71 [on a group of the *Decollation of the Baptist*].

Schlegel, Ursula. 'Der Kenotaph des Jacob von Hase von F. D.', *Jahrbuch der Berliner Museen*, XVIII (1976), 134–54.

Hadermann-Misguich, 'F. du Q. restaurateur d'antiques', *Annales d'histoire de l'art et d'archéologie de l'Université Libre de Bruxelles*, 4 (1982), 27–42 [not a fully adequate treatment, which adds little new].

EMPOLI

Forlani, Anna. *Mostra di disegni di Jacopo da Empoli* (exhib. cat., Uffizi). Florence, 1962.

Bianchini, Maria Adelaide. 'J.d.E.'. *Paradigma*, 3 (1980), 91–146.

Marabottini, Alessandro. *J. di Chimenti d. E.* Rome, 1988.

——'Postilla all'E.', *Prospettiva*, 57–60 (1989–90), 117–20.

Chappell, Miles. 'Amongst the best: a studied appraisal and some proposals for J. d. E.', *Southwestern College Art Conference Review*, XII (1993), 200–4.

FALCONE

Saxl, Fritz. 'The Battle Scene without a Hero', *J.W.C.I.*, III (1939–40).

Alabiso, Annachiara. 'Aniello Falcone's frescoes in the villa of Gaspare Roomer at Barra', *Burl. Mag.*, CXXXI (1989), 31–6.

Leone De Castris, Pierluigi. 'Un "San Giorgio" a fresco ed altre cose di A.F.', *Boll. d'arte*, LXXVIII, 80–1 (1993), 55–68.

FANTONI

Antonio Fantoni e le sue opere. Ricordo del secondo centenario della sua morte. Alzano Maggiore, 1934.

Tirloni, Pietro. *A. F. scultore.* Milan, 1960.

Bossaglia, Rossana. *I F. Quattro secoli di bottega di scultura in Europa.* Vicenza, 1978.

I F. e il loro tempo (acts of colloquium, 1978). Bergamo, 1980.

Rigon, Lidia. *La bottega dei F.* Bergamo, 1988 [mainly on Andrea].

FANZAGO

Fogaccia, Piero. *Cosimo Fanzago.* Bergamo, 1945 [unsatisfactory as a monograph; contains archival documents, but some dubious attributions].

De Cunzo, Mario A. 'I documenti sull'opera di C. F. nella Certosa di San Martino', *Napoli nobilissima*, VI (1967), 98–107.

Fittipaldi, Teodoro. *Per C. F.: I busti della Certosa di S. Martino in Napoli.* Naples, 1969.

Mormone, Raffaele. 'Sculture di C. F.', *Napoli nobilissima*, 9 (1970), 174–85.

Winther, Annemarie. *C. F. und die Neapler Ornamentik des 17. und 18. Jahrhunderts.* Diss. Tübingen, 1973.

Weise, Georg. 'Il repertorio ornamentale del barocco napoletano di C. F. e il suo significato per la genesi del rococò', *Antichità viva*, XIII, 4 (1974), 40–53.

Madruga Real, Angela. 'C. F. en las Agustinas de Salamanca', *Goya*, CXXV (1975), 291–7.

Architecture

Bösel, Richard. 'C. F. a Roma', *Prospettiva*, 15 (1978), 29–40.

——'Neue Materialien zur Sakralarchitektur des Neapolitanischen Seicento: Die Kirche San Francesco Saverio', *Röm. Jahrb. f. Kunstg.*, XVIII (1979), 113–71.

Brauen, Fred. 'The High Altar at S. Pietro a Maiella: F., the Ghetti, and the Celestine Fathers in Naples' *Storia dell'arte*, 35 (1979), 39–48.

Cantone, Gaetano. *Napoli barocca e C. F.* Naples, 1984 [exclusively Neapolitan, and primarily (but not exclusively) architectural; full documentation and bibliography].

Spinosa, Nicola. 'Precisazioni su C. F.', *Antologia di belle arti*, 21–2 (1984), 53–64.

C. F. e il marmo Commesso fra Abruzzo e Campania nell'età barocca (1992). Ed. Vittorio Casale, L'Aquila, 1995.

Cantone, Gaetana. 'Un teatro sull'acqua: Palazzo Donn'Anna a Posillipo', in *Saggi in onore di Renato Bonelli* (*Quaderni dell'Istituto di Storia dell'Architettura dell'Università di Roma*, n.s., 15–20, 1990–92), 729–36.

FERRATA

Golzio. 'Lo "Studio" di Ercole Ferrata', *Archivi*, II (1935), 64–74.

Montalto, Lina. 'E. F. e le vicende litigiose del basso rilievo di Sant'Emerenziana', *Commentari*, VIII (1957), 47–68.

Cellini, A. Nava. 'Contributo al periodo napoletano di E. F.', *Paragone*, 137 (1961), 37–44.

Bershad, David, 'Some new Documents on the Statues of Domenico Guidi and E. F. in the Elisabeth Chapel in the Cathedral of Breslau (now Wroclaw)', *Burl. Mag.*, CXVIII, (1976), 700–3

Cavarotti, Franco. 'E. F. scultore barocco intelvese', *Como*, 1976, 2, 19–26 [publishes a series of wooden sculptures given by F. to his native city]

FERRETTI

Maser, Edward A. *Gian Domenico Ferretti.* Florence, 1968.

Leoncini, Giovanni. 'G. D. F.: Contributi alla ritrattistica fiorentina del Settecento', *Paragone*, 329 (1977), 58–72.

FETTI

Safarik, Eduard A. *Fetti.* Milan, 1990.

FIASELLA

Donati, Piero. *Domenico Fiasella 'Il Sarzana'*. Genoa, 1974 [no oeuvre cat., or documents].

Donati, Piero (ed.). *D. F.* (exhib. cat.). Genoa, 1990.

Newcome Schleier, Mary. 'Drawings and Paintings by D. F.', *Paragone*, 3 ser., 1–2 (1995), 41–63.

FINELLI

Nava Cellini, Antonia. 'Un tracciato per l'attività ritrattistica di Giuliano Finelli', *Paragone*, 131 (1960), 9–30.

Strazzulo, Franco. 'Documenti vari: Un documento per G. F.', *Ricerche sul Seicento napoletano. Saggi in memoria di R. Causa*. Milan, 1984, 143–7.

Dombrowski, Damian. *G. F. (1601–53). Bildhauer zwischen Neapel und Rom*. Frankfurt am Main, 1997 [a full documented study, with much new information; some controversial attributions].

FOGGINI

Lankheit, Klaus. 'Il giornale del Foggini', *Rivista d'arte*, XXIV (1959 (1961)), 55–108.

Monaci, Lucia. *Disegni di G. B. F. (1652–1725)* (exhib. cat.). Florence, 1977.

Visonà, Mara. 'G. B. F. e gli altri artisti nella Villa Corsini a Castello', *Rivista d'arte*, LXII (1990), 147–84 (Nadia Bacic, app. doc., 185–211).

FONTANA, C.

Fontana, C., *Utilissimo trattato dell'acque correnti (Roma, 1696)*, intro. by H. Hager, Rome, 1998.

Coudenhove-Erthal, Eduard. *Carlo Fontana und die Architektur des römischen Spätbarocks*, Vienna, 1930. [Review by Hans Sedlmayr, *Kritische Berichte zur Kunstgeschichtlichen Literatur*, III/IV (1930–1/1931–2), 93–5. Review of the review by Rudolf Wittkower, *ibid.*, 142–5. Reply by Sedlmayr, 'Zum Begriff der "Strukturanalyse"', *ibid.*, 146–60].

Hager, Hellmut. 'Zur Planungs- und Baugeschichte der Zwillingskirchen auf der Piazza del Popolo: S. Maria di Monte Santo und S. Maria dei Miracoli in Rom', *Röm. Jahrb. f. Kunstg.*, XI (1967/8), 189–306.

—— 'La crisi statica della cupola di Santa Maria in Vallicella in Roma e i rimedi proposti da C. F., Carlo Rainaldi e Mattia De Rossi'. *Commentari*, XXIV (1973), 300–18.

—— 'C. F.'s project for a Church in Honor of the "Ecclesia Triumphans" in the Colosseum', *J.W.C.I.*, XXXVI (1973), 319–37.

—— 'C. F. and the Jesuit Sanctuary at Loyola', *J.W.C.I.*, 37 (1974), 280–9.

—— 'Un riesame di tre cappelle di C. F. a Roma', *Commentari*, 27, n. 3–4 (1976), 252–89.

Lorenz, Hellmut. 'Carlo Fontanas Pläne für ein Landschloss des Fürsten Johann Adam Andreas von Liechtenstein', *Jahrbuch der Liechtensteinischen Kunstgesellschaft*, 3 (1978/9), 43–88.

Braham, Allan and Hager, Hellmut. *C. F.: The Drawings at Windsor Castle*. London, 1977 [the fundamental study with full bibliography].

Marias, Fernando. 'Drawings by C. F. for the "Tempio Vaticano"', *Burl. Mag.*, 129 (1987), 391–3.

Hager, Hellmut. 'Le opere letterarie di C. F. come autorappresentazione', in B. Contardi and G. Curcio, eds. *In Urbe Architectus* (exhib. cat. Museo Nazionale di Castel Sant'Angelo). Rome, 1991, 154–203.

Gonzáles de Zárate, Jesus Maria. *Arquitectura e iconografia en la Basilica de Loyola*. [n.p., n.d.] [1991?].

Hager, Hellmut. 'Osservazioni su C. F. e sulla sua opera del *Tempio Vaticano* (1694)', in M. Fagiolo and M.L. Madonna. *Il barocco romano e l'Europa* (1987). Rome, 1992, 83–149.

—— 'C. F.: Pupil, Partner, Principal, Preceptor', in Peter Lukehart (ed.). *The Artist's Workshop* (Studies in the History of Art, 38). Washington, D.C., XXXVIII (1993), 123–55.

—— 'Bernini, C. F. e la fortuna del "terzo braccio" del Colonnato di Piazza San Pietro in Vaticano', *Quaderni dell'istituto di Storia dell'Architettura dell'Università di Roma*, 25–30 (1995–7), 337–60.

FONTANA, D.

Fontana, Domenico. *Della trasportatione dell'obelisco vaticano et delle fabbriche di Nostro Signore Papa Sisto V*. Rome, 1590. *Libro secondo in cui si ragiona di alcune fabriche fatte in Roma et in Napoli, dal Cavalier Domenico Fontana*. Naples, 1603. Facsimile ed. A. Carugo, Milan, 1978.

Orbaan, J.A.F. 'Die Selbstverteidigung des D. F. 1592–1593', *Röm. Jahrb. f. Kunstg.*, 46 (1925), 176–89.

Muñoz, Antonio. *D. F. architetto 1543–1607*. Rome, Bellinzona, 1944.

Straub, H. 'D. F., ein Tessiner Ingenieur des 16. Jahrhunderts', in *Ausgewählte Aufsätze*. Zurich, 1969, 118–28.

Di Resta, I. 'La maniera a Napoli: il Palazzo Reale del F.', *L'Architettura a Roma e in Italia (1580–1621)*. Ed. G. Spagnesi, Rome, 1989 (343–9).

—— 'Sull'architettura di D. F. a Napoli', in *Saggi in onore di Renato Bonelli (Quaderni dell'Istituto di Storia dell'Architettura dell'Università di Roma*, n.s., 15–20, 1990–92), 675–82.

Pietrangeli, C. (ed.). *Il Palazzo Apostolico Lateranense*. Florence, 1991.

Quast, M. *Die Villa Montalto in Rom: Entstehung und Gestaltung im Cinquecento*. Munich, 1991.

Sette, Maria Piera (ed.). *Sisto V. Architetture per la città*, entire number of *Storia architettura*, n.s., 1 (1992).

FONTEBASSO

Magrini, Marina. *Francesco Fontebasso*. Venice, 1988 [monograph with catalogue of paintings (only), and bibliography].

FRANCESCHINI, BALDASSARE, IL VOLTERRANO

Winner, Matthias. 'Volterranos Fresken in der Villa della Petraia: Ein Beitrag zu gemalten Zyklen der Medicigeschichte', *Mitteilungen des Kunsthistorischen Institutes in Florenz*, X (1961–3), 219–52.

Del Bravo, Carlo. 'La "fiorita gioventù" del V.', *Artibus et Historiae*, I (1980), 47–68.

Sotheby's sale, 3 July 1980, *An Important Group of Drawings by B.F. called Il Voterrano* (cat. by C. McCorquodale)

FRANCESCHINI, MARCANTONIO

Miller, Dwight. 'L'opera de M. A. Franceschini nel duomo di Piacenza', *Boll. d'Arte*, XLI (1956), 318–25.

—— 'F. and the Palazzo Podestà', *Burl. Mag.*, XCIX (1957), 231–4.

—— 'An Early Series of Decorations by F. in the Palazzo Monti, Bologna', *Burl. Mag.*, CII (1960), 32–5.

—— 'Addenda to F.'s Lost Decorations in the Ducal Palace, Genoa', *Burl. Mag.*, CVI (1964), 374–7.

—— 'Two Early Paintings by M. F.; A Gift of the Bolognese Senate to Pope Clement XI', *Burl. Mag.*, CXII (1970), 573–8.

—— 'Some unpublished Drawings by M. F. and a Proposed Chronology', *Master Drawings*, IX (1971), 119–38.

—— 'F.'s Decorations for the Cappella del Coro, St Peter's: Bolognese and Roman Classicism of the later 17th Century', *Burl. Mag.*, CXXIV (1982), 487–92.

—— *M. F. and the Liechtensteins. Prince Johann Adam Andreas, and the decoration of the Liechtenstein Garden Palace at Rossau-Vienna*. Cambridge, 1991.

FUGA

Pane, Roberto. *Ferdinando Fuga*. Naples, 1956. With documents edited by Raffaele Mormone.

Spadolini, G. *Il Palazzo della Consulta*. Rome, 1975.

Kieven, Elisabeth. *F. F. e l'architettura Romana del Settecento* (exhib. cat.). Rome, 1988.

Borsellino, E. *Palazzo Corsini alla Lungara: storia di un cantiere*. Rome, 1988.

Guerra, A., Molteni, E. and Nicoloso, P. *Il trionfo della miseria. Gli alberghi dei poveri di Genova, Palermo, e Napoli*. Milan, 1995.

FURINI

Toesca, Elena B. *Francesco Furini*. Rome, 1950.

Cantelli, Giuseppe. *Disegni di F. F. e del suo ambiente* (exhib. cat., Uffizi). Florence, 1972.

Barsanti, Anna. 'Una vita inedita del F.', *Paragone*, 289 (1974), 67–82; 291 (1974), 79–99.

—— 'Ancora sul F.', *Paragone*, 293 (1974), 54–72.

Mannini, Maria Pia. 'Allegorie profane del F.', *Paragone*, 353, 3979, 46–58.

GAGLIARDI

Germanò, Donatella. *Barocco in Sicilia. Chiese e monasteri di Rosario Gagliardi*. Florence, 1986.

Trigilia, Lucia. 'Il corpus di disegni di R. G. Lo studio dei trattati e l'uso dei modelli nell'attività del maestro', *Annali del barocco in Sicilia*, I (1994), 62–77.

Nobile, Marco Rosario. 'R. G. e il duomo di S. Giorgio a Ragusa', *Storia architettura*, n.s., 2 (1996), 61–70.

See also III.REGIONS, SICILY: Tobriner. *Genesis of Noto*.

GALEOTTI

Sebastiano Carboneri, Nino. *Sebastiano Galeotti*. Venice, 1955.

Torriti, Piero. *Attività di S. G. in Liguria*. Genoa, 1956

Bernini, Giovanni Pietro. 'S. G. a Parma', *Antichità viva*, XIII, 1974, 5, 29–31.

GALILEI

Golzio, Vincenzo. 'La facciata di S. Giovanni in Laterano e l'architettura del settecento', *Miscellanea Bibliothecae Hertzianae zu Ehren von Leo Bruhns, Franz Graf Wolff Metternich, Ludwig Schudt*. Munich, 1961, 450–63.

Kieven, Elisabeth. 'G. in England', *Country Life*, CXXX (1973), 210–12.
——'Rome in 1732: A. G., Nicola Salvi, Ferdinando Fuga', in *Light on the Eternal City* (Papers in Art History from The Pennsylvania State University, 2). Eds H. Hager and S. Munshower, University Park, 1987, 254–75.
——'Überlegungen zu Architektur und Ausstattung der Cappella Corsini', *Studi sul Settecento romano: L'architettura da Clemente XI a Benedetto XIV. Pluralità di tendenze*. Ed. E. Debenedetti, Rome, 1989, 69–96.
——*Alessandro Galilei*. Forthcoming.

GANDOLFI
Cazort Taylor, Mimi. 'The Pen-and-wash Drawings of the Brothers Gandolfi', *Master Drawings*, XIV, 2 (1976), 159–65.
Roli, Renato. 'Aggiunte e precisazioni sui G. plasticatori', *Il Carrobbio*, II (1976), 319–23.
Garstang, Donald. 'A Deposition Figure by Ubaldo G.', *Apollo*, CXXXI (1989), 87–9.
Biagi Maini, Donatella. *Gaetano G.* Turin, 1995.
——*U. G.* Turin, 1990.

GAULLI
Enggass, Robert. *The Paintings of Baciccio. Giovan Battista Gaulli 1639–1709*. University Park, Pa., 1964.
Matitti, Flavia (ed.). *Il Baciccio illustratore*. Rome, 1994.
See also D. Graf, 1976 (IV, under CORTESE).

GENTILESCHI, ORAZIO and ARTEMISIA
Longhi, Roberto. 'Gentileschi, padre e figlia', *L'arte*, XIX (1916), 245–314. Reprinted in R. Longhi. *Scritti giovanili 1912–1922*. Florence, 1961.
Bissell, Richard Ward. *O. G. and the Poetic Tradition in Caravagesque Painting*. University Park, Pa., 1981.
Nicolson, Benedict. 'O. G. and Giovanni Antonio Sauli', *Artibus et Historiae*. XII (1985), 9–25.
Garrard, Mary. *A. G.: the Image of the Female Hero in Baroque Art*. Princeton, 1989.
 Reviews: E. Cropper, *Renaissance Quarterly*, XLII (1989), 864–6.
 K. Lipincott, *Renaissance Studies*, IV (1990), 444–8.
 K. Merkel, *Kunstchronik*, XLV (1992), 34–55.
Contini, Roberto and Papi, Gianni. *Artemisia* (exhib. cat.). Florence, Rome. 1991 [contains many highly problematic, even dubious, pictures].
 Review: J. T. Spike, *Burl. Mag.*, CXXXIII (1991), 732–4.
Cropper, E. 'New Documents for A. G. in Florence', *Burl. Mag.*, CXXXV (1993), 760–1.
De Grazia, Diane and Schleier, Eric. 'St. Cecilia and an Angel: "the heads by Gentileschi, the rest by Lanfranco"', *Burl. Mag.*, CXXXVI (1994), 73–8.

GHERARDI
Mezzetti, Amalia. 'La pittura di Antonio Gherardi', *Boll. d'Arte*, 1948, 157–79.
Pickrel, Thomas. 'Two Stucco Sculpture Groups by A. G.', *Antologia di belle arti*, 7–8 (1978), 216–26.
——'Some New Drawings by A.G.', *Master Drawings*, XVII (1979), 147–52.
——'A.G.'s early Development as a Painter: S. Maria in Trivio and Palazzo Naro', *Storia dell'arte*, 47 (1983), 57–64.
——'L'Élan de la musique: A. G.'s Chapel of Santa Cecilia and the Congregazione dei Musici in Rome', *Storia dell'arte*, 61 (1987), 237–54.

GHEZZI
Lo Bianco, Anna. *Pier Leone Ghezzi, pittore*. Palermo, 1985.
Martinelli, Valentino (ed.). *Giuseppe e P.L.G.* Rome, 1990.

GHISLANDI
Testori, Giovanni. *Fra Galgario*. Turin, 1970 [good colour ills.].
Daninos, Andrea and Bertelli, Carlo. *Fra Galgario. 14 dipinti da collezioni private* (exhib. cat., Galleria Carlo Orsi). Milan, 1995 [reprints biography by F. M. Tassi, Bergamo, 1793].
See also *I pittori Bergamaschi; il Settecento*, I (1982), 1–195 (M. C. Gozzoli).

GIAQUINTO
Orsi, Mario d'. *Corrado Giaquinto*. Rome, 1958 [only monograph, but outdated].
Videtta, A. *Considerazioni su C. G. in rapporto ai disegni del Museo di S. Martino*. Naples, 1965 [mainly attempts to define the graphic principles of G.'s drawings].
Volpi, Marisa. 'C. G. e alcuni aspetti della cultura figurativa del '700 in Italia', *Boll. d'arte*, XLIII (1958), 263–82.

Atti Convegno di studi su G. C. Molfetta, 1971.
G. C. (1703–1766). Atti del II convegno internazionale di studi (1981). Ed. P. Amato, Molfetta, 1985

GIORDANO
Ferrari, Oreste and Scavizzi, Giuseppe. *Luca Giordano. L'opera completa*. Naples, 1992 [much revised edition, with many more works than that of 1966].

GIOVANNI DA SAN GIOVANNI
Giglioli, Odoardo H. *Giovanni da San Giovanni*. Florence, 1949.
 Review: G. Briganti. *Paragone*, 7 (1950), 52–6.
Campbell, Malcolm. 'The Original Program of the Salone di G. da S. G.', *Antichità viva*, XV, 4 (1976), 3–25 [see also E. McGrath, 1994 (III, FLORENCE. *Painting*)].
Banti, Anna. *G. da S. G., pittore della contradizione*. Florence, 1977.
Matteoli, A. 'Addenda a G. da S. G.', *Mitteilungen des Kunsthistorischen Institutes in Florenz*, XXVII (1983), 391–6.
Mannini, Maria Pia. 'Alcune lettere inedite e un ciclo pittorico di G. da S. G.', *Rivista d'arte*, XXXVIII (1986), 191–216.
Della Monica, Ilaria. *G. da S. G.: Disegni* (exhib. cat.). Bologna, 1994.

GRAMATICA
Papi, Gianni. *Antiveduto Gramatica*. Soncino, 1995.

GRASSI, N.
Nicola Grassi (exhib. cat.). Udine, 1982.
N. G. e il Rococò europeo; dagli atti del Congresso Internazionale di Studi 20/22 maggio 1982. Udine, 1984.

GRASSI, O.
Montalto, Lina. 'Il problema della cupola di Sant'Ignazio da padre Orazio Grassi e fratel Pozzo a oggi', *Bollettino del Centro di Studi per la Storia dell'Architettura*, XI (1957), 33–62.
See also II.C above, Patronage: Religious orders, especially Bösel, R. *Jesuitenarchitektur in Italien*.

GREGORINI
Plummer, Ellen. 'Santa Croce in Gerusalemme, Rome: A Drawing and an Attribution', *J.S.A.H.*, 43 (1984), 356–63.
Varagnoli, Claudio. 'Ricerche sull'opera architettonica di Gregorini e Passalacqua', *Architettura. Storia e documenti*, 1988, 1/2, 21–65.
——'Notizie sull'attività di D. G. dall'archivio Aldrovandi di Bologna', *L'architettura da Clemente XI a Benedetto XIV. Pluralità di tendenze*. Ed. E. Debenedetti, Rome, 1989, 131–55.
——*S. Croce in Gerusalemme: la basilica restaurata e l'architettura del Settecento romano*. Rome, 1995.

GRIMALDI
Savarese, Silvana. *Francesco Grimaldi e l'architettura della Controriforma a Napoli*. Rome, 1986.

GUARDI
Guardi (exhib. cat.). Ed. P. Zampetti, Venice, 1965 [includes documents].
Problemi guardeschi [acts of colloquium, 1965]. Venice, 1967 [D.Mahon's contribution especially innovative].
Mahon, Denis. 'When did F. G. become a "Vedutista"?', *Burl. Mag.*, CX (1968), 69–73.
Morassi, Antonio. *I G.: L'opera completa* (2 vols). Venice, 1973.
——*Guardi: I disegni*. Milan, 1984.
Succi, Dario. *F. G.: itinerario dell'avventura artistica*. Milan, 1993.
G.: metamorfosi dell'immagine (exhib. cat., Gorizia). Venice, 1987.

GUARINI
General
Hager, Werner. 'Guarini. Zur Kennzeichnung seiner Architektur', *Miscellanea Bibliothecae Hertzianae zu Ehren von Leo Bruhns, Franz Graf Wolff Metternich, Ludwig Schudt*. Munich, 1961, 450–63.
Anderegg-Tille, Maria. *Die Schule G.s*. Winterthur, 1962.
Passanti, Mario. *Nel mondo magico di G. G.* Turin, 1963.
 Review R. Pommer, *Art Bull.*, XLVIII (1966), 259–60.
Pommer, Richard. *Eighteenth-Century Architecture in Piedmont: The Open Structures of Juvarra, Alfieri and Vittone*. New York, 1967 [Ch. 1 has a penetrating analysis of Guarini in the light of the concept of open structures].
G. G. e l'internazionalità del barocco (1968) (2 vols). Turin, 1970 [an important collection, especially for the insightful essay by Wittkower, Rudolf. 'Introduzione al Guarini', 20–32, translated as 'G. the Man', in *Studies in the Italian Baroque*. London, 1975, 177–86].
Meek, H. A. *G. G. and His Architecture*. New Haven, London, 1988 [best general book, with full bibliography].
Roca De Amicis, Augusto. 'Guarini Guarino "modenese" e la tradizione architettonica emiliana', *Palladio*, 16 (July–December 1995), 79–92.

L'Architettura civile

G. G. *Dissegni d'architettura civile, et ecclesiastica*. Turin, 1686. Re-edition with text: *Architettura civile*. Ed. B. Vittone, Turin, 1737. Facsimile 1964. Polifilo edition by N. Carboneri and B. Tavassi La Greca, Milan, 1968, with extensive annotated bibliography on xl-xlvi.

Di Paolo, Paola. 'L'*Architettura civile* del G. e la trattatistica architettonica del XVII secolo', *Annali della Scuola Normale Superiore di Pisa*, Classe di Lettere e Filosofia, ser.III, II.1 (1972), 311–50.

Bertini, Aldo. 'Il disegno del G. e le incisioni del trattato di "Architettura civile"', *G. G. e l'internazionalità del barocco*. Turin, I (1970), 597–610.

Flynn, E. 'A Baroque Architectural Text: 'Architettura Civile' of G. G.', *Arris*, I (1989), 18–28.

Müller, W. 'The Authenticity of G.'s Stereotomy in his "Architettura Civile"', *J.S.A.H.*, XXVI (1968), 202–8.

Passanti, Mario. 'Disegni integrativi di lastre del trattato della "Architettura civile"', *G. G. e l'internazionalità del barocco*. Turin, I (1970), 425–48.

Ramirez, J.A. 'G. G., Fray Juan Ricci and the "Complete Salomonic Order"', *Art History*, IV (1981), 177–85.

Geometry and Design

Perez-Gomez, Alberto. *Architecture and the Crisis of Modern Science*. Cambridge, Ma., 1983.

Müller, Claudia. *Unendlichkeit und Transzendenz in der Sakralarchitektur G.s*. Hildesheim, 1986.

Robison, Elwin. 'Optics and Mathematics in the Domed Churches of G. G.', *J.S.A.H.*, L (1991), 384–401.

Morrogh, Andrew, 'Guarini and the Pursuit of Originality: the Church for Lisbon and Related Projects', *J.S.A.H.*, LVII (1998), 6–29.

See above BORROMINI: SEDLMAYR. *Die Architektur Borrominis*, ch. 4.

Studies of individual Buildings

Hager, Werner. 'G.s Theatinerfassade in Messina', *Das Werk des Künstlers...Hubert Schrade zum 60. Geburtstag*. Ed. H. Feger, Stuttgart, 1960, 230–40.

Johnson, Kevin Orlin. 'Solomon, Apocalypse and the names of God: The Meaning of the Chapel of the Most Holy Shroud', *Storia architettura*, VIII (1985), 55–80.

Millon, Henry. 'Bernini-G.: Paris-Turin: Louvre-Carignano', in *Il se rendit en Italie. Etudes offerts à André Chastel*. Rome, Paris, 1987, 479–500.

Pacciano, Riccardo. 'Un progetto riferibile a G. G. per il convento dei Teatini di Modena (1662)', *Palladio*, 1 (1988), 83–94.

Roca De Amicis, Augusto. 'Il progetto di G. per la Chiesa di S. Gaetano a Vicenza', *Palladio*, 12 (1993), 109–16.

Klaiber, Susan. 'A New Drawing for G.'s S. Gaetano, Vicenza', *Burl. Mag.*, 136 (1994), 501–5.

Scott, John Beldon. 'Seeing the Shroud: G.'s Reliquary Chapel in Turin and the Ostension of a Dynastic Relic', *Art Bull.*, 77 (1995), 609–37.

——'G. G.'s Invention of the Passion Capitals in the Chapel of the Holy Shroud, Turin', *J.S.A.H.*, 54 (1995), 418–45.

(A monograph the SS. Sindone is in preparation by John Beldon Scott, and Susan Klaiber is preparing an extended study of G. the Theatine.)

GUERCINO

Mahon, Denis. *Studies in Seicento Art and Theory*. London, 1947.

Dirani, Maria Teresa. 'Mecenati, pittori e mercato dell'arte nel Seicento: Il "Ratto di Elena" di Guido Reni e la "Morte di Didone" del Guercino nella corrispondenza del cardinale Bernardino Spada', *Ricerche di storia dell'arte*, XVI (1982), 83–94.

Bagni, Prisco. *G. a Piacenza. Gli afreschi nella cupola della cattedrale*. Bologna, 1983.

Bagni, Prisco. *G. a Cento. La decorazione di Casa Pannini*. Bologna, 1984.

Salerno, Luigi. *I dipinti del G.* Rome, 1988.

Mahon, Denis and Turner, Nicholas. *The Drawings of G. in the Collection of Her Majesty the Queen at Windsor Castle*. Cambridge, 1989.

Il G. (exhib. cat.). Ed. D. Mahon, Bologna, 1991 [revised versions Frankfurt, 1991–2, Washington, 1992].

Mahon, Denis. *Giovanni Francesco Barbieri il G. 1591–1666. Disegni* (exhib. cat.). Bologna, 1991.

Spear, Richard. 'G.'s "prix-fixe": observations on studio practice and art marketing in Emilia', *Burl. Mag.*, CXXXVI (1994), 592–602.

GUGLIELMELLI

Amirante, Giosi. *Architettura napoletana tra Seicento e Settecento. L'opera di Arcangelo Guglielmelli*. Naples, 1990.

GUIDI

Bershad, David. 'A Series of Papal Busts by Domenico Guidi', *Burl.*

Mag., CXII (1970), 805–9.

Bershad, David. 'D. G. and Nicolas Poussin', *Burl. Mag.*, CXIII (1971), 544–7.

Seelig, Lorenz. 'Zu D. G.s Gruppe "Die Geschichte zeichnet die Taten Ludwigs XIV. Auf"', *Jahrbuch der Hamburger Kunstsammlungen*, XVII (1972), 81–104.

Bershad, David. 'D. G.: Some New Attributions', *Antologia di belle arti*, I (1977), 18–25.

Bacchi, Andrea. '"L'Andromeda" di Lord Exeter', *Antologia di belle arti*, 48–51 (1994), 64–70.

See also Bershad, 1976 (IV, under FERRATA)

JUVARRA

Juvarra, Filippo. *Raccolta di varie targhe...* Rome, 1715.

Brinckmann, A.E., Rovere L. and Viale, V. *Filippo Juvarra*, I. Milan, 1937 [essential, early lives and many drawings].

Accascina, Maria. 'La formazione artistica di F. J.', *Boll. d'Arte*, XLI, 38–52; XLII (1957), 50–62; 150–62.

Viale, V. *Mostra di F. J.* Messina, 1966.

Pommer, Richard. *Eighteenth-Century Architecture in Piedmont: The Open Structures of J., Alfieri and Vittone*. New York, 1967.

Hager, Hellmut. *F. J. e il concorso dei modelli bandito da Clemente XI per la nuova sacrestia di S. Pietro*. Rome, 1970.

Viale Ferrero, M. *F. J., scenografo e architetto teatrale*. Turin, 1970.

Boscarino, Salvatore. *J. architetto*. Rome, 1973.

Myers, Mary. *Architectural Ornament and Drawings: J., Vanvitelli, the Bibiena Family and other Italian Draughtsmen* (exhib. cat.). New York, 1975.

Carboneri, Nino. *La reale chiesa di Superga di F. J., 1719–1735*. Turin, 1979.

Pinto, John. 'F. J.'s Drawings Depicting the Capitoline Hill', *Art Bull.*, LXII (1980), 598–616.

Millon, Henry. *F. J. : Drawings from the Roman Period 1704–1714*. Rome, 1984. Further volumes in preparation, including the material announced by Sarah McPhee, 'A New Sketch-book by F. J.', *Burl. Mag.*, 135 (1993), 346–50.

Millon, Henry. 'F. J. and the Accademia di San Luca in Rome in the Early Eighteenth Century', *Projects and Monuments in the Period of the Roman Baroque*. Eds H. Hager and S. Munshower, University Park, 1984, 13–24.

Munshower, Susan. 'City Informs Garden: F. J. As Landscape Designer', in *Projects and Monuments of the Roman Baroque* (Papers in Art History from The Pennsylvania State University, 1). University Park, 1984, 46–67.

Studi Juvarriani (1979). Rome, 1985.

Gritella, Gianfranco. *Rivoli. Genesi di una residenza sabauda*. Modena, 1986.

Caresio, Franco. *Il Castello di Rivoli*. Turin, 1987.

Caresio, Franco. *Stupinigi: La real pallazzina di caccia*. Biella, 1987.

Dardanello, Giuseppe. 'Altari piemontesi: prima e dopo l'arrivo di J.', in Andreina Griseri and Giovanni Romano. *F. J. a Torina: Nuovi Progetti per la città*. Turin, 1989.

Di Macco, Michela and Romano, Giovanni. *Diana trionfatrice. Arte a corte nel Piemonte del Seicento*. Turin, 1989, 'Il barocco degli architetti', 265–380.

Griseri, Andreina and Romano, Giovanni (eds). *F. J. a Torino. Nuovi progetti per la città*. Turin, 1989.

Gritella, Gianfranco. *J. L'architettura* (2 vols), Modena, [n.d.].

Barghini, Andrea. *J. a Roma. Disegni dall'atelier di Carlo Fontana*. Turin, 1994 [a new sketchbook at Vincennes].

Comoli Mandracci, Vera (ed.). *Itinerari juvarriani*. Turin, 1995.

F. J. Architetto delle capitali da Torino a Madrid 1714–1736 (exhib. cat.). Eds V. Comoli Mandracci and A. Griseri, Turin, Palazzo Reale, 1995.

Millon, Henry. 'F. J. e Palladio', *Annali di architettura*, 8 (1996), 7–20.

Dardanello, Giuseppe. '"Open Architecture". Un disegno per il salone di Stupinigi e una fantasia architettonica di F. J.', *Dialoghi di Storia dell'Arte*, 4/5 (December 1997), 100–15.

Filippo Juvarra e l'architettura europea (exhib. cat.), ed. Antonio Bonet Correa, Beatriz Blasco Esquivias, Gaetana Cantone, Milan, 1998.

KEILHAU

Heimbürger, Minna. *Bernardo Keilhau detto Monsù Bernardo*. Rome, 1988.

LAER, P. VAN

Janek, Axel. *Untersuchung über den holländischen Maler Pieter van Laer, genannt Bamboccio*. Würzburg, 1968 [fully documented dissertation, with oeuvre cat., but no ills.].

Michalkowa, Janina. 'Quelques remarques sur P. v. L.', *Oud-Holland*, LXXXVI (1971), 188–95.

See also III, ROME, Painting, for general works on the Bamboccianti, esp.
D. Levine, 1988.

LAMBARDI, C.

Lambardi, Carlo. *Discorso sopra la causa dell'innondatione di Rome*. Rome,
1601.

Parlato, Enrico. 'Il soffitto ligneo di San Marcello al Corso, opera dell'architetto C. L. e del pittore Giovan Battista Ricci', *Per Carla Guglielmi.
Scritti di allievi*. Rome, 1989, 136–47.

LANFRANCO

Hibbard, Howard. 'The Date of Lanfranco's fresco in the Villa Borghese
and Other Chronological Problems', *Miscellanea Bibliothecae
Hertzianae*, 1961, 356–65.

Schleier, Erich. 'L.s Malereien der Sakramentskapelle in S. Paolo fuori le
mura in Rome: das wiedergefundene Bild des "Wachtelfalls"', *Arte
antica e moderna*, VIII, 29–31/2 (1965), 62–81; 188–201; 343–64.

Schleier, Erich. 'Les projets de L. pour le décor de la Sala Regia au
Quirinal et pour le Loge des Bénédictions à Saint-Pierre', *Revue de
l'art*, 7 (1970), 40–67.

Heimbürger, Minna. 'Gli ultimi disegni per decorazioni monumentali di
G. L.', *Paragone*, XXI, 43 (1970), 44–52.

Schleier, Erich. 'Le Serie di Alessandro Magno del Cardinal Montalto',
Arte illustrata, 1972, 50, 310–20.

Bösel, Richard. 'G. L. e la Compagnia di Gesù (Documenti per la sua
attività napoletana)', *Paragone*, 329 (1977), 94–114.

D'Amico, Fabrizio. 'Note su Lanfranco giovane', *Storia dell'arte*, 38–40
(1980), 327–34.

Bernini, Giovanni-Pietro. *G. L. (1582–1647)*. Parma, 1982. Revised 1985
[a very unsatisfactory monograph].

Schleier, Erich. *Disegni di G. L. (1582–1647)* (exhib. cat., Uffizi).
Florence, 1983 [contains also much on the relevant paintings].

Camiz, Franca T. 'Una "Erminia", una "Venere" ed una "Cleopatra" di
G. L. in un documento inedito', *Boll. d'Arte*, LXXVII (1991), 165–8.

Schleier, Erich. 'Note su Carlo Bononi e su G. L.', *Antichità viva*, XXXV
(1996), 9–14.

See also L. Salerno, 1958 (IV, under BADALOCCHIO); D. De Grazia, E.
Schleier, 1994 (IV, under GENTILESCHI); A. Coliva, S. Schütze (eds),
1998 (IV, under BERNINI).

LANGETTI

Stefani Mantovanelli, Marina. 'Giovanni Battista Langetti', *Saggi e memorie di soria dell'arte*, XVII (1990), 41–105 (virtual monograph).

LEGROS

Rovere, Lorenzo. 'Le statue di Pietro Legros nel Duomo di Torino', *Il
Duomo di Torino*, I (1927), 42–60.

March, Giuseppe M. 'Intorno alla statua di Sant'Ignazio di Loiola nel
Gesù di Roma', *Archivium Historicum Societatis Jesu* III (1934),
300–12.

Haskell, Francis. 'P.L. and a Statue of the Blessed Stanislas Kostka', *Burl.
Mag.*, XCVII (1955), 287–91.

Preimesberger, Rudolf. 'Entwürfe P. L.' für Filippo Juvarras Capella
Antamoro', *Römische Historische Mitteilungen*, X (1966–7), 200–15.

Conforti, Michael. 'P. L. and the Rôle of Sculptors as Designers in Late
Baroque Rome', *Burl. Mag.*, CXIX (1977), 556–61.

Baker, Malcolm. 'That "most rare Master Monsii Le Gros" and his
"Marsyas"', *Burl. Mag.*, CXXVII (1985), 702–6.

Bissell, Gerhard. *P. Le G. 1666–1719*. Reading, 1997.

Levy, Evonne. 'Reproduction in the "Cultic Era" of Art: P. L.'s Statue of
Stanislas Kostka' *Representations*, 58 (1997), 88–114.

See also *San Pietro: Arte e storia*, 1996 (III, ROME, Sculpture).

LIGOZZI

Bacci, Mina. 'Jacopo Ligozzi e la sua posizione nella pittura fiorentina',
Porporzioni, IV (1973), 46–84 [full monographic treatment].

Mostra di disegni di J. L. Florence, 1989.

Conigliello, Lucilla. 'Alcune note su J. L. e sui dipinti del 1594',
Paragone, 485 (1990), 21–41.

—— *J. L. Le vedute del Sacro Monte della Verna; i dipinti di Poppi e
Bibbiena* (exhib. cat., Poppi). Florence, 1992.

Tongiorgi Tomasi, Lucia. *I ritratti di piante di J. L.* Pisa, 1993.

LILLI

Andrea Lilli nella pittura delle Marche tra Cinquecento e Seicento (exhib.
cat., Ancona). Rome, 1985.

LIPPI

Sricchia, Fiorella. 'Lorenzo Lippi nello svolgimento della pittura
fiorentina della prima metà del '600', *Proporzioni*, IV (1963), 242–70.

D'Affitto, Chiara. 'Precisazioni sulla fase giovanile di L. L.', *Paragone*,
353 (1979), 61–76.

LOCATELLI

Busiri Vici, Andrea. *Andrea Locatelli*. Rome, 1967.

LOMI

Ciardi, Roberto P., Galassi, Maria Clelia and Carofano, Pierluigi. *Aurelio
Lomi: maniera e innovazione*. Pisa, 1989.

LONGHENA

Wittkower, Rudolf. 'Santa Maria della Salute: Scenographic Architecture
and the Venetian Baroque', *J.S.A.H.*, XVI (1957), 3–10. Reprinted in
Studies in the Italian Baroque. London, 1975, 125–52.

Muraro, Michelangelo. 'Il tempio votivo di Santa Maria della Salute in un
poema del Seicento', *Ateneo Veneto*, XI (1973), 87–119.

Bassi, Elena. 'Baldassare Longhena e l'architettura del Seicento a
Venezia', *Bollettino del Centro di Studi d'Architettura Andrea Palladio*,
XXIII (1981), 165–77.

L. Eds. L. Puppi, G. Romanelli and S. Biadene, Milan, 1982 [with earlier
bibliography].

Selvafolta, O. *L*. Milan, 1982.

Pilo, G.M. *La chiesa dello 'Spedaletto' in Venezia*. Venice, 1987.

Rossi, Paola. 'I "marmi loquaci" del monumento Pesaro ai Frari', *Venezia
arti*, 4 (1990), 84–93.

Frank, Martina. 'B. L. e il palazzo Basadonna a San Trovaso', *Annali di
Architettura*, 2 (1990), 121–5.

Frank, Martina. 'L. in Brenta', *Annali di Architettura*, 6 (1994), 158–63.

Hopkins, Andrew. 'L. before Salute: The Cathedral at Chioggia',
J.S.A.H., 53 (1994), 199–214.

——— 'L.'s Second Sanctuary Design for S. Maria della Salute', *Burl.
Mag.*, 136 (1994), 498–501.

———'Plans and Planning for S. Maria della Salute, Venice', *Art Bull.*,
LXXIX (1997), 440–65.

LONGHI, ALESSANDRO

Moschini, Vittorio. 'Alessandro Longhi', *L'arte*, XXVI (1923), 89–109.

Pedrocco, Filippo. 'Opere inedite o poco noto di A. L.', *Venezia arti*, VII
(1993), 181–5.

LONGHI, MARTINO THE ELDER

Hibbard, Howard. *The Architecture of the Palazzo Borghese (Memoirs of
the American Academy in Rome, 27)*. Rome, 1962 [compact biography,
83–93].

Friedel, Helmut. 'Die Cappella Altemps in S. Maria in Trastevere', *Röm.
Jahrb. f. Kunstg.*, 17 (1978), 89–123.

Patetta, Luciano (ed.). *I Longhi. Una famiglia di architetti tra Manierismo e
Barocco* (exhib. cat.). Milan, 1980.

La Roma dei L.: Papi e architetti tra manierismo e barocco. Ed. M. Fagiolo
dell'Arco, Rome, 1982.

Bevilacqua, Mario. 'Palazzetto Cenci a Roma: un'aggiunta per Martino L.
il Vecchio e un contributo per Giovanni Guerra pittore', *Boll. d'Arte*,
70, no. 31 (1986), 157–88.

Nova, Alessandro. 'Il "modello" di M. L. il Vecchio per la facciata della
Chiesa Nova', *Röm. Jahrb. f. Kunstg.*, 23–4 (1988), 385–94.

Caperna, Maurizio. 'La Chiesa di San Girolamo dei Croati (già "degli
Schiavoni" o "degli Illirici")', *Storia architettura*, n.s., 1 (1992),
254–85 [monograph with new plans and documents].

LONGHI, MARTINO THE YOUNGER

Longhi, Martino the Younger. *Epilogismo di architettura*. Bracciano, 1625.

———*Discorso delle cagioni delle ruine della facciata e campanile del famoso
tempio di S. Pietro in Vaticano*. Rome, 1645. Facsimile in Fagiolo
dell'Arco, Maurizio (ed.). *Architettura barocca a Roma*. Rome, 1972,
115–28.

Golzio, Vincenzo. 'Il testamento di M. L. Juniore', *Archivi d'Italia*, ser. II,
V (1938), 140f. and 207f.

Varriano, John. 'The Architecture of M. L. the Younger (1602–1660)',
J.S.A.H., XXX (1971), 101–18.

——— 'The 1653 Restoration of S. Adriano al Foro Romano: New
Documentation on M. L. the Younger', *Röm. Jahrb. f. Kunstg.*, XIII
(1971), 287–95.

Anselmi, Alessandra. 'The High Altar of S. Carlo ai Catinari, Rome',
Burl. Mag., 138 (1996), 660–7.

LONGHI, ONORIO

Marucci, Laura and Torresi, Bruno. 'Palazzo Medici-Lanti: un progetto
mediceo in Roma e il "raggiustamento" di Onorio Longhi', *Storia
architettura*, V (1982), 39–62; VI (l983), 21–44.

Fusciello, Gemma. 'Restauri di O. L. nella chiesa di S. Eusebia
all'Esquilino', *Palladio*, 13 (1994), 57–72.

LONGHI, PIETRO

Pignatti, Terisio. *Pietro Longhi*. Venice, 1968 [English ed. London, New
York, 1969].

——*P. L. dal disegno alla pittura*. Venice, 1975.

P. L. (exhib. cat., Venice). Ed. A. Mariuz, G. Pavanello and G. Romanelli, Milan, 1993.

Sohm, Philip L. 'P. L. and Carlo Goldoni: relations between painting and theatre', *Zeitschr. f. Kunstg.*, XLV (1982), 256–73.

LUTI

Dowley, Francis H. 'Some Drawings by Benedetto Luti', *Art Bull.*, XLIV (1962), 219–36.

Bowron, Edgar Peters. 'B. L.'s Pastels and Coloured Chalk Drawings', *Apollo*, CXI (1980), 440–7.

Sestieri, Giancarlo. 'Il Punto su B. L.', *Arte illustrata*, VI (1973), 232–55.

LYS (LISS)

Steinbart, Kurt. *Johann Liss. Der Mahler aus Holstein*. Berlin, 1940 [standard work].

Steinbart, Kurt. 'Das Werk des J. L. in alter und neuer Sicht', *Saggi e memorie*, II (1958–9), 157–207 [summarizes all recent research; brief Italian summary].

Johann Liss (exhib. cat.). Ed. B. Bushart, Augsburg, 1975 [also shown Cleveland].

Review: J. Rowlands, *Burl. Mag.*, CXVII (1975), 832–6.

Spear, Richard E. 'J. L. Reconsidered', *Art Bull.*, LVIII (1976), 582–93.

Klessmann, Rüdiger. 'Addenda to J. L.', *Burl. Mag.*, CXXVIII (1986), 191–7.

MADERNO, C.

Egger, H. *Carlo Madernos Projekt für den Vorplatz von San Pietro in Vaticano*. Leipzig, 1928.

Caflish, Nina. *C. M.* Munich, 1934.

Panofsky-Soergel, Gerda. 'Zur Geschichte des Palazzo Mattei di Giove', *Röm. Jahrb. f. Kunstg.*, XI (1967–8), 109–88.

Hibbard, Howard. *C. M. and Roman Architecture 1580–1630*. London, 1971 [the comprehensive monograph with full catalogue and bibliography, as well as a survey of Roman architecture of the period].

Beltramme, Marcello. 'Il progetto di C. M. per la facciata e la piazza di San Pietro in Roma', *Storia dell'Arte*, 56 (1986), 31–47.

Vicioso, Julia. 'La Basilica di San Giovanni dei Fiorentini a Roma: individuazione delle vicende progettuali', *Boll. d'Arte*, 77, no. 72 (1992), 73–114.

Horat, Heinz. 'Santa Croce in Riva San Vitale: ein Frühwerk von Carlo Maderno', *Zeitschrift für Schweizerische Archäologie und Kunstgeschichte*, 49 (1992), 151–64.

Thoenes, C., 'Madernos St.-Peter-Entwürfe', in *An Architectural Progress in the Renaisance and Baroque*, eds. H. Millon and S. Munshower, University Park, 1992, 170–93.

Eichberg, Margherita. 'Un'architettura post-tridentina: la capella Salviati in S. Gregorio al Celio', *Palladio*, 7, 13 (1994), 41–56.

MADERNO, S.

O'Neil, Maryvelma S. 'Stefano Maderno's "Saint Cecilia": A Seventeenth Century Roman Sculpture Remeasured', *Antologia di belle arte*, 25–6 (1985), 9–21.

Androssov, Sergey O. 'Works by S. M., Bernini and Rusconi from the Farsetti collection in the Ca'd'Oro and the Hermitage', *Burl. Mag.*, CXXXIII (1991), 292–7.

MAFFEI

Ivanoff, Nicola. *Catalogo della mostra di Francesco Maffei* (exhib. cat., Vicenza). Venice, 1956.

Review: L. Mangagnato, *Arte veneta*, X (1956), 245–50.

Rossi, Paola. *F. M.* Milan, 1991.

Review: S. Marinelli, *Arte veneta*, XLV (1993), 101–6.

MAGNASCO

Muti, Laura and De Sarno Prignano, Daniela. *Alessandro Magnasco*. Faenza, 1994.

A. M. 1667–1749 (exhib. cat., Genoa). Milan, 1996.

Muti, Laura and De Sarno Prignano, Daniela. *Antonio Francesco Peruzzini*. Faenza, 1996 [Sorts out the works of A. M. from those of his associates].

MANCINI

Sestieri, Giancarlo. 'Profilo di Francesco Mancini', *Storia dell'arte* 29 (1977), 67–79.

MANETTI

Bagnoli, Alessandro. *Rutilio Manetti* (exhib. cat.). Florence, 1978.

——'Aggiornamenti di R. M.', *Prospettiva*, 13 (1978), 23–42.

MANFREDI

Cuzin, Jean-Pierre. 'Manfredi's *Fortune Teller* and Some Problems of "Manfrediana Methodus"', *Bulletin of the Detroit Institute of Arts*, LVIII, 1 (1980), 15–25 [fundamental].

Moir, Alfred. 'An Examination of B. M.'s "Cupid Chastised"', *The Art Institute of Chicago: Museum Studies*, XI, 2 (1985), 157–67.

Dopo Caravaggio: B. M. e la Manfrediana Methodus (exhib. cat.). Cremona, 1988 [important]

Parlato, Enrico. 'M.'s last year in Rome', *Burl. Mag.*, CXXXIV (1992), 442.

MARABITTI

Giudice, Rosalia. *Francesco Ignazio Marabitti, scultore siciliano del secolo XVIII*. Palermo, 1937 [unillustrated; documents].

Malignaggi, Diana. 'I. M.', *Storia dell'arte*, XVII (1973), 5–61.

Fittipaldi, Teodoro. 'Sculture inedite di I.M.', *Napoli nobilissima*, XV (1976), 65–105.

MARATTI

Mezzetti, Amalia. 'Contributi a Carlo Maratti', *Rivista del Istituto Nazionale d'Archeologia e Storia dell'Arte*, n.s., IV (1955), 251–354.

——'C. M.: altri contributi', *Arte antica e moderna*, IV (1961), 377–87.

Dowley, Francis H. 'C. M., Carlo Fontana, and the Baptismal Chapel in Saint Peter's', *Art Bull.*, XLVII (1965), 57–89. With supplementary material by E. Schaar, *ibid.*, XLVIII (1966), 414–15; F. di Federico, *ibid.* (1968), 194–8.

Harris, A.S. and Schaer, Eckhard, *Kataloge des Kunstmuseums Düsseldorf, III; Handzeichnungen I. Die Handzeichnungen von Andrea Sacchi und C.M.*, Düsseldorf, 1967.

Bellini, Paolo (ed.). *L'opera incisa di C. M.* (exhib. cat.). Pavia, 1977.

Rudolf, Stella. 'La prima opera publica del C. M.', *Paragone*, 329 (1977), 46–58.

Westin, Jean K. and Robert H. *C. M. and his Contemporaries. Figurative Drawings from the Roman Baroque* (exhib. cat.). University Park, Pa., 1975.

Feinblatt, Ebria. 'A Drawing by C. M.', *Los Angeles County Museum of Art Bulletin*, XXV (1979), 6–23 [on the drawings for the Salone of the Palazzo Altieri].

Bershad, David. 'The Newly Discovered Testament and Inventories of C. M. and his Wife Francesca', *Antologia di belle arti*, 25–6 (1985), 65–84 [replaces R. Galli's more summary publication, *L'Archiginnasio*, XXII (1927), 217–38].

See also A. Pampalone, 1993, (II, C).

A monograph by Stella Rudolf should be appearing shortly.

MARCHIONNI, C.

Berliner, Rudolf. 'Zeichnungen von Carlo e Filippo Marchionni', *Münchner Jahrbuch der bildenden Kunst*, IX–X (1958–9), 267–396 [rich study with a wealth of new documents].

Gaus, Joachim. *C. M. Ein Beitrag zur römischen Architektur des Settecento*. Cologne, Graz, 1967.

Herbert Beck and Peter Bol (eds). *Forschungen zur Villa Albani*. Berlin, 1982; *Katalog der antiken Bildwerke I: Bildwerke im Treppenaufgang und im Piano nobile des Casino*. Berlin, 1989; *II: Bildwerke in den Portiken, dem Vestibül und der Kapelle des Casino*. Berlin, 1990.

Debenedetti, Elisa (ed.). *C. M.: Architettura, decorazione e scenografia contemporanea (Studi sul Settecentesco Romano, IV)*. 1988 [volume devoted to C. M. and his contemporaries].

MARCHIORI

Coletti, Luigi. 'Marchiori or Morlaiter?', *Arte veneta*, XIII/XIV (1959/60), 138–46.

Menegazzi, Luigi. 'Disegni di G. M.', *Arte veneta*, XIII/XIV (1959/60), 147–54 [Wittkower has identified the drawings as after, not by M.].

Rossi, Paola. 'Lavori settecenteschi per la chiesa di San Rocco: la decorazione della sagrestia e le sculture della facciata', *Arte veneta*, XXXV (1981), 226–36.

——'L'attività di G. M. per la Scuola di San Rocco', *Arte veneta*, XXVI (1982), 262–7.

MARIESCHI

Succi, Dario. *Michele Marieschi: Catalogo ragionato dell' opera incisa*. Turin, 1987.

Toledano, Ralph. *M. M.: L'opera completa*. Milan, 1988.

Succi, Dario. *M. Tra Canaletto e Guardi* (exhib. cat., Gorizia). Turin, 1989.

Manzelli, Mario. *M. M. e il alter-ego Francesco Albotto*. Venice, 1991.

Review: J. Links, *Burl. Mag.*, CXXXIV (1992), 125–6 [with Succi (1989), Toledano, (1988)].

MARINALI

Tua, Carmella. 'Orazio Marinali e suoi fratelli', *Rivista d'arte*, XVII (1935), 281–322.

Pupi, Lionello. 'Nuovi documenti sui Molinari', *Atti dell'Istituto Veneto di Scienze, Lettere ed Arti. Classe di scienze morali, lettere ed arti*, CXX (1966–7), 195–215.

Rugolo, Ruggero. 'L'alchimia in villa: il ciclo erculeo di O.M. nel Giardino delle Esperidi di Villa Cornaro a S. Andrea di Cavasagra',

Boll. d'Arte, LXXXI (1994), 259–77.

Androssov, Sergey. 'Unknown Works of O.M.', *Antologia di belle arti*, 1994, 71–6.

See also F. Barbieri, 1989–90 (IV, under BONAZZA)

MARTINELLI

Hellmut Lorenz. *Domenico Martinelli und die österreichische Barockarchitektur*. Vienna, 1991 [there are a few projects for Rome and Lucca though he was mostly active in central Europe].

MARUSCELLI

Fumagalli, Elena. 'La facciata quattrocentesca del palazzo Medici in piazza Madama: un disegno e alcune considerazioni', *Annali di Architettura*, 3 (1991), 26–31.

Borsi, Franco, Valerio Tesi, Luciano Tubello, Flavia Serego Alighieri. *La facciata di Palazzo Madama*. Rome, 1994.

See also under BORROMINI: Connors. *Oratory*, 109–12 [capsule biography].

MASARI

Massari, Antonio. *Giorgio Massari, architetto veneziano del settecento*. Vicenza, 1971.

Sorato, Paola. 'La Scuola del Cristo nella contrada di San Marcuola a Venezia', *Arte Veneta*, 35 (1981), 204–9.

MASTELLETTA

Monai, Fulvio. 'Un pittore secessionista del '600 a Bologna, Giovanni Andrea Donducci detto il Mastelletta', *Studi di storia dell'arte in onore di Antonio Morassi*. Venice, 1971, 219–26.

Coliva, Anna. *Il Mastelletta; Giovanni Andrea Donducci 1575–1655*. Rome, 1980.

MAZZA

Puglisi, Catherine R. 'The Cappella di San Domenico in Santi Giovanni e Paolo, Venice', *Arte veneta*, XL (1986), 230–8.

MAZZONI

Ivanoff, Nicola. 'Sebastiano Mazzoni', *Saggi e memorie*, II (1956–9), 209–80 [basic study with oeuvre catalogue and bibliography; some attributions (particularly of early years) out-dated].

Safarik, E. 'Per la pittura veneta del Seicento: S. M.', *Arte veneta*, XXVIII (1974), 157–68.

See also M. Valsecchi, 1970 (IV, under PROCACCINI)

MAZZUOLI

Pansecchi, Fiorella. 'Contributi a Giuseppe Mazzuoli', *Commentari*, X (1959), 33–43.

Schlegel, U. 'Some Statuettes of G.M.', *Burl. Mag.*, CIX (1967), 388–95.

—— 'Per G. e Bartolomeo M.: nuovi contributi', *Arte illustrata*, V (1972), 6–8; 38–49.

Westin, Robert and Jean. 'Contributions to the late chronology of G. M.', *Burl. Mag.*, CXVI (1974), 36–40.

Negro, Angela. 'Nuovi documenti per G. M. e bottega nella Cappella Pallavicini Rospigliosi a San Francesco a Ripa', *Boll. d'Arte*, LXXII (1987), 157–78.

Butzek, Monika. 'Die Modellsammlung der M. in Siena', *Pantheon*, XLVI (1988), 75–102.

—— G.M. e le statue degli Apostoli del Duomo di Siena', *Prospettiva*, LXI (1991), 77–81.

——'"Conversio Sancti Galgani". Zu zwei neuentdeckten Reliefs von G.M.', *Begegnung. Festschrift für Peter Anselm Riedl*. Worms, 1993, 137–43.

MEI

Bisogni, Fabio and Ciampolini, Marco. *Bernardino Mei e la pittura barocca a Siena* (exhib. cat., Siena). Florence, 1987.

MICHETTI

Pinto, John. 'An Early Design by Nicola Michetti: The Sacripante Chapel in the Roman Church of S. Ignazio', *J.S.A.H.*, XXXVIII (1979), 375–81.

——'N. M. and Ephemeral Design in Eighteenth-Century Rome', *Studies in Italian Art and Architecture: 15th through 18th Centuries*. Ed. H.A. Millon, Rome, 1980, 289–322.

—— 'N. M. and Eighteenth-Century Architecture in St. Petersburg', *An Architectural Progress in the Renaissance and Baroque: Sojourns in and out of Italy*. Eds H.A. Millon and S. Munshower, University Park, II (1992), 526–65.

MITELLI, AGOSTINO

Feinblatt, Ebria. *Agostino Mitelli. Drawings. Loan Exhibition from the Kunstbibliothek, Berlin* (exhib. cat.). Los Angeles, 1965.

—— 'Observations on some Drawings by "Colonna-Mitelli"', *Master Drawings*, XXI (1983), 167–72.

MITELLI, GIOVANNI MARIA

Varignana, Franca. *Le collezioni d'arte del Casa di Risparmio di Bologna*, 5, *Le incisioni*, I. Bologna, 1978 [devoted to G.M.M.].

MOCHI

Martinelli, Valentino. 'Contributi alla scultura del '600: Francesco Mochi a Roma', *Commentari*, II (1951), 224–35.

——'Contributi alla scultura del '600: F. M. a Piacenza', *Commentari*, III (1952), 35–43.

Gaborit, René. 'Le Bernin, Mocchi et le buste de Richelieu au Musée du Louvre. Un problème d'attribution', *Bulletin de la Société de l'Histoire de l'Art Français*, 1977 (1979), 85–91.

Wardropper, Ian. 'A New Attribution to F. M.', *The Art Institute of Chicago Museum Studies*, XVII (1991), 102–19.

F. M. 1580–1654 (photo exhib., Montevarchi). Florence, 1981.

See also I. Lavin, 1970 (IV, under DUQUESNOY)

MOLA

Cocke, Richard. *Pier Francesco Mola*. Oxford, 1972.

Review: A. Sutherland Harris, *Art Bull.*, LVI (1974), 298–92.

P. F. M. 1612–1666 (exhib. cat., Lugano, Rome). Milan, 1989.

Review: A. Sutherland Harris, *Master Drawings*, XXX, 2 (1992), 216–23.

Tantillo Mignosi, Almamaria. 'Un ciclo inedito di P. F. M.: gli affreschi del palazzo Pamphilj di Nettuno', *Paragone*, 471 (1989), 72–98.

MOLINARI

Pappalardo, Anna Maria. 'Il pittore veneziano Antonio Molinari' *Atti dell'Istituto Veneto di Scienze, Lettere ed Arti. Classe di scienze morali e lettere*, CXII (1953–4), 439–62.

Moretti, Lino. 'A. M. rivisitato', *Arte veneta*, XXXIII (1979), 59–69.

MONNOT

Francastel, Pierre. 'La Marmorbad de Cassel et les Lazienki de Varsovie', *Gazette des beaux-arts*, ser. 6, IX (1933), 138–56.

Fusco, Peter. 'Pierre-Etienne Monnot's Inventory after Death', *Antologia di belle arti*, 33–34 (1988), 70–7.

Bacchi, Andrea. 'L'Operazione con li modelli': P. E. M. e Carlo Maratta a confronto', *Ricerche di storia dell'arte*, LV (1995), 39–52.

Fuchs, Thomas. *Tradition und Inovation im Werk des P. E. M. Das Marmorbad in Kassel*. Weimar, 1997.

MONTANO

Montano, Giovanni Battista. *Libro primo: Scielta d. varii tempietti antichi....* Ed. G.B. Soria, Rome, 1624; *Architettura con diversi ornamenti cavati dall'antico*. Ed. C. Ferrante, Rome, 1636; three MS volumes of M. in Sir John Soane's Museum, London, in L. Fairbairn, *Italian Renaissance Drawings from the Collection of Sir John Soane's Museum*, London, 1998, II, 540–773 [the major treatment of M.].

The older literature includes Sedlmayr 1939, Portoghesi 1967, Noehles 1970 (under Borromini and Cortona above).

Zander, Giuseppe. 'Le invenzioni architettoniche di G. B. M. milanese (1534–1621)', *Quaderni dell'Istituto di Storia dell'Architettura dell'Università di Roma*, 30 (1958), 1–21, and 49/50 (1962), 1–32.

Blunt, Anthony. 'Baroque Architecture and Classical Antiquity', in R.R. Bolgar, *Classical Influences on European Culture A.D. 1500–1700*. Cambridge, 1976, 349–54.

Von Henneberg, Josephine. 'Documentation: Emilio dei Cavalieri, Giacomo della Porta, and G. B. M.', *J.S.A.H.*, 36 (1977), 252–5.

Bedon, Anna. 'Architettura e archeologia nella Roma del Cinquecento: G. B. M.', *Arte Lombarda*, 65, 1983, n. 2, 111–26 [an important synthetic article].

——'I disegni di G. B. M. nella Raccolta Martinelli di Milano', *Il Disegno di Architettura*, 3 (1991), 34–7.

Rodriquez Ruiz, D. in *Disegni italiani di architettura e ornamentazione della Biblioteca Nazionale di Madrid. Secoli XVI e XVII*. Milan, 1991, 75–102.

MONTELATICI

Masetti, Anna R. *Cecco Bravo, pittore toscano del Seicento*. Venice, 1962.

Cantelli, Giuseppe and Bongiari, Piero. *Disegni di Cecco Bravo* (exhib cat., Uffizi). Florence, 1970.

Matteoli, Anna. 'Documenti su Cecco Bravo', *Rivista d'arte*, XLII (1990), 95–146.

MONTI

Ruggeri, Ugo. *Francesco Monti bolognese*. Bergamo, 1968.

——'F.M. bolognese a Brescia', *Critica d'arte*, XVI, 108 (1969), 35–52; XVII, 109 (1970), 37–50.

——'F.M. "falso veneto"', in *Nicola Grassi e il Rococò europeo* [congress papers]. Udine, 1984, 239–54.

MORANDI

Waterhouse, Ellis. 'A Note on Giovanni Maria Morandi', *Studies in Renaissance and Baroque Art Presented to Anthony Blunt on his 60th Birthday*. London, 1967, 37–50.

MORLAITER

Ress, Anton. *Giovanni Maria Morlaiter. Ein venezianischer Bildhauer des 18. Jahrhunderts*. Munich, 1979.

Review: E. M. Pedrocco, *Arte veneta*, XXXV (1981), 204–5.

See also P. Rossi, 1981 (IV, under MARCHIORI)

NACCHERINO

Maresca di Serracapriola, Antonio. *Michelangelo Naccherino ...* Naples, 1924.

Parronchi, Alessandro. 'Sculture e progetti di M.N.', *Prospettiva*, XX (1980), 34–46 [Useful for documents, and illustrations; some implausible attributions].

Kuhlemann, Michael, *M. N.: Skulptur zwischen Florenz und Neapel um 1600*. Münster, 1999.

See also M. I. Catalano, 1985 (III, NAPLES, *Sculpture*)

NIGETTI

Berti, Luciano. 'Matteo Nigetti', *Rivista d'arte*, 26 (1950), 157–84; 27 (1951–2), 93–106.

Cresti, Carlo. *Un episodio del Seicento fiorentino. L'architetto M. N. e la cappella Colloreda. Documenti e disegni* (exhib. cat.). Florence, 1981.

NOLLI

Nolli, Giovanni Battista, *Nuova pianta di Roma*, 1748, ed. Stefano Borsi, Rome, 1994.

De Rossi, G.B. and Gatti, G. 'Note di ruderi e monumenti antichi prese per la Pianta di Roma di G.B. Nolli, conservate nell'Archivio Vaticano', *Studi e documenti di Storia e di Diritto*, IV (1883), 153–9; V (1884), 109–57.

Zänker, Jürgen. 'S. Dorotea in Rom und verwandte Kirchenbauten. Zu G. B. N.s Tätigkeit als praktischer Architekt', *Architectura*, 4 (1974), 165–80.

——'Die "Nuova Pianta di Roma" von G. B. N. (1748)', *Wallraf-Richartz-Jahrbuch*, XXXV (1973).

Michel, Olivier. 'Les péripéties d'une donation. La Forma Urbis en 1741 et 1742', *Mélanges de l'Ecole Française de Rome, Antiquité*, 95 (1983), 997–1019.

Rome 1748. The Pianta Grande di Roma of G. N. in Facsimile. Highmount, N.Y., 1984.

Bevilacqua, Mario. 'N. e Piranesi a Villa Albani', in E. Debenedetti, ed. *Il Cardinale Alessandro Albani patrono delle arti. Architettura, pittura, collezionismo nella Roma del Settecento (Studi sul Settecento Romano*, 9), Rome, 1993, 71–82.

Pinto, John. 'Forma Urbis Romae: Fragment and Fantasy', in C.L. Striker (ed.). *Architectural Studies in Honor of Richard Krautheimer*. Mainz, 1996, 143–7.

Bevilacqua, Mario. *Roma nel secolo dei lumi. La pianta di G. B. N. nella cultura europea*, Rome, 1996.

—— 'Il restauro diSant'Alessio: N., De Marchis e Fuga per il mecenatismo del cardinal Querini', *Palladio* (1998).

NOMÉ

Nappi, Maria Rosaria. *François De Nomé e Didier Barra: l'enigma Monsù Desiderio*. Milan, 1991.

NOVELLI

Di Stefano, Guido. *Pietro Novelli il Monrealese*. Palermo, 1989.

P. N. e il suo ambiente (exhib. cat.). Palermo, 1990.

Campagna Cicala, Francesca. 'Considerazioni sugli esordi di P. N. tra Roma e Napoli', *Storia dell'arte*, (1992), 176–85.

ORIZZONTE (J. F. VAN BLOEMEN, called)

Busiri Vici, Andrea. *Jan Frans Van Bloemen. 'Orizzonte' e l'origine del paesaggio romano settecentesco*. Rome, 1974.

PAGGI

Lukehart, Peter. *Contending Ideals: The Nobility of G. B. Paggi and the Nobility of Painting*. Baltimore, 1987.

PALMA GIOVANE

Mason Rinaldi, Stefania. *Palma il giovane. L'opera completa*. Milan, 1988.

——(ed.). *P. il g., 1548–1628: Disegni e dipinti* (exhib. cat.). Milan, 1990.

See also *I pittori bergamaschi; Il Cinquecento*. Bergamo, 1979, 297–303 (N. Ivanoff, P. Zampetti)

PANNINI

Arisi, Ferdinando. *Giovanni Paolo Panini e i fasti della Roma del '700*. Rome, 1986 [2nd ed., originally *G. P. Panini*. Piacenza, 1961].

Kiene, Michael and Rosenberg, Pierre. *Panini (Les Dossiers du Musée du Louvre)*. Paris, 1992. Reduced, Bruswick, 1993; much expanded, as F. Arisi. *G. P. Panini*, Piacenza, 1993.

Review: E. P. Bowron, *Burl. Mag.*, CXXXVI (1994), 117–18.

PARIGI

Negro Spina, Annamaria. *Giulio Parigi e gli incisori della sua cerchia*. Naples, 1983.

PARODI

Rotondi Briasco, Paola. *Filippo Parodi*. Genoa, 1962 [Not yet the final monograph].

Preimesberger, Rudolf. 'Zu zwei Werken F. P.s in Venedig', *Röm. Jahrb. f. Kunstg.*, XIII (1971), 297–303.

Franchini Guelfi, Fausta. 'Revisione e proposte per F. P.', *Arte cristiana*, LXXIX (1991), 431–40.

PELLEGRINI

Aikema, Bernard and Mijnlieff, Ewould. 'Giovanni Antonio Pellegrini 1716–1718: A Venetian Painter in the Low Countries', *Nederlands Kunsthistorisch Jaarboek*, XLIV (1993), 215–42.

Knox, Robert. *A. P. 1675–1741*. Oxford, 1995.

PEPERELLI

Benocci, Carlo. 'Il rinnovamento seicentesco della Villa Mattei al Celio: Francesco Peparelli, Andrea Sacchi, Andrea Lilli ed altri artisti', *Storia dell'arte*, 66 (1989), 187–96.

Passigli, Susanna. *La pianta dell'architetto Francesco Peperelli (1618): Una fonte per la topografia della regione romana (Miscellanea della Società Romana di Storia Patria*, 21), Rome, 1989.

Longo, Elena. 'Per la conoscenza di un architetto del primo Seicento romano: F. P.', *Palladio*, 5 (1990), 25–44.

PIAZZETTA

Mariuz, Adriano and Pallucchini, Rudolfo. *L'Opera completa del Piazzetta*. Milan, 1982.

Revue: A. Binion. *Art Bull.*, LXVIII (1986), 680–2.

G. P. Il suo tempo, la sua scuola (exhib. cat.). Ed. F. Valcanova and G. Romanelli, Venice, 1983.

Moretti, Lino. 'Notizie e appunti su B. B. P., alcuni Piazzetteschi e G. B. Tiepolo', *Atti dell'Istituto Veneto de scienze, lettere ed arti*, CXLIII, 1984–5, 359–95.

Knox, George. *G. B. P.* Oxford, 1992.

Revue: C. Whistler, *Burl. Mag.*, CXXXV (1993), 769–70.

PIOLA

Newcome, Mary. 'Domenico Piola in the church of San Luca, Genoa', *Paragone*, 519–21 (1993), 99–112.

PIRANESI

Focillon, Henri. *Giovanni Battista Piranesi, 1720–1778*. Paris, 1918; reprint 1964; Italian ed., Bologna 1967.

Hind, Arthur M. *G. B. P., A Critical Study*. London, 1922.

Wittkower, Rudolf. 'P.'s "Parere su L'Architettura"', *J.W.C.I.*, II (1938–9), 147–58.

Murray, Peter. *P. and the Grandeur of Ancient Rome*. London, 1971.

G. B. P. The Polemical Works. Ed. John Wilton-Ely, London, 1972.

P. Drawings and Etchings at the Avery Architectural Library Columbia University, New York. The Arthur M. Sackler Collection (exhib. cat.) New York, 1975 [includes the recently discovered Lateran projects].

Scott, Jonathan. *P*. London, New York, 1975.

P. et les Français 1740–1790 (exhib. cat.). Rome, 1976.

Bettagno, Alessandro (ed.). *Disegni di G. P*. Venice, 1978; *P.: Incisioni, rami, legature, architettura*. Vicenza, 1978 [part of the Piranesi bicentenary of 1978, excellent bibliography].

P. et les français. Colloque tenu à la Villa Médicis 12–14 Mai 1976. Ed. G. Brunel, Rome, 1978. Especially Gilbert Erouart and Monique Mosser. 'A propos de la "Notice historique sur la vie et les ouvrages de J.-B. Piranesi": Origine et fortune d'une biographie', 213–56.

Wilton-Ely, John. *The Mind and Art of G. B. P*. London, 1978 [the classic book, with complete bibliography to date, as well as a list of Piranesi's own publications and reproductions of the *Vedute di Roma* and the *Carceri*].

Miller, Norbert. *Archäologie des Traums: Versuch über G. B. P*. Munich, Vienna, 1978.

Neverov, Oleg. 'G. B. P., der Antikensammler', *Xenia*, 4 (1982), 71–89.

Garms, Jörg. 'Apropos P.', *Daidalos*, 9 (1983), 63–76.

Bettagno, Alessandro (ed.). *P. tra Venezia e l'Europa*. Florence, 1983.

Robison, Andrew. *P. Early Architectural Fantasies. A Catalogue Raisonné of the Etchings*. Chicago, 1986.

Wilton-Ely, John. *P. as Architect and Designer*. New York, New Haven, London, 1993.

Denison, Cara, Wiles, Stephanie and Rosenfeld, Myra Nan (eds.). *Exploring Rome: P. and his Contemporaries* (exhib. cat., New York and Montreal). Cambridge, Ma., 1993.

Pinto, John. 'P. at Hadrian's Villa', *Studies in the History of Art*, 43 (1993), 465–77.

Wilton-Ely, John. *G. B. P. The Complete Etchings* (2 vols). San Francisco, 1994.

Fusconi, Giulia. 'Da Bartoli a P.: spigolature dai Codici Ottoboniani Latini della Raccolta Ghezzi', *Xenia Antiqua*, III (1994), 145–72.

Tomoy, Peter. 'P.'s *Grotteschi*: "All is Vanity..."', *Storia dell'Arte*, 88 (1996), 334–40.

Pinto, John. 'Forma Urbis Romae: Fragment and Fantasy', in C.L. Striker (ed.). *Architectural Studies in Honor of Richard Krautheimer*. Mainz, 1996, 143–7.

Contardi, Bruno. 'Piranese come architetto', in Elisa Debenedetti, ed. *G. B. P. La raccolta di stampe della Biblioteca Fardelliana* (exhib. cat.), Trapani, 1996, 46–56.

David, Paola Raffaella. 'Il recinto piranesiano di piazza dei Cavalieri di Malta a Roma: restaurare l'ambiguità?', *Cantieri e ricerche*. Eds P. R. David and A. Draghi, Rome, 1997, 101–31.

Jatta, Barbara, ed. *Piranesi e l'Aventino* (exhib. cat.), Milan, 1998.

See also Kieven, 1993, above under II.D.2: *General Architecture Surveys*

PITTONI

Zava Boccazzi, Franca. *Pittoni*. Venice, 1979.

 Revue: A. Binion, *Burl. Mag.*, CXXXII (1989), 589–90.

See also *I pittori bergamaschi; il Settecento*, II (1989), 514–21 (A. Brigozzi Brini).

PONZIO

Hibbard, Howard. *The Architecture of the Palazzo Borghese*. Rome, 1962 [a compact biography, 97–104].

Antinori, A. 'Giovanni Ambrogio Magenta, Carlo Maderno, Flaminio Ponzio e altri: La cattedrale di Bologna al tempo di Scipione Borghese arcivescovo', *Architettura: Storia e Documenti*, 1–2 (1990), 57–87.

Zekagh, Abdelouahab. 'La chiesa di S. Sebastiano fuori le mura in Roma e i restauri del Cardinale Scipione Borghese', *Palladio*, 3, n. 6 (1990), 77–96.

POZZO

Pozzo, Andrea. *Perspecta pictorum et architectorum*. Rome, 1693–1700. English translation of Part I, London, [c. 1707]. Reprint New York, 1989.

Carboneri, Nino (ed.). *Andrea Pozzo, architetto (1642–1709)*. Trent, 1961.

Kerber, Bernhard. *A. P.* Berlin, New York, 1971

De Feo, Vittorio. *A. P. Architettura e illusione*. Rome, 1988.

Tubello, Luciano. 'Il restauro dell'altare di Sant'Ignazio al Gesù', *L'Urbe*, 52 (1989), 5–10.

Romano, Giovanni. 'Notizie su A. P. tra Milano, Genova e il Piemonte', *Prospettiva*, 57–60 (1989–90), 294–307.

Dal Mas, Roberta. *A. P. e il Collegio dei Gesuiti di Belluno*. Belluno, 1992.

Franca Mellano, Maria. 'L'attività di A. P. (1672–1681) nella corrispondenza di governo del generale della Compagnia di Gesù', *Arte Cristiana*, 82, n. 764–5 (1994), 473–82 [Pozzo's call to Rome clarified by documents].

Griseri, Andreina. 'A. P.: unità di strategie, prospettiva e pittura', *Arte Cristiana*, 82, n. 764–5 (1994), 483–92 [the devotional quality of Pozzo's paintings in Rome and Mondovì]

De Feo, Vittorio. 'La "Perspectiva Pictorum et Architectorum" di A. P. gesuita', *Disegno di architettura*, 12 (1995), 26–32.

De Feo, Vittorio and Martinelli, Vittorio (eds.). *A. P.* Milan, 1996.

Battisti, Alberta (ed.). *A. P., 1642–1709* (1992). Milan, 1996.

PRETI, F.M.

Puppi, Lionello (ed.). *Francesco Maria Preti, architetto e teorico (Castelfranco Veneto, 1701–1774)*. Castelfranco Veneto, 1990.

PRETI, M. and G.

Corace, Erminia (ed.). *Mattia Preti*. Rome, 1989.

Clifton, James D. and Spike, John T. 'M. P.'s passage to Naples: a documented chronology 1650–60', *Storia dell'arte*, 65 (1989), 45–68.

Corace, Erminia (ed.). *M. P. dal segno al colore*. Rome, 1995.

Spike, John T. *M. and G. P. a Taverna: Catalogo completo delle opere*. Florence, 1997.

Two exhibitions are in preparation (1999) in Naples and Taverna.

PROCACCINI

Valsecchi, Marco. 'Schede lombarde per Giulio Cesare Procaccini (e il Morazzone)', *Paragone*, 243 (1970), 12–35 (with 'Codicilli' by R. Longhi, 35–64).

Brigstocke, Hugh. 'G. C. P. Reconsidered', *Jahrbuch der Berliner Museen*, XVIII (1976), 84–133.

Bober, Jonathan. 'A "Flagellation of Christ" by G. C. P.: Program and Pictorial Style in Borromean Milan', *Arte lombarda*, 73–5 (1985), 55–80.

Berra, Giacomo. *L'attività scultorea di G. C. P.* Milan, 1991.

Rosci, Marco. *G. C. P.* Soncino, 1993.

See also Pesenti, 1980 (IV, under CERANO).

RAINALDI, G. and C.

Hempel, Eberhard. *Carlo Rainaldi*. Munich, 1919.

Wittkower, Rudolf. 'C. R. and the Roman Architecture of the Full Baroque', *Art Bull.*, XIX (1937), 242–313. Republished in *Studies in the Italian Baroque*. London, 1975, 9–52.

Fasolo, Furio. *L'opera di Hieronimo e C. R. (1570–1655 e 1611–1691)*. Rome, 1961 [a preliminary study that has yet to be replaced by a full monograph. Review by Karl Noehles in *Zeitschr. f. Kunstg.*, XXV, 1962, 166–77].

Güthlein, Klaus. 'Die Fassade der Barnabiterkirche San Paolo in Bologna, ein Beitrag zur Tätigkeit der Architekten Girolamo und C. R. für die Familie Spada', *Röm. Jahrb. f. Kunstg.*, 17 (1978), 125–55.

Güthlein, Klaus. 'Der "Palazzo Nuovo" des Kapitols', *Röm. Jahrb. f. Kunstg.*, XXII (1985), 83–190.

Andanti, Andrea. 'Un disegno rainaldiano per la facciata di S. Pietro (1606–1607)', in *Architettura e prospettiva tra inediti e rari*. Florence, 1987, 62–75.

Bösel, Richard. 'La chiesa di S. Lucia. L'invenzione spaziale nel contesto dell'architettura gesuitica', in Gian Paolo Brizzi and Anna Maria Matteucci (eds). *Dall'isola alla città. I Gesuiti a Bologna*. Bologna, 1988, 85–93.

Güthlein, Klaus. 'Zwei unbekannte Zeichnungen zur Planungs- und Baugeschichte der römischen Pestkirche Santa Maria in Campitelli', *Römisches Jahrbuch der Bibliotheca Hertziana*, XXVI (1990), 185–255.

Kelly, Cathie. 'C. R., Nicola Michetti, and the Patronage of Cardinal Giuseppe Sacripante', *J.S.A.H.*, 50 (1991), 57–67.

RAGUZZINI

Rotili, Mario. *Filippo Raguzzini e il rococò romano*. Rome, 1951.

Piazza S. Ignazio

Metzger Habel, Dorothy. 'Piazza S. Ignazio, Rome, in the 17th and 18th Centuries', *Architettura*, XI (1981), 31–65.

Müller, Claudia. 'Die Piazza S. Ignazio in Rome: Guarini Rezeption und Rokoko-Strukturen bei Filippo Raguzzini', *Giessener Beiträge zur Kunstgeschichte*, VI (1983), 138–79.

See also REGIONS, ROME, *architecture*: Connors, 'Alliance and Enmity', 279–93.

Other

Metzger Habel, Dorothy. 'Filippo Raguzzini, the Palazzo and Casino Lercari in Albano, and the Neapolitan Ingredient in Roman Rococo Architecture', *Light on the Eternal City*. Eds H. Hager and S. Munshower, University Park, 1987, 231–52.

Metzger Habel, Dorothy. 'F. R., Carlo de Dominicis and Domenico Gregorini: new documentation', *Paragone arte*, 39, n.7, 455 (1988), 62–7.

Roca De Amicis, Augusto. 'La "rappresentazione in funzione": F. R. e l'Ospedale di S. Gallicano a Roma', *Palladio*, 5, n. 10 (1992), 55–68.

RENI

Birke, Veronika. *Guido Reni – Zeichnungen*. Vienna, 1981.

Pepper, D. Stephen. 'G. R., the New Apelles: A Moral Interpretation of his Work', *Le arti a Bologna e in Emilia dal XVI al XVII secolo (Atti del XXIV Congresso Internazionale di Storia dell'Arte [1979])*. Bologna, 1982, 193–201.

Pepper, D. Stephen. *G. R. A complete catalogue of his works with an introductory text*. Oxford, 1984.

 Revue: J. M. Merz, *Kunstchronik*, XL (1987), 99–107.

Accademia Clementina. Atti e memorie, XXII, 1988 [special number devoted to G.R.].

——XXV, 1989 [special number devoted to G.R.].

G. R. (exhib. cat.). Bologna, 1988 (variants shown also Los Angeles, Fort Worth).

 Review: R. Spear, *Burl. Mag.*, CXXXI (1989), 367–92.

 Reply by S. Pepper, *Burl. Mag.*, CXXXII (1990), 219–23.

G.R. und Europa, Ruhm und Nachruhm (exhib. cat.). Frankfurt, 1989.

Pirondini, Massimo and Negro, Emilio. *La Scuola di G. R.* Modena, 1992.

 Review S. Pepper, *Burl. Mag.*, CXXXVI (1994), 628–30.

Madocks, Susan. '"Trop de beautés découvertes" – new light on G. R.'s late "Bacchus and Ariadne"', *Burl. Mag.*, CXXVI (1984), 544–7.

Fumaroli, Marc. 'Une peinture de méditation. A propos de l'Hippomène

et Atalante du Guide' in *Il est allé en Italie. Mélanges offerts à André Chastel*. Rome, 1987, 337–58. Reprinted in *L'École du silence: le sentiment des images au XVIIe siècle*. Paris, 1994, 183–201. Also translated into Italian.

Cropper, Elisabeth. 'Marino's "Strage degli Innocenti": Poussin, Rubens and G.R.', *Studi secenteschi*, XXXIII (1992), 137–66. Reprinted (with some changes) E. Cropper and C. Dempsey. *Nicolas Poussin. Friendship and the Love of Painting*. Princeton, 1996, 253–78.

Pepper, D. Stephen and Morselli, Raffaella. 'G. R.'s Hercules series: new considerations and conclusions', *Studi di storia dell'arte* (Todi), IV (1993), 129–47.

Spear, Richard E. *The "Divine" Guido: Religion, Sex, Money and Art in the World of G.R.* New Haven, London, 1997.

See also Dirani, 1982 (IV, under GUERCINO).

RIBERA

Brown, Jonathan. *Jusepe de Ribera: Prints and Drawings* (exhib. cat.). Princeton, 1973.

Benito Doménech, Fernando. *R. 1591–1652*, Madrid, 1991.

Pérez Sánchez, Alfonso E. and Spinosa, Nicola. *J. de R. 1591–1632* (exhib. cat., Madrid and Naples). Madrid, 1992. Reduced version, but including prints, New York, 1992.

RICCHINO

Cataneo, Enrico. *Il San Giuseppe del Richini*. Milan, 1957.

Bocciarelli, Cecilia. 'Disegni richiniani all'Ambrosiana', *Arte Lombarda*, 37 (1972), 74–80 and 110–13.

Kummer, Stefan. *Mailänder Kirchenbauten des F. M. R.* Diss. Würzburg, 1974 [the basic study with extensive bibliography and documentation].

Kummer, Stefan. 'Mailänder Vorstufen von Borrominis S. Carlo alle Quattro Fontane in Rom', *Münchner Jahrbuch der bildenden Kunst*, 28 (1977), 153–90 [suggestive comparisons between Ricchini and Borromini].

Il disegno di architettura, o (1989), 33f., 34f.; 3 (1991), 5–24; 5 (1992), 58–62; 7 (1993), 23–34; 8 (1993), 33–47 [mini-articles on drawings by various authors].

Kiene, Michael. 'Die Erneuerung der italienischen Universitätsarchitektur unter Carlo und Federico Borromeo', *Architectura*, 18 (1988), 123–68.

Patetta, Luciano. 'Autografia ricchiniana', *Il Disegno di Architettura*, 5 (1992), 58–62.

Della Torre, Stefano. 'L'archivio edificato dell'architettura milanese', in Gabriella Cagliari Poli. *L'Archivio di Stato di Milano*. Florence, 1992, 173–212.

Giustina, I. 'Un inedito progetto di F. M. R. e alcune precisazioni sulle vicende del Palazzo Monti Sormani a Milano', *Palladio*, 16 (1995), 47–72.

Coppa, Simonetta. *La chiesa di San Giuseppe nella storia artistica milanese dal Cinquecento all'Ottocento*. Milan, 1997.

RICCI, SEBASTIANO and MARCO

Pilo, Giuseppe Maria (ed.). *Marco Ricci* (exhib cat., Bassano). Venice, 1963.

Daniels, Jeffrey. *Sebastiano Ricci*. Hove, 1976.

Pilo, Giuseppe Maria. *S. R. e la pittura veneta del settecento. Problemi e studi*. Pordenone, 1976.

Moretti, Lino. 'Documenti e appunti su S. R. (con qualche cenno su altri pittori del Settecento)', *Saggi e memorie*, XI (1988), 95–125.

Scarpa Sonino, Annalisa. *M. R.* Milan, 1991 [oeuvre cat.; the lack of references to the illustrations renders the text unusable].

Succi, Dario and Delneri, Annalisa. *M. R. e il paessagio veneto del settecento* (exhib. cat. Belluno). Milan, 1993.

Rizo, Aldo. *S. R.* Milan, 1989.

See also 'S. R.', in *I pittori bergamaschi; il Settecento*. II (1939), 1–31 (F. R. Pesenti).

ROSA

Oertel, Robert. 'Die Vergänglichkeit der Künste. Ein Vanitas-Stilleben von Salvator Rosa', *Münchner Jahrbuch*, XIV (1963), 105–20.

Salerno, Luigi. *S. R.* Milan, 1963.
 Review: F. Haskell, *Burl. Mag.*, CVIII (1965), 263.

Wallace, Richard W. 'The Genius of S. R.', *Art Bull.*, XLVII (1965), 471–80 [an exploration of S. R.'s conception of genius, based on an iconological study of his etching *The Genius of Rosa*].

——'S. R.'s "Death of Atilius Regulus"', *Burl. Mag.*, CIX (1967), 393–7.

——'S. R.'s *Democritus* and *L'Umana Fragilità*, *Art Bull.*, L (1968), 21–32.

Salerno, Luigi. *L'opera completa di S. R.* Milan, 1975.

Wallace, Richard W. *The Etchings of S. R.* Princeton, 1979.

Scott, Jonathan. *S. R.: His Life and Times*. New Haven, London, 1995 [readable English account].

ROSSI, G.A. DE

Spagnesi, Gianfranco. *Giovanni Antonio De Rossi architetto romano*. Rome, 1964.

Menichella, Anna. *Matthia de' Rossi discepolo prediletto del Bernini* (*Quaderni di Storia dell'Arte dell'Istituto Nazionale di Studi Romani*, 21), Rome, 1985.

Antinori, Aloisio. 'Alcune notizie sulla Villa Altieri all'Esquilino e sull'attività di G. A. De R. Architettto Romano', *Boll. d'Arte*, anno LXXI, 37–8 (1986), 113–28.

Fairbairn, Lynda. *Italian Renaissance Drawings from the Collection of Sir John Soane's Museum*, 2 vols, London, 1998, II, 'Giovanni Battista Montano 1534–1621 Three volumes', 540–773.

ROSSI, M.A.

Heimbürger, Minna. *L'architetto militare Marcantonio de Rossi e alcune sue opere in Roma e nel Lazio*. Rome, 1971.

ROSSI, MATTIA DE

Hager, Hellmut. 'Bernini, Mattia de Rossi and the Church of S. Bonaventura a Monterano', *Architectural History*, 21 (1978), 68–78.

ROTARI

Barbarani, Emilio. *Pietro Rotari*. Verona, 1941.

Drei, Carla Fiocco. 'P. R.', *Antichità viva*, XIX, 5 (1980), 23–32.

RUSCONI

Montagu, Jennifer. 'Camillo Rusconis Büste der Giulia Albani degli Abati Olivieri', *Jahrbuch der Kunsthistorischen Sammlungen in Wien*, LXXI (1975), 311–29.

Rudolph, Stella. 'C. R. e la Cappellania di Carlo Maratti a Camerano', *Paragone*, 347 (1979), 24–33.

Androssov, Sergey and Enggass, Robert. 'Peter the Great on horseback: a terracotta by R.', *Burl. Mag.*, CXXXVI (1994), 816–21.

Nessi, Silvana. 'Un Monumento ignorato nell'opera di C. R. a Montefalco', *Spoletium*, XX, 23 (1978), 45–53.

Martin, Frank. 'L'Emulazione della Romana anticha grandezza. C.R.s Grabmal für Gregor XIII.', *Zeitschr. f. Kunstg.*, LXI (1998), 77–112.

——'Eine neue Vita C. R.'s', *Röm. Jahrb. f. Kunstg.*, forthcoming.

See also *San Pietro: Arte e storia*, 1996, (III, ROME, *Sculpture*).

SACCHI

Harris, Ann S., in Harris, A. S. and Schaar, Eckhard. *Kataloge des Kunstmuseums Düsseldorf, III; Handzeichnungen I. Die Handzeichnungen von Andrea Sacchi und Carlo Maratta*. Düsseldorf, 1967.

Harris, Ann S. *A. S.* Oxford, 1977.

See also Scott, *Images of Nepotism*, (II C, [Patronage, Urban VIII]).

SALINI

See M. Marini, 1982 (IV, under BAGLIONE).

SALVI

Pinto, John. *The Trevi Fountain*. New Haven, London, 1986.

Madeira Rodrigues, Maria Joao. *A Capela de S. Joao Baptista e as suas colecçoes na igreja de S. Roque, im Lisboa*. Lisbon, 1988 [complete photographs].

See above under Patrons, Rome: Garms in Vasco Rocca, *Giovanni V di Portogallo*. 1995, 113–23.

SANFELICE

Gambardella, Alfonso. *Ferdinando Sanfelice architetto*. Naples, 1974.

Costa, Giovanni. *Il Palazzo dello Spagnuolo ai Vergini in Napoli*. Naples, 1979.

Cavallo, R.M. 'Disegni del S. al Museo di Capodimonte', *Napoli Nobilissima*, 21 (1982), 219–30.

Morrice, R.J. 'S. and St. Florian: Indigenous Tradition and Staircase Design', *Architectural History*, 26 (1983), 82–6.

Thoenes, Christof. 'A Special Feel for Stairs. Eighteenth-century Staircases in Naples', *Daidalos*, 9 (1983), 77–85.

Natella, P. 'F. S. e il monastero di S. Giorgio a Salerno', *Napoli Nobilissima*, 24 (1985), 112–15.

Ward, Alastair. *The Architecture of F. S.* New York, London, 1988 [full bibliography and documentation].

SANMARTINO

Catello, E. *Sanmartino*. Naples, 1988.

See also G. Borrelli (II, B, RELIGIOUS)

SARACENI

Ottani Cavina, Anna. *Carlo Saraceni*. Milan, 1968.
 Review: B. Nicolson. *Burl. Mag.*, CXII (1970), 312–15.

Pérez-Sánchez, Alfonso E. 'C. S. à la Cathédrale de Tolède, et les relations hispano-romaines dans la peinture espagnole au début du XVIIe siècle', *Évolution générale et développements régionaux en histoire de l'art (Actes du XXIIe Congrès Internationale d'Histoire de l'Art)* (1969). Budapest, II (1972), 25–32.

Mortari, Luisa. 'C. S. nella chiesa romana di S. Maria in Aquiro' *Arte veneta*, XXVI (1972), 121–32 [discusses paintings after restoration].

Waddingham, Malcolm. 'An Important S. Discovery', *Paragone*, 419–21–23 (1985), 219–24.

Ottani Cavina, Anna. 'Les peintres de la réalité et le cercle caravaggesque de Rome; réflexions sur l'atelier de S.', in *L'art en Lorraine au temps de Jacques Callot*. Nancy, 1992, 60–8.

See also A. Ottani Cavina, 1976 (II,B, *Landscape*)

SARDI

Mallory, Nina. 'The Architecture of Giuseppe Sardi and the Attribution of the Façade of the Church of the Maddalena', *J.S.A.H.*, 26 (1967), 83–101.

Piffaretti, P. G. *S. architetto ticinese nella Venezia del Seicento*. Bellinzona, 1996.

SASSOFERRATO

Macé de Lépinay, François. 'Archaïsme et purisme au XVIIe siècle: les tableaux de Sassoferrato à S. Pietro de Pérouse', *Revue de l'art*, 31 (1976), 38–56.

Macé de Lépinay, François (and others). *Giovanni Battista Salvi, 'il Sassoferrato'* (exhib. cat., San Severino Marche). Milan, 1990. Review: F. Russell, *Burl. Mag.*, CXXXII (1990), 808–9.

SCAMOZZI

Scamozzi, Vincenzo. *Taccuino di viaggio da Parigi a Venezia (14 marzo–11 maggio 1600)*. Venice and Rome, 1959.

—— *L'idea della architettura universale* (2 vols). Venice, 1615. Reprints: Gregg Press 1964; Bologna, 1982; Eds F. Barbieri and W. Oechslin, Vicenza (CISA Andrea Palladio), 1997. With prior bibliography. English translation, 1676, 1687.

Keith, W.G. 'Drawings by Vincenzo Scamozzi', in *Journal of the Royal Institute of British Architects*, 42 (1935), 525–35.

Barbieri, Franco. *V. S.* Vicenza, 1952.

Elam, Caroline. 'V. S. and the Medici Family: Some Unpublished Letters', *in Renaissance Studies in Honour of Craig Hugh Smyth*. Ed. A. Morrogh, Florence, 1985, 203–18.

Hopkins, Andrew and Witte, Arnold. 'From Deluxe Architectural Book to Builder's Manual: the Dutch Editions of S.'s *L'Idea della Architettura Universale*', *Quaerendo*, 26.4 (1996), 274–302.

SERODINE

Longhi, Roberto. *Giovanni Serodine*. Florence, 1954.

Chiappini, Rudy (ed.). *S., l'opera completa*. Milan, 1987.

Papi, Gianni and Contini, Roberto. *Ampiamenti per G. S.* (*Stumenti e documenti per lo studio del passato della Svizzera italiana*, 6). Bellinzona, 1990 [largely covered in 1990 catalogue].

S. La pittura oltre Caravaggio (exhib. cat., Locarno). Milan, 1990.

G. S. 1594/1600–1630 e i precedenti romani (exhib. cat., Rancate). Ed. R. Contini and G. Papi, Lugano, 1993

SERPOTTA

Meli, Filipo (ed.). *Giacomo Serpotta (Secondon centenario serpottiano 1732–1932)* (2 vols). Palermo, 1934.

Garstang, Donald. 'G. S. and the Casa Professa: A Discovery', *Antologia di belle arti*, 23–4 (1984), 38–61.

——. 'The Oratorio della Madonna della Consolazione e S. Mercurio in Palermo and the early activity of G. S.', *Burl. Mag.*, CXXX (1988), 430–2.

——. 'The Maryrdom of St. Andrew: a Newly Discovered Terracotta Relief by G. S.', *Apollo*, CXXI (1984), 304–9.

——. *G. S. e gli stuccatori di Palermo*. Palermo, 1990 [revised and improved edition of the English version (London, 1984); includes material published in intervening articles].

SILVANI, G. and P.F.

Giglioli, Odoardo. 'La cappella Inghirami nella cattedrale di Volterra', *Rivista d'Arte*, 12 (1930), 429–54.

Lankheit, Klaus. 'Die Corsini-Kapelle in der Carmine-Kirche zu Florenz und ihre Reliefs', *Mitteilungen des Kunsthistorischen Instituts in Florenz*, 8 (1957), 35–60.

Linnenkamp, Rolf. 'Una inedita vita di Gherardo Silvani', *Rivista d'Arte*, 33 (1958), 73–114.

Matteoli, Anna. 'I modelli lignei del '500 e del '600 per la facciata del Duomo di Firenze', *Commentari*, 25 (1974), 73–110.

Chini, Ezio. *La chiesa e il convento dei Santi Michele e Gaetano a Firenze*. Florence, 1984.

SLODTZ

Souchal, François. *Les Slodtz, sculpteurs et décorateurs du roi*. Paris, 1967 [exhaustive treatment of all the members of the family].

See also *San Pietro: Arte e storia*, 1996 (III, ROME, *Sculpture*).

SOLIMENA

Bologna, Ferdinando. *Francesco Solimena*. Naples, 1958.

Angelo e F. S. Due culture a confronto (exhib. cat., Nocera Inferiore). Milan, 1990.

Angelo e F. S. Due culture a confronto. Ed. V. de Martini and A. Braca, Naples, 1994.

SORIA

Ringbeck, Birgitta. *Giovanni Battista Soria: Architekt Scipione Borgheses*. Diss. *Münster*, 1989.

SPADARO

Sestieri, Giancarlo and Daprà, Brigitte. *Domenico Gargiulo detto Micco Spadaro: Paesaggista e 'cronista' napoletano*. Milan, 1994.

SPECCHI

Ashby, Thomas and Welsh, Stephen. 'Alessandro Specchi', *The Town Planning Review*, 12 (1927), 237–48.

Marder, Tod. 'The Destruction of the Porto di Ripetta in Rome', *Storia della Città*, 9 (1978), 62–70.

—— 'The Porto di Ripetta in Roma', *J.S.A.H.*, XXXIX (1980), 28–56.

Giuggioli, A. *Il Palazzo de Carolis in Roma*. Rome, 1980.

Marder, Tod. 'S.'s high altar for the Pantheon and the statues by Cametti and Moderati', *Burl. Mag.*, 122 (1980), 30–40.

Repetto, M.D. 'Le trasformazioni di A. S. in Palazzo Fusconi-Pighini (Pichini)', *Architettura. Storia e documenti*, 1986, 31–54.

Morolli, G. 'Un saggio di editoria barocca: I rapporti Ferri–De Rossi–S. e la trattatistica architettonica del Seicento romano', in Marcello Fagiolo (ed.). *Gian Lorenzo Bernini e le arti visive*. Rome, 1987, 209–40.

Principato, Barbara. 'Documenti inediti per la vita e l'opera di A. S.', *Palladio*, 3, n. 6 (1990), 9–118.

Spagnesi, G. (ed.). *La Piazza del Quirinale e le antiche scuderie papali*. Rome, 1990.

STANZIONE

Schütze, Sebastian and Willette, Thomas. *Massimiliano Stanzione: l'opera completa*. Naples, 1992
Review: O. Bonfait, *Revue de l'art*, 100 (1993), 89–90.

STROZZI

Mortari, Luisa. *Bernardo Strozzi*. Rome, 1966.

Pesenti, Franco R. *L'Officina di B. S.* (exhib. cat.). Genoa, 1981.

Algeri, Giuliana. 'Una Madonna *Odigitria* ritrovata e altre testimonianze per la prima attività di B. S.', *Studi di storia dell'arte* (Todi), III (1992), 149–80.

B. S.: Genova 1581/82–Venezia 1644 (exhib. cat., Genoa). Milan, 1995.

SUBLEYRAS

Pierre Subleyras (exhib. cat., Paris, Rome). Ed. O. Michel and P. Rosenberg, Rome, 1987.

TACCA, FERDINANDO AND PIETRO

Torriti, Piero. *Pietro Tacca da Carrara*. Carrara, 1975.

Brook, Anthea. 'Rediscovered Works of Ferdinando Tacca for the former High Altar of S. Stefano al Ponte Vecchio', *Mitteilungen des Kunsthistorischen Institutes in Florenz*, XXIX (1985), 111–28.

TANZIO

Testori, Giovanni. *Tanzio da Varallo* (exhib. cat.). Turin, 1959. Review: M. Rosci, *Burl. Mag.*, CII (1960), 31–2.

Bologna, Ferdinando. 'Altre prove sul viaggio romano del T.', *Paragone*, 45 (1953), 39–45.

Previtali, Giovanni. 'Frammenti del T. a Napoli', *Paragone*, 229 (1969), 42–5.

TASSI

Waddingham, Malcolm. 'Notes on Agostino Tassi and the Northerners', *Paragone*, 147 (1962), 13–24.

Pugliatti, Teresa. *A. T. fra conformismo e libertà*. Rome, 1977.

Cavazzini, Patrizia. *Palazzo Lancelotti ai Coronari: Officina di A. T.* Rome, 1998.

TESTA

Cropper, Elizabeth. *The Ideal of Painting. Pietro Testa's Düsseldorf Notebook*. Princeton, 1984. Review: D. S. Pepper, *Master Drawings*, XXVI (1988), 363–9.

——(and others). *P. T. 1612–1650: Prints and Drawings* (exhib. cat., Philadelphia and Harvard). University Park, Pa., 1988. Review: H. Brigstocke, *Burl. Mag.*, CXXXI (1989), 175–8.

TIEPOLO, GIAMBATTISTA AND DOMENICO

Knox, George. *Giambattista and Domenico Tiepolo: A Study and Catalogue Raisonné of the Chalk Drawings* (2 vols). Oxford, 1980 [K's views on the function of chalk drawings in the Tiepolo studio are no longer widely accepted; in particular, his argument that the drawings of

details in paintings of the 1740s and '50s are by G.B. rather than copies by D.].

Succi, Dario (ed.). *G. T.: Il segno e l'enigma* (exhib. cat.). Gorizia, 1985 [prints; dating not entirely reliable].

——— *I T. Verismo ed ironia* (exhib. cat.) Mirano, 1988 [prints; dating not entirely reliable].

Barcham, William L. *The Religious Paintings of G. T.: Piety and Tradition in Eighteenth-Century Venice*. Oxford, 1989.

Gemin, Massimo and Pedrocco, Filippo. *G. T.: I dipinti, opera completa*, Venice, 1993 [Replaces earlier catalogues by Morassi and Palluchini]. Review: S. Loire, *Kunstchronik*, Jan. 1997, 23–32.

Aikema, Bernard. *T. and his Circle: Drawings in American Collections* (exhib. cat., New York, Harvard). Cambridge, 1996.

Christiansen, Kieth (ed.). *G. T. 1696–1770* (exhib. cat.). New York, 1996. Italian edition, shown Venice, 1996.

Knox, George and Gealt, Adelheid M. *D. T.: Master Draftsman* (exhib. cat.). Indianapolis, 1996 (previously shown Udine) [see comment on Knox, 1980].

Krückmann, Peter O. (ed.). *Der Himmel auf Erden: T. in Würzburg* (2 vols) (exhib. cat.). Würzburg, 1996.

——*T.: Masterpieces of the Würzburg Years*, Munich, 1996 [based on research for 1996 exhib. cat.].

Brown, Beverly L. (ed.). *G. T.: The Master of the Oil Sketch* (exhib. cat.). Fort Worth, 1998.

TORELLI

Bjurström, Per. *Giacomo Torelli and the Baroque Stage*. Stockholm, 1962 [revised from 1961 ed.].

TRAVERSI

Ghidiglia Quintavalle, Augusta. 'Inediti di Gaspare Traversi', *Paragone*, 81 (1956), 39–45.

Bologna, Ferdinando. *G. T. nell'illuminismo europeo*. Naples, 1980

Heimbürger-Ravalli, Minna. 'Data on the life and Work of G. T. (1722–1770)', *Paragone*, 383–5 (1982), 15–42.

Barocelli, Francesco. 'Per la discussione sul T.: I. Problemi di committenza e il ciclo di Castell'Arquato', *Paragone*, 383–5 (1982), 43–88.

Bologna, Ferdinando. 'Ancora di G. T. e gli scambi artistici fra Napoli e Spagna alla ripresa "naturalistica" del XVIII secolo', in *I Borboni di Napoli e i Borboni di Spagna* (acts of colloquium, 1981). Naples, 1985, 237–350.

TREVISANI

Di Federico, Frederick R. *Francesco Trevisani, Eighteenth-century Painter in Rome: A Catalogue Raisonné*. Washington, 1977. Review: G. Sestieri, *Antologia di belle arti*, I (1977), 372–9.

VACCARINI

Fichera, Francesco. *G. B. Vaccarini e l'architettura del settecento in Sicilia* (2 vols). Rome, 1934.

VALENTIN

Cuzin, Jean-Pierre. 'Pour Valentin', *Revue de l'art*, 28 (1975), 53–61.

Mojana, Marina. *V. de Boulogne*. Milan, 1989.

See also *Caravaggisti francesi* (II,5).

VALLE, F. DELLA

Honour, Hugh. 'Filippo della Valle', *Connoisseur*, CXLIV (1959), 172–9.

Minor, Vernon H. 'F. d. V.'s Monument to Sampaio: An Attribution Resolved', *Burl. Mag.*, CXVII (1975), 659–63.

——'D. V. and G. B. Grossi Revisited', *Antologia di belle arti*, 7–8 (1978), 233–44 [the identification of the sculptor with the brass-worker is suspect].

——'D. V. or Cayot? The Art of Deceiving Well', *Apollo*, CXXIII (1986), 418–21.

——*Passivity and Tranquillity: The Sculpture of F. d. V.* Philadelphia, 1997.

See also *San Pietro: Arte e storia*, 1996 (III, ROME, *Sculpture*).

VALVASSORI

Barroero, L. 'Per Gabriele Valvassori', *Boll. d'Arte*, 60 (1975), 235–8.

Carandente, G. *Il Palazzo Doria Pamphilj*. Milan, 1975.

Gualdi Sabatini, Fausta. 'Opere giovanili di G. V.', *Storia Architettura*, 5, no. 1 (1982), 39–52.

Marcucci, Laura and Torres, Bruno. 'Le vicende architettoniche di due chiese romane: S. Macuto e S. Maria della Pietà', *Palladio*, n.s., 6, n.12 (1993), 59–108.

VAN BLOEMEN, see ORIZZONTE

VANSANZIO (Van Santen)

Hoogewerff, G. 'Giovanni van Santen, architetto della Villa Borghese', *Roma*, 6 (1928), 1–12; 49–64.

——'G. V. fra gli architetti Romani del tempo di Paolo V', *Palladio*, 5 (1941), 49–56.

——'Architetti in Roma durante il pontificato di Paolo V Borghese', *Archivio della R. deputazione romana di storia patria*, 66 (1943), 135–47.

VANVITELLI, GASPAR (VAN WITTEL)

Briganti, Giuliano. *Gaspar Van Wittel e l'origine della veduta setecentesca*. Rome, 1966 [a broad study of topographical landscape painting; ouevre catalogue, fully illustrated. Supercedes all previous writings on G. v. W.]
Review: W. Vitzthum, *Burl. Mag.*, CIX (1967), 317–18.

VANVITELLI, L.

Vanvitelli, Luigi. *Dichiarazione dei disegni del real palazzo di Caserta*. Naples, 1756; facsimile ed. C. de Seta, Milan, 1997.

Fichera, Francesco. *L. V.* Rome, 1937.

Garms, Jörg. 'Die Briefe des L. V. an seinen Bruder Urbano in Rom: Kunsthistorisches Material', *Römische Historische Mitteilungen*, XIII (1971), 236.

——*Disegni di L. V. nelle collezioni pubbliche di Napoli e di Caserta*. Naples, 1973.

Di Stefano, Roberto (ed.). *L. V.* Naples, 1973.

Garms, Jörg. 'Beiträge zu V.s Leben, Werk und Milieu', *Römische Historische Mitteilungen*, XVI (1974), 107–90.

Fiengo, Giuseppe. *V. e Gioffredo nella Villa Campolieto di Ercolano*. Naples, 1974.

Garms, Jörg. 'Altäre und Tabernakel von L. V.', *Wiener Jahrbuch für Kunstgeschichte*, 27 (1974), 140–57.

Vanvitelli, Luigi, Jr. *Vita di L. V.* Ed. M. Rotili, Naples, 1975 [fundamental source].

Strazzullo, Franco (ed.). *Le lettere di L. V. della biblioteca Palatina di Caserta* (3 vols). Galatine, 1976–7 [fundamental].

Carreras, P. *Studi su L. V.* Florence, 1977.

L. V. e il '700 Europeo. Congresso Internazionale di Studi (1973) (2 vols). Naples, 1979 [the major congress].

Garzya Romano, Chiara. *Note Vanvitelliane*. Naples, 1979.

Il lazzaretto di L. V. Ingagine su un'opera (exhib. cat.). Ancona, 1980 [architecture and plague].

Hersey, George. *Architecture, Poetry, and Number in the Royal Palace at Caserta*. Cambridge, Ma., 1983.

Marinelli, C. (ed.). *L'esercizio del disegno, I V.: catalogo generale del fondo dei disegni della Reggia di Caserta*. Rome, 1991.

De Seta, Cesare. *Il Reale Palazzo di Caserta*. Naples, 1991.

Garms, Jörg. 'The Church of the Annunziata in Naples', *Parthenope's Splendor: Art of the Golden Age in Naples*. Eds J.C. Porter and S. Munshower, University Park, Pa., 1993, 397–429.

Ciapparelli, Pier Luigi. *L. V. e il teatro di corte di Caserta*. Naples, 1995.

De Seta, Cesare, ed. *L.V.*, Naples, 1998.

VERMEXIO

Agnello, Giuseppe. *I Vermexio. Architetti ispano–siculi del secolo XVII*. Florence, 1959.

VIGNALI

Mastropierro, Franca. *Jacopo Vignali, pittore nella Firenze del Seicento*. Milan, 1973 [inadequate study]. Review: M. Chappell, *Art Bull.*, LIX (1977), 435–7 [adds much to the subject].

VITTONE

Vittone, Bernardo Antonio. *Istruzioni elementari concernenti l'officio dell'architetto civile*. Turin 1760; *Istruzioni diverse concernenti l'officio dell'architetto civile*. Turin, 1766.

Portoghesi, Paolo. *B. V.: un architetto tra illuminismo e rococò*. Rome, 1966.

Wittkower, Rudolf. 'V.'s Drawings in the Musée des Arts Décoratifs', *Studies in Renaissance and Baroque Art presented to Anthony Blunt*. London, New York, 1967, 165–72.

Quaglino Palmucci, Laura. 'B.-A.-V.: Eglises Saint-Bernardin de Chieri et Sainte-Claire de Verceil', *Société française d'archéologie. Congrès archéologique du Piémont*, 129 (1971), 387–403.

Wittkower, Rudolf. 'Le cupole del V.', in *B. V. e la disputa fra classicisimo e barocco nel settecento* (1970). Turin, 1972, 17–32.

Oechslin, Werner. *Bildungsgut und Antikenrezeption im frühen Settecento in Rom. Studien zum römischen Aufenthalt B. A. V.* Zurich, 1972.

B. V. e la disputa fra classicisimo e barocco nel settecento (2 vols). Turin, 1972 [acts of the symposium of 1970, a fundamental source for future research].

Sitzia, Giuseppe and Paolo. 'La parrocchiale di Grignasco: documenti e cronaca del cantiere. I Parte: B. A. V. e la costruzione del Tempio', *Boll. d'Arte*, n. 53 (1989), 11–66; 'II Parte: I lavori dopo il vittone fino all'Ottocento', n. 54, 63–136 [documents, drawings and bibliography].

See under REGIONS, TURIN AND PIEDMONT: Pommer. *Eighteenth-Century Architecture in Piedmont*. Ch. 9.

VITTOZZI

Carboneri, Nino. *Ascanio Vitozzi. Un architetto tra manierismo e barocco.* Rome, 1966.

Scotti, Aurora. *A. V. ingegnere ducale a Torino.* Florence, 1969.

VOLTERRA, FRANCESCO DA

Marcucci, Laura. 'Due progetti di cappelle nei disegni di Francesco da Volterra', *Palladio*, 19 (January–June 1997), 53–76.

VOLTERRANO, SEE FRANCESCHINI, BALDASSARE

ZANCHI

Riccoboni, Alberto. 'Antonio Zanchi e la pittura veneziana del Seicento', *Saggi e memorie di storia dell'arte*, V (1966), 53–135 [full biography, catalogue, bibliography].

Hannegan, B. 'A. Z. and the ceilings of the salone in the Palazzo Barbaro Curtis', *Arte veneta*, XXXVII (1983), 201–5.

See also *I pittori bergamaschi; Il Seicento*, IV (1987), 389–707 [P. Zampetti (and others).].

ZUMBO

Lightbown, Ronald. 'Gaetano Giulio Zumbo – I: The Florentine Period', *Burl. Mag.*, CVI (1964), 486–96; 'II: Genoa and France', 563–9.

Giansiracusano, Paolo. *G.G.Z. (Siracusa 1656–Parigi 1701)* (exhib. cat., Siracuse). Milan, 1988.

Cumulative Index to Volumes I, II and III

PHOTOGRAPHIC ACKNOWLEDGEMENTS

AKG London 10, 65, 123; Archivi Alinari 2, 3, 6, 7, 9, 11, 12, 13, 14, 16, 21, 27, 29, 37, 45, 50, 54, 55, 56, 62, 64, 66, 68, 69, 70, 71, 72, 73, 74, 76, 77, 78, 86, 87, 89, 90, 92, 95, 98, 106, 109, 113, 118, 119, 121, 122, 130, 131, 132, 139; James Austin 38, 41; Osvaldo Böhm 17, 19, 80, 82, 84; Canali Photobank 22, 83, 93, 105, 114; Joseph Connors 24, 30, 31, 43, 49; The Conway Library, Courtauld Institute of Art, London 79; Foto Fiorentini 85, 138; National Museums and Galleries on Merseyside 117; Rodolfo Pallucchini 125; Paolo Portoghese 59, 61; Scala ii–iii, 15, 42, 44, 51, 88, 120, 124, 128, 133, 134; Archivio Fotografico Storici Provincia di Treviso 116; A. Villani e Figli 107; The Warburg Institute 75.